W. B. YEATS AND THE IDEA OF A THEATRE

W. B. Yeats and the Idea of a Theatre

THE EARLY ABBEY THEATRE
IN THEORY AND PRACTICE

James W. Flannery

New Haven and London
YALE UNIVERSITY PRESS

Originally published in Canada by
The Macmillan Company of Canada Limited.
Published in Great Britain, Europe, Africa, and Asia
(except Japan) by Yale University Press, Ltd., London.
Paperbound edition published 1989 by Yale University Press.

Printed in the United States of America

Library of Congress catalog card number: 74–29721
International standard book number: 0–300–01773–1 (cloth)
0–300–04627–8 (paper)

The paper in this book meets the guidelines for
permanence and durability of the Committee on
Production Guidelines for Book Longevity of the
Council on Library Resources.

10 9 8 7 6 5 4 3 2

This book is dedicated to my parents,
the late JAMES J. FLANNERY
of Clonmacnois, Co. Offaly
and
EILEEN COTTER FLANNERY
of Cloonanaha, Co. Clare,
who instilled within me a love of Ireland
that lies behind everything
I have written.

Contents

Illustrations

Introduction

Although few critics would question W. B. Yeats's stature as the greatest lyric poet of the twentieth century, grave doubts inevitably arise whenever his work as a dramatist is considered. Eric Bentley, for instance, declares that Yeats "did not really like the actual theatre" and "did not subject himself to the discipline of the theatre as he did to the discipline of the book".[1] Robert Hogan is another critic who argues that Yeats was "never interested in the theatre and knew little about it". He goes on to claim that Yeats employed dance in his plays in order to "supply action that [he had] not himself created" and that Yeats "wanted to dispense with both the public and the physical theatre".[2] Even Yeats specialists such as T. R. Henn question Yeats's very instincts as a dramatist. Henn says that Yeats had "none of the true dramatist's incessant curiosity for character" nor the gift of its "detailed creation or development".[3]

The fact that Yeats spent some fifty years of his life not only writing plays but intimately involved in the practical theatre, the fact that he founded his own theatre and worked to keep it alive as a laboratory in which to test his own dramatic theories as well as the work of his colleagues, and the fact that he continually protested his need to express

1. Eric Bentley, *The Playwright as Thinker* (New York: Meridian Books, 1960), p. 187.
2. *After the Irish Renaissance* (London: Macmillan Co., 1968), pp. 187-89.
3. *The Lonely Tower* (London: Methuen & Co., 1950), p. 81. Cf. Richard Ellmann, *Yeats: The Man and the Masks* (London: Faber and Faber, 1960), p. 186.

himself in dramatic terms—all this has with few exceptions made little impression on the critics.[4]

As a corollary to Yeats's own failure to be taken seriously as a dramatist, the extraordinary work of the early Abbey Theatre has also fallen into disrepute. An American drama critic recently dismissed an Abbey production at the Edinburgh Festival with the remark: "The Abbey Theatre, sir, is not what it used to be. No, and it never was."[5] *The Irish Times* celebrated the opening of the new Abbey Theatre in July 1966 with an editorial advising its readers not to harbour nostalgic memories of the Abbey Theatre's past:

The accepted picture of our national theatre is that it once showed noble plays nobly acted and it has now degenerated in both plays and players. It cannot be just as simple as all that. When the Abbey Theatre started there were far fewer opportunities for Irish writers and actors. What was presented at the Abbey would not have seen the light of day anywhere else. . . . If Frank Fay could be brought back from the shades his direction might now embarrass a modern cast and seem stilted to a contemporary audience. . . . It is tacitly agreed that the failure to make Yeats's plays popular is some deficiency in actors or audiences. But of all the arts the theatre is one in which success with the public is an essential element in the art itself.[6]

There is, of course, some truth in these capsule criticisms. But there is also a great deal that is only half-understood or not understood at all.

This book is an attempt to rectify the common misjudgments and misunderstandings of both Yeats and the early Abbey Theatre. Its basic thesis—if one may use the word in a broad sense—is that Yeats's dramatic theories are more important than his actual practices. In setting forth this proposition it is certainly not my intention to imply that the practical results of Yeats's theories—his own dramatic work

4. Cf. Louis MacNeice, *The Poetry of W. B. Yeats* (London: Oxford University Press, 1941), p. 196; Helen Vendler, *Yeats's Vision, and the Later Plays* (Cambridge: Harvard University Press, 1963), in which the last four chapters dismiss every one of Yeats's plays as untheatrical; Edmund Wilson, *Axel's Castle* (New York: Charles Scribner's Sons, 1943), p. 41.

5. James Rosenberg, "Report from Edinburgh", *Arts in Society*, VI, 2 (1969), p. 268. An examination of five recent textbooks for Introduction and Orientation to the Theatre courses in North American universities also reveals the surprising fact that the Abbey Theatre is not at all or barely mentioned.

6. "All Our Yesterdays" (July 23, 1966), p. 18.

and the Abbey Theatre itself—are of negligible value. Nor do I mean that for Yeats practice was not as important as theory. Indeed, I shall demonstrate that Yeats's theories of the drama and his own dramatic work were continually revised and reshaped in terms of his practical experience in the theatre. But throughout his career as a dramatist and his involvement with the Irish dramatic movement Yeats's basic struggle was to reconcile theory with practice. And in the struggle the practical realities of life and the theatre caused his original theories and ideals to be misconstrued, attacked, destroyed, and ultimately forgotten.

With the loss of Yeats's original "Idea of a Theatre"[7] we have lost a considerable part of his own claim to greatness as a dramatist. We have also lost sight of one of the primary reasons for the phenomenal success of the early Abbey Theatre.

Our chief endeavour, then, will be to rediscover what Yeats's dramatic and theatrical ideals actually were as well as how they evolved out of his personal philosophy of life and his aesthetic as a poet and were tested on the stage of the early Abbey Theatre. I hope that in this way we shall be able to make a valid assessment of the reasons for Yeats's failure as a dramatist—or whether, in fact, his dramatic work is a failure at all. I hope that we shall also be in a better position to evaluate the true importance of the Abbey Theatre, both from the standpoint of Yeats's own ideals and from the standpoint of its place within the context of Ireland and the modern theatre as a whole.

It will be evident that a subject of this nature and scope presents a number of special problems with which the author and ultimately the reader must contend. The first of these is that the reader familiar with Yeats is by and large likely to be more conversant with the language of literature than the lan-

7. This book owes its title and some of the concepts upon which it is based to Francis Fergusson's brilliant critical study, *The Idea of a Theatre* (New York:, Doubleday Anchor Books, 1949). Fergusson analyses five major periods in the history of the theatre in terms of Aristotle's theory of action, arguing that "there is an art of drama in its own right, not derived from the more highly developed arts and philosophies, but based upon a uniquely direct sense of life". In the truly great periods in the history of the theatre, playwrights have imitated such actions as have intellectually and spiritually placed their respective theatres "at the centre of the life of the community" (Introduction, p. 15).

guage of the theatre. Unfortunately, this is also true of many Yeats specialists. As a result, most previous studies on Yeats, even those dealing specifically with his plays, have concentrated on literary at the expense of theatrical concerns and values.

Theatre, of course, is a complex art demanding many considerations beyond those that normally fall within the realm of literature. Yeats himself made those considerations—including the practical techniques of the theatre—an important part of his life's work. On this ground alone a detailed analysis of his work in the theatre would seem long overdue.

For the reader who happens to be a student or practitioner of the theatre the problem may be reversed. The anti-literary and anti-intellectual bias of much contemporary theatre has led to a common attitude in which everything but the immediate theatrical effectiveness of a play is deemed irrelevant. Yeats, too, was immensely concerned with theatrical effectiveness. But, far more than this, he was a philosopher-poet with a comprehensive world-view comparable perhaps only to that of Goethe. Yeats was also an intensely personal artist whose life was interwoven into all that he wrote. One simply cannot properly interpret or respond to his work in a glib or facile manner. An understanding of Yeats's world-view, particularly his literary, philosophical, and religious beliefs and his ideas on the relationship of nationalism and art within an Irish context, is essential to an understanding of all that he attempted in the theatre.

I must admit that when I began my research for this book more than ten years ago I was as sceptical of Yeats's concepts of the theatre and his practical ability as a dramatist as some of the critics I have cited. My scepticism was not overcome until I directed a successful production of two Yeats plays, *Calvary* and *The Resurrection*, for the 1965 Dublin Theatre Festival. Many of the conclusions of the book are based upon this and other Yeats productions that I have subsequently staged.

It will be noted that the structure of the book is not a linear one in so far as it does not follow a chronological sequence of events except within individual chapters. This approach has been chosen because, in many respects, Yeats's own philosophy of life and art did not develop according to a

sequential pattern but rather by means of a continual redis-covery, in new forms, of those truths and intuitions that he experienced as early as boyhood and early youth. For this reason I believe there is a fundamental identity between Yeats's early and later work for the theatre that has not been sufficiently recognized or appreciated. Yet another reason for choosing a non-linear structure is in order to focus in depth upon each of the various aspects of Yeats's career as a dramatist and man of the theatre.

Finally, few topics have been subject to greater distortion, speculation, and outright gossip than the history of the Abbey Theatre and Yeats's role in its creation. At the risk of boring some readers and alienating others I thought it better to err on the side of documentation than to perpetuate further myth-making in the name of scholarship.

Acknowledgments

Grateful acknowledgment is made to Miss Anne Yeats and to Senator Michael Yeats for allowing me to examine freely the following material in their possession: unpublished letters from Yeats to Lady Gregory and Synge, letters from Gordon Craig to Yeats, stage designs by Robert Gregory, photographs of Abbey Theatre productions, and notebooks in which Yeats sketched scene designs based upon the Gordon Craig screens. I am grateful to Miss Yeats and Senator Yeats for permission to quote from and to reproduce some of the above material.

Thanks are also due to the staff of the National Library of Ireland for their help in locating material pertinent to the early Abbey Theatre. I am indebted to the Council of Trustees of the National Library of Ireland for permission to quote from and to reproduce some of this material, as cited in the text. I am also indebted to the Bibliothèque Nationale, Paris, for allowing me to examine and quote from material in the Collection Edward Gordon Craig.

This book began as a doctoral thesis for Trinity College, Dublin in which I intended to explore the production methods at the Abbey Theatre. Early in my research I read a doctoral thesis for the University of London by Ann Saddlemyer entitled "Dramatic Theory and Practice in the Irish Literary Theatre". Dr. Saddlemyer's thesis, which she has since transformed into a number of significant books and articles on the Irish dramatic movement, opened up a whole new range of possibilities for me and helped to change the

whole focus of my study. With Dr. Saddlemyer's approval and advice, I retraced many of her own steps in an endeavour to examine the origins of the Irish dramatic movement specifically from the standpoint of Yeats. While my approach and conclusions differ considerably from hers, my indebtedness to her pioneering efforts is none the less considerable.

Considerable assistance has been given to me by Professor R.B.D. French of Trinity College, Dublin, who supervised my doctoral thesis. I am also indebted to Professor Anthony Graham-White, editor of the *Educational Theatre Journal*, Professor Robert O'Driscoll, editor of *Yeats Studies*, Professor George Harper, and Liam Miller, editor of the Dolmen Press, for their generous advice and assistance in preparing the manuscript. I owe special thanks to the Canada Council and to the University of Ottawa for their financial support during the preparation of the manuscript.

Thanks are also due to the late Ernest Blythe, the late Austin Clarke, the late Padraic Colum, the late Dr. Constantin Curran, the late Gerard Fay, the late Dr. Thomas MacGreevy, Micheál MacLiammoir, and the late Ria Mooney, as well as many former Abbey actors and actresses, for granting me hospitality and sharing their memories. Special thanks are owed to Conor and Meryl (Gourley) Farrington as well as many other Irish friends and relatives for giving me a home away from home and for introducing me to the warmth and exhilaration of life in Ireland.

Above all, I owe thanks to my wife, Ildiko, for many patient hours copying manuscripts in the National Library of Ireland and for her continual interest and support.

I wish to express my grateful appreciation for permission to quote material copyrighted by the following or in some other sense belonging to them:

To Anne Yeats and Michael Butler Yeats, and to A. P. Watt and Son, their agents, for quotations from the following works by W. B. Yeats: *Ah, Sweet Dancer*, ed. Roger McHugh, *Autobiographies, The Collected Plays of W. B. Yeats, The Collected Poems of W. B. Yeats, Correspondence 1900-1937, Essays and Introductions, Four Plays for Dancers, The Letters of W. B. Yeats*, ed. Allan Wade, *Letters on Poetry from W. B. Yeats to Dorothy Wellesley*,

Letters to the New Island, ed. Horace Reynolds, *Memoirs,* ed. Denis Donoghue, *Mythologies,* Preface to *The Oxford Book of Modern Verse, Plays and Controversies, Plays for an Irish Theatre, Plays in Prose and Verse, Poems: 1899-1905, The Secret Rose, Uncollected Prose 1886-1896, The Variorum Edition of the Plays of W. B. Yeats,* ed. Russell K. Alspach assisted by Catherine C. Alspach, *The Variorum Edition of the Poems of W. B. Yeats,* ed. Peter Allt and Russell K. Alspach, *A Vision,* and for quotations from the works of W. B. Yeats in the following books and journals: *W. B. Yeats, Man and Poet* by A. Norman Jeffares, *The United Irishman, Yeats and the Theatre,* ed. Robert O'Driscoll and Lorna Reynolds, *Yeats's Golden Dawn* by George Harper.

To Eric Bentley for quotations from *In Search of Theatre.*

To Christy & Moore, Ltd. for quotations from *J. B. Yeats: Letters to His Son and Others, 1869-1922.*

To Collins & Sons Company, Ltd. for quotations from *The Future of Man* and *The Phenomenon of Man* by Pierre Teilhard de Chardin.

To H. E. Robert Craig, as administrator of the Gordon Craig Estate, for permission to reproduce the Craig illustrations and to quote from Gordon Craig's published and unpublished works.

To The Cuala Press for quotations from *Some Letters from J. M. Synge to Lady Gregory and W. B. Yeats,* ed. Ann Saddlemyer.

To Alan Denson on behalf of the George Russell Estate for quotations from *Letters from A. E.*

To The Dolmen Press for quotations from *Towards a National Theatre: Dramatic Criticism of Frank Fay,* ed. Robert Hogan.

To Doubleday & Company, Inc. for quotations from *The Idea of a Theatre* by Francis Fergusson.

To Duckworth & Company, Ltd. for quotations from *The Heather Field* and *Maeve* by Edward Martyn.

To E. P. Dutton for quotations from *J. B. Yeats: Letters to His Son and Others, 1869-1922.*

To R. G. Gregory, as administrator of the Lady Gregory Estate, for quotations from unpublished letters preserved in the Henry W. and Albert A. Berg Collection, The New York Public Library.

To Harcourt Brace Jovanovich, Inc. for quotations from *The Playwright as Thinker* by Eric Bentley.

To Harper & Row Publishers, Inc. for quotations from *The Future of Man* and *The Phenomenon of Man* by Pierre Teilhard de Chardin.

To Hart-Davis MacGibbon, Ltd. for quotations from *The Letters of W. B. Yeats*, ed. Alan Wade.

To Harvard University Press for quotations from *The Feast of Fools* by Harvey Cox and *Yeats's Vision, and the Later Plays* by Helen Vendler.

To The Hutchinson Publishing Group for quotations from *The Fays of the Abbey Theatre* by W. G. Fay.

To Macmillan and Company, Ltd. for quotations from *After the Irish Renaissance* by Robert Hogan, and *The Unicorn: W. B. Yeats's Search for Reality* by Virginia Moore.

To Macmillan and Company, Ltd. for quotations from the following works by W. B. Yeats: *Ah, Sweet Dancer*, ed. Roger McHugh, *Autobiographies, Collected Plays, Collected Poems, Essays and Introductions, Mythologies, The Variorum Edition of the Plays of W. B. Yeats, The Variorum Edition of the Poems of W. B. Yeats, A Vision*.

To The Macmillan Company, New York, for quotations from *J. M. Synge* by David H. Greene and Edward M. Stephens and *The Unicorn: W. B. Yeats's Search for Reality* by Virginia Moore, and for quotations from the following works by W. B. Yeats: *Autobiographies, Collected Plays, Collected Poems, Essays and Introductions, The Letters of W. B. Yeats*, ed. Alan Wade, *Mythologies, The Variorum Edition of the Plays of W. B. Yeats, The Variorum Edition of the Poems of W. B. Yeats, A Vision*.

To MacGibbon & Kee, Ltd. for quotations from *The Empty Space* by Peter Brook.

To McGraw-Hill Book Company for quotations from *Lunatics, Lovers and Poets: The Contemporary Experimental Theatre* by Margaret Croydon.

To J. C. Medley, as administrator of the George Moore Estate, for quotations from *Hail and Farewell: Ave, Vale, Atque.*

To Methuen & Company, Ltd. for quotations from *Drama and Life* by A. B. Walkley.

To W. W. Norton & Company, Inc. for quotations from *Love and Will* by Rollo May.

To Oxford University Press for quotations from *Eminent Domain* by Richard Ellmann and *The Imagination of an Insurrection* by William Irwin Thompson.

To Random House, Inc. for quotations from *Ireland* by Micheál MacLiammoir and Edwin Smith and *The Portable Jung*, ed. Joseph Campbell.

To Simon & Schuster, Inc. for quotations from *How Not to Write a Play* by Walter Kerr and *Towards a Poor Theatre* by Jerzi Grotowski.

To Colin Smythe, Ltd. for quotations from the following works by Lady Gregory: *The Collected Plays*, ed. Ann Saddlemyer, *Journals 1916-1930*, ed. Lennox Robinson, *Our Irish Theatre*.

To The Society of Authors on behalf of the George Bernard Shaw Estate for quotations from *Our Theatre in the Nineties*.

To Southern Illinois University Press for quotations from *Joseph Holloway's Irish Theatre*, ed. Robert Hogan and Michael O'Neill.

To Thames & Hudson, Ltd. for quotations from *Ireland* by Micheál MacLiammoir and Edwin Smith.

To University of Michigan Press for quotations from *Lectures and Essays in Criticism* ed. R. H. Super.

To Vintage Books for quotations from *Behold the Spirit: A Study in the Necessity of Mystical Religion* by Alan Watts and *Memories, Dreams, Reflections* by Carl Jung, ed. Aniella Jaffe.

To the *Irish Times*, the *Sunday Times*, and the *Village Voice* for quotations from their pages.

W. B. YEATS AND THE IDEA OF A THEATRE

Drama as a Dialectic of Opposites

The most obvious difficulty in responding to Yeats's work in the theatre as dramatist, aesthetician, and theatre manager is the sheer complexity of his vision. To a considerable extent, this complexity arose from a lifelong conflict that raged within him—a conflict compounded of contrary impulses pulling him at once towards a life of introspection and towards a life of action and engagement.

In itself, there is nothing unique about this kind of conflict; the struggle to achieve a stable balance between the demands of the public and private self has always been part of man's existence, especially in modern times where heightened pressures have made the disoriented, even schizophrenic, personality commonplace. For Yeats, however, the fusion of these disparate elements of life into an organic whole became a necessity, not only for personal happiness but as a central means to artistic creation.

It is one of the marks of Yeats's greatness as a man that he managed to forge a unified conception and style of life out of his public and private conflicts. His efforts to attain this unity—or wholeness of the personality—were paralleled, indeed evinced, in all his work in the theatre.

In artistic terms, we may define Yeats's conflict as the struggle between lyric instinct and histrionic temperament. The former impulse led him to expression as a lyric poet; the

latter to expression as a dramatist. Again, neither lyric instinct nor histrionic temperament is unique in itself. But in the theatre they are combined only in those artists of the first rank. Such artists are rare in any age; in modern times they are almost nonexistent.

Yeats's genius as a dramatist and man of the theatre may be measured in terms of the unity that he ultimately created out of the dialectic of opposites that raged within his personality. By tracing the evolution towards this unity one can begin to appreciate the significance of his theatrical endeavour and achievement.

THE HISTRIONIC KNOWLEDGE OF THE BODY

Yeats was born in Dublin in June 1865 and spent most of the first ten years of his life at the family residence of his mother in Sligo. From early childhood he evidenced the basic characteristics of an introvert rather than those extroverted qualities that are normally associated with the histrionic, or dramatic, temperament.[1] Of his childhood Yeats himself tells us that he remembered little but the pain, though, he admits, a pain that was the making mainly of his own mind. To his father, even at the age of seven, Willie was a worry because of excessive "shyness, sensitiveness, and nervousness".[2]

Probably as a result of his misery and shyness—a shyness that haunted him until his death in January 1939—Yeats very early acquired the habit of shielding himself from the world by looking within and creating a personal vision of reality based upon his own dreams and fantasies.[3] Yeats says that

1. Peter Slade, *An Introduction to Child Drama* (London: University of London Press, 1958), pp. 3-6, distinguishes between what he calls "Projected Play", a kind of play in which a child, generally of introverted tendencies, employs his mind rather than his body; and "Personal Play", in which the "whole person" is employed through movement and characterization. A preference for the former kind of play usually leads to an enjoyment of non-physical games as well as a love of art, reading, and writing. A preference for the latter kind of play usually leads to athletics, acting, and drama *per se*.

2. Letter from John Butler Yeats to his wife (November 1, 1872), quoted by Joseph Hone in *W. B. Yeats, 1865-1939* (London: Macmillan, 1962), p. 17. Cf. W. B. Yeats, *Autobiographies* (London: Macmillan, 1961), p. 13.

3. In a letter from Yeats to Katharine Tynan quoted in *The Middle Years* (London: Constable & Co., 1916), p. 57, Yeats stated that as a boy in Sligo he used to follow two dogs all day long: "They taught me to dream, maybe. Since then I follow my thoughts as I then followed the two dogs—the smooth and the curly—wherever they lead me."

trying to control the excitement of his thoughts was like "trying to pack a balloon into a shed in high wind". He was naturally difficult to teach, and stood near the bottom of his classes. Locked as he was within a world of reverie, he re-called that his most vivid boyhood memories were of the things he saw when apart from others rather than what he did or saw in company.[4]

At the same time, an interesting counter-development took place in his personality. Perhaps in an endeavour to conquer his shyness, perhaps because of the influence of his father, who drove him to perfection in all things, Yeats very early formed the habit of reacting against the sensitive introspec-tive side of his nature by seeking its opposite.

This reaction first took the form of an exceptional interest in athletics. Although he was admittedly useless at games and ashamed all his boyhood of a lack of physical courage, Yeats tells us that he always admired what was physically beyond his imitation. In 1874 the Yeats family moved to London. Yeats formed a friendship with the best athlete in his London school and, in order to avoid being continually beaten up by the playground bullies of whom he was mortally afraid, attempted to bolster both his courage and self-reliance by taking boxing lessons. In order to demonstrate a physical prowess of which he was scarcely capable, Yeats also forced himself to dive from a greater height, swim farther under water, and run a longer distance without showing strain than any of the other boys of his age.[5]

The significance of Yeats's attempt to find a physical means of asserting himself should not be looked upon as the mere growing pains of a boy. The fact is, by his athletic endeavours ineffectual though they may have been, Yeats took a fundamental step towards developing that essential attribute of the dramatist—histrionic sensibility.

In *The Idea of a Theatre*, Francis Fergusson posits the idea of the histrionic sensibility as the very basis of dramatic art. "Histrionic sensibility," he says, is the ability to "perceive and discriminate actions", particularly physical actions. As music is based upon perception by the ear, drama is based upon a "mimetic" form of perception. Everyone, says Fergusson, is born with a certain degree of the histrionic

4. Vide *Autobiographies*, pp. 41, 23, 63.
5. Ibid., pp. 42, 52, 48, 158, 36-37, 39.

sensibility, for it is a "basic, or primary, or primitive virtue of the human mind". Like the musical ear, this sensibility can be cultivated and trained, but only by conscious practice. It follows that the actor must strive to become a "connoisseur of the histrionic sensibility".[6] It also follows that, as the composer develops his capacity to perceive and interpret sounds, the playwright should seek to develop his capacity to perceive and interpret actions. As Eric Bentley has stated: "The true playwright has the actor's nature, and if he turns out to be a great stage actor, he will probably act all the better in his private life."[7]

The fact that the physicalization of Yeats's boyish dreams and frustrations took the form of athletics is relevant to our discussion. Recent studies in audience psychology have emphasized the similarities between the basic appeals of theatre and of sports. Both primitive theatre and sporting events present archetypal characters in physicalized forms of conflict; both involve forms of ritual which focus the attention of the spectators upon complex physical patterns involving symbolic, as well as authentic, "real life" postures; and both involve a response to highly developed physical skills for their own sake.[8]

The mature art of drama, of course, goes far beyond either athletics or primitive theatre in the intellectual and emotional demands that it makes on spectators and practitioners. But, as Yeats was deeply aware, drama springs from a response to the human body as the potential source of a form of knowledge that in many ways transcends the ratiocinating knowledge of the mind. A dramatic gesture or movement may at times express more than the most eloquent words, as the athlete, actor, or dancer instinctively knows. An understanding of this kind of physical knowledge is essential for the true dramatist. Yeats not only possessed this understanding but made it a fundamental conception of his entire life. Shortly before his death he wrote: "It seems to me that I have found

6. Fergusson, *The Idea of a Theatre*, pp. 250-55.
7. *In Search of Theatre* (New York: Alfred A. Knopf, 1954), p. 300.
8. Vide Richard Schechner, *Public Domain: Essays on the Theatre* (Indianapolis: Bobbs-Merrill, 1969), pp. 71-88.

what I wanted. When I try to put all into a phrase I say 'Man can embody truth but he cannot know it.' "[9]
✕ Yeats cultivated and refined his natural histrionic sensibility to the point where, as we shall see, he wrote both about and for actors with the eye of a connoisseur. At the core of his histrionic responsiveness was an unabashed love of sheer physicality and "the divine architecture of the body". "An exciting person," he once wrote, "whether the hero of a play or the maker of poems, will display the greatest volume of personal energy and this energy must seem to come out of the body as out of the mind."[10] ✕

The essays, letters, and particularly the poetry and *Autobiographies* of Yeats are filled with vivid portraits of those people who moved and inspired him in actual life. Almost always they are portraits etched not with the psychological details of the modern novelist or dramatist, but with the histrionic details of the classical dramatist: telling moments wherein character is delineated through pure physical action.[11] One can tell by his re-creation of these figures that Yeats responded to them as if they were heroic characters who stepped into his life from a stage; in turn, they obviously provided him with living models for the kind of characters he was to create in his plays.

Such a portrait is that in the *Autobiographies* of Yeats's maternal grandfather, William Pollexfen, a former sailing captain with "a good deal of pride", a "violent temper", "great physical strength", and the "reputation of never ordering a man to do anything he would not do himself". Once, Yeats tells us, when his crew refused to dive down to check a damaged rudder, Pollexfen himself dived from the main deck of his ship with all the neighbourhood lined along the shore to watch. "He came up with his skin torn, but well informed

9. Letter to Lady Elizabeth Pelham (January 4, 1939). *The Letters of W. B. Yeats*, ed. Allan Wade (London: Rupert Hart-Davies, 1954), p. 922 (hereafter cited as *Letters*).
10. *Essays and Introductions* (New York: Macmillan, 1961), p. 266.
11. "I delight in the active man," he wrote in 1937, "taking the same delight in soldiers and craftsmen. I would have poetry turn its back upon all that modish curiosity, psychology." *Essays and Introductions*, p. 530.

about the rudder," Yeats says with pride. As a child Yeats both feared and admired the old man: "Even today when I read *King Lear* his image is always before me, and I often wonder if the delight in passionate men in my plays and in my poetry is more than his memory."[12]

Another passionate man to whom Yeats could not help responding was W. E. Henley, who published some of Yeats's early poems and articles on Irish folklore and introduced him to London literary circles in the late 1880s. Henley was Yeats's opposite in almost every respect. As the editor of the *Scots Observer* and the *National Observer* he had set himself up as the leader of the anti-aesthetic, anti-decadent literary movement in England, had an intense dislike for pre-Raphaelitism, and wrote poetry in a *vers libre* style which Yeats associated with the hated scientists Tyndal and Huxley. Politically, he was a violent Unionist and Imperialist. Yet even while disagreeing with Henley about everything, Yeats says that he "admired him beyond words". Again, his response to Henley was couched in histrionic terms. While he dismissed Henley as a poet, the sheer physical energy and passion of the man ate up Yeats's rational objections: "I used to say of his poems, 'He is like a great actor with a bad part; yet who would look at Hamlet in the grave scene if Salvini played the grave-digger?' "[13]

HEROIC DREAMS AND MIMICRY

Along with a heightened response to physical action, a delight in mimicry may be said to be another characteristic of the histrionic sensibility. In simple terms mimicry is the physical re-creation of another person's mannerisms: voice, walk, gestures, carriage, personality, etc. Mimicry may be said

12. *Autobiographies*, pp. 7, 9.

13. *Autobiographies*, pp. 124-25. Again, Yeats's overrating of the poetry of Oliver St. John Gogarty is mainly the result of the impression that the athletic presence and personality of Gogarty had upon him. Justifying his inclusion of seventeen lyrics by Gogarty in his edition of the *Oxford Book of Modern Verse*, Yeats related the story of Gogarty's hair-raising escape from gunmen by swimming the Liffey in cold December. "His poetry fits the incident," said Yeats, "a gay, stoical—no, I will not withhold the word—heroic song." (Oxford: Clarendon Press, 1936), p. xv.

to be the basis of the educative process, for it is by imitating their parents that children learn to walk and talk, and by imitating their teachers to read and write.[14] Mimicry, of course, is the basis of theatre as well. Just as the child imitates the actions of his parents in playing "house", the actor and playwright imitate human actions on the stage. The kind and quality of their imitative actions may thus be said to distinguish playwrights from one another.

Of childhood play-mimicry Yeats once observed: "Children play at being great and wonderful people, at the ambitions they will put away for one reason or another before they grow into ordinary men and women."[15] This insight was certainly true of himself, for in his own childhood play-mimicry Yeats demonstrated many of the characteristics that later distinguished his histrionic sensibility in life as well as in the theatre.

As a boy Yeats tells us that his favourite heroes were sailors like his grandfather. His imagination bestowed upon them the strength of God, perhaps because he sometimes confused his grandfather with God. The seeds of his early play *The Shadowy Waters* may perhaps be found in his favourite childhood romance in which he commanded a fast and beautiful ship with a company of young sailors always in training like athletes. There was to be a battle on the shore near Rosses Point, Sligo, and in the battle Yeats, the heroic young captain, would be killed. Even then something of a pragmatist, Yeats tells us that he began to collect old pieces of wood in order to make the ship. So as to be like the sailors, he adopted a walk with his legs spread wide apart.[16]

As a schoolboy in London, Yeats continued to dream of the heroic life—his notebooks were filled with sketches of himself doing courageous deeds. His friendship with the school athlete was also formed out of a desire to associate himself with "action and adventure". (In later years, it is interesting to note that, although he was unable to recall the name of the athlete, Yeats remembered his face and body

14. Vide *Educational Psychology*, by Lee J. Cronbach (New York: Harcourt, Brace & World, 1964), pp. 423-63. Quote p. 425.
15. *Explorations* (London: Macmillan 1962), p. 20.
16. *Autobiographies*, pp. 8, 14-15, 50.

with "something of the American Indian in colour and linea-
ment".)[17]

At the age of ten or twelve his father took him to see
Henry Irving play Hamlet. Yeats tells us that "for many years
Hamlet was an image of heroic self-possession for the poses
of youth and childhood to copy, a combatant of the battle
within myself".[18] Even in his later teens, Yeats imitated the
heroic walk of Irving. According to Richard Ellmann, in a
further attempt to emulate Irving he may have assumed his
curiously rhythmical manner of speaking—the imitation of
which remains the *chef d'oeuvre* in the repertoire of many a
Dublin raconteur.[19]

In 1880 the Yeats family returned to Ireland, taking up
residence at Howth, the headland that encloses the north-
eastern side of Dublin Bay. Yeats tells us that he began to act
out scenes among the caves and rocky ledges on the Hill of
Howth. The characters he chose to enact were taken from the
dramatic poems that his father read to him as a boy. "I was
now Manfred on his glacier, and now Athanese with his
solitary lamp," he says. But soon Alastor, Shelley's idealistic
hero who is frustrated, defeated, and thrown into despair for
trying to make his dreams become reality, was chosen as
Yeats's "chief of men". Yeats says that in his boyhood fan-
tasies he "longed to share [Alastor's] melancholy and maybe
at last to disappear from everybody's sight as he disappeared
drifting along some slow-moving river between great trees."[20]

Again, however, Yeats's impulse to escape into a fantasy
world was soon countered by a fascination with living men of
power and personality. He dreamed of dominating the crowd
as a leader, of being able "to play with hostile minds as
Hamlet played, to look in the lion's face, as it were, with
unquivering eyelash". Inspired by the example of an obscure
but brilliant Dublin patriotic orator, John F. Taylor, Yeats,
by sheer dint of will, set out to conquer his agonizing fears of
speaking in public. He joined a debating society in his late

17. Ibid. pp. 39, 59, 36.
18. Ibid. p. 47.
19. Ellmann, *Man and the Masks*, p. 29. The writer has heard Austin Clarke,
 Micheál MacLiammoir, and Frank O'Connor all give similar imitations of the
 rolling, cadenced, long-vowelled speech of Yeats.
20. *Autobiographies*, p. 64.

teens where he suffered endless humiliations, particularly in combat with Taylor. But he returned again and again to the fray, in order to perfect himself, going over his errors in his mind, "putting the wrong words right".[21]

In time Yeats developed into a formidable public speaker. His knowledge of rhetorical techniques was skilfully employed both in writing for and in coaching actors. It was equally valuable to him as he wended his way through the bickering of endless committee meetings and faced down howling mobs in the promulgation and sustaining of his ideals for the Irish literary and dramatic movement. Ernest Blythe, the manager of the Abbey Theatre for over twenty years, recalls that, even in old age and feeble health, Yeats dominated the Abbey Board with clear and persuasive argument.[22] Yet at times it was almost with the delight of a child showing off that Yeats exercised his forensic skill. His letters to Lady Gregory contain many proud references to his triumphs over foes. One evidences particular warmth because in it he claims he "beat" the acknowledged master of the art of debate, and his opposite in so many respects, George Bernard Shaw.[23]

It is perhaps only in the light of his histrionic sensibility that one can begin to understand Yeats's peculiar fascination in later years with political leaders such as Mussolini.[24] A major part of his interest was due, of course, to the ideal aristocratic form of government that in his hatred for certain aspects of democracy he had begun to theorize about. But an equal part of the fascination undoubtedly came from the sheer power of personality and physical energy which these leaders evinced so as to compel their followers, in an almost hypnotic fashion, to unite behind them.

In his youth Yeats dreamed of becoming a similar kind of leader in Ireland, not, of course, for the sake of acquiring political power but in order to realize his ambitions for an

21. Ibid., pp. 93-94, 97.
22. *The Yeats We Knew*, ed. Francis MacManus (Cork: The Mercier Press, 1965), p. 63.
23. Letter dated March 12, 1900, *Letters*, p. 335. Cf. *Letters*, pp. 287, 290, 300, 302, 412, 414, 422, 426, 428, 432, 438.
24. Cf. Thomas MacGreevy, "W. B. Yeats—A Generation Later", *University Review* III, pp. 8-9; *Letters*, pp. 806, 811; Ellmann, pp. 248-49.

Irish "Unity of Culture". Again, one finds strange models for the young would-be national poet and seer, ranging from the mystic philosopher and magician MacGregor Mathers, to the Irish politician Tim Healy, to W. E. Henley himself. Always it was some physical or intellectual quality missing in himself that attracted Yeats even when he disagreed with the man in specific aspects of his philosophy. Thus Healy, who was soon to become a bitter enemy of Yeats through his part in bringing about the downfall of Parnell, was admired for the "good earth power" of his oratory in the British House of Commons.[25] Henley, too, was fascinating to Yeats because of the ease with which he dominated the odd collection of literary people whom he had gathered around him in London. By the deliberate projection of a personality which was the antithesis of his own crippled body and nature, Yeats observed that Henley had "built up an image of power and magnanimity till it became, at the moments when seen as it were by lightning, his true self".[26]

Struggling to resolve the contradictory elements in his own nature, however, Yeats most admired the kind of man who had achieved a measury of inner tranquillity while exerting a powerful public influence as an artist or man of affairs. Such a man was the Irish patriot John O'Leary.[27] Another was that extraordinary poet, painter, printer, mythologist, aesthetician, designer, businessman, and social reformer, William Morris, whose home Yeats visited on many occasions when his family resettled in London in 1887. Yeats was at first attracted to Morris simply because he reminded him of his grandfather in "some little tricks of speech and body". However, he grew to respect, even envy, Morris for his physical vigour, unobstructed power of concentration, and most of all his "unheard-of ease and simplicity" in doing "whatever he pleased". These qualities of Morris seemed to Yeats born from an intellect "never conscious of the antithesis" between "the dream world" and "daily life", "unexhausted by speculation or casuistry".[28]

25. Letter to Katharine Tynan (May 8, 1887), *Letters*, p. 35.
26. *Autobiographies*, pp. 125-26, 128.
27. Ibid., pp. 94, 98.
28. Ibid., pp. 141-42, 144.

Throughout the nineties Yeats strove to forge a similar unity among his own private and public activities, his personal and artistic life, his dreams and the world of reality. More than anyone else whom the youthful Yeats met, Morris had achieved a practical kind of unity that enabled him to produce "organization and beauty". Morris, his living "chief of men", became one of the principal models by which Yeats transformed himself from an introspective dreamer into a man of action.[29] It is significant that Yeats viewed the transformation in histrionic terms. In 1910, looking back on almost twenty years of ceaseless organizing in Ireland on behalf of his aesthetic ideals, he wrote: "All my moral endeavour for many years has been an attempt to recreate practical instinct in myself. I can only conceive of it as a kind of acting."[30]

THE DIALECTIC OF THE MASK

As men like William Morris and W. E. Henley provided Yeats with models by which he instilled within himself practical instinct, Oscar Wilde helped to provide him with a philosophy by which he fused together the disparate elements in his personality through the theatrical image of the mask.[31]

29. Ibid., p. 141. Cf. Yeats's tribute to Morris, *Essays and Introductions*, pp. 53-64. Writing of the origins of the Irish literary movement, Yeats stated that he began his crusade "new from the influence, mainly the personal influence, of William Morris". *Essays and Introductions*, p. 248.

30. Letter to Robert Gregory (August 21, 1910) quoted in Ellmann, p. 178.

31. The most complete analysis of Yeats's development of the doctrine of the mask is Ellmann's *Yeats: The Man and the Masks*. Ellmann shows that the idea of a binary creative personality is present throughout the nineteenth century from Byron to Yeats's contemporaries—Wilde, Robert Louis Stevenson, Max Beerbohm, Lionel Johnson, Aubrey Beardsley, Stéphane Mallarmé, and Paul Valéry. Vide esp. pp. 73-78, 175-79. In *The Identity of Yeats* (London: Faber and Faber, 1959), Ellmann also argues that Yeats's reading of Nietzsche provided him with a philosophic depth to his doctrine of the mask, especially in terms of the self-discipline required in order to live up to the ideal conception of one's self. Vide pp. 91-98. Cf. Thomas R. Henn, *The Lonely Tower*, pp. 36-50, for an exploration of Yeats's indebtedness to Blake, Swift, and Berkeley in his theory of artistic creation by means of a dialectic with the antithetical self. Virginia Moore in *The Unicorn* (New York: Macmillan, 1954), pp. 187-88, also traces Yeats's conception of the mask to the ceremonies of the Order of The Golden Dawn, where masks of the lion, eagle, or Osiris were utilized by each officer as "an astral shape suitable to the force he represented".

At the time when he first met Wilde in London in September 1888, Yeats still carried his boyhood image of the world as a kind of epic romance. "I was always planning some grand gesture," he tells us, "putting the whole world into one scale of the balance and my soul into the other and imagining that the whole world somehow kicked the beam."[32] Now, mainly under the influence of Wilde, he donned the raiments of a latter-day warrior of aestheticism: pose, gesture, manner, clothes, mask. In short, like an actor playing a role, he deliberately re-created his whole personality.

The first to note the change in Yeats were his boyhood friends in Dublin. Katharine Tynan remarked on his new "literary dandyism" in dress when she visited him in London. She made it clear that he had become "quite a different person" from the shy, dreaming poet whom everyone used to tease unmercifully.[33] The poet George ("A.E.") Russell perceived the change in much fuller dimensions. He recalled that Yeats vigorously defended Wilde against the charge of being a *poseur*. Yeats, said A.E., claimed that Wilde's pose was "merely living artistically, and it was the duty of everybody to have a conception of themselves, and he intended to conceive of himself. The present W.B.Y. is the result."[34]

Yeats ultimately applied the doctrine of "living artistically" to every facet of his life. The carefully arranged expensive books and *objets d'art* of his darkened study, the elegantly tailored clothes, the languid ceremonious manner, and the ecclesiastical gestures all become part of his lifestyle.[35] Style and personality—"deliberately adopted and therefore a mask"—became, as with Wilde, a means of shielding himself from the vulgarity of the world. The adoption of

32. *Autobiographies*, p. 154. Vide esp. pp. 130-31, 134-37, for Yeats's description of the enormous impression that Wilde's personality and style made upon him.

33. "William Butler Yeats", *The Sketch* (November 29, 1893), quoted in Ellmann, *Man and the Masks*, p. 88; cf. Katharine Tynan, *Twenty Five Years: Reminiscences* (London: Smith, Elder, 1913), p. 256.

34. Letter to George Moore (April 6, 1916), *Letters from A.E.*, ed. Alan Denson (London: Abelard-Schuman, 1961), pp. 109-10.

35. Vide Frank O'Connor's vivid description of Yeats's life style in *My Father's Son* (London: Gill and Macmillan, 1968), p. 32. Cf. Mary Colum, *Life and the Dream* (London: Macmillan, 1947), p. 131.

a mask was also a means of disengaging himself from and thus dominating those whom he needed to influence.[36]

For Yeats, however, the adoption of pose and mask had a much deeper significance than either self-protection or personal advancement. By means of donning a mask he was able to make a virtue out of the war of "incompatibles" that raged in his mind and prevented the achievement of what he termed "Unity of Being". Within the confines of a restrained austere form—"something hard and cold . . . which is the opposite of all that I am in daily life"—his teeming, fantastic inner life was given fuller rein to develop.[37] Yeats discovered a positive moral virtue in the discipline of trying to become his own antithesis, in living, as it were, theatrically:

> If we cannot imagine ourselves as different from what we are and assume that second self, we cannot impose a discipline upon ourselves, though we may accept one from others. Active virtue as distinguished from the passive acceptance of a current code is therefore theatrical, consciously dramatic, the wearing of a mask. It is the condition of arduous full life. One constantly notices in very active natures a tendency to pose, or if the pose has become a second self, a preoccupation with the effect they are producing.[38]

Over a period of years, Yeats elaborated his doctrine of the mask until it became wedded to his whole philosophy of life and his aesthetic as a poet and dramatist. Reality, for Yeats, was to be found neither in the buried unconscious self which

36. *Autobiographies*, pp. 461, 470.
37. Ibid., pp. 354, 274.
38. Ibid., p. 465. Wilde is cited in this passage as one who lived by "classical ideas as second self". Yeats's idea of essentially fabricating one's identity would, of course, be strongly contested by those in our society who proclaim authenticity, or sincerity, to be one of the highest values of life. Thus it is said that our true selves can be expressed only through impulse and spontaneity. However, in a series of remarkable books the sociologist Erving Goffman has countered this viewpoint and its implicit self-indulgence, by arguing that we are all basically performers playing various roles in given social situations. In terms remarkably similar to Yeats, Goffman holds that the "self" does not refer to any actual being who resides either inside or outside our situations; rather, it refers to a *sense* we have of ourselves as somehow continuing through all the roles we play. In other words, the self is felt as something existing in between our desires and the mask, or masks, we present to the world. Vide Erving Goffman, *The Presentation of Self in Everyday Life* (Garden City, New York: Doubleday, 1959).

directed a man's life nor in its mask, the antithetical outward
self, but in the product born of their dialectical struggle. In
his most complete statement on the relationship between the
mask and his process of creation, *Per Amica Silentia Lunae*
(1917), Yeats wrote: "We make out of the quarrel with
others rhetoric, out of the quarrel with ourselves, poetry."[39]
Not for him the way of Keats, who wrote out of a simple
response to the world of appearances like a "school boy with
face and nose pressed to a sweetshop window". Rather, a
model like the dialectical aristocratic mind of Dante, who
had fashioned from his opposite

> An image that might have been a stony face
> Staring upon a Bedouin's horse-hair roof

and sang out of

> A hunger for the apple on the bough
> Most out of reach. . . .[40]

Like Wilde and other adherents of the doctrines of aesthe-
ticism, Yeats believed that the function of the artist was not
to reflect the "common dream" but to imitate, according to
his own unfettered vision of it, the actions of an ideal life.
"All art," he wrote in 1908, "is the endeavour to condense as
out of the flying vapour of the world an image of human
perfection, and for its own not for the art's sake."[41]

Thus, Yeats instinctively rejected the aesthetes' single-
minded pursuit of Beauty for its own sake. "Literature,"
he declared as early as 1892, "must be the expression
of conviction . . . and not an end in itself."[42] Because his own
life-response involved a passionate histrionic engagement
with, as well as a lyrical escape from, the world, Yeats argued
that it was essential to see and understand mankind in every

39. *Mythologies* (London: Macmillan, 1962), p. 331.
40. The passages are quoted from the poem "Ego Dominus Tuus", in which Yeats
 presents an argument between two characters representing opposite means of
 poetic expression: the purely realistic and the dialectical. *Mythologies*, pp.
 321-24.
41. Preface to *The Collected Works of W. B. Yeats* (Stratford-on-Avon: A. H.
 Bullen, 1908).
42. "Hopes and Fears for Irish Literature", *United Ireland* (October 15, 1892),
 reprinted in *Uncollected Prose by W. B. Yeats*, collected and edited by John
 P. Frayne (London: Macmillan, 1970), p. 249.

possible circumstance, in every possible situation: "Only when we have put ourselves in all the possible positions of life, from the most miserable to those that are so lofty that we can only speak of them in symbols and in mysteries will entire wisdom be possible."[43]

By the sheer struggle of endeavouring to create images of an ideal life out of the actions of ordinary life, Yeats believed that the artist discovers a far deeper reality than that known to either the aesthetes or what he termed "the sentimentalists"—those so-called "practical men who believe in money, in position, in a marriage bell, and whose understanding of happiness is to be so busy whether at work or at play that all is forgotten but the momentary aim". No true artist could be a sentimentalist: "The other self, the anti-self or the antithetical self, as one may choose to name it, comes but to those who are no longer deceived, whose passion is reality."[44]

As we shall see, Yeats applied the doctrine of the mask to his entire involvement in the theatre. His conception of tragedy was born out of the continuous dialectic between opposites that warred within his mind—the dialectic being given an external form and meaning through the discipline of the mask. In turn, he sought for a style of acting, speech, and stage decor that, like his personal mask, would exhibit a formal austerity so as gradually to expose the more passionate life beneath. Always his basic endeavour was to remain in touch with and yet preserve an appropriate balance between antithetical extremes. As he declared in 1913:

Great art, great poetic drama is the utmost of nobility and the utmost of reality. The passions and drama fall into two groups commonly, the group where nobility predominates and the group where reality predominates. If there is too much of the first all becomes sentimental, too much of the second all becomes sordid. Nobility struggles with reality, the eagle and the snake.[45]

Yeats also came to believe that the artist functioned most creatively and effectively in a dialectical relationship with his

43. *Samhain* Number Three (September 1903), pp. 30-31. *Samhain* was the literary organ of the Irish dramatic movement.
44. *Mythologies*, p. 331.
45. Fragment dated October 1913, quoted in Norman Jeffares, *W. B. Yeats: Man and Poet* (London: Routledge and Kegan Paul, 1962), p. 318.

society. By means of his deliberate association with the poets of the London Rhymers' Club during the nineties, Yeats developed a sense of craftsmanship, style, scholarship, and intellectual sophistication.[46] This, in turn, governed his response to the raw material of Irish life and culture, as he sought to remain above his subject, balancing emotion with reason, using his own "enthusiasms . . . as the potter the clay".[47] Ireland, and the Irish theatre in particular, stung him into personal expression; England, and his mask of aesthetic detachment, helped him to provide that expression with an artistic shape and form.

History itself was interpreted by Yeats in terms of his doctrine of the mask. Modern culture, he believed, had made man "gentle and passive" because of the self-indulgent "doctrine of sincerity and self-realization". The Middle Ages and the Renaissance had attained a large measure of their creative energy by being founded upon the imitation of Christ and classical heroes. Saint Francis and Caesar Borgia were not satisfied living merely as their natural or "heterogeneous selves". Instead, they "made themselves overmastering, creative persons by turning from the mirror to meditation upon a mask".[48]

In a similar manner, Yeats set out to create an Irish theatre in the image of a mask—not the mirror, but the antithetical self of Ireland. By the mid-1890s Yeats had come to believe that "every passionate man is, as it were, linked with another age, historical or imaginary, where he alone finds images that rouse his energy".[49] Yeats linked himself with the Irish heroic age, finding Homeric images of "savage strength", "tumultuous action", and "overshadowing doom",[50] a vanished world in which "the soul had only to stretch out its arms and fill them with beauty", that he set against the modern world "of whirling change and heterogeneous ugliness".[51] Through the Irish literary and dramatic movement

46. Ellmann, *Man and the Masks*, pp. 138-56. Cf. *Autobiographies*, pp. 164-71.
47. Introduction to *A Book of Irish Verse* (London: Methuen, 1895), p. xiv; cf. *Autobiographies*, pp. 216, 318.
48. *Mythologies*, pp. 333-34.
49. *Autobiographies*, p. 152.
50. *Uncollected Prose*, p. 363.
51. Ibid., p. 295.

he sought to "stiffen the backbone" of Ireland.[52] In play after play—at first spiritual and ideal and then with increasing irony and bitterness—he sought to rid Ireland of sentimentality by challenging her, as he challenged himself, with all that by nature he was not. Thus he urged other writers to join him in his difficult task, creating not out of what was facile, tawdry, and ephemeral but out of the best in the living and historical Irish tradition:

What I myself did, getting into an original relation to Irish life, creating in myself a new character, a new pose—in the French sense of the word—the literary mind of Ireland must do as a whole, always understanding that the result must be no bundle of formulas, not faggots but a fire. We never learn to know ourselves by thought, said Goethe, but by action only; and to a writer creation is action.[53]

52. Letter to Dorothy Wellesley (December 23, 1936), Letters, p. 876.
53. Samhain Number Seven (November 1908), p. 8.

Mysticism, Tragedy,
and the War of the Spiritual
and Natural Order

No aspect of Yeats's life and work has provoked more con-
troversy, confusion, and downright hostility than his lifelong
concern with mysticism and occult study. T. S. Eliot dis-
missed Yeats's mystical ideas as utterly unreal: "His remote-
ness from life is not an escape from the world", for he is
"innocent of any world to escape from".[1] W. H. Auden was
more brutal; he loftily proclaimed Yeats's occult interests to be
"Southern Californian", not "the kind of nonsense that can
be believed by a gentleman".[2] Among the Yeats scholars,
T. R. Henn tells us that mysticism, magic, and spiritualism
were but "pretexts for the play of the mind",[3] while Richard
Ellmann describes Yeats simply as "a zealot in search of a
creed".[4] Similarly, critics and scholars are sceptical about the
depth of Yeats's belief in God, Christianity, or even his own
quasi-religious and philosophical system, as put forth in *A
Vision*. Helen Vendler declares herself "uncomfortable" with
any view imputing mystical beliefs to Yeats and argues that
because he had no faith in an afterlife his theological symbols

1. Quoted by Richard Ellmann in *Eminent Domain: Yeats Among Wilde, Joyce,
 Pound, Eliot, and Auden* (New York: Oxford University Press, 1967), p. 91.
2. Ibid., p. 111.
3. Henn, *The Lonely Tower*, p. 168.
4. *Man and the Masks*, p. 43.

have "primarily aesthetic and human purposes".[5] Ellmann finds Yeats ambivalent to Christianity, while Henn, A. G. Stock, and Morton Seiden are agreed that Yeats was no sort of Christian at all.[6] Even such close friends and artistic colleagues of Yeats as George Russell and T. Sturge Moore were not convinced that he was more than a sceptic, essentially scientific in spirit, with a desire to be convinced intellectually of the truth of mysticism that was never fulfilled.[7]

As of this writing, only one major study, Virginia Moore's *The Unicorn*, has been devoted to an extended analysis of Yeats's psychic development. Moore's is a minority report which concludes that "there is no evidence that [Yeats] doubted the spiritual world he had long seen lying behind his vision". She also claims that, if not an orthodox Christian, Yeats was "not at all unchristian in the deeper drive of his life, that towards an understanding and experience of love in the high metaphysical sense".[8]

Undoubtedly, the qualified judgments and disagreements on these matters are largely due to the fact that Yeats's philosophic and religious beliefs, especially as elucidated in *A Vision*, are complex and at times seemingly contradictory. But as Kathleen Raine points out, another and perhaps more telling reason is that academic commentators generally know little about the faith towards which Yeats aspired because it cannot be understood in academic terms.[9] Indeed, the idea

5. *Yeats's Vision, and the Later Plays*, p. 157.
6. Cf. Ellmann, *Identity of Yeats*, pp. 51-52; Henn, pp. 349-50; A. G. Stock, *W. B. Yeats: His Poetry and Thought* (Cambridge: Cambridge University Press, 1961), pp. 163-64; Morton Irvine Seiden, *William Butler Yeats: The Poet as a Mythmaker* (East Lansing: Michigan State University Press, 1962), pp. 210-18.
7. Vide Preface to *W. B. Yeats and T. Sturge Moore: Their Correspondence, 1901-1937*, ed. Ursula Bridges (London: Routledge and Kegan Paul, 1953), p. xxiii; letter from "A.E." to Sean O'Faolain (1935), quoted by Monk Gibbon, in "The Early Years of George Russell (A.E.) and his Connection with the Theosophical Movement" (Ph.D. thesis, Trinity College, Dublin, 1948).
8. *The Unicorn*, pp. 218, 431. Similarly, George Harper in his recent study of Yeats's involvement with the Hermetic Order of the Golden Dawn does not try to make Yeats into an orthodox Christian but does emphasize Yeats's own insistence on the Christian foundations of the Order. *Yeats's Golden Dawn* (London: Macmillan, 1974), pp. 71-72.
9. *Yeats, The Tarot, and the Golden Dawn* (Dublin: The Dolmen Press, 1972), p. 5.

that religion, if it is to have any fructifying influence in life, must be mystical has itself been denied by large numbers of people, including some theologians, who, according to Alan Watts, simply do not understand what mysticism is:

They associate [mysticism] with ecstatic trances, with the solitary life of the hermit, with keeping one's mind perfectly blank for hours on end, with vague reasoning, with pantheism, with a distaste for action and concrete, physical life, forgetting that all these things are the freaks or aberrations of mystical religion and have nothing to do with its essence. Its essence is the consciousness of union with God, and this will only involve these freaks of negativism if God is thought of as hostile to the world, and not as its loving creator. . . . The meaning [of Christianity] is God himself, the ultimate Reality, not as an idea conceived but as a reality experienced.[10]

In one respect at least, we can be grateful that prolonged disputation over Yeats's mystical beliefs is largely irrelevant. The fact is, one can enjoy the benefits of Yeats's best poetry and the majority of his plays without understanding or scarcely knowing about his arcane interests. This is perhaps the supreme tribute that can be paid to his skill and power as an artist. At the same time, this study would fall far short of its intention if we failed to consider the religious implications of Yeats's idea of a theatre. Moreover, by failing to grapple with the complex nature of Yeats's religious aspiration, we would ignore one of the basic impulses behind his entire endeavour as a dramatist.

As in every aspect of his life's work, we may trace the source of Yeats's occult practices and mystical beliefs to the dialectical nature of his own personality. We have seen in Chapter One that this dialectic sprang from a conflict

10. *Behold the Spirit: A Study in the Necessity of Mystical Religion* (New York: Vintage Books, 1972), pp. 5-6, xxv. Watts's views are corroborated by Dom Cuthbert Butler in his admirable study of the tradition of mysticism within the Roman Catholic Church. Butler argues that formal "contemplation" as developed and practised by the great spiritual leaders of the Church was intended at its highest limits to provide an experiential or mystical perception of God's Being and Presence. However, he emphasizes that contemplation was always united to a life of action. The desired effect of a high mystical experience was to send the contemplative back to the active life with a renewed zeal to work for the good of others, hence the glory of God. Vide *Western Mysticism* (London: Arrow Books, 1960).

between Yeats's predilection towards a life of introspection and spiritual repose and his desire for a life of passionate engagement imbued with heightened physical, intellectual, and artistic powers. In matters of religion the dialectic involved a continual struggle between the opposing impulses of doubt and faith. I shall attempt to show in the course of this chapter that out of these manifold internal and external conflicts Yeats ultimately fashioned a concept of tragedy embodying profoundly religious values. I shall also show that, although rooted in ancient tradition, Yeats's concept of tragedy is particularly appropriate for modern man in his difficult though increasingly determined search for spiritual meaning and psychological fulfillment.

A Vision AND THE REAFFIRMATION OF THE DAIMONIC

Issued in 1925 in a private limited edition and later published in 1937 with extensive revisions and additions, A Vision is Yeats's most comprehensive account of the basic convictions underlying all of his work as a poet and dramatist. A Vision may be read as Yeats's attempt to impose a rational interpretation upon the entire universe and man's role within it. In a brief note appended to the first edition, however, Yeats made it clear that A Vision should primarily be understood as "mythology"; that is, it was not intended to appeal to the "logical capacities" alone, as philosophy, but also to the latent "supernatural faculties" inherent in all men.[11] In other words, A Vision was not merely an esoteric collection of theories or facts, but was intended to be the imaginative expression of a poet's religious faith—a faith that could only be truly justified and evaluated in terms of its effect upon the unconscious as well as the conscious mind.

This idea is supported by Yeats's description of how A Vision came to be written. Four days after his marriage on October 20, 1917, in order to distract him from personal

11. A Vision: An Explanation of Life Founded upon the Writings of Giraltus and upon Certain Doctrines Attributed to Kusta ben Luka (London: T. Werner Lourse, 1925), p. 251. On finishing the revised version of A Vision Yeats wrote: "I have constructed a myth, but then one can believe in a myth—one only assents to philosophy. Heaven is an improvement of sense — one listens to music, one does not read Hegel's logic." Letter to Olivia Shakespear (February 9, 1951), Letters, p. 781.

worries, Yeats's wife decided to make an attempt at automatic writing. To her surprise and his own eager interest, odd sentences were produced on a subject of which she apparently knew nothing. Yeats became convinced of the importance of the revelations received and persuaded his wife to devote some hours daily to the arduous task of acting as a medium for the mysterious instructors. Whereas at first Yeats thought the messages were spirit-sent and therefore proof of communion between the living and the dead, he later saw them as emanating from the unconscious world of his wife and himself:

> Spirits do not tell a man what is true but create such conditions that the man is impelled to listen to his Daimon. And again and again they have insisted that the whole system is the creation of my wife's Daimon and of mine, and that it is as startling to them as to us. . . . The blessed spirits must be sought within the self which is common to all.[12]

The idea of the Daimon as a personal emissary from the supernatural world existing within the unconscious mind is originally derived from ancient Greece where the daimonic was understood as the intermediary between the gods and men.[13] From Homeric times the Greeks attributed all events or actions which were not within man's conscious control to the intervention of daimonic, or god-like, forces. "Daimon" was, in fact, up to the fifth century a word that could be used interchangeably with "theos". By the fifth century, however, a new belief arose which associated the Daimon with certain seemingly supernatural powers innate in man himself. The daimonic was thought of as the occult self, or soul, of man that persisted through several incarnations and was the carrier of man's potential divinity and guilt. The daimonic was also thought of as a semi-autonomous inner spirit with a potential for both good and evil that exerted a profound influence on man's personal character and ultimate destiny.

12. *A Vision* (London: Macmillan, 1937, 1962), p. 22.
13. I have drawn much of the material on the history of the daimonic from an informative article by Dr. Wolfgang Zucker, "The Demonic from Aeschylus to Tillich", *Theology Today*, XXV (April 1969), pp. 34-50, and from E. R. Dodds, *The Greeks and the Irrational* (Berkeley: University of California Press, 1968), esp. pp. 12, 42, 153, 217-18.

Plato accepted the special gifts and powers of the poet, prophet, and shaman as being channels for divine or daimonic grace. Similarly, the "divine madness" of Eros, or passionate love, was something that occurred to man without his choosing it or knowing why and was therefore the work of a formidable Daimon. None the less, Plato rated these activities far below those of the rational self and held that they must be subject to the control and criticism of reason. Reason was for him an equally active manifestation of deity in man—a lofty spirit-guide, or Daimon, in its own right. For the Greeks, the negative aspects of the daimonic were especially evident in the *hubris*—or excessive pride—that drove the tragic hero to his downfall. The classical Greek ideal was to preserve a healthy balance between the good and evil aspects of the daimonic and thereby to live an intensely creative though ordered life.

Christianity inherited the concept of the daimonic, but chose to emphasize only its malevolent aspects, projecting the blame for evil upon an external force which acted upon man. This force, personified as the Devil replete with flying horns, removed much of the awful responsibility for evil and suffering from man. However, by associating the affirmative qualities of the daimonic with the totally pernicious and destructive qualities of the Devil, the Church, especially in its more puritanical and moralistic sects, deprived man of much that is life-enriching. Ironically, as enlightened modern Christian leaders have come to realize, by forcing man to be continually on guard against his daimonic passions, the Church deprived man of a personal sense of union with God.

In Latin the daimonic was translated as *genii* and gave rise to the word "genius", which in Roman religion originally meant a tutelar spirit presiding over the destiny of a person. Only later did it refer to a particular mental endowment or talent. The anti-rational cult at the end of the eighteenth century restored some of the original meaning of the term by imputing a supernatural power to the genius of great artists. A man was not a genius because he was a great artist, but, rather, he was an artist because he was possessed by genius. Goethe carried this idea a step further by employing the word "daimonic" to define not only the driving impulse of the

great artist but of all great men and even of nature itself. The daimonic was

discovered in Nature, animate and inanimate, with soul and without soul, something which was only manifested in contradictions, and therefore could not be grasped under one conception, still less under one word. . . . Only in the impossible did it seem to find pleasure, and the possible it seemed to thrust from itself with contempt.[14]

Goethe neither condemned the daimonic as did the rationalist philosophers nor blindly admired it as did the Romantics. Instead, he returned to the original Greek concept of the daimonic as a power beyond good and evil and thus attributable to neither God nor the Devil. By identifying and reaffirming the role of the daimonic as an integral part of life, contradicting though not opposing the rational order, Goethe anticipated one of the primary concerns of contemporary psychotherapy.[15] As we shall see, he also anticipated one of the lifelong concerns of Yeats.

Yeats was probably first introduced both to the concept and an actual awareness of his personal Daimon in the Hermetic Order of the Golden Dawn, a magical society to which he belonged from 1890 to 1922.[16] Significantly, the name that he took upon being initiated into the Order was "Demon est Deus Inversus". One of the basic premises of the

14. Johann Wolfgang von Goethe, *Autobiography: Poetry and Truth from My Own Life*, trans. R. O. Moon (Washington, D.C.: Public Affairs Press, 1949), pp. 683-84.
15. Rollo May is a prominent psychiatrist who argues that by sublimating or altogether disregarding the daimonic, earlier Freudian psychotherapists accepted a "banality and a shallowness in our whole approach to mental disease. This banality was specifically damaging to our experience of love and will, for the destructive activities of the daimonic are only the reverse side of its constructive motivation. If we throw out our devils, as Rilke aptly observes, we had better be prepared to bid goodbye to our angels as well. In the daimonic lies our vitality, our capacity to open ourselves to the power of eros. We must rediscover the daimonic in a new form which will be adequate to our predicament and fructifying for our own day. And this will not be a rediscovery alone but a recreation of the reality of the daimonic." *Love and Will* (New York: Dell Publishing Co., 1969), p. 124. Vide esp. pp. 121-76, for an extensive discussion of the theory and practice of the daimonic in contemporary psychotherapy.
16. Vide Harper, for the most complete account of his involvement with the Order.

Golden Dawn was that the psyche of man contains arche-
typal images emanating from the higher supernatural world.
This unconscious level of the mind was called the Astral
Light or Anima Mundi and is similar to Carl Jung's concept
of the "collective unconscious".[17] The system of ceremonial
magic employed by the Golden Dawn was intended to enable
the Adept to discipline his Will and activate his Imagination
so as to invoke his Holy Guardian Angel or inner Daimon.
(The two terms were almost synonymous in the terminology
of the Golden Dawn.)[18] The Daimon, itself emanating from
the Astral Light, then proceeded to guide the Adept upward,
degree by degree, to an increasingly exalted spiritual condi-
tion until, in the form of an overpowering ecstatic vision,
union with God was experienced. The entire process was
illustrated in a striking double image derived originally from
the Kabbalah, that of a Serpent winding its way up the
Sacred Tree of Life together with a Lightning Flash or Flam-
ing Sword superimposed, among the sacred leaves. The
Serpent symbolized man's tortuous path to higher knowl-
edge, while the Lightning Flash symbolized God's desire to
seek out the uniqueness in man. Thus the relationship
between God and man was seen as one of a mutual desire for
completion through the integration, or union, of seemingly
opposite forces.[19]

The system of the Golden Dawn for attaining higher
spiritual knowledge is similar to the process devised by
Jung for achieving what he termed "individuation", that is, a
reintegration through depth analysis of the deepest levels of

17. Israel Regardie, *The Tree of Life: A Study in Magic* (New York: Samuel
 Weiser, 1973), pp. 68-69. Jung defines the "collective unconscious" as fol-
 lows: "In addition to our immediate consciousness, which is of a thoroughly
 personal nature and which we believe to be the only empirical psyche (even if
 we tack on the personal unconscious as an appendix), there exists a second
 psychic system of a collective, universal, and impersonal nature which is iden-
 tical in all individuals. This collective unconscious does not develop indivi-
 dually but is inherited. It consists of pre-existent forms, the archetypes, which
 can only become conscious secondarily, and which give definite form to
 certain psychic contents." *The Portable Jung,* ed. Joseph Campbell (New
 York: Viking Press, 1971), p. 60.
18. Regardie, p. 180.
19. Vide Colin Wilson, *The Occult* (New York: Random House, 1973), esp. pp.
 203-9, for a concise analysis of Kabbalistic magical practices.

the unconscious with the conscious mind. Jung also saw the daimonic, or "shadow", as a kind of emissary from the "collective unconscious", bearing with it the deepest instincts and archetypal images that help to define the individual. In so far as analytical treatment makes the shadow "conscious" it causes a "cleavage and tension of opposites", which in their turn seek "compensation in unity". If all goes well, this unity is attained, seemingly of its own accord, as an experience, or feeling, of "grace". Jung equated this with an apprehension of "the God-image" whereby man understands, in a sudden insight, that subjective conflict is only a single instance of the universal conflict of opposites. "Our psyche," said Jung, "is set up in accord with the structure of the universe, and what happens in the macrocosm likewise happens in the infinitesimal and most subjective reaches of the psyche." The confrontation with the shadow is therefore, in a sense, a preparation for the birth of God within man.[20]

It is worth noting at this point that Yeats scarcely knew the work of Jung and, in fact, had a profound contempt for all modern psychology as a "modish curiosity".[21] Yet we shall find that the ideas of the poet and the psychiatrist parallel and indeed reinforce one another to a remarkable extent.

In A Vision Yeats defined individual life as the struggle for Unity of Being—the equivalent of individuation—within an endless reincarnational cycle of death, dreaming back, and rebirth. Yeats illustrated this process metaphorically by relating it to the twenty-eight phases of the Lunar Cycle. The phases of the Lunar Cycle correspond to the phases of life that the soul must pass through in the course of several sequential incarnations. They also correspond to the various stages that a man may pass through in the course of a single lifetime. According to Yeats, the individual is caught between the contrary impulses of subjectivism (self-realization) and objectivism (self-abnegation), a concept that approximates Jung's idea of introverted and extroverted personality types. Yeats related the subjective and objective impulses, respectively, to the bright phases of the moon (Eight to Twenty-Two, in his

20. Carl Jung, Memories, Dreams, Reflections, ed. Aniela Jaffé (New York: Vintage Books, 1963), pp. 335-37.
21. Essays and Introductions, p. 530.

system) and the dark phases of the moon (Twenty-Two round to Eight), proceeding counter-clockwise. All of the phases may be experienced in carnate life except for those of the full moon and dark of the moon (Phases Fifteen and One) when the soul takes on the form of a pure spirit rather than of a man. Any individual can be classified as belonging to one of the twenty-eight phases. In fact, the simplest approach to understanding the relationship between the Lunar Cycle and individual life is through the examples, drawn from history and his own life, that Yeats employed to illustrate the characteristics of each phase.[22]

In Yeats's system, the particular aims and fortunes of life are largely predetermined, since the phase into which an individual is born is the result of his past life. The individual personality is also largely predetermined, being shaped by the action of the soul's "Four Faculties", which Yeats calls "Will", "Mask", "Creative Mind", and "Body of Fate". Yeats emphasized that the Four Faculties were not an abstract philosophical concept but an active force in life as "the result of the four memories of the Daimon or ultimate self of . . . man".[23] The Daimon thus contained "co-existing in its eternal moment, all the events of our life, all that we have known of other lives, or that it can discover of other Daimons".[24]

Psychologically, the Four Faculties correspond to Jung's four functions of the psyche—thinking, feeling, sensation, and intuition. The Will is sheer intellectual energy, the drive towards self-realization and fulfillment. It sets before itself an image shaped from moments of exaltation in past lives, of all that it can conceive as most admirable, all that is most opposite to its actual incarnate self, and strives towards that. That image is the Mask. Thus through a dialectic between Will and Mask the soul moulds itself from within.

The Creative Mind is a kind of memory of ideas, or general principles, learned in past lives, and is the power of thought which is inborn. Its purpose is to understand all circumstances that affect it from the outer world, and the sum of these is the Body of Fate. The living man sees his Body of

22. Vide A Vision (1937), pp. 105-84.
23. Ibid., p. 93.
24. Ibid., p. 192.

Fate as something external to himself, but it is not really so; it has come to him by choice or rather by the very nature of his soul, from memories of the happenings of past lives. For ultimately it is his own bent, and the inherent limitations of which he is necessarily unaware, that determine how circumstances will mould his life.

The two processes are always at work: the Will trying to assimilate itself to the Mask, the Creative Mind to understand the Body of Fate. Always these two confuse each other. The man wills to be his ideal self, but the circumstances surrounding him and his efforts to deal with them may confuse the image of his ideal or may change it for a factitious one. He tries to understand the world objectively, but his image of what he desires to be may distract what he sees.[25]

In *A Vision* Yeats applied the same pattern of cycles within cycles, action and recoil, and contrasting and opposing powers not only to individual life but to the life of nations and whole civilizations. Yeats explained the relationship between the individual and history by showing that the Lunar Cycle is caught within the cosmic pattern of a vast Solar Cycle. Here Yeats took the Great Year of the Ancients, a 26,000-year cycle symbolized by the passage of the sun through the Zodiacal constellations, and considered it as but one year of a mightier historical cycle whose months and days and years, all with their own vitality, influence our own evolution. The Great Year is divided up into twelve cycles corresponding to the twelve lunar months and lasting, in theory, approximately two thousand years. History is interpreted as a series of expanding cones, with each age, as it wears on, generating a centrifugal tendency which finally produces decadence or disintegration. This concept is further complicated by Yeats's image of an interpenetrating double cone whereby each age unwinds, or struggles against, what the preceding age has wound. Thus the primary (or objective) Christian age is the opposite of the antithetical (subjective) age of Greek classicism. According to one schematization, of which there are several, by setting the birth of the classical era at 1000 B.C. Yeats perceived the overlapping tension of

25. Ibid., pp. 73-104. I am especially indebted throughout this section to the analysis of *A Vision* contained in Stock's *W. B. Yeats*, pp. 122-64, esp. pp. 123-25.

two contrary civilizations, "living each other's death, dying each other's life".[26] The contraries in the overlapping schema permitted Yeats to view Byzantium as at once the glory of Christian civilization and a manifestation of dying classicism. By positing the birth of a new antithetical era in the year A.D. 1000, Yeats was enabled to see the Renaissance as the inception of a new glory that coincides with the impending death of the Christian era.[27]

The entire system would be depressingly fatalistic except for certain factors relating to the possibility of the individual determining, to a limited extent, his fate in the cycle of reincarnation. These factors are dependent upon the unique powers and attributes that Yeats assigns to Phases Thirteen and Fifteen of the Lunar Cycle. Phase Thirteen is the only phase in which "entire sensuality is possible". It is also the phase in which "complete intellectual unity, Unity of Being" is possible.[28] Remembering Yeats's histrionic understanding of life, we may say that Phase Thirteen is that phase in which man comes closest to embodying, as opposed to having a purely intellectual concept of, truth. As we have noted, Phase Fifteen—that phase corresponding to the full moon of complete subjectivity— is not a phase belonging to earthly life. Being without external conflict, it belongs, instead, to the supernatural order of existence. The closest man can come to realizing the transcendental harmony and perfect beauty of this phase is through an intense, though momentary, visionary or ecstatic experience.[29] Though Yeats does not say so, it is clear that the symbols of poetry expressing the reconciliation of opposites belong to this phase. We shall have more to say about this when we discuss Yeats's concept of "tragic ecstasy".

While the perfect Unity of Being of Phase Fifteen cannot fully be attained in this world, between Phases Twelve to Fifteen the struggle to attain such unity becomes conscious. This occurs as the various conflicting drives and demands of the Four Faculties turn inward and are mirrored in the individual personality. "Hitherto we have been part of some-

26. A Vision (1937), p. 110.
27. Ibid., pp. 267-300.
28. Ibid., p. 128.
29. Ibid., pp. 82, 135-37.

thing else, but now we discover everything within our own nature," Yeats says. He goes on to illustrate the qualities that he associates with Unity of Being through a musical image: "Every emotion begins to be related to every other as musical notes are related. It is as though we touched a musical string that sets other strings vibrating."[30]

A key element in the progression towards Unity of Being is the relationship between Will and Mask. Here is where the element of freedom enters, for Yeats points out that personality, no matter how habitual, is a constantly renewed choice.[31] We should bear in mind, however, that Yeats is talking about a process that takes place over a period of several sequential incarnations. The most undesirable fate that can befall a soul is to be reborn into the same phase. This occurs when in its carnate form a soul has not fully acquired the experiential knowledge appropriate to that phase. It is by choosing the True from the False Mask and thereby living a life of appropriately passionate experience that the soul shakes off the bonds of mortality and progresses most rapidly towards Unity of Being: "The more complete the expiation, or the less the need for it, the more fortunate the succeeding life. The more fully a life is lived, the less need for—or the more complete is—the expiation."[32]

In summation, it is evident that for Yeats life is inescapably a tragedy in which, in the words of William Irwin Thompson, "man may choose between forms of tyranny but never can escape the tyranny of form".[33] Yeats himself was quite explicit in offering no false hope of eternal reward or paradise. "Neither between death and birth nor between birth and death can the soul find more than momentary happiness; its objective is to pass rapidly round its circle and find freedom from that circle."[34] The possibility of ultimate escape from the cycle was limited to the *Thirteenth Cone*, a peculiar geometric configuration existing outside of time and space in Yeats's system. And even here Yeats rejected the

30. Ibid., p. 88.
31. Ibid., p. 84.
32. Ibid., p. 236.
33. *At the Edge of History* (New York: Harper and Row, 1972), p. 118.
34. *A Vision* (1937), p. 236.

idea that the ultimate life of the soul is in any way predictable.[35]

Consistent with the teachings of the Order of the Golden Dawn, Yeats held that the sole means for man to establish direct communication with the supernatural world was through a dialogue with his personal Daimon. This dialogue was itself made possible because the relationship between man and his Daimon was not one of like to like but of mutual and complementary need: "Man and the Daimon feed the hunger in one another's hearts."[36] The Daimon's presence was most directly experienced in man's drive for perfection and in passionate love. The Daimon was also present in man's perpetual quest for knowledge.[37] Approvingly, Yeats quotes Herodotus's definition of the Daimon as man's "destiny" and comments: "When I think of life as a struggle with the Daimon who would ever set us to the hardest work among those not impossible, I understand why there is a deep enmity between a man and his destiny, and why a man loves nothing but his destiny."[38] As an artist, Yeats, like Goethe, found that the struggle with his own Daimon was intensified by a paradoxical mixture of frustration and reward:

He only can create the greatest imaginable beauty who has endured all imaginable pangs, for only when we have seen and foreseen what we dread shall we be rewarded by that dazzling, unforeseen, wing-footed

35. The concept of the cone is that of a three dimensional geometric projection derived from the twelve signs or houses of the Zodiac. Each antithetical pair of these signs is shown in traditional astrological charts as a pair of signs meeting at the apex. If projected into a three-dimensional geometric form these triangles may be seen as cones belonging inherently in Yeats's system to the Solar Cycle. However, according to Yeats the peculiar nature of the *Thirteenth Cone* is that it transcends both the Lunar and Solar Cycles in being unhampered by considerations of either time or space. For that reason it is free to bisect the Lunar or Solar Cycles at any given point. Thus, the imminence of the *Thirteenth Cone* of deliverance is unpredictable: "The particulars of future life are the work of the *Thirteenth Cone* or cycle which is in every man and called by every man his freedom. Doubtless, for it can do all things and know all things, it knows what it will do with its own freedom but it has kept the secret." Ibid., p. 302. Cf. p. 263. I am indebted to Roger Parris for his help in elucidating this extremely difficult aspect of *A Vision*.
36. *Mythologies*, p. 335.
37. *A Vision* (1937), pp. 234, 238, 189.
38. *Mythologies*, p. 326.

wanderer. . . . I am persuaded that the Daimon delivers and deceives us. . . . Always it is an impulse from our Daimon that gives to our vague, unsatisfied desire, beauty, a meaning, and a form all can accept.[39]

Yeats made no direct allusions in *A Vision* to the relationship of the Daimon with God, but one can draw certain conclusions from the fact that he placed the Daimon in the *Thirteenth Cone*, among the souls who have been set free. There, he said, the Daimon functions as a Teaching Spirit or guide of the soul through the significant acts of its past lives until it is reborn in another incarnation. Yet, Yeats emphasized that in spite of their proximity to the source of all creation the Daimons, like men, could be starved for supernatural as well as natural experience.[40]

Clearly, in Yeats's theory of the cosmos there is no means by which the conscious mind of man can directly apprehend God. Consciousness creates conflict, whereas God is the resolution of all conflicts, all dualities.[41] Thus God, being the more powerful, acts upon man rather than vice versa. It would appear that, as in Jungian depth-analysis, man's sole hope and possibility of influencing his personal relationship with God is through the mediation of his Daimon. By the difficult process of confronting and integrating into his conscious mind the deepest levels of the unconscious, man gradually progresses to a state of heightened consciousness which may, or may not, lead to a mystical union with the Godhead. The important thing for Yeats is not so much the attainment of a visionary experience *per se* as the fact that man assumes a distinct measure of responsibility for his own destiny. As Yeats declared in defence of the magical practices of the Order of the Golden Dawn: "We receive power from those that are above us by *permitting* the Lightning of the Supreme to descend through our souls and our bodies. The power is forever seeking the world, it comes to a soul and consumes its mortality *because the soul has arisen into the*

39. Ibid., pp. 332, 336; 362.
40. *A Vision* (1937), pp. 210, 228-29, 239.
41. Ibid., p. 214.

path of the Lightning among the sacred leaves."[42] Yeats carried the same self-determining philosophy into *A Vision*, affirming that the very process of striving to attain Unity of Being was a liberating and fulfilling experience in itself: "He who attains Unity of Being is some man who, while struggling with his fate and his destiny until every energy of his being has been aroused, is content that he should struggle with no final conquest." Because he *"chooses"* his inflicted fate, "for him freedom and fate are not to be distinguished".[43]

The final conclusion one draws from *A Vision* is that, in spite of its deterministic doctrines and fatalistic tone, human life has a distinctive purpose and value of its own. "Every need soon fades except that for unity with God," Yeats declared in 1934.[44] Yet in the perpetual tension between creation in time and escape out of time, Yeats clearly cast his lot with the former, preferring the tumult of life and the intensity of combat to a peaceful preparation for afterlife. As of Goethe, one could say that Yeats was more fascinated by a struggle with his personal Daimon than with worship of an abstract God. Looking back on his life's work while arranging a collected edition including all his poetry written up to 1932, Yeats was astonished to find consistency of themes if not styles: "The swordsman throughout repudiates the saint; but not without vacillation."[45]

The vacillation that Yeats mentions is of particular relevance to our study. As early as 1885 Yeats warned his fellow students in the Dublin Hermetic Society about the dangers of "miracle hunger" and the "dragon of the abstract" which could "devour forever the freedom and the powers of life".[46] None the less, Yeats's youthful hunger for empirical

42. Harper, *Yeats's Golden Dawn*, p. 267. (My italics.)
43. *A Vision* (1925), p. 28. The same freedom also exists for the primary phases, Twenty Three through Three: "When man identifies himself with his Fate, when he is able to say, 'My will is our freedom', or when he is perfectly natural, that is to say perfectly a portion of his surroundings, he is free even though all his actions can be foreseen." Ibid., p. 45.
44. *Essays and Introductions*, p. 462.
45. Letter from Yeats to Olivia Shakespear (June 30, 1932), *Letters*, p. 798.
46. Quoted in Ellmann, *Man and the Masks*, p. 43.

proof of supernatural phenomena[47] led him into a diverse and at times dubious range of occult activities, including attendance at seances and controlled experiments in magical evocation at Madame Blavatsky's London Theosophical Society and with this uncle George Pollexfen, MacGregor Mathers, and many other members of the Order of the Golden Dawn. Philosophically and experientially these pursuits left an ineradicable impression on Yeats's life and art. As numerous scholars have shown, the philosophic basis and the very imagery of *A Vision* may be traced to the teachings and practice of Theosophy and Hermetism.[48] By 1896, however, Yeats was beginning to realize that by concentrating so much of his energy upon psychic pursuits and, in particular, the evocation of supernatural phenomena he was in serious danger of impairing his mental and physical health.[49] Some of his visionary experiences filled him with terror at the thought of mystical oblivion and the possible obliteration of all that bound him to spiritual and social order.[50] Most important, his artistic work suffered because, under the influence of Mathers, he "plunged without a clue into a

47. It should be noted that although Yeats hated the factionalizing influence of the scientific method, from childhood he exhibited many of the positive aspects of the scientific mind including a healthy degree of scepticism, a restless curiosity for knowledge, and an almost fanatical desire to impose an aesthetic and rational order upon natural experience. Moreover, he clearly recognized the value of scientific speculation and research. Near the end of his life he parried a direct question by labelling himself not a "mystic" but "a practical man. I have made the usual measurements, plummet-line, spirit-level and have taken the temperature by pure mathematics." Letter to Ethel Mannin (December 23, 1938), *Letters*, p. 321.

48. The idea of reincarnation, of a perpetual flux between polarities, and of an essential correspondence or unity between all things in heaven and earth is part of Theosophical and Hermetic doctrine. Both systems also involved meditation upon traditional occult symbols such as the circle, the sphere, the cone, two interpenetrating triangles, and the sun, moon, planets, and constellations. In addition, the idea of the Four Faculties is found throughout Western mysticism as the division of the personality into quaternaries. As Morton Seiden aptly observes, Yeats was not at all displeased that in its basic conceptions *A Vision* was not altogether original. Indeed, the very unoriginality of the book proved to him its universality and, hence, its truth. *The Poet as Mythmaker*, pp. 53-54. Cf. Ibid., pp. 23-25, 37, 45; Moore, *The Unicorn*, pp. 262-64, 271.

49. Vide *Autobiographies*, pp. 376-77.

50. Vide, *Mythologies*, p. 307.

labyrinth of images" and thus isolated himself from common experience.[51] As we shall see, this made parts of *The Countess Cathleen* almost incomprehensible to an Irish audience and cost him years of toil in trying to give *The Shadowy Waters* a coherent meaning and form. By 1900 Yeats had determined upon the path that he would follow for the rest of his life: to seek occult power and knowledge not for their own sake, but for the sake of enriching his art and thus "giving the purest substance of his soul to fill the emptiness of other souls".[52] In theatrical terms, this led Yeats throughout the early years of the Abbey Theatre to root his plays in natural life and to seek with ever-increasing intensity to celebrate the soul by exulting in the natural energy of the body.

Similarly, Yeats tells us that throughout his youth he was caught in the dream of a Hindu-Buddhist doctrine of passive acceptance as taught by the Brahmin Theosophist Mohini

51. *Autobiographies*, p. 255.
52. In 1900 Yeats became involved in a bitter internecine quarrel over the elimination of formal examinations for admission to higher degrees and the creation of secret groups within the Order of the Golden Dawn to experiment with hitherto restricted magical rites. Yeats insisted that the purpose of gaining higher knowledge must not be for selfish ends but for the good of all mankind: "The central principle of all the Magic of power is that everything we formulate in the imagination, if we formulate it strongly enough, realizes itself in the circumstances of life, acting either through our own souls, or through the souls of others, or through the spirits of Nature. . . .If any were to become great among us, he would do so, not by shutting himself up from us in any 'group', but by bringing himself to that continual sacrifice, that continual miracle, whose symbol is the obligation taken by the Senior, that he would share alike in its joy and in its sorrow. . . .The great Adept may indeed have to hide much of his deepest life, lest he tell it to the careless and the indifferent, but he will sorrow and not rejoice over this silence, for he will be always seeking ways of giving the purest substance of his soul to fill the emptiness of other souls. It will seem to him better that his soul be weakened, that it be kept wandering on the earth even, than that other souls should lack anything of strength and quiet. He will think that he has been sent among them to break down the walls that divide them from one another and from the fountains of their life, and not to build new walls. He will remember, while he is with them, the old magical image of the Pelican feeding its young with its own blood; and when, his sacrifice over, he goes his way to supreme Adeptship, he will go absolutely alone, for men attain to the supreme wisdom in a loneliness that is like the loneliness of death." Harper, *Yeats's Golden Dawn*, pp. 266-67. Clearly, Yeats is defining not only a great Adept but the public role he foresaw himself fulfilling as an artist.

Chatterjee to the Dublin Hermetic Society.[53] After 1900, although he remained a fascinated student of Oriental philosophy and religion, Yeats's path to mystical wisdom was quintessentially Western rather than Oriental, for he believed that spirit may be incarnated in matter and not that man should obliterate his human identity in order to raise matter into pure spirit. Thus Yeats firmly rejected the Eastern idea that the world is merely an illusion and human activity meaningless. In 1901 he reminded his colleagues in the Order of the Golden Dawn that "it is by sorrow and labour, by love of all living things, and by a heart that humbles itself before The Ancestral Light, and by a mind its power and beauty and quiet flows through without end, that men come to Adeptship, and not by the repetition of petty formulae".[54]

Yeats was profoundly aware that action is shallow if not accompanied by the rich interior life of the spirit known to his Oriental masters, but he feared that "Western minds who followed the Eastern way become weak and vapoury; become unfit for the work forced upon them by Western life".[55] It was, in fact, the completeness and certainty of Oriental religious beliefs that bothered him most: "The East has solutions always and therefore knows nothing of tragedy. It is we, not the East, that must raise the heroic cry."[56]

In a sense, those who quibble over the depth and sincerity of Yeats's religious faith only provide evidence of their failure to fully understand the traditions of Western mysticism from which his convictions sprang. As Yeats himself emphasized, his mystical faith was rooted in humanistic values from which even doubt itself was not excluded.[57]

53. *The Collected Works of W. B. Yeats* (Stratford-on-Avon: A. H. Bullen, 1908), Vol. VIII, p. 191.
54. Harper, p. 265.
55. Unpublished journal, quoted in Moore, p. 346.
56. Letter to Dorothy Wellesley (July 6, 1935), *Letters*, p. 837.
57. Virginia Moore and Morton Seiden have emphasized that the emergence of Hermetism at the end of the nineteenth century was partially the result of the scientific study of the origins of Christianity. The Hermetic students traced their dogmas and practices to the Orphic Mysteries that adumbrated the essence of the religious spirit of Near Eastern and European antiquity. The Orphic Mysteries, whether in the form of elevated mysteries or thaumaturgy (miracle working), had a direct impact on almost all Graeco-Roman literature and thought, were partially incorporated into the teachings and liturgy of the early Christian Church and, in an unbroken but underground tradition, carried down through the centuries in such diverse forms as Jewish and Christian Gnosticism, Neoplatonism, Kabbalism, medieval alchemy, Rosicrucianism, and

"We must not make a false faith by hiding from our thoughts the cause of doubt, for faith is the highest achievement of the human intellect, the only gift man can make to God, and therefore it must be offered in sincerity."[58] Yeats's religious affirmation is all the more compelling precisely because it was wrung out of a dialectic between doubt and faith. Indeed, because this dialectic aroused his entire being, Yeats saw it as ultimately positive in substance and effect. As he declared in 1930:

I am always, in all I do, driven to a moment which is the realization of myself as unique and free, or to a moment which is the surrender to God of all that I am. . . . Could these two impulses, one as much a part of the truth as the other, be reconciled, or if one or the other could prevail, all life would cease.[59]

The struggle between humanist and would-be saint formed the essence of Yeats's vision of life. From the beginning, the fundamental theme of all his work was the "war of the spiritual with the natural order".[60] Tragedy was the dramatic form through which he gave utterance to this vision and theme.

TRAGEDY AND MYSTICAL EXPERIENCE

It cannot be overemphasized that for the mature Yeats tragedy was not an academic abstraction but a veritable way of life. Tragedy was philosophical in that it arose from the effort to act by those "thoughts tested by passion, that we call conviction".[61] To Yeats "profound philosophy [came] from terror", and that terror, which was a necessary element

finally modern Hermetism. *The Unicorn*, pp. 106-14; *The Poet as Mythmaker*, pp. 221-25. Vide Wilson, esp. chapters three, four, and six, for an account of the history of magic. Cf. Butler, *Western Mysticism*, pp. 189-252, and Thomas Merton, *Mystics and Zen Masters* (New York: Dell Publishing Co., 1967), for a comparison of mystical beliefs and practices in the East and West. Merton argues that the affirmation of faith without a measure of intellectual scepticism is, in effect, contradictory to the essential spirit of Western religion. Religion must not merely be an agency that forces people to adjust to and canonize the routines of mass society. Instead, the testament of faith ought to be "an act of complete dedication of the entire man to God, an assent springing from the great and ineffable distress of our finite nature and our sin." Ibid., pp. 271-73.

58. *Mythologies*, p. 332.
59. Ibid., p. 305.
60. Dedication to A.E., *The Secret Rose* (London: A. H. Bullen, 1897), p. viii.
61. *Autobiographies*, p. 189.

of tragedy, was continually evoked by asking "the ancient questions: Is there reality anywhere? Is there a God? Is there a Soul?"[62] Through tragedy the dramatist created heroic images that enabled man to live with the idea that in his struggle with destiny "life is a perpetual injustice".[63]

Obviously, this was no doctrine for the weak of mind or shallow of soul. Nor, despite its recognition of evil and human frailty, was it a doctrine of pessimism. In Yeats's dialectical philosophy there were no purities. Evil was simply an imbalance of perpetually countering forces.[64] Tragedy existed to restore the balance.

Yeats justified tragic suffering as primarily an affirmation of the human will. The tragic hero chose and carried out his fateful action entirely of his own volition and not at the behest of others. Echoing Nietzsche, whom he began to read in the summer of 1902,[65] Yeats declared that by seeking "a life growing always more scornful of everything that is not itself and passing to its own fulness" the hero attained "tragic joy and the perfectness of tragedy—when the world has slipped away into death".[66] Thus, in terms of classical Aristotelian criticism, tragedy provided a supreme example of the true nature of human freedom, with man defeated yet triumphant, having achieved profound self-knowledge.[67]

But Yeats moved beyond the purely humanistic values of tragedy to consider the tragic experience in the light of its religious implications. Yeats defined this experience in terms

62. *Essays and Introductions*, pp. 502-3.
63. *Memoirs*, p. 254.
64. "All that keeps the spirit from its freedom may be compared to a knot that has to be untied or a violence that must end in a return to equilibrium." *A Vision* (1937), p. 226. Moore provides a Christian interpretation of this concept, arguing that because the struggle to achieve psychic equilibrium is in itself of ultimate value to the soul, evil may actually be said to foster man's spiritual progress. *The Unicorn*, p. 387.
65. Vide Ellmann, *Identity of Yeats*, pp. 91-98.
66. *Explorations*, p. 170. Cf. *Explorations*, p. 375.
67. Vide Vinod Sena, "W. B. Yeats and the Storm-Beaten Threshold", *The Dublin Magazine*, Vol. 8, (Summer/Autumn 1970), pp. 56-76, for an analysis of Yeats's rejection of passive suffering, or pathos, in favour of a triumphal joy born out of the tragic hero's deliberate confrontation with despair.

of two closely related theatrical responses, "tragic pleasure" and "tragic ecstasy".[68] Yeats's concept of tragic pleasure arose from his mystical and aesthetic doctrine of commingling opposites. "It was only by watching my own plays," he declared, "that I came to understand that this reverie, this twilight between sleep and waking, this bout of fencing, alike on the stage and in the mind, between man and phantom, this perilous pathos on the edge of a sword, is the condition of tragic pleasure and to understand why it is so rare and so brief."[69] Still rarer than tragic pleasure was tragic ecstasy— "the best that life can give". Tragic ecstasy was evoked and experienced at the penultimate moment of a play when, as if hypnotized, the audience's sense of everyday reality dissolved. At this moment the actor lost his human identity and became a symbol of the one perfection from whence all art had come, carrying the audience with him "beyond time and persons to where passion becomes wisdom".[70]

It would appear, especially in the light of *A Vision*, that Yeats conceived the tragic experience on two interrelated levels. On the purely natural or humanistic level, tragedy provided a living demonstration of how man attained Unity of Being by facing and conquering despair, defeat, and inevitable death. Tragedy also demonstrated, through the sheer psychic energy activated by the hero's struggle with fate (his personal Daimon), the kind of passionate engagement with life that was necessary for the soul to pass on to a higher phase of existence on the Lunar Cycle. "The soul knows its changes of state alone, and I think that the motives of tragedy are not related to actions, but to changes of state."[71] It was by vicariously sharing at once in the suffering and in the triumphant joy of the hero's psychic transformation that

68. I should point out that Yeats himself does not specifically distinguish between tragic pleasure and tragic ecstasy. However, my own experience in staging Yeats, as well as my analysis of the plays from a dramaturgical standpoint, makes me believe that the distinction is valid and important in order to gain a complete understanding of Yeats's dramatic intention and achievement.

69. Preface, *Plays for an Irish Theatre* (London: Bullen, 1911), p. x.

70. *Essays and Introductions*, p. 239.

71. *Autobiographies*, p. 471.

the audience experienced the full value of the exquisitely balanced dialectic of opposites involved in tragic pleasure.

In contrast with tragic pleasure, tragic ecstasy is related more specifically to Yeats's understanding of supernatural experience. By ecstasy Yeats obviously intended more than the usual meaning of the word—to be beside oneself or to be carried away to a state of trance-like reverie or rapture. On a human level tragedy indeed evoked such emotions, but, to Yeats, tragic ecstasy involved much more than this. "Ecstasy," he once wrote, "is the end of art"—that mood "awakened before an ever-changing mind of what is permanent in the world or by the arousing of that mind itself into the very delicate and fastidious mood habitual with it when it is seeking those permanent and recurring things."[72] Distinguishing the effect of tragic ecstasy from the personal joy of the tragic hero, Yeats declared that ecstasy arose from "the contemplation of things vaster than the individual and imperfectly seen, perhaps, by all those that still live".[73] Tragic ecstasy was thus a moment of illumination and insight that lifted the mind out of purely personal and objective concerns to an almost transcendental state in which the fundamental unity of all things was revealed. Clearly, in theatrical terms, the supremely intense experience of tragic ecstasy was intended by Yeats to provide the audience with an experiential perception of his own mystical "faith".[74] By resolving the dialectic of opposites—the antinomies between the one and the many, the self and the anti-self, the natural and the supernatural worlds—tragic ecstasy evoked for those capable of being carried to such heights a fleeting glimpse of that perfect spiritual Unity of Being that Yeats ascribed to Phase Fifteen of A Vision.

72. Essays and Introductions, p. 287.

73. Autobiographies, p. 471.

74. In a letter to his father (August 5, 1913), Yeats declared: "All our art is but the putting of our faith and the evidence of our faith into words or forms and our faith is in ecstasy." Letters, p. 583. Vide Natalie Crohn Schmitt, "Ecstasy and Insight in Yeats", British Journal of Aesthetics, II (1971), pp. 257-67, for a discussion of the religious significance of ecstasy to Yeats. Vide also Abraham H. Maslow, Religious Values and Peak Experiences (New York: Viking Press, 1970), for a psychological analysis of ecstatic religious, or "peak", experiences as a vital element in the lives of healthy, fully functioning individuals.

Yeats emphasized the rarity of tragic ecstasy, but in his essays and letters he provided several illustrations of theatrical performances that succeeded in lifting him to that visionary state. One of the most moving of these experiences is described in "The Tragic Theatre" (1910) in which he recalled the effect of the climactic scene of Synge's *Deirdre of the Sorrows* in its first production at the Abbey Theatre:

And at the last when Deirdre, in the paroxysm before she took her life, touched with compassionate fingers him that killed her lover, we knew that the player had become, if but for a moment, the creature of that noble mind which had gathered its art in waste islands. . . . It was as though we too had touched and felt and seen a disembodied thing.[75]

Rehearsing his own translation of Sophocles' *Oedipus at Colonus* in 1926, Yeats's response was even more explicitly religious in feeling: "I had but one overwhelming emotion, a sense as of the actual presence in a terrible sacrament of the god. . . . I have got this always, though never before so strongly, from Greek Drama."[76] And, in one of his last essays written in 1937, Yeats described his response to the climactic death scenes of Shakespeare's ostensibly secular tragedies in similar terms:

The heroes of Shakespeare convey to us through their looks, or through the metaphorical pattern of their speech, the sudden enlargement of their vision, their ecstasy at the approach of death: 'She should have died hereafter', 'Of many thousand kisses, the poor lost', 'Absent thee from felicity awhile'. . . . The supernatural is present, cold winds blow across our hands, upon our faces. . . .[77]

As we have emphasized, Yeats's plays are not merely about mystical experience but are designed specifically to evoke that

75. *Essays and Introductions*, p. 239.
76. Letter to Olivia Shakespear (December 8, 1926), *Letters*, p. 720.
77. *Essays and Introductions*, pp. 522-23. Vinod Sena writes that by pursuing his explorations of the tragic experience, Yeats not only anticipated developments in subsequent Shakespearean criticism but helped to suggest why death was essential to tragedy. "If tragedy was born of the impulse to come terms with suffering, and the greater the calamity it comprehended the greater its sense of relief, what better, what more ultimate and universal theme could it have than man's triumph over his instinctive fear of physical extinction?" "W. B. Yeats and the Storm-Beaten Threshold", p. 57.

experience in his audience. We have also observed that Yeats's own understanding of the ideal relationship between the natural and supernatural orders of existence changed during the course of his life. These changes naturally were reflected in his plays, and particularly in his expression of tragic ecstasy. We may perhaps see this most clearly by examining the evolution in his treatment of the theme of romantic love.

TRAGEDY AND THE THEME OF LOVE

Yeats equated the ecstasy of the saint with that of the lover, though he distinguished between the saint's renunciation of life in preference to eternity and the lover's projection of his immortal longings upon the physical form and personality of his beloved.[78] In a note concerning the symbolism of his earliest major poem, *The Wanderings of Oisin* (1889), Yeats drew a further distinction between "the desire of the man 'which is for the woman', and the 'desire of the women which is for the desire of the man' ".[79] This distinction, which essentially failed to recognize the autonomy or depth of woman's physical desires and passions, was largely a product of the youthful Yeats's idealistic concept of romantic love. When combined with his equally idealistic and in some ways naïve relationship with his beloved Maud Gonne, the result was that Yeats almost totally sublimated his own sexual urges until he was well into his thirties.

Yeats met Maud Gonne in January 1890 and immediately fell in love with her.[80] Although tortured by physical desire, Yeats tells us that his dreams of a union with Maud were not sexual but, instead, concerned with sharing a life devoted to "mystic truth".[81] Ultimately, Maud confessed to Yeats that she must refuse his hand because she had become the mistress of a French political leader and journalist. However, she softened the blow with a gentle kiss (their first, according to Yeats) and by telling him that she had a "horror and terror of physical love".[82] In 1896 Yeats had attempted to break the

78. Vide *Essays and Introductions*, pp. 286-87; *Mythologies*, pp. 336, 342.
79. *Collected Poems* (London: Macmillan, 1969), p. 526.
80. Vide *Memoirs*, pp. 40-43, for a vivid description of the impact that Maud Gonne made upon Yeats at their first meeting.
81. Ibid., pp. 49, 125, 128.
82. Ibid., pp. 132, 134.

hold that Maud had upon him through an affair with Olivia Shakespear. None the less, Yeats continued to long for Maud until his hopes were irrevocably shattered with the news received in February 1903 that she had married John MacBride, a dashing major of the Irish Transvaal Brigade in the Boer War, who was to become one of the martyr-heroes of the 1916 Easter Rising. It was not until then that Yeats brought the years of self-denial to a decisive end and threw himself into a series of generally unhappy love affairs.[83]

All of this personal experience coloured Yeats's treatment of love in the plays that he wrote during the 1890s. *The Shadowy Waters* was conceived as a hymn to "ideal human marriage",[84] while *The Countess Cathleen* obviously expressed, through the relationship between the adoring poet Aleel and the proud, independent Countess, Yeats's own relationship with Maud. In *The Countess Cathleen* the poet's only reward for his abject subservience is a motherly kiss upon the forehead. *The Shadowy Waters* concludes with an exquisite paean to, rather than any physical expression of, the lovers' mutual affection. This is not to imply that either play is overtly weakened by the absence of explicit sexuality. Indeed, I consider *The Shadowy Waters* to be an almost perfect work of its kind. But in contrast with the plays that followed it would seem as if at this early stage of his development Yeats was seeking to evoke the rapture associated with love while altogether ignoring the sensual pleasures and pains of the flesh.

Beginning in 1904, however, there is a decided change in Yeats's attitude towards love. This change is especially evident in Yeats's treatment of the character of Cuchulain in *On Baile's Strand*. Cuchulain is the first archetypal Yeatsian tragic hero—willful, idealistic, proud, passionate, and more than slightly disillusioned in his experience of physical love:

> I have never known love but as a kiss
> In the mid-battle, and a difficult truce
> Of oil and water, candles and dark night,
> Hillside and hollow, the hot-footed sun
> And the cold, sliding, slippery-footed moon—

83. Ellmann, *Man and the Masks*, p. 182.
84. Letter from Yeats to George Russell (August 27, 1899), *Letters*, p. 324.

A brief forgiveness between opposites
That have been hatreds for three times the age
Of this long-'stablished ground.[85]

In a letter advising the actor Frank Fay how to interpret
the role, Yeats emphasized that Cuchulain "does not love like
a young man. Probably his very strength of character made
him put off illusions and dreams (that make a young man a
woman's servant) and made him become quite early in life a
deliberate lover, a man of pleasure who can never really sur-
render himself."[86] Obviously, Cuchulain is not the man Yeats
was, but the man he would attempt to become by identifying
himself with an objective heroic mask.

It is also evident that Yeats now viewed the war between
the sexes as yet another image of the antinomies existing
everywhere in life. The images of sun and moon are, of
course, especially suggestive because of A Vision and recur
throughout Yeats's work as symbols, respectively, of male
and female lovers.[87] The relationship of lovers is parallel to
the "mystic way" when in the ecstatic moment of their sex-
ual union the eternal antinomies are resolved.[88] But, as Yeats
emphasized in A Vision, most men and women are fated to
lead sexual lives of tragic frustration.[89] This is because, as
with man's dialogue with his Daimon (which Yeats equated
with the relationship between lover and sweetheart),[90] in
physical love hatred is inevitably mixed with desire; sexual
abandonment is accompanied by an ever-deepening awareness

85. Collected Plays (London: Macmillan, 1969), p. 259.
86. Letter (January 20, 1904), Letters, p. 425.
87. Joseph Campbell comments that in pagan mythology the "Meeting of Sun and
 Moon" is everywhere symbolic of the instant when the mind turns inward and
 realizes an identity between the individual and the universe and when all
 opposites are united. The Masks of God: Occidental Mythology (New York:
 Viking Press, 1964), pp. 163-64. Reg Skene analyses the entire Cuchulain
 cycle of Yeats as a romance of the sun god (Cuchulain) and the moon goddess
 (Emer). Vide The Cuchulain Plays of W. B. Yeats (London: Macmillan,
 1974), esp. pp. 38-71. Yeats employs similar lunar and solar imagery in
 The Shadowy Waters, The King's Threshold, and The Herne's Egg. But of all
 his plays, the most explicit rendering of the relationship of the sexes in terms
 of a solar and lunar dialectic is A Full Moon in March.
88. Letter from Yeats to Olivia Shakespear (May 25, 1926), Letters, p. 714. Cf. A
 Vision, (1937), p. 214.
89. Ibid., pp. 130-31.
90. Mythologies, p. 336.

of the ephemeral and incomplete nature of purely mortal fulfillment.

Beginning with his revisions of *The Shadowy Waters* in 1906, Yeats sought a dramatic expression for these ideas that continued for the rest of his life. Perhaps because Yeats saw women as ideally being more in touch with the subjective (lunar) world of the unconscious than men, many of Yeats's richest characters are of self-determining women who assume a dominant role in the love relationship. We shall find when we examine the revisions of *The Shadowy Waters* that it is Dectora, the heroine of the play, who actively, indeed agressively, teaches Forgael the full human meaning of love. But with *Deirdre*, also written in 1906, Yeats created for the first time a heroine who, by functioning in response to her deepest feminine instincts, is driven into conflict with a harsh world of objective masculine values that leads her inevitably to a tragic doom.

As the play opens we learn that Deirdre has chosen seven years of exile with her lover, Naoise, in preference to marriage with the elderly King Conchubar. Promised forgiveness by Conchubar, the two lovers have returned to the court, though Deirdre has ominous forebodings. When she bedecks herself with jewels in order to try to soften Conchubar's heart, Naoise questions her faithfulness to him. Deirdre replies that her wiles are equal to a man's:

> Were it not most strange
> That women should put evil in men's hearts
> And lack it in themselves?[91]

Deirdre's forebodings are realized when Conchubar takes Naoise prisoner and bargains with his life for Deirdre's body. Just as she is on the point of yielding, Deirdre learns that Naoise has been murdered. She then beguiles Conchubar into letting her see Naoise one last time, saying:

> It's better, when you're beside me in your strength
> That the mind's eye should call up the soiled body,
> And not the shape I loved.[92]

91. *Collected Plays*, p. 185.
92. Ibid., p. 200.

Conchubar reluctantly submits to her request, whereupon Deirdre kills herself. She thereby dramatically embodies the ironic attitude towards physical love reflected earlier in the play by the chorus of Musicians:

> What's the merit in love-play,
> In the tumult of the limbs
> That dies out before 'tis day,
> Heart on heart, or mouth on mouth.
> All that mingling of the breath,
> When love-longing is but drouth
> For the things come after death?[93]

For Deirdre the sexual instinct and love are but two halves of the same impulse. In her profound awareness of herself as woman, Deirdre epitomizes Unity of Being as expressed in feminine terms. The problem with the play, however, is that Deirdre appears to know too much too soon. Her only major conflicts are with external human forces rather than within her own soul; there are no vast antinomies to be resolved. Thus, while theatrically effective, *Deirdre* fails to evoke the full intensity and resonance of Yeatsian tragic ecstasy.

The Only Jealousy of Emer, written in 1917 and 1918, provides a striking contrast to *Deirdre*, especially since it explores the same ambiguous relationship between love, sexual desire, and mortal versus immortal fulfillment. As *The Only Jealousy of Emer* opens we find Cuchulain lying in death, watched over by his wife, Emer, and his mistress, Eithne Ingube. At Emer's bidding, Cuchulain's body is brought back to life through a kiss bestowed upon his lips by Eithne. Upon awakening, however, the Ghost of Cuchulain is seen to have been possessed by a spirit of immortal beauty, Fand, the woman of the Sidhe. Emer is called upon to make an agonizing decision. Only if she will renounce every hope of regaining Cuchulain's love will he be fully restored to mortal existence. Emer withholds her fateful decision until Cuchulain's Ghost, struggling itself with memories of Emer's earthly love, is about to yield to the sensual charms of Fand. Only then, as Fand's erotic dance of seduction reaches a climax, does Emer cry out: "I renounce Cuchulain's love forever."[94] Cuchulain

93. Ibid., p. 191.
94. Ibid., p. 294.

reawakens, trembling in fear and calling out for the arms of Eithne Ingube.

The Only Jealousy of Emer is one of Yeats's most deeply moving plays. Much of its emotional power and verisimilitude are undoubtedly due to the fact that the play was written out of the entanglements surrounding Yeats's marriage to Georgie Hyde-Lees in October 1917. In the year preceding his marriage Yeats had once again proposed to and been turned down by Maud Gonne. Then he fell in love with and was rejected by Maud's beautiful seventeen-year-old daughter, Iseult. In a state of severe emotional depression he turned to Georgie Hyde-Lees and was accepted by her.[95] It is little wonder that shortly after his marriage Yeats wondered if he had not "betrayed three people".[96] It is not difficult to find these three people—Georgie, Maud, and Iseult—portrayed, respectively, as Emer, Eithne, and Fand.

Illuminating as the personal background of The Only Jealousy of Emer may be, what is of more relevance to our immediate topic is the relationship of the play to Yeats's mystical beliefs and his concept of tragedy. In his recent study of the five plays forming Yeats's Cuchulain cycle, Reg Skene has brilliantly demonstrated the integral relationship between A Vision and the entire cycle as it portrays the progress of Cuchulain's soul moving from absorption in the objective world to subjective realization and back again to complete absorption in the objective world. Furthermore, Skene associates each of the plays with a specific phase of the Lunar Cycle.[97] As we find Cuchulain in The Only Jealousy of Emer he is in the process of passing through Phase Fifteen of the Lunar Cycle in the form of a pure spirit. Fand is herself an emanation of Phase Fifteen, being a symbol of the perfect womanly beauty associated with the full moon. She is also an image of Cuchulain's Daimon in its pure, subjective feminine form. Emer and Eithne are themselves partial incarnations of Fand, though Emer, by expressing a love that is beyond bodily desire, lives on a higher plane of existence than the sensual Eithne.

95. Hone, W. B. Yeats, pp. 302-6.
96. Letter to Lady Gregory (October 29, 1917), Letters, p. 693.
97. Vide Skene, The Cuchulain Plays, pp. 201-21, for an extensive analysis of The Only Jealousy of Emer.

The metaphysical conflict of the play basically concerns Cuchulain's (Yeats's) struggle between an instinctual preference for mortal fulfillment versus a longing for immortal perfection. Emer's sacrifice is the instrument whereby Cuchulain is enabled to fulfill his true destiny in earthly terms. However, by her sacrificial act Emer brings herself closer to attaining Unity of Being than Cuchulain. At the end of the play she has passed beyond even the desire of hope and accepted a lonely tragic destiny. Cuchulain and Eithne, on the other hand, are destined to continue their struggle for self-realization on a purely physical plane, their love inevitably doomed to extinction with the passage of time. In the final play of the cycle, *The Death of Cuchulain* (1939), Cuchulain, too, attains the detachment of Emer and willingly casts off all mortal bonds including the physical love of Eithne. He thereby finally passes on to the supernatural phase appropriate to his own objective nature, that of Phase One of the Lunar Cycle.

What is perhaps most remarkable about *The Only Jealousy of Emer* is that it shows how extraordinarily compelling the ideas of *A Vision* are when given full dramatic embodiment. Each of the characters in the play conforms to the almost mathematical schematization of *A Vision*. Because Yeats sees the soul's struggle for fulfillment as being intensely personal, one cannot help being involved in the tragic situation as it is experienced by each of the protagonists. We know that the destiny each character must fulfill is fated on the wheel of life and that every moment of triumph is countered by an opposite force. Thus the seeming happiness of Cuchulain and Eithne is only won at the cost of Emer's pain. However, we also know that the wheel must turn and that the agony of Emer encompasses a serenity born of profound self-knowledge that Cuchulain must discover for himself by a different, though equally painful, route.

As Yeats's own life continued to unfold, his expression of tragic ecstasy became increasingly harsh, astringent, and violent. Three plays written in old age—*The King of the Great Clock Tower* (1935), *A Full Moon in March* (1935), and *The Herne's Egg* (1938)—focus on the act of coition as a symbol of the supernatural embodied in natural life. The subject of each play is stark and brutal in its elemental passion. In *A*

Full Moon in March and *The King of the Great Clock Tower* a vagabond poet comes to court a Queen and is slain for his presumption. His severed head then sings, provoking the Queen to a sensual dance that climaxes in their sexual union. In *The Herne's Egg* a blundering warrior commits sacrilege against the deity, the Great Herne, by raping the deity's virgin priestess. As a result of the desecration, the hero is doomed to die at a fool's hand, but rather than allow the prophecy to be fulfilled, and combating the supernal power to the last, he kills himself.

"I think that we who are poets and artists, not being permitted to shoot beyond the tangible must go from desire to weariness and so to desire again and live but for the moment when vision comes to our weariness like terrible lightning, in the humility of the brutes."[98] In tracing the various forms through which Yeats sought to express the theme of love we have, in essence, been exploring the dialectical nature of Yeats's lifelong pursuit of religious truth. Like the heroes and heroines of his early plays, the youthful Yeats sought the supernatural beyond life as it might be experienced in a state of near perpetual reverie. As we have seen, Yeats brought himself to such an emotionally vulnerable state that he was in danger of weakening his intellectual and physical powers and of losing touch with the world of everyday reality. Yeats's reaction against this extreme imbalance took the form of a headlong involvement in practical activities, including the creation of the Abbey Theatre. It also took the form of an attempt to hide his subjective nature behind a stern objective mask. Dramatically, this dialectical process was expressed in plays such as *On Baile's Strand* and *Deirdre* which celebrated ordinary human life lifted to the heights of tragic heroism.

By 1916, however, Yeats once again found the struggle between the extremes of his personality so intense as to be almost unbearable. Beginning seriously in 1909, and especially from 1911 on, he had resumed his search for irrefutable personal evidence of the supernatural by regular attendance at spiritualistic seances.[99] On the other hand, having reached the age of fifty he was haunted by the thought that he had spent the best part of life on a barren passion, with

98. *Mythologies*, p. 340.
99. Vide Ellmann, *Man and the Masks*, pp. 188-208.

neither home, wife, nor children to provide him with a sem-
blance of emotional or material stability.[100] The dialectic
between supernal longings and the physical satisfactions of
ordinary life was momentarily resolved in the marriage bed.
But *A Vision* and plays such as *The Only Jealousy of Emer*
show that, far from leading him into the stasis of bourgeois
stability, his marriage to Georgie Hyde-Lees only heightened
Yeats's conviction that the path to Unity of Being involved a
continual search for new experience appropriate to the par-
ticular condition in which an individual found himself at vari-
ous stages of his life.

The explicit sexuality of the plays written in Yeats's old
age may thus be properly understood not as ultimate truth
but as a continuation of the dialectical process that Yeats
began in youth. The implacable, icy heroines of *A Full Moon
in March*, *The King of the Great Clock Tower*, and *The
Herne's Egg* are dramatic projections of Yeats's final mask of
self-sufficient intellectual certainty. But Yeats realized that,
however complete such a mask might outwardly appear, it
was only a disguise that hid deeper primordial needs. He
further realized as an artist that in order to reactivate the
fecund source of creativity—the subjective feminine half of
his personality—he must continue to seek his elemental oppo-
site or Daimon.[101] The violent energies aroused in the combat
of lovers and the act of sexual congress itself were evidence
to Yeats of the supernatural powers latent in man's own
nature but forever beyond the reach of his conscious mind.
The point I wish to stress is that there is a fundamental
connection between Yeats's early and later dramatic work
that may be properly understood only in terms of his dialec-
tical philosophy of life. Their dramaturgical forms, hence
their theatrical intensities, may differ, but the underlying
tragic theme of Yeats's later plays evolves out of the frus-

100. The Old Man in *At the Hawk's Well* (1917) reflects Yeats's bitter frustration
at having nothing personal to show for his years of ascetic self-denial.
101. The explicit eroticism of Yeats's later plays is unquestionably due to the
effect of the Steinach operation for rejuvenation that he underwent in 1934.
Dejected by poor health, Yeats apparently decided that he had no wish to
prolong life unless he could re-create himself continually, continually com-
pete with himself. The result of the operation was a fresh vitality and
creative energy as well as a renewed interest in sex that continued to obsess
him in varying degrees to the end of his life. Hone, *W. B. Yeats*, pp. 436-37.

trated immortal longings expressed by Forgael in
owy Waters:

> Yet never have two lovers kissed but they
> Believed there was some other near at hand,
> And almost wept because they could not find it.[102]

MYSTICISM, THE ANIMA MUNDI, AND THE IDEA OF A THEATRE

Some forms of mysticism make little of death, making very
little of life, just as some forms of humanism make little of
the spiritual, making very little of man. A major part of
Yeats's claim to greatness lies in the unique combination of
mysticism and humanism that he exhibited throughout his
life's work, but most especially in the drama. From first to
last Yeats sang the perfectability of man coexistent with the
imminent presence of the supernatural in all the actions and
artifacts of the world.

A careful and open-minded examination of Yeats's life
would show that, far from encouraging escapism, his explora-
tion of mysticism and occult experience ultimately enriched
and strengthened him as a man and artist. In particular,
Yeats's involvement with the Hermetic Order of the Golden
Dawn helped him to transform his youthful yearnings for
transcendental experience and magical powers into a faith
that sought its proofs not beyond the world but within the
heart of man. Yeats's notes for his unpublished novel, *The
Speckled Bird*, which he began in the mid-1890s, declare:
"The Rosicrucian magic means the assertion of the greatness
of man in its extreme form. . . . [The hero] may even claim
with the Druids that man created the world."[103] In the first
edition of *A Vision* Yeats reasserted the same thought in the
form of a prophecy that after 1927 "man will no longer
separate the idea of God from that of human genius, human
productivity in all its forms".[104]

As a member of the Order of the Golden Dawn, Yeats had
no quarrel with the Christian religion or its symbolism, but
only with its orthodox interpretation. Writing in 1896 to

102. *Collected Plays*, p. 151.
103. Quoted in Ellmann, *Identity of Yeats*, p. 60.
104. *A Vision* (1925), p. 214.

persuade a friend to join the Order, Yeats emphasized that the Golden Dawn tenets were not at all incompatible with Christianity. "I am convinced," said Yeats, "that for you progress lies not in a dependence upon a Christ outside yourself but upon the Christ in your own breast, in the power of your divine will and divine imagination and not in some external will or imagination however divine. We certainly do teach this dependence only on the inner divinity but this is Christianity."[105] In A Vision Yeats exalted the early Christian image of the Saviour as "perfect physical man" in preference to the modern idea that God is "something outside man and man's handiwork". By promulgating the latter concept, with even the messengers of God deprived of human form and personality, the Church had gotten man to think of himself and the world as being "featureless as clay or dust".[106] In order to counteract this tendency Yeats sought to reconcile the worship of Christ with natural emotion. In his dance drama Calvary (1920) Yeats went so far as to portray Christ riven with terror and spiritual loneliness at the thought that His sacrifice for mankind was meaningless. In The Resurrection (1931) intellectual arrogance is shown to be powerless when confronted with the physical presence of the risen Christ.[107] For Yeats the true meaning of the Incarnation is that God became man in the fullest sense of the word.[108]

105. Quoted in Ellmann, Identity of Yeats, p. 51.
106. A Vision (1937), pp. 273-74.
107. Vide James W. Flannery, "Action and Reaction at the Dublin Theatre Festival", Educational Theatre, XIV, 4 (December 1967), pp. 72-80, for various Christian and non-Christian interpretations of Calvary and The Resurrection provided by critics and audiences in discussions following a production of the two plays.
108. Perhaps Yeats's most direct affirmation of the Christian "faith" into which he was born and hoped to die is contained in the following passage: "My Christ, a legitimate deduction from the Creed of St. Patrick as I think, is that Unity of Being Dante compared to a perfectly proportioned human body, Blake's 'Imagination', what the Upanishads have named 'Self'; nor is this unity distant and therefore intellectually understandable, but imminent, differing from man to man and age to age, taking upon itself pain and ugliness." Essays and Introductions, p. 518. One could certainly not classify Yeats as an orthodox Christian, but his concept of Christ as the pre-eminent ideal of human perfection throughout the ages is by no means inconsistent with that of many contemporary theologians. Vide, for instance, Pierre Teilhard de Chardin, The Phenomenon of Man (London: Wm. Collins & Co., 1955), pp. 319-27.

Many Christian theologians would agree with Yeats that the modern Church has rendered Christianity ineffective by setting Christ on a pedestal of excessive reverence and by making him so unique that he is virtually isolated from the human condition. As a result the modern age has suffered from a vast hunger and impoverishment of the spirit which the organized Christian religion rarely satisfies. Many contemporary psychologists have also come to realize that by throwing out not only the answers provided by organized religion but religious questions in themselves, atheistic nineteenth-century science deprived man of a spiritual dimension of life that is essential to his mental health. In our own time, social historians and philosophers as diverse as Charles Reich, Theodore Roszak, William Irwin Thompson, Herbert Marcuse, and Norman Brown, Zen-based psychotherapists such as Alan Watts, and humanist psychologists including Abraham Maslow, Rollo May, and Carl Rogers have joined forces with Christian theologians such as John Robinson and Harvey Cox in postulating and actively working towards the achievement of a new and higher personal and social consciousness for mankind.[109] Science itself has been transformed by the prophecies of men

109. Vide Charles Reich, *The Greening of America* (New York: Random House, 1970), esp. pp. 233-85; Theodore Roszak, *The Making of a Counter-Culture: Reflections on the Technocratic Society and Its Youthful Opposition* (New York: Doubleday, 1969); William Irwin Thompson, *Passages About Earth* (New York: Harper & Row, 1973); Herbert Marcuse, *Eros and Civilization* (New York: Vintage Books, 1962); Norman Brown, *Life Against Death* (Middletown, Conn.: Wesleyan University Press, 1959); Alan Watts, *Psychotherapy East and West* (New York: Pantheon Books, 1961); Frank G. Goble, *The Third Force: The Psychology of Abraham Maslow* (New York: Grossman, 1970); Rollo May, *Love and Will*; Carl Rogers, *On Becoming a Person* (Boston: Houghton Mifflin Co., 1969); John A. T. Robinson, Bishop of Woolwich, *Honest to God* (London: SCM Press, 1963); Harvey Cox, *The Feast of Fools* (Cambridge: Harvard University Press, 1969).

It is fascinating to note that Cox considers the hippies to be the forerunners of a form of neo-mysticism: "Today's new mystics represent a modern phase in a very old religious movement. They personify man's ancient thirst to taste both the holy and the human with unmediated directness. Like previous generations of mystics, the new ones suspect all secondhand reports. Also they wish to lose themselves, at least temporarily, in the reality of the experience. Above all, like the mystics of old, when they try to tell us what they are up to, we have a hard time understanding them. Mystics speak a language of their own, and sometimes even their fellow mystics do not understand them." *The Feast of Fools*, pp. 102-3.

like the biologist Julian Huxley and the Jesuit paleontologist-philosopher-theologian Pierre Teilhard de Chardin, who have envisaged human evolution culminating in a collective, planetary state of what Teilhard describes as a "super-consciousness . . . corresponding to a new age in the history of the earth".[110]

It is beyond the scope of this book to do more than barely indicate the distinctions and correlations between the ideas of Yeats and these extraordinary spiritual manifestations and movements of today. Certainly, we must emphasize, that with his cyclical theory of history and his belief in the persistence of evil as a concomitant of the perpetual struggle of contraries, Yeats is at variance with the linear concept of progress and the utopian vision of ultimate human destiny postulated by many humanist psychologists and cultural evolutionists. But this much can be said: by deliberately affirming the potential of humanity instead of stressing man's limitations and neuroses, by emphasizing the needs and sympathies that draw men together rather than those drives that cause them to repel one another, by striving to restore, protect, and foster man's awareness of himself, of other people, and of nature, by finding an elemental joy in the phenomena of everyday existence and in the sheer physical energy of being alive, by celebrating the personal satisfactions derived from being true to one's inviolate self in preference to the acceptance of imposed standards and codes, a sizable portion of the intellectual and cultural leaders of our time have espoused the very ideas that formed the basis of Yeats's much maligned mysticism.

110. Pierre Teilhard de Chardin, *The Future of Man* (London: Wm. Collins & Co., 1969), p. 84. Julian Huxley summarizes his own and Teilhard de Chardin's predictions for the advance of man as follows: "global unity of man's noetic organization or system of awareness, but a high degree of variety within that unity; love, with good-will and full co-operation; personal integration and internal harmony; and increasing knowledge." Introduction to Teilhard de Chardin, *Phenomenon of Man*, p. 29. Also of considerable significance is the fact that today scientists throughout the world are devoting increasing attention to the study of para-psychological phenomena which have hitherto only been taken seriously by primitive peoples, mystics and visionary artists such as Yeats. Vide Thompson, *Passages About Earth*, esp. pp. 84-118; Sheila Ostrander and Lynn Schroeder, *Psychic Discoveries Behind the Iron Curtain* (Englewood Cliffs: Prentice-Hall, 1970).

The theatre of Yeats might be described as a temple for the propagation of his faith in a life-affirming, mystical form of humanism. Yeats's idea of a theatre was itself a direct result of his occult pursuits. It will be recalled that in his study of Theosophical and Hermetic doctrines Yeats was introduced to the concept of the Anima Mundi, a great storehouse of universal intelligence suffused through all things and thus bordering on the unconscious mind of every individual. His visionary experiences and especially a series of practical experiments that he carried out in thought transference during the mid-1890s provided Yeats with conclusive proof of the validity of this concept.[111] In an essay entitled "Magic", published in 1901, Yeats made a public affirmation of his belief in three fundamental doctrines of magical practices as handed down through the ages:

1. That the borders of our mind are ever shifting, and that many minds can flow into one another, as it were, and create or reveal a single mind, a single energy.

2. That the borders of our memories are as ever shifting, and that our memories are part of one great memory, the memory of Nature herself.

3. That this great mind and great memory can be evoked by symbols.[112]

The theatrical implications of these ideas were of immense significance to Yeats. From them he derived his concept of tragedy as a powerful medium for effecting a spiritual unity among men, paradoxically, by celebrating their individual uniqueness. To Yeats, the fundamental error of modern realism as a philosophy and mode of art is that it was based upon an imitation of the arbitrary surface peculiarities of life. Thus it tended to emphasize the seeming differences among men and heighten their sense of isolation from one another.[113] True individuality, however, was born in the depths of the unconscious where "no mind's contents [were] necessarily shut off from another".[114]

111. Vide *Autobiographies*, pp. 258-62.
112. *Essays and Introductions*, p. 28.
113. Vide ibid., p. 288; letters to T. Sturge Moore (March 12 and 29, 1926), *Correspondence*, pp. 81, 85-86.
114. Unpublished note of 1919 quoted in Jeffares, *W. B. Yeats*, p. 210. Cf. Jung's definition of the "collective unconscious", note 17 above.

Yeats believed that the poet created tragedy "from his own soul, that soul which is alike in all men".[115] By tapping the depths of his unconscious through a dialogue with his Daimon, the poet discovered his true and unique self. Moreover, he contacted the archetypal images shared by all men through the Anima Mundi, or collective unconscious. While tragedy was born of the individual its final effect was profoundly communal. Echoing almost word for word his description of the social function that the great Adept was obliged to fulfill, Yeats declared: "Tragedy must always be a drowning and breaking of the dykes that separate man from man."[116]

We shall find that these ideas created a profound influence upon Yeats's concepts of acting, staging, and dramaturgy. The very process of writing became equivalent to the methods Yeats learned from MacGregor Mathers for "skrying", or evoking visions through a highly disciplined meditation on selected symbols. Through a similar kind of meditation, said Yeats, the poet purified his mind so that "the little ritual of his verse" more and more resembled "the great ritual of nature . . . mysterious and inscrutable". In this way the poet became, "as all the great mystics have believed, a vessel of the creative power of God".[117]

The creative process was, therefore, not one in which the artist exercised a totally conscious control over either himself or the techniques and instruments of his art. In an argument employed against those who would censor his plays at the Abbey Theatre, Yeats declared that "art, in its highest moments is not a deliberate creation, but the creation of intense feeling, of pure life". "The artist, too, has prayers and a cloister," he continued. It was from the vantage point of a kind of temple of the imagination that the dramatist must picture "life in action, with an unpreoccupied mind, as the musician pictures her in sound and the sculptor in form". Art at its best was not the expression of a point of view but "a reverie about the adventure of the soul, or of the personality, or some obstinate questioning of the riddle".[118]

115. *Autobiographies*, p. 471.
116. *Essays and Introductions*, p. 241 Cf. note 52 above.
117. Ibid., pp. 201-2.
118. *Explorations*, pp. 152, 153, 154, 141.

It is evident that at this point in his career Yeats drew few distinctions between his powers and responsibilities as a poet and as an Adept of the Order of the Golden Dawn. Indeed, four years' study of the mystical writings of William Blake from 1889 to 1893 provided him with an early model for the kind of poet-philosopher he strove to become. Blake, as prophet and seer, heralded to Yeats a "new epoch in which poets and poetic thinkers should be once more, as they were in the days of the Hebrew prophets, the Spiritual leaders of the race".[119] Fortified with the insights of arcane knowledge and the evidence of a decline in unconventional religious observances through the onslaughts of science, Yeats went so far as to claim for himself and fellow mystical artists the rights and functions of a priesthood. In 1898 he wrote: "The arts are about to take upon their shoulders the burdens that have fallen from the shoulders of the priests, and to lead us back upon our journey by filling our thoughts with the essence of things and not things."[120] Artists were enjoined to take upon themselves "the method and fervour of a priesthood"[121] and, by disclosing the mysteries of nature through the equally mysterious process of artistic creation, become, as Blake, the priests of "a religion of art".[122]

It was thus in the role of a would-be poet-priest that Yeats wrote in the issue of *Beltaine* published to coincide with the opening of the Irish Literary Theatre in May 1899:

In the first day it is the art of the people, and in the second day, like the drama acted of old times in the hidden places of temples, it is the preparation of a Priesthood. It may be, though the world is not old enough to show us any example, that this Priesthood will spread their Religion everywhere, and make their Art the Art of the people.[123]

He was to learn, however, that there were other prophets and priests—secular as well as religious—abroad among the people, and their gospel was far from that of a religion of art.

119. Preface to *The Work of William Blake: Poetic, Symbolic, and Critical,* eds. Edwin John Ellis and W. B. Yeats (London: Quaritch, 1893), Vol. I, pp. x-xi.
120. *Essays and Introductions,* p. 203.
121. Ibid., p. 203.
122. Ibid., p. 111.
123. Ibid., p. 168.

Creating a Unity Through Ireland and an Irish National Theatre

UNITY OF BEING, UNITY OF CULTURE, AND UNITY OF IMAGE

Yeats tells us that at the age of twenty-three or twenty-four one sentence—"Hammer your thoughts into unity"—formed in his mind. That sentence haunted him and exerted an influence upon all his subsequent thoughts and actions.[1]

In philosophical and religious terms, occult study was at this time the dominant influence in his life. In literary terms it was aestheticism. The other dominant influence, and the one that he attempted to make the unifying source of and inspiration for the major activities of his lifetime, was Ireland. Yeats's vision of, and relationship to, Ireland was formulated in terms of three interrelated concepts—Unity of Being, Unity of Culture, and Unity of Image. While, like his doctrine of the mask and his idea of tragedy, these concepts were elaborated over a period of years, they may be seen, even in their formative stages, to underlie most of the theories and practices upon which he based the Irish dramatic movement.

As we have seen, by the term Unity of Being Yeats summed up many of his ideas on the ideal state or nature of the human personality. Yeats originally derived the concept

1. *Explorations,* p. 263.

of Unity of Being from his father, who placed particular emphasis on the development of the personality as the supreme human value, with art its fullest expression. To John Butler Yeats the complete personality was one that expressed "all emotions", "all roused to their utmost strength". Such a personality was capable of being invigorated so that the least awakening of feeling caused "every chord of every feeling" to vibrate.[2] His concept of personality was thus a highly physical, histrionic one. "Personality," he declared,

is neither right nor wrong—for it is divine—it transcends intellect and morality. Real Poetry is Real Personality, a little child when it is learning to talk, unburdened with ideas of right or wrong, and without intellect, and often a woman when she is in love or when she has little children—here is Pure Personality.[3]

W. B. Yeats shared some but not all of his father's ideas. He, too, responded histrionically to the fully developed personality as the most perfect embodiment and expression of Unity of Being. He equated Unity of Being with "the thinking of the body"[4] and compared it to the art of Dante in subordinating "all parts to the whole as in a perfectly proportioned human body".[5] Corinna Salvadori has shown how closely Yeats's ideal Unity of Being resembles that of "The Perfect Courtier" of Castiglione, with Yeats finding a modern equivalent in Lady Gregory's son, Robert Gregory, of the courage, pride, athleticism, and sprezzatura—"the art which hides all art", or "grace"—of Castiglione's ideal courtier.[6] Yeats found other living images for his concept. We have noted his admiration for the integrated strength of William Morris. Another example might be John Shawe-Taylor, Lady Gregory's nephew, of whom Yeats wrote that he was one of those men "whose looks are the image of their faculty", who,

2. John Butler Yeats, Letters to His Son W. B. Yeats and Others, 1869-1922, edited with a memoir by Joseph Hone and a preface by Oliver Elton (New York: E. P. Dutton, 1946), p. 48. Cf. Autobiographies, p. 190.
3. Letter from John Butler Yeats to Susan Mitchell (October 21, 1912), Letters to His Son, p. 150.
4. Essays and Introductions, p. 292.
5. Ibid., p. 518.
6. Yeats Poet and Castiglione Courtier (Dublin: Allen Figgis, 1965), pp. 90, 97-100.

"copying hawk or leopard, have an energy of swift decision, a power of sudden action, as if their whole body were their brain".[7]

W. B. Yeats parted from the ideas of his father in two important respects, however: the relation of thought or will to emotion in the individual psyche, and the relationship of the individual to his society.

From all recollections of him, and particularly from his letters, John Butler Yeats appears as an individual completely at one with himself—a man with a vibrant, passionate, delightfully engaging personality.[8] In short, he naturally possessed Unity of Being and could therefore speak of that concept in relatively uncomplicated terms. John Butler Yeats was, furthermore, a man who enthusiastically responded to the company of others. He could argue to his son without contradicting his natural inclinations that *"the true poet is a solitary, as is man in his great moments"*[9] because, for him, the process by which the personality attained completeness was perfectly simple and natural.

The basic personality of W. B. Yeats was almost the complete opposite; he was a born solitary. For him the attainment of Unity of Being was no simple matter of spontaneous expression, but an act of will involving decision and subsequent action. As an introvert, the actions of the workaday world were an intrusion on the more perfect world of his dreams. To attain Unity of Being it was necessary to seek his own opposite—that is, his mask, or anti-self—by deliberately engaging himself with life and society. This involved further complications. Where his father devoted relatively little thought to the quality of social life, for W. B. Yeats society—his opposite—was what he saw most clearly and most objectively. And what he saw, for the most part, he hated, particularly the hideous vulgarity, impersonality, and loneliness of modern urban life such as he experienced in London in his teens and early twenties. "I thought that the enemy of this unity [Unity of Being]," he writes, "was abstraction, mean-

7. *Essays and Introductions*, p. 343.
8. Cf. "Memoir of John Butler Yeats" by Hone, *Letters to His Son;* "An Appreciation" by "A.E.", John Butler Yeats, *Essays, Irish and American* (New York: Books for Libraries Press, 1969), pp. 5-8.
9. Letter (May 9, 1908), *Letters to His Son*, p. 105.

ing by abstraction not the distinction but the isolation of
occupation, or class or faculty."[10]
 Thus the realization of Unity of Being became an ideal
unattainable for individuals such as himself in a society which
had not itself achieved an equivalent unity. That ideal state
of social harmony Yeats termed Unity of Culture.[11]
 It is difficult to know whether Unity of Culture was, for
Yeats, a Platonic ideal or a condition which he believed cer-
tain societies had attained or were capable of attaining.[12]
When he wrote about Unity of Culture it was always in uto-
pian, visionary terms. A country possessed Unity of Culture
when "its religious, aesthetic, and practical life" were one,
when no social or occupational distinctions existed, because
all—the prince and peasant, craftsman and poet, artist and
day-labourer—were "of one mind and heart".[14]
 Yeats was especially concerned with the implications of
Unity of Culture for the artist. True Unity of Culture was
based upon "an inherited subject matter known to the whole
people". Unity of Culture served the artist both by inspiring
him and by providing him with an audience.[15]
 In turn, Unity of Culture was "defined and evoked" by
Unity of Image.[16] The poet, as maker of images, provided a
principal means whereby society attained Unity of Culture
by enshrining in his art the myths and rituals of a race or
nation, and by creating new images that were passed down to
form that society's inherited traditions. The poet also pro-
vided a means whereby society advanced in moral character
by challenging it with "related images, symbolical or evoca-
tive of the state of mind . . . the most difficult in that man,
race, or nation". Such advancement occurred, Yeats believed,

10. *Autobiographies*, pp. 190, 354.
11. Ibid., p. 355.
12. He once wrote: "All my life I have longed for such a country [that is, a
 country with Unity of Culture], and always found it quite impossible to
 evoke without having as much belief in its real existence as a child has in that
 of the wooden birds, beasts, and persons of his toy Noah's ark." *Plays and
 Controversies* (London: Macmillan, 1927), p. 434.
13. *A Vision* (1937), p. 279.
14. *Autobiographies*, p. 191.
15. Ibid., p. 190.
16. Ibid., p. 269.

because "only the greatest obstacle that can be contemplated without despair rouses the will to full intensity".[17]

The poet, as both creator and guardian of culture, thus had a sacred duty to fulfill in society. It was Yeats's conviction that individual life had "only come to perfection", or achieved Unity of Being, in those ancient societies which had been united through the images created and sanctified by poets—images "always praising the one mind, their foundation of all perfection".[18]

Whether in literal or symbolic terms, Yeats held up as examples certain ideal societies, periods, or civilizations in which Unity of Being, Unity of Culture, and Unity of Image had existed. Such a period existed for him around the year 1450, when nations and men, princes and ploughmen "attained to personality in great numbers". Shakespeare, over a century later, still wrote out of that stimulating Zeitgeist, his characters making "all things serve their passion, and that passion for the moment the whole energy of their being".[19] In later life Yeats responded similarly to the Renaissance Court of Urbino and particularly the civilization of Byzantium from A.D. 460 to 520.[20]

One image above all haunted Yeats's imagination—that of ancient Greece, where "civilization rose to its highest mark".[21] At the core of that civilization was a theatre situated on the slopes of the Acropolis, focussed at the centre of the life of the community. Pisistratus had created this ideal theatre with the deliberate intention of unifying the city-state of Athens. His practical means of achieving this objective was through the tragic contests performed at the annual Festival of Dionysus, which, in turn, drew their inspiration from the Dionysian religious rites of the peasantry, the Eleusinian rites of the artistocratic and intellectual leaders of Athens, and ancient Homeric mythology. Following the plan of Pisistratus, the Theatre of Dionysus became a kind of religious temple within the framework of a civic holiday

17. Ibid., pp. 194-95.
18. Essays and Introductions, p. 44.
19. Autobiographies, p. 291.
20. Vide Salvadori, Yeats Poet and Castiglione Courtier, pp. 22-23; Henn, The Lonely Tower, pp. 220-37.
21. Explorations, p. 439.

where the myths and rituals of the people of Athens were transformed into art forms in order to raise their cultural level and evoke within them a powerful sense of communal identity.[22]

Yeats developed a similar plan for Ireland. We have seen that throughout the nineties he was deeply involved in the occult studies and ritual ceremonies of the Hermetic Order of the Golden Dawn. At the same time he was also studying Irish folklore and the legendary lore of pre-Christian Ireland. Through the latter he was introduced to Druidism, the pantheistic religion of the ancient Celts. He found in Druidism yet another corroboration of the beliefs that he had encountered in Theosophy and Hermetism, including reincarnation, the transmigration of souls, and the essential unity of God, nature, and man. Moreover, the Druid priests were masters of magic.[23] As ever, Yeats sought to transform abstract knowledge into concrete personal experience. He tells us that the rituals of the Order of the Golden Dawn filled him with an "obsession" to create his own "mystical rites—a ritual, system of evocation and meditation—to re-unite the perception of the spirit, of the divine with natural beauty". Taking his cue from the strange mixture of paganism and Christianity in the teachings of the Order of the Golden Dawn, Yeats dreamed of creating a ritual in Ireland which would unite the truths of Christianity with the Druidic truths of a more ancient world.[24]

For a time Yeats had what may appear to be the incredibly romantic notion of creating an Irish equivalent of the Eleusinian Mysteries in an unoccupied castle in the middle of Lough Key, County Mayo. To this "Castle of Heroes" would come the intellectual leaders of Ireland in order to participate in an elaborate program of studies, ceremonies, and initiation rituals similar to those of the Order of the Golden Dawn for the purpose of purifying and spiritually fortifying themselves for public service. Yeats worked in close collaboration with Maud Gonne as well as Lady Gregory, George Russell, the

22. Vide George Thomson, *Aeschylus and Athens* (London: Lawrence and Wishart, 1966), p. 182; Fergusson, *The Idea of a Theatre*, p. 15.

23. Vide Virginia Moore, *The Unicorn*, pp. 42-83.

24. *Memoirs*, pp. 123-24.

actress Florence Farr, Annie Horniman, who was to become the patroness of the Abbey Theatre, the Scottish writer William Sharp ("Fiona Macleod"), and MacGregor Mathers in an attempt to formulate a distinctive set of rituals for what was to be called an Order of Celtic Mysteries. (It was apparently for the sake of Sharp and Mathers that the Order was called "Celtic" rather than "Irish".) Through extensive research parallels were drawn between ancient Celtic and Graeco-Roman gods. Meetings of enthusiastic Celts were held in London and Paris, and by means of auto-suggestion a sort of collective rite was drawn up.[25]

We shall see that the process of creating the rituals for the projected Order of Celtic Mysteries exerted a profound influence upon Yeats's dramaturgical theory and practice. However, as a practical project the Order itself was obviously doomed to failure. For one thing, the basic concept was too far removed from the actual *Zeitgeist* of Ireland. There are some indications that Maud Gonne's idea of the "Castle of Heroes" was more like a hospital for wounded Irish soldiers than a mystical retreat.[26] In 1898 she withdrew her support from the project, partly because she became suspicious that the rites owed too much to Freemasonry, which she considered to be one of the bastions of the British Empire, and partly because she had determined that political action was more needed in Ireland than dabbling with the arcane.[27] Although Yeats continued to draft plans for the Order until 1902,[28] he, too, must have come to realize that meaningful rituals, like myths, need to arise from and be relevant to living experience.

Jung has written that secret organizations serve an important function in primitive societies by providing isolated individuals with a sense of collective identity. However, he emphasizes that the secret organization is merely "an intermediary stage on the way to individuation". The mature society and mature individual recognize that it is "really the individual's task to differentiate himself from all the others and stand on his own feet".[29] Ireland, of course, was not a primitive society. But Yeats understood, as many enlightened

25. Vide Moore, pp. 37, 66-80; Ellmann, *Man and the Masks*, pp. 122-30.
26. Henn, p. 172.
27. Jeffares, *W. B. Yeats*, p. 70.
28. Letter from Yeats to Lady Gregory (January 19, 1902), *Letters*, p. 364.
29. *Memories, Dreams, Reflections*, p. 342.

contemporary thinkers such as Ivan Illich, Paolo Soleri, and C. F. von Weizäcker have come to realize, that if a civilization of any quality is to be developed in the heterogeneous modern world it must begin with small communities or fellowships of fully individuated men and women who, in the words of William Irwin Thompson, "look around and recognize that what is unique to them is part of a universal transformation in which cultural evolution is becoming conscious".[30] In Yeats's view, the "Eleusinian Rite" of the Celtic Mysteries, far from being an escape from life, was a necessary step towards the creation of an ideal society. The spiritual regeneration that Yeats hoped to effect among the members of the Order of Celtic Mysteries was only a microcosm of what he hoped to accomplish in Ireland as a whole. The means for effecting this spiritual regeneration in the body public of Ireland was, as it had been for Pisistratus, the creation of a theatre.

In ancient Greece, the wedding of Homeric mythology with Dionysian and Eleusinian rites had resulted in the sublime yet splendidly communal drama of Aeschylus, Sophocles, Euripides, and Aristophanes. Yeats dreamed of creating an Irish equivalent of the Theatre of Dionysus, a national theatre in which the people would watch "the sacred drama of its own history, every spectator finding self and neighbour, finding all the world there as we find the sun in the bright spot under the looking glass".[31]

The greatest attraction that the theatre actually held for Yeats was its power of transforming isolated individuals into the unity of an audience. He felt "most alive", he tells us, "at the moment when a room full of people share the same lofty emotion".[32] Yeats thought of the unity of a nation in similar terms. A nation, he said, should be "like an audience in some

30. *Passages About Earth*, p. 188. Thompson's book is a remarkable record of his visits to Paolo Soleri and the Cosanti Foundation, Arizona, Aurelio Peccei and the Club of Rome, C. F. von Weizäcker of the Max Planck Institute for Research into the Conditions of Life in the Scientific and Technical World, Germany, and many other organizations, communities, and individuals representative of what he terms an emerging planetary culture. In 1973 Thompson founded an educational and cultural centre, the Lindisfarne Association of Southampton, Long Island, for the purpose of fostering the growth of a new culture based upon the ideas of Teilhard de Chardin.

31. Commentary on the "Three Songs to the Same Tune", *King of the Great Clock Tower* (Dublin: Cuala Press, 1934), pp. 36-38.

32. *Plays and Controversies*, p. 416.

great theatre", and he quoted Hugo's dictum: "In the theatre the mob becomes a people."[33]

Yeats believed that it was impossible for a nation to exist if there were "no national institutions to reverence, no national success to admire without a model of it in the mind of the people".[34] The Irish National Theatre was intended by him to provide Ireland with such a model. With the theatre of ancient Greece in mind, Yeats thought constantly of Homer, and dreamed of "creating some new Prometheus Unbound, Patrick or Columcille, Oisin or Finn in Prometheus' stead".[35] Through the drama he hoped to "plunge [art] into social life";[36] provide Ireland with "a vision of the race as noble as that of Sophocles and of Aeschylus".[37]

Thus we see the dream of Yeats defined: nothing less than the re-creation of society and theatre in the image of the greatest society and theatre in the history of Western civilization; nothing less than the creation of an Irish Athens, and an Irish Theatre of Dionysus where a Unity of Being and Unity of Culture might be effected through Unity of Image. Yeats informs us that he used to tell some few friends in secret that he expected to fail in pursuit of his dream because of the divisive elements in modern civilization. However, he also confesses that for a time he held "the wildest hopes" of achieving success.[38]

What were his hopes based upon? Was there, in fact, any substance to his romantic idealism? Which Ireland did he really see: an Ireland already transfigured in his imagination, or the Ireland that really lay before his eyes?

To answer these questions it is necessary to examine Yeats's conception of and relationship to Ireland in more depth, specifically in terms of the four aspects of Irish life that moved him most: the physical beauty of the land; the Irish peasantry; traditional Irish music, poetry, and supernatural and legendary lore; and Irish nationalism. I shall en-

33. Commentary on "Three Songs to the Same Tune".
34. *Autobiographies*, p. 493.
35. Ibid., pp. 191, 194.
36. *Pages Written for a Diary Written in Nineteen Hundred and Thirty Four* (Dublin: Cuala Press, 1944), p. 13.
37. *Autobiographies*, p. 494. Cf. *Explorations*, p. 252.
38. *Autobiographies*, p. 194.

deavour to show that Yeats responded to these aspects of Ireland on three levels: first, a primary human and emotional response; then a transfiguration of that response into personal mythology; and finally, an attempt to transform that mythology into poetic images and forms of dramatic action that all Irishmen ultimately might share. It will become evident that Yeats's understanding of Ireland was as profound as it was complex, and that even if this understanding appeared false or unreal to others it was based upon a direct experience of reality. Moreover, we shall see that in terms of the historical traditions of Irish life and culture Yeats knew and loved his country far better than many of his detractors.

THE ROMANCE OF THE LAND

Our understanding of Yeats's Ireland must begin with his love of the landscape and atmosphere of Sligo as he experienced it in childhood and early youth. Yeats's response to the beauty of Sligo was unaffected, open, and wholehearted. It is perhaps most directly and simply expressed in the following passage from a letter to Katharine Tynan, written in August 1887 when he was home on a visit from London:

It is a wonderfully beautiful day. The air is full of trembling light. The very feel of the familiar Sligo earth puts me in good spirits. I should like to live here always, not so much out of liking for the people as for the earth and the sky here, though I like the people too.[39]

More than almost any other ancient peoples the Celts were known for their worship of natural phenomena.[40] The great French Celtic scholar Arbois de Jubainville observed that "in Ireland, the earth and sea and forces of nature seem for a moment, in the Book of Invasions, to be far more powerful than the gods against whom they are invoked."[41] Celtologist

39. (August 13, 1887), *Letters*, p. 49. Yeats never lost his love of Sligo even after many of his other youthful enthusiasms turned sour. Once, according to Ezra Pound, he looked out at a beautiful Italian landscape and remarked: 'Sligo in heaven'. "Canto 77" (p. 51 of "Pisan Cantos"), quoted by Ellmann in *Eminent Domain*, p. 109.

40. Vide Myles Dillon and Nora K. Chadwick, *The Celtic Realms* (New York: The New American Library, 1967), pp. 134-58, esp. pp. 138, 140.

41. H. d'Arbois de Jubainville, *The Irish Mythological Cycle and Celtic Mythology*, trans. Richard Irvine Best (Dublin: Hodges, Fippis & Co., 1903), p. 220.

John Rhys also noted that in Celtic tradition every locality had its own divinity, with rivers and mountains, for instance, identified with divine beings.[42] Yeats familiarized himself with the works of de Jubainville, Rhys, and other distinguished Celtic scholars. Moreover, from earliest childhood he had personal experience of the spiritual identity with the land that they described. Sligo—particularly the valley between the mountains of Knocknarea, with its great cairn on the summit said to be the grave of Queen Maeve, and Ben Bulben, where Diarmuid and Grania were pursued by Finn and Diarmuid was wounded to death by an enchanted boar— is rich in supernatural legends. The earliest religious sensations of Yeats were stimulated by the very skies of Sligo and later by the fairy and other supernatural stories associated with the area.[43]

Yeats particularly loved Drumcliff, the valley at the foot of Ben Bulben where Saint Columba dwelt, and Rosses Point, a sandy promontory at the mouth of the Sligo River covered with fairy mounds, or *raths*. He described them as "places of unearthly resort" and gathered there many of the stories that appeared in *Fairy and Folk Tales of the Irish Peasantry* (1888) and *The Celtic Twilight* (1893).[44] Once Yeats climbed to the top of Ben Bulben to see the place where Diarmuid died, and described the scene in a letter to Katharine Tynan:

A dark pool, fabulously deep and still haunted. . . . All peasants at the foot of the mountain know the legend, and know that Dermot still haunts the pool, and fear it. Every hill and stream is some way or other connected with the story.[45]

Yeats carried his sensitivity to, and love of, places associated with legendary and supernatural lore with him when he left Sligo. As his knowledge of Irish mythology deepened he made a special study of the sacred places of Ireland, some-

42. *Early Celtic Britain* (London: Society for the Promotion of Christian Knowledge, 1908), pp. 67-68. Cf. Ernest Renan, *Poetry of the Celtic Races*, trans. William G. Hutchison (London: The Walter Scott Publishing Co., 1896), p. 22; Dillon and Chadwick, p. 14.
43. Vide Henn, pp. 1-22. Cf. *Autobiographies*, pp. 16, 26, 70.
44. Vide Preface to *Fairy and Folk Tales of the Irish Peasantry* (London: Walter Scott, 1888); *Mythologies*, pp. 88-94.
45. Autumn 1887, *Letters*, p. 51.

times going on pilgrimages and letting his imagination play upon the stories associated with them until their ancient life unfolded to him in the form of mystical visions.[46] The conviction grew upon Yeats that a writer should "hold, as in a mirror, the colours of [his] own climate and scenery in their right proportion".[47] Echoing in some ways Oscar Wilde's aesthetic dictum that "external nature imitates Art",[48] Yeats exhorted Irish artists to emulate the Greeks and provide images that would create a renewed feeling for the land and history of their country:

> The Greeks looked within their borders, and we like them, have a history fuller than any modern history of imaginative events; and legends which surpass, as I think, all legends but theirs in wild beauty, and in our land, as in theirs there is no river or mountain that is not associated in the memory with some event or legend. . . . I would have our writers and craftsmen of many kinds master this history and these legends, and fix upon their memory the appearance of mountains and rivers and make it all visible again in their art, so that Irishmen, even though they had gone thousands of miles away, would still be in their country.[49]

Yeats cherished the idea that by creating an Irish theatre he might bring the countryman's sacred reverence for the land to the city and, through his own plays in particular, "help the imaginations that are most keen and subtle to think of Ireland as a sacred land".[50]

Yeats tells us that he planned at the age of twenty-four or twenty-five to create an Irish *Légende des Siècles* to set forth something of every century in Ireland.[51] Taken as a whole, his plays might be viewed as the fulfillment of that ambition. All are deeply imbued with a feeling for the Irish landscape, the historical place names of Ireland, and the heroic legends, folklore, supernatural lore, patriotic deeds, and even common

46. *Explorations*, p. 14. Yeats went so far as to mark on a large map every sacred mountain of Ireland. *Autobiographies*, p. 378.
47. *Essays and Introductions*, p. 5.
48. "The Decay of Lying", *Intentions* (London: Methuen & Co., 1919), p. 39.
49. *Essays and Introductions*, pp. 205-6.
50. Letter to John Quinn (June 28, 1903), *Letters*, p. 407; cf. *Essays and Introductions*, pp. 166-67.
51. *Autobiographies*, p. 493.

trades associated with them. Images range from epic battles at Moytura,[52] Tara,[53] and Clontarf[54] to Pearse and Connolly in the General Post Office;[55] from pagan gods associated with the River Boyne[56] to the holy well of Tubbervanach;[57] from the grave of Maeve at "wintry Knocknarea"[58] to the "ruined Abbey of Corcomroe", lying "amid the broken tombs";[59] from "a cottage close to Kilala" in 1798[60] to a lodging house in twentieth-century Dublin where Grattan or Curran was born and Stella lost money at cards to Swift;[61] from a "Spaniard wrecked at Oasis head"[62] to "pigeon's eggs from Duras".[63]

Certain passages stand out in the writer's mind, perhaps because of personal associations. From *The Dreaming of the Bones:*[64]

> So here we're on the summit. I can see
> The Aran Islands, Connemara Hills,
> And Galway in the breaking light; there too
> The enemy has toppled roof and gable,
> And torn the panelling from ancient rooms.

And another, from *Cathleen ni Houlihan:*[65]

BRIDGET. What was it put you wondering?
OLD WOMAN. Too many strangers in the house.
BRIDGET. Indeed you look as if you'd had your share of trouble.
OLD WOMAN. I have had trouble indeed.
BRIDGET. What was it put the trouble on you?

52. *The Countess Cathleen, Collected Plays* (New York: Macmillan, 1960), p. 49.
53. *The Herne's Egg*, ibid., p. 645.
54. *Cathleen ni Houlihan*, ibid., p. 83.
55. *The Death of Cuchulain*, ibid., p. 705.
56. *The King of the Great Clock Tower*, ibid., p. 637.
57. *The Hour-Glass*, ibid., p. 304.
58. *The Countess Cathleen*, ibid., p. 17.
59. *The Dreaming of the Bones*, ibid., pp. 437, 438.
60. *Cathleen ni Houlihan*, ibid., p. 75.
61. *The Words Upon the Window-Pane*, ibid., p. 599.
62. *The Land of Heart's Desire*, ibid., p. 55.
63. *The King's Threshold*, ibid., p. 119.
64. *The Dreaming of the Bones*, ibid., p. 443.
65. *Cathleen ni Houlihan*, ibid., p. 81.

OLD WOMAN. My land, that was taken from me.
PETER. Was it much land they took from you?
OLD WOMAN. My four beautiful green fields.

One would think that any Irishman might be able to make similar choices. But reactionary movements can be powerful and are often blind in their very power. Today, there are Irishmen who hate the very name of Yeats, still associating his vision of Ireland exclusively with the fairy romance of *The Celtic Twilight*.[66] It might be well to listen to the actor-writer Micheál MacLiammoir when he compares the "discovery" of the Celtic twilight by Yeats with the "revelation" of Van Gogh that "the supreme moment of Provence was in the round glare of the midday sun". He continues:

To Yeats in much the same manner the supreme moment of Ireland was revealed at the hour of twilight, and its mood, that hovers between day and night, between light and dark, between waking and sleeping, between, in so many familiar cases, sobriety and intoxication, is at the heart of Ireland's being.[67]

THE CULT OF THE PEASANT

Except for his interest in mysticism and the occult, few aspects of Yeats's career have elicited stronger negative reactions than his espousal of the peasant and peasant lore as the basis for the Irish literary and dramatic movement. Contemporary criticisms range from labelling him "naïve", for attempting to peddle a peasant culture to the middle class,[68]

66. Prof. Donal O'Sullivan, a respected authority on Irish folk music, is not one of those utterly blind to the greatness of Yeats as a poet. None the less, he condemns Yeats for creating the notion that "the genius of Gaelic Ireland possesses some peculiarly occult or esoteric quality. Indeed the very term 'Celtic Twilight' is now commonly accepted as expressive of this supposed characteristic. . . . It must here be stated categorically that a survey of Gaelic literature as a whole discloses no ground whatever for such a belief. . . ." Introduction to *Songs of the Irish* (Dublin: Browne and Nolan, 1967), p. 11.
67. Micheál MacLiammoir and Edwin Smith, *Ireland* (London: Thames and Hudson, 1966), p. 51.
68. Richard J. Loftus, *Nationalism in Modern Anglo-Irish Poetry* (Madison: University of Wisconsin Press, 1964), p. 8.

to violently attacking him in Marxist terms as "a pseudo-artistocrat cultivating a pseudo-peasant".[69] Even so sensitive a critic as Sean O'Faolain, while admitting Yeats's love of Ireland and the fact that through his love he inspired a modern Irish literature and an Irish theatre that would otherwise never have existed, yet concludes: "[Yeats] in a sense knew Ireland better than most people, but I do not believe he knew people in Ireland."[70]

Criticisms of this sort may be refuted by arguing that the critics themselves but partially understand Yeats. It is true that Yeats did not concern himself overtly with the social and economic injustices or the political, linguistic, and religious conflicts that plagued Ireland in his own time and have continued down to the present day. This, however, was only because he did not choose to dwell upon such matters. As we shall see, he was well aware of the harsher realities of Irish life. But in his far-reaching and at once more personal conception of life and art, personality and the histrionic expressiveness of that personality counted far more than material possessions or political, religious, and economic abstractions. In light of the traditions of ancient Ireland, where the wealth of a wandering poet or scholar was measured by the riches carried within his mind, Yeats's ideal was more nearly authentic than that of those who would dismiss him. Remnants of that ancient tradition are still alive in Ireland—for those who truly respond to people and the quality of imaginative life.[71]

69. Brian Farrington, *Malachi Stilt-Jack: A Study of W. B. Yeats and His Work* (London: Connolly Publications Ltd., 1965), p. 5.

70. Sean O'Faolain, *Vive Moi!* (London: Rupert Hart-Davies, 1965), pp. 275-76.

71. Douglas Hyde writes that in the sixth century A.D. one third of the male population of Ireland consisted of wandering bards, who made their living by composing poems in praise of the chieftains. The chieftains, though terrified of the supernational power of the poets, were naturally resentful of this huge drain on their livelihood. Through the intervention of St. Columba, himself a descendant of the highest order of bardic classes, the *files*, or bards, were reduced in number but given for the first time direct income and local stability as the equivalent of university instructors. For one thousand years, the bardic schools existed and continued to educate the lawyers, judges, and poets of Ireland. *A Literary History of Ireland* (London: T. Fisher Unwin, 1899), pp. 488-90. Cf. Dillon and Chadwick, pp. 106, 163, 183, 273, 327.

In his *Autobiographies* Yeats writes that from boyhood he dreamed of finding an audience in Sligo.[72] Elsewhere, he compared the Gaelic-speaking peasants listening to songs and epic Irish poems in their cabins with the audiences of Sophocles, Shakespeare, and Calderon.[73] Where is the source for these thoughts? That, too, may be found in something seemingly ordinary and very human: his personal response to the peasants whom he encountered as a boy and youth in Sligo.

One day it was a cobbler with a doleful discourse about a cat "not to be 'dipinded' upon" because it murdered birds.[74] Another time it was a chance meeting with a man who remembered Yeats as a child, invited him for a row, and in an afternoon provided him with two notebooks of "fairy yarns".[75] Still again, it was an encounter with an old man, a local tax-collector fallen into hard times who drew himself up when Yeats reminded him of a local legend connected with his people: "Yes, sir," he replied, "I am the last of a line of princes."[76]

Even in old age Yeats continued to marvel at the personality and expressiveness of the peasants. He wrote to Olivia Shakespear, for instance, about an old peasant woman who lived near Lady Gregory in Gort and possessed "an amazing power of audacious speech". "One of her great performances," he recounted, "is a description of how the meanness of a Gort shopkeeper's wife over the price of a glass of porter made her so despair of the human race that she got drunk. The incidents of that drunkenness are of an epic magnificence."[77]

Small wonder that Yeats wearied of the literary coteries of London during the nineties. "Here one gets into one's minority among the people who are like oneself," he wrote. "Down at Sligo one sees the whole world in a day's walk, every man is a class. It is too small for minorities."[78] Because he was

72. *Autobiographies*, p. 18.
73. *Essays and Introductions*, p. 167.
74. Letter to Katharine Tynan (August 13, 1887), *Letters*, p. 49.
75. Letter to Katharine Tynan (Autumn 1887), *Letters*, p. 55.
76. *The Celtic Twilight*, p. 33.
77. Letter (postmarked November 23, 1931), *Letters*, p. 786.
78. Letter to Katharine Tynan (March 9, 1889), *Letters*, p. 116.

haunted, he says, with the idea that "a poet should know all classes of men as one of themselves", he went so far as to think of disguising himself as a peasant in order to wander through the West.[79]

In their full-blooded expressiveness and their spontaneity, the Irish peasantry obviously possessed many of the qualities that Yeats associated with that Unity of Being towards which he aspired. In their freedom from the narrow constraints of the materialistic middle class that he despised,[80] Yeats also identified the peasantry with an ideal aristocratic way of life.

It should be noted at this point that Yeats's lifelong concern with aristocratic values had far more than snobbish pretension behind it.[81] Because he drew upon a great body of traditional knowledge and expressed himself in a subtle and highly personal manner, Yeats had need of a particularly discriminating audience. "Neither poetry nor any subjective art," he once declared, "can exist but for those who do in some measure share its traditional knowledge; a knowledge learned in leisure and contemplation."[82] Yeats imagined this essentially aristocratic culture to have existed in the "Big Houses" of the Anglo-Irish Ascendancy in the West of Ireland. More important, he experienced it for himself at Lady Gregory's "Coole".[83]

79. *Autobiographies*, p. 470.
80. Yeats explained his disdain for the middle class as follows: "The average man is average, because he has not attained to freedom. Habit, routine, fear of public opinion, fear of punishment here or hereafter, a myriad of things that are 'something other than human life' . . . work their will upon his soul and trundle his body here and there." *Explorations*, p. 168.
81. As Dorothy Wellesley wrote: "By aristocracy he meant the proud, the heroic mind. This included a furious attitude toward the cheap, the trashy, the ill-made." *Letters on Poetry from W. B. Yeats to Dorothy Wellesley* (London: Oxford University Press, 1964), p. 178.
82. *Plays and Controversies*, p. 208. Comparing his own work and that of Dorothy Wellesley with the abstract, highly intellectual poetry of modern times, Yeats declared: "This difficult work has the substance of philosophy and is a delight to the poet with his professional pattern; but it is not your road or mine. These new men are goldsmiths working with a glass screwed into one eye, whereas we stride ahead of the crowd, its swordsmen, its jugglers looking to right and left, by which I mean that we need like Milton, Shelley, vast sentiments, generalizations supported by tradition." Letter to Dorothy Wellesley (April 20, 1936), *Letters on Poetry*, p. 58.
83. Vide Henn, pp. 3-6. Brian Farrington argues, rightly I think, that Yeats's actual knowledge of the life of the "Big Houses" of Sligo was slight; he was not himself invited to Lissadel, the home of the Gore-Booths, which he immortalized in poetry. *Malachi Stilt-Jack*, p. 2.

Yeats found in the Irish peasantry a similar "aristocratic" respect for traditional values and an innately cultivated sensibility through long association with "courtly things".[84] Irish myths and legends were, he claimed with some justification, different from those of all other European countries because down to the end of the seventeenth century they had "perhaps the unquestioned belief of peasant and noble alike".[85] Because in Ireland they shared Unity of Image, Yeats argued that the peasant and aristocrat also shared Unity of Culture and that through this they were closer to the attainment of the Unity of Being ideally known by the artist than any other classes in modern society:

Three types of men have made all beautiful things. Aristocracies have made beautiful manners, because their place in the world puts them above the fear of life, and the countrymen have made beautiful stories and beliefs, because they have nothing to lose and so do not fear, and the artists have made all the rest, because Providence has filled them with recklessness. All these look backward to a long tradition, for, being without fear, they have held to whatever pleased them. The others being always anxious have come to possess little that is good in itself.[86]

Yeats attempted to unite these seemingly disparate images within his own plays and in his overall concept of the repertoire of the Abbey Theatre. His collaborative efforts with Lady Gregory on such plays as *Cathleen ni Houlihan, The Shadowy Waters, On Baile's Strand, The King's Threshold,* and *The Unicorn from the Stars* were intended to "commingle the ancient phantasies of poetry with the rough, vivid,

84. Vide *The Celtic Twilight,* p. 139; *Explorations,* p. 21.
85. *Essays and Introductions,* p. 516.
86. Ibid., p. 251. In later years Yeats argued that through inter-marriage in the seventeenth and eighteenth centuries, English Protestant and Gaelic Catholic Ireland had become "as much one race as any modern country". Thus, he said, in the eighteenth century the Protestant aristocracy identified themselves with Ireland politically and culturally. Had this bond not been broken with the Act of Union which dissolved the Parliament of Ireland in 1798, Yeats believed that "the country people would have forgotten that the Irish aristocracy was founded like all aristocracies upon conquest, or rather, would have remembered and boasted in the words of a medieval Gaelic poet, 'We are a sword people and we go with the sword.' " However, Yeats admitted that by absentee landlordism and the dissolution of their own culture in the nineteenth century, the Anglo-Irish had lost the right to lead: "what resolute nation permits a strong alien class within its borders?" *Explorations,* pp. 347-50.

every-contemporaneous tumult of the roadside".[87] The folk-
types in those plays were not just appeals to the groundlings
but, as Peter Ure points out, antennae of a submerged con-
sciousness, valued by a highly ordered society precisely
because it had lost the knowledge of that consciousness.[88]
Nor was a playbill at the Abbey Theatre composed of a num-
ber of plays haphazardly strung together. Instead, it was
thought out in terms of how similar themes might be reflec-
ted through contrasting poetic and peasant or tragic and
comic treatments. Yeats viewed his own work as something
like "a Jack-O'-Lantern" set among "more natural and simple
things". As in the ancient Greek theatre it was intended that
the noble art of tragedy should be heightened by juxtaposing
it to comedy, thus becoming all the more "moving and intel-
ligible from becoming mixed into the circumstances of the
world".[89]

FOLK ART, SUPERNATURAL LORE, AND THE RITUALS
OF THE ORDER OF CELTIC MYSTERIES

If Yeats was delighted by the personalities of the peasants, it
was their folk art and supernatural lore that fired his creative
imagination. In his view, the shared traditions of the Gaelic-
speaking peasants in the West of Ireland had preserved some-
thing unique in modern times:

> . . . a people, a community bound together by imaginative possessions,
> by stories and poems which have grown out of its own life, and by a
> past of great passions which can still waken the heart to imaginative
> action. One could still, if one had the genius, and had been born to
> Irish, write for these people plays and poems like those of Greece.[90]

Yeats was most stirred by the traditional music of the Gaelic-
speaking peasantry. This may be surprising in view of the well-
known fact that he was tone-deaf.[91] His response, however, is

87. *Collected Works* (London: A. H. Bullen, 1908), Vol. III, p. 221.
88. *Towards a Mythology: Studies in the Poetry of W. B. Yeats* (New York: Russell and Russell, 1967), p. 102.
89. Preface to *Poems 1899-1905* (London: A. H. Bullen, 1906), p. xix.
90. *Essays and Introductions*, p. 213.
91. It is interesting to note that Yeats himself admitted that he could not tell one tune from another except for folk songs. Cited by Edward Malins, *Yeats and Music* (Dublin: The Dolmen Press Yeats Centenary Papers, XII, 1965), p. 507.

perhaps not so surprising to anyone who has experienced this aristocratic, sensuous, passionate, and complex art of ancient Ireland—an art all but unknown even today outside the Western Gaeltacht. Yeats writes movingly in *The Celtic Twilight* of a typical roadside concert in Sligo, one song calling up memories of others, their famous singers, and the people about whom they were made—"mournful songs of separation, of death, and of exile". Some of the men began to dance, others lilting the measure they danced to; then somebody sang *Eiblin a Ruin*, "that glad song of meeting which has always moved me more than other songs, because the lover who made it sang to his sweetheart under the shadow of a mountain I looked at every day through my childhood". As ever, Yeats's imagination elaborated on the experience:

The voices melted into the twilight and were mixed into the trees, and when I thought of the words they too melted away, and were mixed with the generations of men. Now it was a phrase, now it was an attitude of mind, an emotional form, that had carried my memory to older verses, or even to forgotten mythologies.[92]

We shall see that the bardic tradition of half-spoken half-sung poetic declamation still preserved in some traditional Irish folk-singing had a profound influence upon Yeats's concepts of verse-speaking. The very metaphor of singer and song for poet and poetry was employed by Yeats throughout his dramatic work as an expression of ancient values embodied in living forms. Traditional Irish music was also employed by Yeats in order to lift his plays out of any narrow particularity of time and place to the universal realm of myth, for, as he put it, folk art enshrined "the most unforgettable thoughts of the generations". It was thus "the soil where all great art is rooted".[93]

Yeats was surprised to discover on a visit to Stratford-on-Avon in 1901 that there were few local stories associated with the memory of Shakespeare. He compared this with the West of Ireland, where, he said, "the glory of a poet" himself is

92. *The Celtic Twilight*, p. 138. The writer experienced several musical evenings similar to the one Yeats describes on a visit to the Aran Islands in August 1968.
93. Ibid., p. 139.

carried down through the ages with his song.[94] To the end of his life, Yeats felt that the thought of being remembered "by the common people", whether "good-tempered or bad, tall or short", both inspired and rendered a personal distinction to Irish poetry. It was this personal note, motivated by a still-living folk tradition, that differentiated Irish poetry from the "impersonal philosophical poetry" of modern times.[95]

All of Yeats's plays are notable for their passionate and deeply personal remembrance of things past. It is this thematic quality that, in part, later attracted him to Japanese Noh drama, with its evocation of ghosts, gods, and goddesses associated with ancient holy places.[96] But perhaps no play by Yeats more directly or immediately evokes the sense of past in present than *Cathleen ni Houlihan* (1902), where a young man is called from his wedding preparations to a higher patriotic duty through the song of an Old Woman representing Ireland herself. Those who have sacrificed themselves for Ireland have not done so in vain, she tells the young man:

> They shall be remembered forever,
> They shall be alive forever,
> They shall be speaking forever,
> The people shall hear them forever.[97]

Despite his responsiveness to folk traditions and folk memory, it is clear that Yeats's intention was by no means literally to reproduce the spirit of the past. He had, he stated as early as 1888, no liking for "retrospective art". While the old poems and songs might be utilized for "inspiration", he called upon Irish artists to "search them for new means of expressing ourselves".[98] Yeats demonstrated what he had in mind in his own attitude towards the Irish fairy tales and other kinds of supernatural lore that he began to collect systematically in 1888. Essentially, he interpreted and utilized this material as a corroboration of his own mystical impulses and practices.

94. *Essays and Introductions*, p. 110.
95. Ibid., p. 506.
96. Ibid., pp. 232-33. Similarly, Yeats equated the wood of the Furies in his translation of Oedipus at Colonus with "any Irish haunted wood". *Explorations*, p. 438.
97. *Collected Plays*, p. 86.
98. Letter to Katharine Tynan (December 21, 1888), *Letters*, p. 98.

Yeats's attempt to base the Order of Celtic Mysteries upon a union of ancient Druidic and Christian rites and symbols also had an authentic source in Irish history. Scholars have emphasized that when Ireland became Christianized, Druidic religious practices prepared the way for and, in fact, were incorporated into many Christian rituals.[99] Down to the present day, pagan superstitions and practices exist side-by-side with, or are even part of, the Roman Catholic rites in certain parts of Ireland. In West Clare, for instance, the ancient Celtic Spring Festival of Beltaine, associated in that part of the country with Mount Callan, is now celebrated as the religious festival of Garland Sunday on the first Sunday of every May. The pagan spirit still associated with the festival is expressed in the humorous description of Garland Sunday given to me by an old country man: "It was the one day of the year when the women of Ireland had their freedom—and the priests beating the bushes behind them with blackthorn sticks."[100]

At the start of his research into folk culture, Yeats was delighted, for their own sake, in the superficial evidences of pre-Christian beliefs that he found in the peasantry. "In Ireland," he declared, "this world and the world we go to after death are not far apart", "the pagan powers are not far from the countrywoman's heart, even though the priest shakes his head at her."[101] Beginning in 1888 with *Fairy and Folk Tales of the Irish Peasantry*, Yeats tried to illustrate his case with a host of charming though often merely quaint tales of the supernatural related to him by the peasants of Sligo.

As his knowledge of folklore and mysticism deepened, Yeats was delighted to discover extraordinary parallels between Irish peasant tales of the supernatural and many traditional beliefs of mysticism. The definition of fairies that he made in 1892, "The fairies are the lesser spiritual moods of that universal mind, wherein every mood is a soul and every

99. Vide Dillon and Chadwick, *Celtic Realms*, Ch. III. Cf. Hyde, *A Literary History of Ireland*, pp. 104, 250-51; Arbois de Jubainville, *The Irish Mythological Cycle*, p. 33.

100. The tradition of holy wells with miraculous healing powers is another example of Druidic nature-worship carried over into Christian practices in Ireland. Yeats may have set *At the Hawk's Well* at Tullaghan well in Sligo, said to have burst forth as a spring at the prayer of St. Patrick. Henn, p. 3.

101. *The Celtic Twilight*, pp. 98, 90.

thought a body",[102] was entirely in accord with Theosophical doctrine and, furthermore, substantially the same as the doctrine of the Anima Mundi. In 1896, with the help of Lady Gregory and his uncle George Pollexfen, Yeats set out in a systematic manner to trace modern philosophical and religious beliefs to their pre-Christian origins through the visions and thoughts of the country people. Their visions, he discovered, were similar to those called up by the occult symbols and rituals of the Order of the Golden Dawn. In turn, by employing the rites of the Order of the Golden Dawn, Yeats found that he was able to summon spirits associated with particular holy places in Ireland.[103] To the end of his life Yeats felt that by questioning the country people about the apparitions they saw he was enabled to get down "into some fibrous darkness, into some matrix out of which everything comes". He encountered visionaries in the West of Ireland of whom "it was impossible to say whether they were Pagan or Christian", memories of philosophies more Oriental than Western, that "associated Eternity with field and road, not with buildings".[104]

The symbolism and allegory of Irish supernatural lore was of particular importance to Yeats as an artist. As we have seen, his exploration of mysticism led him to perhaps his most important theme: "the war of the spiritual with the natural order". The practical problem that he faced was to find a means by which to externalize and communicate to a heterogeneous audience his intensely personal and mystical vision of reality. Traditional symbolism and allegory provided him with this means: "a natural language by which the soul when entranced or even in ordinary sleep, communes with God, and with the angels. They [symbolism and allegory] speak of things which cannot be spoken of in any other language."[105]

102. *Uncollected Prose*, p. 247.
103. Vide *The Celtic Twilight*, pp. 38-40, 55, 115-16, 123; *Autobiographies*, pp. 265-67, 465-76.
104. *Essays and Introductions*, p. 429. Myles Dillon argues on the basis of certain ancient Celtic beliefs that the Druids were the heirs to the Hindu-European priesthood represented in India by the Brahmins. Preface, *The Celtic Realms*, pp. 154-60.
105. *Essays and Introductions*, p. 368.

Yeats came to realize that poetry in the theatre demands immediate responses from an audience. Allegory and symbolism cannot be created solely by the dramatist. They must, to a large extent, already exist in the minds and hearts of his audience. Otherwise the audience becomes baffled and bored by abstractions with which it cannot identify. "It is only by ancient symbols, by symbols that have numberless meanings besides the one or two the writer lays an emphasis upon, or the half-score he knows of, that any highly subjective art can escape from the barrenness and shallowness of a too conscious arrangement," Yeats declared in 1900.[106] And again: "All symbolic art should arise out of a real belief."[107]

It was upon the "real beliefs" held by the Irish peasantry, and by utilizing the symbols and allegories—the "imaginative possessions" that bound them together in their beliefs—that Yeats sought to base the Order of Celtic Mysteries and subsequently an Irish poetry and drama. Yeats found that the peasants, by giving themselves wholly to their own images, had, in a sense, remade the natural and supernatural worlds according to their own unified conception of them.[108] It was by means of traditional symbolism that the artist, too, was enabled to bridge the gap between the mortal and immortal worlds, reawakening through the magical power of the word a sense of the "Great Mind" or "Great Memory" from which all things had sprung.[109] Such mystical symbols being alive in the peasant culture of the West of Ireland, it was Yeats's hope to tap them in his art, recharging them through his own imagination so as to make them more powerful and personal, and thus create a religious Unity of Culture in Ireland.[110]

This religious Unity of Culture would transcend the rigid formulas and strictures that divided Protestant and Catholic

106. Ibid., p. 87.
107. Ibid., p. 294.
108. "I am certain that the water, the water of the seas, and of mist and rain, has all but made the Irish after its image." *The Celtic Twilight,* p. 80.
109. *Essays and Introductions,* pp. 28, 44-46, 50.
110. "I have desired, like every artist, to create a little world out of the beautiful, pleasant and significant things of this marred and clumsy world, and to show in a vision something of the face of Ireland to any of my own people who would look where I bid them." "This Book", *The Celtic Twilight* (Dublin: Lawrence and Bullen, 1893), p. 1.

Ireland. It would be a return to the form of Christianity that Yeats found in the West of Ireland—a Christianity where "the natural and supernatural are knit together", unified by a conception of Christ "posed against a background not of Judaism but of Druidism, not shut off in dead history but flowing, concrete, phenomenal".[111]

As an Irish equivalent of the Eleusinian Mysteries, the Order of Celtic Mysteries was to be a school wherein the poets and intellectual leaders of Ireland might organize a "common symbolism, a common meditation".[112] The Irish theatre, then, was to be a mystical temple wherein this new doctrine would be publicly enshrined and disseminated. It is significant that, as the dramatic festivals of ancient Greece opened with religious observances, the Irish Literary Theatre inaugurated its efforts in May 1899 with a prologue, "The Lord of Light", written by Lionel Johnson (himself a Catholic), which proclaimed a new religious rite based upon the ancient Celtic celebration of Beltaine united with the doctrines of Christianity and mysticism.[113]

All of Yeats's plays written during the nineties—*The Countess Cathleen* (sub-titled "A Miracle Play"), *The Shadowy Waters*, and the *Land of Heart's Desire*—drew upon the Celtic Mysteries for their symbolism. Along with *The Hour-Glass* (written in 1902 and sub-titled "A Morality Play") these plays deliberately were intended to manifest the influence of the invisible upon the visible world and thus reawaken Ireland's sense of her ancient holiness.[114] In this as in so many

111. *Essays and Introductions*, p. 518. Cf. *Autobiographies*, pp. 101-2.

112. Unpublished draft of *Per Amica Silentia Lunae*, quoted in Ellmann, *Identity of Yeats*, p. 305.

113. The May fire once on every burning hill
 All the fair land with burning bloom would fill;
 All the fair land, at visionary night,
 Gave loving glory to the Lord of Light.

 Come, then, and keep with us an Irish feast,
 Wherein the Lord of Light and Song is priest;
 Now at this opening of the gentle May,
 Watch warring passions at their storm and play;
 Wrought with the flaming ecstasy of art,
 Spring from the dreaming of an Irish heart.

 Extracts from "The Lord of Light" by Lionel Johnson. *Beltaine* Number One.

 Beltaine was the literary organ of the Irish Literary Theatre.

114. Vide Ellmann, *Man and the Masks*, pp. 130-37.

other respects Yeats found that his ideas were at odds with the prevailing temper of the times. After 1902 Yeats wrote the majority of his plays on less obviously religious themes. But even in his most ostensibly secular dramas one is always conscious of a vast cosmic background before which the ephemeral actions of man are carried out.

This sense of other-world mystery in Yeats's plays is to a large extent directly attributable to the influence of the ceremonies of the Order of the Golden Dawn and the ritual that he helped to create for the Order of Celtic Mysteries. Twelve sets of the latter rituals have been preserved in Yeats's diaries and notebooks. The majority of them have simple plots consisting of allegorical voyages in which the initiate encounters a series of obstacles symbolizing the material or spiritual impurities that he must discard or overcome on his path to self-knowledge—"the truth that is his and not another's". Archetypal characters based upon Celtic mythology were to be enacted by members of the Order. Dialogue was sometimes written out, generally in the form of dialectics between the initiate and his appointed teacher-guide or the ancient gods, heroes, and personified natural and supernatural forces whom he encountered. Rhythmical reiterative chants were also employed to invoke the presence of invisible beings or to serve as a kind of meditation upon the meaning of the particular rite being enacted.[115]

The most obvious influence of the Order of Celtic Mysteries is upon Yeats's dramaturgy. In terms of plot, Yeats's plays are notable for their sheer simplicity. He once told Frank O'Connor: "You must always write as if you were shouting to a man across the street who you were afraid couldn't hear you, and trying to make him understand."[116] By placing relatively uncomplicated though compelling dramatic situations within a ritualistic context, and by deploying the traditional techniques of ritual—poetry, song, dance, and drama with their multiple range of images reverberating amongst each other—Yeats was enabled to appeal to his audience on both a conscious and unconscious level simultaneously. Far from being merely "devices within which to embody lyrics", as one critic has rather foolishly asserted,[117] Yeats's plays are

115. Vide Moore, *The Unicorn*, pp. 73-80.
116. Quoted by Ellmann, *Identity of Yeats*, p. 201.
117. Vendler, *Yeats's Vision, and the Later Plays*, p. 141.

structured to enable purely lyric passages and ritualistic scenes to form an integral part of the dramatic action. Moreover, ritual enabled Yeats to exploit dialectically both his lyric and histrionic gifts within a highly effective theatrical format. In *The Shadowy Waters* and *The Countess Cathleen*, for instance, dialogues between two or more characters are deliberately juxtaposed with lyrical passages and ritualistic scenes in order to lift the overall atmosphere of the plays into the realm of reverie. Even within relatively representational plays such as *The Land of Heart's Desire, The King's Threshold, Deirdre*, and *The Resurrection*, the dramatic line is broken periodically by lyrics that cause us to reflect or meditate upon the action that has just transpired. But the reiterative cyclical pattern of ritual is most evident in the Dance Plays. Each of them opens with an invocation that suggests the themes of the play in haunting, elusive imagery. These themes are then given physical embodiment in short dramatic episodes which are usually followed by further lyrics that comment upon the action and turn the audience's imagination inward to the deeper mythopoeic and metaphysical meanings of the play. The climax of the play—inevitably a ritual dance—is followed by a lyric epilogue which restates the themes in terms of their multifarious implications for the conduct of life.[118]

We shall see in Chapter Ten that Yeats reinforced all of these dramaturgical techniques with a corresponding ritual

118. The dramaturgical method of Yeats is similar to that of Brecht in that they both attempt to break the flow of the dramatic action in order to jolt the spectators out of a conventional identification with the story line and characters and thus focus their attention on the larger issues of the play. As a Marxist, Brecht sought to provoke an objective critical response in the audience which would lead them to demand social change based upon a deeper awareness of the economic realities of life. Yeats, too, sought social change, but he believed that Marxist doctrines placed too great an emphasis on economic issues at the expense of more fundamental human concerns. Furthermore, he objected to the indiscriminate application of Marxist principle and methods with a total disregard for indigenous ways of life developed by communities of people or nations. As he put it: "Karl Marx puts too much emphasis upon the re-made world and not enough upon the living; only when we contemplate those living can we re-make the world. The re-creation is from love of perfect and mercy for the imperfect." *Explorations*, p. 326. Cf. Ibid., pp. 268, 278.

deployment of the visual arts of the theatre. From the very beginning of his involvement in the theatre every element in a Yeats play, from dialogue to music to properties to settings to the actions of the performers themselves, was intended to serve as specific a dramatic purpose as if it were part of an archaic rite.

But besides dramaturgy and visual appeal, ritual created another, far more profound, influence on Yeats's playwright-ing theory and practice. In the early 1890s Yeats read the first volumes of Sir James Frazer's The Golden Bough where he probably learned about the relationship between mythic narratives and primitive ritual, and where he also learned that in primitive ritual, there are, whether stated explicitly or not, archetypal stories which define simultaneously cyclical movements in nature and themes of death and rebirth in human life.[119] Yeats's reading of Celtic scholars taught him that the mythology and religious rituals of ancient Greece and Ireland were almost identical in providing an explanation of natural phenomena—especially the cycle of the seasons and the eclipses of the sun and moon. From John Rhys he learned that the epic hero Cuchulain was the most prominent sun-god of Druidic Ireland and, as such, had innumerable counterparts in the mythology of the pre-Christian world.[120] In the Order of the Golden Dawn Yeats experienced for him-self a grade-by-grade entry into higher knowledge that was accomplished through a series of ritual dramas in which the initiate symbolically killed his lower self in order to rise to a consciousness of, and union with, the "Divine Man latent in himself".[121]

All of these ideas and experiences were carried by Yeats into the Celtic Mysteries and subsequently incorporated into his philosophy of life and his work in the theatre. The rituals of the Celtic Mysteries essentially depict man as a pilgrim, with life a quest, the purpose of which is the attainment of true individuality or Unity of Being. Yeats defined his doc-trine of the mask in terms of the same cyclical process: "All

119. Seiden, Poet as Mythmaker, p. 9.
120. Moore, The Unicorn, pp. 46-49.
121. Preface to The Kabbalah Unveiled, S. L. MacGregor Mathers (London: Routledge and Kegan Paul, 1951), p. iv.

joyous or creative life is a rebirth as something not oneself, something which has no meaning and is created in a moment and perpetually renewed."[122] Similarly, the true meaning and value of tragedy was only understood when one accepted a ritualistic cyclical pattern of daily regeneration as a way of life: "We begin to live when we have conceived life as tragedy."[123]

Yeats's plays, taken as a whole, might be described as a dramatic projection of the theme of spiritual regeneration. Almost every play explicitly or implicitly depicts life as a pilgrimage, with the dramatis personae involved in the ritual process of becoming whole men. The actions of the plays written during the 1890s reflect the initiatory stages of the rite, portraying men and women who, while living under a spell of enchantment, pursue their own dreams in preference to common life until some unforeseen event profoundly alters their way of experiencing the world. The plays written for the early Abbey Theatre reflect Yeats's own emerging sense of individuation—his delight in the energy of the body and his determination to celebrate man ascending out of "common interests", but "only as far as we can carry the normal passionate, reasoning self, the personality as a whole".[124] Though less obviously ritualistic in form and structure, the plays of this period exhibit an underlying pattern whereby the internal and external conflicts of the characters are only resolved through a material or psychic change of some kind that leads them to a spiritual rebirth.

Ritual murder as a path to higher knowledge is the implicit underlying action of such early plays as The Countess Cathleen, Where There is Nothing, The Hour-Glass, Deirdre, and On Baile's Strand. In later plays such as The Resurrection, The King of the Great Clock Tower, A Full Moon in March, Purgatory, and The Death of Cuchulain, ritual murder becomes the explicit focus of the drama, the shock of violent action being deliberately exploited by Yeats in order to provoke a powerful psychic reaction in the audience.[125] The very process of psychic evolution, or rebirth, which is mainly im-

122. Autobiographies, p. 523.
123. Ibid., p. 189.
124. Essays and Introductions, p. 272.
125. Explorations, p. 399.

plied in the early plays, is now directly depicted and openly described. This is especially true in the dance plays, where death becomes a prelude to the dramatic resolution of antinomies through ritual enactment and utterance. Within a ritual format, Dionysus, Christ, and Cuchulain are not separate historical personages but are coalesced into symbolic representations of the mysterious forces that have moved through and continue to create an influence upon life.

As Morton Seiden notes, even on a humanistic level, with the supernatural understood as the idealized human mind, Yeats's plays form a liturgy, with their performances a sacred rite in which actor and audience, in close communion, offer up their energies to one another.[126] Moreover, Yeats's mystical vision made its influence felt upon the Irish dramatic movement as a whole, thereby giving the movement from Synge and Lady Gregory down to Samuel Beckett one of its most distinctive characteristics and marking it in this respect as perhaps the sole modern equivalent of the greatest dramatic eras of the past.

MYTHOLOGY AND THE HEROIC IDEAL

From his earliest extended effort based upon Irish mythology, The Wanderings of Oisin, it seems evident that in Yeats's mind the heroic mythology of Ireland was the humanist counterpart to Irish supernatural lore. Although in Yeats's poem Oisin gives up mortal existence for three hundred years of spiritual wandering under the spell of the fairy queen, Niamh, in his heart he is never free from the memory of the Fenians and "the ancient sadness of man". For Oisin, as for Yeats himself, there might be escape to an "Island of Forgetfulness", but nowhere did there exist an "Island of Content".

Unfortunately, in the imagination of the youthful, dreaming Yeats, the distinction between journeying out of time into the immortal world of mystical ecstasy and journeying to an ancient mythological world of heroic idealism was not very clear. The one passage in The Wanderings of Oisin where action and conviction appear to replace mere longing occurs at the end of the poem, when Oisin rejects the bleak prospect

126. Vide Seiden, Poet as Mythmaker, pp. 203-29, for an especially good analysis of the relationship of Yeats's major plays to the ritual theatre of antiquity.

of fasting and prayers which Patrick offers him, saying fiercely:

> Put the staff in my hands; for I go to the Fenians
> O cleric, to chaunt
> The war-songs that roused them of old.[127]

In this moment, as Peter Ure observes, Oisin discovers his own identity and thus becomes the first Yeatsian hero to choose nobly.[128] In this all too brief moment Yeats also expresses, perhaps for the first time, the intensely human passion and will that were to give him strength as a dramatist.

This blurred distinction between mortal and immortal reality in *The Wanderings of Oisin* was characteristic of Yeats's response to and use of folklore and mythological material throughout the nineties. In 1891, for instance, he drew a rather strained comparison between the Platonic idealism of Pater's *Marius the Epicurean* and a maudlin patriotic ballad evoking the heroism of ancient Ireland, in terms of "kingly men", "shining sword[s]", and "shamrocks". Pater and Irish folklore were alike, said Yeats, in their conception of "spiritual beings having their abode without and within us, thus uniting all things as by a living ladder of souls with God himself".[129] Writing in 1897 on "The Celtic Element in Literature", Yeats argued that because of the "ancient worship of nature", all folk tradition delighted in "unbounded and immortal things".[130] So far so good—Celtic scholars are agreed that one of the distinguishing qualities of Celtic mythology is its evocation of a "strange loveliness of the other world atmosphere".[131] But again Yeats went on to weaken his case by expressing himself in terms which associate Irish folk tradition with the world-weary languor and sentimentality of *fin de siècle* aestheticism and decadence:

Life was so weighed down by the emptiness of the great forests and by the mystery of all things, and by the greatness of its own desires, and,

127. *Collected Poems*, p. 445.
128. Vide Peter Ure's analysis of "The Wanderings of Oisin" in *Yeats* (Edinburgh: Oliver and Boyd, 1963), pp. 18-22.
129. "A Ballad Singer", *The Boston Pilot* (September 12, 1891), reprinted in *Letters to the New Island*, edited and with introduction by Horace Reynolds (Cambridge: Harvard University Press, 1934), p. 140.
130. *Essays and Introductions*, pp. 176, 179.
131. Dillon and Chadwick, p. 158. Cf. Daniel Corkery, *The Hidden Ireland* (Dublin: Gill and Son, 1967), p. 149.

as I think, by the loneliness of so much beauty; and seemed so little and so fragile and so brief, that nothing could be more sweet in the memory than a tale that ended in death and parting.[132]

Shortly afterwards, Yeats rejected these concepts as "sentimental", and the work written under their influence as "womanish" and "false", "blurred with desire and vague regret".[133] This was after he had seen his "Celtic" ideals travestied by other writers in the Irish Literary Theatre and had had *The Countess Cathleen* and *The Land of Heart's Desire* rejected by audiences for their remoteness from life.

Nevertheless, Yeats continued the practice of drawing upon Irish mythology as a source for plots, characters, and themes. Twelve of his twenty-six plays are set in the distant Irish Heroic Age; but Yeats succeeded in giving this legendary material flesh-and-blood reality by making it the expression of his most immediate personal concerns. As his own personality and philosophy of life gradually hardened this was reflected in a sense of irony that began to balance the earlier sentimentality.

We find evidences of this change in tone and point of view as early as 1897 in the haunting prose legends and stories of *The Secret Rose*. In one of the legends,[134] an Old Knight of St. John, fighting in service of the Rose of heroic idealism, saves a group of peasants from robbers and then is left to die alone. One of "the dreamers who must do what they dream, the doers who must dream what they do", the Knight is clearly an image of Yeats himself, fighting on behalf of his ideals, yet knowing that he will not be understood by those whom he would enlighten. The theme and certain elements of the plot were later employed by Yeats in *On Baile's Strand*, *Calvary*, and *The Death of Cuchulain*. In *On Baile's Strand*, Cuchulain's heroic ideal of honour is juxtaposed with the blank indifference and greed of the Fool and the Blind Man; in *Calvary*, Christ's sacrifice for mankind is ignored by the Roman Soldiers who want nothing but to toss dice for his cloak; and in *The Death of Cuchulain*, after binding himself into an upright position in order to die heroically in battle,

132. *Essays and Introductions*, p. 182.
133. Vide Preface to *Letters to the New Island*, p. xiii; Letter to George Russell denouncing *The Land of Heart's Desire* (April 1904), *Letters*, p. 434; Preface to *Poems 1899-1905*, p. ii.
134. *Mythologies*, pp. 157-64.

Cuchulain is murdered by a blind old beggar man (the same character who appears in *On Baile's Strand*) for the sake of a mere twelve pennies.

Again, in what is perhaps the most beautiful of the legends in *The Secret Rose*, "The Crucifixion of the Outcast",[135] Yeats created an image that was unhappily portentous of his own career and that of Synge in Ireland. In "The Crucifixion of the Outcast", the wandering glee-man, or ballad-singer, Cumhal, is condemned to death by a group of monks for making poems in honour of the ancient Druid gods and for mocking in verse their own lack of charity. After sharing his last strips of bread and bacon with some beggars, Cumhal is stoned and finally abandoned by them for having called them outcasts like himself. Yeats employed a similar image in *The King's Threshold* (1904). Here Seanchan, the poet, chooses to starve to death rather than relinquish his rightful place of honour at the King's table, while a chorus of monks and cripples curse him for having lived by a higher idealism than they are able to comprehend.

The development of an ironic counterpoint to his concept qf the heroic ideal was of great importance to Yeats in both dramaturgical and thematic terms. The heroism of Cuchulain in *On Baile's Strand* is believable and meaningful to a theatre audience in almost direct proportion to the degree that Yeats imbues the opposite force—that embodied by the Fool and the Blind Man—with dramatic verisimilitude. (The situation is, of course, similar to the dramaturgy of his "miracle plays" such as *The Hour-Glass*, where in order to express faith Yeats learned that doubt must be granted an equal voice.) Because, we are convinced in histrionic terms of the basic human reality of the Fool and the Blind Man our minds dwell upon their symbolic meaning in the play, particularly their association with the venal rationalistic anti-heroic bias of modern life. Thus we understand the idealism of Cuchulain in a fuller perspective. We come to perceive with shattering dramatic power and insight the existential courage needed to take a heroic stance, knowing that an action must be taken for the sake of that action alone, and that, regardless of individual idealism, the mob will go on with indifference—blindly, foolishly, grubbing for its daily matter.

135. Ibid., pp. 147-56.

"One thing calls up its contrary, unreality calls up reality," Yeats declared in 1904.[136] By creating a dramatic form in which heroism and its ironic counterpart are interwoven, each balancing and strengthening the impact of the other, Yeats made an original, indeed unique, contribution to the modern drama. As Alec Zwerdling has observed, in contrast to the sentimental concept of Victorian hero-worship which emphasized social usefulness, mindless altruism, and pietistic morality at the expense of self-fulfillment, the heroes of Yeats's plays are dramatically conceived characters whose sole service to the world lies in a private exaltation that indirectly may function as a service to others. In contrast to the cynicism and negativism of most twentieth-century drama, Yeats created an asocial, even anti-social, ideal of heroism that affirms both the potential and actual stature of man and embodies rather than preaches the standards of a better society.[137]

Yeats, of course, was as much a social revolutionary and reformer as the intellectuals and artists who purport to speak for the "counter-culture" of today's society. In many ways he was also as didactic a dramatist as George Bernard Shaw or Bertolt Brecht. But in Yeat's view of history social change was meaningless if not accompanied by a change in the total consciousness of mankind. The strength as well as difficulty of Yeats's dramatic method is that he sought to effect this change by appealing to the ideal self latent in the personality of every man: "When the imaginary saint or lover or hero moves us most deeply, it is the moment when he awakens within us for an instant our own heroism, our own sanctity, our own desire."[138] Of all the implicit theatrical challenges of Yeats's plays, none has proven more demanding for their interpreters as their audiences.

CREATING A UNITY OF HEROISM AND PATRIOTISM

Among the various images which have stirred Irishmen throughout history none is more moving than that of "a majestic radiant maiden", mourning the loss of a man who had slain hundreds, ever flying from the insults of foreign

136. *Explorations*, p. 147.
137. Vide Alec Zwerdling, *Yeats and the Heroic Ideal* (New York: New York University Press, 1965), esp. pp. 1-25.
138. *Explorations*, p. 196. Vide note 117 above.

suitors in search of her real mate. The image is, of course, that of Ireland herself. It is an image real enough in terms of Ireland's history of conquest and suffering; but it was transformed into mythology by the Irish poets of the eighteenth century, those last straggling descendants of the classical bards of ancient Ireland, who created a new poetic form, the *aisling,* or "vision" poem, in order to express their "almost unvarying cry of agony" at the destruction of Gaelic civilization and all that this implied for their own formerly honoured way of life and art. The very name of Eire was not allowed to be used by the poets. But, unknown to their conqueror, in the form of the *aisling* they continued to sing their love of Eire, symbolized by a woman whose name might be Caitilin Ní Uallacháin, Gráinne Mhaol, Cáit Ní Dhuibhir, Síle Ní Ghrade, Caitlín Triall, and, most beautiful of all, Róisín Dubh.[139]

As English gradually became more widely used in Ireland throughout the eighteenth and nineteenth centuries, the aristocratic poetic culture of the bards descended into the hands of the folk; the bards themselves became almost indistinguishable from the peasantry, and their poetry became folklore. The spirit of the *aisling* was carried over into English, but in a much debased form. The poetic synonyms for Eire were translated into relatively banal English equivalents: Cathleen ni Houlihan, Grannaile, Kate O'Dwyer, Sheila O'Gara, Cathleen Tyrell, and My Dark Rosaleen. A new synonym was added whose sentimental connotations would have been foreign to the earlier tradition: that of Sean Bhean Bhocht, which was translated as "Shan Van Vocht", or "The Poor Old Woman".[140]

The aristocratic musical tradition of Gaelic Ireland was gradually supplanted by a new tradition of popular ballads written in English. Many of these ballads, such as "The Boys of Wexford", "Bold Robert Emmet", and "The Wearing of the Green", as well as "The Shan Van Vocht" itself, were written as patriotic commemorations of the unsuccessful insurrections of 1798 and 1803. Few of them were composed

139. Vide Hyde, *Literary History of Ireland,* pp. 591-607; Corkery, *The Hidden Ireland,* pp. 143-54; O'Sullivan, *Songs of the Irish,* pp. 130, 133.
140. Vide Hyde, pp. 608-37; O'Sullivan, p. 130.

to native Irish airs, and of those that were, the melodies were often originally dance tunes. In their commonness of thought and diction, their lack of musical sophistication and style, and particularly in their appeal to obvious sentimentality, most of the Irish ballads of the nineteenth and twentieth centuries make a vulgar contrast to the far richer tradition that preceded them. But the ballad tradition served one important function: it kindled and kept alive a spark of national identity and a sheer love of Ireland that perhaps might otherwise have died with the loss of the Irish language.

Today, many Irishmen view the patriotism of this period in their country's history as an embarrassing memory, associated in the mind with the green beer and plastic shamrocks of American St. Patrick's Day observances. What they forget, perhaps, is that a sense of patriotism and nationalism existed in Ireland at the turn of the century which, sentimental as it may have been, united men of a variety of political creeds, from Unionists and Orangemen to militant Republicans, in a genuine love of Ireland.[141] In the tradition of the *aisling* the very name of Ireland, or her varied synonyms, evoked passionate feelings in men of sturdy natures who were otherwise touched by little. These feelings, in turn, moved them to sacrifice their families, positions, friendships, even their very lives—all in the service of Cathleen ni Houlihan. It was mainly the images of Ireland enshrined in patriotic ballads that Irishmen carried with them when forced to emigrate to other lands. The spirit which these images evoke still marks the affections of their descendants, generations later, for an Ireland most of them have never seen.

W. B. Yeats was not only aware of the emotional force of the patriotic images binding so many disparate Irishmen together; indeed, he was himself as deeply stirred by them as the most sentimental emigrant. His own first response to the "pleasure of rhyme" occurred upon reading a book of Orange ballads

141. Conor Cruise O'Brien in his Preface to *The Shaping of Modern Ireland* (London: Routledge and Kegan Paul, 1960), p. 4, links such disparate figures as Tom Clarke, Edward Carson, Archbishop Walsh, Francis Sheehy-Skeffington, Timothy Michael Healy, Horace Plunkett, and Yeats himself: "They all, in their way, loved Ireland, and to all of them the idea of a lasting division of their country was, almost literally, unthinkable."

owned by a stable boy, and he tells us that as a result one of his boyhood dreams was to die fighting against the Fenians. Later his patriotic feelings were stirred in the opposite direction. He writes of being moved to tears by some poor verses describing the shore of Ireland as seen by a political exile returning home to die.[142] "Nothing could be more simple, nothing more sincere", than the ballad tradition of Ireland, he declared in 1891, and quoted in proof from a popular ballad about a patriotic hero's death in prison:

> Oh! 'tis a glorious memory,
> I'm prouder than a queen
> To sit beside my hero's grave
> And think on what has been;
> And, oh my darling, I am true
> To God—to Ireland—and to you.[143]

One would probably have to be Irish to understand why, but Yeats says that not even Shelley or Spenser ever moved him as did these patriotic poets. He knew in his heart that they wrote badly, yet "such romance clung about them, such a desire for Irish poetry was in all our minds, that I kept on saying, not only to others but to myself, that most of them wrote well, or all but well". Yeats dreamed of creating a ballad style which would not be English "and yet be musical and full of colour" and so inspire others. By turning his own attention to folklore and legends he hoped to give the ballad-writers new subject matter to write about.[144]

Again, Yeats carried his ideas into his work in the theatre. One of the most remarkable aspects of his dramaturgy is the effective use that he made of music, particularly ballad music. Each of his plays employs songs, most of them based on traditional ballad airs, for a variety of dramatic purposes: to lend a *brio* and verisimilitude to comic characters in *The Pot of Broth, The Hour-Glass, The Green Helmet, The Player Queen, The Cat and the Moon,* and *The Herne's Egg*; to intensify the mood of serious passages in *The Land of Heart's Desire, The King's Threshold, Deirdre, The Resurrection, Words Upon the Window-Pane,* and *Purgatory*; to serve as an

142. *Autobiographies*, pp. 14, 102.
143. *Letters to the New Island*, p. 126.
144. *Essays and Introductions*, pp. 3-4.

ironic almost casual counterpoint to the heroic personages and lofty poetic diction of plays such as *On Baile's Strand, A Full Moon in March, The King of the Great Clock Tower*, and *The Death of Cuchulain*; and to express thematic ideas without being overtly didactic as in the final lyrics of all the dance plays.

Yeats's nationalistic feelings were also stirred by the stories associated with the popular patriotic heroes of Ireland, particularly those men who had given their lives for the cause of Ireland's freedom and so had achieved immortality in the book of the people. He claimed that there was a "moral beauty" in their deaths—not so much for patriotic reasons as for the idealism implied in a willingness to die for "something beyond one's self".[145] Yeats believed that the acceptance of these heroes as part of the popular mythology of modern Ireland implied much about the moral fibre and idealism of the Irish people. He declared in 1904:

I would not be trying to form an Irish National Theatre if I did not believe that there existed in Ireland, whether in the minds of a few people or of a great number, an energy of thought about life itself, a vivid sensitiveness as to the reality of life itself. . . . I do not think it a national prejudice that makes me believe we are a harder, a more masterful race than the comfortable English of our time. . . . If one remembers the men who have dominated Ireland for the last one hundred and fifty years, one understands that it is strength of personality, the individualising quality in a man, that stirs the Irish imagination most deeply in the end. There is scarcely a man who has led the Irish people, at any time, who may not give some day to a great writer precisely that symbol he may require for the expression of himself.[146]

Yeats was fortunate in being closely associated with two individuals who embodied his concept of heroic Irish nationalism. One was John O'Leary (1830-1907), an authentic political hero, who had suffered five years of imprisonment and

145. *Sambain* Number Seven (November 1908), p. 5. Yeats is referring to a "frankly propagandist" play which he had seen, based on the life of the Republican martyr Robert Emmett. The play touched him because it "had the dignity of a long national tradition". During the nineties Yeats planned to write a play of his own on Emmett for a travelling theatre in Ireland. *Memoirs*, p. 58.
146. *Explorations*, p. 147.

fifteen years of exile in France for his part in the unsuccessful Fenian uprising of 1867. On returning to Ireland in 1885, O'Leary's sense of personal dignity, his upright moral character, and his idealistic concept of national service gathered to him a group of young writers and would-be patriots united in a desire to serve Ireland. Yeats was among that company, and was indeed first converted to the idea that a spirit of nationalism could be directed for literary ends by the personal example and the precepts of O'Leary.[147]

Yeats's other image of living heroism was the beautiful Maud Gonne. Maud Gonne had also been converted to the nationalist movement by O'Leary. When Yeats met her for the first time in January 1890, his youthful response was typical in being direct, emotional, and very human; which is to say, he fell in love with her immediately. Just as immediately, however, that love was transformed into something of mythological proportions. For the rest of his life, Maud Gonne was sung as Yeats's Beatrice, the image of many of his most cherished personal ideals: mystical perfection ("The Rose of the World"); physical and intellectual beauty ("He Tells of the Perfect Beauty"); nobility of mind ("No Second Troy"); heroic idealism ("A Woman Homer Sung"); and perfect love itself ("His Phoenix"). It was partially out of his unrequited longing for Maud Gonne that Yeats wrote *The Land of Heart's Desire*, and out of his dream of a mystical union with her that he wrote *The Shadowy Waters*.[148] It is evident that Yeats also based the character of the Countess Cathleen on the real life image of Maud Gonne as an Irish Joan of Arc—the saviour of the starving, evicted Irish peasantry after the fall of Parnell.[149]

Both John O'Leary and Maud Gonne were of practical as well as inspirational help to Yeats, in his difficult organiza-

147. Ellmann sums up O'Leary's ideas as they were given in two speeches in 1886 entitled "What Irishmen Should Know" and "How Irishmen Should Feel". In the first speech, O'Leary recommended study of the classics, of English history, of Irish geography, history, and folklore. He declared that an Irishman should feel first of all that he was an Irishman, second, that Irish unity must be secured, and finally, that he should make some sacrifice for Ireland. *Man and the Masks*, pp. 46-47. Cf. *Autobiographies*, pp. 96-98, 109. pp. 46-47. Cf. *Autobiographies*, pp. 96-98, 109.

148. Vide Ellmann, *Man and the Masks*, pp. 111, 134.

149. *A Servant of the Queen*, pp. 63-65, 176, 240-41. Cf. *Letters*, p. 109.

tional efforts in Ireland during the nineties. Those efforts were mainly directed towards the development of an Irish Unity of Culture, but they necessitated, along with purely cultural activities, a considerable amount of time spent in the smoke-filled back-rooms of Irish politics. A climax to all the work was reached in 1898, a year before the opening of the Irish Literary Theatre, when Yeats assumed the presidency of an association formed to commemorate the centenary of the death of the Republican hero Wolfe Tone. Mainly through the efforts of John O'Leary and Maud Gonne, Yeats succeeded in the monumental task of bringing together Unionists, Nationalists, and political extremists for at least the one day of ceremonious observances.[150]

Maud Gonne provided the greatest aid in uniting the various political factions. Indeed, it was mainly at her bidding that the Tone Centenary became directed as a protest against the dissension which had riddled Irish politics since the fall of Parnell in 1890. Yeats wrote movingly of her incredible capacity to enflame the hearts of patriotic Irish men and women:

Her power over crowds was at its height, and some portion of the power came because she could still, even when pushing an abstract principle to what seemed to me an absurdity, keep her mind free, and so when men and women did her bidding they did it not only because she was beautiful, but because that beauty suggested joy and freedom. Besides, there was an element in her beauty that moved minds full of old Gaelic stories and poems, for she looked as if she lived in an ancient civilisation where all superiorities whether of the mind or the body were a part of public ceremonial, were in some way the crowd's creation.[151]

As Yeats developed a deeper knowledge of the folklore and mythology of ancient Ireland, he began to meditate upon the heroic concept which had provided that society with a Unity of Culture. Had the Irish bards of old not created "a fellowship . . . for learned and unlearned alike", a "communion of heroes", based upon a belief in "the historical reality of their wildest imaginations"?[152] Was the sense of idealism in their society not based upon a conception of life in which

150. *Autobiographies*, pp. 353-66.
151. Ibid., p. 364.
152. *Explorations*, pp. 6-7.

reality and the image of that reality become ideal had both existed side by side, "the invisible life but the life about them made more perfect and more lasting"?[153]

By drawing upon the living presence of heroic personages such as John O'Leary and Maud Gonne and upon the tradition of sacrifice and unselfish service preserved in popular myth and song, Yeats believed that an heroic and ideal concept of Unity of Culture might be re-created in modern Ireland. With Maud Gonne at his side as "the fiery head of the intellectual movement", and John O'Leary as its spiritual leader,[154] he dreamed that it was possible to "unite literature to the great passion of patriotism and ennoble both thereby". Was it not possible, he dreamed, that Irishmen would "do for love of Ireland what they would not do for the love of literature"?[155]

Yeats was not so naïve as to expect or even desire a Unity of Culture in which politicians shared the same policies for the development of the Irish nation. That would be an "artificial unity", he declared, for "only dead sticks can be tied into convenient bundles."[156] Instead, like the philosopher-poets of ancient Greece, he was concerned with the moral implications of political action. By evoking "a more imaginative love of Ireland" he hoped to "forward a nationality that [would be] above party", to develop a political spirit moulded on "self-sacrifice" like that of the "heroic generation" of John O'Leary. In time the Irish nation might be served by the creation of "a true cultivated patriotic class".[157]

Following the successful Tone Centenary celebration, Yeats hoped that with the help of Maud Gonne and John O'Leary he might create a "permanent centre of Irish policy" representing all points of view and thus begin to establish political independence from England.[158] When that grandiose plan failed to materialize, the theatre became a means of realizing a similar objective in cultural terms. By "rediscovering the association of literature with music speech and

153. Ibid., p. 23.
154. *Memoirs*, p. 58; *Essays and Introductions*, pp. 246-47.
155. *Letters to the New Island*, pp. 155-56.
156. Letter to Ethel Mannin (November 30, 1936), *Letters*, p. 869.
157. Vide *Explorations*, p. 29; *Letters to the New Island*, p. 26; *Uncollected Prose*, pp. 403-6.
158. Vide *Autobiographies*, pp. 361-63; *Memoirs*, pp. 109-10.

dance" Yeats intended to "so deepen the political passion of the nation that all, artist and poet, craftsman and day-labourer would accept a common design".[159]

In his earliest published poem, "The Two Titans: A Political Poem" (1886), Yeats created a rather strained form of *aisling*, with Ireland symbolized as a sybil chained to a rock, freed for a fleeting moment by the songs and kiss of a poet.[160] *The Countess Cathleen*, inspired by Maud Gonne and performed as the first production of the Irish Literary Theatre in May 1899, may be read as a dramatic *aisling* embodying many of Yeats's most cherished ideals of nationalism and art. We shall see that political factionalism played a large role in preventing *The Countess Cathleen* from being accepted by an Irish audience. None the less, as an indication of the support that at the time buoyed Yeats's hopes for the future of the Irish dramatic movement, it is significant to note that the patrons list for the first season of the Irish Literary Theatre contained the names of a number of prominent Irishmen and women representing sharply conflicting political points of view.[161]

In 1902, following the break-up of the Irish Literary Theatre, Yeats deliberately aligned himself with the militant Irish nationalists by writing another *aisling* in the form of a play for Maud Gonne. With Maud herself playing the title role at the first production of *Cathleen ni Houlihan*, both she and the play itself created an overwhelmingly powerful impression. To Yeats she made Cathleen seem "a divine being fallen into our mortal infirmity".[162] To the poet and mystic James Cousins she brought to the play "a curious sense of 'presence', of something to live up to: she became not only an actress but an incarnate responsibility."[163] To the militant

159. *Autobiographies*, p. 194.
160. Ellmann, *Man and the Masks*, pp. 49-51.
161. These names included Unionists such as W. E. H. Lecky, John Pentland Mahaffy, Horace Plunkett, Lord Castleton, and Lord and Lady Ardilaun, the contesting leaders of the Nationalist Party, John Dillon, John Redmond, and T. M. Healy, as well as militant Republicans such as Maud Gonne. Lennox Robinson, *Ireland's Abbey Theatre* (London: Sidgwick and Jackson, 1951), p. 3.
162. "Notes to Cathleen ni Houlihan", *Plays in Prose and Verse* (London: Macmillan, 1922), p. vii.
163. James H. and Margaret Cousins, *We Two Together* (Madras: Ganeth & Co., 1950), p. 71.

nationalists, however, the production was seen as a clarion cry to political action, and in the years ahead, although Maud never again played the role, *Cathleen ni Houlihan* became one of the sacred works of the Sinn Fein and Republican movements.[164]

Political passion carried to violent extremes ultimately contributed to the dissolution of Yeats's most cherished ambitions for the Irish dramatic movement. But throughout the controversy that surrounded all of his efforts we shall see that Yeats remained true to his original intention: the creation of "a great community" where "the finest minds and Sean the Fool think the same thing, though they may not think the same thought on it".[165]

The creation of an Irish National Theatre was of central importance to all of Yeats's personal and public concerns as man and artist. By plunging literature into social life through the drama, he hoped to achieve a unity of those forces that warred within him: the struggle between self and anti-self; the disparate claims of mysticism, aestheticism, and nationalism. By means of a theatre such as he envisaged the cycle would be complete: Unity of Image would invoke that Unity of Culture through which Unity of Being might flourish.

In the light of these ideas surely nothing could be more mistaken than the common assumption that, "for Yeats, the ideal theatre was a drawing room, the ideal audience an assembly of verse-minded *dilettantes*".[166] A drawing-room audience is indeed what Yeats ended up with. But this was only due to the incompatibility of his idealistic vision with the reality of the contemporary theatre in England and Ireland.

164. Vide Dorothy Macardle, *The Irish Republic* (London: Corgi Books, 1968), p. 58; John J. Horgan, *Parnell to Pearse* (Dublin: Browne and Nolan, 1948), pp. 33-34.

165. *Explorations*, p. 28.

166. Hugh Leonard, Review of "The Silver Tassie", *Plays and Players*, Vol. 17, No. 2 (November 1969), p. 20. Cf. Robert Hogan, *After the Irish Renaissance*, pp. 147-51.

A Dramatist in Search of
a Theatrical Form

From almost every standpoint, there could not have been a more inauspicious period in the history of the theatre for a poetic dramatist such as W. B. Yeats to have appeared. For the kind of idealistic drama and theatre that Yeats sought to create three conditions were essential: a fully developed dramatic form through which he might objectivize his highly personal response to life; theatre artists with an understanding of the conventions and techniques necessary to interpret that form; and an audience for whom the conventions of the form were meaningful as a reflection of the myths and rituals intrinsic to their own lives.

It was obviously impossible for Yeats to look to the nineteenth-century theatre of England—or Ireland, its theatrical offshoot—for either a dramatic form or artists such as he required. Bowdlerized by almost a century of illiterate mob-rule, Victorian puritanism, and commercial management, the theatre in England had degenerated to an unprecedented low ebb. The scene carpenter held sway over the actor and playwright; an unsurpassable gulf existed between the man of letters and the man of the theatre.[1]

1. Allardyce Nicoll, *British Drama* (London: Harrap & Co., 1962), pp. 200-246. Cf. George Rowell, *The Victorian Theatre* (London: Oxford University Press, 1956).

The immediate inspiration for Yeats's theatre came, therefore, not from England, but from the Continent—specifically from the theatrical reforms of Richard Wagner and the French symbolists.

YEATS AND WAGNER

Brooding over the entire symbolist movement in the theatre was the domineering hypnotic spirit of Richard Wagner (1813-83). Musician, poet, playwright, thinker, administrator—no other figure of the nineteenth century came closer to having postulated and realized so many of Yeats's own ideals for an Irish National Theatre.

Like Yeats, Wagner felt that the disassociation between public and private sensibility was the basic problem besetting modern man. To Wagner, rationalism lay at the core of the problem, for it had created a dualism between subjective and objective conceptions of reality, with the sensory perceptions of emotion and feeling consistently devalued in comparison with the perceptions of the mind. As a result, modern man was "bewildered, wandering, piecemeal", isolated from his cultural and social environment.[2]

Through art Wagner sought to restore the lost balance between feeling and intellect. Art must no longer be an expression of the mind alone. That kind of expression was only appropriate to science. Instead, art must spring from the deepest impulses of the unconscious mind progressing by means of an emotional logic "from within outwards". "We must become knowers through the feeling," Wagner declared.[3]

In order to heal the breach between man and his environment, Wagner turned to the theatre of ancient Greece as a practical source of inspiration. Hating the superficial realism of the contemporary bourgeois German theatre which was based upon "fashion" rather than upon "Life", Wagner called for a theatre reflective of the full "public conscience". The Greek theatre owed its strength to having roots in the living poetic and musical arts of the people. Modern art must also

2. Vide Michael Kirby, ed., Introduction to *Total Theatre* (New York: Dutton, 1969), pp. xvi-xvii.

3. Richard Wagner, "Essence of Drama is knowing through Feeling", *Total Theatre*, pp. 5-6. Cf. Arthur Symons, "The Ideas of Richard Wagner", *The Theory of the Modern Stage*, ed. Eric Bentley (Baltimore: Penguin, 1968), p. 287.

be rooted in "natural culture" if it were to get below the surface actions of life to the deeper impulses that united men.[4] It was on the legendary lore and music of "the Folk", a people who felt a "common want", "an absolute need", and possessed the will to "revolt and fight for that need" that Wagner sought to base his art.[5]

Although Wagner's success as an artist was achieved mainly through his musical genius, he thought of himself equally at home as a poet and man of the theatre. Again drawing his inspiration from ancient Greece, Wagner described the theatre as "the one indivisible supreme creation" of man. Rationalism had destroyed the unity of Greek theatre, leaving in its stead the fragmented isolated arts of rhetoric, sculpture, dance, and music.[6] Opera had failed to restore that unity because of the predominance of music; conventional theatre had also failed to reunite the arts because of the predominance of poetry. Wagner sought to create what he termed "The Art Work of the Future"—a theatre like that of ancient Greece involving a union of all the arts in which "each separate art would be at hand in its utmost fulness".[7]

Wagner insisted that poetry must be the fecundating source of music drama; the form of his work was dictated by the subject matter of texts that he created himself.[8] In the process of combining the two arts, however, Wagner was by no means content to have the musician simply underscore the words. "The union of music and poetry must always end in a subordination of the latter" was his firm conviction.[9]

It is therefore in musical and not, strictly speaking, in dramatic terms that Wagner attempted to resolve the problem of man's dual consciousness of the world. He did this by symbolically uniting man with the external world through the medium of tone. In Wagner's music dramas the individual, or self, is identified with the solo voice while the orchestra represents the "voice" of the world.[10] By means of the *leitmotiv*, the musical equivalent of a poetic symbol which is

4. Symons, pp. 287-88, 298.
5. Richard Wagner, *The Prose Works of Richard Wagner*, trans. W. A. Ellis, (London: Kegan Paul, Trench, Trubner, 1892-99), Vol. I, p. 123.
6. Kirby.
7. Wagner, *Prose Works*, I, pp. 83-84.
8. Ibid., p. 346.
9. Ibid., pp. 154-56.
10. Kirby, pp. xvii-xviii.

repeated throughout a work, Wagner sought to evoke a complex set of feelings and mental associations connected with specific characters.[11] Characters are in turn linked with the outer world through the symphonic development of a stream of "endless melody" reflected in common tonality by both singers and orchestra.[12] Wagner's ultimate aim is to carry the spectator in one enormous flood-tide of emotion to the transcendental plane of tragic ecstasy. Thus, in the words of Francis Fergusson, "reason is rejected" and "the whole action and meaning is placed in a realm of outer darkness".[13]

To achieve his extraordinary artistic ambitions Wagner demanded nothing less than an opera house devoted to his own works where he would also be given complete control of singers, conductors, instrumentalists, and scene designers. Wagner realized that such a theatre would have to be heavily subsidized in order that experimentation might take place without undue economic pressure and in order that he might have the opportunity of educating his audience without compromising artistic standards. Wagner had faith that the people would ultimately support his work, though he hoped that, as in ancient Greece, a state subsidy ultimately would enable tickets to be free. To make a beginning, however, he had need of a few powerful, wealthy, cultivated, and vastly understanding patrons. There is perhaps nothing more remarkable in his entire career than the fact that Wagner found such patrons, convinced them of his ideas, and persuaded them to give their financial support to his mighty project. The result was the creation of the fully subsidized *Festspielhaus* at Bayreuth in 1876.[14]

By the 1890s Wagner's influence made itself felt in England. Throughout the decade a steady stream of pilgrims flowed to Bayreuth, among them many of Yeats's closest associates and acquaintances, including Arthur Symons, Edward Martyn, and George Moore. The idea of a theatre in England on a Wagnerian scale was on the minds of many people. George Bernard Shaw in 1889 called for a public

11. Symons, pp. 288-89, 298, 301-4.
12. Cf. Bentley, *The Playwright as Thinker*, pp. 83-85; Fergusson, *The Idea of a Theatre*, pp. 88-89.
13. Fergusson, p. 81.
14. Ernest Newman, *Wagner as Man and Artist* (New York: Tudor, 1946), p. 161. Cf. Symons, pp. 305-6.

subscription to erect an English *Bühnenfestspielhaus* which would also serve the drama of Shakespeare.[15] Indeed, by formulating his concepts and by the example of his music dramas and Bayreuth itself, Wagner exerted an influence that has lasted down to present-day experiments in "total theatre".

Yeats openly acknowledged his debt to the theory and practice of Wagner, "the most passionate influence in the arts of Europe". In 1899, promoting his idea of an heroic Irish drama based on primitive mythology, Yeats pointed out that Wagner's music dramas "were becoming to Germany what the Greek Tragedies were to Greece". By deploying the sacred legends of the German *Nibelungen* in *The Ring, Parsival, Lohengrin*, and *Tristan und Isolde* Wagner had shown a way by which Ireland too might become, as in ancient times, "a holy land to her own people".[16]

Yeats naturally responded to Wagner's stance as the poet-priest of a cultural form of nationalism that transcended political, social, and religious divisions. In their pure artistry and passion he noted that Wagner's music dramas crossed all parochial boundaries between nations, being performed not only at Bayreuth "but before large crowds of not particularly elect persons" throughout Germany and other countries in Europe.[17] At the same time Bayreuth provided a glowing example of a theatre which was respected, even venerated, by the German people as the matrix of their national culture. In the midst of a clash with militant Irish nationalists over the dramas of Synge in 1906, Yeats quoted at length from Wagner in calling for a similar respect for the mission of the Irish National Theatre:

In the Theatre there lies the spiritual seed and kernel of all national poetic and national moral culture. No other branch of Art can ever truly flourish or ever aid in cultivating the people until the Theatre's all-powerful assistance has been recognised and guaranteed.[18]

The subsidy from private and state sources that made Bayreuth possible provided Yeats with a practical illustration of

15. G. B. Shaw, *The Perfect Wagnerite* (London: Constable, 1902), p. 135.
16. John Eglington et al., *Literary Ideals in Ireland* (London: T. Fisher Unwin, 1899), pp. 18-19, 25.
17. Ibid., p. 32.
18. *The Arrow*, ed. W. B. Yeats, I (October 20, 1906), p. 3.

how his own ideal theatre might be created. In 1891, Yeats declared that the "higher drama" would only come into existence by

appealing first to the refined and cultivated and well-read, elaborating piece by piece its convention, then widening its range by gathering converts slowly among the many like a new book, not going to the public, but drawing them to itself. . . . On some such terms did Wagner find an audience.

Yeats went on to describe how, ideally, such a theatre would function:

It should be subsidised by the State, in all matters be under the control of the greatest artists and critics of the time, enact at stated intervals the greatest works of the greatest poets of all times, announce each performance to the universe years ahead.[19]

In 1904 Yeats persuaded that devoted Wagnerian Miss Annie Horniman to subsidize the creation of his own Bayreuth-in-miniature, the Abbey Theatre. Yeats proclaimed on the opening of the Abbey that the great virtue of Miss Horniman's subsidy was that it freed himself and his play-writing colleagues from the pressure of having to placate their audience: "We shall be able to ask ourselves, when we put a play on, first, 'Does it please us?' and then, 'Does it please you?'"[20]

By 1906, Yeats was already advocating to his fellow Abbey Theatre directors, Lady Gregory and John Synge, the need for a "National endowment" to enable the Theatre to "complete its work" by performing "world masterpieces".[21] When Miss Horniman withdrew her subsidy in 1910, the Abbey struggled along on private donations, proceeds from foreign tours, and scanty box-office receipts until 1924. In June of that year, Lady Gregory and Yeats wrote to President Cosgrave of the newly formed Free State Government, declaring that because the Abbey Theatre "by tradition and

19. *Letters to the New Island*, p. 176.
20. *Freeman's Journal* (December 28, 1904), preserved in Henderson Press Cuttings, National Library of Ireland (N.L.I.) Ms. 1730, p. 3.
21. Letter from Yeats to Synge (December 2, 1906), N.L.I. Ms. P5380.

accomplishment" had become "the National Theatre of Ireland, it should no longer be in the possession of private individuals, [but] should belong to the State." This offer was accepted by the government. While leaving the actual control of the Theatre in the hands of the directors, the Abbey Theatre was voted a grant which made it the first state-subsidized theatre in the English-speaking world.[22]

From a dramaturgical standpoint, Yeats admitted that the theories of Wagner touched on his own ideas at several points, especially Wagner's insistence that a play must appeal not to the intelligence but "by being a piece of self-consistent life directly to the emotions".[23] One can, of course, parallel Wagner's usage of the *leitmotiv* with Yeats's deliberate repetition of poetic symbols, one play lighting up another so as to produce a cumulative response of emotional richness and increasing clarity. As Reg Skene has demonstrated, the full effectiveness of this idea can be experienced through a performance of the complete Cuchulain cycle, Yeats's equivalent of Wagner's *Der Ring des Nibelungen.*[24]

Theatrically, there is again an obvious similarity between Wagner's "endless melody" and the "continually varied music" that Yeats demanded from actors speaking his verse.[25] Yeats also sought for a unification of the arts in which sound, colour, and form would be employed in a musical relationship to one another so as to become "one sound, one colour, one form, and evoke an emotion that is made out of their distinct evocations and is yet one emotion".[26] Here the theory and practice of Wagner and Yeats are closely related to the magical doctrine of correspondences between specific organs of the body, the underlying principles of music and the visual

22. Robinson, *Ireland's Abbey Theatre*, pp. 125-26.
23. Letter to Arthur Symons (September 10, 1905), *Letters*, p. 460.
24. Skene's study of the Cuchulain plays is based upon a production of the entire cycle that he staged at the University of Winnipeg in 1969. The production convinced him that "the major patterns of the plays can only become apparent when they are considered together." Introduction, *The Cuchulain Plays*, p. 4. I have had the same experience staging productions made up of two or more Yeats plays which explored similar themes: e.g. *Calvary* and *The Resurrection; The Shadowy Waters* and *A Full Moon in March.*
25. *Explorations*, p. 173.
26. *Essays and Introductions*, p. 26.

arts, and the mysterious laws and forces that bind the universe together.[27]

But despite their obvious agreement on these points, closer analysis of the practical application of their dramaturgical and theatrical theories shows that in many respects Yeats and Wagner were poles apart. Where Wagner relied ever increasingly upon the orchestra rather than the singer as the principal means of revealing the dramatic action and the underlying sentiments of the characters, we shall find that Yeats developed a dramaturgical form in which the actor was the focal point of the dramatic action. Where Wagner sought to employ the hypnotic spell of music to obliterate all actual or intelligible distinctions between the audience and the stage action itself, Yeats endeavoured to provide the audience with heroic images that would strengthen their individualism and at the same time develop their communal awareness. Where Wagner sought to by-pass the rational world of daily existence in order to transport his audience to the outer darkness of nihilism,[28] Yeats sought to create a dialectical drama out of the "mingling of contraries", the tragic struggle between "reality" and "nobility".[29]

These variances of Yeats from the dramaturgical and theatrical methods of Wagner illustrate the differing approaches of the musician and the poet to the theatre. More important, they illustrate, in a particularly cogent manner, the extraordinary dramatic intentions of Yeats as well as some of the reasons why he found it so difficult to create a dramatic form to express those intentions.

To Yeats, however valid the other arts might be in their own right, within the context of the theatre they could be viewed as merely "the applied arts of literature".[30] This is

27. Yeats declared: "Every organ of the body has its correspondence in the heavens, and the seven principles which make the human soul and body correspond to the seven colors and the seven planets and the notes of the musical scale." Letter quoted in Moore, *The Unicorn*, p. 27. Israel Regardie shows that traditional magical rites are scientifically designed to activate the will and imagination by appealing to all the bodily senses: sight, sound, smell, taste, and touch. *The Tree of Life*, pp. 106-7.

28. Bentley, *Playwright as Thinker*, p. 88.

29. Jeffares, *W. B. Yeats: Man and Poet*, p. 318.

30. *Autobiographies*, p. 194.

primarily because, as a poet, he believed that the expression of profound philosophical convictions was of greater importance than simply stirring emotional responses, however powerful or exquisite those responses might be. If either music or the visual arts were allowed to dominate language in the theatre, the inevitable result was a form which drew the audience "into the impersonal land of sound and colour".[31]

The real point is this: Yeats was not a nihilist; life was of value in itself. Thus he saw the theatre on a much more human and intimate scale than Wagner's grand opera. Yeats sought to transport the audience out of their physical surroundings to a world of tragic ecstasy, but, unlike Wagner, he did not intend that human identity should be lost in a transcendental void. Instead, he sought to return the audience to everyday life again, spiritually rejuvenated and inspired from having experienced a moment of infinite perfection.

In order to realize his intentions Yeats had need of a dramatic form that possessed the lyricism, passion, and theatrical unity of Wagner's music-dramas. At the same time it must be a form that never ceased reminding the audience of its own humanity, of the origins of art itself among the common people. Yeats therefore based his art upon words, "the most personal of things".[32] He sought to create a dramatic form in which thoughts and feelings might flow *to* as well as *from* the stage, forging a ritual bond between spectators and performers, but without breaking down the aesthetic distance between them. He found a form which appeared to realize these intentions in the experiments of the French symbolist poets in the theatre.

THE SYMBOLIST REVOLT IN THE THEATRE

The poets of the French symbolist movement for the most part remained aloof from the theatre until, with the success achieved by the reform movement of the naturalists led by Zola, Becque, and Brieux during the 1870s and 1880s, it appeared as if there were a market for a minority theatre as well as a popular theatre for the bourgeoisie. As André Antoine founded Le Théâtre Libre in 1887 in order to pro-

31. *Essays and Introductions*, p. 268.
32. Ibid.

test against commercialism in the French theatre,[33] the theatre of the poets, Le Théâtre d'Art, was founded in 1890 as a protest against naturalism and Le Théâtre Libre itself.[34]

From 1886 to 1890, in fact, a counter-revolution to naturalism took place in French letters as a whole. The death of Victor Hugo in 1885 marked a turning point for the poets; along with Hugo the heavy weight of the romantic tradition was buried, and the iconoclastic, exuberant spirit of *la belle époque* took its place. Concurrent with this new artistic spirit was the loss of prestige that science began to suffer. Because of philosphers such as Henri Bergson, who introduced new ideas in the nature of intelligence, and scientists such as Herbert Spencer, whose concept of the unknowable came to be familiar, science no longer seemed to possess absolute answers as to the nature of man and the universe. As the certitude of objective science declined, members of the decadent and symbolist movements in poetry began to feel less reluctant about celebrating their subjective dreams and desires in art. Hitherto, even romantic French poetry had been characterized by clarity of language and intellect. Now reason was replaced by intuition and emotion was expressed by the use of images and symbols. The evocation of ideal essences and forms, rather than the depiction of exterior reality, the expression of ideas, or social criticism was considered to be the proper function of art.[35]

While the decadent poets, led by Paul Verlaine (1844-96), attempted to express their personal experiences and subconscious thoughts and feelings, the symbolists, inspired by Stéphane Mallarmé (1842-98), desired most of all to express the mystical relationship between man and the universe. The

33. Cf. Allardyce Nicoll, *World Drama* (London: Harrap, 1966), pp. 485-518; Matthew Josephson, *Zola and His Time* (New York: Russell and Russell 1969), pp. 204-50; S. M. Waxman, *Antoine and the Théâtre Libre* (Cambridge: Harvard University Press, 1926).

34. Vide Margaret Croyden, *Lunatics, Lovers and Poets: The Contemporary Experimental Theatre* (New York: McGraw-Hill, 1974), pp. 3-23, for a perceptive analysis of the influence of the naturalists and symbolists upon one another and subsequently upon the whole modern theatre.

35. Vide May Daniels, *The French Drama of the Unspoken* (Edinburgh University Press, 1953), pp. 20-22; Arthur Symons, *The Symbolist Movement in Literature* (London: Heinemann, 1899), pp. 4-6. In Symons's words, the symbolist movement was "an attempt to spiritualize literature, to evade the old bondage of rhetoric, the old bondage of exteriority". p. 8.

symbolist poets thus sought for a means of expressing a col-
lective unconscious through the employment of myth. They
believed that external reality in its multifarious forms was
but a manifestation of a universal mystical reality, and that
this reality could be expressed, even created, through the
power of the word.[36]

It was under the influence of Richard Wagner that some of
the symbolists began to evolve a philosophy of the theatre.
Wagner's concept of a union of the arts particularly excited
their imagination. In 1885, *La Revue Wagnérienne* was
founded in Paris to promote the ideas of Wagner as they
might be translated into a support of the symbolists' posi-
tion. The poet Edward Dujardin, one of the founders of the
journal, called for a poetic drama which would be like Wag-
ner's music-drama in employing a minimum of action, long
speeches in melodious rhythmic patterns, and the use
of verbal *leitmotivs* through the repetition of symbols,
theme sentences, phrases, and even vowels, consonants, and
syllables considered appropriate by their sound to the idea or
the emotion expressed.[37]

In August 1885 Mallarmé wrote an article for *La Revue
Wagnérienne* in which he expressed a similar ideal. Instead of
a "union of the arts", however, Mallarmé spoke of a single
juxtaposition, "a harmonious compromise" of "two elements
which are mutually incompatible".[38] As their ideas deve-
loped, it became increasingly evident that Mallarmé and most
of the other symbolists objected to the pre-eminence of mu-
sic over language in Wagnerian music-drama. In scores of
articles written for *La Revue Indépendente* from November
1886 to July 1887, Mallarmé postulated a new form—a

36. Daniels, p. 23. Symons considered "Decadentism" a term only applicable to
 style, as an "ingenious deformation of language". As such it was but a literary
 bypath. Symbolism was a more serious form, "conscious of itself" as a means
 whereby "art returns to the one pathway, leading through beautiful things to
 the eternal beauty". *Symbolist Movement*, pp. 3, 6, 7. Vide Edith Starkie,
 Arthur Rimbaud (New York: New Directions, 1961), esp. pp. 118-28, for a
 discussion of how Rimbaud sought to explore the "magic in the color of
 vowels".
37. Jacques Robichez, *Le Symbolisme au Théâtre: Lugné-Poe et les Débuts de
 l'Oeuvre* (Paris: L'Arche, 1955), pp. 33-34.
38. Mallarmé, *Oeuvres Complètes* (N.R.F. Bibliothèque de la Pléiade), p. 543,
 quoted in Robichez, p. 39. All passages quoted from Robichez have been
 translated by the writer.

"L'oeuvre" or "total art" combining the separate arts of music, decor, poetry, and mime. At the same time, he insisted that language—and language alone—was sufficient to express all that a dramatist might want to say.[39]

An obvious contradiction existed in the ideas of the symbolist poets concerning the drama. On the one hand, they called for the creation of a Wagnerian kind of drama which would bring together all the arts of the theatre in a harmonious relationship; on the other hand, they denigrated the validity of a theatrical as opposed to a literary experience. "Le spectacle dans un fauteuil", or the armchair theatre, was in fact superior in the eyes of the symbolists to anything that might be experienced in the living theatre. It is not surprising that, although several symbolists wrote plays, very few of them ever intended or even wanted their works to be actually produced on the stage.[40]

None the less, it was under the direct inspiration of the theories of Mallarmé and the other symbolist poets that the poet Paul Fort, at the time only seventeen, founded Le Théâtre d'Art to promote symbolist drama.[41] Totally lacking in theatrical experience or even a good organizational sense, Fort somehow managed to hold his theatre together for three years during which he attempted productions of such classics as Shelley's The Cenci and Marlowe's Dr. Faustus as well as unpublished symbolist plays by Mallarmé, Verlaine, Catulle Mendès, Morice, Dujardin, Maeterlinck, and himself.

39. Vide Haskell M. Black, Mallarmé and the Symbolist Drama (Detroit: Wayne State University Press, 1963), pp. 83-100.

40. Baudelaire, for instance, disdainfully proclaimed that the most beautiful thing he had ever found in the theatre was "the chandelier, a beautiful, luminous, crystalline, circular and symmetrical object". "Mon coeur mis à nu", Oeuvres posthumes, p. 97. Quoted by A. G. Lehmann, The Symbolist Aesthetic in France (Oxford: Basil Blackwell, 1968), p. 231. Lehmann comments: "Between Wagner and the symbolists there is this difference, that Wagner not only recognized the possibility of gaining a wide audience, and in some sense at least allying his art to religion, but took steps to achieve that end; while the symbolists spoke much of making art a religion, but in fact made it no more than a private cult." p. 240.

41. Robichez, p. 113. Le Théâtre d'Art was preceded by two other theatrical ventures: Le Théâtre Idéaliste (April 1890), which was to have acted as an opposition theatre to the naturalists, and Le Théâtre Mixte (June 1890) founded by Fort as a theatre open to all new styles. pp. 86-87.

As Le Théâtre Libre had become known for a style of acting and staging adapted to naturalistic plays, Fort attempted to create a style which would be suited to the poetic plays performed by Le Théâtre d'Art. Rejecting all details which might interfere with the spoken word, Fort called for the deployment of a new kind of symbolic set design which would blend with symbolist poetry. Unfortunately, few of Fort's ideals were realized because his actors and designers were as limited in talent and experience as he was himself as a stage director.

So limited were the resources of Le Théâtre d'Art that in December 1892 it was forced to reject Maurice Maeterlinck's *Pélleas et Mélisande*, a new work by the dramatist whose plays had helped most to keep the name of the theatre alive. After a disastrous series of productions in the spring of 1893, it was evident even to the poets and intellectuals who were the principal supporters of Le Théâtre d'Art that the time had come for Paul Fort to leave the production of plays to someone who was capable of doing the job with some degree of artistic competence.[42]

One of the few bright stars in the dismal company of Le Théâtre d'Art was a young actor who achieved a personal triumph with his interpretation of the leading role in Maeterlinck's *L'Intruse (The Intruder)* when it was first performed in May 1891. Aurélien Lugné-Poe had himself been a member of the company of Le Théâtre Libre when only eighteen and a student at Le Conservatoire. He remained with Antoine until 1890, functioning as an actor and stage manager. After doing his military service he returned to Paris and, despite a series of altercations with Fort, remained with Le Théâtre d'Art long enough to convince Maeterlinck that he was a man of the theatre who not only understood Maeterlinck's literary and philosophical ideals but was capable of bringing them to life on the stage. When Le Théâtre d'Art rejected *Pélleas et Mélisande*, Maeterlinck was only too happy to grant Lugné-Poe the privilege of its first production. This took place with a company assembled by Lugné-Poe in May 1893. Thus, the death of Le Théâtre d'Art coincided with the birth of a new

42. Ibid., p. 158.

experimental theatre headed by Lugné-Poe, Le Théâtre de
l'Oeuvre.

Lugné-Poe had parted from Antoine mainly because of his
dislike for naturalism, but he admired certain aspects of
the style that Antoine brought to Le Théâtre Libre: namely,
the simplicity of diction and scenery and the importance
that Antoine gave to movements appropriate to the style
of the plays themselves. According to Jacques Robichez,
the principal historian of the symbolist movement in the
theatre, Lungé-Poe was also influenced in his concepts of
acting and staging by a puppet theatre company, Le Petit
Théâtre des Marionettes, which opened in Paris in 1888.
Some of the leading actors in Paris lent their voices to the
productions, and the puppets became famous in Paris for
their slow hieratic gestures and movements.[43] Through his
experience with Le Théâtre d'Art, Lugné-Poe developed and
refined the style by which his own theatre, Le Théâtre de
l'Oeuvre, became famous—a style which utilized a minimum
of scenery, acting and staging noted for slow and ample ges-
tures, a certain rigidity and lack of animation in expression
and movement, and monotonous chant-like delivery of
lines.[44]

The initial brochure of Le Théâtre de l'Oeuvre announced
that the repertoire would include shadow plays, puppets,
pantomime, and even clowns. Lugné-Poe's basic premise was
simply to "create in the theatre a work of art which in some
fashion might more or less lead us to new ideas".[45] Thus,
while Paul Fort deliberately identified Le Théâtre d'Art with
the symbolist movement, Lugné-Poe from the outset was ec-
lectic in his aims and practices. From 1894 to 1897 Le Théâ-
tre de l'Oeuvre became, in fact, mainly known in Paris for its
productions of the plays of Ibsen, opening with *Rosmers-
holm* in October 1893 and continuing with *An Enemy of the
People* (November 1893), *Solness* (April 1894), *Little Eyolf*
(May 1895), *Brand* (June 1895), *The Pillars of Society* (June
1896), *Peer Gynt* (November 1896), *The Game of Love*
(June 1897), and *John Gabriel Borkman* (November 1897).
Le Théâtre de l'Oeuvre also introduced to Paris such plays as

43. Ibid., pp. 75-76.
44. Ibid., pp. 330, 366, 61, 76, 141.

Hauptmann's *Lonely Souls* (December 1893), Björnson's *Beyond Human Might* (February 1894), and Strindberg's *The Father* (February 1894), as well as Oscar Wilde's *Salomé* (February 1896).

Aside from Lugné-Poe's deliberately eclectic policy, there were several other reasons for the preponderance of foreign non-symbolist plays in the repertoire of Le Théâtre de l'Oeuvre. Chief among these was the fact that by 1893 the full thrust of the symbolist movement, as interpreted by Baudelaire, Verlaine, Mallarmé, and Rimbaud, had hit its peak and was beginning to split up into diverse secondary movements. As a result fewer strictly symbolist plays were written and of these still fewer were suitable for the stage. Symbolic language employed in the drama for its own sake passed out of favour, and naturalism renewed its strength as the most vital force in French literature and the theatre. The social plays of Ibsen were particularly well suited to the new critical, social, and political spirit of the time. His work, therefore, was adopted by the naturalists as part of their own movement. Furthermore, because of the symbolic realism of Ibsen's dramaturgical method, the symbolists also accepted him.[46]

A decisive end to the symbolist movement in the theatre was marked when Le Théâtre de l'Oeuvre presented the first production of Alfred Jarry's revolutionary play, *Ubu Roi*, in December 1896. Jarry accepted many of the formulas of the symbolists but proceeded to turn them upside down. In a letter to Lugné-Poe, he called for the use of a mask for the principal character; one catch-all backdrop to eliminate the curtain; the introduction of a costumed figure to bring in signs indicating scene changes as in puppet shows; the substitution of one figure to symbolize crowds of people or soldiers; and costumes with as little local colour reference or historical accuracy as possible, "the better to suggest eternal things".[47] But where the symbolists sought to present exquisitely synthesized images of an ideal world or to escape

45. Ibid., p. 195.
46. Ibid., pp. 20-23, 339-43, 349.
47. Letter quoted in *Modern French Theatre: The Avant-Garde, Dada, and Surrealism*, ed. and trans. Michael Benedikt and George K. Wellwarth (New York: Dutton, 1964), p. x.

out of the world altogether, Jarry employed their own techniques to savagely lacerate the bourgeoisie. He presented them with a distorted image of their own viciousness in the character Père Ubu who, waving aloft his sceptre of a toilet brush, murders his way to the throne of Poland, pillages the country, is defeated, and then cravenly flees to France where he promises to perpetrate further enormities on the population.

Because of its satirical exactitude *Ubu Roi* had a theatrical immediacy and potency that none of the other symbolist plays was capable of attaining. To Jarry's followers, Ubu became a symbol of the grossness and greed of modern middle-class society. The play itself became the model for an anti-realistic satirical form of drama that has continued down to the contemporary Theatre of the Absurd and the Theatre of Cruelty.[48]

A near riot took place on the opening night of *Ubu Roi*, but it was due to something far more complicated than the moral outrage of the bourgeoisie. What was really being fought was something almost uniquely French—a battle over conflicting literary and aesthetic philosophies of the theatre. In 1897, the symbolists attacked Lugné-Poe's eclecticism and made one last effort to revive Le Théâtre de l'Oeuvre in their own image. But it was too late. Lugné-Poe was not one for living in an ivory tower. He extended his hand to the naturalists and Le Théâtre de l'Oeuvre continued as a broad, rather doctrinaire theatre, performing everything from Shakespeare to Paul Claudel.[49]

None the less, it is as an anti-realist that Lugné-Poe made his principal contribution to the modern French theatre. As a director and reformer in the theatre, he made possible the victory of painters over traditional set designers—that is, the victory of plastic imagination in direct relation to the text over the indifferent routine of technicians. He also inspired a continuing tradition of literate French stage directors and teachers, from Jacques Copeau down to Jean-Louis Barrault, all devoted to enlarging the concept of the theatre as a coordinate effort involving all the arts. It was Lugné-Poe's pro-

48. Ibid., p. ix.
49. Robichez, pp. 394-95, 478-79.

ductions of Maeterlinck and his staging of the first produc-
tion of Alfred Jarry's *Ubu Roi* that prepared the way for the
Surrealist, Dadaist, and Absurdist course taken by the experi-
mental theatre of France in the twentieth century.[50]

ARTHUR SYMONS, YEATS, AND VILLIERS DE L'ISLE ADAM

Poet, translator, theorist, musician, playwright, and journa-
list—the lasting importance of Arthur Symons lies in his influ-
ence as a critic.[51] Equally at home in Paris or London,
Symons introduced Mallarmé, Verlaine, and the French
symbolist movement into English with his translations of
their work published in 1889. It was Symons who brought
Yeats into touch with the exciting intellectual and artistic
climate of *fin de siècle* Paris. By the mid-1890s he had be-
come Yeats's most intimate friend among the poets of the
London Rhymers' Club. Through Symons's sympathetic criti-
cal interest Yeats's thought developed in "richness and clear-
ness", while his "practice and theory" as a poet owed much
to the passages from Verlaine and Mallarmé that Symons read
to him. Moreover, the romantic stories of a bond between
mysticism and art that Symons brought back from Paris
greatly encouraged Yeats in his plans to transform Ireland
through creation of a national theatre.[52]

In February 1894, Yeats visited Paris for the first time,
accompanied by Maud Gonne and provided by Symons with
letters of introduction to Verlaine and Mallarmé. On this trip
Yeats witnessed a production of the symbolic poetic play
Axël, by Villiers de l'Isle Adam. The play and its production
made a profound impression on him.

Artist and mystic adept, friend of Wagner and Baudelaire,
Villiers de l'Isle Adam (1838-89) was revered by Maeterlinck
and Verlaine as the philosophic father of the symbolist move-
ment. Symons described him as "the Don Quixote of ideal-
ism", living a life of poverty, practically unknown except to

50. Vide Jacques Guicharnaud, *Modern French Theatre from Giraudoux to
 Beckett* (New Haven: Yale University Press, 1961), pp. 240-62.
51. Vide tributes to Symons's importance as a critic by Dame Edith Sitwell, Iaian
 Fletcher, and Frank Kermode in *Poets of the Nineties*, ed. Derek Stanford
 (London: John Baker, 1965), pp. 99-100.
52. *Autobiographies*, pp. 319-20, 193-94.

the inner circle of his fellow adepts and poets, yet enduring
what others called reality with contempt.[53]

In *Axël*, which was considered by Paul Fort the "chef
d'oeuvre" of the symbolist movement in the theatre,[54] Vil-
liers sought to create a "symphonic drama with a densely
woven web", reflecting not only his personal ideals, but "the
characteristics and elements of a nation".[55] *Axël* is, in fact, a
dramatization of Villier's own philosophy of life. Its charac-
ters are not identifiable human beings but types of different
ideals: the religious ideal, the occult ideal, the worldly ideal,
and the passionate ideal of love. Axël, the intellectual hero,
rejects all of these ideals "since infinity alone is not a decep-
tion". Sara, the beautiful heroine of the play, is part of what
he rejects, but she too submits to his own more noble ideal,
giving up her life out of love and a similar scorn for anything
less than infinite perfection.

Taking more than five hours to perform, *Axël* was inten-
ded more as a ceremonial rite than a play. Symons noted that
throughout the play a mood of "religious calm" was evoked
by long deliberate sentences which gradually introduced
"that divine monotony which is one of the accomplishments
of great style".[56]

It is not difficult to understand why, at this period in his
life, Yeats was impressed with *Axël*. Struggling through the
play before seeing it, despite his bad French, he could "with-
out much effort imagine that here was the Sacred Book that I
longed for".[57] In Paris, with Maud Gonne, his muse, his love
goddess, and the high priestess of his projected Celtic Myster-
ies, by his side, the performance of *Axël* must have seemed
like an enactment of his own most profound personal, philo-
sophic, and artistic ideals. Even the setting for Axël and
Sara's love-death, a "très vieux château fort, le burg des mar-
graves d'Auërsperg, isolé au milieu du Schwartzwald", was
equivalent to the "Castle of the Heroes" that Maud and he
planned as the headquarters of their movement.

53. Symons, *Symbolist Movement*, pp. 134-35. Cf. Daniels, p. 34.
54. Robichez, p. 124.
55. James Huneker, *Iconoclasts* (London: T. Werner Laurie, 1908), p. 363.
56. Symons, *Symbolist Movement*, p. 143.
57. *Autobiographies*, p. 320.

Reviewing the production for *The Bookman* in April 1894,[58] Yeats was particularly moved by the "four renunciations of the play": the renunciation of the cloister, the active life of the world, the labouring life of the intellect, and the passionate life of love. In *The Celtic Twilight* Yeats declared that death was "but the beginning of wisdom, power and beauty".[59] The Indian swami Mohini Chatterjee had taught him that "all action and all words were a little vulgar, a little trivial".[60] Yeats found the same "moral" in *Axël*: "The infinite is alone worth attaining and the infinite is the possession of the dead. . . ."[61]

Thirty years afterwards, though he still admired *Axël*, Yeats found himself "a little ashamed" at the "revivalist thoughts" of his earlier response.[62] There is no doubt, however, about the influence that *Axël* had upon Yeats's dramaturgical ideas at the time. Engrossed in occult research, he believed that the function of "supreme art" was to "win us from life and gather us into eternity".[63] In *Axël* he experienced a drama culled from the rituals of the Kabbalah, employing allegory and symbolism to transport the audience to the trance-like state of mystical ecstasy. The actor was deployed as a priest-like "reverent reciter of majestic words".[64]

All of these lessons Yeats was to apply during the nineties in attempting to create plays for the Irish theatre which would have a "secret symbolic relationship" with the Celtic Mystery rites.[65] More than ten years were to be devoted to his own equivalent of *Axël*, *The Shadowy Waters*, a play with both a similar set of symbolic lovers and a similar theme: the renunciation of love for the call of the Infinite. It is significant that, although Yeats had the idea for *The Shadowy*

58. *Uncollected Prose*, pp. 320-25.
59. *Mythologies*, p. 115.
60. *Collected Works*, VIII, p. 279.
61. *Uncollected Prose*, p. 324.
62. Jean-Marie Mathias Philippe Auguste, Comte Villiers de l'Isle Adam, *Axël*, trans. H. P. R. Finberg, with a preface by W. B. Yeats (London: Jarrold, 1925), p. 9.
63. *The Tables of the Law, Mythologies*, pp. 300-301.
64. *Uncollected Prose*, p. 325.
65. *Memoirs*, p. 124.

Waters as early as 1883, he did not put it into writing until 1894.[66]

The memory of the performance of *Axël* was also the image by which Yeats measured other theatrical experiences well into the early years of his involvement with the Abbey Theatre. This was mainly because of the ritual unity which had been created between actors and spectators in the 1894 Paris production. In the 1904 issue of *Samhain*, published to coincide with the opening of the Abbey, Yeats declared that "ritual, the most powerful form of drama, differs from the ordinary form because everyone who hears it is also a player".[67] He was to learn through practical experience, however, that in order to create a ritual bond between actor and audience, even for the brief moment of tragic ecstasy, the dramatist either had to create his own rituals and hope that in time they would be shared, or find his audience, like Villiers, in a small circle of the already converted.

YEATS, MAETERLINCK, AND LUGNÉ-POE

Originally, Maurice Maeterlinck (1862-1949) was himself one of those symbolist playwrights who had no desire to have his works performed upon the stage. His earliest plays were actually written for marionettes, and it was only after considerable persuasion that he allowed Le Théâtre d'Art to stage the first production of *L'Intruse* in May 1891. Happily for both Maeterlinck and Paul Fort, this production was the first critical success of Le Théâtre d'Art. Lugné-Poe scored a personal triumph in the role of the blind father, and when Le Théâtre d'Art undertook the first production of *Les Aveugles* in December 1891 Maeterlinck requested him to assume the leading role. After the triumphal reception of *Pélleas et Mélisande* in May 1893, Maeterlinck was firmly established as the

66. The most detailed comparison between the two plays is Harry Goldgar's "*Axël* de Villiers de l'Isle Adam et *The Shadowy Waters* de W. B. Yeats", *Revue de Littérature Comparée*, XXIV (1950), pp. 563-74. Michael Sidnell, George P. Mayhew, and David R. Clark, authors of *Druid Craft: The Writing of "The Shadowy Waters"* (Amherst: The University of Massachusetts Press, 1971), demonstrate that the major influence of *Axël* upon *The Shadowy Waters* is not seen until Yeats's revision of 1906. Vide pp. 79, 297-98.

67. *Explorations*, p. 129.

leading symbolist writer for the theatre, with Lungé-Poe recognized as the foremost interpreter of his work.[68]
Maeterlinck's early plays might be considered a prologue to his own theories on the drama. Le Trésorie des Humbles (The Treasury of the Humble), his main theoretical work on the drama, was not published until 1894, or translated into English until 1897. By this time, however, his major plays had been published, produced, and also translated into English. By 1895, a definite "Maeterlinck vogue" existed in England,[69] and it was mainly on the strength of its reputation for producing Maeterlinck that Le Théâtre de l'Oeuvre was invited to London for an engagement in 1895.[70]

As a self-proclaimed mystic, Maeterlinck believed that the noblest aim of life was "to seek out [man's] own special aptitude for a higher life in the midst of the humble and inevitable reality of daily existence".[71] Basing many of his dramatic theories on the example of Axël,[72] Maeterlink advocated a new approach to drama wherein violent stage action was to be replaced by a symbolic action reflecting the "inner dialogue" of the mind.[73] Maeterlinck, in fact, posited what he termed a "static drama", and argued on behalf of this concept:

I have grown to believe that an old man, seated in his armchair, waiting patiently, with his lamp beside him, giving unconscious ear to all the external laws that reign about his home, interpreting the silence of doors and windows and the conscious ear to all the eternal laws that reign about his house, interpreting without comprehending, the silence of doors and windows and the quivering voice of the light, submitting with bent head to the presence of his soul and his destiny . . . I have

68. Robichez, p. 83, 85, 119, 122-23, 128, 169-171.
69. Vide Max Beerbohm, Around Theatres (London: Rupert Hart-Davies, 1953), p. 94.
70. Vide Shaw's review of the company's visit to London in March 1895, Our Theatre in the Nineties (London: Constable & Co., 1948), I, pp. 76-77.
71. Maurice Maeterlinck, Treasury of the Humble, trans. Alfred Sutro (London: Allen, 1897), p. 171.
72. Maeterlinck once declared: "All that I have done, I owe to Villiers, to his conversations more than his works, which I also admire." "Enquête sur l'évolution littéraire" (1891), p. 60, quoted in Robichez, p. 34.
73. Maeterlinck, Treasury of the Humble, pp. 98-111.

grown to believe that he, motionless as he is, does yet live in reality a deeper, more human and more universal life than the lover who strangles his mistress, the captain who conquers in battle, or the husband who avenges his honour.[74]

Consistent with his theories, the plays of Maeterlinck are notable for their deployment of allusion rather than direct statements of fact. Essentially, Maeterlinck's plays are based upon a single and rather simplistic dramatic situation: the struggle of pure innocence in the face of evil. Maeterlinck did not wholly suspend the traditional linear plot; rather, he distended it, merely reducing its importance. Dramatic interest is sustained in his plays mainly by a vague atmosphere of mystery through which his helpless characters stumble towards their fate with almost mute cries.

Technically, Maeterlinck evoked this sense of mystery by drawing few distinctions among characters, whether of nobility (in *Pélleas et Mélisande*) or peasant (in *Les Aveugles* or *L'Intérieur*). Dialogue is reduced to a monotonous repetition of broken phrases and seemingly prosaic utterances. Pauses are employed, during which the silence speaks of unknown terrors, as in the plays of Pinter and Beckett. Maeterlinck also echoed Wagner and symbolist theory in his thematic use of musical effects. For full effectiveness his plays depend upon actors capable of an exceptional variety of vocal tones and speech melodies.

In order to emphasize the disembodied helpless plight of his characters, Maeterlinck's plays employ a repetitive use of abstract symbolical scenery: towers, prisons, overhanging trees, stern cliffs, fountains, open windows. Once involved in the details of the practical theatre, Maeterlinck displayed great concern for the careful realization of colour and design schemes for costumes and scenery. His overall intention was that a work of art for the theatre should possess the "unity of a poem".[75]

74. Ibid., p. 238.
75. J. Huset, "Conversation avec M. Maurice Maeterlinck", *Le Figaro* (17 Mai, 1893), quoted in Robichez, pp. 168-69. Arthur Symons paid tribute to Maeterlinck's extraordinary use of stage pictures: "No dramatist has ever been so careful with his scenes, or has made the actual space so emotionally significant." *Symbolist Movement*, p. 313.

There is a significant difference between Yeats's response to the plays of Maeterlinck as compared with his response to *Axël.* Despite Maeterlinck's theatrical effectiveness, Yeats found that his work "touch[ed] the nerves alone" when he should "touch the heart". What Maeterlinck lacked, said Yeats, was "that ceaseless reverie about life which we call wisdom".[76]

Yeats found that this lack—essentially a lack of philosophic or religious depth and conviction—was most evident in Maeterlinck's delineation of character. While the characters of Villiers thirsted for their mystical oblivion "with a pride like that of the Magi", Maeterlinck, he said, "plucked away even this thirst and set before us faint souls, naked and pathetic shadows, already half vapour and sighing to one another upon the borders of the last abyss".[77] Again, writing of Maeterlinck's *Aglavaine et Sélysette* for *The Bookman* in September 1897, Yeats found it "sentimental" and "absurd" that the characters should be able to do "little but tremble and lament" in the face of their fate. In contrast, "the persons of *Axël* were lifted above the pride of the world by the pride of Hidden and August destinies."[78]

These incisive comments are important for the light they throw on the development of Yeats's concept of tragedy. In his sharply differing responses to Villiers and Maeterlinck it is evident that as early as the mid-nineties Yeats had already begun to grapple with the multiple meanings of tragedy, particularly with respect to "will" and "passion" as essential elements of the tragic character. As Yeats pointed out, the essential difference between the two playwrights is that while the characters of Maeterlinck meet their fate with terrified whimpers that can only evoke a sentimental pity, those of Villiers, by actively willing their fate, by scorning anything less than fealty to their convictions, and by sacrificing themselves to themselves alone, attain a truly tragic stature. It was the latter model that Yeats followed as he attempted to restore tragedy to the modern stage.

76. Letter to Olivia Shakespear (April 7, 1895), *Letters*, p. 255. Cf. *Explorations*, p. 257.
77. *Essays and Introductions*, p. 195.
78. "Aglavaine and Sélysette", *The Bookman*, XII, 72 (September 1897), p. 155.

Yeats may have been acutely conscious of Materlinck's deficiencies as a man and artist, but he was equally aware of the techniques that made Maeterlinck's plays stageworthy. A close examination of Yeats's dramatic theory and practice at the time when he founded the Irish Literary Theatre and even well into his career at the early Abbey Theatre reveals many striking parallels and direct borrowings from the theory and practice of Maeterlinck.

In his *Bookman* review of *Aglavaine et Sélysette,* Yeats praised Maeterlinck for ignoring external details of locale and period, leaving the audience to ponder even over the exact age and personal relationship between the hero and heroine. Yeats sought for a similar indefiniteness of period and locale in his own early work. In the first edition of *Beltaine* (May 1899), he took pains to contradict Lionel Johnson, who had tried to place the events of *The Countess Cathleen* in the sixteenth century. Yeats declared:

The play is not historic, but symbolic and has as little to do with any definite place and time as an *auto* by Calderón. One should look for the Countess Cathleen and the peasants and the demons not in history, but as Mr. Johnson has done, in one's own heart, and such costumes and scenery have been selected as will preserve the indefinite.[79]

As will be seen, after the three year Irish Literary Theatre experiment, Yeats moved on to a relatively more realistic form of dramaturgy at the Irish National Theatre Society. But he continued to stress the fact that because "tragedy comes from that within us", there was need for "surroundings where beauty, decoration, pattern—that is to say, the universal in form—takes the place of accidental circumstances."[80] Like Maeterlinck, Yeats attempted to commingle peasant and noble characters in early plays such as *The Shadowny Waters, The Hour-Glass, The King's Threshold, On Baile's Strand,* and *Deirdre*—a practice he returned to intermittently during his later dramatic career. Through his early experiments he discovered that in order to maintain a tragic mood it was necessary to achieve "a certain even richness" in dialogue somewhat similar to the "experience in mono-

79. P. 8.
80. Preface to "The Theatre of Beauty", *Plays for an Irish Theatre* (London: A. H. Bullen, 1911), p. xi.

chrome" that Symons held to be the secret of Maeterlinck's success.[81]

Yeats also grew to believe that while individualized characters were appropriate for comedy, the precise opposite was true for tragedy. At the moment of "tragic reverie", Hamlet, as a defined character such as one might meet on the street, disappeared. Through his lyrical passion he transcended for that moment his isolated individual self, becoming a symbolic embodiment of the highest thoughts and feelings of all men. Employing the words Maeterlinck had used to describe Racinean tragedy (and echoing, as we have seen, his own mysterious beliefs concerning the social function of art), Yeats declared: "Tragedy must always be a drowning and a breaking of the dykes that separate man from man."[82]

There is no doubt that Yeats was also fascinated by the methods evolved by Lugné-Poe to produce Maeterlinck.[83] He, too, sought at the Irish National Theatre for an acting style that would rid the stage of "everything that is restless, everything that draws attention away from the sound of the voice".[84] He recalled it as "a day of triumph when the first act of The Well of the Saints held its audience, though the two chief characters sat side by side under a stone cross from start to finish".[85] For a time, he was inclined to accept the stiff, puppet-like movements of the actors trained by Willie and Frank Fay as an approproate stylé for his own plays. Still later, he called for movements like a marionette for characters in his dance plays.[86]

With regard to the practical deployment of scenery and costumes, Yeats again borrowed a number of ideas from

81. "Theatre and Drama in the Making", Plays for an Irish Theatre, p. 288. Cf. Arthur Symons, Dramatis Personae (Indianapolis: Bobbs-Merrill, 1923), p. 27.

82. Essays and Introductions, p. 238. In "The Awakening of the Soul", Treasury of the Humble, p. 29, Maeterlinck declared: "Racine's characters have no knowledge of themselves beyond the words by which they express themselves, and not one of those words can pierce the dykes that keep back the sea." Yeats reviewed The Treasury of the Humble for The Bookman, XII, 70 (July 1897), p. 94. Cf. Chapter Two, note 52.

83. In a letter to Lady Gregory (June 13, 1902), concerning a London production of Maeterlinck's Monna Vanna by Lugné-Poe's company Yeats stated: "I am less anxious to see the play than to see the method of the performance." Letters, p. 3.

84. Explorations, p. 109.

85. Essays and Introductions, p. 238.

86. Vide stage directions to At the Hawk's Well, Collected Plays, p. 210.

Lugné-Poe. It was in Paris, probably at Le Théâtre de l'Oeuvre, that he saw for the first time stage scenery that was able to "suggest a scene while attempting nothing that an easel painting can do better".[87] At the Irish Literary Theatre Yeats called for a similar "symbolic and decorative scenery" and, like Lugné-Poe, sought for his scenic artists among painters rather than in the commercial theatre.[88]

Like Lugné-Poe, Yeats made a virtue out of poverty, advocating from the outset of the Irish dramatic movement "scenery and costumes which will draw little attention to themselves and cost little money".[89] Lugné-Poe and Maeterlinck may have given Yeats the inspiration for suggesting that costumes might be repeated from play to play in order to symbolize different ranks and classes of men.[90] For pressing financial reasons, the same idea was later applied to stage settings.[91]

Prior to Lugné-Poe's appearance in 1895, the attempt to revive poetic and imaginative drama in England during the nineties had fared badly. In April 1894, Yeats's own *Land of Heart's Desire* was produced at London's Avenue Road Theatre as a curtain raiser to a pretentious poetic drama by John Todhunter entitled *A Comedy of Sighs.* Todhunter's play was hooted off the stage by a popular audience disposed to hate the new "intellectual" drama, while the fairy lore of *The Land of Heart's Desire* was laughed at by the audience and condescendingly dismissed by the critics.[92]

Yeats therefore viewed the London success of Maeterlinck as "of immense value in helping to understand a more ideal drama".[93] The fact that Maeterlinck had achieved this success mainly through the efforts of Lugné-Poe and a company devoted to interpreting his work must have been of deep significance to Yeats.[94]

One other aspect of Lugné-Poe's work made a lasting but unhappily portentous impression on Yeats. This was the riot

87. *Autobiographies*, p. 281; Hone, *W. B. Yeats*, pp. 107-8.
88. Vide Letter to Fiona Macleod (January 1897), *Letters*, p. 280.
89. Letter to the Editor of the *Daily Chronicle* (January 27, 1899), *Letters*, p. 308.
90. *Explorations*, p. 126.
91. Ibid., p. 181.
92. Vide *Autobiographies*, p. 281; Hone, *W. B. Yeats*, pp. 107-8.
93. Letter to Olivia Shakespear (April 7, 1895), *Letters*, p. 255.
94. *Explorations*, p. 131.

that greeted Lugné-Poe's production of Alfred Jarry's *Ubu Roi* in 1896. Yeats attended that tumultuous performance with Arthur Symons and no one realized more acutely than himself that it marked the end of symbolism as a vital force in the French theatre. Recalling years later the effect that the production had upon him Yeats wrote:

Feeling bound to support the most spirited party, we have shouted for the play, but that night at the Hotel Corneille I am very sad, for comedy, objectivity, has displayed its growing power once more. I say "After Stephane Mallarmé, after Paul Verlaine, after Gustave Moreau, after Puvis de Chavannes, after our own verse [that of the Rhymers], after all our subtle colour and nervous rhythm, after the faint mixed tints of Conder, what more is possible? After us the Savage God."[95]

By the time Yeats wrote these lines he had experienced a recurrence of the same pattern in Ireland. His own deeply subjective poetic plays had projected images of an ideal Ireland but had been superseded on the Abbey stage by superficial farces and comedies written in a naturalistic style. The satiric genius of Synge had appeared, had challenged the Abbey audiences with images that mocked their most cherished illusions, and had been rejected with the same fury as Jarry's *Ubu Roi.*

95. *Autobiographies*, pp. 348-49.

An Irish "Literary" Theatre

In order to understand fully Yeats's idea of the theatre, his role in the development of the Irish dramatic movement, the enormous practical problems that he faced in attempting to realize his own dramatic intentions, and the success and failure of the movement as a whole, it is essential to see his work within the context of the theatrical conditions that existed in England and Ireland.

Inspired by the Continental reform movements—especially the example of Henrik Ibsen (1828-1906) in Norway and the naturalist movement in France—since the mid-1880s the English commercial theatre was subjected to a full-scale attack led by critics and men of letters such as Matthew Arnold, George Moore, William Archer, A. B. Walkley, and George Bernard Shaw. The basic aim of their endeavour was to restore the playwright to his rightful eminence in the theatrical hierarchy.[1]

George Moore, as the first naturalistic novelist in English, argued that what was most needed was a British equivalent of André Antoine's Théâtre Libre, a subsidized theatre for the

few devoted to the presentation of new plays.[2] His efforts
were rewarded with the establishment of the Independent
Theatre Society in 1891, whose announced intention was to
give "special performances of plays which have a literary or
artistic rather than a commercial value".[3]

1. Vide Matthew Arnold, *Letters of an Old Playgoer* (New York: Dramatic
Museum of Columbia University, 1919); George Moore, *Impressions and
Opinions* (London: T. Werner Laurie, 1913); William Archer, *English Drama-
tists of Today* (London: Sampson, Low, Merston, Searle and Rivington,
1892); idem, *The Old Drama and the New* (London: Heinemann, 1923); A. B.
Walkley, *Drama and Life* (London: Methuen, 1908); idem, *Dramatic Criticism*
(London: Murray, 1903); idem, *Playhouse Impressions* (London: T. Fisher
Unwin, 1892); George Bernard Shaw, *Our Theatre in the Nineties*, 3 vols.
(London: Constable & Co., Ltd., 1948) and *The Quintessence of Ibsenism*
(New York: Hill & Wang, 1960).

George Moore blamed the actor-managership system, the long run, and
"mummer-worship" for the decline in dramatic writing. In 1889, he com-
plained that because of a general lack of taste and culture in the theatre "no
first-rate man of letters now writes for the stage. None of those who supply
the theatres with plays can, if looked at from a literary side, compare with
any leading novelist or essayist." Vide article by Moore on Le Théâtre Libre
(1884) quoted in "Our Dramatists and Their Literature", *Fortnightly Review*
(November 1, 1889), revised and reprinted in *Impressions and Opinions*, pp.
157-58; George Moore, *Confessions of a Young Man* (London: Heinemann,
1928), pp. 233-34; "Why I Don't Write Plays", *Pall Mall Gazette* (September
7, 1892), p. 3.

Moore was supported in his campaign by younger critics such as Walkley,
Archer, and Shaw (vide especially *Drama and Life*, pp. 37-38, 41-42, 182; *The
Old Drama and the New*, p. 267).

In three years as drama critic of *The Saturday Review* (1895-98), Shaw
excoriated virtually every aspect of the contemporary theatre in England,
from the actor-manager system to a progressive tendency towards excessive
scenic and histrionic realism on the stage. Despite his disavowal of a literary
bias, Shaw, too, basically viewed the theatre's ills from the vantage point of a
man of letters. This was especially evident in his continued attacks on the
methods of Henry Irving. Shaw bluntly stated that by commissioning plays by
hack dramatists Irving demonstrated that he "did not know fine literature
from a penny-liner's fustian" (*Theatre in the Nineties*, I, p. 34). It was thus no
wonder that Shaw's "own art", "the art of literature [was] left shabby and
ashamed amid the triumph of the arts of the painter and actor" (Ibid., pp. 14-15).

2. Moore, *Impressions and Opinions*, pp. 176-82.
3. Program reproduced in Michael Orme, *J. T. Grein: The Story of a Pioneer,
1862-1935* (London: Murray, 1936), p. 76.

The Independent Theatre opened on March 13, 1891, with a production of Ibsen's *Ghosts*. Although Ibsen's work had been known in England since the late 1870s, largely through the translations and articles of William Archer, neither critics nor audiences were prepared for his thrusts at the conventions and proprieties that held middle-class society together. Moreover, as occurred with the first productions of *Ubu Roi* and *The Playboy of the Western World*, the sheer innovative power of Ibsen's symbolic realism served to obliterate any objective consideration of his artistic merit. The response to *Ghosts*, in the words of Archer, consisted of "an outburst of foul-mouthed abuse in the newspapers as has seldom disgraced the name of criticism".[4]

Under the direction of its founder and chief benefactor J. T. Grein, the Independent Theatre tottered through seven more years of sporadic and generally inept productions. It had been hoped particularly to foster new English dramatists, but of the twenty-eight plays produced by the Independent Theatre, only fifteen were English. Thirteen of them were new works: seven one-act plays and six full-length plays. Of the new English plays produced, the only ones of any lasting dramatic interest—and that mainly for historical reasons— were *Widowers' Houses*, by George Bernard Shaw, which was first produced in December 1892, and the equally Ibsenesque *Strike at Arlingford*, which was written in order to win a wager by George Moore and first produced in February 1893.[5]

With the final collapse of the Independent Theatre in December 1898, the English literary reform movement appeared to have failed and failed dismally. Not only was the commercial theatre still firmly in the hands of the actor-managers, but the literary reformers themselves had split up into various groups, depending upon which of the Continental movements they supported. Instead of acting as a united force to win over their potential audience, the respective followers of naturalism, Ibsenism, poetic drama, symbolism, and aestheticism began to move in smaller and smaller circles, emerging from their own literary coteries only long enough to fire an occasional broadside at the members of other coteries.

4. *The Old Drama and the New*, p. 306.
5. Vide N. H. G. Schoonwoerd, *J. T. Grein: Ambassador of the Theatre* (Netherlands: Van Gorcum and Co., 1963), pp. 96-97, 114-16.

As a literary movement, naturalism was rejected with parti-
cular vehemence by the puritanical Victorians as well as the
adherents of aestheticism, symbolism, and poetic drama.[6] It
was not, in fact, until *The Silver Box,* the first "social trage-
dy" of John Galsworthy, was produced at the Court Theatre
in 1906, that naturalistic plays began to be accepted on the
English stage. By then, however, the kind of naturalism de-
monstrated by Galsworthy was far from being so extreme as
in its original French source, owing more to the example of
Ibsen than to Zola.[7]

Ibsen himself was largely unproduced throughout the nine-
ties except for sporadic semi-professional efforts involving no
more than one or two performances. Because his plays re-
mained unfamiliar, the memory of the violent response to
Ghosts continued to frighten off London commercial mana-
gers from attempting to bring his work to the attention of a
wider audience. Another problem was that his supporters
continued to be drawn mainly from the literary and social
reactionaries. Ibsen's own artistic objectivity was ignored,
and his work was greeted with the same negative responses
that the reactionaries themselves evoked.[8]

The Independent Theatre originally intended to produce
poetic and symbolist as well as naturalistic plays. Difficulties
with staging prevented these ideas from being carried out.

6. George Moore's naturalistic novel *A Modern Lover* (1883) was banned by the
lending libraries in England, sending Moore into a lifelong campaign against
censorship. Joseph Hone, *The Life of George Moore* (London: Gollancz,
1936), p. 93. As late as 1913, the line "Not bloody likely" in Shaw's *Pygmal-
ion* caused an outcry when the play was produced at London's fashionable St.
James Theatre. Hesketh Pearson, *The Last Actor-Managers* (London:
Methuen, 1930), p. 26.

Arthur Symons looked down his nose at the scientific method adopted by
the naturalists, seeing in it "only another proof of the small amount of
individuality in the average man, his deplorable faculty of imitation, his
inability not only to think but to see for himself." "The Painting of the
Nineteenth Century" (1903), *Studies in Seven Arts* (London: Secker, 1924),
IX, p. 40. Yeats declared: "Put the man who has no knowledge of literature
before a play of this kind and he will say, as he has said in some form or other
in every age at the first shock of naturalism, 'Why should I leave my home to
hear but the words I have used there when talking of the rates?' " *Essays and
Introductions,* p. 276.

7. Vide Galsworthy, Preface to *The Inn of Tranquility* (London: Heinemann,
1912), p. 190.

8. Shaw, *Quintessence of Ibsenism,* p. 20.

The Independent Theatre's chief contribution to poetic drama was in sponsoring six performances of plays by Maeterlinck and Ibsen given by Le Théâtre de l'Oeuvre in March 1895.[9]

While from a literary standpoint the reform movement in the English theatre appeared to be a failure, from a theatrical standpoint a number of seeds were planted which would only begin to bear fruit during the first two decades of the twentieth century. For one thing, the respectful attention that Archer and Shaw paid to amateur and semi-professional companies devoted to non-commercial experimental forms of new drama[10] inspired the development of a number of small theatre companies in England modelled after Le Théâtre Libre, Le Théâtre de l'Oeuvre, and the Independent Theatre.[11] Most these continued into the early years of the twentieth century, leading eventually to the establishment of the Court Theatre in 1904, which, under the direction of Harley Granville-Barker and John Vedrenne, in two and a half years gave English drama a quite new direction by presenting the first performances of eleven plays by Shaw, as well as new works by Galsworthy, Masefield, Houseman, and Granville-Barker himself.[12]

Another result of the attacks on the spectacular productions of Shakespeare by the actor-managers was the formation of the Elizabethan Stage Society by William Poel in 1894. Poel, an admirer of Lugné-Poe, set out to restore simplicity of staging and the musical utterance of verse to the

9. Schoonwoerd, p. 111; vide Shaw's review of Le Théâtre de l'Oeuvre's visit to London in March 1895, *Theatre in the Nineties*, I, pp. 76-77.

10. In Shaw's review of Lugné-Poe's production he stated: "Shall I violate the sacredness of professional etiquette, and confess . . . that the distinction some of our critics made between the amateur and the expert is really a distinction between a rich enterprise and a poor one, and has nothing to do with the distinction made by the trained senses of the critic who recognizes art directly through his eyes and ears, and not by its business associations?" Ibid.

11. Vide Anna Irene Miller, *The Independent Theatre of Europe* (London: Long and Smith, 1931), pp. 183-94. These companies included The New Century Theatre, The Stage Society, The Pioneers and Pioneer Players, The Play Actor's Society, The English Drama Society, and The New Stage Club—all amateur societies devoted to various kinds of theatrical experimentation.

12. Desmond MacCarthy, *The Court Theatre 1904-1907* (Miami Beach, Florida: Atlantic Printers, 1966). Vide introduction by Stanley Weintraub (xi-xxvi) for list of plays produced at the Court Theatre.

theatre.[13] In time, through the work of Gordon Craig and Granville-Barker, both inspired by Poel, the plea of the literary critics of the 1880s and 1890s to free Shakespeare from the bondage of the actor-managers was answered, and the untutored commercial producer was ultimately replaced by the literate man of the theatre.

Perhaps most important of all, the attacks by the literary critics on the run-of-the-mill theatre critics, dramatists, and actors-managers prepared the way for a new breed of intellectual and socially committed dramatists. Because the public was told often enough that the theatre should not be run simply as a commercial enterprise, that the theatre could be a place of intellectual stimulation, that drama should be related to actual life, that acting need not be mere bombast, and that settings could be less than spectacular without being less effective dramatically, a new and more literate audience was gradually created that not only expected but demanded a literate and intellectual drama. This, of course, was not achieved without the loss of the popular audience, which has yet to be brought back to the theatre.[14]

All of these factors were of considerable importance in gaining a respectful hearing in England for the efforts of the early Abbey Theatre.

We have leaped ahead, however. In 1898, a year before the Irish Literary Theatre was founded, the prospects in England for a vital literate drama of any sort appeared dim. When, in that year, the irrepressible George Bernard Shaw published his *Plays Pleasant and Unpleasant,* even he appeared to have little hope of their immediate production. All that he could do was support William Archer's reiterated call for a publicly subsidized theatre devoted to the production of new plays and announce his faith that "the public [subsidized] theatre will be independent of the greed of syndicates and will have

13. Robert Speaight, *William Poel and the Elizabethan Revival* (London: Heinemann, 1954), p. 72 et passim. Shaw noted that Poel had trained an amateur company to "acquit themselves much better, in point of delivery, than average professional actors". *Theatre in the Nineties,* III, p. 329.

14. Vide Allardyce Nicoll's condemnation of the tendency towards "intellectual" as opposed to "dramatic" objectives in the threatre, beginning with the social realists at the Court Theatre. Nicoll blames the decline in theatre attendance in the twentieth century on the resultant cleavage between "entertainment and instruction". *British Drama,* pp. 253, 268.

moral, as distinguished from purely capitalistic, aims". Point-
ing to Ibsen as the uncrowned champion of the New Drama,
Shaw insisted that "in all higher developments . . . the theatre
will follow the dramatic poet, and not the dramatic poet the
theatre".[15]

A. B. Walkley was even more pessimistic. When he com-
pared the high hopes of the literary critics with the actual
results of their efforts, he commented, sadly:

> For it comes to this, that the brisk movement of the nineties has left us
> in a condition only a degree less stagnant than that of the eighties. Our
> stage needs a current of fresh ideas, a spirit of eager and audacious
> experimentation; even a little reckless iconoclasm would do no harm.[16]

Regarding the English theatrical scene with the detachment
that has always been one of the chief characteristics and
strengths of the Anglo-Irish tradition, W. B. Yeats may have
been reminded of an old Irish adage: "England's trouble is
Ireland's opportunity." If the impulse of the literary reform
movement appeared to have failed in the English theatre,
there could surely be no more propitious time to offer a new
direction and approach through the establishment of an
"Irish Literary Theatre". Yeats did not realize it, but the
same literary and theatrical conflicts that had plagued the
reform movements on the Continent and in England were to
reappear again in Ireland.

THE POET IN THE THEATRE

The Irish Literary Theatre was firmly rooted in Irish soil. But
for sound practical reasons, from the very outset it also ap-
pears to have been conceived and promoted by Yeats so as to
take maximum advantage of the difficulties besetting the
English theatre. It was, first of all, a theatre intended to
forward the aims of men of letters as distinct from men of
the theatre. This is evident by its very title. And to make
certain that nobody missed the point, the playbill in the first
issue of *Beltaine*, the journal of the Irish Literary Theatre,

15. *Theatre in the Nineties*, III, p. 316.
16. Walkley, *Drama and Life*, p. 66.

contained the following note which echoed almost verbatim
the guiding philosophy of the Independent Theatre:

By the word "literary" is meant productions which—however much it
may fall short of its aim—will at least be inspired by ideas uninfluenced
by the purposes which under present conditions govern the production
of plays on the regular stage, that of achieving an immediate commer-
cial success.[17]

The leaders and founders of the Irish Literary Theatre—
W. B. Yeats, George Moore, Edward Martyn, and Augusta
Lady Gregory—were furthermore all people with literary
rather than theatrical backgrounds. It will be evident as we
study the evolution of the Irish Literary and Abbey Theatres
that this had mingled advantages and disadvantages. In their
eyes, however, there was no question on the matter. The
theatre was in a state of decadence because for too long it
had been in the hands of unlettered men of the theatre. The
Irish Literary Theatre was therefore going to be, first and
foremost, a playwrights' theatre, and in order to maintain
this ideal control must be kept firmly in the hands of play-
wrights.

Yeats, as the principal spokesman of the Irish dramatic
movement, condemned the nineteenth-century English com-
mercial theatre in sweeping statements that were as devast-
ating as anything penned by George Bernard Shaw. Even
more than the managers, Yeats blamed English actors for the
low calibre of English drama. What Yeats hated most was
that actors, because of their insensitivity to language, had
forced dramatists to write plays appealing to the eye rather
than the ear.[18] Actors in London continually crossed the
stage, "not because the play compelled them, but because a
producer said they must do so to keep the attention of the
audience".[19] "This emphatic delivery and movement—which
is the essence of the English idea of romantic acting—

17. Playbill for *Beltaine* Number One.
18. *Essays and Introductions*, pp. 168-69.
19. Ibid., p. 528.

evidently fits nothing but plays written in short sentences without music or suggestion," he observed.[20]

Because actors had for so long been forced to cater to the tastes of audiences responsive only to crude and vulgar theatrical effects, Yeats believed that they had begun to speak

as if they were reading something out of the newspaper. They forgot the noble art of oratory, and gave all their thought to the poor art of acting, which is content with the sympathy of the nerves, until at last those who love poetry found it better to read alone in their rooms.[21]

One should not interpret Yeats's condemnation of English acting as being in any way similar to the condescending attitude of the French symbolist poets. Yeats was not only a discriminating critic but an ardent admirer of the art of acting—though, as we shall see, acting of a very particular quality and style.

No qualifications need be added to Yeats's wholesale denunciation of the spectacular stagings employed by actor-managers in the English theatre. They reminded him of little more than "a childish peepshow" with their "over development of the picture-making faculty" of the theatre.[22] Where Shaw's chief *bête noire* was Henry Irving, Yeats was particularly scathing in his denunciation of the methods of Herbert Beerbohm Tree. He defined Tree's ideal of beauty as "thrice-vomited flesh", and dismissed his spectacular production of *The Tempest* as "vulgar pantomime".[23] When told by an official at Dublin Castle that, because Tree had recommended it, certain passages should be cut from a projected Abbey Theatre production of Shaw's *The Shewing-up of Blanco Posnet*, Yeats retorted that Tree was "the chief repre-

20. Letter to Lady Gregory concerning a London production of Synge's *The Tinker's Wedding* (November 26, 1909). Yeats left the theatre after the first act, having found "every poetical and literary value sacrificed to continuous emphasis and restlessness". *Letters*, p. 538. Alan Downer, in a comprehensive study on the evolution of nineteenth-century acting styles in England, corroborates Yeats's criticism, stating that gradually solid vocal technique was replaced by "the bric-a-brac of business". "Players and Painted Stage: Nineteenth Century Acting", *PMLA*, June 1946, pp. 522-76, esp. 560-65.

21. *Essays and Introductions*, p. 168.

22. Letter to Frank Fay (November 4, 1905), *Letters*, p. 466.

23. Letters to Lady Gregory (November 26, 1909; November 7, 1904), *Letters*, pp. 539, 443.

sentative of the commercial theatre that we are opposed to".[24]

In the first issue of *Beltaine,* Yeats attempted to explain his objections to spectacular and realistic scenery in terms of the historical devaluation of poetry in the theatre. Yeats argued that in the great theatres of ancient Greece and Elizabethan England poetry still possessed the power to evoke in the minds of the audience all the scenery that was necessary. This was because audiences then possessed "some imagination, some gift for daydreams" which enabled them "to see the horses and the fields and flowers of Colonus as one listened to the elders about Colonus, or to see 'the pendant bed and procreant cradle' of the 'martlet' as one listened to Banquo before the castle of Macbeth."

As audiences—and actors—changed, however, managers had destroyed the oral sensibility, and with it much of the imaginative impact of the theatre by "substituting meretricious landscapes, painted upon wood and canvas, for the descriptions of poetry, until the painted scenery . . . became as important as the story." At the same time, said Yeats,

the managers made the costumes of the actors more and more magnificent, that the mind might sleep in peace, while the eye took pleasure in the physical beauty of women. These changes gradually perfected the theatre of commerce, the masterpiece of that movement towards externality in life and thought and art against which the criticism of our day is learning to protest.[25]

It was specifically as a poet that Yeats attacked the debilitating influence of the actor-managers on nineteenth-century English playwrights. With his own aesthetic and mystical conception of art as "an image of human perfection", Yeats preferred to believe that actors, managers, audiences, and playwrights themselves had changed rather than the spirit of true art—"that imagination, which is the voice of what is eternal man". Thus Yeats dismissed the would-be poetic dramatists of the early nineteenth century, not so much because they failed to come to grips with the mechanics of the stage

24. Quoted by Lady Gregory in *Our Irish Theatre: A Chapter of Autobiography* (London: G. P. Putnam, 1914), p. 155.
25. *Essays and Introductions,* p. 169.

or because they lacked the "dramatic faculty", but because, as poets, they had violated a basic principle of their calling: they had written down to their audience, "the general public", instead of for their own higher selves. Or, to put it another way, they had thought of the theatre as outside the general movement of literature.[26]

Naturally, Yeats was in full sympathy with the efforts of the reformers in England to bring the man of letters back into the theatre. However, as he saw it, the failure of their reform movement was due mainly to the fact that in promoting Ibsen and the naturalists they had chosen the wrong literary models.

Yeats was fully responsive to Ibsen's influence as a symbol of revolt in the theatre: "Tho' we and he had not the same friends, we had the same enemies," he admitted.[27] It was, indeed, because he recognized that Ibsen had not been given a proper hearing in England that Yeats insisted on having Synge's *Playboy of the Western World* performed at the Abbey Theatre until it was finally heard and accepted by the Irish mob who howled for its suppression in 1907.[28]

Yeats also had no objections to drawing useful parallels between the successful Norwegian dramatic movement and the yet-to-be proven Irish movement. The very opening statement in the first issue of *Beltaine* hailed Norway as an "example and inspiration" to the founders of the Irish Literary Theatre. Elsewhere in the same issue was an article which drew an analogy between the cultural dominance of England over Ireland and that of Denmark over Norway before Ibsen and Björnson had stimulated the Norweigian national revival.[29]

26. Vide Letter to the Editor of *The Daily Chronicle*, London (January 27, 1899), *Letters*, p. 310; Preface to *Letters to the New Island*, p. ix. "The modern author, if he be a man of genius, is a solitary," Yeats declared in 1891; "he does not know the ever-changing public well enough to be their servant. He cannot learn their conventions; they must learn his." *Letters to the New Island*, p. 176.

27. *Autobiographies*, p. 279.

28. Yeats declared, as early as 1905, that the struggle to win an audience for Synge in Dublin was similar to the fight over the first realistic plays of Ibsen. Letter to John Quinn (February 11, 1905), *Letters*, p. 448.

29. C. H. Berford, "The Scandinavian Dramatists", *Beltaine* Number One, pp. 14-19.

As a dramatist, however, Yeats could not view Ibsen as anything other than the most powerful representative of the scientific movement in literature that he and his mystical, symbolist, and Rhymers' colleagues had determined to counteract. It is interesting to note that Yeats criticized Ibsen's delineation of character in terms almost identical to those which he applied in criticizing Maeterlinck. Recalling his impression of the Independent Theatre's production of *Ghosts,* Yeats wrote:

All the characters seemed to be less than life-size. Little whimpering puppets moved here and there in the middle of that great abyss. Why did they not speak out with louder voices or move with freer gestures? What was it that weighed upon their souls perpetually? Certainly, they were all in prison, and yet there was no prison.[30]

Yeats admitted that both Maeterlinck and Ibsen successfully employed "vague symbols that set the mind wandering from idea to idea, emotion to emotion".[31] At the same time, because of Ibsen's realistic form Yeats found the obvious symbolism attempted "in moments of excitement"—the flag-waving at the end of *Little Eyolf,* for instance—to be simply "stupid".[32] More than anything else, Yeats objected to the "stale odour of spilt poetry" that he found in William Archer's translations of Ibsen. Again, he blamed this on a realistic form that made "music and style" impossible.[33] (It is significant that, even with Synge, Yeats found emotion-carrying words to be out of place in certain scenes "because the realistic action [did] not permit that stalling and slowing which turns the imagination in upon itself".)[34]

To a large extent, it was out of his own reaction against the influence of Ibsen that Yeats responded so enthusiastically to the French symbolist movement in the theatre. In his *Bookman* review of *Axël* in 1894, Yeats declared that "the younger generation of writers has grown tired of the photography of life." Villiers and his fellow-symbolists were hailed as the harbingers of a new generation of writers throughout

30. *Explorations,* p. 168.
31. *Essays and Introductions,* p. 216.
32. Ibid., p. 275.
33. *Autobiographies,* pp. 280, 279.
34. *Essays and Introductions,* p. 529.

Europe who, in a revolt against Ibsen and naturalism, were returning "by the path of symbolism to imagination and poetry, the only things that are ever permanent".[35]

By 1897, in their deployment of symbols to mirror the "Divine Essence", Yeats equated the artists of the symbolist movement with the great religious artists of the past, such as Giotto and Blake. Wagner, Villiers, and Maeterlinck were, he declared, part of

a great revolution of thought which is touching literature and speculation alike in an insurrection against everything that says the external and the material are the only fixed things, the only standards of reality.[36]

In a series of articles which he wrote for the *Dublin Daily Express* just a few weeks before the opening of the Irish Literary Theatre, Yeats carried his messianic enthusiasm to chiliastic heights:

I believe that all men will more and more reject the opinion that poetry is "a criticism of life", and be more and more convinced that it is a revelation of a hidden life, and that they may even come to think painting, poetry and music the only means of communing with eternity left to man on earth.[37]

Yeats brought these arguments into an Irish context by attempting to relate the symbolist movement to the Celtic Renaissance. Here his ideas were influenced by, and in turn undoubtedly received acceptance in England because of, Matthew Arnold's famous essay "On the Study of Celtic Literature" (1867). Throughout the first half of the nineteenth century, Irish archaeologists and philologists had sought to disprove the common notion that Ireland had no civilization prior to the Norman Conquest. Although the research of the Irish scholars gained European attention, it was not until Arnold bestowed his prestigious sanction on their efforts that the Celtic Renaissance was taken seriously in England.[38] Arnold, however, interpreted the Celtic Renaissance in the

35. *Uncollected Prose*, p. 323.
36. "The Treasury of the Humble", *The Bookman* (July 1897), p. 94.
37. "John Eglington and Spiritual Art", *Literary Ideals in Ireland*, p. 36.
38. Vide John Kelleher, "Matthew Arnold and the Celtic Renaissance", *Perspectives of Criticism*, ed. Harry Levin (Cambridge: Harvard University Press, 1950), pp. 197-221, for a perceptive analysis of the importance of Arnold's essay in the advancement of the Celtic Renaissance.

light of his own theories on the relationship between art and civilization.

As the principal critic of the early Victorian period, Arnold felt that he was presiding over the final dissolution of English civilization. Searching for a means to combat the debilitating influence of the industrial revolution, the rise of a vulgar middle class, and the loss of religious faith due to Darwinism, Arnold was inspired by the striking accomplishments of Goethe and the German renaissance at the beginning of the nineteenth century. Arnold noted that Goethe was a classical scholar who had come to view Greek literature and art as a model from which the modern world should draw inspiration. Goethe's efforts at Weimar had been nourished by combining classicism with the newly awakened knowledge of an ancient Teutonic mythology fit to set beside the Greeks.[39] Similarly, Arnold argued that England might recover from middle-class "Philistinism" under the influence of the "Grecian" qualities that he found in the newly discovered "Celtic genius":

Now then is the moment for the greater delicacy and spirituality of the Celtic peoples who are blended with us, if it be but wisely directed, to make itself prized and honoured. In a certain measure the children of Taliesin and Ossian have now an opportunity for renewing the famous feat of the Greeks and conquering their conquerors.[40]

Arnold thus prepared the way for Yeats to conquer England through his promotion of the Irish literary and dramatic movement. Certainly, Arnold's comparison between the Celts and ancient Greece was not lost upon Yeats. But by emphasizing the alleged "spirituality" of Celtic culture Arnold created stereotyped images of the Celt that ultimately were to be of dubious value to Yeats and the movement as a whole.

During the nineties, however, Yeats directly echoed Arnold's overly enthusiastic claims. Reviewing the poetry of the Scottish poetess "Fiona Macleod" for The Bookman in December 1896 Yeats compared it to the French symbolists in that both symbolism and Celtic legend and mythology "were born out of a man's longing for the mysterious and the infi-

39. "The Function of Criticism at the Present Time", reprinted in Lectures and Essays in Criticism, ed. R. H. Super (Ann Arbor; University of Michigan Press, 1962), pp. 261-63.
40. "On the Study of Celtic Literature", ibid., p. 386.

nite".[41] Because of the influence of Wagner, Villiers, and Maeterlinck, Yeats argued that the "new movement" throughout Europe was sending artists back to legends and mythology in search of

the magical beryls in which we see life, not as it is, but as the heroic part of us, the part which desires always dreams of emotions greater than any in the world. . . . Because a great portion of the legends of Europe, and almost all of the legends associated with the scenery of these islands, are Celtic, this movement has given the Celtic countries a sudden importance, and awakened some of them to a sudden activity.[42]

Finally, Yeats applied these ideas to his concept of the Irish dramatic movement. The first issue of *Beltaine* announced that "the Irish Literary Theatre will attempt to do in Dublin something of what has been done in London and Paris". Then came an important qualification:

The plays will differ from those produced by associations of men of letters in London and in Paris, because times have changed, and because the intellect of Ireland is romantic and spiritual rather than scientific and analytical.[43]

The Countess Cathleen AND
PRACTICAL REALITIES OF THE THEATRE

Many of Yeats's most cherished ambitions and plans came crashing to earth when *The Countess Cathleen* was staged as the first production of the Irish Literary Theatre, May 8, 1899. In making the move from the study to the stage, Yeats learned that there was a great difference between idealism and the practical realities of the contemporary theatre.

The Countess Cathleen was a work of great importance to Yeats, not only in terms of his ambitions as a dramatist but for many personal reasons. This is evidenced alone by the

41. *Uncollected Prose*, p. 423.
42. "Mr. Rhys' Welsh Ballads", *The Bookman*, XIV (April 1898) pp. 79, 14-15.
43. *Beltaine* Number One, pp. 6-7. Yeats's optimism was also expressed to Lady Gregory when he declared that there would be "reaction after the realism of Ibsen, and romance will have its turn". Quoted by Lady Gregory in *Our Irish Theatre*, pp. 2-3.

fact that he revised the play no less than five times over a period of thirty years.[44]

Yeats included the original fable of the play among traditional Irish stories of the devil in *Fairy and Folk Tales of the Irish Peasantry*, published in 1888.[45] Demons bring plague and famine to Ireland and then offer the oppressed peasants gold for their souls. Countess Cathleen O'Shea, who is so good she would be nobility in Heaven as on earth, in desperate pity redeems the other souls with the sale of her own. She dies broken-hearted, but Heaven cancels the bargain; her soul is saved and the demons disappear.

By early 1889, shortly after he first met Maud Gonne, Yeats was endeavouring to turn the fable into a play, and had hopes of getting it acted by an amateur dramatic society in Dublin.[46] In 1892 the first version of *The Countess Cathleen*, with an elaborate dedication to Maud Gonne, was published.[47] In May of the same year Yeats, with John O'Leary's help, founded the Irish National Literary Society in Dublin. Yeats planned, as one of its principal activities, to stimulate an interest in traditional Irish culture by starting small lending libraries throughout the country. He and Maud Gonne also planned to send a small travelling theatre to the country towns to perform plays on patriotic subjects. Among his own contributions was to be *The Countess Cathleen*.[48]

In the preface to the 1892 version of the play Yeats declared that it was "an attempt to mingle personal thought and feeling with the beliefs and customs of Christian Ireland".[49] The personal elements included Yeats's belief that Maud Gonne, whom from the outset of the work he identi-

44. Vide Peter Ure, *Yeats the Playwright* (London: Routledge and Kegan Paul, 1963), pp. 12-15, for an analysis of the various revisions of *The Countess Cathleen*.
45. *Fairy and Folk Tales of the Irish Peasantry*, pp. 232-35.
46. Vide *Letters*, pp. 114, 117, 125, 129.
47. *The Countess Cathleen and Various Legends and Lyrics* (London: T. Fisher Unwin, 1892). Cf. Michael T. Sidnell, "Yeats's First Work for the Stage", *W. B. Yeats, 1865-1965: Centenary Essays*, ed. D. E. S. Maxwell and S. B. Bushrui (Ibadan: Ibadan University Press, 1965), pp. 167-88.
48. *Autobiographies*, p. 200.
49. *Countess Cathleen and Various Legends and Lyrics*, pp. 7-8.

fied with the Countess, even to the point of hoping she would act the role,[50] was sacrificing herself to the "fanaticism and hate" of politics. The play was also personal in that it may be read as an attempt by Yeats to "hammer into unity" the previously noted claims of his life: art, mysticism, and nationalism.

The theme—or themes—of *The Countess Cathleen* are thus extremely difficult to unravel. In elemental terms, the play delineates a struggle between the forces of good and evil. To this may be added the overtones of a political struggle, for in the play the demons become merchants who symbolize English imperialism and materialism. The play also portrays the religious and psychological inner struggle of the Countess over whether to save the people by the sacrifice of her soul. On a philosophic level, however, *The Countess Cathleen* represents the perennial Yeatsian conflict of dreams versus human responsibility. As David Clarke points out, the Countess is caught in a quandary, "forced to choose between love and beauty, or patriotism, or God".[51]

Any one of the choices of the Countess appears, in purely rational terms, to be but partially satisfying. Yet, by choosing to serve her people (that is, the nation) rather than God or Aleel (the poet who represents love and beauty), the Countess acts in accordance with her own deepest convictions. In terms of Yeats's conception of the social responsibility of art weighed against responsibilities of the individual, she resolves the tragic struggle through her self-annihilating act for a love beyond self. Love, art, and religion are themselves unified through her rejection of them, for they, too, are—or should be—part of the life of the people. Thus the Countess provides an image of that Unity of Being that Yeats strove to attain for himself and pass on to his countrymen as an image of Unity of Culture.

If in purely literary terms, the full ramifications of *The Countess Cathleen* are difficult to grasp, the theatrical challenges of the play are even more formidable. *The Countess*

50. Vide Maud Gonne's account of Yeats's desperate efforts to persuade her to play the title role in the first production of *The Countess Cathleen*. *A Servant of the Queen*, p. 169.
51. David R. Clark, "Vision and Revision: Yeats's *The Countess Cathleen*", *The World of W. B. Yeats*, ed. Robin Skelton and Ann Saddlemyer (Dublin: The Dolmen Press, 1965), p. 161.

Cathleen demands an exquisitely sensitive production that evokes a response on a visceral emotional level and at the same time allows the spectator sufficient breathing space to balance and synthesize the various themes of the play as in a delicately woven tapestry of the mind. The challenge to the director lies in creating a stylistic unity so that the play neither sinks into the bathos of realism, in which case the heroic aspects of the play become sentimentally melodramatic, nor waffles in abstract poesie, in which case the play becomes simply irrelevant.

Always the sense of aesthetic distance must be preserved, so that the stage picture becomes a symbol with a vibrant self-contained life of its own. And the means of doing this is by adopting the very conventions of verse delivery and stage decor that Yeats was at the very time groping to discover.

Within a few days of rehearsal it became evident to Yeats that the professional English actors engaged to perform *The Countess Cathleen* were incapable of realizing his histrionic intentions, particularly with regard to the delivery of verse. May Whitty, a noted Shakespearean actress, had assumed the title role; but she apparently lacked rhythmic sensitivity and, instead, sought to make her effects through the conventional tear in the voice. Only Florence Farr, Yeats's model speaker of verse who played Aleel, seemed to be aware of the musical possibilities of the lines.[52]

When Yeats's efforts to coach the actors caused only confusion and irritation, George Moore took the matter in hand by banishing him from rehearsals altogether.[53] The result was that *Beltaine* Number One carried an *apologia* by Yeats for the performance which the audience was about to see:

The speaking of words, whether to music or not, is . . . so perfectly among the lost arts that it will take a long time before our actors, no matter how willing, will be able to forget the ordinary methods of the stage or to perfect our new methods.[54]

Unhappily for his ambitions as a dramatist, Yeats's prediction was to prove all too accurate. By the second season of the Irish Literary Theatre he was already forced to submit to

52. *Autobiographies*, pp. 413, 417.
53. Moore, *Hail and Farewell, Ave* (London: Heinemann, 1911), p. 93.
54. *Beltaine* Number One, pp. 7-8.

the histrionic realities of the theatre. Announcing in *Beltaine* Number Two that he had completed a play in verse (*The Shadowy Waters*), Yeats complained: "I rather shrink from producing another play unless I get some opportunity for private experiment with my actors with the speaking of verse."[55]

The second theatrical reality faced by Yeats was that of creating an appropriate stage decor for *The Countess Cathleen*. His problem was not just a matter of employing symbolic and decorative scenery in the style of Lugné-Poe. What he demanded for the climax of the play was a dazzling Wagnerian panoply of the theatre arts that would have challenged Bayreuth itself.

This climactic scene is worth describing in some detail, for it vividly demonstrates the rather grandiose scale of Yeats's dramatic conception at this point in his career. It therefore presents a sharp contrast with the much more austere—and practical—stage works that followed.

Following a scene in which the Countess Cathleen barters her soul with the merchants, a great storm breaks forth. The Countess is carried in by the peasants and gives directions for the division of her money after her death. In a beautiful speech she bids farewell to her foster-mother, Oona, and to Aleel, and expires.

Oona tests Cathleen's breath with a mirror and half screams "O, she is dead." Aleel shatters the mirror, since it can no longer show her live face, and cries out:

I shatter you in fragments, for the face
That brimmed you up with beauty is no more:
And die, dull heart, for she whose mournful words
Made you a living spirit has passed away
And left you but a ball of passionate dust.
And you, proud earth and plumy sea, fade out!
For you may hear no more her faltering feet,
But are left lonely amid the clamorous war
Of angels upon devils.

(*He stands up; almost every one is kneeling, but it has grown so dark that only confused forms can be seen.*)

55. *Beltaine* Number Two (February 1900), p. 23.

And I who weep
Call curses on you, Time and Fate and Change,
And have no excellent hope but the great hour
When you shall plunge headlong through bottomless space.

(A flash of lightning followed by immediate thunder.)

A PEASANT WOMAN
Pull him upon his knees before his curses
Have plucked thunder and lightning on our heads.

ALEEL
Angels and devils clash in the middle air,
And brazen swords clang upon brazen helms.

(A flash of lightning followed by immediate thunder.)

Yonder a bright spear, cast out of a sling,
Has torn through Balor's eye, and the dark clans
Fly screaming as they fled Moytura of old.

(Everything is lost in darkness.)

AN OLD MAN
The Almighty wrath at our great weakness and sin
Has blotted out the world and we must die.

*(The darkness is broken by a visionary light. The peasants seem to be
kneeling upon the rocky slope of a mountain, and vapour full of storm
and ever-changing light is sweeping above them and behind them. Half
in the light, half in the shadow, stand armed angels. Their armour is old
and worn, and their drawn swords dim and dinted. They stand as if
upon the air in formation of battle and look downwards with stern
faces. The peasants cast themselves on the ground.)*

ALEEL
Look no more on the half-closed gates of Hell,
But speak to me, whose mind is smitten of God,
That it may be no more with mortal things,
And tell of her who lies there.

(He seizes one of the angels.)

 Till you speak
You shall not drift into eternity.

THE ANGEL

The light beats down; the gates of pearl are wide;
And she is passing to the floor of peace.
And Mary of the seven times wounded heart
Has kissed her lips, and the long blessed hair
Has fallen on her face; the Light of Lights
Looks always on the motive, not the deed,
The Shadow of Shadows on the deed alone.

(Aleel releases the Angel and kneels.)

OONA

Tell them who walk upon the floor of peace
That I would die and go to her I love;
The years like great black oxen tread the world,
And God the herdsman goads them on behind,
And I am broken by their passing feet.

*(A sound of far-off horns seems to come from the heart of the light.
The vision melts away, and the forms of the kneeling Peasants appear
faintly in the darkness.)*[56]

Aside from the rhetorical bombast of Aleel's longer
speeches and the obscurity of some of the mythological refer-
ences, the sheer theatrical impact of this scene is immensely
impressive if one imagines it upon the stage. In histrionic
terms, it ranges from effective "business" (the aural and visu-
al impact of the broken mirror) and deft realistic touches
(the whimpering cries of the peasants) to powerful physical
action (Aleel's challenge to the Angels followed by the sub-
missive gesture of his kneeling) and pure lyricism (Oona's
resigned but mystically exalted lament). We shall see Yeats's

56. *Poems* (London: T. Fisher Unwin, 1895), pp. 154-56. In view of the Wagner-
ian scale of *The Countess Cathleen* it is perhaps not altogether surprising to
learn that in 1911 Yeats seriously considered turning it into an opera libretto.
Music was to have been written by the Italian composer Franco Leoni with
the leading role to have been taken by the English contralto Clara Butt.
Yeats insisted that the stage designer Gordon Craig should be involved in the
project from the very outset for, as he wrote to Leoni: "A musical play is
above all things a composite work, is it not? If the stage decoration is a poor
conventional creature, and most of them are that, musician and poet are
miserable alike, and their work more than half ruined. I want never again to
go through what I have at certain productions of my own plays." Unpublished
letter dated May 9, 1911, and preserved in the Craig Collection, Bibliothèque
Nationale, Paris. This project was never realized.

histrionic sense of the theatre demonstrated in a similar manner throughout his entire career as a dramatist.

What is most fascinating, however, are the demands that Yeats placed upon the visual and musical resources of the theatre. By employing them to the fullest possible extent, out of physical action and language comes the apotheosis of the play, wherein the war of immortal upon the mortal worlds, the struggle of opposites, is resolved. In the final tableau, Ireland—symbolized by the kneeling peasants with Aleel among them—is mystically transformed into the perfect nation of Yeats's dreams: a community of people sharing the one religious, cultural, and aesthetic ideal.

What happened to this lyrical theatrical image when it was interpreted by scene painters, costumers, and technicians drawn from the commercial theatre, working on a badly equipped and tiny stage, has been recorded by numerous observers. Max Beerbohm complained that the scenery was "as tawdry as it should have been dim";[57] Joseph Holloway was distracted in the final scene by a "creaky door" and "the too liberal use of palpable tin-trayed-created thunderclaps";[58] George Moore declared that the production of *The Countess Cathleen* "met with every disadvantage. . . . Many times I prayed during the last act that the curtain might come down at once."[59]

But the most revealing comment of all was made by Yeats, who years later wrote: "It was indeed the first performance of *The Countess Cathleen* when our stage pictures were made out of poor conventional scenery and hired costumes, that set me writing plays where all would depend on the player."[60]

THE REALITY OF AN IRISH AUDIENCE

The theatrical reality that was probably the most disappointing and disillusioning of all for Yeats was the rejection of *The*

57. "In Dublin", *The Saturday Review* (May 13, 1899). Reprinted in *The Genius of the Irish Theatre*, ed. Sylvan Barnet, Morton Berman, and William Burton (New York: Mentor Books, 1960), p. 340.
58. *Joseph Holloway's Abbey Theatre*, ed. R. Hogan and M. J. O'Neill (Southern Illinois University Press, 1967), p. 7.
59. "The Irish Literary Theatre", *Samhain* Number One (October 1901), p. 12.
60. *Collected Works* (1908), III, reprinted in *The Variorium Edition of the Plays of W. B. Yeats*, ed. Russell K. Alspach (London: Macmillan, 1966), p. 1291.

Countess Cathleen by the Irish audience in whom he had placed so much hope. A major reason for this rejection was, of course, the poor production that the play received. There were other reasons, however, that were much deeper and longer-lasting in their effect.

As has been noted, *The Countess Cathleen* was the result of Yeats's deliberate effort to interweave symbols drawn from the Pagan and Christian cycles as he found them mingled in the peasant beliefs of Gaelic-speaking Ireland.[61] Through the character of Aleel, Yeats linked the old gods with the people of the present: Aleel sings the pagan Irish myths, but has given his own soul to the Christian Cathleen. Moreover, in his defiance of the foreign merchants, Aleel stands for a national art—Yeats's own art—which is intensely Irish in its religious and political unity.

None of these ramifications of the play was grasped by the audience. Instead, even before the opening performance, Edward Martyn threatened his withdrawal from the entire enterprise and Cardinal Logue publicly condemned the play because of alleged "heretical" passages which it contained.[62] Nor was this all. A political enemy of Yeats circulated a pamphlet which attacked the play as a slander on "Catholic Celtic Ireland", giving details of specific offences—such as a starving peasant kicking at a broken statue of the Virgin. The pamphlet concluded with the following statement: "Mr. Yeats has the right to preach to his heart's content the loathsome doctrine that faith and conscience can be bartered for a full belly and a full purse. Only he has no right to lay the scene in Ireland."[63]

Behind this attack lay a political philosophy originally derived from Germany and developed in Ireland during the 1840s which equated nationalism with the distinctive quali-

61. Preface to the 1892 edition of *Countess Cathleen and Various Legends and Lyrics*, pp. 7-8.
62. Lennox Robinson, *Ireland's Abbey Theatre*, pp. 5-9. Cf. *Autobiographies*, pp. 413-15; unpublished letters from Edward Martyn to Yeats, preserved in N.L.I. Ms. 13068; *Letters*, pp. 315-20.
63. F. Hugh O'Donnell, "Souls for Gold: Pseudo-Celtic Drama" (London: 1899), a pamphlet preserved in Henderson Press Cuttings, N.L.I. Ms. 1729, p. 325.

ties in the *Volksgeist.*[64] Chief among these qualities when interpreted by the patriotic Young Ireland poets led by Thomas Davis (1814-45), was the supposed "sanctity" of ancient Ireland. Supported by the Gaelic League, which was established in 1891 in order to revive the Irish language, and the moral authority of the Jansenistic Irish Catholic Church, the philosophy of Young Ireland was revived during the 1890s and given a new twist when attached to the allegedly pure-minded Gaelic-speaking peasantry in the West of Ireland. The "holy peasant" became a symbol to the nationalists of the unique qualities of life which distinguished Ireland as a whole from atheistic and immoral England. By a curious rationalization, evil itself was dismissed from the Irishman's concept of Ireland.[65]

Because Yeats realized that the old mythology was as yet "imperfectly known in modern Ireland", he explained in some detail the pagan symbolism for the good and evil forces combatting in the final scene of *The Countess Cathleen.*[66] The Christian symbolism of the play was, of course, well known, but to Yeats's apparent surprise it was taken by the predominantly Catholic audience as literal reality. When to this naïve misconception was added the wide-spread suspicion

64. Throughout the nineteenth century, inspired by the example of Germany, national movements were linked to folk culture in Spain, Poland, and Prussia as well as smaller countries such as Hungary, Norway, and Croatia. Vide Carleton J. H. Hayes, *The Historical Evolution of Modern Nationalism* (New York: Macmillan, 1930), pp. 160, 162.

65. Popular ballads such as "The West's Awake", "Innis-Eophain", "An T-Sean Bhean Bhocht", "Celts and Saxons", "The Banks of the Lee", and "A Nation Once Again" originally brought this idea into the hearts of a generation of patriotic Irishmen. They were first published in the columns of *The Nation,* the the journal of the Young Ireland Movement founded in 1842, and reprinted in 1895 to imbue yet another generation with their moralistic platitudes. Vide *The Spirit of the Nation* (Dublin: T. Caldwell, 1895), esp. pp. 86, 110-11, 191, 247, 274-75; Charles Gavan Duffy, *Young Ireland: A Fragment of Irish History, 1840-1845* (London: T. Fisher Unwin, 1896). Cf. William Irwin Thompson, *The Imagination of an Insurrection* (New York: Oxford University Press, 1967), pp. 30-62; Richard Loftus, *Nationalism in Modern Anglo-Irish Poetry* pp. 14-15.

66. *Beltaine* Number One, p. 9.

in Dublin of Yeats's occult and mystical pursuits,[67] the reaction of the audience to *The Countess Cathleen* was inevitable.

In performance, the audience could see nothing but the actions of the play that were closest to their own life experience. They interpreted the play on its most elementary level: a struggle between good (Catholicism and the Irish peasantry) and evil (the devil). In this struggle, all that appeared evident to the unsophisticated spectator was that by condoning evil (the sin of the Countess) and by somehow mixing up an occult, pagan, and foreign form of art with Catholicism and the holy peasantry of Ireland, Yeats was trying to undermine the spiritual foundations of the historic Irish nation.[68]

What Yeats obviously needed was an objective literate criticism that might have interpreted his complex work for the undiscriminating theatre-goer. Unfortunately, no review of *The Countess Cathleen* even remotely referred to the symbolic implications of the play on any of its many levels of meaning. Because the play appeared to be intellectually demanding, it was dismissed, at best, as simply undramatic.[69]

The religious, political, and aesthetic problems raised by the staging of *The Countess Cathleen* were to follow Yeats throughout his career as a dramatist. Indeed, his work was never to be freed from a suspicion that it was motivated by an anti-Catholic bias. That suspicion persisted after Yeats's death, and continues even to the present day in Ireland.[70]

67. Yeats observed that at the time when *The Countess Cathleen* was first performed booksellers in Dublin refused to sell his works because of their alleged heretical passages. Letter to Ethel Mannin (December 11, 1936), *Letters*, p. 873. Cf. Mary Colum, *Life and the Dream*, p. 38.

68. Vide Rev. George O'Neill, "The Imagination of the Irish Literary Theatre", a scathing attack on *The Countess Cathleen* as "immoral and irreligious, un-Irish and anti-Irish". It was, according to the reviewer, "grievously wrong" to represent the Irish peasantry as "demoralised poltroons, starveling in soul as well as in body". *The New Ireland Review*, XI, 4 (June 1899), p. 248. A group of prominent students from the Royal University were equally upset at this alleged slight to their national feelings and staged a mild protest by interrupting the first performance with hisses from the galleries. Hogan and O'Neill, *Joseph Holloway's Abbey Theatre*, p. 6.

69. Vide a sampling of reviews of *The Countess Cathleen* reprinted in Robinson, *Ireland's Abbey Theatre*, pp. 5-11.

70. Vide Loftus, *Nationalism*, p. 10. Conor Cruise O'Brien, "Passion and Cunning", *In Excited Reverie: A Centenary Tribute to W. B. Yeats, 1865-1939*, ed. A. Norman Jeffares and K. G. W. Cross (London: Macmillan, 1965), p. 211.

In terms of its political implications, the production of *The Countess Cathleen* marked the beginning of what was to be a continual struggle by Yeats to win an Irish audience that would respond to dramatic art, not in terms of its service to nationalist propaganda, but in terms of its intrinsic artistic worth. Throughout this struggle Yeats's position was clear and unalterable: the mission of the artist was to "serve taste rather than any definite propaganda".[71]

From the very outset of the Irish literary movement, Yeats realized that in order to counteract the tradition inherited from the Young Ireland propagandists it was essential to develop a school of criticism in Ireland that would neither praise indiscriminately for the sake of "mere national vanity",[72] nor condemn distinguished Irish work "amid an empty ritual of convention and prejudice".[73] It was essential above all that Irish criticism not be provincial in its standards. "The true ambition is to make criticism as international, and literature as National as possible," Yeats declared in 1894. Bearing in mind the "uneducated" public in Ireland, he continued: "A contrary opinion would be particularly evil in Ireland, for it could but set the opinions of our daily papers above the opinions of great scholars, and make a vacant and uninstructed public the masters of men of intellect."[74]

Through the hostile responses to *The Countess Cathleen* Yeats learned that he must not only be a principal dramatist but the chief critic—and spokesman—of the Irish dramatic movement. Yeats's ultimate critical stand was not to be taken on his own dramatic work, but on the work of Synge when Synge's portrayal of the Gaelic-speaking peasantry was violently attacked in the name of a narrow puritanically fanatic nationalism.

Unfortunately, no one during his lifetime was to do a similar turn for Yeats.

All of the problems we have been discussing resulted from Yeats's transformation from a pure man of letters to a man of letters directly involved in that most pragmatic and public

71. Letter to Lady Gregory (May 25, 1901), *Letters*, p. 352.
72. Letter to Katharine Tynan (March 12, 1895), *Letters*, p. 253. Vide *Autobiographies*, pp. 224-28, for Yeats's struggle during the nineties to publish new Irish writers who were not mere propagandists.
73. Letter to the Editor of *United Ireland* (December 1, 1894), *Letters*, p. 242.
74. Letter to the Editor of *United Ireland* (November 10, 1894), ibid., p. 239.

of arts, the theatre. Yeats's next step was to become an actual man of the theatre. We may follow this important phase in his development by examining his relationship with his colleagues in the Irish Literary Theatre, Edward Martyn, George Moore, and Lady Gregory.

Men of Letters and a Man of the Theatre

IBSENISM AND THE SEEDS OF LITERARY DISSENSION

Yeats, Edward Martyn, and George Moore may have been united in condemning the commercial theatre of England, but it soon became apparent that they held strongly differing views on the nature of the reforms that might be effected through the Irish Literary Theatre. Essentially, their differences arose from the fact that in their basic philosophies of art Martyn and Moore were totally opposed to Yeats. This may be evident alone in the fact that Martyn and Moore were ardent disciples of Ibsen.[1]

In many ways Edward Martyn (1859-1924) was an extraordinary, though extraordinarily limited, man. According to Moore, Yeats once described him as "the sketch of a great man".[2] Born to wealth and position, few Irishmen of his time gave more unstintingly of themselves to Ireland. In both moral and financial support, such diverse movements and institutions as the Gaelic League, the Sinn Fein Party, the Palestrina Choir of Dublin, and the revival of traditional Irish music and Irish stained glass and sculpture all owed much of their success and in some cases their very existence to

1. Vide Ann Saddlemyer, "All Art Is a Collaboration? George Moore and Edward Martyn", *The World of W. B. Yeats*, pp. 203-22.
2. *Hail and Farewell, Salve*, p. 211.

Martyn.[3] Indeed, the same might be said of the Irish Literary Theatre itself.

The theatre was a deeply important part of Martyn's conception of Irish nationalism. Like Yeats, he believed that the theatre should be a "national centre of education and refinement",[4] and the drama "a vehicle for enunciating high and philosophical truths".[5] Bringing his theories of an ideal theatre and drama directly to bear on the emerging sense of national identity in Ireland, Martyn argued that it was of utmost importance to create an Irish national theatre in order to blot out "the vast cosmopolitanism and vulgarity of England's influence".[6] Ibsen and the National Theatre of Norway provided a superb example for Ireland to follow. Ibsen was "primarily intensely Norwegian, and [was] only international by reason of his immense genius," Martyn declared.[7] Ireland was "virgin soil, yielding endless inspiration to the artist", "but her foreign influences must come from the Continent (particularly Norway) not from England."[8]

George Moore (1852-1933) lent enthusiastic endorsement and amplification to Martyn's comparison between Norway and Ireland. Having been one of the original champions of Le Théâtre Libre in England during the 1880s, and one of the founding members of the Independent Theatre Society in 1891, Moore now declared that he had cast London and the Independent Theatre adrift because "there were not 1500 people who cared . . . to pay one guinea a year to save dramatic writing from the grave into which it was slipping." The Independent Theatre had ceased to exist, as had Le Théâtre Libre in France. Art had thus passed from England and France—not to mention Germany and Russia—and remained only in Norway. But when it left Norway, Moore avowed that surely it must find "another small small nation, one

3. Vide Denis Gwynn, *Edward Martyn and the Irish Revival* (London: Jonathan Cape, 1930), pp. 14, 257-58.
4. Collected Papers of Edward Martyn, quoted by Sister Marie Thérèse Courtney, *Edward Martyn and the Irish Theatre* (New York: Vantage Press, 1957), p. 65.
5. Preface to Henry B. O'Hanlan's *The All-Alone* (Dublin: Kiersey, 1922), p. vii.
6. "A Comparison Between Irish and English Stage Audiences", *Beltaine* Number Two (February 1900), p. 13.
7. Gwynn, p. 142.
8. "A Comparison Between Irish and English Stage Audiences".

which has not yet achieved its destination—a nation such as Greece was before Marathon, such as England was before the Armada, and again before Trafalgar. In the Western Hemisphere Ireland is the only place which seems to fulfil these conditions."[9]

As a confirmed disciple of Ibsen, one might have expected Martyn to become involved in literary conflicts with Yeats. Conflicts were still more inevitable in the light of two other factors: first, that the deepest motivating passion of Martyn's life—far deeper than even his fervent nationalism—was a rigidly moralistic form of Catholicism; second, that although Martyn longed for nothing more than to be considered a literary artist, he simply lacked the talent to rise even to the ranks of the second rate.

Martyn displayed his queasy conscience to the full during the storm that he created over "uncatholic and heretical" passages which he thought existed in *The Countess Cathleen*. That storm was kept out of the public eye and ultimately quelled, thanks to the skillful diplomacy of Lady Gregory and Yeats.[10] Unfortunately, because Martyn was the principal guarantor of the Irish Literary Theatre,[11] little could be done to prevent the production of two of his plays, *The Heather Field* as part of the opening program in 1899, and *Maeve* the following year.

As literature Martyn's plays are worthless. It would not be far from the truth to say that they were parodies of everything that Yeats founded the Irish literary and dramatic movement to foster. They are worth examining for one reason only—the fact that they were acclaimed by the Dublin audience as the outstanding popular successes of the three year Irish Literary Theatre venture.[12] This response demonstrates the low level of dramatic taste in Dublin. Moreover, it

9. Preface to *The Heather Field* and *Maeve* (London: Duckworth, 1899), p. viii.
10. *Autobiographies*, pp. 154, 414-15.
11. Martyn's initial contribution to the Irish Literary Theatre was £130 (£100 of his own money and £30 from his mother). Apparently, Martyn also paid any debts incurred by the Theatre at the end of its third year. Vide Letter from Martyn to Yeats (March 31, 1899) preserved in N.L.I. Ms. 13068; Robinson, *Ireland's Abbey Theatre*, p. 11.
12. Cf. *Autobiographies*, p. 417; *Hail and Farewell, Ave*, p. 148; Robinson, *Ireland's Abbey Theatre*, pp. 9-11, 15.

serves as yet another indication of the struggle that Yeats had to face in attempting to realize his own ambitions for a non-Ibsenesque "ideal" drama in Ireland.

George Moore, in a preface to *The Heather Field*, claimed that it was rejected by the London managers because they did not understand that "it was the first play written in English inspired by the example of Ibsen."[13] For once, it appears that the London managers made a valid literary judgment. Ibsenesque though *The Heather Field* may be in its realistic structure, dialogue, and crude attempts at symbolism, there is little of the master's inspiration evident in any other aspect of the work. One cannot help wondering how it even held, much less excited, audiences of the Irish Literary Theatre.

There is but one dramatic conflict to sustain any interest in Martyn's play: whether or not Carden Tyrell will be able to reclaim his beloved heather field before it has been sold to pay off the mortgage on his estate, or before his wife has him declared insane for trying to hold on to it. The heather field is thus the central symbol of the play, being perhaps an image of the departed joys of Carden's lost youth, or, in a larger sense, an image of the pure idealism of Ireland which must be preserved against the onslaughts of materialism.

Throughout the play Martyn strains after emotional effects in order to prop up his theme. One can scarcely imagine anything more banal and sentimental, even in English melodrama, than the final scene of *The Heather Field* when Carden Tyrell, finally driven to madness through the foreclosure of his mortgage, moves to the window with his small son for one final look at the field and a curtain speech:

Oh, the rainbow *(To Kit):* Come quick, see the lovely rainbow *(They go to watch it hand in hand)*. Oh, mystic highway of man's speechless longings! My heart goes forth upon the rainbow to that horizon of joy![14]

With *Maeve*, produced in February 1900, Martyn's unconscious parody of Yeats's idealism moved still closer to home. This time, he unwittingly managed to create a caricature of

13. Preface to *The Heather Field* and *Maeve*, p. viii.
14. Ibid., p. 83.

the worst excesses of both aestheticism and the Celtic Renaissance. The plot of *Maeve* again appears to exist mainly in order to illustrate a moralistic theme: the conflict between idealism and pragmatism, or, more simply, good and evil. However, Martyn added a touch of political melodrama, by placing on one side Maeve, "a sweet symbol of [Ireland] in her subjection", and on the other Hugh Fitz Walter, "a bandit like his English predecessors", whom she hates but is, perforce, about to marry. Completing the picture are two other overly familiar characters on the "stage Irish" landscape: Maeve's father, a representative of the old Gaelic-speaking aristocracy who bemoans "the persistent ill luck that has pursued me all my life", and Peg Inerny, an old visionary hag who represents the spirit of the Irish peasant—indomitable, looking to the aristocracy for leadership yet inspiring them as a living incarnation of the past.

Throughout the play, a cloying Celticism dampens the twilight air, from the setting itself with a ruined Abbey, castle, cairn, and romantic ash trees, to lines which refer to "the last flame of our country's life", "the fairy lamp of Celtic Beauty". Martyn, who was drawn to the Irish language through his study of Greek, even includes passages which compare the brotherhood of the Greek and Celtic races, with Maeve asserting that the Greeks invented "a curious unreal beauty" which has only been approached by the Celt.[15]

The influence of Ibsen may be noted particularly in the structural device of attempting to make the past an active agent in the present. Peg Inerny, as the incarnation of the spirit of ancient Ireland, steals Maeve away on her wedding night to "that other life" in the ancient fairyland of Tir-nan-Ogue, where her true "lover" awaits—with a beauty "like the old Greek statues". To enable the audience to travel along this ghostly way, Martyn borrowed a theatrical trick from the nineteenth-century actor-managers. The climactic scene of the play involves a spectacular procession replete with ancient Irish harpers, boy pages in garlanded tunics wearing wreaths of roses on their heads, and Queen Maeve herself in a golden crown and gold-embroidered robes.[16]

15. Vide *The Heather Field* and *Maeve*, pp. 91, 94, 113-14.
16. Ibid., p. 117.

It was surely upon seeing plays such as these and Alice Milligan's vacuous Celtic pageant play, *The Last Feast of the Fianna*, performed on the same program with *Maeve*,[17] that Yeats was haunted by the hollow echo of his own utterances —an Irish intellect "romantic and spiritual", an Irish drama "remote, spiritual and ideal". Little wonder that he tells us he had already begun to turn from the Celtic movement.[18]

Perhaps nothing so sharply delineates the difference between the literary ideals of George Moore and W. B. Yeats as the fact that at first Moore had no compunctions about producing Martyn's third play, a crude social satire entitled *The Tale of a Town*, as part of the second season of the Irish Literary Theatre. Moore viewed *The Tale of a Town* "not as a work of art—i.e., something which would be acted in fifty years for the delight of numerous audiences. . . . —but as a play to which literary people could give attention without feeling ashamed of themselves afterwards." There was no reason to expect anything profound when a subject was "merely one of topical interest", he told Yeats; it was, in fact, "a mistake . . . to be very particular about the literary quality of such a play" at all.[19]

One cannot help but feel that this relativistic attitude of Moore typifies his entire involvement with the Irish literary and dramatic movement. Having left Ireland, that country of "abandoned dreams" with its "damp flaccid smell of poverty", ten years previously in order to return to "civilisation" on the Continent;[20] having embraced the aesthetic move-

17. *The Last Feast of the Fianna* was, according to its author Alice Milligan, an attempt to transliterate the original legend into what she termed an "Ossianic stanza". This, she claimed, would have been "the natural form of Gaelic drama, if that form of drama had ever developed a step further than dialogue recitals". As such, the work was far more a pageant than a play. Music, which included the *Tannhäuser* overture, and spectacle assumed more dramatic importance than character, plot, or dialogue. What plot there was consisted simply of bickering among Finn, Grania, and Ossian over Grania's betrayal of Diarmuid. Ossian concluded the play by obeying (as Maeve) a summons to Tir-nan-Ogue—this time conveyed by a chorus and a singer representing the siren Niamh. Vide a copy of the play preserved in Henderson Press Cuttings, N.L.I. Ms. 1729, pp. 130-33. Cf. reviews of *The Last Feast of the Fianna*, Henderson, pp. 124-26.
18. *Autobiographies*, p. 429.
19. *Hail and Farewell, Ave*, p. 280.
20. George Moore, *Parnell and His Ireland* (London: Sonnenschein, 1887), pp. 22, 56.

ment, then turned to Zola and the naturalists, then Ibsen, and finally the symbolists,[21] the decision of Moore to return to his native land and sing the praises of the Celtic movement strikes one as just another junction on his lifelong journey in search of a literary subject and a style.

Yeats, with the uncanny insight that he often displayed in characterizing people, once described Moore, Wilde, and Shaw as "abstract, isolated minds, without a memory or a landscape".[22] His opinion of Wilde and Shaw was qualified elsewhere, mainly because of his respect for their skill in writing dialogue.[23] Yeats never qualified his judgment of Moore, however. It was born out of the bitter memory of their attempted collaboration at the Irish Literary Theatre and a feeling of personal resentment that Moore had embarrassed him and made his whole movement look ridiculous by publishing the satirical trilogy Hail and Farewell. Giving his version of their many altercations—especially the conflicts that arose when they endeavoured jointly to compose Diarmuid and Grania for the third season of the Irish Literary Theatre—Yeats declared:

Because Moore thought all drama should be about possible people set in appropriate surroundings, because he was fundamentally a realist . . . he required many dull, numb words. But he put them in more often than not because he had no feeling for words in themselves, none for historical associations. He insisted for days upon calling Fianna "soldiers". . . . Our worst quarrels, however, were when he tried to be poetical, to write in what he considered my style. He made dying Diarmuid say to Finn: "I will kick you down the stairway of the stars."[24]

It is doubtful that Moore would have had any objection to being termed a "realist". His stated ambition in the drama was the same as in the novel: that of "conveying an interest-

21. Moore once described himself as "the youngest of the naturalists, the eldest of the symbolists", Memoirs of My Dead Life (London: Heinemann, 1921), pp. 48-49.

22. Note on "A Parnellite at Parnell's Funeral", The Variorum Edition of the Poems of W. B. Yeats, ed. Peter Allt and Russell K. Alspach (New York: Macmillan, 1957), p. 834.

23. According to Yeats, Wilde and Shaw were "the only dramatists of the nineteenth century whose plays were worth going to hear". Unpublished letter from Yeats to Frank Fay (December 11, 1902), N.L.I. Ms. 13068.

24. Autobiographies, p. 435.

ing and truthful reflection of life".[25] Nor could one really
expect him to share Yeats's mystical-aesthetic conception of
art. "Nothing human is alien to me, not even the London
theatre," he declared in *Beltaine* Number Two.[26]

None the less, Moore's enthusiasm for the romantic and
spiritual aspirations of the Celtic Renaissance was, while it
lasted, undoubtedly genuine. Typically, it was also demon-
strated in a wide and often contradictory variety of ways.
Though scarcely knowing a word of Irish himself, Moore
threatened to disinherit his nephews if they did not learn to
speak the language, called for a "Gaelic" instead of "Catho-
lic" national university, and even wrote a series of short sto-
ries in English which were translated and then first published
in Irish.[27] At one point Moore took it upon himself to re-
nounce publicly his native Catholicism, declaring that it drew
one's thoughts away from life and hence caused literature
written by Catholics—Irish Catholics in particular—to lack a
"healthy realism".[28] At the same time, he paradoxically
called for a "clerical censorship" of the drama in Ireland in
order to "free the stage from the unintelligent and ignorant
censorship of the public".[29] It is no surprise that Yeats found
Moore an "embarrassing ally".[30] On the question of clerical
censorship he felt himself obliged to challenge Moore openly,
declaring that he would abandon the dramatic movement al-
together if it accepted any censorship except that imposed by
the literary artist on himself.[31]

Ironically, Moore declared that it was the artistry of Yeats
and his faith in Yeats's ideals that originally brought him
back to Ireland. Such was his admiration for Yeats that at
one point he proclaimed Shakespeare and Yeats to be the
only playwrights who had mastered the art of writing blank-
verse drama.[32] *The Countess Cathleen* was, he enthused, "a
play as beautiful as anything in Maeterlinck", containing

25. Note to *The Strike at Arlingford* (London: Walter Scott, 1893), p. 14.
26. "Is the Theatre a Place of Amusement?" p. 10.
27. *Hail and Farewell, Ave*, pp. 327-28; *Salve*, pp. 162-63. Moore's book of short
 stories was published in English as *The Untilled Field* (Dublin: T. Fisher
 Unwin, 1903).
28. *Hail and Farewell, Salve*, p. 229.
29. *The Freeman's Journal* (November 13, 1901), preserved in Henderson Press
 Cuttings, N.L.I. Ms. 1729, p. 80.
30. Vide *Autobiographies*, pp. 423, 427, 431-34.
31. *The Freeman's Journal* (November 14, 1901), Henderson Press Cuttings, p. 82.
32. *Hail and Farewell, Ave*, p. 152.

"verses equal to the verses of Homer".[33] "I am your best advertiser in all the houses I frequent," he wrote to Yeats in October 1899. "I cry, I am not the Lord. There is one greater than I, the latchet of whose shoe I am not worthy to tie."[34]

Yeats's refusal to allow *The Tale of a Town* to be produced by the Irish Literary Theatre provided Moore with the opportunity of giving dramatic expression to his newly discovered enthusiasm for Ireland. This occurred through his own adaption of *The Tale of a Town* entitled *The Bending of the Bough*, which was presented as part of the second season of the Theatre in February 1900.

One can scarcely blame Yeats for his aversion to *The Tale of a Town*. It amounted to little more than a series of incidents strung together in order to demonstrate another of Martyn's didactic themes—that Irish disunity and self-interest were enabling England to take advantage of Ireland. Moore took the basic outline of Martyn's plot, but probably in order to make the thesis a trifle less blatant, changed the setting from Ireland to Scotland. By doing so, instead of making the conflict one between Irish and English interests, he allowed the audience to draw its own analogies and conclusions. Several of the scenes remained essentially the same as in the original play; but Moore deepened the character relationships so that a secondary theme arose—the conflict between public duty and private interests. This theme was expressed through the character of a town alderman, Jasper Dean, pulled between his obligation to the town and a love affair which involved business complications detrimental to the interests of his constituents.

The Bending of the Bough was scarcely a major improvement over *The Tale of a Town* except in one important respect. Because of his emotional identification with Ireland, Moore was moved to transcend the play's conventional format with occasional passages of dialogue that approach poetry in their lyricism and feeling. One such passage occurs in a scene between Jasper Dean and his friend Ralf Kirwan, a character who appears to symbolize many of the historical qualities and ideals of the Celtic race, particularly the love of the land. Kirwan says:

33. Preface to *The Heather Field* and *Maeve*, p. xx.
34. Unpublished letter (October 13, 1899), Moore-Yeats Correspondence, N.L.I. Ms. 8777.

We are lonely in a foreign land because we are deprived of our past life; but the past is about us here; we see it at evening glimmering among the hollows of the hills.

DEAN

We miss that sense of kinship which the sight of our native land awakens in us—the barren mountains over there, so lonely, draw me by their antique sympathy; and the rush of the river awakens echoes of old tales in my heart; truly our veins are as old as our rivers. But if I had not met you, Kirwan, I should have known nothing of these things. It is a necessity of my being to believe in the sacredness of the land underfoot; to see in it the birthplace of noble thought, heroism and beauty, and divine ecstasies. These are souls, and in a far truer sense than we are souls. This land is the birthplace of our exterior selves, at once ourselves and our gods.[35]

There is, of course, little intrinsically remarkable about these lines, and even if there were, a few such purple passages are not enough to validate a play whose subject is all but meaningless outside Ireland. But this much should be said on behalf of Moore: within their context the passages of prose poetry in *The Bending of the Bough* strike a new note in Irish drama. *The Bending of the Bough* is the first of a long series of Irish plays, many of them thesis plays written basically within a realistic framework, but nevertheless distinct from any similar plays in English by an almost mystical evocation of place and a musical deployment of language. From Padraic Colum, T. C. Murray, Lennox Robinson, and St. John Ervine on down to Paul Vincent Carroll, Teresa Deevy, and the present-day dramatists such as Eugene McCabe and Brian Friel, the best of the so-called Irish realists rise out of the parochialism of their subject matter by employing the kind of heightened prose poetry first utilized in *The Bending of the Bough*.

From Yeats's standpoint, of course, the success of the early Abbey realists was but another feather in the cap of Ibsen, a final blow to his own dreams for a "romantic and spiritual" Irish theatre.[36]

Little need be added to the well-known story of the collaboration between Yeats and Moore on *Diarmuid and Grania*, which was presented in October 1901 as part of the third and

35. *The Bending of the Bough*, p. 58.
36. *Explorations*, pp. 248-50.

last season of the Irish Literary Theatre. Incredible as it may seem, Moore's record of the strife between them, which resulted at one point in a scheme whereby Moore was to write the play in French, Lady Gregory would translate it into English, the English text would then be translated into Irish, and Lady Gregory would then turn it back into dialect English, appears to be substantially correct. In theory Yeats was supposed to respect Moore's superior knowledge of construction with Moore content to submit to Yeats's authority on style. In practice, it was a conflict of two utterly opposed minds.[37]

The final result was, as might be expected, only partially successful. *Diarmuid and Grania* is at its best in terms of its construction, especially the "planting" of thematic ideas, and in its characterization. Grania is an especially well-drawn character. Her wilfulness and lust are delineated in frank and bold strokes, probably because Yeats and Moore were united, for once, in a mutual fascination with passionate women.[38] Otherwise, it is a dull effort with no lyrical flights—a mere retelling of the legend.

Of considerably more interest than the play itself are the responses it evoked. Yeats and Moore were attacked by the nationalists on various grounds: for writing a play about "degenerate and unwholesome sex problems";[39] for presenting a "coarse English society play . . . in fancy dress", thus practising a "heartless piece of vandalism on a great Irish story";[40] for employing English music by Edward Elgar instead of music "in the appropriate Gaelic style";[41] and for writing a play which, instead of creating a true "Celtic atmosphere", landed one in "A WORLD OF METAPHYSICAL MEANDERINGS" where "Grania argues as if she took out her M.A. degree in Boston" and "Diarmuid replies with rocks of Thought as if he were a deep student of Herbert Spencer."[42]

37. *Hail and Farewell, Ave*, pp. 352-60. Cf. *Variorum Plays*, p. 1169.
38. Vide *Variorum Plays*, pp. 1168-222 for the complete text of *Diarmuid and Grania*. Cf. Yeats's ironic description of Moore's erotic flights and fancies, *Autobiographies*, pp. 431-34.
39. *The Leader* (November 24, 1910), Henderson Press Cuttings, p. 79.
40. Standish O'Grady, "The Story of Diarmuid and Grania", *All Ireland Review* (October 19, 1901), p. 244.
41. *The Gael* (December 1901), Henderson Press Cuttings, p. 84.
42. Unidentified review preserved in Henderson Press Cuttings, p. iii.

Perhaps the most enthusiastic yet judicious review of the final series of plays presented by the Irish Literary Theatre was written in *The United Irishman* by a young amateur actor and scholar of the theatre, Frank J. Fay. To Fay, the chief importance of the event was not the production of *Diarmuid and Grania* but the response of the audience to the first production of a play in the Irish language, Douglas Hyde's *Casadh an t-Sugain*, which was presented on the same bill. With Hyde himself in the leading role and a company of actors drawn from the politically motivated but ostensibly cultural society Inghinidhe-na-h-Eireann, the production was staged by Frank's elder brother, Willie Fay.[43]

Frank Fay's description of the occasion takes on some of the colour and pageantry of an ancient epic:

Monday evening was a memorable one for Dublin and for Ireland. The Irish language has been heard on the stage of the principal metropolitan theatre, and 'A Nation Once Again' has been sung within its walls, and hope is strong within us once more. The Gaiety Theatre was crowded in all parts, and Ireland's greatest daughter, Miss Maud Gonne, sat beside Ireland's greatest poet, Mr. W. B. Yeats.

Fay went on to disagree with the general criticism of *Diarmuid and Grania:*

I cannot say that I am displeased that the authors have humanised the heroic Diarmuid and made Grania a woman of flesh and blood like ourselves: our hearts go out to them more readily than if they were merely beautiful statues. . . .

But he reserved his main point for the end of the article:

To my mind, the greatest triumph of the authors lies in having written a play in which English actors are intolerable. All the way through the play the English voice grated on one's ears, and the stolid English temperament was equally at variance with what one wanted. The actors did not act the play as if they believed in it; the fact is they could not,

43. Vide Maire Nic Schiubhlaigh and Edward Kenny, *The Splendid Years* (Dublin: James Duffy, 1955), pp. 2-5, for a description of how *Casadh an t-Sugain* came to be staged by Inghinidhe-na-h-Eireann.

for it is not in their nature. I do not, therefore, intend to say anything about the interpretation, because the play was not interpreted at all.[44]

Fay clearly had ideas about the direction that the Irish dramatic movement ought to take. What he could not have known was that Yeats at the very time was in the process of deciding about his own future in the theatre. The result of his decision was to alter drastically both their lives.

EXIT: MARTYN AND MOORE

The production of *Diarmuid and Grania* and *Casadh an t-Sugain* marked the end of the Irish Literary Theatre. Edward Martyn's active involvement with the Theatre had ceased the previous year with the rejection of *The Tale of a Town*. But although he disapproved of *Diarmuid and Grania* on moral grounds, Martyn continued to pay the bills, to handle most of the tedious administrative details, and even to offer Yeats accommodation so that he might continue writing while Lady Gregory was away from Coole. This magnanimous gesture was made, according to Moore, simply because Martyn believed Yeats to be Ireland's greatest poet and would do nothing that might prevent him writing masterpieces which would redound to Ireland's credit.[45]

With the end of the Irish Literary Theatre, Martyn felt that he had had enough of co-operative ventures. When Yeats tried to urge him to finance the experimental English designer Gordon Craig in an Irish touring company led by Frank Benson (the noted actor-manager who had produced *Diarmuid and Grania*), Martyn refused, saying: "Henceforth I will pay for nobody's plays but my own."[46] To continue the work of the Irish Literary Theatre Martyn called for the crea-

44. "The Irish Literary Theatre", *The United Irishman* (October 26, 1901), reproduced in *Towards a National Theatre: Dramatic Criticism of Frank J. Fay*, ed. Robert Hogan (Dublin: Dolmen Press, 1970), p. 71. Cf. Padraic Colum, *Arthur Griffith* (Dublin: Browne and Nolan, 1959), p. 75, and William Irwin Thompson, *The Imagination of an Insurrection*, pp. 57-58, for other descriptions of that memorable evening, especially the effect made by the spontaneous singing of traditional Irish airs during the intermission.

45. *Hail and Farewell, Ave*, p. 287.

46. *Autobiographies*, pp. 446-47.

tion of a stock company of native Irish actors and a school of drama whose function would be to train actors to act plays in the Irish language. In this way, he hoped that somehow the public would ultimately become accustomed to seeing Irish works and translations of the dramatic masterpieces of all lands.[47]

Martyn devoted the rest of his life trying to realize his own ideals for an Irish theatre.[48] Not surprisingly, he became more and more embittered and frustrated by the success of the Abbey plays and players, while he was forced to suffer productions of his own plays at the hands of incompetent amateur actors, whom he compared to "performing dogs".[49]

The closest Martyn came to realizing his personal ideals was in 1914, when in partnership with Joseph Mary Plunkett and Thomas MacDonagh he founded a theatre "for production of non-peasant drama by Irishmen, of plays in the Irish language, and of English translations from European masterworks for the theatre."[50] Frank Fay became involved with this company as an actor, stage director, and teacher. The adventure was short-lived, however, because Plunkett and MacDonagh soon became deeply involved in the political activities which culminated in the Easter Rising.[51]

With all the trials and tribulations that it brought him, and despite the many other important contributions that he made to Ireland, Martyn looked upon the founding of the Irish Literary Theatre as "the most significant action" of his life.[52] Lady Gregory, whose single-minded devotion to purely Irish interests was probably closer to Martyn's than any of the other founders of the Irish Literary Theatre, recalled his saying that he was sorry he had not built his own theatre twenty years ago and put the key in his pocket.[53]

47. "A Plea for a National Theatre in Ireland", *Samhain* Number One (1901), pp. 14-15.
48. Vide Courtney, pp. 75-76; Nic Shiubhlaigh, pp. 76-77, for Martyn's other theatrical ventures, including The Theatre of Ireland.
49. Preface to *The All-Alone*, p. vi.
50. Ibid., pp. v-vi. Cf. "A Plea for the Revival of the Irish Literary Theatre", *The Irish Review*, IV, 38 (April 1914), pp. 79-84.
51. Vide unpublished letters from Thomas Mac Donagh to Frank Fay, preserved in Fay Papers, N.L.I. Ms. 10951-52.
52. Collected Papers, quoted in Courtney, p. 65.
53. *Lady Gregory's Journals, 1916-1930*, ed. Lennox Robinson (London: Putnam & Co., 1946), p. 159.

George Moore also favoured continuing the work of the Irish Literary Theatre by creating a stock company of Irish actors under the direction of Frank Benson. According to Moore's plan, this company would perform in Dublin for six weeks of the year, touring Ireland the rest of the time with productions of Spanish, Scandinavian, French, and Greek plays.[54] Moore's plan was derived from Continental models; but unlike that of Martyn, it was not motivated by any deep-rooted sense of Irish nationalism. Nor was he devoted, like Yeats, to the creation of a theatre reflecting any particular social, religious, or aesthetic ideals. In spite of his sporadic protestations against or on behalf of one theatrical cause or another, Moore was, in fact, not at all a true man of the theatre. He was and always remained a man of letters who preferred to read rather than see plays enacted.[55]

It is not surprising that *Diarmuid and Grania* remained Moore's last serious involvement with the Irish dramatic movement. He would not have been Moore, of course, without severing his connection with a quarrel. This occurred when Moore tried to prevent Yeats from writing the play *Where There is Nothing* (1902), claiming that he [Moore] had first conceived the plot. Yeats not only finished the play but rushed it into print. Thereafter, he and Moore looked upon one another with mutual distrust.[56]

Once apart from Yeats, Moore's enthusiasm for the Celtic Renaissance rapidly cooled.[57] He resumed his more natural stance of ironic detachment, recording his impressions of the passing scene with apparently never-failing fascination. *Hail and Farewell* was the result—a personal record of his entire involvement with the Irish literary and dramatic movement, in which he cast a mocking eye on:
a) folk literature: "If a story be told three or four times by different people it becomes folk."[58]

54. "The Irish Literary Theatre", *Sambain* Number One, pp. 5-13.
55. Moore declared that "plays read to me exactly as they act—only better". *Impressions and Opinions*, p. 163.
56. *Autobiographies*, p. 453.
57. In 1908, still in Dublin, Moore wrote to Edward Dujardin in Paris: " 'The Celtic Renaissance' ... does not exist, it is a myth, like a good many other things." *Letters of George Moore to Edward Dujardin, 1886-1922*, ed. with an introduction by John Eglington (New York: Crosby Gaige, 1929), p. 64.
58. *Hail and Farewell, Ave*, p. 142.

b) epic heroes: "Heroes are dependent upon chroniclers and Ireland never produced any, only a few rather foolish bards."[59]

c) racial superiority: "All races are the same; none much better than another; merely blowing dust; the dust higher up the road no better than the dust lower down."[60]

d) literary movements: "A literary movement consists of five or six people who live in the same town and hate each other cordially."[61]

e) Yeats and peasant lore: "I don't think that one can acquire the dialect by going out to walk with Lady Gregory. She goes into the cottage and listens to the story, takes it down while you wait outside, sitting on a bit of wall, Yeats, like an old jackdaw, and then filching her manuscript to put style upon it, just as you worked to put style on me."[62]

Yeats had very good reason to dub Moore "the Aristophanes of Ireland".[63]

NEW DIRECTIONS WITH AN IMPORTANT QUALIFICATION

The end of the Irish Literary Theatre left Yeats puzzling over his future in the theatre, both in terms of his personal ambitions as a dramatist and his ideals for the Irish dramatic movement as a whole. In *Samhain* Number One (October 1901) Yeats outlined two alternatives as he saw them. One was to create a stock company on the Continental model as advocated by Martyn and Moore; the other was to build an Irish theatre from the ground up by giving plays to a company of Irish players organized and trained by Willie and Frank Fay.

Yeats declared that he had not yet made up his mind which if either of these alternatives to support. He was weary of organizational work, he said, and desirous of getting back to the work of a pure man of letters, putting "the old stories" and "the heroic age" into verse.[64] A closer look, however, reveals that although Yeats may have longed for the

59. Ibid., p. 5.
60. Ibid., p. 153.
61. Ibid., *Vale*, p. 117.
62. Ibid., *Ave*, pp. 348-49.
63. Eglington, Introduction to *Letters of George Moore to Edward Dujardin*, p. 6.
64. *Samhain* Number One, pp. 5-6. Cf. *Autobiographies*, p. 447.

peace and quiet of the study, every other influence and im-
pulse in his life was drawing him irrevocably towards a more
active involvement in the theatre.

One of the strongest impulses in this direction was Yeats's
rejection of the manufactured romance of the Celtic Renais-
sance in favour of a more authentic expression of Irish life.
This was evident as early as 1898 when, advising George Rus-
sell to join Horace Plunkett's Farm Co-operative Movement
as a travelling agent in the country districts of Ireland, Yeats
declared: "if we would express Ireland we must know her to
the heart and in all her moods."[65] Yeats had himself already
set out to do this very thing with the help of Lady Gregory.
Despite the mockery of George Moore, it was she who by
taking Yeats from cottage to cottage in search of folklore
reintroduced him to the authentic spirit of Gaelic-speaking
Ireland. In doing so Lady Gregory showed Yeats that he need
not graft mysticism and symbolism onto an Irish tree; these
were already inherent in a living Irish folk tradition if he
would come to know and express it.

Within the context of the theatre, Yeats was deeply im-
pressed by the powerful impact that Martyn's peasant char-
acter Peg Inerny had upon an Irish audience. To him, she
personally "typified Ireland",[66] and in the second issue of
Beltaine he went to some lengths to explain her roots in
peasant folklore and in the spirit of old peasant women still
living in the west of Ireland.[67] With the enthusiastic response
to *Casadh an t-Sugain*, Yeats had all the proof he needed that
an authentic peasant drama drawn directly from the life and
folklore of Gaelic Ireland might provide the base upon which
to build a popular Irish theatre.

It is particularly significant that the first issue of *Samhain*,
which contained the farewell addresses, as it were, of Martyn
and Moore, also contained Lady Gregory's translation of
Casadh an t-Sugain, The Twisting of the Rope. The publica-
tion of *The Twisting of the Rope* marked the beginning of a
whole new direction for the Irish dramatic movement. By

65. Letter to George Russell (January 22, 1898), *Letters*, p. 294.
66. Memorandum for Abbey Theatre Patent Enquiry (1904), preserved in N.L.I.
 Ms. 13068.
67. " 'Maeve' and Certain Irish Beliefs", *Beltaine* Number Two, pp. 16-17.

translating—perhaps transliterating would be a better term—
directly from Irish into an idiomatic English Lady Gregory
created a vibrant new dramatic language, braced with the
passion and earthiness of actual life yet eloquent in its ex-
pressiveness, that was to become one of the trademarks of
the Irish dramatic movement and serve as a model for the
more lyrical peasant dialogue later developed by Synge.[68]
The Twisting of the Rope also introduced the first of a long
series of romantic poet-tramps who were to crowd the pages
of Irish drama from Lady Gregory, Synge, and Yeats himself
on down to Samuel Beckett.

Lady Gregory thus announced herself as a powerful new
creative presence in the Irish dramatic movement. Moreover,
her belief in "a theatre with a base of realism, with an apex
of beauty"[69] was identical with Yeats's own idea of a theatre.
Working in collaboration with Lady Gregory, Yeats, as we
shall see, now turned from the heights of symbolist and ritu-
alistic poetic drama to a more realistic dramatic form which
took its roots from the life of the peasantry.

A second point to note is the change in Yeats's ideas about
the composition of an ideal audience for the Irish theatre.
Yeats, of course, was never as insensitive to the plaudits or
rejection of the crowd as he often pretended to be.[70] He
confesses that at the time when he was involved in the work
of the Irish Literary Theatre he "felt acutely" his own un-
popularity.[71] Part of the reason for this unpopularity came
from a misunderstanding of what Yeats meant when he wrote
about desiring a "limited public", a "theatre for ourselves
and our friends".[72] Critics such as Frank Fay pounced upon

68. According to Lady Gregory, when her *Cuchulain of Muirthemne* was pub-
 lished Synge told Yeats that in it he was amazed to find the dialect he had
 been trying to master. *Our Irish Theatre*, p. 124.
69. Lady Gregory, *The Collected Plays of Lady Gregory*, Vol. I, ed. Ann Saddle-
 myer (Gerrard's Cross: Colin Smythe, 1970), p. 262.
70. Yeats, for instance, was irritated by the reactions of three members of an audi-
 ence for *The King's Threshold* when it was performed at the Court Theatre in
 London. One, he said, was "obviously bored, yawning and stretching"; the
 other two "only interested in the superficial aspects of the production". When
 he recalled the performance of the play, however, he could not get "that
 bored man" out of his mind. As a result, he shrank from sending his muses
 where they were "but half welcomed". *Four Plays for Dancers* (London:
 Macmillan, 1921), p. 86.
71. *Autobiographies*, p. 432.
72. *Beltaine* Number One, pp. 6-7, 21.

such statements as evidence that Yeats intended to cater mainly for the "monied classes". With his own troupe of politically minded Thespians in mind, Fay argued in the pages of *The United Irishman*, the organ of what was to become the Sinn Fein Party under the leadership of Arthur Griffith, that among the supporters of the burgeoning nationalist movement existed a potentially far more vital audience for Irish drama if Yeats would only seek it out.[73]

Yeats evidently came to believe this himself, to judge from his positive reaction to the popular interpretation of *The Heather Field* and *Maeve* as political allegories.[74] For all his later qualms about *The Bending of the Bough*, at the time of its production Yeats was tremendously exhilarated by the political impact of the play. He declared in a letter to Lady Gregory that it was "a splendid and intricate gospel of nationality", which would be "almost epoch-making in Ireland".[75] During performances Yeats took particular note of the fact that the cheapest parts of the house were loudest in applause. *The Bending of the Bough* "touched the heart as greater drama on some foreign theme could not", because the audiences shared "those interests common to the man of letters and the men in the crowd".[76] Indeed, Yeats claimed some of the credit for this success himself, as Moore had elicited his aid with speeches drawing parallels to specific political situations in Ireland.[77]

Yeats had further proof of the theatrical power of patriotic passion in the volatile responses both on behalf of *Casadh an t-Sugain* and against *Diarmuid and Grania*. From the very outset of the Irish literary and dramatic movement he had, of course, dreamed of tapping such patriotism in

73. Vide "Mr. Yeats and the Stage" (May 4, 1901), "The Irish Literary Theatre" (November 23, 1901), reprinted in *Towards a National Theatre*, pp. 52, 86.

74. *Autobiographies*, pp. 417, 430. In his Memorandum for the Abbey Theatre Patent Enquiry Yeats described *Maeve* as an allegory in which Maeve represented "Ireland wavering between her religious ideal, her spiritual dreams and the material civilisation of England. The audience showed itself a very clever audience by very quickly understanding this."

75. (December 21, 1899), *Letters*, p. 332. In his *Autobiographies* Yeats said that *The Bending of the Bough* was "badly constructed, had never become a single thought or passion, but was the first dramatization of an Irish problem." p. 430.

76. *Beltaine* Number Three (April 1900), pp. 4-5.

77. *Autobiographies*, p. 430.

order to create a more imaginative and self-sacrificing love of Ireland. Now the opportunity presented itself for continuing the dramatic movement on a path which fulfilled these earlier ambitions—with plays drawn more immediately from the life of Ireland and actors and audiences from the supporters of the nationalist movement. In the light of these factors Yeats's chief objection to the idea of creating a stock company of actors under the direction of Frank Benson becomes significant: "it could not touch on politics, the most vital passion and interest in the country."[78]

The final but perhaps most important point for us to note is that at the close of the Irish Literary Theatre experiment Yeats had yet to see his plays adequately performed. This was because he had not found any actors, except for Florence Farr, who were capable of speaking verse with the meticulous sensitivity to sounds and rhythms demanded for his plays, or designers, stage technicians, and directors capable of transforming his dramatic conceptions into appropriate theatrical images.

Unlike Martyn and Moore—or indeed any of the would-be literary reformers of the English theatre except Shaw—Yeats was a man with a driving determination to realize his dramatic ideals not merely on paper but within the context of the theatre. It was inevitable, therefore, that he should choose to continue his work in a format which would provide him with a means of experimenting with actors and with the arts of the theatre. For the extraordinary kind of drama that Yeats sought to create he needed, in fact, a theatrical laboratory through which he might transform himself from a man of letters into a complete man of the theatre.

The company organized by Frank and Willie Fay appeared to be capable of fulfilling that need. Seeing them in August 1901—two months before the final series of the Irish Literary Theatre—perform an old-fashioned historical melodrama by Alice Milligan, Yeats forgot about the time-worn conventions of the play and its tawdry production when he heard the Irish voices trained by Frank Fay: "I came away with my head on fire. I wanted to hear my own unfinished On Baile's Strand, to hear Greek tragedy spoken with a Dublin accent."[79]

78. Samhain Number One, p. 5.
79. Autobiographies, p. 449.

The Irish Literary Theatre, founded upon Continental theories and models applied to Irish life, had clearly failed after its three-year trial. That failure was due mainly to the fact that it was, in the worst sense of the word, a "literary" theatre, created by men of letters with only an abstract awareness of the life they were attempting to imitate and only an armchair knowledge of the full theatrical implications of what they were attempting to do. Yeats was deeply conscious of these errors, perhaps even more deeply aware of the fact that, to a large extent, he was responsible for them. Wagner, Villiers, and Maeterlinck might provide valid sources for many of his own dramatic ideals, but Yeats realized that he must create a dramatic form, indeed an entire conception of the theatre, in terms of the actual theatrical artifacts at his disposal. From this time on, we shall see that Yeats's theories of the drama rose out of his practical experience in the theatre.

Yeats drew only one firm qualification among the opinions that he publicly ventured at the time. "It is of the utmost importance," he declared in *Samhain* Number One, "that those among us who want to write for the stage study the dramatic masterpieces of the world. If they can get them on the stage, so much the better, but study them they must if Irish drama is to mean anything to Irish intellect." Commenting on the possible development of a company led by the Fays, Yeats again noted that, although we might have to wait, "we would get even the masterpieces of the world in good time."[80]

Yeats thus turned with open eyes to an involvement with "W. G. Fay's National Dramatic Society"[81] However, he served notice of his intention to remain above his subject with the warning remarks that he made to the Irish nationalists and to the Fays in particular. At the time little attention was paid to them; but, to Yeats, all that they implied remained forever at the heart of his concept of the Irish dramatic movement. Indeed, from his standpoint, the success or failure of the Abbey Theatre was ultimately to rest upon his attempt to bring this concept to life.

80. *Samhain* Number One, pp. 8, 11.
81. This was the pretentious title that Willie Fay bestowed upon his little troupe. Robinson, *Ireland's Abbey Theatre*, p. 27. Yeats's qualms about involving himself with Fay and his followers are expressed in a letter sent to Lady Gregory on April 10, 1900, in which he declared that if it were necessary to prove his sincerity to the nationalists by making himself "unpopular to wealth" he would have to accept "the baptism of the gutter". *Letters*, p. 339.

The Fays and the Early Abbey Theatre

It is perhaps natural that literary historians and critics tend to devote far more attention to dramatists than to the theatre artists or theatrical conditions which may have been responsible for bringing those dramatists to light. When the dramatists themselves are among the chief historians and critics of a movement it is even more likely that a not wholly accurate impression of that movement may emerge. Such is the case with regard to the contributions of W. G. and Frank Fay to the Irish dramatic movement and, in particular, the creation of the Abbey Theatre.

From the outset it should be made clear that, quite rightly, neither of the two Fays looms large in the overall context of twentieth-century theatre. Both were limited by their intellectual capacity, their educational background, their basic talent, and their training in the theatre. Notwithstanding all this, any examination of the early Abbey Theatre would be far from complete without exploring the life and work of the Fays. Without their efforts the Abbey Theatre simply would not have come into existence. Without their individual personalities and particular talents the playwriting efforts of Yeats, Synge, and Lady Gregory would have taken entirely different courses.

In a wider sense, however, the Fays are of interest and importance because the theatrical ideas and traditions that

they represented ultimately came into conflict with the loftier literary and theatrical ideals of W. B. Yeats. In exploring the conflicts between the Fays and Yeats one can begin to see not only some of the reasons why the Abbey Theatre developed into the kind of theatre it did, but why men of the theatre and men of letters have, by and large, had a relatively unhappy relationship throughout the twentieth century.

A COLLABORATION OF OPPOSITES

In many respects the work of the Fay brothers reflects the fruitful collaboration of opposite forces and natures that was such a marked characteristic of the *Zeitgeist* of Dublin at the turn of the century. According to the writer T. G. Keller, who was a member of the Irish National Theatre Society in its earliest days, while Willie Fay was "the incarnation of the seemingly easygoing, take-it-as-comes, nature", Frank was "cautious, careful, anxious almost to a fault".[1]

Perhaps the basic difference between the two brothers is most clearly indicated by the fact that at the same time that Willie Fay was traipsing about the Irish countryside gaining practical experience in the theatre, Frank was settling into a relatively comfortable position as secretary to the director of a Dublin firm of accountants and in his spare time pursuing a more scholarly study of the history and aesthetics as well as the practical arts of the theatre.

Willie Fay (1872-1947) commenced his professional career in 1891 when, after a brief round of "do-at-home" and amateur theatricals and an even briefer period of study with an ex-professional actress named Maud Randford, he ran away from home to join one of the troupes of wandering Irish players known as "fit-ups". (The name "fit-up" is derived from the fact that these small theatrical companies were prepared to set—or "fit"—up a simple stage on short notice in any Irish country town.) Willie Fay set out to become not just an actor or stage director but a complete man of the theatre. During his theatrical apprenticeship he either studied or worked as a draughtsman, an electrician, a stage-lighting technician, an advance-man for a circus, a scene painter, and

1. T. G. Keller, "The Irish Theatre Movement—Some Early Memories", *Sunday Independent* (January 6, 1929).

even a song-and-dance man. In six years on the road with various companies, playing four or five one-act plays per night followed by variety items and concluding with a farce, Willie Fay acquired the rudiments of theatrical know-how that he was to apply for the rest of his career.[2] Much of this experience was doubtless of the rough workmanlike sort, but by the time he resettled in Dublin in 1897 Fay certainly had as complete a knowledge of the technical skills of the theatre as many an M.A. in drama.

One cannot help wishing, however, that Willie Fay's intellectual development had kept pace with his mastery of theatrical skills. Following elementary school Fay entered Belvedere College, Dublin, later to be immortalized by James Joyce in *A Portrait of the Artist as a Young Man.* Fay left Belvedere College at the age of sixteen, having taken by his own admission no interest in any subject which did not pertain to the theatre. Fay's education was, in fact, based almost entirely upon his rather haphazard private reading. By the age of eighteen he claims to have read most of the great classics of the English theatre—Beaumont and Fletcher, Ben Jonson, Marlowe, Dekker, and Dryden—but "without the least idea that they were of great importance either as drama or literature".[3] Not surprisingly, the Irish literary revival of the nineties hardly touched him except by arousing a faint hope that plays on Irish life might someday be written. "Poetry was not my strongest point," he confesses, and his brother Frank virtually had to drag him to the first performance of *The Countess Cathleen.*[4]

Although the formal education of Frank Fay (1870-1931) was even more limited than that of his brother, as early as twelve years of age he may have begun the extraordinary interest in theatre history, particularly the history of speech and acting, that was to remain his passion for a lifetime.[5] By

2. W. G. Fay and Catherine Carswell, *The Fays of the Abbey Theatre* (London: Rich and Cowan, 1935), pp. 16, 27-28, 30, 36, 52-53, 59, 92.

3. Ibid., p. 11.

4. Ibid., p. 110.

5. Vide articles on the theatre dating back to 1882 compiled by Frank Fay and listed by Joseph Holloway in *Impressions of a Dublin Playgoer* (June 28, 1915), N.L.I. Ms. 4456, pp. 1471-73.

collecting and reading every book and article on the theatre that he could lay his hands on, Frank Fay built up an encyclopedic knowledge of productions, acting styles and techniques, and biographical miscellanea concerning theatrical personalities past and present.[6] Yeats described Fay as someone who "knows more than any man I have ever known about the history of speech upon the stage".[7] Moreover, Yeats borrowed books and articles from Fay for his *Samhain* articles on "The Reform of the Stage"[8] and stated that he hoped to give his own "vague principles definite knowledge" through Fay's knowledge of the history of the theatre.[9]

It was mainly through his interest in the history of acting styles that Frank Fay began the serious study of speech techniques. He became convinced that all good acting and speaking depended on proper voice production, and he determined that he would produce a good speaking voice in himself by employing the techniques utilized by the great Italian singing masters.[10] Through a systematic series of exercises, which he was later to employ as a teacher,[11] Fay succeeded in turning his basically weak voice into a beautiful instrument that was undoubtedly his chief strength as an actor.[12]

6. Dr. Constantin Curran, a close friend of Fay's, recalled for me an instance in which Fay proved an academic point about eighteenth-century staging by going to Curran's bookshelves and showing the changes in editions of Sheridan's work which had led to confusion. Interview with Dr. Curran (April 26, 1966).

7. Letter to *The Academy and Literature* (May 16, 1903), quoted in *J. M. Synge* by David Greene and Edward Stephens (New York: Collier Books, 1961), p. 130.

8. Letter from Yeats to Frank Fay (August 8, 1903), *Letters*, p. 408.

9. Letter from Yeats to Frank Fay (August 28, 1904), ibid., p. 440.

10. *Fays of the Abbey Theatre*, p. 32.

11. Information from Gerard Fay, Interview (July 19, 1966). In an interview, Sara Allgood said that, in teaching voice production, "Frank Fay emphasised clearness of speech, strength without loudness, and particularly the greatest possible tone variety." Udolphus Wright, who was with the Abbey Company from 1902, supplied additional information about Fay's methods: "He would make us sound a's and o's for hours, raising and lowering the key. He insisted on distinct final d's and t's. The ends of our sentences had to be well out. Sharp! He saw to it that we took breathing exercises." Andrew J. Stewart, "The Acting of the Abbey Theatre", *Theatre Arts*, XVII (March 1933), p. 245.

12. *Fays of the Abbey Theatre*, p. 33.

Frank Fay's practical theatre experience was relatively slight compared with his brother's. However, as a natural outgrowth of his self-training in speech he began to make public appearances as a practitioner of that quaint Victorian form of popular amusement, the dramatic recitation. When Willie Fay organized a small group of friends and relatives for "do-at-home" theatricals, Frank was drawn in, at first to provide entr'acte entertainment by contributing recitations. Later, on his brother's return to Dublin in 1897, he found himself an active member and teacher of a company of amateur Thespians who were to develop into the Irish National Theatre Society.[13]

Frank Fay's relationship with his brother Willie seems to have been unusual for a successful theatre partnership. Although in matters of literature he was Willie's acknowledged mentor—Willie credited reading and discussion of Frank's collection of old plays with having first aroused his own interest in the theatre—Frank preserved a deference to Willie's judgment in almost all theatrical matters other than acting. Then as now, apparently, professional experience in the theatre was enough to awe the humble amateur into reverence. According to the actor Dudley Digges, Willie's contact with the profession "lifted him to heights poor Frank never hoped to reach. He always spoke of Willie with bated breath, and what the brother said was gospel, for he had had experience."[14] In Padraic Colum's opinion it was indeed only by Frank Fay's enhancement of Willie's prestige "continuously and voluntarily" that Willie was able to stabilize a group of individualistic Dubliners long enough to create a base for a national theatre.[15]

It would be a mistake, however, to think that Frank Fay was in any way backward about expressing his opinions. To T. G. Keller he was the "Napoleon" of their little theatre group. "His word was law, and, loyally aided by his brother, he saw that it was carried out."[16] On any subjects not concerned with the theatre it was the habit of Willie Fay at all times to refer final judgments to "the brother".[17]

13. Ibid., p. 16.
14. Dudley Digges, "A Theatre Was Made", *The Irish Digest* (October 1939), p. 14.
15. Padraic Colum, "Early Days of the Irish Theatre", *The Dublin Magazine* (October-December 1949), p. 15.
16. "The Irish Theatre Movement—Some Early Memories".
17. Nic Shuibhlaigh and Kenny, *The Splendid Years*, p. 8.

From July 1899 to November 1902 Frank Fay gave public utterance to his theatrical ideas as the drama critic of *The United Irishman*. His reviews, which range from contemptuous attacks on the neo-Boucicaultian Irish melodramas of J. W. Whitebread at the Queen's Theatre to well-considered appraisals of Constantin Coquelin in Molière and Rostand, Madame Réjane in Ibsen, and Mrs. Patrick Campbell in Maeterlinck and Pinero, provide one of the best records of what the Dublin theatre was really like at the turn of the century. They also provide an indication of what the future acting style of the Abbey Theatre was to be, especially in Fay's criticism of unnecessary movement, his admiration for the economy with which Coquelin produced stage effects, and his increasing impatience with slovenly diction.[18]

Supremely self-confident, forthright, and arrogant as he appeared to those who worked with him,[19] Frank Fay did not hesitate to clash even with Yeats, Synge, or Lady Gregory if his views differed from theirs. In an article written for *The United Irishman* in May 1901,[20] when all his hopes depended on drawing the attention and favour of Yeats to the little troupe of amateur players trained by himself and his brother, Frank Fay attacked Yeats head on, telling him exactly where he thought he was going wrong, not only in his conception of an Irish National Theatre, but in his own work as a dramatist.

"An Irish Theatre must, of course, express itself solely in the Irish language," Fay began; but, recognizing that "for some time to come it will be in English", he warned Yeats that as a dramatist who wished to write plays for a National Theatre he must avoid "certain pitfalls". "Firstly," said Fay,

such plays should be so written as to appeal to as large a section of his countrymen as possible; otherwise no good can result to us from their production. . . . Mr. Yeats can, undoubtedly, be an immense power for good in our Theatre (why should he not act, at any rate in his own plays? Jean Richepin did in Paris); but if he insists on sitting among the stars or living in the land of feary [sic] of which he and I and all our countrymen are only too fond, he can be of no use to us at present.

18. Vide Robert Hogan, Introduction to *Towards a National Theatre*, pp. 8-9.
19. "It is mighty hard to pull with them [the Fays], their tempers are vile and they treat those under them like dogs." Joseph Holloway, *Impressions of a Dublin Playgoer* (September 21, 1906), N.L.I. Ms. 1804, pp. 425-26.
20. *Towards a National Theatre*, pp. 50-53.

Fay went on to criticize Yeats's form and style as a dramatist. Highly poetic plays such as *The Countess Cathleen* and *The Land of Heart's Desire* reminded him of "exquisitely decorated corpses". Yeats was "too much the artist in words", said Fay. "His appeal would be stronger were his form less polished." What Yeats needed most was to write on "more vigorous themes. Let him emulate Shakespeare and Molière and Ibsen whose plays, while not lacking in poetry, are living things." Far more the nationalist than his brother, Fay argued:

In Ireland we are at present only too anxious to shun reality. Our drama ought to teach us to face it. Let Mr. Yeats give us a play in verse or prose that will rouse this sleeping land. There is a herd of Saxon and other swine fattening on us. They must be swept into the sea along with the pestilent breed of West Britons with which we are troubled, or they will sweep us there.

One wonders how much influence this article had upon Yeats, whose next play, the fervently patriotic *Cathleen ni Houlihan*, was given its first production by W. G. Fay's National Dramatic Society less than a year later.

Unfortunately, Frank Fay's soaring enthusiasms had their negative counterparts in his personality. According to his erstwhile friend, Joseph Holloway, Fay was inclined to fall into deep fits of depression, "ever dissatisfied with his own work".[21] Fay was also inordinately sensitive to criticism, and did not easily brook opposition. Too often he carried his querulous and quixotic temperament into the rehearsal room, where he was not usually amenable to coaching except by his brother. Holloway, for instance, notes a rehearsal when Lady Gregory was attempting to direct Fay in a scene from *The White Cockade*: "Mr. F. J. was in one of his moods and when with great clearness and dramatic effectiveness (for the dramatic instinct is strongly defined in her) Lady Gregory showed Fay how she would like a particular passage delivered, Fay turned crusty and sulked at it, saying it was out of the mood of the role and adding that if she wished to make Sarsfield a comedy part he would play it as such! After much

21. *Impressions of a Dublin Playgoer* (June 28, 1915), N.L.I. Ms. 1803, p. 491.

talk and explanation Frank Fay went half-heartedly through the passage."[22] Other instances of Fay's temperament in re-hearsal sessions were noted by Synge and again by Holloway when Yeats attempted to coach him in *On Baile's Strand* for the opening production of the Abbey Theatre. Holloway writes: "Frank Fay, I thought, would explode with suppress-ed rage at his [Yeats's] interruptions during the first speeches he had to utter."[23]

Both Fays had violent tempers, and their eruptions against each other were just as frequent and violent as against their fellow actors. At one rehearsal for A. E.'s *Deirdre*, Willie and Frank became so angry that they flew at each other with fists flying. One of the lines of the play was "I foresee that the Red Branch will go down in a sea of blood", which A. E. quickly changed to "I foresee that the National Theatre Soci-ety will go down in a sea of fists".[24]

When working in harmony, however, the Fay brothers made a formidable team. Like many other famous theatri-cal partnerships—Nemirovich-Danchenko and Stanislavsky, Granville-Barker and Vedrenne, Hilton Edwards and Micheál MacLiammoir, Yeats and Lady Gregory themselves—they were that ideal combination of the theorist and the doer. Introspective, scholarly, and abstract in his nature, Frank Fay needed the down-to-earth pragmatism of his brother to gal-vanize him into decisive action. In turn, Willie Fay needed the ideas, ideals, and dedication of his brother in order to create a focus and structure for his own talents to function most effectively. Stimulated by each other, as a team the Fay brothers were able to communicate their enthusiasm and ideals to a most unlikely group of amateurs and, by dint of hard work, turn them into a company of some accomplish-ment.

22. Ibid. (October 25, 1905), N.L.I. Ms. 1803, p. 620.
23. Ibid. (October 31, 1904), N.L.I. Ms. 1802, p. 452. Cf. Letter from Synge to Lady Gregory (September 11, 1904) complaining about the difficulty of rehearsing Frank Fay. *Some Letters of John M. Synge to Lady Gregory and W. B. Yeats*, Edited by Ann Saddlemyer (Dublin: The Cuala Press, 1971), pp. 9-10.
24. Colum, "Early Days of the Irish Theatre", p. 16.

A THEATRE FOR PLAYWRIGHTS

Poets such as Padraic Colum, George Russell, and James Cousins have testified that the Fays urged them to write plays for their little company.[25] In addition, instead of simply taking a playwright's script off his hands, leaving him with no further theatrical involvement until the opening night, the Fays made it clear that they wanted the playwright to function as an active collaborator in their work, using rehearsals as a means of testing and developing dramaturgical conceptions. An effort was thus consciously made to bridge the gap between literature and theatre, with playwrights and actors sharing each other's problems and striving for similar artistic goals.[26] It is notable that even the playwright members of W. G. Fay's National Dramatic Company were required to undergo "a gruelling course of 'voice production' " at the hands of Frank Fay.[27]

The fact that their company was composed of amateurs was seen as an advantage rather than a disadvantage by the Fays. With André Antoine's Théâtre Libre as an inspiration for what might be accomplished by a troupe of trained amateur actors devoted to serving new playwrights, Frank Fay declared to Yeats: "I revel in the word amateur and have never posed as anything else. . . . I think it would be a mistake . . . for the acting portion of the Society to model themselves on the professional except doing to the best of one's ability what we have set out to do."[28]

Yeats, in turn, upon first seeing the Fays' company, was struck above all by their respect for the playwright. This was evidenced, he said, by the fact that "the actors kept still long enough to give poetical writing its full effect upon the stage".[29] Upon the opening of the Abbey Theatre in 1904, X
Yeats took pains to emphasize the fact that amateur actors with a devotion to their own art and the art of literature had

25. Vide Cousins and Cousins, We Two Together, pp. 67, 72; Colum, "Early Days of the Irish Theatre", p. 25; Denson, Letters from A.E., p. 97; Fays of the Abbey Theatre, pp. 115-18.

26. Unpublished letter from Frank Fay to Yeats (December 15, 1902), N.L.I. Ms. 13068. Cf. Cousins and Cousins, We Two Together, p. 67; Nic Shuibhalaigh and Kenny, pp. 23, 35.

27. Seumas O'Sullivan, The Rose and Bottle and Other Essays (Dublin: The Talbot Press, 1946), p. 122.

28. Unpublished letter to Yeats (August 16, 1902), N.L.I. Ms. 13068.

29. Explorations, p. 86.

throughout history exerted a profound influence upon the course of the drama:

The Mystery Plays and the Miracle Plays got their players at no great distance from the church door, and the classic drama of France had for a forerunner performances of Greek and Latin classics, given by students and people of quality, and even at its height Racine wrote two of his most famous tragedies to be played by young girls at school. . . . When the play is in verse, or in rhythmical prose . . . a company of amateurs, if they love literature, and are not self-conscious, and really do desire to do well, can often make a better hand of it than the ordinary professional company.[30]

It soon became evident, however, that while in theory Yeats and the Fays agreed on many of the same objectives and even the means of realizing them, there were considerable differences in their ideas of what kinds of playwrights ought to be produced by the Irish National Theatre Society. Essentially, their differences boiled down to a conflict between Yeats's ideal of plays "written in the spirit of literature"[31] and the Fays' search for "plays that will act".[32]

We have discussed Yeats's idea of a "literary" theatre in some depth. It is important in order to see the picture as a whole to have a clearer idea of what the Fays had in mind when they spoke of a "theatrical" theatre.

THE IDEA OF A THEATRICAL THEATRE

For both Willie and Frank Fay, the basic idea of a good play sprang from their concept of what constituted effective theatre. Weaned on the grandiloquent productions and acting styles of the famous English touring companies who came to Dublin in their youth,[33] neither of the Fays ever lost his

30. Ibid., p. 128.
31. Ibid., p. 164.
32. Unpublished letter from Frank Fay to Yeats (December 15, 1902), N.L.I. Ms. 13068.
33. Willie Fay recalled that one of the most important parts of the theatrical education of Frank and himself was derived from the sixpenny gallery of the Gaiety Theatre and an occasional visit to the shilling pit of the Queen's. When "special stars" such as Beerbohm Tree, Osmond and Edmund Tearle, Lewis Waller, Fred Terry, Mr. and Mrs. Kendal, the Bensons, Edward Compton, and his wife Virginia Bateman came to Dublin, "by hook or by crook we managed three or four nights". *Fays of the Abbey Theatre*, p. 19.

admiration for the kind of theatrical experiences they provided.

As the Fays saw it, the actor and not the playwright occupied the foremost position in the theatrical hierarchy. "The actor comes first in the theatre," declared Frank Fay. "Everything exists to show him off. He has very foolishly allowed the decorator and writer of plays to shove him into the background and that's largely what's wrong with the theatre."[34]

Fay carried his love of the sheer histrionics of the theatre to near fanaticism. His notebooks were crammed with clippings, articles, and personal comments on the great actors of the past as well as those he had seen in person. The latter included Henry Irving, Mr. and Mrs. Kendal, Charles Wyndham, J. L. Toole, Beerbohm Tree, Charles Hawtree, Wilson Barrett, and the touring companies of Edward Compton, the Bensons, and Louis Calvert, as well as the actresses Bernhardt, Réjane, and Duse, and particularly the great French actor who became Fay's idol and model in many respects, Constantin Coquelin.[35]

Like many a devotee and connoisseur of the art of acting, Frank Fay's delight in performers extended beyond the legitimate theatre to include mimists, clowns, verse reciters, dancers, and variety or music-hall artists. For Fay the music-hall review was, in fact, the last vestige of a pure form of theatre wherein the actor was asked simply to entertain his audience. "Review," he said, "is the theatre's answer to the literary man who for some years has turned the theatre into a lecture hall."[36]

In Fay's opinion, and it was this opinion that for a time made him hope in Yeats as a verse dramatist who would be the chief glory of the Irish National Theatre, a kiss of death had been bestowed upon the modern theatre by playwrights who had forgotten how to write vivid and vibrant language for the stage. "The old dramatists," said Fay, "know what the modern don't or ignore—the value of sound—Shakespeare more than any other because he was also an actor and gave

34. Letter from Frank Fay to Bache Mathews (August 8, 1926), Fay Papers, N.L.I. Mss. 10951-52.
35. Lectures and scrapbooks of Frank Fay, ibid., Mss. 10951-53.
36. Untitled essay on the traditions of English acting preserved in "Lectures and Articles on the Theatre by Frank Fay", ibid., Mss. 10951-52.

actors opportunity to use it. . . ."[37] And again: "The man of words has had a long innings—I mean preachers—and the actor has been merely a mouthpiece of ideas. The type of play written by Tom Robertson and by Boucicault (actors both) which gave acting opportunities all along must be rediscovered."[38]

The decline of great acting roles meant far more to Fay than a simple decline in the quality of plays. He went so far as to blame the decline of popular interest in the theatre throughout the early part of the twentieth century on the fact that the stock companies with star-personality actors had gone out of fashion. "When I began playgoing," Fay recalled in later years, "people were keenly interested in actors and in plays, thanks to the acting of many generations of stock companies. How the older generation of actors were loved by their audiences. The theatre of today appears to be on its last legs, and the Cinema has thoroughly got hold of the entertainment-seeking public."[39]

What Fay grew to hate most in the modern theatre was the diminution of sheer theatricality brought about by realism. In his opinion, not only did realism severely restrict the actor's deployment of voice, gesture, and movement on the stage, it also greatly diminished other theatrical appeals, such as the elaborate scenic devices which had been exploited by theatre managers for the delectation of nineteenth-century audiences. Fay recalled with enjoyment, for example, a small locomotive which came across the stage in a pantomime of *Gulliver's Travels* which he had seen as a boy: " 'What was it doing there?' says the realist of today. What does it matter? Anything may happen in Pantomime. Realism—or what is mistaken for realism—was kept in its place then—outside the theatre. Since it got into the theatre the dry rot has set in."[40]

Obviously, Frank Fay placed slight value on the intellectual or literary quality of plays.[41] Indeed, he proclaimed his admiration for the works of Shakespeare, Sheridan, and Goldsmith in the same breath as such "famous old plays" as *Black*

37. Ibid.
38. Letter to Bache Mathews (October 9, 1926), Fay Papers, N.L.I. Mss. 10951-52.
39. Essay on the traditions of English acting.
40. Ibid.
41. *Fays of the Abbey Theatre*, p. 173.

Eyed Susan, The Corsican Brothers, The Hunchback of Notre Dame, Rip Van Winkle, and Browning's *A Blot on the Scutcheon.*[42] When similarly arbitrary judgments were applied to plays chosen for production by the Irish National Theatre Society controversies between Yeats and himself inevitably arose. The first of these occurred as early as September 1902 when the Fays sought to produce a play by James Cousins that Yeats considered to be "vulgar rubbish".[43] Defending their choice, Frank Fay argued to Yeats that new plays should not be criticized harshly so long as they would "act".[44] In 1907, a few months before leaving the Abbey Theatre, Fay complained to his friend the theatre historian W. J. Lawrence about the "effeminate artistry" that Yeats had brought into the Irish dramatic movement. "I declare I loathe the Wagners, Ibsens, Maeterlincks and other people with messages," said Fay. "This rotten self-conscious age gets on one's nerves with its conceited self-analysis."[45]

Frank Fay had at first been a champion of Yeats's plays; but his brother never considered Yeats to be a stageworthy dramatist.[46] Among the plays performed during the early years of the Irish dramatic movement Willie Fay most preferred the second-rate peasant comedies of William Boyle. This was because Boyle had "theatre sense"—meaning, as Willie Fay put it, the power to establish "fellowship with an audience".[47] In contrast with his brother, who had no use for peasant drama, Willie Fay also admired the Ibsenesque peasant dramas of Padraic Colum. Shortly after leaving the Abbey Theatre he told an American interviewer that the Abbey needed to forsake "pretty romantic drama" in favour of realistic plays modelled after Ibsen which would "fearlessly uncover all that was false in Irish life".[48] Fay had contradicted his own argument, however, in the attitude that he took towards the plays of J. M. Synge. Although he took leading

42. Essay on the traditions of English acting.
43. Letter from Yeats to Lady Gregory (September 26, 1902), *Letters,* p. 379.
44. Unpublished letter from Frank Fay to Yeats (December 15, 1902), N.L.I. Ms. 13068. Cf. Cousins and Cousins, *We Two Together,* p. 72.
45. Letter dated May 24, 1907, Fay Papers, N.L.I. Mss. 10951-52.
46. Rough draft for *The Fays of the Abbey Theatre,* N.L.I. Ms. 5988.
47. *Fays of the Abbey Theatre,* p. 173.
48. Interview with Burns Mantle, Chicago, 1908, Fay Papers, N.L.I. Ms. 5981, p. 21.

parts in all of Synge's plays and even braved the rioters at the Abbey Theatre so that *The Playboy of the Western World* might be heard, Fay disliked the "merciless realism" with which Synge depicted peasant characters.[49] To him it was nothing less than theatrical heresy to antagonize an audience as Synge had done. "The public has to be humoured at times," Fay told his American interviewer. "There's no use trying to force a new kind of drama down its throat. It's all right to tell people they ought to know better, but it's a costly business trying to prove it to them."[50]

Frank and Willie Fay clearly represented a theatrical philosophy and tradition entirely opposed to that of Yeats and the other literary artists and critics who set out to reform the commercial theatre at the turn of the century. But to dismiss their views as simply ignorant would be unjust and erroneous. In criticizing the modern tendency to downgrade theatricality and sheer audience appeal in favour of literary and intellectual values in the drama, the Fays articulated a point of view that has only recently begun to receive serious consideration from critics and practitioners of the drama.

There is no doubt that by forcing audiences to understand and respond to plays critically as well as emotionally Ibsen and his successors from Shaw on down to the existential and social dramatists of the 1950s and 60s have made theatre intellectually respectable. But in doing so there is equally no doubt that the theatre has sacrificed much of the power that it once possessed to move audiences in purely theatrical terms. As a result the theatre has retreated more and more from a widely supported popular form of entertainment at the turn of the century to a minority art supported today by a social, economic, and intellectual elite. With good reason, the American drama critic Walter Kerr blames the decline of theatre as popular entertainment on the very kind of intellectual and aesthetic snobbery that both Frank and Willie Fay deplored:

Since the principal dramatist of the new order [Ibsen] had not been a popular dramatist, and since most twentieth-century playwrights have chosen to work in a form which was by definition not a popular one,

49. Interview in *The New York Sun* (February 28, 1908), p. 38, Fay Papers, N.L.I. Ms. 5975, p. 36. Cf. *Fays of the Abbey Theatre*, p. 130.
50. Interview with Burns Mantle.

we should not be surprised that we have finally created for ourselves an unpopular theatre.[51]

One of the chief modern reactions against the anti-theatrical tendencies of Ibsen and the social realists has involved efforts to bring the kinetic impact of the live actor's voice and body once again to bear in the theatre. As Laurence Olivier has stated: "My life's ambition has been to lead the public toward an appreciation of acting, so that they will come not only to see the play but to watch acting for acting's sake."[52]

Such seminal twentieth-century figures as Bertolt Brecht, Antonin Artaud, and Constantin Stanislavsky devoted their lives to exploring new ways of training and utilizing actors in the theatre. Many of the most influential contemporary directors, such as Peter Brook, Joseph Chaikin, and Jerzy Grotowski are convinced, as was Frank Fay, that the salvation and future of the theatre lies, to use Grotowski's words, in considering "the spiritual and scenic technique of the actor as the core of theatre art".[53]

Ironically, W. B. Yeats and Frank Fay ultimately came to the same conclusion about the necessity of refocusing attention on the actor. In the early years of their association, however, each had only a partial understanding of the dual literary and theatrical partnership that is involved in the making of significant drama. Even more unfortunate for both their sakes, while Yeats came to have a profound understanding of the total art of theatre, Frank Fay never learned to trust the man of letters in the theatre.

51. *How Not to Write a Play* (New York: Simon & Shuster, 1955), p. 32. Cf. Nicoll, *British Drama*, pp. 258, 263.
52. "The Great Sir Laurence", *Life* magazine (May 1964), p. 54.
53. Jerzy Grotowski, *Towards a Poor Theatre* (New York: Simon & Schuster, 1968), p. 15. Cf. Richard Schechner, *Public Domain*, pp. 11-12; Peter Brook, *The Empty Space* (London: MacGibbon & Kee, 1968), pp. 28-30, 49-52, 59-60, 110-25; Bertolt Brecht, "On the Experimental Theatre", *Theatre in the Twentieth Century*, ed. Robert W. Corrigan (New York: Grove Press, 1965), pp. 94-110; Antonin Artaud, "The Theatre of Cruelty, First and Second Manifestos", *The Theory of the Modern Stage*, ed. Eric Bentley, pp. 55-65.

CHAPTER EIGHT

Yeats and the Actor

Players and painted stage took all my love
And not those things that they were emblems of.[1]

It is commonly thought that Yeats failed as a dramatist primarily because he cared and knew little about acting and therefore wrote unactable plays. In part, Yeats himself is to blame for this. A cursory reading would lead one to believe that his dramatic theories, especially on acting, are hopelessly vague and continually shifting. He thus appears to be an archetypal man of letters who never came to grips with the practical realities of the theatre.

This conspectus of Yeats's views on acting is intended to show that such conceptions are largely wrong. In more than fifty years involvement with the theatre, Yeats's ideas did shift, but it was a shifting in methods to achieve an end rather than a change in the end itself. Invariably, his shifts were the result of practical experimentation and were the only possible solution for his theatrical problems. Yeats never formally systematized his ideas on acting, but it will be evident that there is, in fact, a remarkable underlying consistency to his entire philosphy of life, poetry, theatre, and the drama.

1. "The Circus Animals' Desertion", *Collected Poems,* pp. 391-92.

Perhaps the main reason that Yeats's ideas appear vague is because they are couched in the language of a poet. I have tried to impose a kind of organization on his wide-ranging theories, but I have been reluctant to attempt clarification merely by paraphrasing. To do so, in my view, would be to transform language redolent with meaning into relatively banal prose, and so risk losing much of Yeats's original intent. Furthermore, I believe we must do Yeats, as any great artist, the service of trying to understand him through the terminology that he chooses to employ. Brecht's idea of "alienation", Artaud's "theatre of cruelty", and Grotowski's concept of "confrontation" are, after all, more not less theatrically useful because they are intellectually demanding and provocative.

As ever, Yeats's ideas are his own. Some were derived from his personal histrionic sensibility; others he developed gradually by working with and observing actors in the theatre. In striving to find actors possessing poetical culture, passion, musical speech, and bodily energy, Yeats reveals his high aspirations as a dramatist as well as why it was so difficult for him to achieve theatrical success in his own time.

POETICAL CULTURE

"Poetical culture", as he termed it, was to Yeats an essential quality for the actor of imaginative plays. Basically, what he meant by the term was "a learned understanding of the sound of words", an imaginative response to language in terms of its "literary and mythological allusions".[2] One did not acquire poetical culture through a knowledge of literature alone, but from a cultivation of poetry in association with the visual and musical arts. Yeats's ideal actor, therefore, must have an acute sensitivity to the vocal properties inherent in every word. At the same time he must be capable of transporting himself into the imaginative world of the poet, however remote from ordinary life that world might seem to be.

Poetical culture for the actor also involved an awareness of and a pride in the aristocratic, even sacred, tradition of his art. Thus Yeats particularly responded to the idea that the Japanese word Noh meant "accomplishment", in the sense

2. Vide *Autobiographies*, p. 121; *Plays and Controversies*, p. 177; *Essays and Introductions*, p. 229.

that Noh actors were born into families with a long and proud heritage as actors, and were trained from birth to be accomplished in the intellectual as well as physical disciplines of their art.[3]

Throughout his lifetime Yeats took an ironic pleasure in finding amateur actors who, because they possessed poetical culture, were able to surpass experienced professionals in the performance of imaginative plays.[4] As we have noted, on the founding of the Abbey Theatre with its troupe of amateur players trained by Willie and Frank Fay, he reminded critics of all that unpaid actors with a love of literature had accomplished in the past.[5] In 1916, Ezra Pound provided him with a supreme example when for half an hour he replaced the noted actor Henry Ainley during rehearsals for the first production of *At the Hawk's Well.*[6]

But from the time Yeats saw the actress Florence Farr at the Bedford Park Playhouse, London, in 1890, she provided him with his most perfect image of a refined poetical culture applied to acting. To Yeats, she possessed "three great gifts": a "tranquil beauty" like that of a Greek statue, "an incomparable sense of rhythm", and a "beautiful voice". Florence Farr was also a trained musician, and possessed an insatiably curious if paradoxical mind which led her to explore many esoteric subjects, including traditional mysticism. All of these personal qualities lent to her delivery of verse a "nobility" and "passionate austerity" that forever haunted Yeats's imagination.[7]

PASSION

"Passion" is another term with very personal connotations to Yeats. Essentially, it summed up his concept of the intellectual and emotional qualities required for the actor of tragedy.

Yeats compared the actor of passion with the character actor, borrowing the latter term from common theatre usage. The character actor, of course, is one who builds up his part out of observation, adapting his voice, body, and manner in small details so as to enable him to play a variety of roles. By

3. *Essays and Introductions*, pp. 229-32.
4. Preface to *Letters to the New Island*, p. vii.
5. Vide Chapter Seven, p. 185.
6. *Explorations*, p. 256.
7. *Autobiographies*, pp. 120-23.

contrast, the actor of passion, or emotional actor as Yeats sometimes called him, creates his role not through observation or by employing "reason", but out of his own "personality" and "instinct".[8] Thus, like a great athlete, singer, dancer, or political leader, he appears to display, as it were, "some one quality of soul again and again".[9]

We must not be misled by Yeats's deployment of words such as emotion and instinct, however. Yeats was exceedingly careful to distinguish between "commonplace" emotional natures, which evoke mere "pity" or "pathos" in the theatre, and the far more complex nature required for true passion. Passion, to Yeats, was the very core of the tragic actor's personal distinction. It sprang from sources much deeper than mere "vitality" or "charm". Reflecting as ever the experiential knowledge derived from his occult research Yeats declared that passion conveyed an "intensity" born from the "sleepwalking of the subconscious", the "brooding of the mind".[10]

Kenneth Tynan has described the primary acting attribute of Laurence Olivier as "the ability to communicate danger. . . . Watching Olivier you feel that at any moment he may do something utterly unpredictable—something explosive, unnerving in its emotional nakedness."[11] Yeats held this potential explosiveness to be an essential quality of the true actor of passion. Indeed, he argued that much of the theatrical impact of the actor of passion arose from a sense of powerful inner conflict, as if he were struggling to batter down "violence or madness". "All depends on [the] completeness of the holding down, on the stirring of the beast underneath. Without this conflict we have no passion only sentiment and thought."[12]

8. Letter to J. B. Yeats (February 23, 1910), *Letters*, pp. 548-49. Contrasting "character" with "personality" in daily life Yeats declared: "Character is made up of habits retained, all kinds of things. We have character under control in the normal moments of life. But everyone has not the same personality, which means a certain kind of charm and emotional quality. If we want to speak of an artist who is really good we say he has personality." Lecture entitled "Friends of My Youth", *Yeats and the Theatre*, ed. Robert O'Driscoll and Lorna Reynolds (Toronto: Macmillan Company of Canada, 1975), p. 38.
9. *Autobiographies*, p. 125.
10. Vide *Autobiographies*, p. 524; Preface, *Plays for an Irish Theatre*, p. x.
11. "In His Talent, Shakespeare Summed Up", *Life* magazine (May 1964), p. 54.
12. Letter to Dorothy Wellesley (August 5, 1936), *Letters on Poetry*, p. 86.

The actor of passion had no conventional desire to please or play down to an audience because his energies were fully concentrated on the dialectic within his own soul. "Passion asks no pity, not even of God," said Yeats. "It realises, substantiates, attains, scorns, and is most mighty when it passes from our sight."[13] As with his Platonic concept of the relationship between the poet and his audience, and in terms similar to Stanislavsky's idea of "public solitude", Yeats argued that the actor achieved his greatest strength when he appeared on stage as if "wrapped in solitude", wearing a mask of "intellectual pride" or "half animal nobility".[14]

Yeats did not draw his images of passion from the world of literature but from observing on the stage actors such as Henry Irving, Tomaso Salvini, Florence Farr, and Mrs. Patrick Campbell.[15] One could almost say that passion experienced first in a theatrical context was what he then sought to achieve in his poetry. In 1901 Yeats wrote to Mrs. Patrick Campbell that her performance of a particular role was an image of all that he was striving for as a poet: "To be impassioned and yet to have a perfect self-possession, to have a precision so absolute that the slightest inflection of voice, the slightest rhythm of sound or emotion plucks the heart strings."[16]

MUSICAL SPEECH

But actors lacking music
Do most excite my spleen.[17]

Two basic misconceptions exist with regard to the speaking of Yeats's dramatic verse. One is that his ideal method of verse delivery was a monotonous form of chanting. The other is that his requirements were the same for both lyric and dramatic verse. These misconceptions, perhaps more than any other cause, have either frightened directors away from producing his plays or have marred those productions that have taken place.

13. *Autobiographies*, p. 524.
14. *Explorations*, p. 256.
15. Ibid. Cf. Letter to J. B. Yeats (July 21, 1906), *Letters*, p. 475.
16. Letter dated November 1901, *Letters*, p. 360.
17. "The Old Stone Cross", *Collected Poems*, pp. 365-66.

The idea that Yeats wanted his dramatic verse to be chanted—or cantillated as in a religious ceremony—arises from his early experiments with Florence Farr and her psaltery. During the latter 1890s Florence Farr was closely involved with Yeats in his efforts directed towards the creation of the Order of Celtic Mysteries. One of the things they attempted to do together was rediscover the methods of speaking verse to music employed by the bards and minstrels of ancient Greece and Ireland. There is no doubt that in both their minds the method they chose also was intended to recapture some of the religious aura of the bardic art. Yeats was haunted, he tells us, by an image of ancient ceremonies with "wild-eyed men speaking harmoniously to murmuring voices while audiences in many-coloured robes listened."[18] At the time when Yeats founded the Irish Literary Theatre his theatrical ideas were strongly influenced by his work with Florence Farr. He dreamed of reinvoking the ancient religious feeling of Ireland through a new form of poetic drama to be half acted and half chanted.[19]

Yeats spoke his own verse in a rhythmical kind of chant, and he believed that this chant, or tune, had a relatively specific melodic line which was woven into his poetry. (John Masefield described Yeats's unique method of reading verse as follows: "He stressed the rhythm until it almost became a chant. He went with speed, marking every beat and dwelling on the vowels. That ecstatic wavering song . . . was to remain with me for years.")[20] Hating vehemently the "accidental variety" in English actors' voices when they attempted to speak verse, Yeats set out with Florence Farr to find a method whereby the "tune" to which a poet composed a particular poem might be discovered and annotated for further reproduction.[21]

18. *Essays and Introductions*, pp. 14, 19. Cf. *The music of speech, containing the morals of some poets, thinkers and music makers regarding the practice of the Bardic Art together with fragments of verse set to its own melody by Florence Farr* (London: Elkin Matthews, 1909); Edward Malins, *Yeats and Music*, pp. 485-86.

19. Vide Ellmann, *Man and the Masks*, pp. 118-37. Cf. Letters to George ("A.E.") Russell, and to the Editor of the *Daily Chronicle* (November 1899 and January 27, 1899), *Letters*, pp. 327, 309.

20. Quoted in Malins, p. 484.

21. *Essays and Introductions*, pp. 17-18.

Their efforts were aided considerably when the noted instrument-maker Arnold Dolmetsch made for Miss Farr a twelve-stringed instrument based upon the Grecian lyre. which was tuned chromatically, with semitones and quarter tones, so that it was able to follow all the intonations of the speaking voice.[22] After a considerable amount of experimentation, Yeats and Miss Farr believed that they had discovered, not only his own speech tunes but those of George Russell and a number of other lyric poets going all the way back to the Elizabethans.[23] Yeats felt confident enough in their discoveries to advocate a new method of declaiming verse to annotated pitches and stresses which would, he hoped, revolutionize the art of verse-speaking.

Yeats formulated his theories on the delivery of verse in terms that closely resembled his doctrine of the mask. The actor was, in a sense, called upon to don a kind of vocal mask, assuming "a monotony in external things for the sake of an interior variety". In his essay on "Speaking to the Psaltery" (1902), Yeats provided several musical illustrations of what he had in mind, including the following excerpt from the lyric sung by Aleel in the first act of *The Countess Cathleen:*[24]

This passage gives a clear illustration of Yeats's own chant-like delivery of verse, especially at this Celtic Twilight stage of his poetic development. What may be discerned is a speech melody wavering through half and quarter tones, varying no more than one pitch per line; a subtle modulation of dyna-

22. Malins, pp. 484-87.
23. Letter to Robert Bridges (July 20, 1901), *Letters*, pp. 353-54.
24. Reproduced in *Essays and Introductions*, p. 17.

mics within phrases; a lingering over vowels to give slight emphasis to important words; and a careful rhythmic stressing of strong and weak beats to give the whole lyric a sense of inner body and life.

What may also be discerned are the considerable technical demands placed upon anyone asked to interpret poetry in this manner. These requirements include a beautiful and well-placed voice, capable of giving infinite shades of colour to individual words while sustaining the long melodic lines; an exquisite sense of rhythm; and a perfect sense of pitch. In addition to all of this, as Florence Farr pointed out, the performance style must not seem to be artificially adopted or merely copied from stereotyped religious ceremonies. Instead, it must arise from a personal and imaginative identification with "the inmost meaning of the words".[25]

Yeats emphasized the time and patience that would be required to perfect this new art of "regulated declamation". It would, for example, be necessary to develop listeners as well as speakers, and he urged that the recital of verse to music be taught in schools in order to develop beauty of voice and rhythm in children. It was his hope that a body of listeners would thus develop who

would soon find it impossible to listen without indignation to verse as it is spoken in our leading theatres. They would get a subtlety of hearing that would demand new effects from actors and even from public speakers, and they might, it may be, begin even to notice one another's voices till poetry and rhythm had come nearer to common life.[26]

Yeats brought his concepts of chanting directly to bear on the verse-speaking in *The Countess Cathleen* when it was performed as the first production of the Irish Literary Theatre. Quite naturally, he found it impossible within the space of a few short weeks of rehearsal to transform technically unqualified and intellectually unresponsive commercial English actors into Florence Farrs.[27] Moreover, he found himself dissatisfied with a chanted style when applied throughout a

25. Ibid., p. 22.
26. Ibid., p. 19. Cf. *Collected Works* (1908), III, pp. 222-24.
27. *Autobiographies*, p. 413. Cf. George Moore, *Hail and Farewell, Ave*, pp. 74-92, for an amusing description of Yeats's difficulties in rehearsing *The Countess Cathleen*.

whole play. Looking back on the experience, Yeats declared that he had striven for "too austere a delivery", too "obvious all-pervading" a rhythm.[28]

After the Irish Literary Theatre ended, Yeats determined that it was more feasible to carry out his experiments with amateur rather than professional actors. Thus, in 1902, he turned his attention to the little company of actors placed at his disposal by the Fays. Over the next few years he took full advantage of the new possibilities presented to him—writing plays specifically for the company and testing his theories of verse-speaking for the stage.

One of the first things that Yeats undoubtedly learned from coaching actors was that words like "monotony" and "chanting" can mean different things to different people. Interpreted by actors in the wrong way they certainly meant boredom for the audience. Therefore, in his 1904 declaration of the acting principles which would apply at the Abbey Theatre, Yeats emphasized the fact that he did not want "a monotonous chant"; rather, that the actor should "understand how to discriminate cadence from cadence, and so cherish the musical lineaments of verse or prose that he delights the ear with a continually varying music".[29]

By 1904 Yeats had evolved a form of poetic drama which demanded a mastery of no less than five different styles of vocal utterance: peasant dialect such as that of the Fool and Blind Man in *On Baile's Strand*; a declamatory kind of prose like that of the Wise Man in *The Hour-Glass*; the iambic pentameter of heroic characters such as Cuchulain and Conchubar in *On Baile's Strand* and Seanchan in *The King's Threshold*; an impassioned lyric verse such as that spoken by Forgael and Dectora in *The Shadowy Waters*; and the pitched incantatory verse style that was employed for the lyrics in *The Countess Cathleen* and was also appropriate for such characters as the Angel in *The Hour-Glass* and the Chorus of Singing Women in *On Baile's Strand*. Quite apart from their other theatrical appeals, Yeats's plays, even at this early stage in his career, are exciting for the sheer range and variety of their potential soundscape.

28. Vide Preface, *Plays for an Irish Theatre*, p. x; *Autobiographies*, p. 413.
29. *Explorations*, p. 173.

Contrary to common belief, Yeats was not at all averse to sacrificing words for the sake of occasional purely theatrical effects. An example of this is the Fire-and-Sword ritual in *On Baile's Strand*, where the written text was intended simply to provide a counterpoint and accompaniment to the dialectic between Cuchulain and Conchubar.[30] In 1929, for his ballet *Fighting the Waves* the *avant-garde* American composer George Antheil provided Yeats with a score that made the delicate opening and closing lyrics impossible to understand. However, Yeats was so pleased with the overall result that he left the lyrics unchanged: "sung to modern music in the modern way they suggest strange patterns to the ear without obtruding upon it their difficult, irrelevant words."[31] Directors would perhaps do well to bear these examples in mind lest they be overly intimidated by the towering literary dimension of Yeats's plays.

Willie Fay provided Yeats with a model for the delivery of Irish peasant dialect and his brother Frank for that of heroic characters.[32] The particular ideal of a pitched declamation continued to haunt and frustrate Yeats, however. The reasons for this stem from his concepts of "tragic pleasure" and "tragic ecstasy", as discussed in Chapter Two. Yeats explained that one of the principal reasons for the rarity of tragic pleasure was the sheer technical difficulty of maintaining an appropriate theatrical mood throughout a play. The "fragile power" of tragic pleasure was destroyed in a moment if an actor became "overemphatic, picking out what he [believed] to be the important words with violence and running up and down the scale; or if he stressed his lines in the wrong places."[33] Yeats's practical work with actors was directed towards the development of a style of acting and speech which would be so tempered as to preserve the balanced qualities of tragic pleasure throughout a play, yet sufficiently lyrical and passionate to be able to transport the audience to the threshold of tragic ecstasy.

30. *Variorum Plays*, p. 526.
31. *Explorations*, p. 370.
32. In *Samhain* Number Three, p. 8, Yeats declared: "We owe our National Theatre Society to him [Willie Fay] and his brother, and we have always owed to his playing our chief successes." In "The Play, the Player and the Scene", *Explorations*, pp. 173-74, he paid a similar tribute to Frank Fay's delivery of verse.
33. Preface, *Plays for an Irish Theatre*, p. x.

PLATE 1 Scale Model of Old Abbey Theatre.

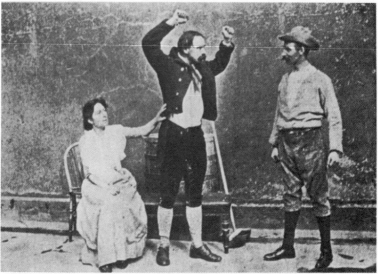

PLATE 2 (*Above*) Douglas Hyde as Hanrahan in *The Twisting of the Rope* (1901). *Source:* Henderson Collection, National Library of Ireland.

PLATE 3 (*Right*) Advertisement for A.E.'s *Deirdre* and Yeats's *Cathleen ni Houlihan* (1902). *Source:* Henderson Collection, National Library of Ireland.

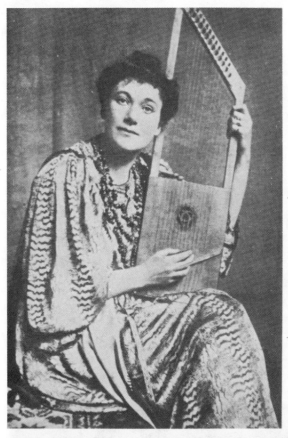

PLATE 4 *(Left)* Florence Farr with the Psaltery made for her by Arnold Dolmetsch. *Source: Yeats and Music* by Edward Malins, No. XII, Yeats Centenary Papers (Dublin: Dolmen Press, 1965). PLATE 5 *(Below)* Frank and Willie Fay in *The Hour Glass* (1903). *Source:* Holloway Collection, National Library of Ireland.

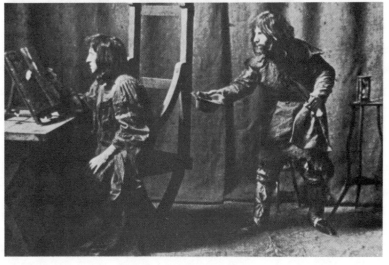

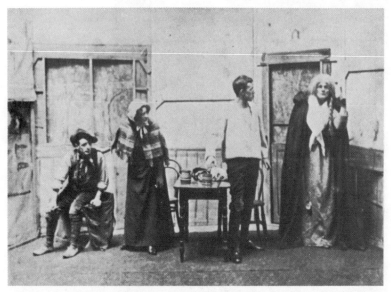

PLATE 6 *(Above)* Maud Gonne as Cathleen ni Houlihan.
Source: Senator Michael Yeats.

PLATE 7 *(Below)* Michio Ito as The Guardian of the Well in
Yeats's *At the Hawk's Well* (1916). *Source:* Senator Yeats.

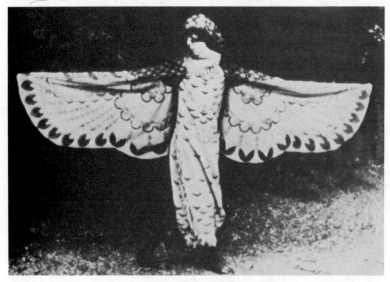

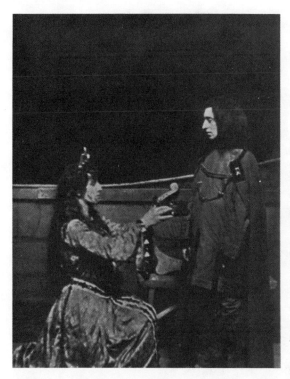

PLATE 8 *(Left)*
Maire Nic Shiu-
bhlaigh and Frank
Ray in *The Sha-
dowy Waters*
(1904). *Source:*
Senator Yeats.
PLATE 9 *(Below)*
Design by
Edmund Dulac for
Black Cloth em-
ployed in *At the
Hawk's Well*
(1916). *Source:*
Senator Yeats,
courtesy of Liam
Miller.

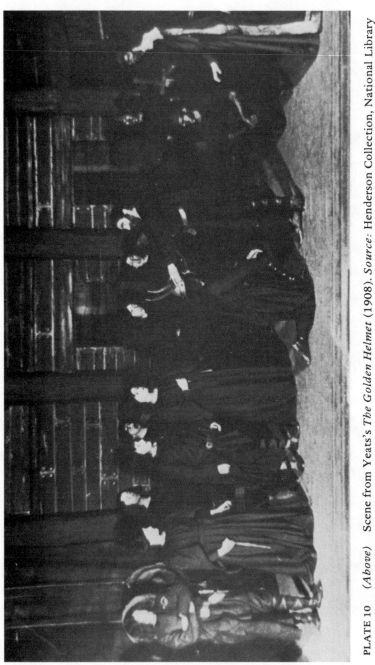

PLATE 10 (*Above*) Scene from Yeats's *The Golden Helmet* (1908). *Source:* Henderson Collection, National Library of Ireland.

PLATE 11 (*Below*) Scene from Lady Gregory's *The Rising of the Moon* (1907). *Source:* Holloway Collection, National Library of Ireland.

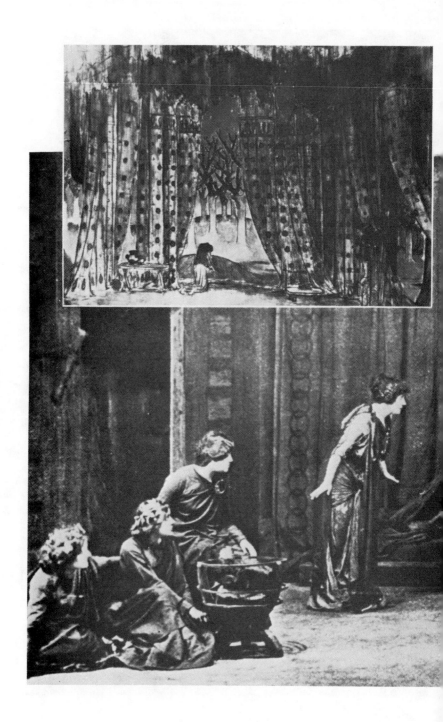

PLATE 12 *(Below)* Scene from Yeats's *Deirdre*, with Mrs. Patrick Campbell as Deirdre (1908). *Source:* Henderson Collection, National Library of Ireland. PLATE 13 *(Left)* Idealized Rendering of Set Design by Robert Gregory for W. B. Yeats's *Deirdre. Source:* Senator Michael Yeats, courtesy of Liam Miller.

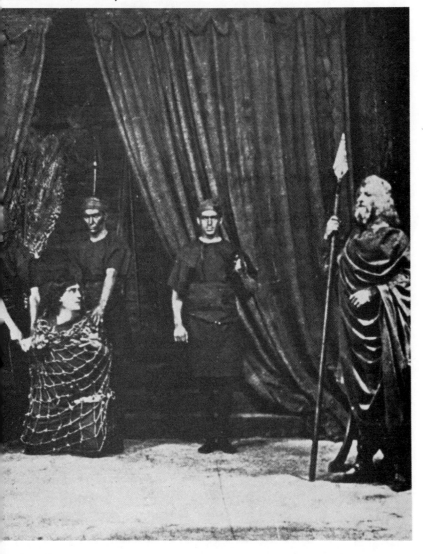

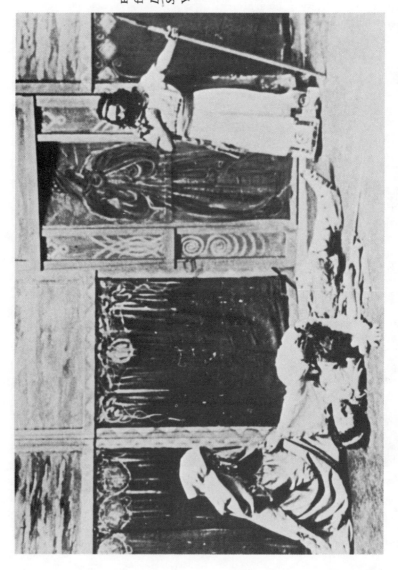

PLATE 14 Scene from Yeats's *Deirdre* (1906). *Source:* Senator Yeats.

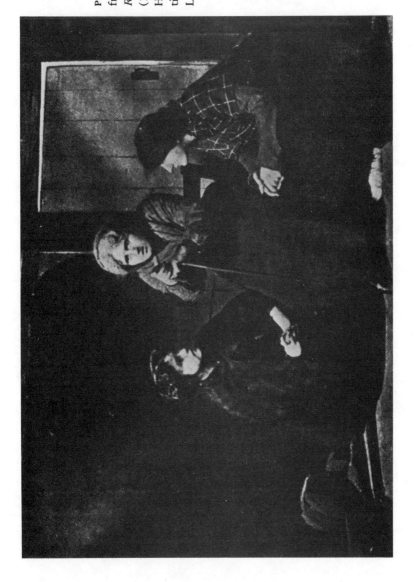

PLATE 15 Scene from Synge's *Riders to the Sea* (1904). *Source:* Holloway Collection, National Library of Ireland.

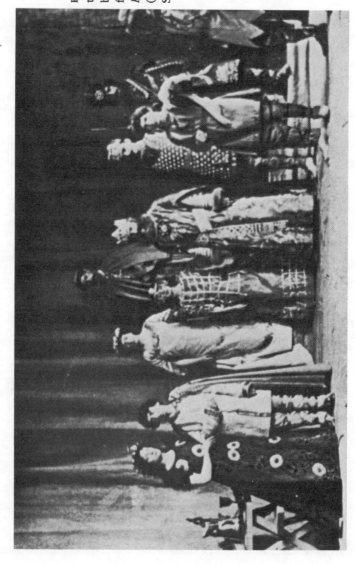

PLATE 16 Costumes designed by Miss Horniman for Yeats's *The King's Threshold* (1903). *Source:* Senator Yeats.

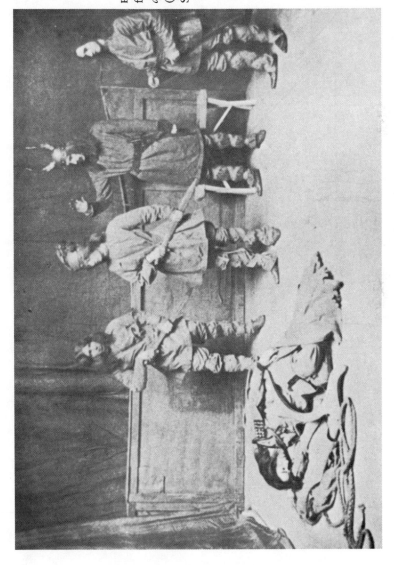

PLATE 17 Scene from *The Sha- dowy Waters* (1904). *Source:* Senator Yeats.

PLATE 18 (*Above*) Idealized Rendering of Set Design by Gordon Craig for *The Hour Glass* (1911). *Source:* W. B. Yeats, *Plays for an Irish Theatre* (London: Bullen, 1911), p. 168. PLATE 19 (*Right*) Design by Craig for the Fool's Mask in *The Hour Glass. Source:* Janet Leeper, *Edward Gordon Craig: Designs for the Theatre* (Harmondsworth: King Penguin, 1948), p. 23.

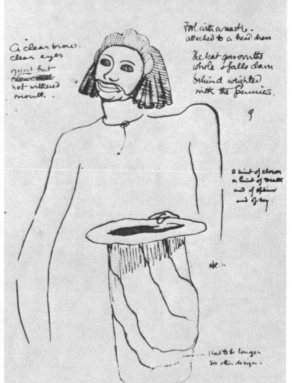

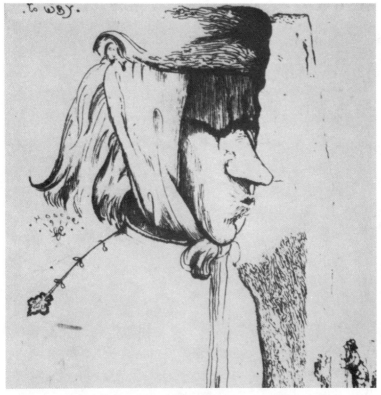

PLATE 20 *(Above)* Design by Craig for Mask of the Blind Man for *On Baile's Strand* (1911). *Source:* Janet Leeper, *Edward Gordon Craig*, p. 22. PLATE 21 *(Below)* Sketches by Yeats for settings of Lady Gregory's *The Deliverer* and *The Hour Glass. Source:* Senator Yeats.

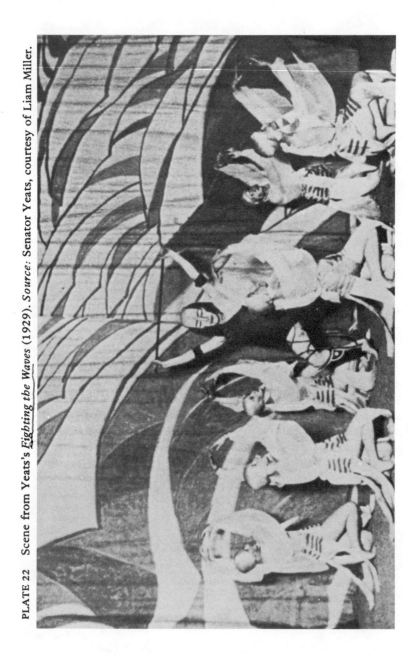

PLATE 22 Scene from Yeats's *Fighting the Waves* (1929). *Source*: Senator Yeats, courtesy of Liam Miller.

A subtle yet continuous rhythmic stress is one of the out-
standing characteristics of Yeats's poetry. Thus a rhythmic
sensitivity that embraced " the natural passionate rhythms of
common speech" as well as the more delicate rhythms be-
neath the surface wherein "the spirit of all intense literature
exists" became an essential quality for the actor of his
plays.[34] Yeats found that without this special sensitivity the
actor tended to turn poetry into prose and could never
achieve the "poetic reverie" demanded by the "great pas-
sages" in a play.[35] He also discovered that as the actor ap-
proached the moment of tragic ecstasy, his melodic line
narrowed to one or two notes, but the stress of rhythm
became more and more pronounced.[36] As in ritual, insistent
rhythm existed in order to

prolong the moment of contemplation, the moment when we are both
asleep and awake by hushing us with an alluring monotony, while it
holds us awake by variety, to keep us in that state of perhaps real
trance, in which the mind liberated from the pressure of the will is
unfolded in symbols.[37]

Yeats based some of his ideas for the speaking of dramatic
verse on the style of great Irish political orators who under-
stood (as did Martin Luther King, for instance) how to move
a crowd by gradually assuming "that subtle monotony of
voice which runs through the blood like fire".[38] In a similar
way, Yeats sought for a method of speaking verse which
would vary from a calculated assumption of the speech melo-
dies and rhythms of common life to a formal soaring lyri-
cism. His ideal verse speaker would base his work on a "mi-
nute passionate understanding" of words. He would seek to
preserve the "keenness and salt" natural to words, and not,
like a singer, turn them into "honey and oil".[39] "No vowel
must be preserved unnaturally, no word of mine must ever
change into a mere musical note," Yeats declared.[40] "What
was the good of writing a love-song if the singer pronounced

34. *Variorum Plays*, pp. 1008-10.
35. Letter to Dorothy Wellesley (September 27, 1937), *Letters*, p. 899.
36. *Explorations*, pp. 171-72.
37. *Essays and Introductions*, p. 159.
38. Ibid., p. 18. Cf. *Autobiographies*, pp. 96-97.
39. Vide *Collected Works*, Vol. III, p. 223.
40. Note to "The Music for Use in the Performance of These Plays", *Plays in Prose and Verse*, p. 435.

love 'lo-o-o-o-o-ve', or even if he said 'love', but did not give it its exact place and weight in the rhythm?"[41] When speech became song, it must do so imperceptibly, "as if mere speech had taken fire".[42]

Unfortunately, Yeats was able to pursue his experiments with pitched verse speaking for only a short time. In 1904 he still dreamed that it might be "barely possible" to write whole plays to musical notes as did the Greeks, actors being taught to speak upon them—"not sing but speak". He hoped that, at least where one wished to make the voice "immortal and passionless", as in the Angel's part in *The Hour-Glass*, the player might speak to definite pitches, and he recorded his excitement when in a rehearsal he achieved this ambition: "the contrast between the crystalline quality of the pure notes and the more confused and passionate speaking of the Wise Man was a new dramatic effect of great value."[43] Soon afterwards, however, he explained that he could not achieve this effect on stage at the Abbey Theatre because the actress in question was technically incapable of maintaining specific pitches during performances.[44] According to Dr. John Larchet, the musical director of the Abbey for many years, this was a problem repeated again and again throughout Yeats's career.[45]

Despite these obstacles, Yeats maintained his ideals for the musical delivery of verse to the end of his life. In 1936 and

41. *Essays and Introductions*, p. 14.
42. Ibid., p. 223. As E. M. Eno observes, Dylan Thomas provides a model of verse-speaking such as Yeats would have admired, "neither bloodless nor polite, but stunningly theatrical". "Yeats's Theatre", *The Dublin Magazine* (Winter-Spring, 1979), Vol. 1, No. 1., p. 12. Another example might be the Russian poet Evgenii Yetvushenko, whose passionately rhythmical verse delivery transcends all language barriers.
43. *Explorations*, p. 174. I was able to employ this idea in a production of *The Cat and the Moon*, the chanted declamation of the lyric sections contrasting effectively with the rough peasant dialect of the two beggars.
44. *Collected Works*, Vol. III, p. 223.
45. For instance, Yeats wanted to return to a form of pitched declamation for the choruses in the production of his Oedipus translation at the Abbey Theatre in December 1926. To realize this idea a liturgical choir was engaged, but they disappointed Yeats by emphasising purely musical values at the expense of the drama inherent in the text. Interview with John Larchet (July 11, 1966). Vide Skene, *The Cuchulain Plays of W. B. Yeats*, pp. 94-95, for a description of Yeats's struggles with musicians and performers during the rehearsals for the first production of *At the Hawk's Well* in 1916.

1937 he made a series of three broadcasts on modern poetry for the BBC. In the initial broadcast Yeats defined poetry as "an elaboration of the rhythms of common speech and their association with profound feeling. To read a poem like prose that hearers unaccustomed to poetry may find it easy to understand, is to turn it into bad florid prose."[46] The succeeding two broadcasts involved experiments in the use of musical instruments between stanzas or between poems so as to heighten their intensity. Yeats also experimented with the unaccompanied singing of certain refrains. No words, however, were spoken through music, nor was there a musical accompaniment to any of the texts.

The BBC producer George Barnes recorded the delight and exasperation of working with Yeats on these programs. According to Barnes only one of the performers, the singer-actress Margot Ruddock, thoroughly satisfied Yeats because she had "the ability to pass naturally and unself-consciously from speech to song". Unfortunately, though she quickly grasped Yeats's ideas in rehearsal, Margot Ruddock lacked the professional training to reproduce these effects in transmission.

Difficulties also arose with the musicians because Yeats was unable to hum the tunes he wanted. Yet, says Barnes, "his ear for the sound of speech was so sensitive that it outran comprehension. He noticed nuances which the actors could hardly hear." Margot Ruddock was able to get what Yeats wanted, but mainly by intuition. "The pleasure of rehearsals was to hear him trying to convey the sounds which were running in his head, and when he succeeded they remained unforgettably in the ear."[47]

Yeats obviously made demands upon actors that only trained singers could have met. Yet he felt that most singers were too abstracted from ordinary life to succeed in his plays—that is, in their endeavour to produce beautiful sounds they became more like musical instruments than people.[48] The problem of finding actors rather than singers who were capable of mastering the various kinds of musical speech in his plays was the single greatest frustration of Yeats's theatrical career. Indeed, he encountered only three actors

46. *Essays and Introductions*, p. 508.
47. Joseph Hone, *W. B. Yeats* (London: Macmillan, 1942), pp. 453-57.
48. *Collected Works*, Vol. III, p. 223.

who were able to "chant or sing" the lyric sections of his plays to his satisfaction. These were Florence Farr, a pupil of hers named Miss Taylor, and the Abbey actress Sara All-good.[49] All others had "the sense of pitch without the understanding of the words or the understanding of the words without the sense of pitch". And even with Florence and Sara there were personal drawbacks of intellect and temperament which, for him, ultimately marred their work.[50]

It was because of these difficulties that Yeats was delighted to discover in the Japanese Noh drama a form that allowed him to separate completely the actor from the singer of lyric passages. The moment of tragic ecstasy was thus transferred to the dancer—an artist with a much greater knowledge of the traditions and techniques of his art than any actors he was likely to encounter.

ENERGY OF THE BODY

There are three incompatible things man is always seeking—infinite feeling, infinite battle, infinite repose.[51]

Another difficult problem faced by Yeats as a dramatist was that of finding a theatrical form to express these three incompatibles in terms of the corporeal histrionic energy of the human body. We have seen that from childhood Yeats exhibited a powerful responsiveness to the "energy of the body". He made the perfectly proportioned body an image of Unity of Being, equating personality with physical expressiveness. Thus he criticized modern portrait painting for its failure to portray men "thinking" with their "whole body".[52] In a similar manner, one of Yeats's basic criticisms of the theatre was that for three centuries "invention [had] been making the human voice and the movements of the body seem always less expressive".[53]

49. Ibid. Yeats described a performance of a Greek tragedy translated by Gilbert Murray in which Florence Farr and her pupil "sang or spoke about 'the daughters of sunset' " as an image of what the Greeks meant when they said "I sing" poetry. *Variorum Plays*, p. 1009.
50. Sara was able to realize Yeats's intentions, but only in the realm of "folk singing". *Variorum Plays*, p. 1009. Florence Farr exasperated Yeats with her inability, at times from "sheer laziness", to reproduce consistently her "moments of inspiration". Cf. *Letters*, pp. 394, 373.
51. Letter to Katharine Tynan (February 6, 1889), *Letters*, p. 111.
52. Vide *Essays and Introductions*, p. 292; *Autobiographies*, p. 292.
53. *Essays and Introductions*, p. 222.

Although such concepts would seem to call for an almost athletic form of histrionic expressiveness, Yeats abhorred the over-physicalized acting styles of the nineteenth-century English stage. Being pre-eminently concerned with the techniques of verse delivery, he believed that any sudden jarring of the eye made it impossible to concentrate on the text.[54] Undoubtedly, he also was influenced by the magical belief that the unconscious is tapped by keeping the body still, the mind awake and clear, so as to avoid any confusion between "the images of the mind and the objects of sense".[55]

Up to 1905 or 1906, the unifying histrionic image employed by Yeats was that of Greek sculpture in motion. He described the statues of Mausolus and Artemisia in the British museum as "half animal, half divine figures", "images of an unpremeditated joyous energy, that neither I nor any other man, racked by doubt and inquiry can achieve". Yeats saw them as respresentative of an unselfconscious art, where the artist's handiwork would hide beneath his form, where the egoism of modern psychology might disappear, being replaced by "those single emotions which resemble the more, the more powerful they are, everybody's emotion".[56] In precisely these terms, he described the physical impact that Maud Gonne had upon a crowd:

Her beauty, backed by her great stature, could instantly affect an assembly, and not, as often with our stage beauties, because obvious and florid, for it was incredibly distinguished, and if—as must be that it might seem that assembly's very self, fused, unified, and solitary—her face, like the face of some Greek statue, showed little thought, her whole body seemed a master-work of long labouring thought.[57]

In the theatre Yeats responded similarly to actors who embodied passion within clearly defined archetypal forms. He found this quality in the acting of Florence Farr, at its best "distinguished, solitary, proud".[58] He wrote at length of Sara Bernhardt's production of *Phèdre*—"the most beautiful thing I had ever seen upon the stage"—describing actors posed up to twenty-seven seconds without a move, every

54. Vide ibid., pp. 168-70, 528.
55. *Mythologies*, p. 344.
56. *Autobiographies*, pp. 156-57.
57. Ibid., p. 364.
58. Letter to John Butler Yeats (July 21, 1906), *Letters*, p. 475.

gesture progressing to the rhythm and melody of the lines, against a crowd of white-robed men who never moved at all. "The whole scene had the nobility of Greek sculpture and an extraordinary reality and intensity," he declared.[59]

Yeats applied these images and concepts to the task of creating an appropriate acting style for his plays at the early Abbey Theatre. Not so foolishly as has often been thought, he suggested that actors might rehearse in barrels in order to "forget gesture and have their minds free to think of speech for a while".[60] Movements were to be slow and quiet, "decorative and rhythmical as if they [the actors] were paintings on a frieze".[61] Gestures were to be rhythmic and sparingly employed so that they might seem to "flow up into the imagination from some deeper life than that of the individual soul".[62] Above all, the discipline of the actor's art must come from within instead of seeming imposed. In terms that remind one of Antonin Artaud and Jerzy Grotowski, Yeats called for "the expression of the individual soul turning itself into a pure fire and imposing its own pattern".[63]

Gradually, however, a change took place in Yeats's ideas as he found the Abbey actors unable to fill their sculpted forms with passion, unable to hold an audience with the power of language alone. By 1911 he had begun to feel that in his hatred of mere "vitality", he had "imposed too statuesque a pose" together with "too monotonous a delivery".[64]

Gradually, also, Yeats's concept of theatre changed from that of 1894 in which the actor functioned mainly as "a reverent reciter of majestic words"[65] to one in which a greater focus might be given to the individual actor in his full physical as well as vocal strength. He learned, mainly by ob-

59. *Explorations*, p. 87.
60. Ibid. Stanislavsky employed a similar exercise in order to cut down on the stereotyped gestures of an opera singer. He made the singer repeat an aria while sitting on his hands until the meaning of the words began to be expressed. Joshua Capon, "Rehearsals with Stanislavsky", *Vogue* (June 1949), p. 78.
61. *Explorations*, pp. 176-77.
62. Ibid., p. 109.
63. Ibid., p. 26.
64. Preface, *Plays for an Irish Theatre*, p. x.
65. *Uncollected Prose*, p. 324.

serving responses of audiences at the Abbey Theatre, that a successful play must use "the bodily energies of the principal actor to the full".[66] Under the influence of Gordon Craig he discovered the theatrical truth that the deepest emotions may often best be expressed not through the medium of language but through physical actions that eloquently speak where words no longer suffice.[67] By 1921, having written his *Four Plays for Dancers*, each of which climaxes in a dance, Yeats had come to believe that in tragical art "expression is mainly in those moments that are of the entire body".[68]

It is really not surprising that Yeats ultimately turned for an answer to his theatrical problems to that first and purest of histrionic artists, the dancer. He tried to explain his change from an almost non-physical theatre to a theatre highly dependent on the sheer energy of the body as if it were the result of a failure to find adequate verse speakers: "I wanted a dance because where there are no words there is less to spoil."[69] But one can find, even from his earliest writing, a fascination with the dancer and the dance. Oisin and Niamh in *The Wanderings of Oisin* join the immortal spirits in a wild hundred year dance of defiance in the face of Time, Fate, and Chance. It is also a dance by which The Faery Child summons the soul of Mary Bruin to *The Land of Heart's Desire* (1894). Above all, there is the brilliant passage in *The Secret Rose* (1897) where Ahern has his mortality torn from him through the magic of a ritual dance.

But where these earlier dances employ the rhythm and pattern of ritual movement to suck the soul out of a man, as it were, Yeats was now concerned with the power of the individual to will his own tragic fate. Writing in 1916 of the Japanese dancer Ito as "the tragic image that has stirred my imagination", Yeats emphasized the human element in his art. Seated in the middle of a room, with no other theatrical appurtenances than his own body, Ito was able simply by throwing out an arm "to recede from us into some more powerful life. Because that separation was achieved by *hu-*

66. *Essays and Introductions*, p. 266.
67. Ibid., p. 239.
68. *Four Plays for Dancers*, pp. 86-87.
69. *The Death of Cuchulain, Collected Plays*, p. 694.

man means alone, he needed but to inhabit as it were the depths of the mind".[70]

It is somewhat difficult to know exactly what Yeats had in mind regarding a style of dancing for his dance plays because, as he admitted himself, his ideas were only vaguely formulated.[71] He hated traditional ballet, finding it restricted, artificial, and, as with trained singing, too remote from ordinary life. Likewise, improvised runs, leaps, and free movement in the style of Isadora Duncan were too formless for his purposes.[72]

What Yeats obviously admired in Japanese dancing were its qualities of histrionic expressiveness, emotional truth, and precision. He noted that every gesture and pose was associated with "some definite thought", every moment of dramatic intensity framed with a "pause" and an increased "muscular tension". Presumably, however, Yeats did not want a literal transposition of this already cultivated dance form, for his philosophy of art called for the evocation of profound emotions born from common tradition. In his essay on Noh drama he suggested the use of dance forms based upon the patterns and rhythms of traditional Irish dancing.[73]

What Yeats desired, then, was an art of stage dancing based upon the common actions of life, but rising to the ecstasy of tragedy through a gradual process of elimination and refinement. It would be a stylized art, yet one that glorified man in the expressive beauty of his natural physicality, energy, and passion. It would thus provide a synthesis of incompatibles, "the pulse of life" with "the stillness of death".[74]

Dame Ninette de Valois has described the choreography that she created for a number of Yeats's dance plays presented at the Abbey Theatre in the late 1920s and early 1930s as

what we might call modern. . . . That is modern in the way classical dancers can move into any style they want. . . . One really did use the simplest gestures possible, rather symbolic movements, really. . . . There was no question of pseudo-Oriental graduations. . . . These were all barefoot dances, of course, but what one did was stylized to bring out the spirit of the thing.[75]

70. *Essays and Introductions*, p. 224. (My italics.)
71. Preface, *Four Plays for Dancers*, p. v.
72. *The Death of Cuchulain.*
73. *Essays and Introductions*, pp. 230-31, 236.
74. *Four Plays for Dancers*, p. 87.

Again, however, Yeats was to suffer continued frustration in trying to realise theatrical ideas that were far ahead of their time. Except for Ito and his brief association with Ninette de Valois at the beginning of her career, he never found dancer-actors who understood what he was trying to achieve. Perhaps more than any other dramatist of the twentieth century Yeats required the co-operation of artists who were capable of capturing his vision in theatrical terms. The fact that he could not find such artists was his ultimate limitation as a dramatist.

THE MECHANICS OF ACTING

In terms of the implications of each of his concepts of poetical culture, passion, musical speech, and bodily energy, it should be evident by now that Yeats had not only a theoretical but a practical interest in all aspects of the actor's art. Records of his work in coaching actors are sparse, but those that exist reveal that, far from being a theatrical dilettante, he also had an exceptional knowledge of the basic mechanics of acting.

Yeats had an abhorrence of realistic stage direction, feeling that it aimed at "keeping the stage in a state of quite superficial excitement".[76] Yet the Abbey director Lennox Robinson noted that after the performance of realistic plays Yeats would often make dozens of acute criticisms of the directing and acting.[77] One should not be surprised at

75. G. M. Pincier, "A Dancer for Mr. Yeats", *Educational Theatre Journal*, XXI, 4 (December 1969), p. 389.

76. Letter to Frank Fay (August 28, 1904), *Letters*, p. 441.

77. "The Man and the Dramatist", *Scattering Branches*, ed. Stephen Gwynn (London: Macmillan, 1940), p. 78. In a wonderfully incisive passage, Yeats contrasted the "joyous spontaneity" of the Sicilian Players with conventional realistic acting as employed in an English production of John Galsworthy's *Justice*. Yeats pointed out that the Sicilians had learned to express their "instincts" through the art of improvised comedy upon which their work was based. In contrast, the English actors gave the impression that they could "do nothing right unless taught to do it, intonation by intonation, movement by movement. You felt also as you looked at the Sicilians that these players were showing their whole natures. They had confidence in themselves; they poured themselves out; you felt they went home exhausted because they had expressed themselves so completely. In the other you felt the player was using only a little of himself. He was depressed. You watched him with a feeling of depression." Lecture on "The Theatre" (1910), *Yeats and the Theatre*, pp. 17-18. It is only in recent years that ideas such as these have come to inform serious actor training.

this—Yeats's acute histrionic sensibility was employed in life as well as the theatre as is clearly indicated in a striking passage taken from his diary of 1909:

I noticed in the train, as I came to Queenstown, a silent, fairly well-dressed man, who struck me as vulgar. It was not his face, which was quite normal, but his movements. He moved from his head only. His arm and hand, let us say, moved in direct obedience to the head, had not the instinctive motion that comes from a feeling of weight, of the shape of an object to be touched or grasped. There were too many straight lines in gesture and in pose. The result was an impression of vulgar smartness, a defiance of what is profound and old and simple.

Yeats applied such observations to his work in coaching actors:

I am watching Miss Nic Shiubhlaigh to find out if her inanimate movements when on stage come from a lack of experience or if she has them in life. I watched her sinking into a chair the other day to see if her body felt the size and shape of the chair before she reached it. If her body does not so feel she will never be able to act, just as she will never have grace or movement in ordinary life.

Yeats concluded the passage:

As I write I see through the cabin door a woman feeding a child with a spoon. She thinks of nothing but the child, and every movement is full of expression. It would be beautiful acting.[78]

Margot Ruddock once complained to Yeats about her lack of success as an actress, and received the following reply: "You cannot act because, absorbed in spiritual things you have lost interest in the particulars of life."[79] Yeats's concern with such particulars when applied to acting is demonstrated in a letter to Frank Fay advising him how to build up the role of Cuchulain for the first production of *On Baile's Strand*:

He lives among young men but has himself outlived the illusions of youth. He is probably about 40, not less than 35 or 36 and not more than 45 or 46, certainly not an old man, and one understands from his talk about women that he does not love like a young man. . . . He is a

78. *Autobiographies*, p. 526. In the same passage Yeats observed that beginning actors appear awkward because "the 'idea' of doing something is more vivid than the doing of it. One gets an impression of thinness in the nature."

79. Letter dated October 17, 1935, *Ah, Sweet Dancer: Correspondence Between W. B. Yeats and Margot Ruddock*, ed. Roger McHugh (London: Gill & Macmillan, 1970), p. 55.

little hard, and leaves people about him a little repelled—perhaps this young man's affection is what he had most need of. . . . The touch of something hard, yet alluring, self-assertive yet self-immolating is not all, but it must be there.[80]

On another occasion an English actress was criticized because she had not given a role an overall shape and structure:

She thought of nothing but herself and her poses, and her poses were as disagreeable as her self. . . . She exhausted every possible movement of her body in the first five minutes, and when she came to her most important scene she had squandered her whole capital.[81]

To Yeats, the actor was no mere craftsman, but a living image of humanity at its finest. Like Stanislavsky, he believed that the training of the actor must be a total educational process involving a refinement of his intellectual and spiritual as well as physical resources. Analysing the personality and deportment of a shrill-voiced young actress whom he once encountered, Yeats said that her education should have started with "the personality, the habitual self". Then:

Somebody should have taught her to speak for the most part on whatever note of her voice is most musical, and soften those harsh notes by speaking, not singing, to some stringed instrument, taking note after note and, as it were, caressing her words a little as if she loved the sound of them, and have taught her after this some beautiful pantomimic dance, till it had grown a habit to live for eye and ear. A wise theatre might make a training in strong and beautiful life the fashion.[82]

Surely no one with a love and understanding of the art of acting could fail to respond to insights such as these. Indeed, many of Yeats's theatrical ideas are beginning to be realized today due to the influence of Artaud and Grotowski as well as teaching methods evolved to train the total actor. With its anti-literary bias, however, most "New Theatre" falls far short of fulfilling the lofty social, religious, and aesthetic function envisaged by Yeats. One might reasonably argue that it is by discovering the histrionic techniques necessary to perform Yeats's own plays that the theatre may rediscover an important portion of its true identity and purpose.

80. August 28, 1904, *Letters*, p. 441.
81. Letter to T. Sturge Moore, *W. B. Yeats and T. Sturge Moore: Their Correspondence, 1901-1937*, ed. Ursula Bridge (London: Routledge and Kegan Paul, 1953), pp. 24-25.
82. *Essays and Introductions*, pp. 269-70.

Yeats and the Abbey Theatre Company

1902-1905: THE POLITICS OF CREATING A THEATRE

From the very outset of his dramatic endeavours Yeats was determined to have his own theatre. Following the successful production of *Cathleen ni Houlihan* by W. G. Fay's National Dramatic Society in April 1902, he set out to achieve this objective with a plan of action that was as skilful as it was bold. During the summer of 1902 he saw to it that the loosely structured company of the Fays was replaced by a new organization, the Irish National Theatre Society. In February 1903, Yeats assumed the office of president, with Maud Gonne, George Russell, and Douglas Hyde as vice-presidents, Willie Fay as stage manager, and one of the actor-authors, Frederick Ryan, as secretary. Members were mainly drawn to the Irish National Theatre Society for patriotic reasons, but they included a number of talented actors and actresses, as well as budding playwrights. Membership dues were solicited, with Lady Gregory and Yeats contributing twenty-five and twenty pounds, respectively. Everyone had an equal voice and everyone decided on the choice of plays until, as a result of conflicts with the Fays, Yeats threatened to resign if a Reading Committee was not created. Even then, final acceptance or rejection of plays rested on a vote by the full membership of the Society. With actors outnumbering play-

wrights, considerable "lobbying" was involved as art vied with nationalistic politics in determining the repertoire of the company.[1]

Headquarters for the Irish National Theatre Society was a dismal little hall at the back of a butcher shop on Lower Camden Street. Rental for the Hall was ten shillings per week and, to cut costs, on three evenings a week it was sub-let to the Gaelic League.[2] No more than fifty spectators could be accommodated. There were no backstage facilities and the stage itself was less than six feet deep.[3] Nevertheless, from August 1902 until 1904 the Camden Street Hall served for meetings, rehearsals, and even occasional performances by the little amateur company.

Depsite these obstacles, the Irish National Theatre Society began to draw attention in Dublin. This was mainly due to new plays by Yeats, Lady Gregory, Synge, and other dramatists, which were performed on the equally unsuitable stages of the Molesworth Street Hall and the Ancient Concert Rooms. But the greatest boost to their efforts was the extraordinary critical response to the company's first London appearance—a one-night stand on Saturday, May 2, 1903. Thanks to Yeats's literary reputation and his genius with public relations, such an urbane English critic as A. B. Walkley declared that in spite of the actors' "natural clumsiness" the Irish dramatic movement was the long-sought answer to his call for a drama devoid of a "theatrical bag of tricks".[4] When the company made another visit to London in March of the following year Max Beerbohm was persuaded that the "blank faces and stiff movements" of the Irish actors were part of a "conscious inexpressiveness" somehow appropriate to the

1. Vide Ann Saddlemyer, "Worn Out with Dreams", The World of W. B. Yeats, pp. 104-32, for the most complete examination of the behind the scenes political struggles to create the Abbey Theatre. Cf. Autobiographies, pp. 563-67; Robinson, Ireland's Abbey Theatre, pp. 27-28; G. Fay, The Abbey Theatre, pp. 45-46.
2. Records of the Irish National Theatre Society, preserved in George Roberts Collection, N.L.I. Ms. 7267.
3. Robinson, Ireland's Abbey Theatre, p. 28.
4. "The Irish National Theatre" (May 1903), Drama and Life, pp. 310-15. Cf. G. Fay, The Abbey Theatre, pp. 56-58, for other reviews of the 1903 appearance.

"spiritually and intellectually much finer Keltic [*sic*] race. . . ."[5]

The next decisive step in the realization of Yeats's plan was taken when he persuaded a wealthy and eccentric English patron of the arts, Miss Annie Horniman, to purchase and renovate a small but fully equipped theatre for the Irish National Theatre Society. Miss Horniman had definite reservations about the ability of the Fays to manage such a theatre, but her belief in Yeats overruled all other considerations.[6] On December 27, 1904, the Abbey Theatre opened its doors, the tangible result of nearly fifteen years' effort by Yeats.

His plan was not complete, however. Yeats, Lady Gregory, and Synge were by this time the official Directors of the Irish National Theatre Society, Maud Gonne having resigned over the production of Synge's *In the Shadow of the Glen* in October 1903 and George Russell having withdrawn from the Society in the summer of 1904 when Yeats insisted on further reforms to the democratic method of choosing plays.[7] But a certain amount of power still remained in the hands of the Fays, especially with regard to the choice and casting of plays. In the autumn of 1905 this power was removed when a subsidy from Miss Horniman enabled the part-time amateur company to turn fully professional. The Irish National Theatre Society became a Limited Company, with complete artistic and financial authority delegated to the Directors. Yeats and his fellow playwrights were at last in complete control of the Theatre, with the Fays relegated to the distinctly subservient position of "employees".[8]

1906-1907: THE TURNING POINT

Yeats could not have known it at the time, but the 1906-07 season of the Abbey Theatre was to prove a most significant turning point in his career as a dramatist. As Yeats was

5. "Some Irish Plays and Players" (April 9, 1904), *Around Theatres* (New York: Alfred A. Knopf, 1930), Vol. II, p. 403.
6. James W. Flannery, *Miss Annie Horniman and the Abbey Theatre* (Dublin: Dolmen Press, 1970), pp. 9, 12-14.
7. Saddlemyer, "Worn Out with Dreams", pp. 113-14.
8. Cf. Rules of the Irish National Theatre Society (1903) and Rules of the Irish National Theatre Society, Ltd. (1905). In the latter version the actors, including the Fays, are listed as "Employees". Preserved in N.L.I. Ms. 13068.

among the first to proclaim, the extraordinary success of the
Irish National Theatre Society owed as much to the acting
style developed under the guidance of the Fays as it did to
the plays that were performed. When contrasted with the
bombastic extravagance to be seen on the commercial English
stage, the simplified but focussed stage blocking, musical de-
livery, and sincere unaffected deportment of the Irish players
all combined to give the company an innocent, slightly exotic
charm all its own.[9] Indeed, the low-keyed style of the Abbey
Theatre served as an inspiration for many English repertory
companies founded towards the end of the decade.[10]

But, while such seemingly naturalistic techniques may have
been appropriate for peasant plays, they obviously left a great
deal to be desired when applied to the heroic verse tragedies
which by 1903 Yeats had begun to write. In the Abbey Com-
pany's London engagement of December 1905 critics were
enthusiastic about productions of plays by Lady Gregory,
Padraic Colum, and William Boyle. But the acting in Yeats's
On Baile's Strand, particularly that of Frank Fay as Cuchu-
lain, was attacked by a number of important reviewers, in-
cluding William Archer.[11] As a result, no verse plays were
scheduled for the spring tour of 1906.

For the autumn season of 1906 Yeats determined that
some drastic changes were necessary if his personal dramatic
needs were to be served. With Miss Horniman giving him
strident encouragement, Yeats argued to his fellow Directors
that it was essential for him to import from England an Irish
actress named Florence Darragh to play the title role in the
first production of his Deirdre as well as Dectora in a revival
of The Shadowy Waters. In a letter to Synge, dated August
13, 1906, Yeats explained his reasons for this move:

You and Lady Gregory and Boyle can look forward to good perfor-
mances of your plays from the present Company and from people who

9. Vide esp. C. E. Montague, "Good Acting", Dramatic Values (London:
 Methuen, 1911), pp. 52-55.
10. J. C. Trewin, The Birmingham Repertory Theatre (London: Barrie & Rock-
 cliff, 1963), pp. 12, 15.
11. Archer complained that Frank Fay was "not well suited to the heroic char-
 acters of Irish legend. For such a part as Cuchulain the Company ought to
 find and train an actor of somewhat more impressive physical presence." The
 World (December 12, 1905), p. 1027.

will join it in the natural course of things. You are already getting
better performances than you could from any English Company. I am
getting them, of course, for my prose plays. But I am essentially not a
prose writer. At this moment in spite of Frank Fay's exquisite speaking
I could get a much better performance in England of a play like
Deirdre. . . . I require for Deirdre an emotional actress of great experi-
ence. . . . Miss Darragh is I think a great tragic actress, and she is Irish. It
will probably be necessary . . . to add a man of equivalent power. . . .
With a proportion of say one romantic or verse play to every three
peasant plays, and that one play passionately played, we shall sweep the
country and make enough money to make ourselves independent of
Miss Horniman. We have also to think of playing several weeks in Lon-
don each year. The alternative to this is the giving of my plays to
English companies, for if I am to be any use ever in Ireland I must get
good performances. Till I get that I shall be looked on as an amateur.[12]

Neither of Yeats's fellow Directors were enthusiastic about
the prospect of bringing an outsider to the Abbey Company.
Lady Gregory had a strong suspicion that Miss Darragh was
being sent by Miss Horniman in order to gain control over the
Theatre. Synge's objections were apparently motivated out of
loyalty to the Fays and a fear that Willie Fay was on the
verge of resigning.[13]

Willie Fay was indeed furious about this new departure,
and one can understand some of the reasons why. From the
very outset of their relationship, one of the most bitterly
contested fights between Yeats and Fay had been over the
power of casting plays.[14] In amateur theatre troupes, the
interest of good actors is often sustained mainly by the chal-
lenge and variety of roles being offered them. The power of
assigning roles is therefore one of the director's most effec-
tive means of maintaining authority over his actors. Thus
Willie Fay insisted on having a clause in the original rules of
the Irish National Theatre Society to state that "the choice
of actors shall be left to the decision of the Stage Manager in
consultation with the author".[15] When the Abbey turned

12. Unpublished letter in the possession of Michael Yeats.
13. Ibid. Cf. Green and Stephens, *J. M. Synge*, p. 208.
14. Unpublished letter from Willie Fay to Yeats (January 19, 1903), N.L.I. Ms.
 13068.
15. Clause III "The Stage Manager", Rules of the Irish National Theatre Society,
 (1903).

professional this clause was removed. Thereafter, the Directors governed casting with the result that they, rather than the Fays, held this important psychological control over the company.

A second problem for the Fays was the resignation of some of the most talented members of the early company, because of religious and political objections to plays chosen for production in 1903 and because of a reluctance to turn professional in 1905.[16] Frank Fay was as anxious as Yeats to develop "the special kind of acting" necessary to perform his verse plays. But his idea was to work slowly—carefully training and then giving practical experience to the talented young actors and actresses who had since come into the company.[17]

Among the most promising of the new recruits was Sara Allgood, already a favourite of Lady Gregory because of her ability as a comedienne.[18] Willie Fay had promised her the role of Deirdre and Frank Fay was giving her special lessons in verse-speaking when a series of letters began to arrive from Lady Gregory saying first that Deirdre was to be played by Miss Darragh, then that Sara was to have her choice of either Deirdre or Dectora, and finally that Miss Darragh was going to play the role. Willie could restrain himself no longer. In exasperation he wrote to Yeats on August 18: "What am I to make of it? I don't care a red cent which of them plays either part but is Dectora now finally to be rehearsed by Miss Allgood? I've got to keep down rows here but I can't if we change about week by week."[19]

With all these obstacles in her path, it is not surprising that Miss Darragh had a very difficult time during her short stay at the Abbey Theatre. As she saw it, the Fays were slipshod and amateurish in all the practical aspects of running a profession-

16. Nic Schiublaigh and Kenny, *The Splendid Years*, pp. 12, 70-73.
17. Unpublished letter from Frank Fay to Yeats (August 16, 1902). Fay wrote to Yeats on July 7, 1902; "I doubt whether we ought to talk much about a national theatre yet. It's a rather large order. After ten years' work we may have something to say. I look on our work as pioneer work. We even in a stronger measure than 'L'Oeuvre' represent the protest against commercialism." Preserved in N.L.I. Ms. 13068.
18. Elizabeth Coxhead, *Daughters of Erin* (London: Secker & Warburg, 1965), pp. 175-76, 178-79, 211.
19. Unpublished letter from W. G. Fay to Yeats (August 18, 1906), N.L.I. Ms. 5977.

al theatre.[20] As Willie Fay saw it, her "substantial salary" and "special status" on playbills introduced into the company the "star" system which the Irish dramatic movement had originally set out to oppose.[21]

Artistically, Miss Darragh appears to have satisfied no one, including Yeats himself.[22] The reasons for this are probably best given in a letter which John Butler Yeats sent to his son:

She is an actress born, an actress genius, possibly a great actress. But her present style is altogether too florid, what is called too stagy. . . . It is unfortunate that Miss Darragh's acting "shows up" too glaringly the faults of the others—she has too much style. They hardly any. Frank Fay's dragging deliberation in speech and movement is a growing evil.[23]

Yeats had not yet given up the fight, however. Increasingly, he had grown to believe that the Fays were incapable of building the kind of acting company that might do his plays justice. He was also under a considerable amount of pressure from Miss Horniman to realize her original ideal of an "international art theatre".[24] In order to solve both problems Yeats presented to his fellow Directors a proposal in December 1906 whereby an experienced managing director would be appointed to the Abbey Theatre whose duties would include handling administrative matters as well as staging Yeats's own verse plays and an increased number of plays from the classical repertoire.[25]

Again Yeats went into great detail to explain why he thought this change necessary for the general good of the Theatre. At present, he declared, the Abbey Company was capable of performing "Irish peasant comedy and nothing else". To continue on this course would only serve to "tire its

20. Letter from Yeats to Florence Farr (October 1906), Letters, p. 481.
21. W. Fay, Fays of the Abbey Theatre, pp. 208-9. Synge also opposed star billing for Miss Darragh: "We go to the cultured people of these places to show them something that is new to them—our plays and the ensemble acting of our little company. If, however, we placard Miss Darragh, a very ordinary if clever actress, as the attraction, we put ourselves on a very different, and, I think, a very ridiculous footing. I am vehement against it." Synge to Lady Gregory and Yeats (May 7, 1907), Some Letters of J. M. Synge to Lady Gregory and Yeats, ed. Ann Saddlemyer, pp. 50-51.
22. Letter from Lady Gregory to Synge (December 1906). Cf. note 116, Chapter Ten.
23. (December 1906), J. B. Yeats, Letters to His Son, p. 99.
24. Vide Flannery, Annie Horniman, p. 23.
25. Memorandum from Yeats to Lady Gregory and Synge (December 2, 1906), N.L.I. Ms. 13068.

[Dublin] audience out". It was also a mistake to perform only comedies, particularly on tour, because "if we don't get an audience for work more burdened with thought pretty early we will make our audience expect comedy and resent anything else".

Yeats pointed out that other dramatists, encouraged by the success of peasant comedies by Lady Gregory and William Boyle, were producing bad imitations of their work. It was therefore necessary for the Theatre to "widen its capacity of performance" in order to create a wider school of dramatists. The natural means of doing this was by performing "foreign masterpieces chosen as much for a means of training as for anything else".

Returning to some of the ideas which had originally motivated his concept of the Irish Literary Theatre, Yeats stated:

We should keep before our minds the final object which is to create in this country a National Theatre something after the Continental pattern.... Such a National Theatre would perforce keep in mind its educational as well as artistic side. To be artistically noble it will have to be the acknowledged centre for some kind of art which no other Theatre in the world has in the same perfection. This art would necessarily be the representation of plays full of Irish characteristics, of plays that cannot be performed except by players who are constantly observing Irish people and things.... Such a Theatre must, however, if it is to do the educational work of a National Theatre be prepared to perform even though others can perform them better, representative plays of all the great schools.

Yeats then turned to the practical implications of his ideas as they would affect acting and staging at the Abbey Theatre. Noting a recent decline in Willie Fay's acting, which had been evident to several other observers, including Miss Horniman and that indefatigable chronicler of the Irish dramatic movement Joseph Holloway,[26] Yeats declared that this was mainly due to overwork. Furthermore, it was a condition which, if

26. Vide Flannery, pp. 18-22, for Miss Horniman's criticisms of Willie Fay's decline as an actor. Holloway corroborates her criticisms, which included an inconsistency from performance to performance, overacting, "gagging" (i.e., paraphrasing dialogue), and an inability to speak verse. *Impressions of a Dublin Playgoer* (1903), N.L.I. Ms. 1801, pp. 130, 565; (1906) Ms. 1804, p. 528. Willie Fay, on the other hand, quite rightly complained about the strain of having to create sometimes four different characters for one evening's bill of plays at the Abbey Theatre. *Fays of the Abbey Theatre*, p. 169.

not checked, would ultimately destroy Willie Fay's effective-
ness as a comedian:

If he has to do the work of an assistant Stage Manager as well as that of
a producer and actor in a year's time people will begin to talk of the
monotony of his acting. He will be satisfied to express his personality
instead of creating self-consistent personalities. The business side of
the Theatre and the non-artistic side of the stage work must be put into
other hands—this will ensure the efficiency of the comedy.

Frank Fay's tendency in both *Deirdre* and *The Shadowy
Waters* to "sing his words too much" had been noted by
Holloway, an astute critic of acting if not of drama. Hollo-
way also observed that all the Abbey actors but Sara Allgood
were "unconvincing" because "there was no real sap in
them".[27] Yeats employed similar terms to criticize Frank
Fay's work as both an actor and teacher. Though "always
beautiful to listen to", Fay was "not improving". Further-
more, actors left his tutelage

with no great clearness of elocution, with a fine feeling for both line
and passage as units of sound with a sufficient no less fallible sense of
accent, but without passion, without expression, either in voice or ges-
ture.

Yeats could not wholly condemn Fay for the Abbey ac-
tors' inability to speak verse. Having tested them individually,
he found that they were insensitive to the music and rhythm
of poetry. More than anything else, however, they lacked
that personal, scornful, soul-rending passion which he consi-
dered essential for the actor of tragedy. "From the first day
of the Theatre," Yeats declared ruefully, "I have known that
it is almost impossible for us to find a passionate woman
actress in Catholic Ireland."

Yeats proposed two solutions to these problems: first, that
Florence Farr be brought in for periodic six-week sessions to
work with the Abbey Company on voice production and
verse-speaking; second, that he be granted the right to "bring
in a player or players from without when I can do so without
burdening the finances of the Company more than my work

27. *Impressions of a Dublin Playgoer* (November 24 and December 1, 1906),
 N.L.I. Ms. 1804; (December 8, 1906), pp. 676, 635.

is worth". To do this, he added, "it will be necessary that he or she sometimes play in other work than mine."

The responses of Synge and Lady Gregory to this detailed proposal reveal a good deal about the attitude they had come to take towards the Abbey Theatre and their own work in particular. Synge made his views known in a vehement three-page typewritten letter sent to Lady Gregory and Yeats. In it he argued strongly against taking Continental municipal theatres as a model. He saw no reason for producing foreign plays, because the strength of the Irish movement had been "entirely creative". The company, therefore, should remain small in order that the "native work" might keep it occupied. Willie Fay's problems might be handled simply by engaging an assistant stage manager for him. Synge was particularly reluctant to encourage any kind of arrangement whereby Miss Horniman would have "control of some of the departments". Naturally, he was cognizant of the special "skill" required for Yeats's plays, but felt it was a mistake to go to England for actors. Looking back on Miss Darragh's performance, he argued that her kind of "emotion" was "best left to the imagination of the audience". Perhaps Yeats, like Shakespeare, would do better to think of having his heroines played by small boys than by imported English actresses. "I would rather go on trying our own people for ten years than bring in this readymade style that is so likely to destroy the sort of distinction everyone recognizes in our own company," he concluded.[28]

Synge's arguments seem reasonable, but they appear in a truer perspective if one realizes that he did not totally share Yeats's theatrical ideals. Behind Yeats's back, Synge in fact mocked what he termed a "Cuchulanoid National Theatre".[29] Moreover, Synge had been well served by the Fays. Thanks to the "special feeling" that Willie Fay had for his

28. *Some Letters of J. M. Synge*, pp. 41-45.
29. The phrase is not Synge's invention but that of his friend Stephen MacKenna who used it in a letter to Synge supporting Yeats's ideals. In reply (January 28, 1904), Synge declared that "no drama can ever grow out of anything other than the fundamental realities of life which are never fantastic, are neither modern nor unmodern and, as I see them, rarely spring-dayish, or breezy or Cuchulanoid". Vide Greene and Stephens, *J. M. Synge*, pp. 161-63.

plays[30]— and, ironically, thanks also to Yeats's unselfish pro-
motion of his name—Synge was already recognized as the
outstanding dramatist of the Irish movement.[31] Besides all of
this, Synge was in the process of completing *The Playboy of
the Western World*, with Willie Fay in mind for the title role.
Obviously, the last thing he wanted was to have Fay's peace
of mind disturbed.[32] Yeats could not have picked a worse
time to press his case.

Lady Gregory's response to Yeats's memorandum is chief-
ly remarkable for its ambiguity. On the whole, she agreed
with Synge's objections, and for many of the same reasons.
Apart from her suspicion that any idea supported by Miss
Horniman could only bode ill for the Abbey Theatre, keeping
the Fays at the Abbey appears to have been her main inten-
tion.[33] Again, one cannot really blame her, for the Fays had
contributed as much to the theatrical success of her plays as
they had to Synge's. Many of her comic characters were, in
fact, inspired by and written to suit their striking personal-
ities.[34]

The ambiguity of Lady Gregory's response lies in the fact
that, although she protested to Synge that it was necessary to
procure good performances for Yeats because "the right to
the first production of [his] plays is our chief distinction",[35]
she either failed or did not really want to understand Yeats's
real theatrical problems. In a series of letters to Synge, Lady
Gregory implied that Yeats, with his typical "impetuosity",
had not really known what he was doing when he brought
Miss Darragh from England.[36] If Miss Darragh had remained
with the Theatre, she would have cared more for "showy
parts" than for the good of Yeats. "Verse not being an easy

30. Vide Maurice Bourgeois, *John Millington Synge and the Irish Theatre*
(London: Constable & Co., 1913), p. 175. Cf. *Fays of the Abbey*, p. 138.
31. Joseph Hone, *W. B. Yeats*, p. 222; cf. Lady Gregory, *Our Irish Theatre*, p.
221; Greene and Stephens, *J. M. Synge*, p. 271.
32. Letter from Synge to Yeats (January 9, 1907), N.L.I. Ms. P5380, quoted in G.
Fay, *The Abbey Theatre*, p. 111.
33. Letter from Lady Gregory to Synge (December 1906), N.L.I. Ms. P5380.
34. The roles of the "rebel" in *The Rising of the Moon* (described as being "five
feet five" in height) and Cooney in *The Jackdaw* and *The Canavans* were
obviously written for Willie Fay, while the title role in *Hyacinth Halvey* and
Nestor in *The Jackdaw* were close to Frank Fay's off-stage personality.
35. Letter from Lady Gregory to Synge (December 6, 1906), N.L.I. Ms. P5380.
36. Unpublished letter from Lady Gregory to Synge (January 6, 1906), N.L.I. Ms.
P5380.

success would probably be put aside for more popular plays with a tragic or melodramatic side to balance them." The result would be that "the distinction of our work would be lost". For this reason Lady Gregory firmly opposed the idea of importing any more thespians from England, either for Yeats's plays or for classical roles. To do this, she warned Synge with misplaced patriotic fervour, would be "a case of calling the Normans into Ireland".

If the idea of bringing in another Miss Darragh was upsetting to Lady Gregory, the possibility of having an English managing director appalled her. "I wonder if the Managing Director would have a vote equal to yours or mine?" she prodded Synge. "If so it would be for the bringing in of English actors, in which we are not in agreement with Yeats, and Yeats's casting vote would carry it against us." Synge was told to breach the whole matter delicately to Fay. "If he has valid reason for rejecting, then I think we should all refuse—and not be like Dillon and Co., giving up Parnell to please in English howl."[37]

Yeats's power of persuasion—and the practical need of staying in Miss Horniman's good graces in order to retain the Abbey subsidy—were ultimately the deciding factors. Under strict conditions with regard to his artistic and administrative powers and duties, Ben Iden Payne was appointed as the managing director of the Abbey Theatre in January 1907. Willie Fay's bruised feelings were somewhat assuaged with a salary increase of one hundred pounds.[38] Miss Horniman opposed Florence Farr's being brought in to teach verse-speaking on the grounds that she was "careless",[39] but Frank Fay was none the less told by Yeats that in this capacity his services were no longer required.[40]

Payne's stay at the Abbey was a brief but turbulent one. Rumours that his salary was to be five hundred pounds per year aroused the actors' antagonism even before his arrival in mid-February.[41] The closest he came to directing a classical

37. Unpublished letter from Lady Gregory to Synge (December 1906), N.L.I. Ms. P5380.
38. Letter from Synge to Yeats (January 11, 1907), Synge Papers, N.L.I. Ms. P5381, quoted in Greene and Stephens, p. 235.
39. Letter from Lady Gregory to Synge (December 1906), N.L.I. Ms. P5380.
40. Holloway, *Impressions of a Dublin Playgoer* (January 24, 1907), N.L.I. Ms. 1805, p. 59.
41. Ibid.

play was a successful production of Maeterlinck's *L'Intérieur* in March. He got to direct only one play of Yeats—a revival of *Deirdre* in April—and further irritated the company, especially Sara Allgood, by casting his wife, Mona Limerick, in the title role.[42] Payne resigned from the company in June 1907. Within a month it was announced that he was to become the managing director of a new repertory theatre, the Manchester Gaiety Theatre, to be operated by Miss Horniman.

Payne went on to establish a highly successful career as a stage director, theatre manager, and teacher in both professional and university theatre. Looking back on his unhappy experience at the Abbey Theatre, however, he recalled that all his efforts were somehow stifled by "a form of passive resistance" from the actors and a vague "atmosphere of suspicion and intrigue".[43]

There is little doubt that the continued opposition of Synge and particularly Lady Gregory to Payne's presence at the Abbey contributed to his difficulties. Writing to Synge about Payne in March 1907, Lady Gregory found him "tiresome, very conscientious and energetic—but too great a craving for foreign masterpieces".[44] When Yeats apparently sought to have Payne produce Corneille's *Polyeucte* in order to develop a tragic actress, she opposed the idea, declaring: "I don't see why we should go out of our way to find parts for a great tragic actress, just the thing we haven't got. And in any case those immensely long speeches are out of date".[45]

Both Lady Gregory and Synge felt strongly that Payne's English methods did harm to the vocal style evolved by Frank Fay.[46] Joseph Holloway again provides a clue as to what they meant in his observation that, under Payne, the Irish players tended to "shout or rant where they used to be dignified, calm and expressive".[47]

42. Ibid. (March 19, 1907), p. 184.

43. Letter from Ben Iden Payne (May 25, 1927) quoted by Dawson Byrne in *The Story of Ireland's National Theatre* (Dublin: The Talbot Press, 1929), pp. 60-61.

44. (March 5, 1907), N.L.I. Ms. P5380.

45. Letter from Lady Gregory to Synge (January 1907), N.L.I. Ms. P5380.

46. Letter from Lady Gregory to Synge (May 10, 1907), N.L.I. Ms. P5380. Synge dismissed Payne's production of *Deirdre* as "a bastard literary pantomime, put on with many of the worst tricks of the English stage". Letter to Lady Gregory (May 7, 1907), *Some Letters of J. M. Synge*, p. 51.

47. *Impressions of a Dublin Playgoer* (April 20, 1907), N.L.I. Ms. 1805, pp. 270-73.

None the less, it is evident that Lady Gregory had no understanding of why Fay's lack of inner passion and short physical stature made him so unsuitable for heroic roles in the plays of Yeats. Writing to Synge after the *Playboy* opening, she noted that it was well acted. Then she commented with a remarkable lack of theatrical insight: "It made me a little sad to think how long it will be before the verse plays can get anything like as good an all round show, though Frank Fay's beautiful speaking is enough to carry them through."[48] Lady Gregory's oversimplified solution for Yeats's difficulties—an idea with which Synge concurred—was to have him "do his best play in prose for acting, and put it into verse afterward".[49]

One cannot help concluding that, as much as any other single cause, the intransigence, theatrical ignorance, and downright selfishness of Lady Gregory and Synge thwarted Yeats's ambitions for the early Abbey Theatre. By blocking Yeats's efforts to widen the theatrical scope of the Abbey, they effectively limited the repertoire to Irish peasant plays. In so doing, they also destroyed Yeats's hopes of receiving satisfactory productions of his own poetic plays. From 1906, with the exception of *The Green Helmet* in 1908, a satirical experiment in rhymed couplets utterly unlike any of his early works, no new plays were written by Yeats specifically for the Abbey Theatre Company until his adaptation of *The Only Jealousy of Emer* into the ballet *Fighting the Waves* for Ninette de Valois and the Abbey School of Ballet in 1929.

THE DEPARTURE OF THE FAYS

Miss Horniman announced her plans for the formation of the Manchester Gaiety Theatre in June 1907. At the same time she made it clear to the Abbey Directors that after 1910 her subsidy would not be renewed. Lady Gregory received this news with a feeling close to jubilation. At last both the Abbey Theatre and Yeats were to be rid of Miss Horniman's baleful influence. Lady Gregory's biggest fear was that Miss Horniman would somehow persuade Yeats to take an active

48. Letter from Lady Gregory to Synge (January 1907), N.L.I. Ms. P5380.
49. Ibid. Cf. Letter from Synge to Lady Gregory (July 1, 1907) in which he argued that by writing his plays first in prose Yeats "could then make the alterations he thought necessary . . . without the worry of continually re-writing the verse". *Some Letters of J. M. Synge*, p. 54.

part in her new venture.[50] When Yeats declined to do this, on
the grounds that he was too old to change his nationality,[51]
Lady Gregory felt that the way was clear to start afresh. The
first thing to do was re-establish a feasible working relation-
ship with the Fays.[52]

What Lady Gregory failed to realize was that now the Fays
had come to view their relationship with the Abbey Theatre
in a new light. Until the announcement of the withdrawal of
Miss Horniman's subsidy they had put up with much that was
really at variance with their basic concepts of theatre. Yeats's
mysticism, the obscurity of some of his dramatic verse, and
experiments such as pitched verse speaking had little appeal
to them.[53] Nor did they enjoy facing a howling mob night
after night in order to keep The Playboy of the Western
World on the boards. When Yeats insisted on challenging that
mob, and when attendance figures began to drop drastically
as a result, a spirit of rebellion began to set in.

Disheartening as it was to play to empty seats, the Fays
were bothered even more by the thought that no money was
coming into the box office. The Directors might have in-
comes from other sources, but the very livelihood of the Fays
and the other Abbey actors depended on their salaries from
the Theatre. To them the principal significance of the loss of
Miss Horniman's subsidy was that salaries were going to have
to be paid through ticket sales. It was obviously going to be
necessary to win back the "man in the street". And the only

50. Letter from Lady Gregory to Synge (June 21, 1907), N.L.I. Ms. P5380.
51. Letter from Yeats to Miss Horniman, Letters, pp. 500-501. Wade dates this
 letter tentatively as "early 1908". Judging from the context, however, it is
 more probable that it was written in June or July 1907.
52. Letter from Lady Gregory to Synge (June 21, 1907), N.L.I. Ms. P5380.
53. In an interview with the writer on March 17, 1966, Padraic Colum said that the
 Fays objected to the obscurity of the opening speech of the King in The
 King's Threshold. Yeats replied to this criticism in a prologue to the play:
 "The stage manager says I've got to juggle for you. That I'm to cause a vision
 to come before your eyes, but he doesn't want to let me please myself. He
 says it must be simple, easy to understand, all about real human beings, but
 I'm going to please myself this time...." "The Black Jester's Prologue",
 Variorum Plays, p. 313. This prologue was never performed. Letters, p. 409.
 Cf. Unpublished letter from Frank Fay to Yeats objecting to his pitched verse
 experiments (December 15, 1902), N.L.I. Ms. 13068.

way that could be accomplished was by performing "popular" plays.[54]

The second problem, as the Fays saw it, was the recurrent one of maintaining company discipline. In the first flush of the nationalist impulse which fostered the Irish National Theatre Society it had been relatively easy to get actors to turn out, not only for three nights a week of rehearsals, but for two additional nights of elocution lessons by Frank Fay.[55] Such was the spirit of the Camden Street Hall, that everyone felt they were "doing something for Ireland", whether sewing a costume or rehearsing a walk-on role for six months.[56]

The Fays had hoped that some of this early idealism would carry over into a professional company, with the added advantage that the players could devote themselves on a full-time basis to perfecting their art.[57] They found themselves sadly disillusioned when, although artistic standards might be higher, motivations were no longer so selfless. Laziness, born from a lack of seriousness and artistic pride, was a continuing frustration.[58] Willie Fay found it difficult at times even to get

54. Conversations between the Fays and Joseph Holloway (July 4, 1907, July 26, 1907), reported in *Impressions of a Dublin Playgoer*, N.L.I. Ms. 1805, pp. 419, 452.

55. Holloway, *Impressions of a Dublin Playgoer* (March 9, 1904), Ms. 1802, p. 579; (November 16, 1904), pp. 488-91.

56. Nic Schiubhlaigh and Kenny, *The Splendid Years*, pp. 8-9, 26; cf. Letter from George ("A.E.") Russell to Sara Purser (August 15, 1902) in which he noted that "the fiery youths of the company are rehearsing up to 12 o'clock". *Letters from A.E.*, p. 42.

57. Unpublished letter from Frank Fay to Yeats (March 18, 1903), N.L.I. Ms. 13068.

58. On August 22, 1906, Willie Fay wrote to Yeats complaining about the new members recruited for the company: "It's got round down that we are paying people and that we did well on tour so that every sundowner that turns up expects to be paid. . . . They can't speak English, walk or do a thing. One has to begin at the very beginning with each of them and waste the time of our own people" (N.L.I. Ms. 5977). Fay's difficulties were not unusual. Micheál MacLiammoir sums up the attitude of the typical Irish actor towards his craft: "They don't care about the stage at all. They don't care about anything much except being agreeable to everyone and having a good time." *All for Hecuba* (Dublin: Monumental Press, 1961), pp. 116-17.

the company to rehearse and learn roles.[59] By the autumn of 1907 insubordination was rife, with Molly O'Neill running to Synge if Willie worked her too hard, and her sister Sara finding a soft ear in Lady Gregory whenever she felt that she was not getting satisfactory roles.[60]

The supercilious attitude of the Directors, particularly Lady Gregory and Yeats, also contributed to dissatisfaction within the company. Lady Gregory, except to the few who were her favourites, appears to have presented a forbidding, chilly façade. At times, her solicitude for the welfare of the company caused her to interfere unnecessarily in people's personal lives.[61] Yeats's mask of lofty detachment was another problem. Despite the continued objections of the actors, he publicly referred to them as "shopgirls" and "clerks". In turn, they thought of him as a "poseur".[62] Stanislavsky has emphasized the care that he took at the Moscow Arts Theatre to develop a sense of mutual respect between actors and directors as an essential element for true theatrical creativity. What many old Abbey Theatre actors remember most about being in the presence of Lady Gregory and Yeats is simple fear.[63]

All of this may explain, in part, Willie Fay's greatest personal problem in dealing with the early Abbey Company, his erratic and highly explosive temper. In his later years as a director in England, Fay was a model of charm and affableness to all who worked with him,[64] but at the time with which we are dealing, undoubtedly because of the pressure of his own uncertain position and of too many artistic and administrative worries, his hot temper kept people around him continually on edge. This, more than anything else, made

59. Letter from W. Fay to Yeats (December 17, 1907), N.L.I. Ms. 13068.
60. Cf. Greene and Stephens, p. 219; Coxhead, *Daughters of Erin*, p. 193.
61. Cf., for instance, her embarrassment over Synge's love affair with Molly O'Neill (Greene and Stephens, p. 206); her concern over Frank Fay's infatuation with Sara Allgood (Letter to Synge, January 6, 1906, N.L.I. Ms. P5380); and especially her fear of "scandal or a row at the theatre" over Willie Fay's love affair with his wife-to-be, Brigit O'Dempsey (Letter to Synge August 26, 1906, N.L.I. Ms. P5380).
62. Holloway, *Impressions of a Dublin Playgoer* (February 11, 1904), N.L.I. Ms. 1802, pp. 69-71. Cf. ibid. (December 9, 1908), N.L.I. Ms. 1807.
63. Interviews with numerous former Abbey actors and other personnel, including Emma Bodkin, Padraic Colum, May Craig, Eileen Crowe, Gabriel Fallon, Eric Gorman, Christine Hayden, Dr. John Larchet, Dr. George O'Brien, Shelah Richards, and Dolly Robinson.

Yeats believe that Fay was "thoroughly unfitted for the management of people".[65]

It was therefore only with the greatest reluctance that, in June 1907, Yeats agreed to restore the powers that Willie Fay held before the advent of Payne. In a letter to Synge he predicted that Fay would never be able to hold the company together, but added: "I don't see what else we can do. We want him to work for us as enthusiastically as possible with a view to ultimately making his living out of the thing and helping others to make theirs. The Theatre is now a desperate enterprise and we must take desperate measures."[66]

Ironically, within a few months Lady Gregory came around to Yeats's view of the Fays. What apparently convinced her was that the Fays now made no attempt to hide their dislike not only for Yeats's plays but for her own as well. It was only with the greatest reluctance that the Fays presented a production of her full-length historical drama *Dervorgilla* in October 1907, and the production was poorly done.[67] This was followed by an even worse production of *The Unicorn from the Stars*, a none too successful adaptation by herself and Yeats of Yeats's *Where There is Nothing*. During one of the performances, out of sheer boredom Frank Fay fell asleep onstage. The Fays began to declare openly that Lady Gregory and Yeats were ruining The Abbey Theatre by "not giving other dramatists a chance".[68]

Among the "other dramatists" whom the Fays had in mind was a young Kerry author named George Fitzmaurice.[69] Fitzmaurice's *The Country Dressmaker* had been given an

64. In a letter from Peggy Ashcroft to the writer, she says of Fay: "He was the first professional director I worked with and I remember gratefully his kindness and charm and humour" (March 28, 1966); Laurence Olivier also worked under Fay at the Birmingham Repertory Theatre and recalled him as "a very kind, slightly rough-shod, but warm director of me and the company I played with". Letter from Laurence Olivier to the writer (March 23, 1966).

65. Letter to Synge (August 14, 1907), quoted in part in Greene and Stephens, p. 274.

66. Yeats to Synge (August 14, 1907).

67. Holloway, *Impressions of a Dublin Playgoer* (October 31, 1907), N.L.I. Ms. 1805, pp. 714-16.

68. Conversation between Holloway and J. M. Kerrigan, the actor (June 6, 1908), N.L.I. Ms. 1806, pp. 583-84. Cf. Willie Fay's dismissal of both *Dervorgilla* and *The Unicorn from the Stars, Fays of the Abbey*, p. 228.

69. Conversation between Holloway and Willie Fay (November 23, 1907), N.L.I. Ms. 1805, pp. 290-92.

extremely successful first production by the Abbey Theatre in early October. Despite a rich and original talent, he was never given proper recognition by Yeats or Lady Gregory, and at his death in 1963 left behind a considerable number of excellent unproduced plays.[70] It is to the credit of Willie Fay that he immediately championed Fitzmaurice's work citing *The Country Dressmaker* as an example of the new kind of play that the Abbey ought to be producing. Whether the Directors liked, it or not, he intended to revive *The Country Dressmaker* as soon as possible, he told Holloway.[71]

The question of presenting popular new dramatists and of regaining effective control over the Abbey acting company came to a head by the end of the year. On a tour to Manchester, Glasgow, and Edinburgh, Willie Fay found it impossible to maintain discipline. Sara Allgood and Molly O'Neill repeatedly missed rehearsals; J. M. Kerrigan, one of the most promising of the new players, was persistently late.[72] Willie's patience ran out. Upon returning to Dublin he fired off a letter to the Directors, in which he demanded:

1. That the Directors put up a notice shortly that all contracts with the National Theatre Society terminate on such a day. That people wishing to re-engage write in to W. G. Fay.

2. That all engagements be for a season only and terminable by a fortnight's notice on either side.

3. That where the Directors require special actors or actresses for their performances I should engage them on terms to be decided between the Directors and myself and for such parts or performances as the Directors shall decide.

4. That the power of dismissing those under my contracts shall rest with me after due consultation with the Directors in the case of principals.

70. Vide Howard K. Slaughter, *George Fitzmaurice and His Enchanted Land* (Dublin: Dolmen Press, 1972); Austin Clarke, "The Dramatic Fantasies of George Fitzmaurice", *The Dublin Magazine*, XV, 2 (April-June 1940), pp. 9-14; Robert Hogan, *After the Irish Renaissance*, pp. 164-75, for appreciative studies of Fitzmaurice's plays.

71. Conversations with Willie Fay (October 4 and November 23, 1907), Holloway, *Impressions of a Dublin Playgoer*, N.L.I. Ms. 1805, pp. 627, 790-92.

72. Letter from Willie Fay to Yeats (January 10, 1907), N.L.I. Ms. 13068; conversation with Willie Fay (January 4, 1908), Holloway, *Impressions of a Dublin Playgoer*, N.L.I. Ms. 1806, pp. 18-20.

5. That there shall be no appeal to any other authority than mine by the people engaged by me on all matters dealt with in their contracts.[73]

At a Directors' meeting held on December 4, Willie Fay's demands for the right to dismiss and re-engage the company on a personal contract were refused. The Directors also refused to "abrogate the right of appeal . . . already possessed by the company"; but agreed that "an improvement in discipline is necessary". Their surprisingly democratic suggestion was that a committee from the company be selected to formulate "rules of discipline" in consultation with the stage manager and the Directors. These rules would then be "put to the company as a whole for their decision".

One final point is of considerable significance:

That it be explained to the company that this Theatre must go on as a theatre for intellectual drama, whatever unpopularity that may involve. That no compromise can be accepted on this subject, but that if any member find himself unable to go on with us under the circumstances, we will not look upon it as unfriendly on his part if he go elsewhere, on the contrary we will help him if we can.[74]

It seems evident that the Directors were not only calling Willie Fay's bluff: they were preparing to ease him out the door as expeditiously as possible.

Events began to move rapidly towards a climax. J. M. Kerrigan and Sara Allgood submitted letters of resignation. Kerrigan complained of the abusive language of Willie Fay; Sara's reason was that Fay had replaced her with his wife for a performance without changing her name on the program. Lady Gregory became furious at the affront to her favourite actress, especially since she was afraid that Sara might win a contract from Miss Horniman at the Manchester Gaiety Theatre.[75] Synge, who earlier in the year had been on the side of the Fays in thinking that he too was being discriminated

73. Letter from Willie Fay to the Directors (December 1, 1907), N.L.I. Ms. P5380, quoted in Fay, The Abbey Theatre, p. 127.

74. N.L.I. Ms. P5380, quoted in Fay, The Abbey Theatre, p. 127.

75. Letters from Lady Gregory to Synge (December 12 and 30, 1907), N.L.I. Ms. P5380. Cf. Greene and Stephens, pp. 280-81.

against by Lady Gregory and Yeats,[76] now turned against them largely because of the influence of his sweetheart, Molly O'Neill. Synge declared himself "sincerely sorry" that Fay had "put himself in an impossible position by a generally unwise behaviour that he is largely unconscious of". At the same time he blandly excused the lack of company discipline, particularly that of Molly O'Neill, as due to "highly excitable" artistic temperament. "The difficulty of our position," he wrote, "is that Fay's claims are logical and reasonable if he was the right man for the position, but are impossible when we take into consideration all the little details of his personality."[77]

Together, Lady Gregory and Yeats concocted a plan whereby advantage would be taken of the general unrest in order to force the Fays' resignation. Thus it was to appear that it was not their idea but the will of the company.[78] Writing from London on December 30,[79] Yeats provided Synge with a detailed list of instructions. Synge was asked by Yeats first to calm down Kerrigan and then to draw up a list of grievances for the actors to present against Fay. These, he suggested, might include:

1. Violent language.
2. Irregularity at rehearsals, sometimes no importance being put on punctuality and at other times unexpected indignation (possibly this may be difficult to formulate).
3. Mrs. Fay being put into Sally Allgood's place in Glasgow and no attention paid to the fact on the programme. The Company are not concerned with Fay's explanation, which concerns us. He has done, so far as Sally Allgood is concerned, something upon which she could base an action. What we want is, first of all, violent language complained of and then some definite thing, which prevents the whole thing from seeming too vague.

Some idea of the remarkable skill that Yeats had developed as a man of affairs may be gathered from the care that

76. Vide Greene and Stephens, p. 269.
77. Letters from Synge to Lady Gregory (December 18, 1907) and Yeats (December 19, 1907), *Some Letters from J. M. Synge*, pp. 65-67, 68-70.
78. Letter from Lady Gregory to Synge (December 30, 1907), N.L.I. Ms. P5380.
79. N.L.I. Ms. P5380.

he took in planning the confrontation between the Fays and the Directors. "We cannot state the case of the members. They must do that," he told Synge—having, of course, already advised him which of the actors' complaints to emphasize. "If they would threaten to resign, so much the better; but we have no right to demand that of them."

Even the procedure at the projected meeting was planned:

I shall be in the chair. If I have a written statement before me of the Company's grievances I can give it priority and force Fay to fight on that issue. If I haven't I must hear the first speaker, or the first amendment. This will be equally the case whether we three Directors hold the meeting with nobody there except Fay and a few representatives of the whole Company, or with any possible arrangement of attendance. I mean everything must be in the most perfect order. If we meet alone by ourselves and Fay were to send in a written complaint, it would have to be considered, and any counter-action upon our part would seem a reply to it and not the cause of it.

Yeats's care to deny Fay the initiative was for fear that he would indict the Directors for trying to "suppress a popular work like the Dressmaker in the interests of our unpopular work". Yeats's chief worry was that militant nationalist papers would take up the case against them. *The Leader* and Griffith's *Sinn Fein* could not be expected to understand that "the Playboy which they hate is fine art and that the Dressmaker which they like is nothing." Minutes must "carefully be kept and signed" because of the possibility of appeal to the public.

In view of the overall circumstances Yeats's final comment appears somewhat ironic: "Fay is a man of genius and often a very pleasant fellow, but he is just the kind of man who will make a very unfair opponent."

For all the Machiavellian plotting, the final exit of the Fays apparently was handled in a much more mundane fashion. Following a trip to Galway in mid-January, during which Fay further enraged Lady Gregory by altering a bill of her plays, he was handed a letter signed by all but one member of the company in which they threatened to resign if he were

given the powers he demanded.[80] Seeing no alternative, Fay handed in his own resignation on January 13, 1908. Probably more out of a sense of loyalty than anything else, he was joined by his brother Frank on the same day.[81]

THE EFFECTS OF THE FAYS' DEPARTURE

For everyone concerned, the long-term effects of the Fays' departure from the Abbey Theatre were unfortunate. Willie Fay went on to a fairly successful career in England as an actor, director, and teacher. In a sense, however, the rest of his career was anti-climactic. He often felt frustrated by the thought that his work at the early Abbey had been forgotten, and more particularly, that the major share of credit for establishing the Theatre was taken by Yeats and Lady Gregory.[82]

For Frank Fay it was a similar story. He drifted through a number of English Shakespearean touring companies for ten years before returning to Dublin. Increasingly, he was embittered by the supercilious manner with which Yeats habitually referred to his efforts in training the early company.[83] Until his

80. Conversation between Frank Fay and Joseph Holloway (June 29, 1913). *Impressions of a Dublin Playgoer*, N.L.I. Ms. 1815, p. 1148. Letter from Lady Gregory to Synge (December 30, 1907), N.L.I. Ms. P5380.

81. Holloway, *Impressions of a Dublin Playgoer* (January 13, 1908), N.L.I. Ms. 1806, pp. 28-29. Another motive for Frank Fay's resignation was his longing for professional experience as a Shakespearean actor with one of the English stock companies that he admired. Letter from Frank Fay to Maire Garvey (May 27, 1908), Roberts Papers, N.L.I. Ms. 8320.

82. In the lecture which Yeats delivered to the Royal Swedish Academy on receipt of the Nobel Prize in 1923, he outlined the history of the Irish dramatic movement, singling out Maire O'Neill and Sara Allgood as "players of genius", but mentioning the Fays only as "our two best men actors", one "a stage-struck solicitor's clerk and the other a working man who had toured Ireland in a theatrical company managed by a negro". *Autobiographies*, p. 563.

When Yeats apparently employed the same terms ten years later in a lecture to the Royal Dublin Academy, Mrs. W. G. Fay fired off an angry letter protesting the "contemptuous" reference. Letter (February 27, 1933), Fay Papers, N.L.I. Ms. 2652, p. 52.

83. Frank Fay was particularly bitter about Yeats's declaration that the famed Abbey style of minimal movement with focussed "blocking" came into being only because of the "inexperience" of the actors. "All we did was done deliberately, and *with knowledge*", said Fay. "I saw the same principle carried out when the great Sara Bernhardt played Phèdre." Lecture by Frank Fay, "Some Thoughts on Acting", delivered to the Playhouse Circle, Dublin (1925), N.L.I. Ms. 10953.

death in 1931, he eked out a difficult living as a teacher of elocution and director of amateur productions of Shakespeare and other Elizabethan dramatists.[84]

Lady Gregory, Yeats, and, until his death in March 1909, Synge attempted to carry on the practical work of the Fays: staging plays, handling administrative duties, and even teaching acting.[85] Occasionally, a stage director was brought over from England to give a new spark to the company. But sooner or later difficulties with the actors, conflicts with Yeats and Lady Gregory, or sheer lack of funds caused the experiment to be abandoned.[86] As a result, the company settled into the famous "Abbey style"—a style which up to the present time, as the writer has experienced it, is compounded of a fumbling, shambling awkwardness, broadly stereotyped characterizations based more on earlier actors than on life, a masterly sense of word colouration which is all too often exploited for cheap laughs, and a vague feeling throughout that

84. Vide Gerard Fay, *Fay's Third Book* (London: Hutchinson, 1964), p. 109 et passim; Austin Clarke, *A Penny in the Clouds* (London: Routledge & Kegan Paul, 1968), p. 40.

85. Cf. Greene and Stephens, p. 284; Hone, *W. B. Yeats*, p. 220; Robinson, *Ireland's Abbey Theatre*, p. 71; Elizabeth Coxhead, *Lady Gregory*, pp. 96, 160, 175. Vide letter to Joseph Holloway from Frank Fay (April 7, 1908) for Fay's caustic opinion of Yeats's ability as an acting coach and stage director. Yet Holloway noted no immediate decline in the acting standards at the Abbey after the departure of the Fays. *Joseph Holloway's Abbey Theatre*, pp. 110, 113.

86. William Poel was imported for a few weeks during the summer of 1908 to give lessons to the company in speech and voice production; Norreys Connell came to the Abbey in the spring of 1909 as a stage director and manager; Nugent Monck in the autumn of 1911 as a teacher and stage director; and A. Patrick Wilson in the autumn of 1913 as a stage director and manager. Poel's methods were mocked by the company (*Joseph Holloway's Abbey Theatre*, pp. 114-15); Connell ran into trouble with the actors when he sought to eliminate sloppy speech habits and "artistic snobbishness" (Ibid., p. 280; Robinson, *Ireland's Abbey Theatre*, p. 76); Monck was apparently unable to get along with Lady Gregory on the American winter tour of 1912-13 (*Impressions of a Dublin Playgoer*, May 9, 1913, N.L.I. Ms. 1820, p. 852); A. Patrick Wilson, an Orange Scotsman, was thoroughly disliked by the company, and, furthermore, antagonized Lady Gregory and Yeats by attempting to promote his own plays (Theatre correspondence preserved in N.L.I. Ms. 13068). As with the Fays, a major part of the problem was that none of the imported directors and managers was given any effective control over the artistic or administrative operation of the Theatre. Vide Theatre correspondence, N.L.I. Ms. 13068; Coxhead, *Lady Gregory*, p. 175.

everything is underrehearsed.[87] Paradoxically, attempts are made to justify this ineffective sloppiness by quoting from the canon of Abbey tradition. As Eric Bentley learned through a bitter experience as a visiting director: "At the Abbey, everything is sacrosanct, especially what is indefensible."[88]

Yeats, of course, ultimately suffered most of all, for he was never to have a company of Irish actors capable of adequately interpreting his plays. Obviously, what he needed most was a literate man of the theatre, such as Stanislavsky or Lugné-Poe to work side by side with him as both a stage director and acting teacher. Along with this he needed a school or conservatory of the theatre to educate and train theatre artists possessing the profound qualities of mind and spirit, talent and technique essential for interpreters of his plays.

The closest Yeats ever came to realizing these needs was with the short-lived Abbey Second Company and School of the Theatre which he ran in conjunction with the brilliant actor and director Nugent Monck in 1912 and 1913.[89] A wide variety of theatrical experiments were carried out with a group of young actors dedicated to acquiring a complete education in the theatre.[90] However, a combination of lack of funds and, as with Ben Iden Payne, Lady Gregory's antipathy

87. Holloway records a consistent decline in the quality of acting in the company from 1912 onwards, mainly because of a lack of discipline and the need of careful direction and training, *Impressions of a Dublin Playgoer* (1912), N.L.I. Ms. 1814, 1129; (1913) N.L.I. Ms. 1816, pp. 108, 402-3, 408, 734. Cf. Ernest Boyd, "The Irish National Theatre: A Criticism", *The Irish Times* (December 27, 1912), p. 5; Andrew Malone, "The Decline of the Irish Drama", *The Nineteenth Century*, XCVVII (April 1925), p. 588; Mervyn Wall, "Some Thoughts on the Abbey Theatre", *Ireland Today*, I (September 1936), pp. 4, 59; and Sean O'Faolain, Preface to *She Had to Do Something* (London: Jonathan Cape, 1938), pp. 15-19. This last is written from the standpoint of a playwright whose work was destroyed by insensitive acting and directing.

88. Eric Bentley, *In Search of Theatre*, p. 308.

89. Vide Norman Marshall, *The Other Theatre* (London: John Lehman, 1948), pp. 92-97, for a description of Nugent Monck's work staging medieval plays with the Madder Market Theatre in Norwich, England.

90. Vide Interview with Yeats (*The Irish Times* September 8, 1911) concerning the purposes and working methods of the Abbey Second Company under Nugent Monck. Preserved in Henderson Press Cuttings, N.L.I. Ms. 1734 (1911), V, p. 208.

to an English intruder forced Monck's resignation. For most of Yeats's career as a playwright, the staging of his and other imaginative works at the Abbey Theatre were left in the hands of the ineffectual Lennox Robinson.[91]

It is, of course, extremely doubtful whether under the best of circumstances Willie Fay could have helped Yeats to realize his ideal "Theatre of Beauty". Yeats found that Fay had a "very defective ear for verse".[92] Moreover, he had little imaginative or intellectual sympathy with Yeats's plays.[93]

The case of Frank Fay was different. With more understanding and patience on both sides during those difficult years when Yeats was trying to work out an acting style and dramaturgical method appropriate to his vision, it is probable that Frank Fay could have been of considerable help. Certainly, Abbey actors were never again to have so meticulous a training in voice production, diction, and verse-speaking as he gave to the early company.[94] Yeats himself admitted as much when, in 1937, he wrote a warm tribute to Fay and his knowledge of the history of acting. The article concluded: "Were

91. By Robinson's own admission, when he was appointed as a stage director and manager at the Abbey Theatre in 1910, his sole practical experience in the theatre had been a three-month observation period under Granville-Barker and Shaw's direction at the Court Theatre, London. Lennox Robinson, *Curtain's Up* (London: Michael Joseph, 1942) p. 23. The general impression of Robinson as a stage director is that he was effective in coaching actors for realistic plays, but lacking any sense of visual or musical style in staging more imaginative plays. Cf. Michael O'Neill, *Lennox Robinson* (New York: Twayne, 1966), pp. 71-72; Interviews with Hilton Edwards (November 13, 1964), Micheál MacLiammoir (August 4, 1966), Shelah Richards (May 1, 1966).

92. Memorandum to Lady Gregory and Synge (December 2, 1906), N.L.I. Ms. P5380; Holloway corroborates this criticism, *Impressions of a Dublin Playgoer* (1903), N.L.I. Ms. 1801, p. 488.

93. Yeats explained Willie Fay's intellectual limitations as follows: "His whole generation were either useless to the arts, or almost so. He, like most of the actors who have left us for one reason or other, grew up at a time when nothing outside the ordinary business of life was taken seriously. He could not make himself work at it. He prided himself upon management, which made him important in the eyes of his friends, and he had not the self-control for that." *Memoirs*, pp. 143-44.

94. Actors such as Sara Allgood, Maire Nic Shiubhlaigh, and Dudley Digges have paid tribute to Frank Fay's ability as a teacher of speech. Sara Allgood, Lecture on the Abbey Theatre given in Manchester (1909) with corrections by W. B. Yeats, N.L.I. Ms. 13572; Nic Shiubhlaigh and Kenny, *The Splendid Years*, pp. 8-9; Dudley Digges, "A Theatre Was Made", *The Irish Digest* (October 1939), p. 13.

he living now and both of us young I would ask his help to elaborate new conventions in writing and representation.''[95]

Given their limited educational and cultural backgrounds, it is also evident that the members of the early Abbey Company were incapable of realizing Yeats's dramatic ideals.[96] None the less, looking back on a lifetime of frustration in the theatre, Yeats paid tribute to the early Abbey actors along with the few great interpreters with whom he had been associated:

I have aimed at tragic ecstasy, and here and there in my own work and in the work of my friends I have seen it greatly played.... I am haunted by certain moments: Miss O'Neill in the last act of Synge's *Deirdre*, "Draw a little back with the squabbling of fools": Kerrigan and Miss O'Neill playing in a private house that scene in Augusta Gregory's *Full Moon* where the young mad people in their helpless joy sing *The Boys of Queen Anne*; Frank Fay's entrance in the last act of *The Well of the Saints;* William Fay at the end of *On Baile's Strand;* Mrs. Patrick Campbell in my *Deirdre*, passionate and solitary; and in later years that great artist Ninette de Valois in *Fighting the Waves*. These things will, it may be, haunt me on my death-bed; what matter if people prefer another art. I have had my fill.[97]

95. *Essays and Introductions*, p. 529.
96. Vide *Memoirs*, p. 183. Typical of the average Abbey actor's response to Yeats's ideas is the oft-repeated story of his attempt to have Arthur Sinclair "anticipate on his face the idea of the following phrase". (In other words, to motivate his lines.) Yeats is said to have worked with Sinclair until suddenly he cried, "You've got it." The next day Yeats stopped the rehearsal in despair, saying: "You've lost it." Sinclair's response was: "How could I have lost what I never knew I had." The story is usually told as proof that Yeats "knew nothing about acting." Cf. Holloway, *Impressions of a Dublin Playgoer* (November 8, 1913), N.L.I. Ms. 1816, pp. 405-6; Coxhead, *Daughters of Erin,* p. 182; Robinson, *Ireland's Abbey Theatre*, p. 75; Hogan, *After the Irish Renaissance*, pp. 150-51, for similar attempts to denigrate Yeats as a practical man of the theatre.
97. *Explorations*, p. 416.

Yeats and the Visual Arts of the Theatre

RITUAL AND PATTERN

Complicated though the notorious difficulties of W. B. Yeats with actors may have been, these difficulties were more than equalled by the problems he faced in trying to develop an appropriate visual style for his own and other plays staged during the early years of the Irish dramatic movement. We have noted that the spectacular staging methods of the nineteenth-century actor-managers were abhorrent to Yeats because they subordinated dramatic values appealing to the ear in favour of coarse theatrical values appealing solely to the eye. It was therefore necessary for him to create not only the aesthetic of a new art of the theatre but the practical means of bringing his ideals to life on the stage.

Two concepts—those of ritual movement and patterned scenic decor—dominated Yeats's theory and practice throughout the 1890s. His interest in ritual arose primarily from his involvement with the Hermetic Order of the Golden Dawn. The rituals of the Golden Dawn employed colourful masks, richly adorned costumes, and formal dance-like movements, ambulations, and gestures focussing on or about the central symbols of the Order. Yeats studied these rituals carefully,

for he based many of the rites for his own projected Celtic Mysteries upon them.[1]

Yeats's interest in patterned decor sprang from the art of Rossetti and the Pre-Raphaelite Brotherhood, to which his father introduced him at an early age. At the age of eighteen, Yeats began to study painting at the Dublin School of Art, but soon found himself bored by the mechanical exercises assigned to him. "When alone and uninfluenced," he says, "I longed for pattern, for Pre-Raphaelism, for an art allied to poetry."[2]

Yeats experienced for the first time a form of drama employing both ritualistic movement and Pre-Raphaelite patterned scenic decor at the Bedford Park Playhouse, a little theatre created by the consciously aesthetic community of poets, scholars, artists, and actors in which he lived with his family in London from 1888 to 1891. With the help of the brilliant architect and designer Edward Godwin, various experiments were carried out in the staging of poetic drama. At the time, Yeats was particularly impressed with the "semi-religious effect" produced by the burning of incense and the movements of a white-robed chorus in *Helena of Troas* by John Todhunter, as well as the "perfect unity" of acting, scenery, and verse in *A Sicilian Idyl* by the same author.[3] In later years, he recalled an adaption of *Pilgrim's Progress* played "before hangings of rough calico in crewel work". This idea may have been taken from the example of William Morris, who was deeply involved in reviving the dead art of tapestry-making. Yeats says that on seeing the production he thought that some such method, based upon the arts of embroidery or tapestry, might provide a new means of creating non-realistic scenery.[4]

Philosophically and practically, Yeats found many of his early concepts corroborated by the example of the French symbolist movement in the theatre. His ideas were given further support by the man whom he considered his "chief instructor" in the visual arts—the English painter, sculptor, wood engraver, lithographer, and later distinguished set and costume designer, Charles Ricketts (1866-1931).[5] As an art-

1. Vide Virginia Moore, *The Unicorn*, pp. 125-82.
2. *Autobiographies*, pp. 81, 114-15.
3. *Letters to the New Island*, pp. 114, 117. Cf. *Autobiographies*, pp. 113-23.
4. Preface to *Letters to the New Island*, pp. ix-x.
5. *Autobiographies*, p. 169. Cf. *Essays and Introductions*, p. 495.

ist in the Pre-Raphaelite tradition, Ricketts worked with the eye of a painter, striving to build a stage picture not in terms of broad theatrical strokes but in terms of decorative details, "each portion exquisite in itself, yet coordinate".[6]

We can perhaps best see the effect which these cumulative influences had upon Yeats's visual concepts of the theatre by examining a passage from his essay on "Symbolism in Painting", written in 1898:

All art that is not mere story-telling, or mere portraiture, is symbolic and has the purpose of those symbolic talismans which medieval magicians made with complex colours and forms, and bade their patients ponder over daily and guard with holy secrecy; for it entangles in complex colours and forms a part of the Divine Essence. A person or a landscape that is part of a story or portrait evokes but so much emotion as the story or portrait can permit without loosening the bonds that make it a story or portrait; but if you can liberate a portrait from all bonds of motives and their actions, causes and their effects, it will always change under your eyes, and become a symbol of an infinite emotion, a perfected emotion, a part of the Divine Essence, for we love nothing but the perfect, and our dreams make all things perfect, that we may love them.[7]

Translated into the language of the stage, what this statement implies is that Yeats viewed the overall stage picture as

6. A Bibliography of the Books Issued by Bacon and Ricketts at the Vale Press (London: Ballantyne Press, 1914), p. vi. Vide Saddlemyer, "The Heroic Discipline of the Looking Glass", The World of W. B. Yeats, pp. 96-101.

7. Essays and Introductions, pp. 148-49. Yeats's image of the talisman is especially fascinating in view of the essay that he wrote in April 1901 in an effort to persuade the members of the Order of the Golden Dawn to maintain their traditional practices. The essay concludes: "If we preserve the unity of the Order, if we make that unity efficient among us, the Order will become a single very powerful talisman, creating in us, and in the world about us, such moods and circumstances as may best serve the magical life and best awaken the magical wisdom. Its personality will be powerful, active, visible afar, in all that powerful world that casts downward for its Shadows, dreams, and visions. The right pupils will be drawn to us from the corners of the world by dreams and visions and by strange accidents; and the Order itself will send out Adepts and teachers, as well as hidden influences that may shape the life of these islands nearer to the magical life. We have set before us a certain work that may be of incalculable importance in the change of thought that may be coming upon the world. Let us see that we do not leave it undone because the creed of drifters is being cried into our ears." Harper, Yeats's Golden Dawn, pp. 267-68. Yeats failed in his endeavour to preserve the unity of the Order of the Golden Dawn, but, to a remarkable extent, his ideals were realized through the Abbey Theatre.

a kind of magical charm—a charm which through a highly formalized and patterned interrelationship of shapes and colours became for the audience a symbol of infinite perfection. The stage picture thus contained a tiny world of its own—a world almost completely removed from the artifacts of daily life.

The actor was not seen as a three-dimensional, flesh-and-blood figure. Instead, he was but another element in the overall stage pattern—a symbol of human perfection rather than a reflection of life as it existed in the stalls and pit of the theatre. With characters "loosened" from the "bonds" and "motives" of daily life, the play unfolded as a ritual, no more attempt being made deliberately to capture the spectators' attention than if they were participants at a religious ceremony. Costumes served to blend the actors with the scenic background, in pattern, cut, and colour contributing to a stage picture of "severe beauty such as one finds in Egyptian wall-paintings". Such an abstract stage picture called for a non-realistic form of scenery that would be, as Yeats put it, "an accompaniment not a reflection of the text". Scenery should ideally be forgotten "the moment an actor said, 'The dew is falling' or 'I can hear the wind among the leaves.' " Nothing about it should serve to remind the audience of the life it left in the streets so as to "baffle the evocation which needs all one's thought". Sometimes "a shadowy background, a pattern of vague forms upon a dim background would be enough, for," said Yeats, "the more the poet describes, the less should the painter paint." "A forest, for instance, should be represented by a pattern and not by a forest painting."[8]

Both *The Shadowy Waters* and *The Countess Cathleen* were written by Yeats with these concepts and visual images in mind. Yeats thought of *The Shadowy Waters* as "more a ritual than a play"—a work that would, he hoped, "leave upon the mind an impression like that of a tapestry where the forms only half reveal themselves amid the shadowy folds."[9] Because the play was conceived as "deliberately

8. Vide Letters to the Editor of the *Daily Chronicle* (January 27, 1899) and to Fiona Macleod (January 1897), *Letters*, pp. 309, 280.
9. Program note for *The Shadowy Waters* (August 1905) quoted by Richard Ellmann, *The Identity of Yeats*, p. 21.

without human character", the actors were lost in the "general picture". Instead, the whole stage picture moved together —"sky and sea and cloud [becoming] as it were actors".[10] Similarly, Yeats looked back upon his early version of *The Countess Cathleen* as "a piece of tapestry".[11] For the original version of the play, published in 1892, he, in fact, called for several scenes to be played before tapestries "representing the loves and wars of the Fenian and Red Branch warriors".[12]

The experience of staging *The Countess Cathleen* taught Yeats that in order to succeed in the theatre of his time it was necessary to imitate more directly the common actions of life. This led him to a dramaturgical form that laid increasing emphasis upon more realistically portrayed and individualized characters. But in order to lift his plays out of any particularity of time and locale, Yeats continued to employ ritual as a staging device. As we have seen, by structuring his plays so as to include ritualistic scenes side-by-side or even within relatively realistic scenes, he was enabled to slow down the stage action, heighten the dramatic impact, and thus carry the audience beyond the world of temporal affairs to the mystical realm of "tragic ecstasy".

Instances of this occur throughout the plays that Yeats wrote for the early Abbey Theatre. Cuchulain's oath of fealty to the High King Conchubar in *On Baile's Strand*, for example, is given theatrical significance by a ritual in which his sword is joined in the fire with those of the lesser kings—a symbolic rite directly borrowed from the Celtic Mysteries. Throughout the ceremony an almost inaudible murmur of chanting women's voices adds to the aura of suspense and mystery.[13] Similarly, the Musicians in *Deirdre* set the scene for the impending doom of Naoise and Deirdre as they slowly light the torches on the sconces, while chanting a beautiful lyric on the emphemeral nature of life and love.[14] A powerful theatrical and thematic climax to *The Unicorn from the Stars* is effected when, in defiance of social and religious constraints, the visionary young tradesman, Martin, puts out

10. Letter to Frank Fay (January 20, 1904), *Letters*, p. 425.
11. *Autobiographies*, p. 417.
12. *The Countess Cathleen and Various Legends and Lyrics*, p. 96.
13. *Collected Plays*, pp. 262-63. Cf. Moore, *The Unicorn*, p. 76.
14. Ibid., p. 191.

a row of lighted church candles, saying to a priest who has come to save him:

> I thought the battle was here, and that the joy was to be found here on earth, that all one had to do was to bring again the old wild earth of the stories—but no, it is not here; we shall not come to that joy, that battle, till we have put out the senses, everything that can be seen and handled, as I put out this candle. (*He puts out candle.*) We must put out the whole world as I put out this candle. (*puts out another candle*). We must put out the lights of the stars and the light of the sun and the light of the moon (*puts out the rest of the candles*), till we have brought everything to nothing once again. I saw in a broken vision, but now all is clear to me. Where there is nothing, where there is nothing—there is God![15]

To perceptive critics such as John Masefield the acting style of the early Abbey Company was distinctive precisely for those ritualistic qualities that Yeats had admired at the Bedford Park Playhouse and later in Paris. "With an art of gesture admirably disciplined and a strange delicacy of enunciation they perform the best dramas of our time in the method of a lovely ritual," Masefield observed. "Their art lacks personality, but it is never obvious, it never intrudes."[16] It was precisely this lack of "personality" that made the early Abbey actors unsuitable for the heroic plays of Yeats. But when in 1915 Yeats turned to Japanese Noh drama as a dramaturgical model that focussed the spectator's attention almost exclusively on the bodily energy of the actor-dancer within the space of a drawing room, he continued to insist that it was through a formalized ritual that this "intimate" art kept its appropriate distance from a "pushing world".[17]

Patterned scenic decor, too, remained a consistent element in Yeats's concept of staging. For the Molesworth Hall pro-

15. Ibid., pp. 381-82.
16. Review of the opening performance of the Abbey Theatre quoted by Fraser Drew in "The Irish Allegiance of an English Laureate: John Masefield and Ireland", *Eire-Ireland* (Spring 1968), p. 27.
17. *Essays and Introductions*, p. 224. Some idea of choreographic patterns appropriate for the dance plays may be inferred from Yeats's interest in the ritual wheel dances in which the Druids celebrated the revolving seasons. Similar dances from other ancient cultures are also described by Madame Blavatsky and appear to have been prominent in the rituals of the Order of the Golden Dawn. Vide *Mythologies*, pp. 220-28, 286; Seiden, *The Poet as Mythmaker*, pp. 74, 328; Regardie, *The Tree of Life*, pp. 148-51.

duction of *The King's Threshold* in October 1903 he hoped, at one point, to have an embroidered curtain made, probably according to a design by Charles Ricketts, that would be utilized behind the speaker of the Black Jester's prologue, as well as for other plays.[18] Later this idea was adopted in a somewhat different manner for the dance plays, which opened with a ceremonious unfolding of a patterned cloth (see Plate 9).

Yeats also maintained his interest in abstract patterns painted upon flat backgrounds and in backdrops of embroidered cloth so as to create stylized interior and woodland scenes[19] (see Plate 13). With the dance plays, however, he returned to his original concept of the stage picture as an intricate jewel-like image, the actor-dancers themselves forming part of the overall scenic pattern. It was thus a return to

a mysterious art, always reminding and half-reminding those who understand it of dearly loved things, doing its work, not by direct statement, a complexity of rhythm, colour, gesture, not space pervading like the intellect—but a memory and a prophecy[20] (see Plate 22).

From a strictly chronological standpoint, the year 1902 marked a decisive turning point in Yeats's dramaturgical and theatrical development. Besides becoming involved with the Irish National Theatre Society, this was the year that Yeats rejected explicit ritual and pattern as the dominant influences upon his work. Over the next few years, in visual terms Yeats was pre-eminently concerned with the problem of space—particularly the spatial relationship of the three-dimensional actor to his two-dimensional background. The most vital impulse and direction to his experiments were provided by the innovations of that extraordinary theatrical revolutionist Gordon Craig.

GORDON CRAIG AND DECORATIVE DESIGN

There are few more controversial figures in the modern theatre than Gordon Craig (1872-1966). Depending on which critic one reads, Craig is either the Messiah of a new theatre or a romantic impractical dilettante.

18. Vide Letters to Frank Fay (August 8, 1903) and to Charles Ricketts (July 26, 1904), *Letters*, pp. 409, 436.
19. Yeats, "The Theatre of Beauty", *Harper's Weekly* (November 11, 1911), p. 11.
20. *Explorations*, p. 255.

Craig was the son of Ellen Terry and Edward Godwin. He began his theatrical career as an actor, playing minor roles for Henry Irving intermittently between 1889 and 1897. Torn between an intense admiration for Irving the man and a growing dissatisfaction with the grandiose style of theatre embodied in Irving's productions, Craig gave up acting at the end of the 1897 season in order to devote himself to artistic inquiry and scene design.

As with Yeats, Craig's basic aim was to restore theatre to its former dignity. Like Wagner and the French symbolists, he sought to create out of a combination of all the arts an entirely new "Art of the Theatre". His ideal was a visionary art based not upon "man or nature or anything else on the boards of a theatre", but upon the personal response of the designer-producer (that is, stage director) to a particular play or series of plays.[21] Craig was a product of the aesthetic movement and an enemy of the naturalists in that he insisted that the function of the theatre was to evoke a sense of Beauty divorced from any other end. "Once let the meaning of this word 'Beauty' begin to be thoroughly felt once more in the theatre," he said, "and we may say that the awakening day of the theatre is near."[22]

Where Wagner placed the ultimate authority in the musician, Craig viewed the stage director as the most important figure in the theatrical hierarchy. He displayed the bias of the visual artist, however, in claiming that the pre-eminence of the poet had kept the theatre from becoming a popular art:

The theatre was for the people, and always should be for the people. The poets would make the theatre for a select company of dilettanti. They would put difficult psychological thoughts before the public, expressed in difficult words, and would make for this public something which is impossible for them to understand and unnecessary for them to know; whereas the theatre must show them sights, show them life, show them beauty, and not speak in difficult sentences.[23]

It would seem as if in many ways the aims of Yeats and Craig were diametrically opposed. Yet, in fact, they deeply

21. Vide Edward Gordon Craig, *On the Art of the Theatre* (1905, London: Heinemann, 1966), pp. 11-27.
22. Craig, "The Artists of the Theatre of the Future", *The Mask*, I (1908), p. 66.
23. Craig, *Art of the Theatre*, pp. 11-12.

admired each other's art and ideas. Craig considered Yeats to be "a great playwriter and without question the greatest of the Irish playwriters".[24] When he founded his famous School of the Theatre at Florence in 1912, he carefully distinguished his intentions from those of "literary drama". At the same time he declared that "we shall in our way and with our material hope to do what Yeats and Synge have done with their material".[25] When Yeats himself considered attending the School, Craig wrote to him:

My school is not for the likes of you, I fear. You could learn nothing there. What you've learnt you've learnt already—and what you have of the theatre is positively appalling. Now we shall learn from you about fairies and red dogs.[26]

Yeats, in turn, was one of the earliest and staunchest champions of Craig's theatrical reforms. Chiefly, this may be attributed to Yeats's persistent desire to realize his dramatic ideals in terms of the living theatre. Here Craig offered not only an example but practical help.

Craig's new ideas for the stage were first seen in a production of Purcell's *Dido and Aeneas*, presented in London in May 1900. Two elements—colour and light—were of primary importance in the production. The backdrop, a great purple-blue cloth, bore no resemblance to the two-dimensional perspective views in which the nineteenth-century scene-painters took such pride. Against this backdrop, costumes which consisted chiefly of draped robes and veils stood out, coloured in broad strokes of green, purple, blue, and scarlet. In the last act, Craig created a particularly beautiful picture by projecting a yellowish light on to the stage which turned the backdrop into a deep shimmering blue, and brought the greens and blues into rich harmony.[27]

In January 1901 the production was revived in a program which included another theatre piece called by Craig *The*

24. Craig, "Plays for an Irish Theatre with Designs by Gordon Craig", *The Mask*, IV (1911-12), p. 342.

25. Craig, "Is Poetic Drama Born Again?", *The Mask*, V (1912-13), p. 291.

26. Unpublished letter from Craig to Yeats (May 11, 1911) in the possession of Michael Yeats.

27. Denis Bablet, *Edward Gordon Craig* (London: Heinemann Educational Books, 1966), pp. 41-42.

Masque of Love and based upon music by Purcell. Yeats saw this production and sent Craig a warmly appreciative letter in which he described the setting as "the only good scenery I ever saw".[28] In *The Speaker* for May 11, 1901, Yeats wrote:

Naturalistic scene-painting is not an art but a trade, because it is, at best, an attempt to copy the obvious effects of Nature by the methods of the ordinary landscape-painter, and by his methods made coarse and summary. It is but flashy landscape painting and lowers the taste it appeals to, for the taste it appeals to has been formed by a more delicate art. . . . Decorative scene-painting would be, on the other hand, as inseparable from the movements as from the robes of the players and from the falling of the light; and being in itself a grave and quiet thing it would mingle with the tones of the voices and with the sentiment of the play, without overwhelming them under an alien interest. . . . Mr. Gordon Craig used scenery of this kind at the Purcell Society performance the other day, and . . . it was the first beautiful scenery our stage has seen. He created an ideal country where everything is possible, even speaking in verse, or speaking to music, or the expression of the whole life in a dance.[29]

A year later, when *The Saturday Review* gave its readers to understand that productions such as Craig's were not worth seeing, Yeats promptly sent a letter to that journal in which he declared that the staging of *Dido and Aeneas* and *The Masque of Love* had given him "more perfect pleasure than I have met in any theatre these ten years". By discovering how to "decorate a play with severe, beautiful, simple effects of colour, that leave the imagination free to follow all the suggestions of the play", Craig had created "a new and distinct art", an art that "can only exist in the theatre". "The staging of *Dido and Aeneas*," he concluded, "will someday, I am persuaded, be remembered among the important events of our time."[30]

Yeats did more than simply offer Craig praise. Shortly after the break-up of the Irish Literary Theatre, he tried to persuade Edward Martyn to employ Craig in an Irish touring company led by the English actor-manager Frank Benson.[31] He also hoped, for a time, to raise enough money to enable

28. Quoted by Edward Craig in *Gordon Craig* (London: Gollancz, 1968), p. 135.
29. Quoted in Bablet, pp. 44-45.
30. Ibid., p. 47.
31. *Autobiographies*, pp. 446-47.

Craig to give *The Countess Cathleen* the exquisite staging that it required.[32] Most important, he made Craig's personal acquaintance and set out to learn as much as he could about Craig's "little stage dodges", particularly lighting and costumes.[33]

By the time of the first performance of *Cathleen ni Houlihan* in April 1902, Yeats knew enough about Craig's methods to declare to Frank Fay:

Two years ago I was in the same stage about scenery that I am now in about acting. I knew the right principles but I did not know the right practice because I had never seen it. I have now learnt a great deal from Gordon Craig.[34]

Craig's influence is evident in the criticism that Yeats made of the scenery and costumes designed by George Russell for the production of Russell's *Deirdre*, performed on the same bill as *Cathleen ni Houlihan*. Writing in *Samhain* Number Two (October 1902), Yeats stated that Russell's decor was "not simple enough. I should like to see poetic drama staged with but two or three colours," he declared.

The background, especially in small theatres, where its form is broken up and lost when the stage is at all crowded should, I think, be thought out as one thinks out the background of a portrait. One often needs nothing more than a few shadowy forms to suggest wood or mountain.[35]

Intricate pattern was now replaced by the focussed compositional technique of portrait painting. But the principal new visual element is colour. It was by employing vivid colour relationships that Yeats sought either to harmonize or to contrast the actor with his scenic background and lift the play as a whole out of time and place to the realm of "fairyland".[36]

Yeats's first experiment with this new style of decor was made with *The Hour-Glass*, when it was first produced at the Molesworth Hall on March 14, 1903. Staged with costumes

32. Letter to Lady Gregory (January 6, 1903), *Letters*, p. 394.
33. Letters to Lady Gregory (September 26 and December 4, 1902), *Letters*, pp. 380, 384.
34. Letter dated April 21, 1902, *Letters*, p. 371.
35. *Samhain* Number One, p. 5.
36. *Collected Works*, Vol. IV, p. 243.

designed by Robert Gregory according to an overall design created by T. Sturge Moore, the colour scheme was striking and effective. The action, as Yeats describes it, took place in front of an olive-green curtain with the Wise Man and his Pupils garbed in various shades of purple. A third colour, subordinate to the other two, was added by dressing the Fool in a red-brown costume with touches of green to harmonize with the curtain. Because Yeats found himself "annoyed . . . beyond words" by the brown back of the Wise Man's chair during the performance, it was painted for later performances to match the red-brown of the Fool's costume.[37]

Yeats took an active role in every aspect of the production, from approving the material, colour, and patterns of the costumes to personally designing the Botticellian costume of the Angel. During the intermission between the plays (Lady Gregory's comedy *Twenty Five* was given its first performance as the second play on the bill), he lectured, with the aid of a model made for him by Craig, on the new art of "decorative" stage design.[38]

The success of *The Hour-Glass* production confirmed Yeats's belief in the practical effectiveness of decorative design. This is evident in his criticism of a sketch submitted a short time afterwards by T. Sturge Moore for a projected production of *The Shadowy Waters:*

I don't like the colour schemes at all. . . . The white sail will throw the hounds into such distinctness that they will become an irritation. . . . Further, the black, brown and white effect is just one of those effects we like in London because we have grown weary with the more obvious and beautiful effects. But it is precisely those obvious and beautiful effects that we want here. . . . Your scheme would upset all my criticism here. I have been explaining on these principles:

1. A background which does not insist on itself and which is so homogeneous in colour that it is always a good background to an actor wherever he stands. Your background is the contrary of all this.

2. Two predominant colours in remote fanciful plays. One colour predominant in actors, one in backcloth. This principle for the present

37. Vide letter to T. Sturge Moore (March 1903), *W. B. Yeats and T. Sturge Moore: Their Correspondence,* pp. 5-7; *Collected Works* (1908), pp. 238-39.
38. Vide letter to Lady Gregory (December 9, 1902), *Letters,* p. 388; *The Fays of the Abbey Theatre,* p. 130; W. G. Fay, "The Poet and the Actor", *Scattering Branches,* p. 133.

at any rate until we have got our people to understand simplicity. *The Hour-Glass* as you remember was staged in this way and it delighted everybody.[39]

Yeats went on to make highly contrasting and vivid deployment of colour one of the continuing principles of stage design at the early Abbey Theatre. Decorative design was employed not only for his own plays but for those of Lady Gregory, Synge, and even for cottage settings for naturalistic peasant plays.[40]

Some idea of Yeats's efforts to employ colour to express the emotional mood of particular plays may be seen by comparing his colour scheme for *The Shadowy Waters* with that of *The Green Helmet*. For *The Shadowy Waters*, which was given its first production on January 14, 1904, Yeats asked T. Sturge Moore for a design which would be as "dreamy and dim" as the play itself: "A blue-green sail against an indigo-blue backcloth, and the mast and bulwark indigo blue. The persons in blue and green with some copper ornaments."[41]

The Green Helmet, "An Heroic Farce", was first performed at the Abbey Theatre on March 19, 1908, under the title *The Golden Helmet*. Intended as a grotesque satire on the bitter quarrels which had by this time destroyed many of Yeats's plans for the Irish National Theatre, the play called for a colour scheme "intentionally violent and startling". The set consisted of a house made of logs, painted in orange-red, with a door showing low rocks and a "green and luminous" sea beyond. Properties, consisting of a table, cups, and a flagon of ale, were painted black with a slight purple tinge. All the characters except the Red Man and the Black Man were dressed in various shades of green, one or two with touches of purple which looked nearly black. The Black Men all wore dark purple with "eared caps". At the end of the play Yeats suggested that "their eyes should look green from the reflected light of the sea".[42]

The title change is itself significant, possibly being made because the Golden Helmet of the Red Man did not show up

39. Letter dated March 1903, *Correspondence*, pp. 5-7.
40. Vide Lady Gregory, *Our Irish Theatre*, p. 107; *The Fays of the Abbey Theatre*, p. 170; *Essays and Introductions*, p. 305; *Memoirs*, pp. 275-77.
41. Letter to Lady Gregory (January 2, 1904), *Letters*, p. 419.
42. W. B. Yeats, *The Green Helmet and Other Poems* (Dublin: Cuala Press, 1910), p. 13.

against an orange background. For the later version of the play Yeats called for this character to be dressed all in red, "his height increased by horns on the Green Helmet".[43]

There were obviously sound financial as well as theatrical reasons for the deployment of simplified decorative scenery at the early Abbey Theatre. So limited were production budgets that the same settings and costumes often had to be used for a number of different plays.[44] Gordon Craig showed Yeats that an imaginative use of lighting was the most effective means for overcoming this difficulty. But here, as in every aspect of his theatrical work, Yeats adapted other people's ideas to suit his personal ends.

LIGHTING THE STAGE

One recurring criticism of Gordon Craig's early experimental work in England is that his extraordinary theatrical effects were created at the expense of the actors. This occurred in three ways: the proportions of his huge sculpturesque settings dwarfed the human figures onstage; his deployment of light and shade often left the actors' faces in shadow; and his heavy reliance on coloured lighting competed with the actors in expressing mood variation.[45]

Yeats was well aware of these flaws. In April 1903, he attended a London production of Ibsen's *The Vikings of Helgeland* staged by Craig. His reaction was in some ways similar to his response to Wagner's music in that he found the scenery "amazing" but felt that it "distract[ed] one's thoughts from the words".[46] Writing in the December 1904 edition of *Sambain* that coincided with the opening of the Abbey Theatre, Yeats stated firmly:

I have been the advocate of the poetry as against the actor, but I am the advocate of the actor as against the scenery. . . . The actor and the words put into his mouth are always the one thing that matters, and the scene should never be complete of itself, should never mean anything to the imagination until the actor is in front of it.

43. Ibid., p. 10.
44. Vide *Our Irish Theatre*, p. 107; *Explorations*, p. 126.
45. Vide Lynton Hudson, *The English Stage: 1850-1950* (London: Murray, 1951), p. 156; Janet Leeper, *Edward Gordon Craig: Designs for the Theatre* (Harmondsworth: Penguin Books, 1948), esp. plates 9, 17, 20, 21, 25.
46. Letter to Lady Gregory (April 1903), *Letters*, p. 398.

Yeats went on to draw a distinction between Craig's conception of the theatre and his own, specifically in terms of Craig's deployment of lighting as it affected the actor:

If we remember that the movement of the actor, and the graduation and the color of the lighting, are the two elements that distinguish the stage picture from an easel painting, we may not find it difficult to create an art of the stage ranking as a true fine art. Mr. Gordon Craig has done wonderful things with the lighting, but he is not greatly interested in the actor, and his streams of colored direct light, beautiful as they are, will always seem, apart from certain exceptional moments, a new externality. We should rather desire, for all but exceptional moments, an even, shadowless light, like that of noon.[47]

Yeats's theories on stage lighting were put into practice for the production of *On Baile's Strand* with which the Abbey Theatre opened on December 27, 1904. Willie Fay has described some of the effects that were achieved. The setting itself was made of curtains of unpainted jute, which, when flooded with amber light, "looked like cloths of gold". Upstage centre were a pair of doors, nine feet in height, on which were hung six large round shields designed by Robert Gregory: "When the doors were opened to Aoife's son, he stood silhouetted against a background of topaz blue, giving an effect of sea and sky, with an atmosphere that could never be obtained by paint."[48]

Craig's ideas were obviously used, but only for "exceptional moments" in the production. The main focus of attention was never taken from the actor.

Yet as Yeats developed in his knowledge of the theatre, he increasingly called for more complex lighting effects. Sometimes he sought to employ light as an ironic commentary on action. This is evident from his description of the effect desired for the final scene in *Deirdre* when the two fated lovers sit, playing chess, awaiting their doom:

47. *Explorations*, pp. 177, 179. Yeats maintained similar views to the end of his career: "The essential thing is always full or almost full stage light, because the actor comes first. Once accept that and artiness is impossible. A production that disturbs and obstructs the actor should be abandoned at once." "Journal" (October 30, 1930), *Memoirs*, p. 277.
48. "The Poet and the Actor", p. 134.

The sky outside is still bright so that the room is dim in the midst of a wood full of evening light, but gradually during what follows that light fades out of the sky; and except during a short time before the lighting of the torches, and at the end of all, the room is either dark amid light or light amid darkness. The lighting and the character of the scenery, the straight trees, and the spaces of sky and mountains between them suggest isolation and silence.[49]

Like Craig, Yeats experimented with light and shade as participating agents in the dramatic action. He toyed, for instance, with the idea of having the "barbarous dark-faced men" who pass outside Deirdre and Naoise's room appear only as shadows in front of a "blood-red" sunset.[50] This idea, like so many others, was never realized at the Abbey Theatre because of the shallowness of the stage.

Lighting was also employed to great dramatic effectiveness in staging the plays of Lady Gregory and Synge at the early Abbey Theatre. One is struck, for instance, by the image of the Sergeant and the Rebel sitting back to back on a barrel, isolated in the moonlight in *The Rising of the Moon*—an idea apparently suggested to Lady Gregory by Yeats[51] (see Plate 11). The great American designer Robert Edmund Jones, himself a disciple of Craig, has left a vivid recollection of the impression made by the scenery and lighting in Synge's *Riders to the Sea*, which he saw on the Abbey Theatre's first American tour:

The setting was very very simple. . . . Neutral-tinted walls, a fireplace, a door, a window, a table, a few chairs. The red homespun skirts and bare feet of the peasant girls. A fisher's net perhaps, nothing more. But through the window at the back, one saw a sky of enchantment. All the poetry of Ireland shone in that little square of light, moody, haunting, full of dreams, calling us to follow on. . . . By this one gesture of excelling simplicity, the setting was enlarged into the region of great theatre art.[52]

49. *The Variorum Edition of the Plays of W. B. Yeats*, p. xv. This stage direction is omitted from the Macmillan edition of the *Collected Plays*.
50. "Note to 'Deirdre' ", *Plays for an Irish Theatre*, p. 215.
51. Frank O'Connor, *The Backward Look*, p. 168.
52. "To a Young Designer", *The Context and Craft of Drama*, ed. Robert Corrigan and James L. Rosenberg (San Francisco: Chandler Publishing Co., 1964), p. 392.

But none of the Abbey peasant plays remotely approached the plays of Yeats in their demands for special lighting effects. In *The Shadowy Waters* Forgael quells a threatened mutiny by the sheer theatrical impact of his magical glowing harp. Perhaps feeling it necessary to justify such an effect after his attacks on the stage trickery employed by the nineteenth-century actor-managers, Yeats declared:

There is no reason for objecting to a mechanical effect when it represents some material thing, becomes a symbol, a player as it were. One permits it in obedience to the same impulse that has made religious man decorate with jewels and embroider the robes of priests and hierophants even until the robe, stiffened and weighted, seems more important than the man who carries it. He has become a symbol, and his robe has become a symbol of something incapable of direct expression, something that is superhuman.

Consistent with his philosophy of the theatre as essentially the art of the actor, however, Yeats added: "If the harp cannot suggest some power that no actor could represent by sheer acting, for the more acting the more human life, the enchanting of so many people by it will seem impossible."[53]

By 1908 Yeats was again experimenting with a form of "total theatre" that, like *The Countess Cathleen*, employed all the theatre arts to their fullest potential. The particular importance that Yeats gave to stage lighting is evident in his notes to *The Green Helmet:*

No breadth of treatment gives monotony when there is movement and change of lighting. It concentrates attention on every new effect and makes every change of outline or of light and shadow surprising and delightful. Because of this one can use contrasts of colour between clothes and background or in the background itself, the complementary colours for instance, which would be too obvious to keep the attention in a painting.[54]

Without careful lighting the vivid decorative colour scheme of *The Green Helmet* would have been garish, the action of the play itself indeed monotonous. Now, however, Yeats

53. *The Variorum Edition of the Poems of W. B. Yeats*, ed. Peter Allt and Russell K. Alspach (New York: Macmillan, 1957), p. 276.
54. *Collected Works*, Vol. IV, p. 243.

built lighting changes into the very stage action. The play
climaxes in a fight which produces a "deafening noise". The
stage directions read:

Suddenly three black hands come through the windows and put out the
torches. It is now pitch-dark, but for a faint light outside the house
which merely shows that there are moving forms, but not who or what
they are, and in the darkness one can hear low terrified voices.

Three frightened cries pierce the darkness. Then the stage
directions continue:

A light gradually comes into the house from the sea, on which the
moon begins to show once more. There is no light within the house,
and the great beams of the walls are dark and full of shadows, and the
persons of the play dark too against the light. The Red Man is seen
standing in the midst of the house.[55]

Even if the symbolism of the black hands or of the Red
Man himself is not understood, the sheer theatrical impact of
the scene is as impressive as that of the climax of *The Count-
ess Cathleen*. Unfortunately, it was no more possible to
achieve many of these effects at the Abbey Theatre than it
was on the makeshift stage where *The Countess Cathleen* was
first performed.

TECHNICAL PROBLEMS

It is important to understand the technical problems faced by
Yeats at the Abbey Theatre in order to understand his sub-
sequent experiments and development in the theatre.

The first problem was the sheer physical limitation of the
Abbey stage, which measured twenty-one feet wide, fourteen
feet high, and only fifteen feet deep. A look at some
of the photographs of productions at the early Abbey
Theatre (see Plates 10-16) reveals the disastrous results of
having to work on this peculiarly shaped stage. Yeats re-
quired stage pictures that in their compositional density
would reflect and support his poetic vision. Instead, we find
characters strung along the edge of the stage in straight un-
broken lines, like paste-board figures stuck on to the scenic
backdrop. There is a particular incongruity in the contrast

55. *The Green Helmet and Other Poems*, p. 31.

between the three-dimensional figures of the actors, and the old-fashioned, crudely painted stage flats (see Plate 14). In comparison, the photograph of Mrs. Patrick Campbell's 1908 London production of *Deirdre* illustrates what might have been accomplished with a larger stage that allowed imaginative and compelling stage pictures to be created (see Plate 12).

In discussing these problems with stage composition it is also important to note the evolution of Yeats's ideas on the shape of the stage itself. Writing on the theatre at Stratford-on-Avon in 1901, Yeats criticized the half-round stage because the actors recited their lines "as if they were speakers at a public platform". "Our art is the art of making a series of pictures," he declared.

> Were our theatres of the shape of a half-closed fan, like Wagner's theatre, where the audience sit on seats that rise towards the broad end while the play is played at the narrow end, their pictures could be composed for eyes at a small number of points of view, instead of for eyes at many points of view.[56]

By 1904, having seen *The Hour-Glass* and *The King's Threshold* staged on the shallow stage of the Molesworth Hall (the dimensions of which were sixteen feet in width, eleven feet in depth), Yeats had changed his mind about the picture-frame proscenium theatre. In the December 1904 edition of *Samhain* he vehemently attacked the development of the proscenium theatre in England because it coincided with realism and a proportional "decline in dramatic energy". He complained that at the Abbey Theatre "the necessities of a builder" had "torn from us, all unwilling as we were, the apron, as the portion of the platform that come in front of the proscenium used to called." Thus, he said, "we must submit to the picture-making of the modern stage", although "we would have preferred to be able to return occasionally to the old stage of statue-making, of gesture."[57]

56. *Essays and Introductions*, pp. 99-100.
57. *Explorations*, p. 173. In a letter to Frank Fay dated November 4, 1905, Yeats declared: "I think the whole of our literature as well as our drama has grown effeminate through the over development of the picture-making faculty. The great thing in literature, above all in drama, is rhythm and movement. The picture belongs to another art." *Letters*, p. 466.

A second major technical problem of the early Abbey Theatre was the lack of an adequate lighting system. Until 1923, when a complete set of lights, battens, and a dimmer board was purchased from the Birmingham Repertory Theatre, the lighting system at the Abbey consisted merely of footlights, a number of crude arc lamps hung from three battens over the stage, and standing carbon spots from the wings. Only five lamps could be attached to dimmers, but they could not be operated from a single lighting board. Instead, each had to be specially rigged and operated independently.[58]

These problems were complicated by the fact that Dublin theatrical supply houses of the time did not even carry coloured lamps such as Yeats required for his plays. A letter from Yeats to Synge, written in September 1906, illustrates the lengths to which he had to go in order to cope with such difficulties:

We will want a very considerable number of amber lamps and if we are short a stock of plain lamps will have to be laid in and proper stuff for dipping them got from electricians. I absolutely refuse to countenance any more makeshift stuff made up at the local oilshop. Somebody will have to be set to dip them. We all require these amber lamps, but I for my own purposes require a large number of blue and green lamps. . . . I want to be able to get the lighting of Shadowy Waters in order and the whole effect depends on the lighting.[59]

Some of the effects demanded by Yeats would have taxed the technical resources of almost any theatre of the time. The scene description for *The Shadowy Waters* calls, for instance, for a semi-circular backcloth representing the sea or sky upon which "there are deep shadows which waver as if with the passage of clouds over the moon".[60] Such an effect could only have been produced with a cloud projector.

It is little wonder that Willie Fay and the Abbey carpenter Shawn Barlow, despite their well-meaning attempts to rig up old bicycle wheels and the like, were unable to create a "cres-

58. Alan Cole, "Stagecraft in the Modern Dublin Theatre" (PH.D. thesis, Trinity College, Dublin), pp. 42-44.
59. Unpublished letter dated September 1906, preserved in Synge Papers, N.L.I. Ms. P5380.
60. *Collected Works*, Vol. II, p. 231.

cent shaped harp that was to burn with fire" for *The Sha-
dowy Waters*. Ultimately the idea of a harp was given up and
a sort of psaltery covered with glass substituted[61] (see Plate
8).

Despite the technical limitations of the Abbey Theatre, the
most serious problem faced by Yeats was to find designers
and technicians capable of understanding and then realizing
his extraordinary theatrical intentions. As with the acting of
peasant plays, it was a relatively easy matter for the early
Abbey Theatre to make an effective impression simply by
copying cottage and other realistic interiors, replete with au-
thentic spinning wheels, turf baskets, panniers, and even little
wooden barrels brought from the West of Ireland.[62] But the
plays of Yeats, which were created out of a world of the
imagination, required not only an original scenic style but a
means of actually realizing that style in terms of the money,
materials, and manpower available.

Yeats himself met this challenge by becoming a serious
student of the techniques as well as the principles of set
design, set painting, and construction. As one is impressed
with his technical knowledge of acting, one cannot help being
impressed with his concern for the detailed mechanics of
scenery, not only for his own plays but those of Lady Gre-
gory and Synge. We find him experimenting with a model set
so as to avoid bad sight-lines for the ship and sail in *The
Shadowy Waters*; suggesting to the designer that bushes be
"shaped Dutch fashion into cocks and hens, ducks, peacocks,
etc." in order that the opening scene of the 1902 London
production of *Where There is Nothing* be "made fantastic";
looking up Japanese prints at the British Museum to find tree
patterns for the scenery of the first production of Synge's
The Well of the Saints; and fussing over appropriate wings to
go with the fanciful plays of Lady Gregory.[63] A letter to

61. Vide Letter to Florence Farr (October 6, 1905), *Letters*, p. 463; *Collected
 Works*, Vol. II, p. 276.
62. The "authenticity" of properties and costumes was stressed on the early tours
 of the Abbey Theatre. Vide playbills preserved in N.L.I. Ms. 13068.
63. Vide Letter to T. Sturge Moore (March 1903), which includes a sketch by
 Yeats of a proposed setting for *The Shadowy Waters*, *Correspondence*, p. 7;
 Letters to Lady Gregory (December 1902, September 1904), *Letters*, pp. 386,
 445; Letter to Synge (October 1906), Synge Papers.

Synge, dated April 6, 1908, contains meticulous instructions for painting a set designed by Charles Ricketts for a revival of *The Well of the Saints*:

He wants the execution of the designs to be as vague as possible. Shawn, he says, should first paint it all in and then sponge over the details. It should all be scenery low in tone—lower in tone than anything he ever did. When he wants to darken he should glaze with size or scramble it over. He is not giving minute measurements. Shawn must follow the designs so as to get the general effect as broadly and simply as possible. He is to use blue and violet in the shadows as well as brown and make the base of all the stones and the trunks green as if they were grown where they touch the ground. The glen could be improved by a green flour cloth—at the borders seeming grey. Plants at the bottom of the backcloth to give distance. Everything moss green. Backcloth can be changed to evening by a change of light. Green and black and dark blue should be the clothes of the persons. Bush and piece of ruined wall should be one piece but can be made up of whatever height fits the height of your two players.[64]

It is not known whether the ideas of Yeats and Ricketts were realized for this setting. But it is clear that throughout the early years of the Abbey Theatre one of Yeats's greatest frustrations was the execution of decorative designs by Willie Fay, who was trained in the naturalistic scene painting traditions of the nineteenth century that Yeats abhorred, and Shawn Barlow, who had to be shown by Lady Gregory even how to hold and stroke a brush.[65] Again and again Yeats's letters complain of their ineffectual efforts to realize sets and properties for non-realistic plays. His sole consolation was that, although his scenic intentions might be "often mistaken in execution", they were "obviously right in principle".[66]

Design and execution of costumes for Yeats's plays were perhaps an even greater technical problem than scenery. Naturalistic peasant plays and the more poetic peasant plays of Synge and Lady Gregory again were dressed with relative ease and charm simply by utilizing authentic peasant shawls, col-

64. Preserved in Synge Papers.
65. Vide *Fays of the Abbey Theatre*, p. 16; Robinson *Ireland's Abbey Theatre*, p. 70.
66. Letter to John Quinn (February 15, 1905), *Letters*, p. 448; cf. pp. 444, 449, 463-64.

ourful petticoats, ancient frieze coats, and even "pampoot-ies"—the cowskin wrap-around sandals still worn by the fisherman in the Aran Islands. The plays of Yeats, however, demanded special treatment, not only in the design and colour of costumes but in their material, cut, and fit. A glance at photographs of the first productions of *The King's Threshold*, *The Shadowy Waters*, and *Deirdre* (see Plates 14, 16, 17) tells an unrelieved tale of tasteless shoddiness. One would think it far more likely to find these ill-fitting, crudely decorated costumes made of dyed hessian, with street shoes peering out from beneath the stiffened cloth, in a school pageant than on the stage of the famous Abbey Theatre. Comparing them with the costumes employed in Mrs. Patrick Campbell's production of *Deirdre* (see Plate 12) it is easy to understand why Yeats complained that until his plays received adequate productions he would be considered nothing more than an "amateur".[67]

Yeats's particular concern with experiments in lighting may therefore be explained not only by the need to give depth to the shallow Abbey stage but, above all, by the need to tone and mute the garish scenery and costumes created for his and other non-realistic plays at the Abbey Theatre. Not only was he unable to achieve the lighting effects he wanted, but his very experiments were a source of mockery to the Abbey Company.[68]

As the actor was able to destroy the exquisite mood of tragic reverie by arbitrarily running up and down the scale, Yeats learned that even an electric light peering out from behind a door might expose "the proud fragility of dreams".[69] We can imagine his reaction when, because of inadequate side lighting, an immense black shadow of the horns on Aibric's helmet in *The Shadowy Waters* (see Plate 17) was thrown down, so that, in Lady Gregory's words, when he moved it seemed as if there was "a he-goat going to butt at him over the side of a ship".[70]

67. Unpublished letter from Yeats to Synge (August 13, 1906) in the possession of Michael Yeats.
68. Vide Robinson, *Ireland's Abbey Theatre*, p. 75.
69. Preface to *Plays for an Irish Theatre*, p. h.
70. *Our Irish Theatre*, p. 35.

By 1908 Yeats had begun to search for another far more simplified means of staging his plays. Once again Gordon Craig appeared to have some of the answers to his quest.

THE CRAIG SCREENS, THE ÜBERMARIONETTE, AND THE MASK

In 1905 Gordon Craig published *On the Art of the Theatre*, in which he laid down his principles for the ideal theatre of the future. From 1904 to 1906 he attempted, with varying degrees of success, to realize his ideals in productions on the Continent for such noted theatrical figures as Otto Brahm, Max Reinhardt, and Eleanora Duse. In Germany he was excited by technical innovations such as hydraulic lifts in operation at many theatres. In Italy he renewed his interest in the spectacular Renaissance scenic artist and theoretician Sebastian Serlio. Most of all, he was inspired by the improvised movements of the dancer Isadora Duncan. He began dreaming of a new theatre art that, like her dancing, would express ideas in time and space. No longer would scenery be a mere background to the stage action. By becoming three dimensional—as flexible and as interesting as the body of the trained dancer—and by changing shape directly before the eyes of the audience, it would provide a wholly new kind of theatrical experience.[71]

Craig believed that his visionary theatre of the future would also demand an entirely new kind of acting. No longer would the actor be allowed to exhibit his "incomplete" art, expressed through the accidental whims of his personality, emotions, body, and voice. Nor would the actor be allowed to indulge his ego in the forefront of the stage picture, hypnotizing spectators with superficial studies of the world of human appearances and causing them to lose their sense of the totality of the dramatic work.[72]

Craig began implementing such ideas in Florence in February 1907. He built a model stage using a set of screens that he learned by experimentation to manipulate almost imperceptibly during the action of a play. To give scale to his screens, he made tiny wooden mannequins which were also capable of being manipulated so as to produce very slight movements, such as the slow rising of a hand or the turning

71. Vide Bablet, *Edward Gordon Craig*; Edward Craig, *Gordon Craig*, pp. 234-35.
72. Edward Gordon Craig, *Art of the Theatre*, p. 55.

of a head. Most of them were draped like ancient Greeks, for at that time the Greek tragedies interested him, and it was the scenic background for these plays that most challenged his theatrical imagination.[73]

Craig's experiments with mannequins led him, as it had some of the French symbolists, to a concept of acting based upon puppet movements. Craig postulated the creation of what he termed the *übermarionette*—a supremely beautiful creature, something like a Greek statue, that could be made to move, but would not suffer from or be affected by personal emotions. In histrionic terms, this creature would be an actor who had acquired some of the virtues of the marionette, and thus released himself from the servitude of his own human weakness. Acting, therefore, would consist for the main part in "symbolic gesture". By covering his face with a mask, the fleeting and variable expression of the actor would be formed into an everlasting image of the "Poetic spirit". The ideal of the *übermarionette* would, he said, not be "the flesh and blood but rather the body in trance—it [would] aim to clothe itself with a death-like beauty while exhaling a living spirit".[74]

By February 1908, Craig was ready to publish some of his findings. In that month he succeeded in achieving one of his earliest ambitions—the creation of a theatrical journal called *The Mask*. Five hundred copies of the first issue, which included his celebrated essay, "The Actor and the Übermarionette", were printed in Florence and distributed to leading theatrical figures throughout the world. A copy of *The Mask* reached Constantin Stanislavsky at a critical juncture in the development of the Moscow Art Theatre. It was a time when Stanislavsky had begun to see that further work in the naturalistic genre could only lead to an artistic *cul de sac*. Stanislavsky was so much impressed by Craig's ideas that he issued an invitation for him to come to Moscow to produce a play. Invitations were received at the same time from Beerbohm Tree in London and Reinhardt in Berlin.[75]

For Yeats also, the period from 1907 to 1909 was a time of great personal and artistic soul-searching. He had staked his own hopes as a dramatist on the development of a com-

73. Edward Craig, *Gordon Craig*, pp. 234, 239-40.
74. Vide *Art of the Theatre*, pp. 84-85; note by Craig, quoted by Leeper, p. 18.
75. Edward Craig, *Gordon Craig*, pp. 244-45.

pany of actors trained to speak verse by a skilled man of the theatre. As we have seen, these hopes collapsed with the departure of Ben Iden Payne from the Abbey Theatre in June 1907. The failure of the Abbey Theatre to win and educate an audience from the followers of the nationalist movement was a second grave disappointment to Yeats. Once again he spoke in *Samhain* (November 1908) of returning to his own "proper work without the ceaseless distraction of theatrical details" [76] It was considered an event when, during the summer of 1908 at Coole, Yeats began to write lyric verse again.[77] Now, however, it was a blistering satiric verse that mocked the very time he had wasted

> On the day's war with every knave and dolt,
> Theatre business, management of men.[78]

For Yeats, then, the impact of Gordon Craig's theoretical and practical innovations in the theatre were of profound importance. What they did, in fact, was revive his interest in the theatre at a time when, at least in terms of his own work as a dramatist, he was about to retire to the study.

Yeats renewed his acquaintance with Craig when Craig visited London in December 1909 to present Beerbohm Tree with his designs for an ill-fated production of *Macbeth*. Yeats displayed such enthusiasm and so deep an understanding of his work that Craig offered to make him a set of his model screens as well as to design costumes and masks for a production of one of his plays at the Abbey Theatre.[79]

Yeats had first to convince Lady Gregory of the feasibility of utilizing the Craig screens at the Abbey. Writing to her in

76. 6-7. A passage from an unpublished letter to Synge written in the midst of the controversy over engaging Payne reveals in graphic detail Yeats's frustration with the details of theatre management: "None of us are fit to manage a theatre of this kind and do our work as well. Lady Gregory's work this autumn would have been twice as good if she had not the practical matters of the theatre on her mind. Several times in the last two or three years the enormous theatrical correspondence has been the chief event of both her day and mine. Many and many a time we have to go to the typewriter the first thing after breakfast with result that our imaginations were exhausted before we got to our playwriting. Every little question has often to be debated in correspondence when we are away." (December 1906), Synge Papers.

77. Hone, *W. B. Yeats*, p. 225.

78. W. B. Yeats, *Collected Poems*, p. 104.

79. Edward Craig, pp. 254-55, 263.

January 1910, he stated that through Craig's invention it might be possible to solve "all our scenic difficulties". "It would not prevent Robert Gregory designing," he added carefully, "but would give us all the mechanism [sic] — a mountain to put our mountain on." A few days later he wrote that he had "gladly" promised Craig to use his screens in all his poetical work. Not only would the invention be appropriate for "open air scene[s]", but he had hopes that through them a new method even for staging naturalistic plays might be developed.[80]

Yeats had the model screens in his hand by early February. The first public reference to them occurs in a program note to Lady Gregory's translation of Goldoni's *Mirandolina*, which was performed at the Abbey Theatre on February 24, 1910. Yeats declared:

The rather unsatisfactory scenic arrangements have been made necessary by the numerous little scenes and the necessity of making the intervals between them as short as possible. We hope before very long to have a better convention for plays of the kind.[81]

During the summer of 1910, Yeats experimented with Craig's model. His excitement with their theatrical possibilities is expressed in the preface to *Plays for an Irish Theatre*, which contained three designs by Craig (see Plate 18). Yeats declared that he had now "a scene capable of endless transformation, of the expression of every mood that does not require photographic realsim". "Henceforth," he enthusiastically proclaimed:

I shall be able, by means so simple that one laughs, to lay the events of my plays amid a grandeur like that of Babylon; and where there is neither complexity nor compromise nothing need go wrong, no lamps become suddenly unmasked, no ill-painted corner come suddenly into sight. Henceforth I can all but produce my play while I write it, moving hither and thither little figures of cardboard through gay or solemn light and shade, allowing the scene to give the words and the words the scene. I am very grateful for he has banished a whole world that wearied

80. Letters to Lady Gregory (January 5 and 8, 1910), *Letters*, pp. 545-46.
81. Preserved in *Impressions of a Dublin Playgoer* (February 24, 1910), p. 268, N.L.I. Ms. 1809.

me and was undignified and given me forms and lights upon which I can play as upon some stringed instrument.[82]

Craig's ideas on the *übermarionette* and the mask also came to Yeats's attention at an opportune time. In 1909 and 1910, Yeats became increasingly interested in the multifarious philosophic, religious, and theatrical implications of masks.[83] It was also at this time that he began to formulate his concept of tragedy, which in its subordination of "character" to "passion" is related to Craig's *übermarionette* theory as well as to Yeats's own ideas on the dialectic between self and anti-self (or mask) as a means of personal expression. Yeats's important essay, "The Tragic Theatre", which contains the seeds of these dramaturgical and theatrical conceptions, was first published in *The Mask* of October 1910.[84]

Ezra Pound is credited with having introduced Yeats to Japanese Noh drama. Here again, however, Craig may have played a larger role than is generally suspected. As early as 1908, Craig began to relate his theories to Oriental theatre. In 1910 *The Mask* concerned itself specifically with Noh drama. With its emphasis on symbolical gesture and its subordination of accidental traits of "character" to essential passion, Noh drama provided Craig with yet another ancient manifestation of what he had been pursuing through his theory of the *übermarionette*.[85]

It is significant to note how closely Yeats's ideas paralleled those of Craig when he came to discuss Noh drama. Writing in 1916, he declared that in the Noh he had discovered an ideal dramaturgical model that would synthesize the "pulse of life" with the "stillness of death". Actors of the dance plays were even enjoined to "move a little stiffly and gravely like marionettes".[86]

Yeats may have thought of employing masks for the "eagle faces" of some of the characters in the early versions of *The Shadowy Waters*.[87] Craig, however, offered him the first prac-

82. Preface to *Plays for an Irish Theatre*, p. xiii.

83. Jeffares, *W. B. Yeats: Man and Poet*, p. 161.

84. Vol. III, pp. 77-81.

85. Charles R. Lyons, "Gordon Craig's Concept of the Actor", *Total Theatre*, p. 72.

86. Vide *Four Plays for Dancers*, pp. 86-87: Preface to *Four Plays for Dancers*, p. vi.

87. *Our Irish Theatre*, pp. 2-3; cf. David R. Clark, "Half the Characters Had Eagle's Faces", *Irish Renaissance*, pp. 26-55.

tical means of actually bringing masks to the stage. In October 1910, writing to Lady Gregory about a production of *The Hour-Glass* to be designed by Craig, Yeats remarked that he was "much excited by the thought of putting the Fool into a mask." If the masks "worked" he also intended to employ them for the Fool and the Blind Man in *On Baile's Strand*. "It would," he declared, "give a wildness and extravagance that would be fine. I should like the Abbey to be the first modern theatre to use the mask," he declared.[88] A few weeks later Yeats wrote to Craig urging him to read *On Baile's Strand* to see whether he thought that the dramatic intention of the Fool and the Blind Man would be heightened or lessened through the use of masks:

It would put them into a world of mythology, and that idea delights me, but their facial expression is amusing. One could put a terrible mask on the Blind Man for he like the Fool is a symbol. He is the shadow of Concubar, the High King, as the Fool is Cuchulain's shadow. In a sense they are reason and impulse, policy and heroism, the cold and the hot, the mind and the senses and a thousand other things that should suggest themselves to the imagination when the curtain falls. Indeed above all they are the Wiseman and the Fool over again. If the Fool in "The Hour Glass" goes well that mask will do for other Fool and I will make Bullen [Yeats's publisher] pay for a Blind Man's mask[89] (see Plates 19, 20).

Yeats also had sound practical reasons for welcoming the use of masks. By 1910 the Abbey actors were losing the first flush of their enthusiasm as well as the charm that youth had previously given them on stage. As Yeats explained it, by utilizing masks he was able to "substitute for the face of some commonplace player, or for that face repainted to suit his own vulgar fancy, the fine invention of a sculptor". Moreover, the following passage indicates that Yeats must have experienced for himself—in an opera no less—the startling and uncanny power of masks to evoke the very kind of theatrical response that he had sought from the beginning of his career:

In poetical painting and in sculpture the face seems the nobler for lacking curiosity, alert attention, all that we sum up under the famous word of the realists, "vitality". It is even possible that being is only

88. Letter to Lady Gregory (October 21, 1910), *Letters*, p. 554.
89. Unpublished letter (November 3, 1910), preserved in Craig Collection, Bibliothèque Nationale, Paris.

possessed completely by the dead, and that it is some knowledge of this that makes us gaze with so much emotion upon the face of the Sphinx or of Buddha. Who can forget the face of Chaliapine as the Mogul King in Prince Igor, when a mask covering its upper portion made him seem like a phoenix at the end of its thousand wise years, awaiting in condescension the burning nest, and what did it not gain from that immobility in dignity and in power.[90]

Stimulating as Yeats may have found Craig's *übermarionette* and masks, there is no doubt that what most excited him at the time was the idea of actually staging his plays within the three-dimensional scenic environment provided by Craig's screens. A notebook containing thirty-five sketches of scenes employing the Craig screens provides tangible evidence of what Yeats hoped to achieve. They include prospective scenic arrangements for a wide range of plays: Lady Gregory's translation of *Mirandolina* as well as her own *Shanwalla*, *The Canavans*, *The Deliverer*, and *The Gaol Gate*; Yeats's *Deirdre*, *On Baile's Strand*, *The King's Threshold*, *The Land of Heart's Desire*, *The Hour-Glass*, and *The Countess Cathleen*. One cannot help but be impressed with the variety of the possible configurations as well as the meticulous detail with which Yeats worked out ground plans, lighting effects, and colour schemes[91] (see Plate 21).

Again, however, Yeats was to discover that it is one thing to conceive an ideal technique of theatre, but quite another thing to bring that conception to life on the stage itself.

The correspondence between Craig and Yeats over the installation and practical use of the Craig screens at the Abbey Theatre must be one of the most fascinating studies in twentieth-century theatre history. From all the evidence at my disposal, Yeats emerges as by far the more practical of the two.

Yeats's first practical question arose out of the odd shape of the proscenium opening of the Abbey Theatre, which would, he thought, have marred the perspective of Craig's designs. Craig responded by designing a separate proscenium opening that could be moved up and down.[92]

A second problem was how to move the screens—which were set on castors—upon the raked stage of the Abbey Thea-

90. *Essays and Introductions*, pp. 226-27.

tre. Craig protested that the slope of the stage did not really matter,[93] but Yeats saw to it that by July 1910 the Abbey stage floor was made level, despite much grumbling from Joseph Holloway and Shawn Barlow who were consulted on the matter.[94]

Yet another problem was that of lighting the stage. In order to retain perspective it would be necessary to construct a transparent roof covering the entire Abbey stage, which would be manipulated on ropes as the screens were moved in and out of place.[95]

When Yeats inquired how the surface of the screens was to be finished, he received an all too typical reply:

As to the surface of the screens I like best the natural surface if it is distinguished enough—

A *silk* yes—or when the screens are made oak—yes—(Bronze we shall reach *in time*)

But meantime I don't much like the natural canvas surface. I should

91. Notebook in the possession of Michael Yeats. In an undated letter to Craig, which included a sketch for a proposed setting of Lady Gregory's *The Deliverer* (see Plate 21), Yeats enthused about the effect gained by placing a group of actors downstage, silhouetted against the lighted screens: "The power of massing and subordinating a group in the foreground and keeping them in shadow delights me. They think as a group not as individuals, just what we have always wanted, while the man who plays to them is further off in full light. At last one composes like a painter." In another letter (May 8, 1911) Yeats tactfully tried to persuade Craig to allow doors to be cut in one of the screens for a production of *Mirandolina*: "There is a famous scene with three doors, one of which has to be held against an excited lover who is on the other side of it, by the Innkeeper herself. Now your scene changing like some sunlit cloud under an enchanter's will, giving one now a corridor, now a whole room, now the angle of a wall, now a room corner, and being the world where characters, it may be like those people of the Commedia dell'Arte you picture in the Mask, would make a play of that kind a beautiful thing throughout, if that one scene altogether essential and yet lasting only five minutes which requires three doors, is not to make the screens impossible. I can see the stage with the proscenium low, a little gilt pattern, perhaps the mask of comedy repeated again and again, running along the tops of the screens, and I can see a new art of comedy coming to birth." Unpublished letters preserved in the Craig Collection, Bibliothèque Nationale, Paris.

92. Letter from Craig to Yeats, dated January 18, 1910. All of the letters cited from Craig to Yeats are in the possession of Michael Yeats.

93. Letter from Craig to Yeats (January 25, 1910).

94. *Joseph Holloway's Abbey Theatre*, p. 140.

95. Letter from Craig to Yeats (February 9, 1910).

propose something more frankly artificial than paint (which however you may still find suits you best).

Now for it—take 3 girls—3 pairs of scissors & innumerable pieces of paper.

Cream, white—grey—greyer (even pale colours) (rose)

For grey paper what better than
 the Dublin rags
 that attack the Abbey Theatre
let the girls cut up all the shapes and sizes of paper & make sacks full of what we will call our paper mosaic
Then let the artist loose on it—and two strong & obedient stickers—poster paint will be the best — & the slime of it will (I believe) just add that gloss which is needful to relieve it
 here & *there* but not all over gloss please—
See the value of this

I take it you must repair your screens after some accident in an hours time—you can do it & guarantee the rise of the curtain. Suppose on Monday you want more blue at the tragedians feet than you had on Saturday it can be added—& removed by Tuesday when you want more yellow. . . .

As a rule let your darker tones fall about the base of the screens & never harm the top which like the ceiling [*sic*] should be *generally* pure cream.

 I can no more
 The King, the Kings to blame.[96]

"The King" is, of course, Hamlet's uncle. And some of the vagueness in this and other letters sent by Craig to Yeats may be explained by Craig's involvement at the time in his first practical experiments with the screens for the famous Moscow Art Theatre production of *Hamlet*. Many of Craig's manifold problems and worries over this production—which is recognized as one of the landmarks of the modern theatre—spill over into his correspondence with Yeats. At one point, for instance, he asked whether Yeats had discovered a way of getting his actors on and off the stage "without our knowing how they came—keeping them *quite still* (quite!) & returning

96. Undated letter from Craig to Yeats.

them as mysteriously". Again, he asked Yeats to inform him whether he had devised "some special method for opening and closing [the screens] rapidly & smoothly & safely".[97] (Craig had particular reason to worry about this problem since it proved extremely difficult for the Moscow Art Theatre technicians to shift the screens for the many scene changes in *Hamlet*. When the screens fell over just one hour before the opening performance, Stanislavsky reluctantly decided to lower the curtain for all changes of scene.)[98]

Despite a final difficulty in fitting the screens through the stage door they were set up on the stage of the Abbey Theatre for the first time on November 29, 1910. Apparently Craig's ideas on finishing the surfaces proved either impractical or undesirable, for Holloway described them as "a series of square box-like pillars saffron-hued, with saffron background, wings, sky pieces, and everything".[99]

On January 12, 1911, the Craig screens made their debut at the Abbey Theatre when they were employed for a revival of *The Hour-Glass* and the first production of *The Deliverer*, by Lady Gregory. *The Irish Times* reviewer declared that the new method was "a great improvement on the old staging of *The Hour-Glass*". He went on to illustrate the innovations in some detail:

There is in the first place a reduction of the stage furniture to its simplest elements, so that the figures of the players stand out more prominently against the primitive background and attention is concentrated on the human and truly expressive elements of the drama. There is next a careful design and adjustment of the simple elements of staging which still further tends to secure that effect. Lastly, there is a similar care in regard to the supplementary elements—lighting arrangements and costuming.

The review closed, however, with a qualification of considerable significance:

97. Letters from Craig to Yeats (April 1910, September 6, 1910).
98. Constantin Stanislavsky, *My Life in Art*, trans. J. J. Robbins (New York: Theatre Arts Books, 1948), p. 521. Cf. Kauro Osanai, "Gordon Craig's Production of Hamlet at the Moscow Art Theatre", trans. Andrew T. Tsanbaki, *Educational Theatre Journal*, XX, No. 4 (December 1968), pp. 586-93.
99. *Joseph Holloway's Abbey Theatre*, p. 146.

The success of these aims is the result of the genius of an individual producer, who combines with artistic and thoughtful ideas on the principles of staging, an unusual ability to deal with the mechanical problems involved in giving effect to those principles.[100]

The production of *The Deliverer* proved this last point. While *The Hour-Glass*, with costumes and other accessories designed by Craig, benefitted from being staged in the abstract environment created by the Craig screens, the production of *The Deliverer* was an unmitigated failure. Yeats himself in a curtain speech attributed this failure to the haphazard costumes. Holloway declared that there was "nothing about the dress or scenery to suggest Egypt", the locale of the play.[101]

To realize the full potential of the screens, it was evident, as Craig himself insisted, that a skilled, imaginative stage director was needed to produce an aesthetically harmonious and theatrically effective whole. In the autumn of 1911, accordingly, Nugent Monck was engaged by Yeats specifically to experiment with classical and modern works employing the Craig screens.[102]

100. *The Irish Times* January 13, 1911), preserved in W. H. Henderson Press Cuttings, N.L.I. Ms. 1734, p. 6. In a letter to Craig written the day after the opening performance of *The Hour-Glass* Yeats expressed his enthusiasm for the stage setting: "Your screens and costumes for 'The Hour-Glass' had a triumph last night. The girl who played the Angel [Maire O'Neill] —alas that it had to be a woman—told me that everyone who spoke to her (and being our best looking player she had a troop about her in the green room) was raving about their beauty! There were several curtains. The play seemed to be performed in the heart of a great pearl through which darted the sunlight shadows falling through a meridean sea. The great chair and table copied from your drawing seemed also cut from the pearl. I had them painted the colour of the screens but the bell and hourglass (on the same iron support which hung from the lip and screens T[op] R[ight])were black. This I think is right as it makes the lines between the screens dim and shadowy by contrast." Unpublished letter preserved in the Craig Collection, Bibliothèque Nationale, Paris.
101. *Impressions of a Dublin Playgoer* (January 12, 1911), N.L.I. Ms. 1811, p. 68.
102. Memorandum concerning the establishment of the Abbey Theatre Second Company, probably composed in the summer of 1911. Preserved in N.L.I. Ms. 13068. In a letter to Craig (May 8, 1911) Yeats declared that he did not intend to write any more plays for "a considerable time" in order to devote himself to "getting good performances of those I have written and to writing some lyrics." Unpublished letter preserved in Craig Collection, Bibliothèque Nationale, Paris.

Nugent Monck's own speciality in the theatre was the staging of medieval plays. With a company of amateur actors at the Maddermarket Theatre in Norwich, England, he achieved a reputation as one of the first half-dozen producers in England, especially for his skilful handling of crowd scenes.[103]

When he arrived at the Abbey Theatre, Monck's first innovation was to extend the stage into the auditorium to create the kind of apron stage that Yeats had longed for since 1904. For the first time Yeats had at his disposal the physical means of staging his plays so as to interweave portrait and pattern throughout the same play—the actor now being loosened from the bonds of the proscenium picture as he moved out upon the apron toward the audience only to return upstage again, if desired, to the formality of the scenic pattern.

Full advantage was taken of this flexibility in a series of plays staged by Monck with the Abbey Second Company during the autumn of 1911. On November 16, 1911, a production of *The Interlude of Youth* was staged in which most of the characters came and went from the auditorium up a set of stairs leading to the apron. In a production of *The Second Shepherd's Play* incense was burned in the foyer, followed by an opening procession with a hymn in order to put the audience into a proper frame of mind. Subsequently, Douglas Hyde's *Nativity Play* was produced with the set and actors dressed in an appropriate medieval style. (Monck himself apparently brought over some of his own costumes from Norwich for these productions.)[104]

All of this was a prelude to an impressive production of a revised version of *The Countess Cathleen* on December 14, 1911. With Yeats himself sitting near the operator of a limelight in the balcony calling the cues for lighting changes, the play was staged as a medieval pageant, one scene rapidly merging into another, actors entering through the audience and by the wings.[105] Lyrics were written for the processions, including one in which the spirits dance and sing as they steal

103. Marshall, *The Other Theatre*, pp. 94-95.
104. *Impressions of a Dublin Playgoer* (November 16, 1911; November 23, 1911; November 30, 1911), N.L.I. Ms. 1812, pp. 783-87, 820, 867.
105. *Impressions of a Dublin Playgoer*, pp. 933-36.

the Countess's money away. Upstage centre was a curtained recess with a great grey backdrop coloured with rich tints of amber from the arc lights. Gauzes were hung from two arches for the third scene in the Hall of the Countess, behind which one dimly saw trees of a garden.[106]

The spectacular but impossible effects of the last scene in the original version—the thunder and lightning, and the elaborate vision of armed angels on the mountain, ending with the distant note of a horn—were cut. Instead, in this revised version "suitable for performances at the Abbey Theatre", Aleel (who was played by Monck with Maire O'Neill playing the Countess) briefly described the clash of the angels and devils "in the middle air". Then the stage directions called for the entrance of a winged Angel, carrying a torch and sword from stage right. The Angel is stopped by Aleel, and the final dialogue between them and Oona continues as originally written.[107]

Nugent Monck proved that it was possible to use Craig's screens with great success in a production of a Yeats play. Moreover, the combination of skilled direction and imaginative settings was enormously stimulating to Yeats. The short period during which these two factors combined was one of the most creative in his career as a dramatist, especially with regard to the revisions of his earlier work for the Abbey stage.[108] It is significant that Yeats declared that the revised versions of *The Countess Cathleen* and *The Land of Heart's Desire*—the latter also staged by Monck as a kind of morality play[109]—depended "less upon the players and more upon the

106. W. B. Yeats, *The Countess Cathleen* (London: T. Fisher Unwin, 1912), pp. 65-66; stage directions, p. 127.

107. Ibid., pp. 125-27.

108. In addition to *The Countess Cathleen* and *The Hour-Glass*, *The Land of Heart's Desire*, *Deirdre*, and *The King's Threshold* were revised with the Craig screens in mind. Yeats also declared that the gaiety of *The Player Queen* owed something to the play of light on the ivory-coloured screens of Craig. Vide *Plays for an Irish Theatre*, pp. 215-16; Notes and Preface to *Plays in Prose and Verse*, p. vii. Cf. Karen Dorn, "Dialogue into Movement: W. B. Yeats's Theatre Collaboration with Gordon Craig", *Yeats and the Theatre*, pp. 109-36, for a detailed analysis of the above revisions.

109. *Impressions of a Dublin Playgoer* (February 22, 1912), N.L.I. Ms. 1873, p. 275. Yeats adapted the ending of *The Land of Heart's Desire* so that the curtain fell before the priest's last few lines. The priest remained outside the curtain on the apron and spoke his last lines to the audience, like an epilogue in a morality play. *Plays and Controversies*, p. 327.

producer, both having been imagined more for variety of mood in the player".[110] It is equally significant that to many astute critics Monck's productions were, from a visual point of view, by far superior to any others staged at the early Abbey Theatre.[111]

FROM PUBLIC THEATRE TO DRAWING ROOM

After Monck's departure from the Abbey Company the screens of Gordon Craig were rarely employed. In 1913 they were used for only two of sixteen productions: the staging of *The Post-Office*, a one act play by the Indian dramatist Rabindranath Tagore, and a revival of *The King's Threshold*, the only production of any play by Yeats at the Abbey Theatre that year.[112]

One of the problems was, of course, the sheer technical difficulty of setting up and manipulating the screens on the limited Abbey stage. Another was the continual reluctance of the Abbey technicians and stage directors to accept scenic innovations. Not only did Shawn Barlow (who was often given charge of designing as well as building stage scenery) have little use for the Craig screens—or any other special demands for the plays of Yeats—but shortly after they were first introduced he had them "cut down a bit in order to fit on to the Abbey stage".[113] To the present day they remain in the Abbey Theatre scene dock, painted a robin's-egg blue by some enterprising technician in the mid-1930s.[114]

Craig was himself partly to blame for the failure of the Abbey Theatre to make use of his invention. Tours had by 1911 become an essential means of supporting the Theatre, but Craig refused to allow his screens to be used outside Dublin unless he was on hand to supervise personally every

110. *Variorum Plays*, p. 1291.

111. This was the opinion of H. O. White, Professor of English Literature, Trinity College, Dublin, Joseph Holloway, and the noted theatre historian W. J. Lawrence. Vide Cole, *Stagecraft in the Modern Dublin Theatre*, p. 37; tribute by Holloway on Monck's departure from the Abbey Theatre, *Evening Telegraph* (March 5, 1912) preserved in *Impressions of a Dublin Playgoer*, N.L.I. Ms. 1813, p. 286; and W. J. Lawrence Press Cuttings, N.L.I. Ms. 4296, p. 53.

112. *Impressions of a Dublin Playgoer* (May 17, 1913; October 30, 1913), N.L.I. Ms. 1815, pp. 895-97; N.L.I. Ms. 1816, pp. 744-46.

113. Cole, *Stagecraft in the Modern Dublin Theatre*, p. 36.

114. Interview with Tanya Moisievitch (October 3, 1965).

aspect of their operation. Likewise, and with greater justification, he insisted on personally making and showing the Abbey actors how to use the masks that he designed for Yeats.[115]

It is clear that, on his part, Yeats was extremely reluctant to have any more direct collaboration with Craig than at letters' length. Correspondence between himself and Florence Darragh in 1913 concerning a proposed theatre venture in London with Craig as "producer" and himself as "literary advisor" reveals some of Yeats's qualms about working more closely with Craig. Warning Miss Darragh about Craig's "vagueness", Yeats refused to consider any further commitment to the project until a "written statement . . . signed by all three" had been prepared. Without such an agreement, he explained,

Craig and I might . . . very quickly find ourselves opposed to one another and suspecting each other of things. Craig has a difficult temperament. He is a great genius, but we will need more skill than the others have shown if we are not to disappoint his hopes or our own.[116]

115. Letters from Craig to Yeats (January 25, 1910; May 1, 1910; May 11, 1911; November 20, 1910).

116. Unpublished letter from Yeats to Miss Florence Darragh (March 28, 1913) in possession of Michael Yeats. Another letter from Yeats to Craig reveals that Yeats supported the scheme despite certain misgivings as to Miss Darragh's ability to carry it out: "If I were to choose my own players I should be hard to please but as I cannot do that I am content that players should choose me. There cannot be many who believe in a dramatist who writes in verse so even if they are 'women managers' I must be content. They can do some of the things I want if I give them their head and every performance teaches me. Miss Darragh is a player of considerable though narrow talent, but she proves to me by asking, with one exception, for plays of mine that could give her little personal opportunity, that she was speaking the truth when she did not want important parts, however. The exception was my 'Shadowy Waters'. She has given a fine performance in this. I mean that I do not know an English-speaking actress whose work had been better in it though it is possible that Mrs. Campbell might, for Mrs. Campbell has in the midst of external egotism and violence, a faint lyrical personality. This fits work of the kind. If I could like the Welsh wizard take leaves of flowers from the forest and make a woman out of them, I should reject both Miss Darragh and Mrs. Campbell. But then it is they who choose." Unpublished letter in the Craig Collection, Bibliothèque Nationale, Paris.

For the Abbey tours of 1913-14, however, Yeats himself designed an extremely flexible scenic arrangement that bore a striking resemblance to Craig's screens. Within the proscenium opening was constructed an "inner proscenium" formed by placing two rectangular pillars shaped like matchboxes on end, with a third laid across the top. In each "matchbox" was a door. The colour of the pillars was grey, and around the stage was hung a grey-blue cyclorama cloth which was flooded with light. The chief virtue of the arrangement was the variety of settings which it could accommodate. When a big cross was placed in the middle of the stage, for instance, the setting was complete for the first act of *The Well of the Saints*, with the door on the stage-left side leading to the church. When the cross was replaced by a well, a small piece of hillside scenery placed at the back and red lights placed within the stage-left door, the scene was transformed to Timmy's forge, the setting of the second act.

By the deployment of various backdrops and simple stage properties the setting was made appropriate for other plays, including Lady Gregory's *The Canavans* and *The Rising of the Moon*. Of Yeats's plays, however, only *The King's Threshold* appears to have been performed within this inner proscenium that, in its deliberate concentration and framing of the stage action, is reminiscent of Yeats's earlier idea of the stage as a tiny jewel-like image. The setting for *The King's Threshold* production consisted of a long flight of stairs set between the two pillars, with a patterned backdrop of a mountain range and a waterfall.[117]

It is significant, however, that it was not so much this setting as the costumes designed and made by Charles Ricketts that excited Yeats's imagination when the Abbey presented a London revival of *The King's Threshold* in June 1914. He wrote to Ricketts:

I think the costumes the best stage costumes I have ever seen. They are full of dramatic invention, and yet nothing stands out, or seems eccen-

117. Vide Interview with Lennox Robinson (April 1914), preserved in Holloway Press Cuttings, N.L.I. Ms. 4418; *Impressions of a Dublin Playgoer* (October 30, 1913), N.L.I. Ms. 1816, pp. 744-46.

tric. The Company never did the play so well, and such is the effect of costume that whole scenes got a new intensity, and passages or actions that had seemed commonplace became powerful and moving.[118]

A comment of Lady Gregory in a letter to Ricketts requesting advice in "shuffling costumes" for other plays is still more revealing: "I feel you are giving us a new start in life. Yeats will enjoy seeing his plays, which he hasn't done for years."[119]

Mainly because of a financial crisis which the Abbey Theatre underwent in 1914, it was impossible to think of giving Yeats any further productions of such visual splendour. Within a year, out of sheer frustration at being unable to realize his theatrical ideals, he turned to the austere model offered by Japanese Noh drama: an ancient theatre made simply by "unrolling a carpet or marking out a place with a stick, or setting a screen against a wall", a stage which, instead of employing light and shade to cast a "veil" between the sound of the actor's voice and his audience, would require only "the light we are most accustomed to", properties which could all be carried by the actors in a cab; the only "picture" that of the player's mask, itself an image which would make the face of the speaker "as much a work of art as the lines that he speaks or the costume that he wears".[120]

Yeats, the man of letters, became involved with the Irish National Theatre Society in order to master the practical problems of the theatre. Now, once again for practical reasons, he left the public theatre for the theatre of the drawing room.

118. Letter dated June 14, 1914, *Letters*, p. 587.
119. Letter dated June, 1914. Reproduced in *Self-Portrait, Letters and Journals of Charles Ricketts*, comp. T. Sturge Moore, ed. Cecil Lewis (London: Peter Davies, 1939), p. 198.
120. *Essays and Introductions*, p. 224; *Four Plays for Dancers*, pp. 86, 87. Yeats became particularly excited with the dramatic possibilities of masks. In fact, he stated that the double role of the Figure of Cuchulain and the Ghost of Cuchulain in *The Only Jealousy of Emer* was created in order to find what effect one gets out of changing a mask in order to support a change of personality during the course of the dramatic action. Preface, *Four Plays for Dancers*, p. vii.

Yeats the Dramatist

DRAMA AS PERSONAL UTTERANCE

Throughout his entire career as both poet and dramatist Yeats's basic intention was to celebrate "that little infinite faltering flame that one calls oneself" and so bring back "personal utterance" into literature.[1] What Yeats meant by personal utterance was, as we have seen, complicated by the struggle between the two antitheatical halves of his personality out of which he formed his doctrine of the mask. This led him as early as 1891 to call for a drama that would range from "the deep notes of realism to the highest and most intense cry of lyric passion".[2] This also led him to desire a

1. Dedication to "A.E.", *The Secret Rose* (London: Lawrence & Bullen, 1897); *Autobiographies*, p. 102. Yeats tells us that his father convinced him at an early age that "the only noble poetry was dramatic poetry, because it always put human life, tumultuous, palpitating, behind every thought." Later, being moved to tears by an Irish patriotic ballad, he determined that its effectiveness was due to the author's "simplicity and directness of personal expression". At this point, he decided to renounce "poetry of abstract personality" in favour of "poetry as full of my own thoughts as if it were a friend". On going to London, Yeats found that the same ideal of "personal utterance" was being espoused by the poets who came together to found The Rhymers' Club. "Friends of My Youth" (1910), *Yeats and the Theatre*, pp. 29-31.
2. *Letters to the New Island*, p. 216.

dramaturgical form that would be flexible enough to express his continually evolving response to life, thus enabling his plays to be "as personal as a lyric".[3]

We have also observed that in his childhood play-fantasy Yeats exhibited many of the qualities that he carried into his mature work as a dramatist. He actually began to compose plays in his early teens. Under the influence of his father, who educated Yeats as a boy by reading to him passages from the poetic masterpieces of English literature, the first of these plays were written in imitation of Shelley and of Edmund Spenser. One was suggested by a Pre-Raphaelite design of his father. Another was rehearsed and possibly presented by Yeats and a group of friends at a private house in Howth in 1884.[4]

Four of his early plays survive. All illustrate the dialectical themes which were to concern Yeats for the rest of his life: retreat from the world versus revolt; a lust for "power outspeeding envy" as opposed to "pity for the fleeting race of men who bend to every sudden blast"; the duality of mortal and immortal longings in men; the natural versus the spiritual order; temperal versus eternal satisfactions; and scientific "grey truth" versus the truth in "thine own breast". Whatever the conflicts represented, one single thought was sustained: that "words alone are certain good". And, as Professor Ellmann points out, words were equated with the poet's dream.[5]

Yeats wrote these plays aloud, chanting the lines to himself in a voice that he modulated to suit the various characters.[6] The central character of each piece, however, was obviously a projection of his own personality, whether the magician hero of *Vivien and Time*; the twin mortal and immortal brothers of *Love and Death*, who reflect his own divided self; the proud and solitary hero of *Mosada*; or the poet in *The Island of Statues* who chooses an Arcadian immortality rather than life amidst the world of living men.[7]

3. Letter to J. B. Yeats (January 17, 1909), *Letters*, p. 524.
4. *Autobiographies*, pp. 66, 74; Ellmann, *Man and the Masks*, p. 36.
5. Vide a thematic analysis of these four plays, all written between January and August 1884, in *Man and the Masks*, pp. 34-40.
6. Letter from J. B. Yeats to Edward Dowden (January 7, 1884), quoted in Hone, *W. B. Yeats*, p. 43.
7. Ellmann, *Man and the Masks*, pp. 35-39.

Self-dramatization was deliberately practised by Yeats for the rest of his dramatic career.[8] The world-weary Aleel in *The Countess Cathleen* and Forgael in *The Shadowy Waters*, the rebellious Paul Ruttledge in *Where There is Nothing*, the defiant poets Seanchan and Septimus in *The King's Threshold* and *The Player Queen*, the doubting Wise Man in *The Hour-Glass*, and the heroic figure of Cuchulain as he appears in *On Baile's Strand*, *The Green Helmet*, *At the Hawk's Well*, *The Only Jealousy of Emer*, and *The Death of Cuchulain* are all thinly disguised projections of Yeats at various stages in his life. Almost every one of these dominant figures is balanced by a secondary character who embodies the opposite half of Yeats's dualistic personality. In his last play, *The Death of Cuchulain*, the disguise of character was dropped altogether for the challenging Old Man in the prologue speaks directly as Yeats himself.

Personal utterance is, of course, rarely successful in the theatre, being more conducive to the one-to-one communication in solitude of lyric poetry. Effective drama, moreover, must be imbued with a feeling for the flesh-and-blood realities of life in order that it may evoke responses from a heterogeneous audience on a primary human level. Passionately felt though the artist's initial impulses for expression may be, those impulses must be objectivized into forms of action that, by means of the instruments and arts of the theatre, makes the drama continually appealing and significant to an audience.

Yeats's natural instinct was almost quintessentially that of the lyric poet. But it must be remembered that by an act of will he transformed himself from a private man into a public man of action. As a result, Yeats lived an extraordinarily rich and varied life. Contrary to the opinion of many of his crit-

8. A passage from the *Autobiographies* (p. 532) illustrates this clearly: "Every now and then when something has stirred my imagination, I begin talking to myself. I speak in my own person and dramatize myself, very much as I have seen a mad woman do upon the Dublin quays, and sometimes detect myself speaking and moving as if I were still young, or walking perhaps like an old man with fumbling steps. Occasionally, I write out what I have said in verse. I do not think of my soliloquies as having different literary qualities. They stir my interest, by their appropriateness to the men I imagine myself to be, or by their accurate description of some emotional circumstance, more than by any aesthetic value."

ics, the lineaments and emotions of his intensely human life are woven into the fabric of his plays. Examples are too numerous to cite but in passing: his passionate defence in *The King's Threshold* of artistic freedom in the face of political oppression; his fealty to the traditional long-suffering image of revolutionary Ireland in *Cathleen ni Houlihan*; his bitter disillusionment with the political factions dividing Ireland in *The Green Helmet*; his sorrow in *The Dreaming of the Bones* at the unforgiving, ungenerous hearts of militant Irish nationalists; his quest for religious certitude in *The Hour-Glass*; his ribald mockery of a religious casuistry abstracted from the reality of the flesh in *The Herne's Egg*; his stoic acceptance of imminent death in *The Death of Cuchulain*; his unappeasable longing for Maud Gonne in *The Shadowy Waters*; his all-too-human jealousy, loneliness, and sexual frustration in *On Baile's Strand, Deirdre, The Green Helmet*, and *The Only Jealousy of Emer*. All of these themes came directly out of Yeats's personal engagement with life; all were objectivized into universal experience through the drama. However abstract his thought or formal his dramatic structure, it is the troubled humanity of Yeats that, in his best work, moves us and makes him continually relevant.

Had his work remained pure self-dramatization—like that of Browning, for instance—Yeats would indeed have been a failure as a dramatist. Yeats's histrionic temperament was, however, one of the dominant influences of his life. It was by histrionic means that he created a new personal character for himself. In turn, he was continually preoccupied with the "effect" that his "pose" produced upon others. It is natural, then, that the actor should play a dominant role in his theory and practice as a dramatist.

THE ACTOR AS MEDIUM AND INSPIRATION

Yeats once defined a play as "merely a bunch of acting parts. There must always be something for the actor to do."[9] Contrasting himself with Browning, who said that he could not write a successful play because he was interested "not in character in action but in action in character", Yeats declared that, whether in lyric or dramatic poetry, his basic intention

9. Letter to Brinsley MacNamara (June 29, 1919), *Letters*, p. 658.

was to "get rid of everything that is not . . . in some sense character in action; a pause in the midst of action perhaps, but action always its end and theme".[10] Indeed, Yeats's ultimate justification for struggling to become a dramatist instead of remaining satisfied with his success as a lyric poet was that he desired "to show events and not merely tell of them".[11]

Because of his delight in the histrionic energy of the body, Yeats had no use for so-called "literary plays" meant to be read in the privacy of one's study. He particularly hated the drawing-room social dramas of Ibsen and Shaw in which actors sat around simply turning some philosophical question over and over. "Thought is not more important than action," he declared. "Masterpieces, whether of the stage or study, excel in their action, their visibility. . . . Our bodies are nearer to our coherence because nearer to the 'unconscious' than our thought."[12]

As we have seen, Yeats's concepts of the art of acting were considerably influenced by the actors at his disposal. One of the most fascinating aspects of his dramatic career is how actors, in turn, influenced his theories and practical work as a dramatist.

Because they were not conceived in terms of the actor, the plays of Yeats's late teens are of purely literary value. But from the time that he met Maud Gonne in 1890, who was herself considering a career as an actress, Yeats's dramaturgy was transformed. Maud Gonne inspired him to write *The Countess Cathleen*, and even in its earliest published version there are some remarkably effective acting scenes. Thereafter, many of Yeats's characters were written with the talents and personalities of specific actors in mind. The role of the Faery Child in *The Land of Heart's Desire* was written at the request of Florence Farr in order that her niece, Dorothy Paget, a child of eight or nine with a beautiful speaking voice and trained as a dancer, might make her stage debut.[13] The roles of Aleel, Dectora, and the First Musician in *Deirdre* were

10. *Essays and Introductions*, p. 530.
11. *Plays and Controversies*, p. 416.
12. *Explorations*, pp. 446-47.
13. *Autobiographies*, pp. 280, 413.

obviously written to take advantage of Florence Farr's unique talents as a reciter of pitched verse, although it is interesting to note that Yeats declared that it was her face even more than her voice that inspired the latter character.[14] Similarly, the haunting physical presence and personality of Maud Gonne inspired the character of Cathleen ni Houlihan.[15]

In May 1906 Yeats wrote T. Sturge Moore: "To do anything you must have a group of players who will stick to you and learn their business . . . and you must write and choose such plays as will display them at their best."[16] The plays written for the Irish National Theatre Society illustrate this dictum, for they were obviously written with the particular talents—and limitations—of the Irish Players in mind. The role of the Tramp in *The Pot of Broth* took maximum advantage of Willie Fay's genius in the handling of comic business, as did the role of the Mayor in *The King's Threshold*. The whimsical nature of Fay's personality was again exploited to the full in the two Fool characters of *The Hour-Glass* and *On Baile's Strand*. The latter play is, in fact, dedicated to him "because of the beautiful fantasy of his playing".[17]

Frank Fay inspired the character of Seanchan. At the time when *The King's Threshold* was written, Yeats was particularly proud of its verse passages, and wrote to tell Fay that he would have a role that would give him "plenty to act" and so "establish all our fames".[18] Later, the play was dedicated to the memory of Fay's "beautiful speaking".[19]

In 1906, when Yeats was trying to persuade the Fays, Lady Gregory, and Synge to allow him to import Miss Darragh to play the roles of Deirdre and Dectora, he stated in a

14. Vide Preface to letters of W. B. Yeats by George Yeats in *Florence Farr, Bernard Shaw, W. B. Yeats: Letters*, ed. Clifford Bax (London: Home and Van Thal, 1946), p. 33; Letter to Florence Farr (October 1906), *Letters*, p. 482.

15. *Plays in Prose and Verse*, p. 240.

16. *Correspondence*, pp. 8-9.

17. *Collected Plays*, p. 247. Yeats wrote of Fay's performance of these comic roles: "He could play dirty tramp, stupid countryman, legendary fool, insist on dirt and imbecility, yet play—paradox of the stage—with indescribable personal distinction." *Autobiographies*, p. 472.

18. (August 8, 1903), *Letters*, p. 409.

19. *Collected Plays*, p. 105.

letter to Fay that merely imagining her as Deirdre made him write better. "I thought of moments of her Salome, and ventured and discovered subtleties of emotion I have never attempted before."[20] Two years later, the performance of Deirdre given by Mrs. Patrick Campbell at the Abbey so excited his creative imagination that scenes which had previously given him trouble were easily rewritten. Yeats paid tribute to her "genius" as an actress by dedicating Deirdre to her.[21]

We shall see that Yeats's adaptation of The Hour-Glass from a prose to a poetic version for Nugent Monck was one of the most significant revisions of his entire playwriting career. In his preface to the 1934 edition of his Collected Plays, Yeats declared that the poetic version of the play had been played but once at the Abbey Theatre: "speakers of verse are rare."[22] Likewise, he warned that neither Deirdre nor The King's Threshold should be performed unless a central actor of "subjectivity and variety" were available.[23]

Yeats continued to be stimulated and inspired by actors well on into his later career as a dramatist. In 1915 the Japanese dancer Ito was to a large extent responsible for his conversion to dance drama. Yeats himself spent some time with Ito at the London Zoo, studying the movements of hawks which were incorporated into the climactic dance of At the Hawk's Well[24] (see Plate 7). In 1926 Ninette de Valois restored Yeats's flagging interest in the theatre. At the Hawk's Well and The Dreaming of the Bones were revived with the company of dancers trained by her at the Abbey School of Ballet. In 1929 Yeats adapted The Only Jealousy of Emer into the ballet Fighting the Waves for the Abbey School of Ballet. In 1934 Miss de Valois inspired him to create for her the role of the dancer Queen in The King of the Great Clock Tower.[25] That same year he rewrote the play as A Full Moon in March with a speaking part for the Queen so that Margot Ruddock might act as well as dance the role.[26]

20. Unpublished letter (August 13, 1906) in the possession of Michael Yeats.
21. Vide Collected Works, Vol. II, p. 251; Collected Plays, p. 171.
22. Collected Plays., p. v.
23. Preface to Plays in Prose and Verse, p. vii.
24. Hone, W. B. Yeats, p. 289.
25. Pinciss, "A Dancer for Mr. Yeats", pp. 386-91.
26. Letter to Margot Ruddock (October 11, 1934), Ah! Sweet Dancer, p. 23.

Yeats was pre-eminently an actor's dramatist because of his natural histrionic temperament and his responsiveness to the talented performer on the stage. We may see how these qualities affected his dramaturgy by examining the histrionic actions upon which even his earliest plays were based.

THE HISTRIONIC ACTIONS OF THE PLAYS

Throughout his career, Yeats, working with the eye of a painter, displayed an extraordinary ability to create striking histrionic actions in order to express his dramatic intentions on the stage. Not only did these actions invariably contribute to and heighten the verisimilitude of the acting; often they were also extremely effective for their pure theatricality.

One is impressed as early as the first version of *The Countess Cathleen* with Yeats's deployment of stage "business" in order to establish mood and create the sense of an actual environment within which characters/actors might function. The physical and spiritual havoc wrought by the famine upon the starving peasants of Ireland, for instance, is evoked by means of vivid images such as the hunger-stricken Shemus carrying home a dead wolf to eat. Later in the same scene, when a statue of the Virgin falls and breaks, Shemus kicks it to pieces, crying out:

> The Mother of God has dropped asleep
> And all her household things have come to wrack.[27]

This scene is followed by the arrival of the Merchants in order to offer gold for the peasants' souls. As soon as they enter the cottage, water on the stove stops boiling, thus contributing to the sense of terror that Shemus's wife, Maire, feels in their presence. This device also helps to persuade the audience of the Merchants' supernatural reality as a logical development out of the already established stage atmosphere of mystery and foreboding. Yeats continues the scene by having Maire tell the Merchants that they should give alms to the poor. The following dialogue then takes place:

FIRST MERCHANT
We know the evils of mere charity,
And would devise a more considered way.
Let each man bring one piece of merchandise.

27. *Poems* (1895), p. 80.

MAIRE

And have the starving merchandise?

FIRST MERCHANT

We do but ask what each man has.

MAIRE

Merchants,

Their swine and cattle, fields and implements
Are sold and gone.

FIRST MERCHANT

They have not sold all yet.

MAIRE

What have they?

FIRST MERCHANT

They have still their souls.

(Maire shrieks. He beckons to Teig and Shemus.)[28]

This scene could easily have degenerated into melodrama, but because it was written with an eye for significant theatrical details the final line of the Merchants, followed by Maire's shriek, have an awesome effect. Yeats thus created a specific, immediate, and powerful dramatic expression for "the war of the spiritual with the natural order".[29]

The deployment of imaginative stage business with properties remained one of Yeats's strongest weapons as a dramatist. By this means he provided actors with concrete physical actions that enabled them to bring the audience back from flights of poetry and philosophical speculation to a more familiar world of tactile human experience. Many of the most telling moments in the plays of Yeats are structured around familiar objects which take on profound symbolic importance as they are utilized by actors. Examples include the shriek of the pagan Faery Child in *The Land of Heart's Desire* when she suddenly sights a black crucifix; Cuchulain's wiping of the blood from his sword with feathers from the Fool's hair after he has unwittingly killed his own son in *On Baile's Strand*; the desperate bargaining between Deirdre and Conchubar over the life of Naoise, as he struggles between them

28. Ibid., p. 87.
29. Preface to *The Secret Rose*, p. viii.

entangled in a net (see Plate 12); the dropping of the Queen's veil in *A Full Moon in March* to indicate the loss of her virginity to the Swineherd; and the grotesque death of Congal, the mock hero of *The Herne's Egg*, impaled on his own soup spit.

Sometimes Yeats employed the very bodies of actors in order to evoke similar theatrical responses. The exquisite love duet which brings *The Shadowy Waters* to a climax is given a human yet deeply symbolic meaning when the kneeling Forgael gathers Dectora's hair about him in a golden net. There are few more effective moments perhaps in all modern dramatic literature than the climax of *The Resurrection*, when the Greek, arrogant in his intellectual conviction that man and the gods are separate, that man has in fact no need of a external god, approaches the figure of the risen Christ to prove his point. He touches the breast of Christ and in a chilling cry, "The heart of the phantom is beating! The heart of the phantom is beating!" crystallizes Yeats's theme:

> Odour of blood when Christ was slain
> Made all Platonic tolerance vain
> And vain all Doric discipline.[30]

Yeats displayed, even in the earliest version of *The Countess Cathleen*, yet another aspect of his histrionic sensibility— that of developing character through situation and dialogue. The second act of *The Countess Cathleen* opens with a scene in which a group of musicians chant a dreamy air evoking memories of the mythical Celtic past. Suddenly the Countess cries out:

Be silent. I am tired of tympany and harp.

(The musicians go out. The Countess Cathleen goes over to Oona.)

You were asleep.

OONA
No, child, I was but thinking
Why you have grown so sad.

CATHLEEN
The famine frets me.[31]

30. *Collected Plays*, pp. 593-94.
31. *Poems* (1895), p. 76.

This brief scene shows the inner conflict of the Countess: her desire to escape to a world of reverie versus the pressing demands of the world of reality. Its theatrical effectiveness lies in the contrast of the ritualistic formality of the music and the stage picture with the spare dialogue and the precise physical actions given to the Countess. The dialogue is carefully structured to lead to the final line, which in its utter simplicity expresses perfectly the anguish of the Countess.

A similar theatrical effect is attained in another scene in the play when three peasant women mourn, almost as in a chorus, the death of the Countess:

A PEASANT WOMAN
She was the great white lily of the world.

ANOTHER PEASANT WOMAN
She was more beautiful than the pale stars.

AN OLD PEASANT WOMAN
The little plant I loved is broken in two.[32]

Here, the effectiveness lies in the parallel rhythmic movement of the three lines, the beautiful imagery drawn from the natural life of the peasantry, and above all, the slight twist given to the third speaker, who expresses her grief in the first person. Significantly, as "An Old Peasant Woman" she is also the only one of the three speakers for whom Yeats has indicated characterization.

One could find equally striking examples throughout the dramatic work of Yeats. From the beginning of his career it is evident that he displayed a distinct talent for writing actable plays. If that were all that Yeats wanted to do, his problems would, of course, have been relatively simple. But in striving to create a form of drama that would be as personal and as philosophically significant as his lyric poetry, Yeats set himself a formidable challenge. In meeting that challenge no one during the early years of the Abbey Theatre exerted a greater influence on him than Lady Gregory.

THE INFLUENCE OF LADY GREGORY

It is impossible to overestimate the importance of Augusta, Lady Gregory (1852-1932) to Yeats and to the Irish dramatic

32. Ibid., pp. 152-53.

movement as a whole. From the time when she first met him in August 1896 until her death in May 1932, Lady Gregory's home at Coole was a sanctuary for Yeats, her presence a continual support. Both financially and spiritually, Lady Gregory made it possible for Yeats to function free from many of the mundane demands of life that would otherwise have sapped his creative time and energy. At the beginning of his career she, in fact, made it possible for him to assume almost literally the stance of an aristocrat, which in turn sustained his aristocratic stance as an artist.[33]

Were it not for Lady Gregory it is doubtful that the Irish Literary Theatre would have come into being at all. With her "feeling for immediate action", as Yeats put it, Lady Gregory convinced him at a time when he had lost hope of establishing a theatre in Ireland that it was a practical possibility. By employing her social connections to maximum advantage, Lady Gregory raised most of the patronage money which guaranteed the three-year series.[34] Later, she was instrumental in persuading Yeats to turn his attention to W. G. Fay's National Dramatic Society. According to Padraic Colum, she was also the main political force behind the gradual usurpation of the Fays' control over the Society in favour of herself and Yeats.[35]

From an artistic standpoint the influence of Lady Gregory was of equal importance to Yeats. As we have seen, he gave her full credit for bringing him back to the authentic spirit of peasant folklore. Her collections of Celtic mythology were extravagantly praised by him as the Irish equivalent of the Welsh *Mabinogion*, the *Morte d'Arthur*, and the *Nibelungenlied*.[36] They also provided Yeats with the mythical foundation for many of his plays. All of the Cuchulain cycle, for instance, is based (with variations) upon her translations.[37] But vital as her contributions may have been in these respects, Lady Gregory undoubtedly made her greatest and most lasting contribution to Yeats's dramatic career by ac-

33. Vide Salvadori, *Yeats Poet and Castiglione Courtier*, pp. 22-23.
34. *Autobiographies*, pp. 380, 398, 562.
35. "Early Days of the Irish Theatre", Part II, *Dublin Magazine* (January-March, 1950), p. 23. Cf. *Our Irish Theatre*, p. 30.
36. Vide *Explorations*, p. 4; *Essays and Introductions*, p. 188.
37. Vide *Plays in Prose and Verse*, pp. 417-18.

tively collaborating with him in the creation of plays for the Irish National Theatre Society.

Yeats and Lady Gregory may have begun their collaborate efforts with his rewriting of *The Stories of Red Hanrahan* in 1897 so as to purge them of "that artificial elaborate English" inspired by the prose of Walter Pater.[38] Yeats worked upon all the tales with Lady Gregory's help, each of them alternately "suggesting a new phrase or thought . . . till all had been put into that simple English she had learned from her Galway countrymen, and the thought had come closer to the life of the people".[39] Later, Yeats dictated parts of *Diarmuid and Grania* to Lady Gregory and, in her own words, she again suggested "a sentence here and there". Lady Gregory credited the latter experience with starting her on her own career as a dramatist.[40]

With the transfer of their attention to the Irish National Theatre Society, Yeats and Lady Gregory began to collaborate more seriously in the composition of plays. Beginning with *Cathleen ni Houlihan* in 1902, a remarkable series of plays emerged within the space of two short years: *The Pot of Broth, Where There is Nothing, The Hour-Glass, The King's Threshold, On Baile's Strand*, and a revised version of *The Shadowy Waters*. All of these plays were written with the help of Lady Gregory; Yeats, in fact, wanted her to publish *The Pot of Broth* in her own name. Later, he declared that up to the *Four Plays for Dancers* only *The Green Helmet* and *The Player Queen* were entirely written by himself.[41]

What was the method of their collaboration? That is perhaps best revealed by a passage in which Yeats paid tribute to Lady Gregory's role in the creation of *Cathleen ni Houlihan*:

One night I had a dream almost as distinct as a vision of a cottage where there was well-being and firelight and talk of a marriage, and into the midst of that cottage, there came an old woman in a long cloak. She was Ireland herself, that Cathleen ni Houlihan for whom so many sto-

38. *Mythologies*, p. i.
39. Vide note in John Quinn's copy of *Stories of Red Hanrahan* (1904) quoted by Allan Wade, *A Bibliography of the Writings of W. B. Yeats* (London: Rupert Hart-Davies, 1958), p. 72.
40. *Our Irish Theatre*, p. 81.
41. *Plays in Prose and Verse*, pp. 3, 7.

ries have been told and for whose sake so many have gone to their death. I thought if I could write this out as a little play I could make others see my dream as I had seen it, but I could not get down out of that high window of dramatic verse, and in spite of all you had done for me I had not the country speech. One has to live among the people, like you, of whom an old man said in my hearing, 'She has been a serving-maid among us', before one can think the thoughts of the people and speak with their tongue. We turned my dream into the little play *Cathleen ni Houlihan*, and when we gave it to the little theatre in Dublin and found that the working people liked it, you helped me to put my other dramatic fables into speech.[42]

It appears, then, that Lady Gregory's initial function was, as it had been with the revisions of *The Stories of Red Hanrahan*, to bring Yeats's lofty thought down "from the clouds" by providing his characters with "speech from real life".[43] During the summer of 1902 they worked to create a "swift-moving town dialect" for *The Pot of Broth* which would be distinct from the "slow-moving country dialect" of *Cathleen ni Houlihan*. Aided by Douglas Hyde, they also turned another fable into the play *Where There is Nothing*.[44] Working from a prose scenario, Yeats dictated the lines to Lady Gregory and found that he had never composed "so easily and quickly". As he explained in dedicating the play to her: "when I hesitated you had the right thought ready, and it was always you who had the right turn to the phrase and gave it the ring of daily life".[45]

Yeats's collaboration with Lady Gregory in writing realistic, particularly peasant, dialogue continued throughout his dramatic career. As late as 1928 Yeats declared, concerning her help with his "plain man's Oedipus": "Lady Gregory and I went through it all, altering every sentence that might not be intelligible on the Blasket Islands."[46]

Lady Gregory also aided Yeats with play construction during the years of his active involvement with the Irish National Theatre Society.[47] Indeed, Yeats trusted her judgment

42. *Collected Works* (1908), Vol. IV, pp. 240-41.
43. *Plays in Prose and Verse*.
44. *Autobiographies*, pp. 451, 453.
45. Dedication to Lady Gregory of *Where There is Nothing* (1902), quoted in *Variorum Plays*, p. 1292.
46. *New York Times* (January 15, 1933), quoted in *Letters*, p. 537.
47. Preface to *Plays in Prose and Verse*, p. vii.

so implicitly that he scarcely allowed his early plays to be produced or published without her approval.[48]

PHILOSOPHY, STYLE, AND STRUCTURE

Apart from writing dialogue that had the ring of daily life, Yeats's chief problem as a budding dramatist was the development of an appropriate form and structure for his plays. As he declared in the September 1903 edition of *Samhain*: "If we do not know how to construct, if we cannot arrange much complicated life into a single action, our work will not hold the attention or linger in the memory."[49]

Yeats's difficulties with form and structure were complicated by two factors. First, as we have emphasized was his belief that art must be the "expression of conviction". Because of this belief, however much Yeats may have tried to explain his method of creation as a process over which he had little rational control,[50] almost every one of his plays was written to dramatize a specific philosophical, religious, or social theme. This, in turn, led Yeats to a second consideration: the necessity of sublimating philosophy to the action of the play as a whole in order that his mystical ideas might achieve their full impact through a profound emotional response.[51] Yet, if he were to remain true to his ideal of "personal utterance", the action of the play must seem as if "one mind could have made it", with "everything [having] a colour and form and sound of that mind".[52]

48. Vide *Letters*, pp. 395, 545.

49. *Explorations*, p. 108.

50. Vide Chapter Two, p. 56.

51. Yeats applied the knowledge gained from his own dramaturgical struggles in criticizing plays submitted to the Abbey Theatre. Rejecting a play by the novelist Brinsley MacNamara, Yeats declared: "We should not as a rule have to say things for their own sake in a play but for the sake of emotion. The idea should be inherent in the fable." Letter to MacNamara (June 22, 1919), *Letters*, p. 656.

Again, in the controversy over the rejection of Sean O'Casey's play *The Silver Tassie*, Yeats wrote to O'Casey: "Dramatic action is a fire that must burn up everything but itself; there should be no room in a play for anything that does not belong to it; the whole history of the world must be reduced to wallpaper in front of which the actors must pose and speak. Among the things that the dramatic action must burn up are the author's opinions; while he is writing he has no business to know anything that is not a portion of that action." (April 20, 1928), *Letters*, p. 741.

52. Letter to John Quinn (June 29, 1905), *Letters*, p. 452. "Remember that a

Reacting against the loose episodic action of *The Countess Cathleen*, which reflected so much of his amorphous thought and feeling throughout the nineties, Yeats sought to develop a style and structure that was the equivalent of his personal mask. This, he declared in 1903, would involve the creation of a dramaturgical form as strictly ordered as the logic of mathematics, but containing within it a teeming inner life of "imagination and poetry". His dramaturgical form would be modelled on "the severe discipline of French and Scandinavian drama" rather than "Shakespeare's luxuriance".[56] Above all, it would be "organic"—springing from the histrionic actions of the play—for, as he put it, "No actor will ever succeed in inorganic work."[54]

Almost inevitably, Yeats was led by these considerations to the one-act play in which logic "work[ed] itself out most obviously and simply in a short action with no change of scene".[55] Following *Where There is Nothing*, which was written in five acts as an experiment to see how "loosely" he could make the construction "without losing the actable quality",[56] except for *The Unicorn from the Stars*, *The Player Queen*, and *The Herne's Egg*, Yeats worked exclusively in the one-act play form. Indeed, he succeeded in making the one-act play as personal a medium of expression as lyric poetry by employing an astounding variety of dramaturgical styles and structures within that strict form. Examples include *On Baile's Strand*, with its delicate tension between the heroic and the absurd expressed through a double plot with two sets of mirror characters; *The Hour-Glass* and *The King's Threshold*, with the action focussed on a single heroic character; realistic plays, such as *The Words Upon the Window-Pane* and *The Resurrection*, in which the characters embody, as in a Shavian dialectic, differing philosophical points of view; *The Shadowy*

play, even if it is in three acts, has to seem only one action," Yeats warned Lady Gregory when she tackled a three-act play for the first time. (January 21, 1904), ibid., p. 427.

53. Vide *Essays and Introductions*, p. 215; letter to J. B. Yeats (June 14, 1918) in which Yeats writes of the "mathematics" of construction taking "a lifetime to master". *Letters*, p. 649.

54. Letter to T. Sturge Moore (May 6, 1906), *Correspondence*, p. 8.

55. Letter to "Michael Field" (July 27, 1903), *Letters*, p. 408.

56. Letter to A. B. Walkley (June 20, 1903), ibid., p. 405.

Waters, where the characters, the world they inhabit, and the supernatural presences about them are symbolically almost indistinct from one another; the dance plays which combine ritual and pure lyric utterance with short scenes of relatively realistic conflict; and his three last plays, *The Herne's Egg, Purgatory*, and *The Death of Cuchulain*, which combine almost all of the previous styles and structures.

Taken as a whole, Yeats's one-act plays indeed range from "the bass notes of realism to the highest and most intense cry of lyric passion". But by deliberately choosing to discipline his poetic imagination by forcing it to operate within the limitations of the one-act form, Yeats created yet another problem—that of imposing too rigid a control over his material. As he declared in 1907:

> The principal difficulty with the form of dramatic structure I have adopted is that, unlike the loose Elizabethan form it continually forces one by its rigour of logic away from one's capacities, experiences and desires, until there is rhetoric and logic and dry circumstances when there should be life.[57]

We may see how Yeats sought to combat this tendency by examining his revisions of *The Shadowy Waters, The King's Threshold, On Baile's Strand*, and *The Hour-Glass* after he saw them performed by the Irish National Theatre Society. Nothing more clearly demonstrates Yeats's intention to be taken seriously as a "practical dramatist" than his continual efforts to make his plays philosophically significant and stylistically coherent, but above all, stageworthy in terms of the practical demands of the theatre.[58]

POETRY VERSUS DRAMATIC ACTION

In recent years as the unpublished manuscripts of Yeats have come to light considerable attention has been focussed on *The Shadowy Waters* as a work of central importance to

57. *Collected Works*, Vol. II, p. 251.
58. In publishing both an acting version and a poetic version of *The Shadowy Waters* in 1913, Yeats declared: "I am most anxious that this book, which I hope will go among people who have a technical interest in the stage, should show that I understand my trade as a practical dramatist. It will injure me if it contains a play which is evidently unfit for the stage as it stands." Letter to E. M. Lister, Yeats's agent in dealing with A. H. Bullen (August 15, 1911), *Letters*, pp. 561-62.

Yeats's development.[59] Yeats apparently conceived *The Shadowy Waters* as early as 1883 and completed the first draft of the play in 1885. It appears that he would have published this version except that he could not bring it to a satisfactory conclusion. The experience of Villiers de l'Isle Adam's *Axël* and of an unhappy love affair that he commenced in an unsuccessful attempt to forget Maud Gonne prompted further revisions in 1894 and in 1896-97. Another series of revisions took place in 1899 when Yeats was contemplating a production of the play by the Irish Literary Theatre. *The Shadowy Waters* was first published in the May 1900 edition of the *North American Review* after which it underwent two more revisions in 1905 and 1906 following productions in London and at the Abbey Theatre. *The Shadowy Waters* was finally given its definitive publication in two forms: in an "Acting Version" in 1908 and as a "Dramatic Poem" in 1913.[60]

Perhaps the chief significance of the many revisions of *The Shadowy Waters* is that they demonstrate the unceasing determination of Yeats to unify and express his vision of a transcendental reality beyond the material world as he experienced this in nature worship, peasant art and supernatural lore, mythology, and arcane knowledge. The various revisions also reflect Yeats's struggle to find an appropriate balance between personal poetic expression and effective dramatic action.

The one consistent element in all the versions of *The Shadowy Waters* is the voyager hero, Forgael, and his quest for physical and magical powers, wisdom, and perfect love. The early versions of the play exhibit in the various plot changes—especially with regard to the ending[61]—Yeats's own indecision concerning man's fulfillment upon a mortal as

59. Vide Sidnell, Mayhew, and Clark, *Druid Craft: The Writing of "The Shadowy Waters"; A Tower of Polished Black Stones: The Early Versions of "The Shadowy Waters"*, arranged and edited by David R. Clark and George P. Mayhew (Dublin: Dolmen Press, 1971).

60. Preface to *Druid Craft*, pp. xiv-xv, 144; *Tower of Polished Black Stones*, pp. 39-40.

61. In one version Forgael slays Dectora's lover, wins her from hatred to love by magic, and then turns her into a sacrificial victim. At another extreme, in another version Forgael kills himself out of pity for Dectora. As late as 1899 the play ended with Dectora having brought Forgael to a recognition of love only to have him reject her because this represented merely a temporal fulfillment of his quest. *Druid Craft*, pp. 5, 240.

opposed to an immortal plane of existence. By 1900, however, the main plot line had been worked out and was substantially the same as Yeats provided in a program note for the production of the play at the Abbey Theatre in 1906:

Once upon a time, when herons built their nests in old men's beards, Forgael, a Sea-King of ancient Ireland, was promised by certain human-headed birds love of a supernatural intensity. These birds were the souls of the dead, and he followed them over seas towards the sunset, where their final rest is. By means of a magic harp, he could call them about him when he would and listen to their speech. His friend Aibric, and the sailors of his ship, thought him mad, or that this mysterious happiness could come after death only, and that he and they were being lured to destruction. Presently they captured a ship, and found a beautiful woman upon it, and Forgael subdued her and his own rebellious sailors by the sound of his harp. The sailors fled upon the other ship, and Forgael and the woman drifted on along following the birds, awaiting death and what comes after, or some mysterious transformation of the flesh, an embodiment of every lover's dream.[62]

John Reese Moore has described the early versions of *The Shadowy Waters* as "a kind of dramatic encyclopedia of Yeats's knowledge and theories of symbolism".[63] It is precisely the layer upon layer of obscure poetic symbols that make the 1900 version of the play so clearly an unstageworthy effort. The stage directions, for instance, call for a pattern on the sails of the ship consisting of "three rows of hounds, the first dark, the second red, and the third with red ears".[64] Forgael's costume was to have a lily on the breast; Dectora's a rose. These, and many of the other symbols, are explained by the characters in their dialogue. But, in doing so, the dialogue all too obviously is forced to turn aside from the main action, with the result that the themes are merely described and not depicted. The single theatrically effective scene in this version of *The Shadowy Waters* is the climactic love duet between Dectora and Forgael. Significantly, it is the only scene that Yeats preserved intact in his later versions of the play.

62. Quoted in *The Identity of Yeats*, pp. 80-81.
63. *Masks of Love and Death* (Ithaca: Cornell University Press, 1971), p. 79.
64. *Variorum Poems*, p. 747.

As early as 1899, Yeats began working on *The Shadowy Waters* in order to make it "act better".[65] What he meant by this is evident in the version of the play published in 1906,[66] which was revised as a result of a production staged in London by Florence Farr on July 8, 1905.[67] This version, performed by the Abbey Company in December 1906, in turn led to the "Acting Version" published in 1908.[68]

For the 1906 version of the play Yeats made some vital changes in terms of language, characterization, and structure. He sought to introduce "homely phrases" and "the idiom of daily life" into the dialogue. The sailors in particular were made "rough, as sailors should be", while all the other roles were "characterized". Above all, Yeats sought to remedy the disembodied quality of the stage action by "making the people answer each other and [by] making the ground work simple and intelligible".[69]

Yeats was successful in so far as the sheer theatrical impact of the play was increased considerably. Scenes such as a dialogue between Aibric and Forgael were introduced which give the conflict between reality and the longing for an impossible ideal deeply human expression. The layers of symbolism which clouded the earlier version were drastically pruned, allowing the theme of the play to spring naturally from the histrionic and theatrical actions of the work as a whole.

But in his efforts to bring the play closer to the "idiom of daily life" Yeats swung too far in the opposite direction. A problem of stylistic unity occurred, with the lyrical language of Forgael and Dectora making them appear to inhabit too entirely a different world from that of the prose-speaking sailors. Realistic business, such as Aibric's being flung to the deck of the ship during the sailors' mutiny, jarred with the dramatic mood necessary to express the play's delicate theme. In his effort to clarify the meaning of the human-

65. Letter to George Russell (November 1899), *Letters*, p. 327.
66. *Poems 1899-1905*, pp. 10-67.
67. Yeats gave *The Shadowy Waters* to Florence Farr for a Theosophical convention in London so that he might see the play onstage before rewriting it. *Collected Works*, Vol. II, pp. 257-58; *The Arrow* Number One (November 24, 1904), p. 3; *Letters*, pp. 449, 451, 454.
68. *Collected Works*, Vol. II, pp. 231-50.
69. Letter to John Quinn (September 16, 1905, June 29, 1905), *Letters*, pp. 462, 451.

headed birds who lead Forgael on to his pursuit of the ideal, Yeats became too explicit, thus reducing their spiritual connotations for the audience.

The revision of *The Shadowy Waters* that was made as a result of the 1906 production throws some light on Yeats's efforts to solve these essentially stylistic problems. The first thing one notes is that now the sailors speak a dialect similar to Lady Gregory's "Kiltartanese". With the heightened imagery, inverted grammatical structure, and languorous musical rhythm of this dialect, a unity was effected between the speech of the sailors and that of Forgael and Dectora. Thus Yeats achieved the "certain even richness" of dialogue that, we have noted, was also apparent in the peasant and noble characters of Maeterlinck.[70]

By observing the performance of prose plays, Yeats learned that "the stage picture is so much more powerful than the words that there are whole passages that lose their weight".[71] Yeats applied this knowledge in cutting many of the purely descriptive and expositional passages of the sailors, a number of their entrances, and much of their realistic stage business.

Structurally, *The Shadowy Waters* was also greatly improved, especially in terms of mood variation and suspense. The sighting of the ship with Dectora upon it now takes place immediately after a new speech written for Forgael in which he beautifully expresses the full philosophical and human depths of his quest for immortality. Thus the audience is prepared to accept the imminent presence of Dectora onstage as a possible answer to this quest. The dramatic tension evolving from the actual and symbolic conflict between Dectora and Forgael is thereby anticipated and sustained right through to the final resolution of the play.

Perhaps the most significant alteration to the play occurred in the climactic scene where Forgael, after killing Dectora's husband and taking her captive, seeks to win her

70. Cf. S. B. Bushrui *Yeats's Verse Plays: The Revisions, 1900-1910* (Oxford: Clarendon Press, 1965), pp. 34-35, for a detailed study of the opening scene in the three versions of the play. Professor Bushrui's study is the most comprehensive work on the revisions of Yeats's early plays, although he does not, perhaps, sufficiently emphasize their histrionic and theatrical alterations. As a result, in analysing the revisions of *The Shadowy Waters*, he finds that Yeats progressively moved towards a greater realism.

71. Letter to T. Sturge Moore (January 26, 1916), *Correspondence*, p. 124.

love by enchanting her with his magical harp. In the earlier versions of *The Shadowy Waters*, Dectora simply fell asleep and awakened to find herself in love with Forgael. In the 1906 version, under the spell of the harp she passes through a series of changes—first mourning the loss of her husband, then equating that loss with the sorrow of lovers throughout the ages, and finally coming to the realization of a love for Forgael that is commingled with the spirit of love itself, immortal and eternal. Dectora thereby becomes a much richer acting role. But the scene as a whole now pulls together all the complex interwoven themes of the play: the unifying essence of perfect love, the transmigration of souls, and the identity of Forgael's music (or poetry) with mystical perfection as embodied in the cries of the birds that call him to immortality. In the final image of the play, Forgael, wrapped in the net of Dectora's golden hair, finds immortality not beyond the world, where he has been seeking it, but within the arms of his beloved.

Some critics have complained that by making *The Shadowy Waters* more stageworthy and, in particular, by humanizing the relationship between Forgael and Dectora, Yeats lost a sense of interpenetrating mystery related to a cosmic Blakean and Kabbalistic ontology that is present in the early unpublished versions of the play.[72] Other critics have remarked on the shortcomings of *The Shadowy Waters* both as a dramatic conception and as a work for the stage.[73] I cannot agree with either viewpoint. It seems to me that by coming to grips with his *dramatis personae* as actors would have to embody them Yeats found a way of expressing himself not only more effectively but truer in a philosophical sense. The distinction to be found in *The Shadowy Waters* between vapid immortal longing and mortal fulfillment is Yeats's final wisdom. Later, of course, he expressed the same theme much more directly and forcefully in plays such as *A Full Moon in March*. Nowhere, however, does Yeats portray the infinite anguish and ecstasy of love between man and woman with greater tenderness and compassion than in *The Shadowy Waters*. In staging the play I found it to be an

72. *Druid Craft*, p. 305.
73. Vide Leonard Nathan, *The Tragic Drama of William Butler Yeats* (New York: Columbia University Press, 1965), pp. 72-74, for an account of this criticism.

exquisitely poetic work of art. It is, as Yeats intended all of his drama to be, an image of "something in the depths of the mind [made] visible and powerful" through a unity of colour, sound, and form.[74]

CREATING STRUCTURE THROUGH CHARACTER

With *The King's Threshold*, *On Baile's Strand*, and *The Hour-Glass*, Yeats's main problem was almost the entire opposite of the one he faced in revising *The Shadowy Waters*. Instead of having to bring a sense of stage reality to an overtly poetical play, his problem now was of imbuing prose plays with an internal life seeking for expression through the characters.

Yeats's experiments with prose plays began with his desire to bring a greater realism to his dramaturgy in order to win a popular audience for the Irish National Theatre Society. He was, of course, strongly urged in this direction by Lady Gregory, who apparently felt that it was the key to Yeats's problems in mastering dialogue and structure.[75] Yeats's experiments also coincided with his desire to break away from the ritual and pattern of his earlier plays by focussing the attention of the audience upon the actor isolated from his stage environment. In dramaturgical terms, Yeats explained this as an attempt "to try if a play would keep its unity upon the stage with no other device than one dominant character about whom the world was drifting away.[76]

The Hour-Glass and *The King's Threshold*, both written for production in 1903, were the immediate results of this deliberate change of style. Each focusses on a single character who embodies a philosophic conception to which other characters are generally opposed. In *The King's Threshold*, Seanchan the poet chooses to starve to death rather than submit to a dictate of the King that he must yield his traditional place of honour at the great Council of State. The plot consists of a series of confrontations in which the King, the Mayor, the Lord High Chamberlain, a Monk, a Soldier, and two Cripples—the symbolic representatives of the whole society—try to persuade him, for various selfish reasons, to

74. *Essays and Introductions*, p. 276.
75. Vide *Letters*, pp. 391, 405-6; Dedication to Lady Gregory of *Where There is Nothing*.
76. Letter to A. B. Walkley, *Letters*, p. 405.

break his fast. The will of the poet prevails, however, and the King is forced to accept the final triumph of poetry by receiving his own crown from the poet's hand.

In *The Hour-Glass*, a cynical scholar who has taught his pupils and even his wife and children that there is no reality beyond the material world is visited by an Angel. The Angel tells the Wise Man that he will die when the last grain of sand has fallen through the hour-glass, and that he will be damned unless he can find one soul who still believes in Heaven. The Wise Man accosts his Pupils, his Wife, and his Children in a frantic effort to restore their belief. But he learns that his teachings have been all too convincing. His soul is saved at the end of the play, however, when Teigue, the simple Fool whom he has previously scorned, demonstrates that he alone has retained a faith in God.

In their initial versions,[77] both *The King's Threshold* and *The Hour-Glass* suffer from the same basic weakness: each play appears to be nothing more than a contrived exposition of its theme. Secondary characters parade mechanically on and off the stage with no seeming internal or extrinsic motivation. Because they fail to take on even the semblance of a flesh-and-blood reality, it is impossible for the audience to believe in or care about their symbolic meaning, hence the meaning of the play as a whole.

The central characters of the two plays are naturally affected by these dramatic flaws. Seanchan relates to none of the other *dramatis personae*, seeming to exist in a world of his own. He therefore appears as little more than a petty egotistical figure, entranced with illusions of his own self-importance. The Wise Man is likewise a one-dimensional character. His quest for a single person who believes is depicted merely as a monotonous whining cry of fear.

For the revisions of *The King's Threshold*, which took place early in 1905,[78] Yeats's attention was chiefly devoted to reworking the roles of the secondary characters. Here the

77. *The Hour-Glass* was first published in Volume Two of *Plays for an Irish Theatre*, pp. 9-32. The script employed for the first production is preserved, with stage directions, in the Papers of Frank Fay, N.L.I. Ms. 10950.

 The King's Threshold was first published in Volume Three of *Plays for an Irish Theatre*, pp. 5-66.

78. Published in *Poems 1899-1905*, pp. 192-270.

help of Lady Gregory is apparent, particularly in the develop-
ment of the character of the pompous Mayor and his entou-
rage of Cripples as comic reflectors of the main action. In the
first version of the play, the Mayor simply appeared and
waited on stage during a lengthy dialogue between Seanchan
and his Pupils, which climaxed in the ceremonial laying down
of their harps and trumpets. Not only was the Mayor a dis-
tracting presence during this scene, but he was given no real
preparation for the following scene in which he played a
major role. In the revised version of the play, the Mayor's
entrance takes place following the completion of the cere-
mony, thus providing a sharp and necessary break in mood.
His entrance itself is given a much greater prominence by
providing him with a number of stock phrases ("Chief poet,
Ireland, townsmen, grazing land") that he mutters to himself
as he bumbles his way on to the stage. To make his absurdity
still more complete, these phrases are cut onto an Ogham
stick so that he will not forget them in making a formal
speech to Seanchan—which is, of course, also for the benefit
of his political constituents, the Cripples. The Mayor's speech
acquires a richly satiric verisimilitude through the inter-
ruptions of the Cripples, as they remind him of specific local
issues pertinent to the case.

Out of this comical byplay written in a rich Kiltartanese
dialect, the Mayor's basic ignorance and stupidity are given a
sharp definition when, in response to the arguments of
Seanchan, he suddenly asks the Cripples:

> What is he saying?
> I never understood a poet's talk
> More than the baa of a sheep.[79]

The Mayor's role as an enemy of poetry is also given a
much deeper significance (particularly in view of the political
climate in Ireland at the time) when, in answer to a curse of
the Cripples upon Seanchan, he replies:

> What good is in a poet?
> Has he money in a stocking,
> Or cider in the cellar,

79. Ibid., p. 216.

> Or flitches in the chimney,
> Or anything anywhere but his own idleness?[80]

Yeats similarly developed the characters of the other secondary roles, so that not only were they more actable but greatly intensified in their satiric power. Because the forces that Seanchan is opposed to are no longer merely indicated, the poet's character is greatly strengthened. He does not now appear to be arguing out of pettiness but in defence of all that is beautiful in life and art.

Yeats employed many of the same dramaturgical techniques in the revisions of *On Baile's Strand*, which he undertook just three days after its first production on December 27, 1904.[81] By utilizing a double plot that involved two pairs of antithetical characters, Yeats had two purposes in mind. One was to reflect the dialectical theme of the play by contrasting the relationship between the Fool and the Blind Man with that of the heroic characters, Cuchulain and Conchubar.[82] His other purpose was to break the logical rigidity of the one-act form by evoking an almost Elizabethan multi-layered response that he termed "emotion of multitude".[83] On seeing the play performed, however, Yeats discovered that his problem was again one of imposing "abstract ideas" upon flesh-and-blood characters.[84]

As with his revisions of *The King's Threshold*, Yeats was aided in overcoming his problems with language, structure, and characterization by Lady Gregory. This is particularly evident in his reworking of the characters of the Fool and the Blind Man. In the initial version of *On Baile's Strand*,[85] the exposition of the play was handled by means of an opening dialogue between the Fool and the Blind Man in which they

80. Ibid., p. 222.
81. Vide unpublished letter to Lady Gregory (December 30, 1904) quoted by Brigit Bjersby, *The Interpretations of the Cuchulain Legend in the Works of W. B. Yeats* (Uppsala: Lundequistska Bokhanden, 1950), p. 75. *On Baile's Strand* was first published in *In the Seven Woods* (Dundrum: Dun Emer Press 1903), pp. 26-66.
82. Vide Letter to Frank Fay (January 20, 1904), in which Yeats analyses the characters in terms of these antitheses, *Letters*, p. 425.
83. *Essays and Introductions*, p. 215.
84. *Explorations*, p. 393.
85. Published in *In the Seven Woods*, pp. 26-63.

blatantly provided the audience with background information. The scene was not helped by the fact that the characters possessed neither charm nor individuality, but instead were close to being "stage Irish" farcical types. In the revision of the play published in 1906,[86] however, the background information concerning Cuchulain's relationship with his former mistress, Aoife, her subsequent enmity for him, and the existence of an unknown son, who has vowed to kill him, is skilfully introduced by the Blind Man in the form of a story to divert the attention of the Fool from his hunger. Then Yeats—and Lady Gregory—pull the threads of the plot together, delineate the main character relationships, and deepen the audience's interest by the clever device of having the Fool puzzle out the story again, this time in strikingly histrionic terms appropriate to his own character:

FOOL. What a mix-up you make of everything, Blind Man! You were telling me one story, and now you tell me another story. . . . How can I get the hang of it at the end if you mix everything at the beginning? Wait till I settle it out. There now, there's Cuchulain (*he points to one foot*), and there is the young man (*he points to the other foot*) that is coming to kill him, and Cuchulain doesn't know. But where's Conchubar? (*Takes bag from side.*) That's Conchubar with all his riches—Cuchulain, young man, Conchubar.—And where's Aoife, high up on the mountains in high hungry Scotland. Maybe it's not true after all. Maybe it was your own making up. It's many a time you cheated me before with your lies. Come to the cooking-pot, my stomach is pinched and rusty. Would you have it to be creaking like a gate?[87]

Perhaps the most important difference between the expositionary scenes in the 1903 and 1906 versions is that in the latter version the Blind Man withholds from the Fool (and the audience) the dreadful knowledge that the Young Man is none other than Cuchulain's own son. Thus, as S. B. Bushrui points out, the audience is absorbed by the tale of the Blind

86. *Poems 1899-1905*, pp. 73-138.
87. Ibid., p. 78. The fact that Lady Gregory aided Yeats in rewriting this scene is evident from an unpublished letter of January 14, 1905, in the possession of Michael Yeats.

Man, but does not fully discover its tragic implications until later in the play.[88]

Yeats's second major change in the 1906 version of *On Baile's Strand* was in vastly enriching the characters of Cuchulain and Conchubar. In the 1903 version of the play, Cuchulain appears to be almost petty in his opposition to Conchubar's order that he must take an oath of obedience to him. His only expression of rebellion consisted of a few mild expletives muttered from the far end of the Council Chamber, like a naughty schoolboy. For the revised version Yeats created a confrontation scene between the two characters that allows each to plumb the full range of the conflict between them. As with the scene between Aibric and Forgael in *The Shadowy Waters*, the philosophic issues at stake—Conchubar's desire for a rational social order versus Cuchulain's will to retain his personal sense of freedom—are eloquently debated. But the most striking element in the scene is that, in the course of their debate, the characters move far beyond mere argument and take on a passionate life of their own. It is the sheer humanity of Cuchulain and Conchubar that ultimately touches the heart and engages the mind. Cuchulain's disdain for Conchubar's life of settled ease is mingled with his longing for a son; Conchubar's arrogant awareness of his power is mingled with his envy of Cuchulain's wild abandon. Neither point of view is absolutely right or wrong, and thereby we perceive the tragic dilemma inherent in Yeats's dialectical philosophy.

At length, the other Kings, who have already submitted to Conchubar, persuade Cuchulain that he, too, must obey. Cuchulain agrees to take the oath, but only in defiance of them and of whatever fate may have in store for himself:

> I'll take what oath you will
> The moon, the sun, the water, light or air
> I do not care how binding[89]

This scene is followed by another new interpolation—the ritual enactment of Cuchulain's oath of obedience. The

88. Bushrui, *Verse Plays*, p. 58.
89. *Poems 1899-1905*, p. 101. Reg Skene brilliantly relates the natural imagery employed by Yeats throughout the Cuchulain cycle to the doctrine of elementals taught by Madame Blavatsky and by the Order of the Golden Dawn. Vide *The Cuchulain Plays of W. B. Yeats*, pp. 125-27.

hypnotic rhythm of the swaying bodies, the flames burning with "fragrant herbs", and the chanted lyrics of the "Singing Women" carry the action far beyond the Council Room and into the mythic realm of the supernatural. Suddenly, the mood is broken and the Young Man is at the door. The dreadful knowledge of the Blind Man is suddenly upon us: Cuchulain's fate—that he must kill his own son—is tied with mortal and immortal bonds that he is powerless to break.

On Baile's Strand is possibly the finest of all Yeats's plays. Certainly it is the most perfect early realization of his ideal of a dialectical drama. But it is by examining the process by which The Hour-Glass was transformed from a prose into a verse play that the development of Yeats into a poetic dramatist and tragedian of major stature may be most fully understood.

POETRY AND THE TRAGIC VISION

Even before the first production of The Hour-Glass, which took place in March 1903, Yeats intended to put parts of it into verse. This is evident from a letter to Lady Gregory, dated January 3, 1903, in which he explained that this step was necessary "in order to lift the 'Wise Man's' part out of a slight element of platitude".[90] The production of the play doubtless confirmed Yeats's fears. As we have noted, in its initial version The Hour-Glass was only a short step removed from melodrama.

Whereas Yeats went on to revise The King's Threshold, On Baile's Strand, and The Shadowy Waters immediately following their first productions, The Hour-Glass was not extensively revised until 1912. Then, under the inspiration of the Gordon Craig screens, Nugent Monck, and the Abbey Second Company, the entire play was rewritten in verse.[91]

It is probable that the influence of Lady Gregory was one of the principal reasons for Yeats's long delay in realizing his original intention. From the outset, she appears not to have sympathized with Yeats's plan to turn even part of The Hour-Glass into verse.[92] (Lady Gregory may also have been the "friend" who advised Yeats to "write comedy and have a few

90. Letters, p. 391.
91. Plays in Prose and Verse, p. 428.
92. Vide Letters, pp. 393, 396.

happy moments in the theatre", thus preventing him from giving *The King's Threshold* the tragic ending that he had originally intended.[93] Yeats did not change the ending until 1921, when he had Seanchan die rather than submit to the will of the King, thereby achieving a spiritual rather than a practical victory in defence of his ideals).[94] As we have observed, along with Synge, Lady Gregory argued up until 1907 that most of Yeats's theatrical difficulties would be solved if he simply wrote out his scenarios in prose before attempting to put them into verse.

This reasoning of Lady Gregory's is, of course, understandable in view of the considerable contribution that she made to the success of Yeats's early plays. Practical woman that she was, she undoubtedly also realized that, given the talents of the Abbey Players, Yeats was more likely to be given adequate performances in relatively realistic, even comic, plays than in plays which demanded a high proficiency in verse-speaking. But beyond all these reasons one cannot help feeling that, basically, Lady Gregory's and Yeats's respective minds, talents, and dramatic interests were the antitheses of one another.

Yeats himself clearly indicated this when he assigned Lady Gregory to Phase Twenty-Four of *A Vision*—a Phase that she shares with Queen Victoria and John Galsworthy. Yeats defined the qualities of this Phase in terms which might have been used to describe Lady Gregory's personal character:

There is great humility—"she died every day she lived"—and pride as great, pride in the code's acceptance, an impersonal pride, as though one were to sign "servant of servants". There is no philosophical capacity, no intellectual curiosity, but there is no dislike for either philosophy or science; they are a part of the world and that world is accepted.[95]

These objective qualities of mind and character made Lady Gregory a writer of what Yeats termed "pure comedy".[96]

93. Vide *Plays in Prose and Verse*, p. 423.
94. Bushrui argues convincingly that Yeats was directly influenced to make this change by the death of Terence MacSwiney, the Lord Mayor of Cork, while on a hunger strike in an English prison in 1920. Vide *Verse Plays*, pp. 109-19.
95. *A Vision*, pp. 169-70. Vide Yeats, "Modern Ireland (An Address to American Audiences 1932-1933)", reprinted in *Irish Renaissance*, p. 16, for a direct assertion that Lady Gregory "had no philosophical interests".
96. *Explorations*, p. 184.

Again Yeats observed that "her only fault is a habit of harsh judgment with those who have not her sympathy, and she has written comedies where the wickedest people seem but bold children."[97]

During the early years of his involvement with the Irish National Theatre Society, Yeats recognized his need to be associated with the rational comedic mind of Lady Gregory if he were to write plays which had an immediate dramatic appeal. By 1906, however, Yeats was coming to understand that his own strength as a dramatist lay in a more strictly poetic form. His revisions of On Baile's Strand in 1905 taught him how to combine psychological verisimilitude with a natural poetic diction. He applied this knowledge in the second revision of The Shadowy Waters which, as we have seen, brought him much closer to his original concepts of poetic drama. Ironically, the theatrical success of Lady Gregory and Synge moved him even further in this direction, for he discovered that when played with their realistic prose comedies his own poetic tragedies were heightened in their effect.[98]

Out of his practical experience by 1905 Yeats began to formalize a theatrical theory of tragedy that distinguished his own plays from the satirical comedy of Synge and the pure comedy of Lady Gregory.[99] As usual, Yeats drew his distinctions in histrionic terms: it was, in fact, by observing actors at the Abbey Theatre that he was first made aware of them. Watching a performance of a play by Lady Gregory he discovered that the key to good comic acting is the absence of passion. In comedy the actor might display the fear of death, if it were the subject of a play, but it must all seem "a game, all like a child's game".[100] Yeats went on to analyse comedy in terms of the "character" actor. "Character", he declared in his essay on "The Tragic Theatre" (1910), was "continually present in comedy alone", and even in tragi-comedy, such as that of Shakespeare, it was "in the moments of comedy that character was defined". Because character was concerned with the qualities that make one person different from another, comedy required particular "circum-

97. Mythologies, p. 326.
98. Preface to Poems 1899-1905, p. xiv.
99. Explorations, pp. 183-84.
100. "The Theatre of Beauty", Harper's Weekly (1911), p. 11.

stances", "a real environment; some one place, some one moment of time". The limitation as well as the strength of comedy was its temporality, its total acceptance and dependence upon the actions of the "real world".[101]

To Yeats, the art of tragedy was the antithesis of comedy. He again based his theories upon the actor—this time the actor of "passion". Yeats described tragedy as "passion defined by motives".[102] Because the tragic impulse arose from the depths of the unconscious, character, which was based upon the circumstances of the external world, was inappropriate to tragedy. In place of character, tragedy substitued "passionate emotions and the clash of will".[103] Tragedy sought to allure one "to the intensity of trance", the persons of the stage greatening in emotional intensity "till they became humanity itself". In place of the objective and rational actions of the "real world" of comedy, tragedy drew upon "rhythm, balance, pattern, images that remind us of vast patterns, the vagueness of past times all the chimeras that haunt the edge of trance".[104]

Tragedy, then, demanded the multifarious, hypnotic, and evocative power that could only be summoned through poetry.

It is obvious that the theoretical understanding of comedy and tragedy that Yeats began to evolve from 1905 moved him further and further from Lady Gregory's sphere of influence. His last major collaborative effort with her was *The Unicorn from the Stars* (1907), and the result was theatrically disastrous. Yeats described the experience of writing the play in a manner that plainly understated his real problems:

I began to dictate but since I had last worked with her, her mastery of the stage and her knowledge of dialect had so increased that my imagination could not go neck and neck with hers. I found myself, too, stopped by an old difficulty, that my words never flow freely but when people speak in verse; and so after an attempt to work alone I gave up my scheme to her.[105]

101. *Essays and Introductions*, pp. 241, 243; cf. "The Theatre of Beauty".
102. Undated letter to Lady Gregory quoted in *Our Irish Theatre*, p. 106.
103. Advice of Yeats to playwrights who submitted plays to the Abbey Theatre, Henderson Press Cuttings, N.L.I. Ms. 1732, p. 259.
104. *Essays and Introductions*, p. 243. Cf. "The Theatre of Beauty".
105. *Plays in Prose and Verse*, p. 426.

The key phrase is, of course, Yeats's reference to the difficulties of writing in prose. It must have been shortly after this unhappy experience that Yeats determined that nothing must any further tempt him from "this craft of verse".[106] His political satire, *The Golden Helmet*, was produced in March 1908 at the Abbey Theatre. Immediately, Yeats set out to transform it into a verse play in rhymed couplets. In the process he had further proof that his true *métier* was pure verse drama, for in characterization, structure, and satiric intensity *The Green Helmet* is an immense improvement over its banal predecessor in prose.[107]

But the finest proof of all was yet to come. Compared with any of the earlier prose versions, the poetic version of *The Hour-Glass* published in 1913 is superior not only technically but above all in the expression of its tragic theme.

In all of its earlier prose versions[108] the theme of *The Hour-Glass* is rather crudely stated in a long opening soliloquy of the Wise Man in which he broods over certain dreams and visions that have made him question his religious scepticism. In contrast, the 1913 poetic version of the play opens with a scene in which the Wise Man's Pupils discuss their next lesson with him. Their doubts about the wisdom of his teaching that there is no God subtly introduce a sense of spiritual frustration that is reflected and amplified throughout the whole play. Another structural weakness of the early prose versions of *The Hour-Glass* is that no preparation is given for the Angel's entrance, making it difficult for the audience to jump from the natural to the supernatural world when the Angel suddenly appears on stage to confront the Wise Man with the results of his sceptical teaching. In the poetic version of the play, however, the audience is prepared

106. "All Things Can Tempt Me", *Collected Poems*, p. 109, first printed in *The Green Helmet and Other Poems* (1910).

107. Vide Bushrui, *Verse Plays*, pp. 183-90, for a complete analysis of the revision of *The Golden Helmet* into *The Green Helmet*.

108. The poetic version of *The Hour-Glass* was first published in *The Mask*, V (1912-13), pp. 327-46. The 1914 revision in verse was first published in *Responsibilities: Poems and a Play*. Four early prose versions of *The Hour-Glass* were published (1903, 1904, 1908, and 1911) before the definitive prose version appeared in *Plays in Prose and Verse* (1922). Vide S. B. Bushrui, "*The Hour-Glass*: Yeats's Revisions, 1903-1922", *Centenary Essays*, p. 195.

for the appearance of the Angel by a beautiful speech in which the Fool tells the Wise Man about having seen angels in the smell of flowers and in the blades of grass. The entrance of the Angel follows immediately and naturally out of this speech.

One is struck especially by the fact that the poetic version of *The Hour-Glass* is far more actable than the previous prose versions. This is accomplished by means of a number of precise and imaginative histrionic actions that enrich the characterizations and lend a much deeper theatrical verisimilitude to the whole play. The scene where the Wise Man questions his Pupils, for instance, is improved by having them enter for their lesson. Finding Teigue the Fool in the room, they laugh and dance in mockery about him until the Wise Man interrupts them. When the Wise Man proceeds to question the Pupils about the existence of God, they act like typical schoolboys, cowering before him until one of them is reluctantly pushed forward to bear the brunt of the quiz.

None of these details exists in the early prose versions of *The Hour-Glass*. By writing in verse Yeats rediscovered the histrionic sensibility that he first displayed in *The Countess Cathleen*. It is as though in verse Yeats's characters took on a life of their own, weaving situation, action, and the very structure of the play out of their personal motives and feelings. This sense of vital self-determining characterization is most evident in Yeats's treatment in verse of the part of the Wise Man. In the early prose versions of *The Hour-Glass*, the Wise Man has no inner dignity. He does not act—he is acted upon. The audience is therefore never convinced that his sudden belief in God is motivated by anything other than weakness.

In the poetic version of the play, however, the Wise Man has a clearly defined will of his own. This is most evident in the confrontation scene with the Angel where, instead of grovelling in submissiveness, the Wise Man's fear is tempered by his endeavour to explain the rational reasons for his doubts:

WISE MAN
Pardon me, blessed Angel,
I have denied and taught the like to others

But how could I believe before my sight
Had come to me?

ANGEL
 It is too late for pardon.

WISE MAN
Had I but met your gaze as now I meet it—
But how can you that live but where we go
In the uncertainty of dizzy dreams
Know why we doubt? Parting, sickness, and death,
The rotting of the grass, tempest and drouth,
These are the messengers that come to me.
Why are you silent? You carry in your hands
God's pardon, and you will not give it me.[109]

It is the Wise Man's sense of personal dignity that led to a new ending for yet another poetic version of the play published in 1914 and later reproduced in the 1934 definitive edition of *The Collected Plays*. In this new ending which Yeats also incorporated in the definitive prose version of the play published in 1922, the Wise Man no longer kneels to the Fool. Instead, when the Fool comes to say that the Angel wishes him, in return for a penny, to tell the Wise Man all that he wishes to know, the Wise Man silences him, crying out:

May God's will prevail on the instant
Although His will be my eternal pain.
I have no question.
It is enough, I know what fixed station
Of star and cloud.
And knowing all, I cry
That whatso God has willed
On the instant be fulfilled,
Though that be my damnation.[110]

Although the Fool's purchased belief may win the Wise Man his salvation, the Wise Man has won for himself a per-

109. *Collected Plays*, p. 309.
110. Ibid., p. 323, The Wise Man's stance is, of course, entirely consistent with Yeats's own philosophy as expressed in *A Vision*. Vide Chapter Two, pp. 27, 32-33.

sonal victory through the triumph over his own suffering. He thus becomes a Yeatsian tragic hero, an image of man defining himself through his own will and passion and accepting freely his ultimate fate: to perish into the eternal mind of God.

THE POET'S DISCOVERY OF HIMSELF

> The friends that have it I do wrong
> When ever I remake a song
> Should know what issue is at stake
> It is myself that I remake.[111]

Yeats's quest for a means to bring "personal utterance" into the theatre led him through perhaps the widest range of experiment of any major dramatist in the history of the theatre. As I have emphasized, I believe it is a mistake to view Yeats's development as a continuous evolution towards a definitive dramatic form. No one play or series of plays at any given time can adequately reveal the many-sided greatness of Yeats. Taken as a whole, Yeats's work ranges from the epic sweep of *The Countess Cathleen* to the taut Beckettian introspection of *Purgatory*; from the exquisitely poetical *Shadowy Waters* to the total theatricality of *Fighting the Waves* and *The King of the Great Clock Tower* in which words were intended to be lost in "patterns of sound as the name of God is lost in Arabian arabesques".[112] In almost every instance, the form of an individual play is an organic reflection of its content. Yet there is an astonishing consistency of purpose and coherence of thought to the entire body of Yeats's dramatic work.[113] While some of his plays are undoubtedly more successful than others, at his best Yeats was not merely a poet in the theatre but a poetic dramatist

111. *Collected Works*, Vol. II, p. 73. These "friends" certainly included Lady Gregory, who as early as 1907 objected to Yeats's plan to revive *The Countess Cathleen*. Vide *Letters*, p. 346.

112. *Variorum Plays*, p. 1010.

113. This is perhaps the quality that Yeats most admired in the Greek dramatists. When compared to their "perfection" Shakespeare was only a "mass of insignificant fragments", he told Dorothy Wellesley. "Last Days", *Letters on Poetry*, p. 194.

who combined the arts of literature and the theatre so as to create effective and profoundly significant drama.[114]

The development of Yeats the dramatist cannot be separated from the development of Yeats the poet; nor can the development of Yeats the poet be separated from the society in which he lived or the theatre in which he first practised. During the short period of time in which Yeats specifically wrote plays for the Abbey Theatre, he learned his trade as a dramatist. One may ask whether *The Hour-Glass* is theatrically as successful as *Purgatory*, but without question its revisions prepared the way for the success of his later plays. It is also probable that the revisions of *The Hour-Glass* encouraged Yeats to explore again the theatrical possibilities of ritual through the dramaturgical form of the dance plays.[115]

Through his involvement with the Abbey Theatre, Yeats developed not merely dramaturgical skills and innovative theatrical ideas but a much deeper awareness of himself as a man and artist. Out of his personal struggles and disappointments at the early Abbey Yeats evolved his conception of tragedy with its profound implications for the conduct of life. From his practical work as a dramatist Yeats

114. As late as 1937 Yeats declared: "I would have all the arts draw together, recover their ancient association, the painter painting what the poet has written, the musician setting the poet's words to simple airs, that the horseman and the engine-driver may sing them at their work. Nor am I for a changeless tradition. I would rejoice if a rich betrothed man asked Mr. T. S. Eliot and Ninette de Valois to pick a musician and compose a new marriage service, for such a service might restore a lost subject-matter to the imaginative arts and be good for the clergy." *Essays and Introductions*, p. ix. The fact that Eliot never fully became involved with the total art of theatre provides the chief distinction between his dramatic work and that of Yeats.

115. This is especially evident from a letter of Yeats to Gordon Craig (May 23, 1910) in which he declared: "I am myself busy with 'The Hour Glass' again. I have put it into verse much to its advantage. I have got rid of the touch of platitudes. I have just done the Wiseman's dying speech in rhyme, and the Fool rings the bell for the pupils and the strokes of the bell come at certain arranged moments of his speech like a Dirge. These kind of effects begin to amuse me more and more. I conceive of the play as a ritual. It must not give all to the first hearing any more than the Latin ritual of the Church does, so long as the ultimate goal is the people." Unpublished letter preserved in the Craig Collection, Bibliothèque Nationale, Paris.

discovered that it was only as a poet that he was able to express the full metaphysical and spiritual implications of his tragic vision of life.

We should not allow the full significance of the 1914 revision of the ending of *The Hour-Glass* to escape us. Yeats himself declared in 1922 that he was "ashamed" of the previous prose endings of the play.[116] Undoubtedly, this was because Yeats had come to realize that, by the obsequious gesture of humbling himself to the Fool, the Wise Man unconsciously was expressing Yeats's own submission to the rationalistic, materialistic, prosaic realities of the modern world.

The point is that by 1914, after his bitter experience in search of an audience at the early Abbey Theatre, Yeats had determined that those realities were ones to which he would never again submit.

116. *Plays in Prose and Verse*, p. 422.

Yeats the Theatre Manager and the Search for an Audience

FROM DISEMBODIED BEAUTY TO THE PASSION OF REALITY

In 1890 Yeats advised Katharine Tynan not to endow a religious biography she was writing with too much "piety". "Remember," he said, "it is the stains of good earth colour that make man differ from man and give interest to biography."[1] By 1899 Yeats had come to realize that he was guilty of a similar piety in both his life and art. Because of his lofty detachment from the fundamental realities of Irish life, Maud Gonne had rejected his dream of their marital union and an Irish audience had rejected his mystical vision of a Unity of Culture expressed through *The Countess Cathleen*.

With characteristic integrity Yeats took much of the blame upon himself for the dissolution of these two all-consuming dreams of his young manhood. He realized that, by espousing an "esoteric Irish literature for the few",[2] he had cut himself off from the "vigorous and simple men" who comprised his ideal Irish audience.[3] He further realized that by deliberately seeking for a remote, spiritual, and ideal art he had merely escaped into the world of abstract "super-refinement" that

1. Letter to Katharine Tynan (July 5, 1890), *Letters*, p. 155.
2. Letter to John O'Leary (May 30, 1897), *Letters*, p. 286.
3. *Essays and Introductions*, pp. 265-66.

ten years earlier he had decried in the work of the English aesthetes.[4] As he explained in a letter to George Russell, it was not that his earlier artistic and religious ideas were "untrue", but that he "mistook for a permanent phase of the world what was only a preparation. The close of the last century was full of a strange desire to get out of form, to get to some idea of disembodied beauty," he continued; "now it seems to me that the contrary impulse has come."[5]

In order to break out of the intellectual and aesthetic trap into which he had fallen, Yeats determined to reshape not only his art but himself as well. Thus, as we have seen, he deliberately sought to involve himself with a wider range of human activity. Once again, he renewed the dialectical process of attempting to discover his "anti-self" by expressing "the passion [of] reality".[6]

In this process toward fuller self-realization a continuing involvement with the theatre was of immense importance to Yeats. Drama was the principal means by which he attained "more manful energy, more of a cheerful acceptance of whatever arises out of the logic of events".[7] This, in turn, led Yeats to a new concept of the relationship between the theatre and an Irish audience. The hostile reception to *The Countess Cathleen* taught Yeats that the Irish people were generally "not educated enough to accept images more profound . . . than the schoolboy thoughts of Young Ireland".[8] If he were to win and hold the audience of patriotic working men and office clerks who had gathered in support of the Irish National Theatre Society, Yeats realized that he had to meet them on their own intellectual and cultural level. Plays such as *The Shadowy Waters*, though still "legitimate art", were rejected as "a kind that [was] . . . the worst sort possible for our theatre".[9] Yeats turned from a lyric and highly

4. *Letters to the New Island*, p. 146. Cf. *Essays and Introductions*, p. 201.
5. (May 14, 1903), *Letters*, p. 402. Cf. *Essays and Introductions*, pp. 271-72.
6. *Mythologies*, p. 331. Cf. Jeffares, *W. B. Yeats*, pp. 124-58; Ellmann, *Man and the Masks*, pp. 157-63.
7. Preface to *Poems 1899-1905*, p. xii.
8. *Autobiographies*, p. 494.
9. Letter to Frank Fay (January 20, 1904), *Letters*, p. 425.

symbolic dramatic form to the writing of prose plays "on public themes deliberately chosen—religion, humour, patriotism".[10]

Yeats began his quest for a greater dramaturgical realism by attempting to collaborate with George Moore in writing *Diarmuid and Grania*. This quest also led him to his collaborative endeavours with Lady Gregory. But with the arrival of John Millington Synge (1871-1909), Yeats's plans for his own development and for the development of the Irish dramatic movement as a whole underwent a drastic revision.

PAUL RUTTLEDGE, ANTI-SELF, AND SYNGE

Looking back on the development of the Irish dramatic movement, Yeats declared that the change that Synge brought about· was to make the movement "critical" and "combative".[11] In more personal terms, Synge showed him that it was no longer possible to write out of the life of the race but that it was necessary to "express the individual".[12] While all of this is true, a closer examination reveals that, to a great extent, Yeats himself anticipated in his own theory and practice much of what Synge brought to the dramatic movement. This is particularly evident in Yeats's play *Where There is Nothing*.

As a dramatic work *Where There is Nothing* is a failure. It was hurriedly written during the summer of 1902 in order to prevent George Moore from utilizing the plot. And this hurry is evident in almost every aspect of the play: awkward structure, banal language, and poor character definition. The play was never published among Yeats's *Collected Plays*, although it was later adapted by him and Lady Gregory as *The Unicorn from the Stars*. *Where There is Nothing* is none the less a fascinating and important work because of its theme, a hymn to joyous liberation from middle-class constraints, and its

10. Preface to *The Unicorn from the Stars and Other Plays* (1908), reprinted in *Variorum Plays*, p. 1295.
11. Ibid.
12. *Autobiographies*, p. 494.

central character, Paul Ruttledge, a reflection not only of
Yeats's own mind at the time but of what he found so
appealing in the mind and work of John Synge.[13]

Yeats anticipated the theme, the central character, and the
events of *Where There is Nothing* in several of the tales in
The Secret Rose. The very title of the play comes from a tale
of the same name in which a ragged beggar is taken into a
monastery and miraculously changes a young dullard into a
scholar. The beggar is then recognized by the monks as
Aengus, the pre-Christian Celtic God of Love, who has attained
sanctity and wisdom only by espousing poverty. In "The
Twisting of the Rope" (which was adapted by Douglas Hyde
from a scenario by Yeats into *Casadh an t-Sugain*), the
wandering poet Red Hanrahan all but succeeds in stealing a
comely girl away from her well-to-do home with songs of a
joyous life on the roads, until by a clever ruse he is led
outside and the door is locked to prevent him from returning.
"The Crucifixion of the Outcast" is, as we have seen, a tale of
a wandering glee-man who is crucified and stoned to death
for preaching religious freedom to the people.[14]

Where There is Nothing translates these images and plot
ideas into a more immediate context. Paul Ruttledge is an
upper-class Anglo-Irishman who has entered a monastery in
order to escape his stultifying background of wealth, easy
comforts, and social restraints (the latter represented by the
army, the local Horticultural Society, and the Masonic
Lodge). He scorns his social equals, saying: "They never had
a dangerous thought, never a dangerous thought." After five
years in the monastery he leaves in order to travel the roads
with a band of roistering tinkers. With the tinkers he finds at
last the abundant life he is seeking. A priest comes to
persuade Paul to return to respectable society and asks:
"What can you possibly gain by coming here? Are you going
to try and teach them?" Paul replies: "Oh! no, I am going to
learn from them."

In the end Paul is beaten to death by an angry mob of
townspeople, but not before he has led the tinkers in a revolt

13. Yeats described Paul Ruttledge as "a man like William Morris, who was too
 absorbed and busy to give much of himself to persons". He admired the
 same dedication in Synge. Vide an extract from a letter of Yeats to John Quinn
 quoted in *Variorum Plays*, p. 1167; *Essays and Introductions*, pp. 319,
 328-29.
14. Vide *Mythologies*, pp. 184-90, 225, 233, 147-56.

against the local minions of the religious, legal, and military establishment, set the countryside—including the monastery —dancing, and preached the revolutionary doctrine of "becoming King and priest in one's own house".[15]

Where There is Nothing was first published in a special supplement of *The United Irishman* on November 1, 1902. Yeats later declared that he did not consider producing the play in Dublin because of "religious reasons".[16] This is undoubtedly true. Throughout his career as a Director of the Abbey Theatre Yeats was exceedingly careful not to produce plays that would give overt religious offence,[17] and *Where There is Nothing* is, among other things, a blatant attack upon institutional religion. But there is probably another reason why *Where There is Nothing* was not considered for a Dublin production at the time. Just a few weeks before its publication John Synge brought to Coole two plays he had also written over the same summer, *Riders to the Sea* and *In the Shadow of the Glen*.[18]

One can imagine the excitement with which Yeats must have read *Riders to the Sea* and *In the Shadow of the Glen* during that early October of 1902. Of the two plays, he immediately preferred *In the Shadow of the Glen*,[19] and one can easily understand why. With its rough humour and, particularly, the vagabond spirit of the tramp who lures Nora away from the bondage of her loveless marriage to an old man, the play reflects the same joyous hymn to liberty as *Where There is Nothing.* Moreover, it expresses that theme with far more cogency and dramatic power than Yeats himself was at the time capable of doing.

The parallels may be carried still further. If, as Richard Ellmann asserts, Paul Ruttledge is "a kind of metamorphosis of Yeats's secret dreams"[20] —his anti-self, in fact—then one might argue that Synge was a living incarnation of those dreams. With his own rejection of conventional religion, the constraints of bourgeois society, and his joy in the life of the road,[21] the scenario of Synge's life might have been written

15. *Variorum Plays*, pp. 1072, 1097, 1127, 1133.
16. *Autobiographies*, p. 454.
17. Vide Ernest Blythe's reminiscence of Yeats in *The Yeats We Knew*, pp. 66-67.
18. Greene and Stephens, p. 136.
19. *Essays and Introductions*, p. 336.
20. Ellmann, *Man and the Masks*, p. 136.
21. Vide Greene and Stephens, pp. 13-26.

by Yeats himself. Indeed, in Synge's own determination to write out of "the fundamental realities of life"[22] he was the embodiment, even in literary terms, of the very anti-self that Yeats was seeking.

From his first reading of *In the Shadow of the Glen*, Yeats must have known that a bitter fight was in store if Synge's vision—his own vision, in fact—was to be accepted in Ireland. As we have seen in Chapter Five, Yeats was fully aware that the hostile responses to his early work were, to a large extent, due to the puritanical idea of Irish peasant life fostered by the Church and given popular embodiment in the poems and ballads of the Young Ireland tradition. Throughout the nineties Yeats's literary ideals were attacked by such adherents of that tradition as Sir Charles Gavan Duffy, who with Thomas Davis was one of the founders of *The Nation* (the journal that originally published the Young Ireland poets in the 1840s), and Dr. George Sigerson, the president of the Irish Literary Society and a minor translator of old Irish texts. In 1892 Duffy and Sigerson joined in denouncing Yeats's choice of books to be published under the auspices of the Irish Literary Society as representative of the modern literary movement in Ireland.[23] Duffy argued that it was necessary to "drive out the impure and atheistical but sensational literature borrowed from the French", replacing it with "stimulating stories of our own land which would celebrate the virtues for which our people were distinguished, purity, piety and simplicity".[24] In a similar vein, Sigerson declared that Irish writers must work "with earnest hearts and high ideals . . . in vindication of this old land which genius has made luminous".[25]

Yeats lost the battle of art-versus-Young-Ireland propaganda, both within the committee rooms of the Irish National Literary Society and, later, before the audience of the Irish Literary Theatre. But he was determined not to lose

22. Letter to Stephen MacKenna (January 28, 1904), quoted in Greene and Stephens, p. 158.

23. Vide Philip Marcus, *Yeats and the Beginnings of the Irish Renaissance* (Ithaca: Cornell University Press, 1970), pp. 81-103.

24. "Books for the Irish People", an address before the Irish Literary Society, London (June 1893), reprinted in *The Revival of Irish and Other Addresses* by Sir Charles Gavan Duffy, Dr. George Sigerson, and Douglas Hyde (London: T. Fisher Unwin, 1894), pp. 12-13.

25. "Irish Literature: Its Origin, Environment, and Influences", ibid., p. 114.

again, at least not before his own ideals were made public and Ireland had been forced—as he had forced himself—to face "the heroic discipline of the looking glass".[26] What Yeats could not fight for in his own name he could and would fight for in the name of Synge. Thus he planned a careful series of steps that led up to the first production of *In the Shadow of the Glen* in October 1903.

SINN FEIN IDEOLOGY VERSUS THE FREEDOM OF THE ARTIST

One of the principal reasons for Yeats's involvement with the Irish National Theatre Society was his realization that it placed him in direct touch with politics. The specific form of politics he had in mind was that which ultimately developed into the militantly nationalistic Sinn Fein movement under the leadership of Arthur Griffith. However, at the time when Yeats first sought to align his interests with those of Griffith and his followers, politics were less a paramount concern of their movement than a cultural kind of consciousness-raising. Yeats himself aided Griffith with the drafting of a program for the Cumann na Gaedheal, an organization founded in September 1900 by bringing together fourteen nationalist clubs with widely diversified interests. Among the general aims of the Cumann na Gaedheal were:

1. Cultivating a fraternal spirit among Irishmen.
2. Diffusing a knowledge of Ireland's resources and supporting Irish industries.
3. The study and teaching of Irish history, literature, language, music and art.
4. The assiduous cultivation and encouragement of Irish national games, pastimes and characteristics.
5. The discountenancing of everything tending towards the Anglicisation of Ireland.[27]

Interpreted liberally, there was little in this program that Yeats could not have supported.

Griffith himself was at first one of Yeats's most ardent champions in Ireland. In an early issue of *The United Irishman* he stated that it was unforgivable for any intelligent

26. *Essays and Introductions*, p. 270.
27. P. S. O'Hegarty, *Ireland Under the Union*, p. 639, quoted in Richard Percival Davis, "The Rise of Sinn Fein, 1891–1910" (M. Litt. thesis, Trinity College, Dublin, 1956), p. 16. Cf. MacBride, *A Servant of the Queen*, p. 307.

Irish man or woman not to have read Yeats, for he was "Irish literature and Irish belief, and Irish faith, hope and aspiration".[28] When *The Countess Cathleen* was performed, Griffith, at the time vehemently anti-clerical in sympathy, led a group of men from the Dublin Quays to the production, telling them to "applaud everything the Church would not like".[29] In January 1902 Griffith proposed Yeats as one of the directors of *The United Irishman*—a position Yeats wisely refused because he did not wish to be responsible for the paper's attitude towards the Irish Members of Parliament.[30]

Initially, Griffith was also an ardent supporter of the Irish National Theatre Society. In the summer of 1902 he was even elected one of its vice-presidents.[31] When Cumann na Gaedheal sponsored a revival of A.E.'s *Deirdre* and *Cathleen ni Houlihan* for the Samhain Festival held that August, Griffith enthusiastically declared: "This week has demonstrated that we have in Dublin Irish men and women far more capable of acting Irish plays than any foreigners." In expanding his remarks, however, Griffith displayed certain views on the function of art in society that were to have unfortunate consequences for the Irish dramatic movement:

We look to the Irish National Theatre primarily as a means of regenerating the country. The Theatre is a powerful agent in the building up of a nation. When it is in foreign and hostile hands, it is a deadly danger to the country. ... In the Ireland we foresee it will be an extremely dangerous thing to tell an Irishman that God made him unfit to be master in his own land.[32]

In effect, what Griffith did was commend the Irish National Theatre Society as a national organization and at the same time issue a public warning to Yeats and the members of the company that art must be subservient to nationalism. In Yeats's mind, this must have evoked memories of his bitter struggles with the likes of Gavan Duffy and Sigerson.

28. Quoted by Padraic Colum in *Arthur Griffith* (Dublin: Browne & Nolan Ltd., n.d.), p. 47.
29. *Autobiographies*, p. 416.
30. Letter to Lady Gregory (June 16, 1900), *Letters*, p. 376.
31. Padraic Colum, *The Road Round Ireland* (New York: Macmillan, 1926), p. 278.
32. *The United Irishman* (August 26, 1899), preserved in Henderson Press Cuttings, N.L.I. Ms. 1729, p. 156.

Now the narrowly nationalistic ideals of Young Ireland were being reinvoked by Griffith, who was a fervent admirer of Thomas Davis.[33] Yeats immediately realized that Griffith's philosophy would destroy his own idea of the Irish dramatic movement unless the situation were handled with utmost skill and diplomacy.

Yeats began to set his own plans into motion. His first problem lay with the membership and structure of the Irish National Theatre Society. For many of the members, the production of plays was viewed as simply another aspect of their political activities. This became an immediate problem when Lady Gregory's *Twenty Five* was rejected in September 1902 because it showed an emigrant returning to Ireland with one hundred pounds in his pocket, the objection being raised that such a large sum "might incite to emigration". After much haggling and Lady Gregory's agreement to reduce the amount to twenty pounds the members finally agreed to put the play into rehearsal.[34] Another skirmish within the company occurred over a propagandistic anti-British recruiting play by Padraic Colum entitled *The Saxon Shillin'*. In November 1902 *The Saxon Shillin'* won the first prize in a one-act-play contest sponsored by the Cumann na Gaedheal and was accepted for production by the Irish National Theatre Society. As originally written, the play ended with an Irish deserter from the British Army being shot by British soldiers for defending his father from eviction. When Willie Fay changed the ending so as to make it less melodramatic he incurred the wrath of Maud Gonne and Griffith. Yeats backed Fay's decision, causing Griffith's resignation from the Society.[35]

It was only by threatening to resign from the Society himself if a sentimental poetic drama by James Cousins were accepted for production that Yeats was able to force the

33. Vide Preface by Arthur Griffith to *Thomas Davis: The Thinker and Teacher. The Essence of His Writings in Prose and Poetry*, ed. Griffith (Dublin: Gill and Son, 1914).

34. Vide letter from Frank Fay to Yeats (September 26, 1902) quoted in Robinson, *Ireland's Abbey Theatre*, pp. 28-29; *Autobiographies*, p. 565.

35. Vide unpublished letter from W. G. Fay to Yeats (January 30, 1903), N.L.I. Ms. 13068; Colum, *Road Round Ireland*, p. 278. *The Saxon Shillin'* was published in *The United Irishman* (November 15, 1902).

creation of a Reading Committee in February 1903. This gave him a measure of control over the repertoire.[36] But until the establishment of a Limited Company in the fall of 1905, with the artistic control absolutely in the hands of Yeats, Synge, and Lady Gregory, the "preposterous" democratic method of approving plays and even roles by a three-quarters vote of the membership continued to allow politics to interfere with art. At one meeting held in March 1904, Lady Gregory was advised that *The Rising of the Moon* would not be produced unless the role of the policeman were rewritten to show him in a less favourable light.[37]

Yeats carried his ideas to the general public by means of a series of articles and lectures. His campaign opened with an article entitled "The Freedom of the Theatre" which was published in *The United Irishman* of November 1, 1902, to coincide with the publication of *Where There is Nothing*. Yeats began by noting that in *Where There is Nothing* he had touched on so many controversial issues, particularly religious issues, that he felt "a little anxious". He recalled that *The Land of Heart's Desire* and *The Countess Cathleen* had also aroused religious controversy. Yeats then attempted to answer his critics by explaining his method of creation—a method he equated with that of Shakespeare, Wagner, and Ibsen. "Drama," he said, "is a picture of the soul in man, and not of his exterior life. . . . Drama describes the adventures of men's souls rushing through the thoughts that are most interesting to the dramatist, and therefore probably most interesting to his time."

Yeats then attempted to relate his work specifically to the *Zeitgeist* of Ireland. The Elizabethan age had been interested in "questions of policy and kingcraft" and these questions were naturally reflected in the work of Shakespeare and his contemporaries. "Ireland," said Yeats, "was preeminently interested in religion and in morals and in personal emotion." Because of this national characteristic Yeats declared:

36. Correspondence between Frederick Ryan, Secretary of the Irish National Theatre Society, and Yeats, in the possession of Michael Yeats.

37. Reading Committee notes, preserved in George Roberts Collection, N.L.I. Mss. 5651-2. Cf. *Autobiographies*, p. 465.

I who have been bred and born here, can hardly write at all unless I write about religious ideas. In the "Land of Heart's Desire" a dreamy girl prefers her own dreams and a wandering voice of the night to the priest and the crucifix. In "The Hour Glass" which is soon to be acted, it is the proud spirit that has seemed folly to the wise. And in "The Countess Cathleen" the commandment of mercy is followed to the forgetting of all else. In "The Shadowy Waters" human love, and in "Cathleen ni Houlihan" love of country, through their mere intensity become a cry that calls beyond the limits of the world. In "Where There is Nothing" Paul, because he is a seeker after God, desires the destruction of all things.

The article concluded:

So far as I am a dramatist, so far as I have made these people alive, I watch them with wonder and pity and do not even ask myself were they right to go upon that journey.[38]

Yeats, of course, was not merely writing in defence of artistic freedom but proclaiming himself a product of and, in a sense, the spokesman for the religious sensibility of Ireland. For a Protestant—particularly a Protestant with his well-known mystical ideas—to make such claims would be dangerous enough in Ireland today. In 1902 it was reckless to the point of being foolhardy. Yeats was immediately attacked in *The United Irishman* by Thomas Kettle, a highly intelligent, politically minded, young Catholic economist who, incidentally, had been one of the Royal University students protesting the first production of *The Countess Cathleen*. Kettle argued that *The Countess Cathleen* was "artistically bad" because in order to create a background against which "the white soul of Cathleen [might] shine", Yeats had pictured the peasantry as "universally faithless". The Irish Catholic was "a type that [had] a determinate historical value", and the struggle to preserve Catholicism in Ireland had been so bitter and so recent that it still carried "intense emotional significance" for Irishmen. "It will be well for Mr. Yeats when he comes out of his rationalistic whimsies, and understands the sanctity and compulsion with

38. Henderson Press Cuttings, p. 211.

which the Catholic religion has established itself in the imagination of Ireland," Kettle declared. "The last veil will have fallen which now shuts from his dream her inmost passionate heart."[39]

Yeats deliberately answered this and other far less cogent attacks on his claims to be a religious writer with his morality play, *The Hour-Glass*, first produced by the Irish National Theatre Society on March 14, 1903.[40] In a lecture on "The Reform of the Theatre", delivered before the performance and printed in *The United Irishman* of April 4, 1903, he pleaded for freedom from religious and political censorship. Noting it had been said in Dublin that he did not care whether a play was moral or immoral Yeats declared: "Every generation of men of letters has been called immoral by the pulpit or the newspaper, and it has been precisely when that generation was illuminating some obscure corner of the conscience that the cry against it has been most confident." He called upon the best in the tradition of the Irish people to help him create a theatre, which would be "a place of intellectual excitement, a place where the mind is liberated, as it was liberated by the theatres of Greece and England and France at certain great moments of their history, and as it is being liberated in Scandinavia today. If we are to do this," he continued, "we must learn that beauty and truth are always justified of themselves, and that their creation is a greater service to our country than any writing that compromises either in the seeming service of a cause." Catholic Ireland in particular was called upon to "remember the gracious tolerance of the Church when all nations were its children"— especially since her "new puritanism [was] but an English cuckoo".[41]

Yeats's words fell upon deaf ears. He was making his plea to a people whose intellectual development had been restricted by a narrow educational system and by exceptionally conservative forms of both Protestantism and Catholi-

39. *The United Irishman* (November 22, 1902), Henderson Press Cuttings, pp. 224-25.
40. Vide letter to Lady Gregory (April 10, 1902), *Letters*, p. 370.
41. Henderson Press Cuttings, p. 177.

cism.[42] Above all, he was speaking in the face of a political movement whose attitudes were already beginning to harden into firm policies with a rigidly moralistic tone.

In May 1903, motivated by the impending visit of Edward VII to Ireland, Arthur Griffith called for the creation of a National Council to bring together Home Rulers or Nationalists who "believe in the absolute independence of the country, for one purpose on which both can agree—the stamping out of toadyism and flunkeyism in this land".[43] In August 1903 that National Council, which led to the official formation of the Sinn Fein Party and the adoption of a separatist policy in November 1905, became a reality. Membership was restricted to those "opposed to the British Government in Ireland"; objectives were defined as generally "to aid every movement calculated to be of benefit to the Irish nation, and particularly, to use every means whereby the popularly elected bodies shall be composed of Irish nationalists."[44]

Within the Irish National Theatre Society Yeats was aided in his battle by the Fays, who were as determined as himself that neither political nor religious censorship should interfere with the artistic development of the company.[45] The phenomenal success of the company's first trip to London in May 1903 helped, for a time, to persuade some of the members to accept the combined leadership of the Fays and Yeats. But, ironically, this very success brought the Irish National Theatre Society into an open conflict with the doctrine of separatist nationalism now being propounded by Griffith.[46]

Yeats decided to take a much firmer stand against the extreme nationalists. Three new factors influenced this deci-

42. Vide L. Paul Dubois, *Contemporary Ireland* (Dublin: Maunsel & Co. 1908), p. 473; Arland Ussher, *The Face and Mind of Ireland* (New York: Devin-Adair Co., 1950), p. 63.

43. *The United Irishman* (May 30, 1903), quoted in Davis, "Sinn Fein", p. 23.

44. *The United Irishman* (August 8, 1903), ibid., p. 30. Cf. Nicholas Mansergh, *The Irish Question: 1840-1921* (London: Allen & Unwin, 1965), pp. 221-44.

45. Vide unpublished letter from W. G. Fay to Yeats (January 30, 1903), N.L.I. Ms. 13068.

46. Interview with Padraic Colum (February 20, 1966).

sion. The first of these was the marriage of Maud Gonne to Major John MacBride on February 21, 1903. During the nineties, Yeats's love of Maud Gonne had led him against his better judgment to become involved in revolutionary politics. Undoubtedly because he hoped to marry her eventually, Yeats had restrained himself from expressing his true feelings about the narrowness inherent in the hard-line nationalist doctrine. Now that there was no longer hope of marriage, his raging bitterness at the political "fanaticism and hate" that had stolen his love knew no bounds.[47]

The second factor was the imminent possibility of financial support from Miss Horniman. From the outset of the Irish dramatic movement, Yeats believed that some form of subsidy was going to be necessary if his lofty ideals were to be realized. Now subsidy became an absolute essential in the face of increasing political interference. It is certain that Irish politics formed a considerable portion of the discussions that Yeats and Miss Horniman held at this time on the future of the Irish National Theatre Society.[48]

The third factor was, of course, the advent of Synge. For almost a year after receiving Synge's plays Yeats bided his time, arousing the curiosity of the members of the Irish National Theatre Society with hints of an "Avatar" to come —a dramatist who, through his genius, would make all their fame.[49] In January 1903 he and Lady Gregory first read Synge to their London literary acquaintances John Masefield, G. K. Chesterton, Arthur Symons, and others.[50] Their response was most encouraging and later that spring Synge himself read *Riders to the Sea* to the company. Yeats apparently did not wish to leave any doubts that this was indeed the "Avatar" he had promised. According to George Moore, when the reading was over, he cried, "Sophocles!" across the table; and fearing it was not impressive enough, said "No, Aeschylus!"[51]

It was not until June, however, following the Irish National Theatre Society's trip to London, that the company

47. Vide *Man and the Masks*, pp. 157-63.
48. Vide Flannery, *Annie Horniman*, pp. 7-9.
49. Reminiscence of Padraic Colum, *The Yeats We Knew*, p. 19.
50. Greene and Stephens, p. 138.
51. Moore, *Hail and Farewell, Vale*, p. 135.

was exposed to *In the Shadow of the Glen*. Lady Gregory, who was by now one of the leaders of the Society, read the play to the assembled membership in her rooms at the Nassau Hotel. The play was accepted for production, but not without general grumbling that it was untrue to the "idealistic" spirit of the movement, and the resignation at this "insult to Irish womanhood" of the company's best actor Dudley Digges, his wife-to-be Maire Quinn, and, not surprisingly, Maud Gonne.[52]

Synge was introduced to the Dublin public as "a new writer and a creation of our movement" when *Riders to the Sea* was published in the September 1903 issue of *Samhain*.[53] In the same issue Yeats reprinted "The Reform of the Theatre" prefaced by a number of remarks clearly addressed to Griffith and his followers. Noting the heightened political climate in Ireland, Yeats declared that it was inevitable, even desirable, that this should lead to a greater number of political plays over the next three or four years. The danger lay in allowing "mere propaganda" to overshadow true dramatic values. "Though one welcomes every kind of vigorous life, I am," he said, "most interested in The Irish National Theatre Society which has no propaganda but that of good art." Yeats went on to attack criticism of the Irish National Theatre Society's London trip as an example of the kind of propaganda that he was bound to oppose: "a vested interest disguised as an intellectual conviction". Finally, he declared that the Irish National Theatre Society must be tolerant enough to find an audience among all those who love the arts, "whether among Unionists or among the Patriotic Societies". This, in practical terms, meant the acceptance of "every kind of patronage", provided there were no strings attached. Obviously alluding to the imminent subsidy of Miss Horniman, he proclaimed: "if a mad king, a king so mad that he loved the arts and their freedom should offer us uncondi-

52. Vide Greene and Stephens, p. 141; Nic Shiubhlaigh and Kenny, pp. 41-42; Cousins, p. 93. Padraic Colum notes that by persuading the members to hold meetings in her apartment Lady Gregory changed the focus of the Society from nationalism to art and from that time on became herself a dominant influence in the movement. "Early Days of the Irish Theatre", Part II, *The Dublin Magazine* (January-March 1950), p. 23.

53. *Explorations*, p. 106, pp. 100-101, 105.

tional millions, I, at any rate would give my voice for accepting them."[54]

But these remarks were only the prelude to the real confrontation. That took place a few weeks later with the first production of *In the Shadow of the Glen* preceded by Yeats's own drama on the theme of artistic freedom, *The King's Threshold*. Clearly Yeats had determined that it was time to take his fight into the theatrical arena itself.

THE RATIONALE OF THE REACTION TO SYNGE

The story of the reaction to *In the Shadow of the Glen* is well known, especially through the detailed account given in the biography of Synge by David Greene and Edward Stephens.[55] Arthur Griffith naturally led the attack, claiming that the play was not Irish at all but based upon the pagan libel of womankind, the "Widow of Ephesus" and drawing its inspiration from "the decadent cynicism that passes current in the Latin *Quartier* and the London salon". He was supported in the pages of *The United Irishman* by Maud Gonne, who with Dudley Digges conspicuously walked out of the theatre on the opening night, and by the labour leader James Connolly, who was to give his life in the Easter Rising. Connolly argued directly out of the tradition of Young Ireland that since a spirit of nationalism did not yet exist in Ireland, a National Theatre ought not to lend its support to "the widespread spirit of decadence". Instead, its primary function must be that "of restoring our national pride".[56]

In succeeding issues of *The United Irishman* the controversy raged, with Griffith and Yeats exchanging blow for blow. The climax was reached when Yeats declared:

Literature is always personal, always one man's vision of the world, one man's experience, and it can only be popular when we are ready to welcome the visions of others. . . . I am a Nationalist, and certain of my intimate friends have made Irish politics the business of their lives. . . . But if some external necessity had forced me to write nothing but drama with an obviously patriotic intention instead of letting my work shape itself under the casual impulse of dreams and daily thoughts I

54. Ibid.
55. Greene and Stephens, pp. 150-56.
56. Ibid., p. 154.

would have lost, in a short time, the power to write movingly upon any theme. I could have aroused opinion, but could not have touched the heart.

Yeats concluded with a challenge:

I would sooner our theatre failed through the indifference or hostility of our audiences than gained an immense popularity by any loss of freedom.[57]

To this Griffith replied:

He who is prepared to give up a good ideal for his country is no doubt a good man, but unless he is prepared to give up all he is not a good Nationalist.[58]

Thus the battle lines between nationalism and art were irrevocably drawn.

It could reasonably be argued that, from a political standpoint, Griffith and his Sinn Fein supporters were justified in their intransigent opposition to Yeats's ideal. Ireland had suffered greatly under English domination, but much of that suffering, particularly from an economic standpoint, was caused by the failure of Irishmen themselves to act together with a common sense of responsibility, firmness, and dignity. Griffith saw this clearly, as did visionary Unionist leaders such as Horace Plunkett and Lord Dunraven. Of course, Yeats himself saw it. All sought to create programs based upon a proud spirit of nationalism that would motivate practical action for the good of Ireland as a whole. Plunkett's and Dunraven's programs called for increased Irish self-reliance in the areas of agricultural co-operation and the development of local industries.[59] Griffith's program stressed a similar economic self-reliance, but he carried his argument into the political realm by calling for the voluntary withdrawal of Irish representation at Westminster until the Act of Union was dissolved and the Irish Parliament reinstituted under a

57. (October 10, 1903), Henderson Press Cuttings, p. 305.
58. *The United Irishman* (October 17, 1903), Henderson Press Cuttings, p. 307.
59. Vide The Right Honourable Earl of Dunraven, *The Outlook in Ireland* (Dublin: Hodges, Figgis Co., 1906), pp. 150, 225, 246; The Right Honourable Sir Horace Plunkett, *Ireland in the New Century* (London: Murray, 1905), pp. 36, 121.

dual monarchy. Griffith's policies had the support of the militant nationalists because they seemed to promise ultimate independence from English rule—that elusive grail for which generations of Irishmen had given their lives. Griffith was not a republican; nor did he believe in violent revolution. But for his highly demanding and idealistic program (essentially a program of passive resistance) to be effective he had need of the unswerving support of the great majority of the Irish people. As in all populist programs this meant that subtle distinctions had to be boiled down into convenient and easily assimilated slogans. Nothing could be more convenient than presenting the case as a struggle between "small moral nation versus decadent empire, Holy Ireland versus England".[60]

The success of Griffith's endeavour is attested by the ultimate triumph of Sinn Fein's doctrine of separatism: the creation of the Irish Free State in 1921, with Griffith himself as its first President. Ironically, this was only accomplished at the cost of a bloody revolution—something that Griffith's policies directly encouraged but which he had desperately striven to avert. To this day, no arguments can persuade militant Republicans that by signing the treaty with England that ended the bloodshed Griffith was not a traitor to the holy cause of Republicanism. Thus Griffith himself became a victim of the very slogans and simple-minded ideologies that he had attacked Yeats for opposing.

One should not think, however, that the opposition to Synge and his plays came exclusively from Griffith and the adherents of Sinn Fein. Journals such as *The Irish Independent*, with a readership made up of the Catholic middle class, and *The Irish Times*, which appealed mainly to the Protestant Ascendancy and upper middle class, violently objected to the "unwholesome" and "excessively distasteful" aspects of *In the Shadow of the Glen*.[61] One can understand such reactions, for *In the Shadow of the Glen* is one of the least satisfactory of Synge's plays. Essentially, it is a problem play with a solution to the problem that could not hope to be acceptable in either Catholic or Protestant Ireland. Even interpreted in the light of today's feminist ideology one is

60. Thompson, *The Imagination of an Insurrection*, pp. 58-59, 65-66.
61. *Irish Independent* (October 8, 1903), *The Irish Times* (October 9, 1903), quoted in Greene and Stephens, pp. 150-53.

not persuaded by either the emotional or rational logic of the play that Nora, after leaving her husband, will find freedom with a tramp upon the open road. Impossible as it may seem, there is also some justification for Griffith's assertion that no such situation could possibly occur in Ireland because Irish women were "the most virtuous in the world".[62] Sociologists such as Conrad Arensberg have noted that, bawdy though the language of the Irish peasant may be, sexual liberty is almost solely the province of his tongue.[63] It is little wonder, then, that moral indignation was aroused—particularly when, just a few days before its first performance, *In the Shadow of the Glen* was described by John Butler Yeats in *The United Irishman* as an attack on "our Irish institution, the loveless marriage".[64]

In every respect, then, it was unfortunate that the play of Synge's upon which Yeats took his stand for the freedom of the artist was *In the Shadow of the Glen*. Synge later far more successfully dramatized the theme of individuality triumphing over social constraints in *The Well of the Saints*, *The Tinker's Wedding*, and his masterpiece, *The Playboy of the Western World*. None of these plays was given a fair hearing in Dublin. (*The Tinker's Wedding* was actually given its first performance in London for fear of offending Irish religious sensibilities.) The combination of Synge's mocking satire, symbolic realism, and earthy dialogue was simply too powerful for audiences that, like those of Ibsen in London and Jarry in Paris, were used to more pallid dramatic fare. By 1907 opposition to Synge had so hardened in Dublin that Griffith had no trouble leading an organized attempt to drive *The Playboy of the Western World* from the stage of the Abbey Theatre.[65]

Dublin's hostility towards Synge was only intensified by the vehemence with which Yeats defended him. After intemperate outbursts such as Yeats's attack on the "obscurantism

62. *The United Irishman* (October 24, 1903), quoted in Greene and Stephens, p. 154.

63. Conrad M. Arensberg and Solon T. Kimball, *Family and Community in Ireland* (Cambridge: Harvard University Press, 1940), pp. 210-11.

64. *The United Irishman* (October 31, 1903), quoted in Greene and Stephens, p. 155.

65. Vide Greene and Stephens, pp. 184-85.

of ignorant journalists, politicians and priests" during the height of the controversy over *In the Shadow of the Glen*,[66] it is little wonder that Synge and Lady Gregory tried to dissuade him from continuing his open warfare with "the clubs" who supported the nationalist movement.[67]

Yeats disregarded these warnings. *The Playboy* riots spurred him to fight as he had never fought before. Synge's play was not only kept upon the boards but extended in its run in defiance of those who would delimit, denigrate, and ultimately destroy the aristocratic qualities of genius. At an open forum held to debate the merits of the play Yeats shouted in the face of a howling mob:

We have put this play before you to be heard and to be judged, as every play should be heard and judged. Every man has a right to hear it and condemn it as he pleases, but no man has a right to interfere with another man hearing a play and judging for himself. The country that condescends either to bully or to be bullied soon ceases to have any fine qualities.[68]

Yeats thus secured a hearing for Synge and ultimately a recognition in Ireland (and elsewhere) of Synge's genius. But his victory was a costly one, for it all but guaranteed the loss of the very audience that might have supported his own plays.

YEATS'S SEARCH FOR AN AUDIENCE

Besides alienating him from the political nationalists whom he had hoped would provide the basic support for the Irish National Theatre, Yeats's defence of Synge hurt him in several other ways. Chief among these was that it increased the basic distrust that Catholics had always felt in Yeats as the leader of the Irish literary and dramatic movement. Thomas Kettle expressed the views of his generation when he declared in 1907: "Ireland awaits her Goethe—but in Ireland he must not be a Pagan."[69] Joseph Holloway expressed the

66. "The Irish National Theatre and Three Sorts of Ignorance", *The United Irishman* (October 24, 1903), Henderson Press Cuttings, p. 316. Yeats was equally injudicious in an article entitled "The Theatre, The Pulpit, and The Newspaper", *The United Irishman* (October 17, 1903), ibid., p. 309.
67. Vide Letter to George ("A.E.") Russell (January 8, 1906), *Letters*, p. 466.
68. Vide Quoted in Greene and Stephens, p. 245.
69. Thomas Kettle, *The Day's Burden* (Dublin: Browne & Nolan Ltd., 1937), p. xii.

views of the ordinary man in the street when he described Synge as "the evil genius of the Abbey Theatre and Yeats his able lieutenant".[70] When, in 1912, Yeats made a final effort to re-create his original idea of a theatre rooted in the religious life of Ireland by producing a series of medieval mystery and morality plays, he asked Edward Martyn whether the priests would not lend their support if the Abbey Second Company continued in this direction. "No," replied Martyn, "they are too suspicious. They think that you are not only anti-Catholic but anti-Christian."[71]

Another of Yeats's problems was related to the changing social and economic realities of Ireland. Yeats dreamed of an Ireland that, like Morris's Utopia, would "always be an agricultural country . . . a country where if there are few rich, there shall be nobody very poor".[72] It was this dream that, in part, motivated Yeats's concept of an Irish Unity of Culture expressed through a drama rooted in the peasant life and culture of the west of Ireland. The Land Act of 1903 arranged for government loans to enable the peasants to purchase their own land. Thus, during the formative years of the Irish dramatic movement the very peasants who provided one of its main inspirations were in the process of changing their social and economic status from tenant farmers to small landowners. Furthermore, their sons and daughters were beginning to leave a rural environment for a more prosperous way of life in the towns and cities of England, the United States, and Ireland itself.[73]

One result of the new economic status of the peasant was the gradual decline of what Conrad Arensberg has termed the "romantic human types"—the itinerant tailors, weavers, carpenters, shoemakers, and smiths who, like the ballad singers and poets of old, were accepted everywhere in Ireland, their services exchanged for food and lodging. Yeats, Synge, and Lady Gregory based many of their plays upon the colourful personalities of these free wanderers of the road.

70. *Impressions of a Dublin Playgoer* (January 26, 1907), N.L.I. Ms. 1805, p. 63.

71. Hone, *W. B. Yeats*, p. 257.

72. Lecture delivered in New York (1904), quoted in Ellmann, *Man and the Masks*, p. 116. Cf. *Autobiographies*, p. 190, where Yeats describes himself as being in favour of "a law-made balance among trade and occupations".

73. Vide Dubois, *Contemporary Ireland*, pp. 302-8. Cf. F. S. L. Lyons, *The Irish Parliamentary Party: 1890-1910* (London: Faber and Faber, 1951), pp. 29-38, 67.

Now they were considered nothing more than "landless men" with low status in the eyes of their neighbours. Yet another result of the social unheaval in Ireland was the breakdown of the system of bartering which had hitherto created a bond between town and country life. The move from the country to the town in the Gaelic-speaking districts involved the greatest disorientation of all, for it meant giving up language, culture, and a sense of community for an Anglicized, materialistic, lower-middle-class way of life.[74]

To all of these changes Yeats was firmly opposed, as were Lady Gregory and Synge. It was not that they failed to see the need for improving the living conditions of the peasantry. Lady Gregory and Yeats, for instance, aided Horace Plunkett in establishing the Irish Agricultural Society, while Synge wrote a social study of poverty in the Congested Districts of the west of Ireland that was both sympathetic and incisive.[75] But with their instinctive love of the peasantry and all that it represented in terms of the ancient traditions of Ireland, Yeats, Synge, and Lady Gregory believed that the material development of country life must not be accomplished at the cost of destroying the natural culture of the people. What they feared most is probably best expressed in Synge's words: "The peasants spoil quickly because they are so simple."[76]

As Yeats continued to promote peasant drama at the early Abbey Theatre he encountered little but misunderstanding and opposition on all sides. Yeats particularly needed the support of his own peers, the Protestant Anglo-Irish, to realize his ideals. He called upon the Anglo-Irish to fight against "intolerance against ideas, against books, against European culture" and thus provide a leadership that would make Ireland "fruitful materially and intellectually".[77] He, of

74. Vide Conrad Arensburg, *The Irish Countryman* (Gloucester, Mass: Peter Smith, 1959), pp. 103-4, 167; Dubois, *Contemporary Ireland,* pp. 305-8.

75. Vide Margaret Digby, *Horace Plunkett: An Anglo-American Irishman* (Oxford: Basil Blackwell, 1949), p. 152; Greene and Stephens, p. 173.

76. Quoted by Maurice Bourgeois, *John Millington Synge, and the Irish Theatre* (London: Constable, 1913), p. 90.

77. "Home Rule and Religion", a lecture to a group of Irish Protestants, quoted in *The Irish Times* (January 25, 1913), p. 9, and reprinted in *A Review of English Literature* (July 1963), IV, 3, p. 23.

course, needed the wealth of Anglo-Ireland to maintain the Abbey Theatre.[78]

Unfortunately, Yeats did his cause with the Anglo-Irish no service by commencing his literary career in 1886 with an aggressive attack upon Edward Dowden, Professor of English at Trinity College, Dublin, for not lending his prestige and practical assistance to the Celtic Renaissance.[79] During the 1890s Yeats deliberately continued to antagonize Dowden and the "West British minority" in order to win the support of a nationalist audience.[80] In 1899, professors from Trinity College got a chance to hit back. They demonstrated their profound antipathy to the Celtic Renaissance and the emphasis on peasant culture in the nationalist movement when they mounted a massive attack on the Gaelic League proposal to institute compulsory Irish in the secondary schools of Ireland. Comments ranged from the statement by Dr. Atkinson, Professor of Sanscrit and of Romance Languages, that he did not wish to know about "the vulgar exploits of a dirty wretch who never washed his feet",[81] to the description of the Gaelic League by the Reverend Dr. John Pentland Mahaffy, Professor of Classics, as "a childish and factitious movement, invented by rebels who are trying to foment anti-British feelings". Mahaffy opined in an article written for English consumption in *The Nineteenth Century* that at best the "Celtic Craze" might help to preserve some of the "delightful peculiarities" of the Irish peasantry.[82]

It was only due to their personal friendship with Lady Gregory that Mahaffy and the Professor of History at Trinity College, William Hartpole Lecky, became guarantors of the

78. In a talk to open a campaign for an Abbey Theatre endowment fund Yeats declared that if the Abbey sold twenty more stalls seats per night there would be no need of such a fund. "At Home at the Abbey Theatre", *The Irish Times* (November 22, 1910), Henderson Press Cuttings, N.L.I. Ms. 1733, p. 302.
79. Marcus, *Yeats and the Beginning of the Irish Renaissance*, pp. 104-21.
80. *Autobiographies*, p. 237.
81. "The Irish Language and Irish Intermediate Certificate", evidence given to the Intermediate Education Commission, quoted in Gaelic League Pamphlet 14, N.L.I. Ir. 49162.
82. "The Recent Fuss About Irish Language", *The Nineteenth Century*, XLVI, cclxx (August 1899), pp. 215, 219. Cf. Dubois, *Contemporary Ireland*, pp. 412-19.

Irish Literary Theatre. As a member of parliament Lecky enabled the Theatre to receive a licence for performance by inserting a special clause in the Local Government Bill of 1899.[83] But in the spring of 1900 Lecky and Mahaffy withdrew their support when Yeats openly attacked the visit of Queen Victoria to Dublin.[84] Thus ended the only link of Trinity College with the Irish dramatic movement until a crowd of Trinity students were invited to the Abbey Theatre during the second week of *The Playboy* riots in order to counteract the Sinn Fein demonstrators. Displaying their bias to the full, in response to a patriotic Irish song, the students clambered onto the seats to sing the English national anthem.[85]

Throughout the early years of the dramatic movement, *The Irish Times*, that other bastion of Anglo-Irish political interests and culture, followed the lead of Trinity College by maintaining an attitude of condescending detachment towards the efforts of Yeats and his colleagues. A typical editorial, written in August 1908, announced that the dramatic movement was "very promising", although it had "not yet produced any really great play".[86] Two years later, in reply to a lecture by Yeats in which he attacked the growing materialism which was destroying the countryman's "delight in human nature",[87] another editorial proclaimed that Yeats had shown himself to be against all the "positive aspects of modern Ireland": "The Ireland which he sees in his visions would never create a theatre, or produce a literature. The really great poets have always kept in close touch with the hard facts of life."[88]

Perhaps second only to his disappointment in failing to win the support of the nationalists was Yeats's frustration in being unable to gain approval from the rising generation of Catholic intellectuals in Ireland. It has not always been emphasized sufficiently that, while the Irish literary and

83. *Our Irish Theatre*, pp. 18-19.
84. Hone, *W. B. Yeats*, p. 164.
85. *Joseph Holloway's Abbey Theatre*, pp. 83-84.
86. (August 31, 1908), Henderson Press Cuttings, N.L.I. Ms. 1731, p. 63.
87. Lecture to the Gaelic League, reported in the Dublin *Evening Telegraph* (March 4, 1910), Henderson Press Cuttings, Ms. 1731, p. 21.
88. (March 4, 1910), Henderson Press Cuttings, Ms. 1731, p. 25.

dramatic movement was mainly the creation of Protestants such as Sir Samuel Fergusson, Standish O'Grady, Douglas Hyde, George Russell, Lady Gregory, Synge, and Yeats, the period at the turn of the century was also one of intense intellectual and literary ferment in Catholic circles. George Moore and Edward Martyn were, of course, Catholics, but of an older generation. The younger generation produced such notable figures as Thomas Kettle, Francis Sheehy-Skeffington, Thomas MacDonagh, Padraic Pearse, Oliver St. John Gogarty, and, towering above them all, James Joyce. Without exception this extraordinary collection of poets, patriots, and social philosophers were united in rejecting the dominance of English culture. Without exception they supported the Irish literary and dramatic movement as a profound expression of Irish national ideals. Without exception, however, they parted from Yeats, Lady Gregory, and Synge, in rejecting the idea that peasant culture represented the best and most appropriate source and expression of those national ideals.

Their rejection of the idea of peasant culture is explained, in part, by the fact that as men whose own ancestors had risen mainly from the peasantry they saw little romance in Irish country life. Another reason is that as Catholics they looked to Europe for their intellectual heritage. Thomas Kettle expressed the feelings of many of his contemporaries when he wrote: "If this generation has for its first task the recovery of the old Ireland, it has for its second, the discovery of the new Europe."[89] James Joyce transformed these feelings into a literary conviction when he launched a fierce attack on the Irish Literary Theatre for giving in to the "rabblement" by performing a peasant play in Irish: "A nation which never advanced so far as a miracle play affords no literary model to the artist, and he must look abroad."[90]

Perhaps, in retrospect, the most fascinating personality of his generation was the Gaelic poet and educator Padraic

89. *The Day's Burden*, p. xii. Cf. Ulick O'Connor, *Oliver St. John Gogarty* (London: Jonathan Cape, 1964), p. 66; interviews with Dr. Constantin Curran (April 26, 1966) and Dr. Thomas MacGreevy (May 10 and August 3, 1966).
90. "The Day of the Rabblement" (October 1901), reprinted in *The Genius of the Irish Theatre*, p. 352.

Pearse. In 1897, as a youth of seventeen inspired by the mystical messianic sense of Irish nationalism that filled the air, Pearse declared to an audience of his fellow students at the Royal University:

The Gael is not like other men, the spade and the loom and the sword are not for him. But a destiny more glorious than that of Rome, more glorious than that of Britain awaits him: to become the saviour of idealism in modern intellectual and social life.[91]

Nine years later, as the editor of the Gaelic League Journal, *An Claidheamh Soluis* ("The Sword of Light"), Pearse took a more sober, almost Shavian stance in criticizing the idea of a literature based on folklore. "The folk tale is an echo of old mythologies," he declared; "literature is a deliberate criticism of life. ... This is the twentieth century; and no literature can take root in the twentieth century which is not of the twentieth century." Pearse went on to delineate some of the topics that he felt literature ought to deal with in Ireland: "The loves and hates and desires and doubts of modern men and women; the drama of the land war; the stress and poetry and comedy of the language movement; the drink evil; the increase of lunacy; the loveless marriage."[92]

When queried on the role of traditional Irish singing and music, Pearse tried to show the distinction between peasant culture and Irish culture as a whole: "The traditional style is not the Irish way of singing or declaiming but the *peasant* way; it is not and never has been the possession of the nation at large, but only of a class in the nation."[93]

Pearse showed himself little different from many of his Catholic fellow nationalists when a year later he condemned *The Playboy of the Western World* on moral grounds and Yeats for having promoted the play.[94] But when political bickering continued on into the next decade, dividing the

91. Quoted by David Thornley, "Padraic Pearse—the Evolution of a Revolutionary", *Leaders and Men of the Easter Rising*, ed. F.X. Martin (London: Methuen, 1967), pp. 155-56.

92. "About Literature", *An Claidheamh Soluis* (May 26, 1906), quoted in Frank P. O'Brien, "Poetry and Literary Attitudes in the Language Movement" (PH.D. thesis, Trinity College, Dublin, n.d.), p. 56.

93. "Tradition", *An Claidheamh Soluis* (June 9, 1906), ibid.

94. Vide *An Claidheamh Soluis* (February 9, 1907), quoted in Thompson, *The Imagination of an Insurrection*, p. 71.

nationalists and swerving Ireland from the idealistic destiny Pearse had prophesied in his youth, the rejection of Synge and Yeats began to trouble him. Trying to rouse the sleeping spirit of nationalism, Pearse wrote speeches, poems, and plays that, like those of Yeats, called for heroic self-sacrifice and service to Ireland. Like Yeats, he saw himself in the image of Cuchulain, despised, or worse, ignored by the mob whom he would uplift. In April 1916 he transformed himself into a living incarnation of that image when he led his followers on to the martyrdom of the Easter Rising that subsequently inspired the Irish Revolution.[95]

Pearse was by no means alone in calling for an Irish literature and drama based upon the immediate *Zeitgeist* of Ireland. Indeed, he was restrained by a comparison with the strident outcries of the influential Dublin journalist D. P. Moran. Through the columns of his weekly newspaper, *The Leader*, Moran poured forth a steady stream of vitriolic abuse on the heads of Yeats, Lady Gregory, and the members of the Irish National Theatre Society. Moran was the originator of the doctrine of "Irish Ireland", by which he promoted such causes as the Irish Industrial Revival, the Gaelic League, and the Gaelic Athletic Association. One of his principal ideas was that literature in English by Irishmen, however influenced by Gaelic themes, could never be other than English literature. Thus he attacked the "Celtic note" in Irish literature as being of no use to the Irish nation. "The real Ireland," he declared, "is not a Land of Heart's Desire."[96]

Addressing himself primarily to an upper-middle-class readership of civil servants, professional men, and white-collar workers, Moran, like Griffith, sought with all the fervour of a Victorian reformer to rouse in the Irish a sense of self-respect and initiative. Above all, he sought to rid Ireland of the "West Britain" mentality that aped English manners and customs. From the outset of the Irish dramatic movement he heaped scorn on the few followers of Yeats as a "grey and twilight race" who thought themselves part of a "consciously 'superior' class". In order to win a truly "popu-

95. Vide Thompson, *The Imagination of an Insurrection*, pp. 25, 121-22; Colum, *Road Round Ireland*, pp. 159-60; Yeats, *The Death of Cuchulain, Collected Plays*, pp. 704-5.

96. D. P. Moran, *The Philosophy of Irish Ireland* (Dublin: James Duffy & Co. 1905), pp. 27-28.

lar audience" he warned Yeats and Lady Gregory that they must put on "family drama". "I should like to insist upon the fact that even in post-heroic Ireland there are other classes beside the peasant class," he declared in 1907.[97]

Moran's discontent reached its highest point in July 1910, when, in response to a plea by Yeats for a public subscription to enable the Abbey Theatre to continue its work, he penned a savage diatribe entitled "The Shabby Theatre". Moran declared that the epithet "shabby" was appropriate "in the sense of something mean and unworthy, as applied to the National Theatre". He then proceeded to tell his readers the conditions under which the Abbey Theatre would be worthy of support:

If they really desire to obtain popular support they must tell less and write more (three or four playlets a night in two hours and a half are difficult to assimilate); they must endeavour to justify their assumption of the title National by a less purblind view of Irish life; they must give us more matter with less Art, or else the shabby theatre will wax shabbier and shabbier. . . .[98]

It was only because of Miss Horniman's generous subsidy that the early Abbey Theatre was able to survive in the tempestuous social and political climate of pre-Revolutionary Dublin. By the spring of 1906, however, poor public support made it evident that her subsidy was by itself not sufficient to enable the Abbey to continue on a professional basis. Hoping to stablize the Theatre's financial position, the Directors determined to bring the Irish plays and players on a regular series of tours to England.[99]

Realizing that the educated reading public in Ireland was too small to sustain the efforts of himself and his fellow writers, Yeats had foreseen the need for English financial and critical support from the very outset of the Irish literary

97. *The Leader* (October 12, 1907), Henderson Press Cuttings, N.L.I. Ms. 1730, p. 214.

98. *The Leader* (July 30, 1910), Henderson Press Cuttings, N.L.I. Ms. 1733, p. 223. The poet James Stephens echoed Moran's attack on Abbey peasant drama, "I am very sick of peasants declaring: The Abbey Theatre has given us three or four years of undiluted peasants. We are beginning to wear our peasants as consciously as we do our ancient greatness and our heroes." "Irish Idiosyncrasies", *Sinn Fein* (May 7, 1910), p. 3.

99. *Fays of the Abbey Theatre*, p. 178.

movement. This is the main reason why he so industriously promoted the Celtic Renaissance in England during the nineties. Perhaps to make the idea of a literature rooted in Irish peasant life more palatable to sophisticated English readers, he drew parallels between the budding movement in Ireland and the English romantic movement, even claiming that a still living tradition of peasant culture in the Gaelic-speaking West of Ireland gave Irish writers an advantage over Blake, Shelley, and Morris.[100]

After the Irish National Theatre Society was established Yeats redoubled his promotional efforts in England. He made a particular point of bringing the work of Synge, Lady Gregory, and the other peasant dramatists of the movement to the notice of the leading English critics for, again, he realized that this was the only way in which their plays would receive the serious and objective reviews they deserved.[101]

Yeats's skill in public relations was rewarded by the enthusiastic response of English critics and audiences to the Irish peasant plays. While even Synge's *Riders to the Sea* was first greeted with unanimous hostility by Irish reviewers, when performed in England in March 1904 it was hailed by critics such as Beerbohm and Archer as a masterpiece.[102]The same pattern was repeated with *The Playboy of the Western World* and other works such as Lady Gregory's subtle political satire, *The Image,* and George Fitzmaurice's touching play on the frustrated dreams of a craftsman-artist, *The Pie-Dish.* None of these plays received sympathetic hearings until they were performed in England.[103] (Interestingly enough, critical responses were totally reversed for plays such as Lady Gregory's blatant patriotic allegory, *Dervorgilla.* On the first production of *Dervorgilla* in November 1907, *The Leader*

100. *Essays and Introductions,* pp. 95, 116, 185-86. Cf. Derek Stanford, *Poets of the Nineties,* p. 8.

101. Vide *Letters,* pp. 172, 382, 388, 394; Hone, *W. B. Yeats,* pp. 221-22.

102. Greene and Stephens, pp. 164, 168.

103. Vide Greene and Stephens, pp. 270-73; Howard K. Slaughter, *George Fitzmaurice and His Enchanted Land,* pp. 23-24; reviews of November 12, 1906, in *The Irish Times, The Irish Independent, The Daily Express,* and *The Freeman's Journal,* all condemning *The Image.* In contrast, a review in *The Manchester Guardian* of February 24, 1911, hails it as "an ecstatic leap in Lady Gregory's art". Henderson Press Cuttings, N.L.I. Ms. 1734, p. 59.

pronounced it to be "the best play we have yet seen at the Abbey". Two years later it was dismissed by a London reviewer as "tiresome to one not saturated with the movement".)[104]

Towards the end of the decade, however, English enthusiasm for the Abbey peasant plays began to wane. The main reason for this was the revolt against romanticism that by 1908 had begun to make its way felt in London literary circles. To a younger generation of realistic critics and writers such as T. E. Hulme, T. S. Eliot, and Ezra Pound, the ideals of Yeats and his Irish colleagues seemed irrelevant and *passé*.[105] The "certain wildness" that, as Synge once noted, made his tramp characters romantically appealing to English audiences[106] no longer evoked the same responses.

Just about the same time, a new school of peasant dramatists appeared at the Abbey Theatre. Taking Ibsen as their model, Lennox Robinson, Norreys Connell, R. J. Ray, and T. C. Murray deliberately sought to write out of the harsher realities of Irish country life. Not surprisingly, in Ireland their work was violently attacked. In England, however, the subject matter of their plays was considered simply too parochial to be of general interest. By 1910, the Abbey school of peasant dramas was a source of mockery to some London reviewers, simply a bore to others.[107] A new form of stage Irishman began to appear on the English stage, based, ironi-

104. *The Leader* (November 9, 1907), Henderson Press Cuttings, N.L.I. Ms. 1730, p. 230; *Pall Mall Gazette* (June 8, 1909), Henderson Press Cuttings, N.L.I. Ms. 1732, p. 103.

105. Richard Ellmann, *Eminent Domain*, pp. 61-63.

106. *In Wicklow, Collected Works* (Dublin: Maunsell and Co., 1913), Vol. IV, pp. 11-12.

107. William Archer declared in a review of Padraic Colum's study of life in an Irish workhouse, *Thomas Muskerry*: "One wishes that the Irish dramatists would once in a while look at the brighter side of things, which surely must exist somewhere." The same year in a review of Synge's *Deirdre of the Sorrows* playwright/critic Ashley Dukes parodied the Irish dialect and stated that he had never seen a play of the "Abbey school" in more than one act that "could be said to justify its existence as a work of art". Cf. *The Nation* (June 1910), *The Illustrated and Sporting News* (June 18, 1910), *The New Age* (June 16, 1910), Henderson Press Cuttings, N.L.I. Ms. 1732, pp. 178, 46-47, 141.

cally, upon the very dialects and characters employed in the Abbey plays themselves.[108]

As early as 1905 Yeats had foreseen and tried to prevent these reactions to Irish peasant drama both within and without Ireland. In April of that year the Abbey Theatre produced William Boyle's *The Building Fund*, a crude satire on peasant miserliness. This was followed in June by Padraic Colum's *The Land*, a study of the break-up of traditional peasant life. Both plays received critical acclaim in Dublin with *The Building Fund* becoming the first popular box-office success of the early dramatic movement. Writing in *Samhain* Number Five (November 1905), however, Yeats drew a clear distinction between the peasant plays of Lady Gregory and Synge and those written by Boyle and Colum.

The plays of Lady Gregory and Synge were universal in appeal because the authors had expressed themselves through the imaginative life of the Gaelic-speaking peasantry in the West of Ireland. Colum and Boyle, on the other hand, wrote of the actual life of the English-speaking peasants in the East and Midlands. If their plays had more immediate popular appeal this was because the speech of their characters showed "the influence of the newspaper and the National schools. The people they write of are not the true folk," Yeats proclaimed. "They are the peasant as he is being transformed by modern life, and for that reason the men of the town may find it easier to understand them."[109]

Yeats's analysis of the situation was, as usual, deadly in its accuracy. He reacted with particular vehemence against Boyle because the superficiality of his satire enabled a Dublin audience to feel superior to country life as they saw it depicted on the stage of the Abbey Theatre. But it was only for a limited time that Yeats could continue to hold out against the demands of that audience. In 1907 Miss Horn-

108. In 1915 the Liverpool Repertory Theatre mounted a parody of an Abbey peasant play in which an old Irish woman rocked herself beside a cooking pot, chanting "All Hail, Thane of Cawdor, Ancestor of Harry Lauder". Grace Wyndham Goldie, *The Liverpool Repertory Theatre, 1911-1934* (London: University of London Press, Hodder & Stoughton Ltd., 1935), p. 105.

109. *Explorations*, pp. 183-84.

iman made it clear that her subsidy would not continue past 1910. By the 1908-09 season, poor box-office receipts showed Yeats that, despite his best intentions, if the Abbey Theatre were to pay its way it would be necessary to produce more deliberately popular work. Boyle had withdrawn his plays from the Abbey Theatre in protest against the production of *The Playboy of the Western World,* but in January 1909 Yeats contacted Joseph Holloway in order to arrange a lifting of the ban.[110] Not only were the plays of Boyle revived, but two slick comedies depicting middle-class Dublin life were staged which five years previously would not have even been considered for production. At last, however, *The Irish Times* was given something to cheer about. In an editorial dated August 22, 1910, it was stated that W. F. Casey's *The Suburban Groove* and *The Man Who Missed the Tide* were "of greater educational value than whole Iliads of prehistoric Irish myth, or entire worlds of Irish fancy. In these plays, and in all the best plays of the Abbey Theatre, we may see ourselves with nothing extenuated or aught set down in malice."[111]

Thus, from confronting the audience with the plays of Synge the dramatic movement turned to placating them with superficial vignettes of Irish middle-class and country life. From this time onward the Abbey Theatre acquired a spiritually Anglicized audience that, as Brian Inglis remarks, contributed an element of "look-at-the-Irish, aren't they a scream!" to the performances.[112] It was not until the mid-1920s in the aftermath of the Civil War that followed the establishment of the Irish Free State that the Abbey audience was again confronted with starkly truthful images of Irish life. This occurred with the presentation of Sean O'Casey's powerful trilogy, *The Shadow of a Gunman* (1923), *Juno and the Paycock* (1924), and *The Plough and the Stars* (1926). The latter play, a blistering satire on some of the unholier aspects of the Easter Rising seen from the view of a Dublin slum-dweller, was greeted with another riot. Yeats fought for

110. Conversations between Yeats and Holloway recorded in *Joseph Holloway's Abbey Theatre* (January 23, 1909), p. 123.
111. Henderson Press Cuttings, Ms. 1732, p. 238.
112. *West Briton* (London: Faber & Faber, 1962), pp. 26-27.

O'Casey as he had fought for Synge.[113] Again, it was not merely a case of defending "art for art's sake", but a continuation of his struggle to create an intellectually free society in which "one man's vision of the world" would stand side by side with "the visions of others".

A RETURN TO FIRST PRINCIPLES

Throughout the period under discussion, while Yeats was fighting for the right of Synge and other Abbey dramatists to be heard, his own dramatic efforts were received at best condescendingly by both Irish and English audiences and critics. In part, this was because Yeats alienated those who might have supported him by the very vehemence with which he promoted his ideals. It must also be admitted that Yeats suffered because he was still struggling to create an appropriate form for his plays and then to find artists capable of interpreting them. But to an equal extent, his difficulties in finding an audience were caused by the unwillingness or inability of critics to stretch their imaginations far enough to fully comprehend his extraordinary dramatic intentions. In Dublin, Yeats could scarely believe his eyes when in 1909 he received a eulogistic review of his *Collected Works* in *The Freeman's Journal.* The review, written by the classical scholar Stephen MacKenna, was, it turned out, a chance of fate, for the editor had intended it for someone who would be utterly hostile to Yeats.[114] In England, even an excellent production of his *Deirdre* by Mrs. Patrick Campbell in December 1908 was not enough to win Yeats critical respect. Few would have disagreed with the London *Daily News* reviewer, E. A. Baugham, when he observed that "no stage work of [Yeats] has ever risen above the level of fanciful amateurishness".[115]

We have seen in Chapters Ten and Eleven that Yeats made a final effort to realize his personal ambitions as a dramatist with the experimental seasons of 1912 and 1913 involving

113. Vide Gabriel Fallon, *Sean O'Casey, The Man I Knew* (London: Routledge & Kegan Paul, 1966), p. 93, for a vivid first-hand description of Yeats's appearance before the rioters.

114. Hone, *W. B. Yeats*, p. 230.

115. (November 28, 1908), Henderson Press Cuttings, N.L.I. Ms. 1730, p. 160.

Nugent Monck and the Abbey Second Company. When that effort failed to win even a modest support at the box office, Yeats was given the most compelling reason of all for his decision to retire from the public theatre to the theatre of the drawing room.[116]

Out of loyalty to Lady Gregory,[117] but, one thinks, far more out of his belief in the obligation of the artist to transform personal ideals into tangible forms of social action, Yeats remained by her side as a Director of the Abbey Theatre. Together they continued to read, criticize, and rewrite parts of almost every script submitted to the Abbey.[118] Even at times when Yeats was himself heavily in debt, they raised funds in order that new Irish dramatists might have a chance to develop their craft.[119] Together they continued to endure the spite of Dublin, often from the very playwrights whose work they had helped to foster.[120]

No detail of theatre management was too small for Yeats's concern. Emma Bodkin, the accountant for the Abbey Theatre from 1924 to 1934, told the writer that Yeats was able to add a balance sheet faster than she was. Up to shortly before his death, when in feeble health, Yeats continued to make the vital administrative decisions on the Abbey Board.[121]

Mistakes were undoubtedly made, perhaps the biggest one being Yeats's inclination to engage literary men rather than

116. Vide James W. Flannery, "W. B. Yeats and the Idea of a Theatre" (PH.D. thesis, Trinity College, Dublin, 1970), pp. 388-96.

117. Joseph Hone records that Yeats decided against moving to Cork in 1921 because Lady Gregory said it would imply a desertion of the Abbey Theatre. W. B. Yeats, p. 239.

118. Many of Yeats's letters of criticism to playwrights are contained in N.L.I. Ms. 13068.

119. Flannery, "W. B. Yeats and the Idea of a Theatre", pp. 386-90. In 1914, according to Hone, Yeats owed Lady Gregory no less than £500. W. B. Yeats, p. 195.

120. Holloway's Diaries are filled with a continual stream of complaints by would-be playwrights that Lady Gregory and Yeats were more interested in producing their own work than in helping new Irish dramatists. Ernest Blythe records that when he joined the Abbey Board in 1935 his fellow Directors, the poet F. R. Higgins and the novelist and playwright Brinsley MacNamara, conspired to lessen Yeats's control of the Theatre by deliberately voting against him. Blythe attributes this and other opposition to Yeats to "subconscious jealousy". The Yeats We Knew, pp. 63-64.

121. Interview with Emma Bodkin (August 9, 1966); Blythe, The Yeats We Knew.

competent men of the theatre as managers of the Theatre.[122] As a result the Abbey found it difficult to stage not only Yeats's own plays but any work demanding theatrical imagination. Denis Johnston's expressionistic drama *The Old Lady Says "No!"* was rejected, because it was thought to be beyond the production capabilities of the Theatre.[123] This may also have been one of the reasons behind the notorious rejection of Sean O'Casey's *The Silver Tassie*, which caused O'Casey to leave the Abbey Theatre in 1928.[124]

But the important thing to remember is that, by and large, the work of Yeats as a theatre manager was carried out in aid of plays that he did not even like.[125] Although he worked unselfishly for others, except for occasional periods as when the opportunity of collaborating with Ninette de Valois presented itself, Yeats became increasingly reluctant to press his own poetic dramas upon the Abbey audience and the limited financial and technical resources of the Theatre.[126]

The audience was, in the final analysis, what Yeats blamed most for his failure to win acceptance as a dramatist. Neither in England nor in Ireland was he able to find a general audience with "an ear for verse". The English audience cared only for "light amusement", he said, while in Ireland the

122. These included Lennox Robinson, St. John Ervine, and, later, F. R. Higgins. One reason for this was Yeats's lifelong distrust of professional directors (producers), possibly as an over-reaction against the actor-manager tradition. His proud boast was that Abbey producers did nothing more than help the actors "to understand the play and their own natures". *Explorations*, p. 415. Cf. *Letters*, p. 440; Frank O'Connor, *My Father's Son*, pp. 169, 171, 181-82.

 Another reason is that Yeats believed that it was a "useful experience" for a playwright to have experience with the practical aspects of theatre management. Unpublished letters from Yeats to St. John Ervine (probably May 1916) preserved in N.L.I. Ms. 13068.

123. Ernest Blythe, *The Abbey Theatre*, a brochure published by the National Theatre Society (1966) as a defence of the policies and practices of the later Abbey Theatre.

124. One is also inclined to accept Ann Saddlemyer's view that because Lady Gregory and Yeats made O'Casey rewrite his earlier plays before they were produced at the Abbey, it was taken for granted that O'Casey would accept the same arrangement for *The Silver Tassie*. "Worn Out With Dreams", *World of W. B. Yeats*, p. 117. Yet another reason is Yeats's distaste for passive suffering even in warfare as a fit subject for art. Vide his Introduction to *The Oxford Book of Modern Verse* (Oxford: Clarendon Press, 1936), pp. xxxiv, in which he explains his exclusion of Wilfred Owen and other war poets.

125. *Explorations*, p. 415.

126. Robinson, "The Man and the Dramatist", *Scattering Branches*, p. 74.

audience preferred comedy, "the modern art", caring nothing for mythology.[127] Only in the Abbey Theatre pit—which represented the poorest segment of the society—did Yeats find an instinctive response to poetic imagery, rhythm, and music.[128]

The difficulties of holding an audience with verse are, as Yeats was only too well aware, much greater than with prose plays. From the very outset of his involvement with the theatre it was Yeats's plan to train listeners as well as verse-speaking actors. The method that he proposed for accomplishing this was to start with a small audience of the "refined and cultured" and, after elaborating their awareness of poetic conventions, widen the scope of that audience to include "converts among the many". In keeping with his aristocratic conception of art, he believed that his ideal theatre would develop not by "going to the public, but drawing them to itself".[129]

Yeats had the example of Wagner in mind when in 1891 he first proposed this plan for educating and developing an audience. At the time he was himself involved with the aesthetic colony of poets, scholars, and actors who made up the audience for the Bedford Park Playhouse. It was this audience, as well as the audience that gathered to support the French symbolist movement in the theatre, that inspired his ideas concerning the development of an audience for the Irish Literary Theatre. In the first issue of *Beltaine* Yeats declared that he did not want a theatre comprising large numbers of the mainly "unintelligent". Instead, he said, "We must make

127. *Essays and Introductions*, pp. 529-30. Yeats envied Shakespeare's advantage in having an audience receptive to the subtleties of verse: "Shakespeare's art was public, now resounding and declamatory, now lyrical and subtle, but always public, because poetry was a part of the general life of a people who had been trained by the Church to listen to difficult words and who sang, instead of the songs of the music-halls, many songs that are still beautiful. A man who had sung 'Barbara Allan' in his own house would not as I have heard the gallery of the Lyceum Theatre, receive the love passages of Juliet with ironical chirruping." Preface to *Four Plays for Dancers* (1921), p. 16.

128. *Plays and Controversies*, p. 416. Sara Allgood observed that the Abbey pit audience knew the plays so well that often the actors were cued if they happened to forget a line. "A Lecture on the Abbey Theatre" with corrections by Yeats (1909), N.L.I. Ms. 13572.

129. *Letters to the New Island*, p. 176.

a theatre for ourselves and our friends, and for a few simple people who understand from sheer simplicity what we understand from scholarship and thought".[130]

Yeats attempted to carry this philosophy into his work with the Irish National Theatre Society. He hoped that in the idealism of the nationalist movement at the turn of the century he might find an equivalent response to the heroic idealism of his plays. Perhaps he wanted to believe, as John Reese Moore puts it, that he could make "temporary aristocrats" of his Dublin audience.[131] The Abbey Theatre had a seating capacity of only 536; but Yeats found that even this provided too large, too intellectually and culturally heterogeneous an audience for the delicate nuances of his plays. In 1913, after the failure of the Abbey Second Company, Yeats returned to his "original working theory" of a small audience of fifty that would gradually be expanded.[132] It was not a popular theatre he sought, but that theatre's "anti-self"—a theatre that would "appease all that is within us that becomes uneasy as the curtain falls and the audience breaks into applause".[133] Like the audience he encountered at the Bedford Park Playhouse, his "unpopular theatre" would be composed of kindred souls:

One's own world of painters, of poets, of good talkers, of ladies who delight in Ricard's portraits or Debussy's music, all those whose senses feel instantly every change in the imagination.[134]

Yeats was sadly aware that for the time being such an audience was impossible to find in Ireland. He therefore turned, in a much more symbolic than real sense, to a drawing-room audience in England. The dream of ultimately finding a wider audience for his dramatic work continued to live in Yeats's imagination. But he came to believe that the problems with which he struggled encompassed much more than the theatre itself, being rooted in the "objective" nature of modern society, as described in *A Vision*. It was this objec-

130. *Essays and Introductions*, pp. 165-66.
131. *Masks of Love and Death* (Ithaca: Cornell University Press, 1971), p. 26.
132. Unpublished letter from Yeats to Miss Darragh (March 28, 1913) in the possession of Michael Yeats.
133. *Explorations*, p. 257.
134. *Essays and Introductions*, p. 238.

tivity that made it ultimately much easier for Ireland to accept the tragi-comic vision of Synge and O'Casey than his own sternly tragic vision.[135] It was also this objectivity that had destroyed modern man's faith in individual freedom, God, and immortality and thus made it impossible for tragic art to exist in the fullness of its affirmative possibilities:

Because Freedom is gone we have Stendhal's 'mirror dawdling down a lane'; because God has gone we have realism; because Immortality has gone we can no longer write those tragedies which have always seemed to me alone legitimate—those that are a joy to the man who dies.[136]

Yeats believed that his own plays would "only fully succeed in a civilization very unlike ours in some country where all classes share a half-mythological, half-philosophical folk-belief which a writer and his small audience lift into a new subtlety".[137] To the end of his life he dreamed that Ireland, drawing upon her ancient Celtic tradition, her still-living folk culture and her religious sensibility would re-create such a civilization and thus play an important regenerative role in the modern world. This would occur when the gyres had turned full circle and subjectivity, or Unity of Being, made Unity of Culture once again possible. Then, and only then, would his dramatic work come into its own, and the principles upon which he founded the Irish dramatic movement be vindicated.[138]

It now remains for us to examine whether this dream of Yeats has come to pass.

135. *Explorations*, pp. 253-54, 257-58; *Essays and Introductions*, pp. 529-30. Analysing the reasons for his lack of success in a lecture delivered in London in 1910, Yeats declared: "I believe Mr. Galsworthy's play [*Justice*] is more perfect of its kind than any realistic play which any of us have seen on the English stage. But I feel that my own art is essentially of the Theatre. By its nature it expresses itself in a theatrical way. But the spirit of the age is against it. I believe Mr. Galsworthy's art, so quiet, so essentially of the fireside, is essentially untheatrical; yet I believe it will succeed, because it is also essentially of the age. . . . Only tragic or comic art which uses all the resources of extravagant action, which concentrates the whole of a lifetime into an hour, can move large masses of men and will again in the future, I believe, move large masses of men." *Yeats and the Theatre*, p. 24.
136. *Explorations*, p. 333.
137. *Four Plays for Dancers*, p. 106. Cf. *Autobiographies*, p. 494.
138. *Essays and Introductions*, pp. 525-26; *Explorations*, pp. 256-57; *Autobiographies*, p. 473.

The Legacy of Yeats

THE INFLUENCE AND IMPORTANCE OF THE ABBEY THEATRE

In an open letter to Lady Gregory published in 1919 Yeats described the development of the Abbey Theatre as a "discouragement and defeat". Instead of being the matrix of a reawakened national consciousness—a theatre that embodied all that was most worthy in the ancient and living tradition of Ireland—the Abbey had become merely "A People's Theatre", a theatre that appealed to "the general mind" and, at best, articulated the life of "the dumb classes each with its own view of the world, its own dignity, but all objective with the objectivity of the office and the workshop, of the newspaper and the street, of mechanism and of politics".[1]

1. *Explorations*, pp. 250, 257, 249. The full extent of Yeats's disillusionment with the idea of a "people's theatre" is revealed in two vividly contrasting letters to Gordon Craig. On November 20, 1902, fresh from the enthusiastic response to three new plays produced by the Irish National Theatre Society, Yeats wrote: "Our movement is a real movement of the people. We don't play for the merely curious or for people who want to digest their dinners in peace, but for zealous bricklayers and clerks and an odd corner boy or two. That is to say we have a thorough-going unruly Elizabethan audience. The poor parts of the house are always full." On November 16, 1911, he wrote to Craig warning him about the difficulties of developing an audience for "distinguished work". "The political revolutionist always thinks, 'The people are uncorrupt, are noble; it is only the Governments that are corrupt.' He stakes his life upon that belief, and loses it. On the contrary, the people are no wiser than their education. Let us have no faith in the people. The people have to

Judged in terms of Yeats's lofty ideals, the early Abbey Theatre was indeed a failure. From the standpoint of the Abbey Theatre's importance and influence within and without Ireland, however, there can be no doubt that his judgment was much too severe.

Within Ireland the greatest importance of the early Abbey Theatre was in providing an inspiration and focus for a generation of young dramatists who would otherwise never have even considered writing for the stage. By 1919 the Abbey Theatre had produced no less than 130 new Irish plays as well as twelve original adaptations of Molière and other world classics. In addition, twenty-three new plays were produced by the Irish Literary Theatre and the Irish National Theatre prior to the establishment of the Abbey.[2] Obviously, the vast majority of these plays were of ephemeral value. But besides Lady Gregory, Synge, and Yeats (whose works account for forty-eight of the above total), it is worth noting the considerable achievements of Abbey dramatists such as Padraic Colum, George Fitzmaurice, Lennox Robinson, T. C. Murray, and St. John Ervine, all of whom attained a measure of recognition beyond Ireland. Over the years Sean O'Casey, Paul Vincent Carroll, Brendan Behan, and Brian Friel added their plays to the repertoire of the Abbey Theatre and ultimately the theatres of the world. That towering genius of the contemporary theatre, Samuel Beckett, may also be claimed as a product of the Irish dramatic movement, for during his formative years in Dublin he regularly attended productions at the Abbey. Indeed, a major study of Beckett's indebtedness to Yeats alone is called for with respect to their usage of double characters mirroring two halves of the same personality, their common literary and theatrical symbolism, their similar deployment of myth and ritual, and their common interest in the existential and mystical—as opposed to the social—destiny of man.[3]

be converted very slowly. They have to be taught their ABCs painfully. Let us believe in our ideas and our friends." Unpublished letters preserved in the Edward Gordon Craig Collection, Bibliothèque Nationale, Paris.

2. Statistics based upon playbills contained in Robinson, *Ireland's Abbey Theatre*.

3. Vide Ruby Cohn, "The Plays of Yeats through Beckett-Coloured Glasses", *Threshold* (Autumn 1965), pp. 41-47.

By helping to achieve an international recognition for Irish dramatists and by showing them that they could write out of the life and tradition of Ireland without distorting their characters into "stage Irishmen" for the sake of foreign audiences, the Abbey Theatre realized one of the primary ambitions of its founders: that of raising the dignity of Ireland.[4]

The Abbey Theatre's influence as a cultural force extended far beyond the drama to include every aspect of art and letters in Ireland. The painter Paul Henry credited a performance of *Riders to the Sea* with stimulating him to turn to the landscapes of western Ireland for his subject matter.[5] The great actor Micheál MacLiammoir was inspired by Yeats himself to return to Ireland and, under the very auspices of the Abbey Theatre, to establish, with his partner Hilton Edwards, the Dublin Gate Theatre in 1928.[6] Short-story writer Sean O'Faolain has stated that an Abbey Theatre production of a play by Lennox Robinson showed him for the first time that everyday life in Ireland could be a fit and worthy subject for art.[7] With considerable justification, the novelist and dramatist Brinsley MacNamara described the early Abbey Theatre as the "citadel and symbol of all our writing in that time" as well as "the beginning of all that has been done in letters in this century".[8]

In political and social terms the Abbey Theatre also exerted a far-reaching influence on Irish life. Historians such as Dorothy Macardle, P. S. O'Hegarty, and Nicholas Mansergh have noted the impact of patriotic plays by Lady Gregory and Yeats upon the minds that shaped the Irish Revolution.[9] Thomas MacDonagh, one of the martyr heroes of the Easter Rising, had his remarkably prophetic play, *When the Dawn is Come,* produced at the Abbey Theatre in October 1908. In May 1913, the Abbey Second Company put on a benefit

4. Vide Robinson, *Ireland's Abbey Theatre*, p. 2; *Our Irish Theatre*, p. 37.
5. Paul Henry, *An Autobiography* (London: B. T. Batsford, Ltd., 1951), p. 48.
6. Micheál MacLiammoir, *All for Hecuba*, p. 48.
7. Sean O'Faolain, *Vive Moi!*, p. 190.
8. "Abbey Days of Glory", *Evening Press*, Dublin (July 18, 1966), p. 9.
9. Vide Dorothy Macardle, *The Irish Republic* (London: Transworld Publishers Ltd., 1968), p. 58; Thompson, *The Imagination of an Insurrection*, pp. 143, 146; Mansergh, *The Irish Question*, pp. 245-67.

performance for the St. Enda's School for Boys, an institu-
tion founded by Padraic Pearse with the aim of restoring the
spirit of ancient chivalry to Ireland. Pearse's own students
performed in Irish his allegorical morality play, *An Re (The
King)*, in which a child King redeems his people and saves
them from oppression by the sacrifice of his innocent
blood.[10] Three years later some of those students followed
Pearse into the certain martyrdom of the Rising. It is little
wonder that Brinsley MacNamara declared: "One went to the
Abbey Theatre in those days not as to a theatre but as one
taking part in a movement or, by one's presence, helping to
further a cause."[11]

Ireland not only won her political independence from
England, but, despite a civil war and the pressure of many
years of economic instability, maintained a distinctive national
unity and ethos that has continued down to the present day.
In 1968 the English critic Cyril Connolly wrote:

Ireland could rank with Israel as the most powerful example of the
dynamism and validity of small nations. What has a city of similar
population to show compared to Ireland's contribution? There is even a
mythology which can hold its own with the best, a language and a
literature. Perhaps the nationalism which is causing the world to
splinter into smaller and smaller states may be healthier than it seems,
and political liberty, consciously experienced, an essential vitamin.[12]

Ireland owes to no one more than to W. B. Yeats the extra-
ordinary qualities of individual and social life that she has
preserved well into the twentieth century. His far-reaching
vision and concern embraced every aspect of that life: from
supervising the design of Irish coinage while an Irish Senator
to working for the creation of a Dublin Gallery of Modern
Art; from championing the rights of workers against the
exploitation of employers in the Dublin Lockout of 1913 to
establishing the Irish Academy of Letters in 1932 in order to
protect the rights of artists against government censorship.[13]

10. Holloway, *Impressions of a Dublin Playgoer* (May 13, 1913), N.L.I. Ms. 1815,
 pp. 895-97.
11. "Abbey Days of Glory".
12. *Sunday Times*, London (July 7, 1968), p. 53.
13. Vide Hone, *W. B. Yeats*, pp. 265-68, 384, 424.

Of all his contributions to Ireland, however, none has surpassed the Abbey Theatre in its influence and impact. Even that arch-cynic George Moore was forced to admit that Yeats was correct in knowing exactly what he wanted: that if Ireland were ever to produce any literature it would have to begin in folk and be given expression in a theatre. "He has his reward," said Moore. "Ireland speaks for the first time in literature in the Abbey Theatre."[14]

Outside of Ireland the Abbey Theatre also had an extraordinary theatrical influence which continues down to the present day. The English repertory system which began to develop during the second decade of the century drew one of its chief inspirations from the example of the early Abbey Theatre. Theatres such as the Manchester Gaiety Theatre, under the aegis of Miss Horniman, and the Liverpool Repertory Theatre, modelled themselves after the Abbey in their efforts to discover regional dramatists.[15] The short-lived Scottish National Theatre in Glasgow and, to a certain extent, the National Theatre of England were also inspired by the success of the Irish National Theatre.[16]

Significantly, except for Bayreuth, none of the Continental theatres and dramatic movements that inspired the founders of the Irish Literary Theatre are still in existence. In England, until the advent of subsidies from the British Arts Council after the Second World War, the English repertory movement subsisted in a very precarious state. Many theatres periodically folded or continued to operate only by compromising their artistic standards. Meanwhile, despite its own ups and downs, because of the untiring efforts of Yeats and Lady Gregory, the Abbey Theatre not only managed to survive but remained true to its original ideal of serving Irish dramatists. In 1924, the continuance of this ideal was guaranteed when the Irish Government provided the Abbey Theatre with an annual subsidy, making it, as we have noted, the first

14. Moore, *Hail and Farewell, Vale*, p. 147.
15. Vide Nicoll, *British Drama*, pp. 259-76; Goldie, *The Liverpool Repertory Theatre, 1911-34*, pp. 21-22; Rex Pogson, *Miss Horniman and the Gaiety Theatre, Manchester* (London: Rockliff, 1932), pp. 37-38.
16. Vide Preface by James Bridie to *The Fays of the Abbey Theatre*. Cf. Flannery, *Annie Horniman*, p. 34.

government-subsidized theatre in the English-speaking world.

From the very outset of the Irish literary movement Yeats was deeply concerned about reaching the vast untapped army of Irish exiles in the United States and Canada. This is evident in the articles that he wrote for *The Boston Pilot* and *The Providence Sunday Journal* from 1888 to 1891.[17] Yeats's practical sensibility, however, led him to direct his efforts far beyond this relatively uneducated and exclusively nationalist audience. In a lecture tour of thirty leading American and Canadian universities and colleges during the winter of 1903-04, Yeats made a large number of valuable contacts in both academic and public life.[18] Among the latter was the President of the United States, Theodore Roosevelt, who it is said, carried a copy of Lady Gregory's *Cuchulain of Muirthemne* with him to pass the time on long political train journeys.[19]

These contacts proved particularly helpful during the Abbey Theatre's first American tour of 1911-12. Lady Gregory has recorded that by this time the dramatists of the Irish movement were already prescribed reading on many university and college courses. She was herself invited to lecture at the University of Pennsylvania, Bryn Mawr, Vassar, Harvard, and Yale. Scores of articles on the Irish dramatic movement appeared in learned and popular American journals. One was written by Roosevelt himself in which he held up the Irish playwrights as an example for American dramatists to follow in writing of "the American life with which they are familiar".[20] Roosevelt proved the sincerity of his support when, at Lady Gregory's request, he attended a production of *The Playboy of the Western World* in New York and thus helped to quell another riotous protest against the play, this time by Irish-American would-be patriots.[21]

The full consequences of this Abbey Theatre tour of North America would have astounded even the visionary mind of

17. Reproduced in *Letters to the New Island*.
18. Hone, *W. B. Yeats*, pp. 194-98.
19. Herbert Howarth, *The Irish Writers, 1880-1940: Literature under Parnell's Star* (London: Rockliff, 1958), p. 7.
20. *The Observer* (December 16, 1911), quoted in *Our Irish Theatre*, pp. 314-15.
21. *Our Irish Theatre*, pp. 182, 187, 188, 205, 206, 302, 314-15. Cf. Robinson, *Ireland's Abbey Theatre*, pp. 95-98.

Yeats. From it sprang a major impetus for the amateur Little Theatre Movement across the United States and Canada,[22] which has since evolved into a system of professional regional theatres. Eugene O'Neill saw the Abbey players on tour and declared that they showed him for the first time the possibilities of writing naturalistic plays based upon American life.[23] The influence of the early Abbey Theatre has lasted down to the present day. Herbert Blau has written movingly of the inspiration provided by the ideals of Yeats and the Abbey Theatre when he co-founded the influential Actor's Workshop of San Francisco in 1952.[24] In 1970, the artistic director of a new professional theatre in Edmonton, Alberta, announced that his aim was to create "another Abbey Theatre".[25]

The early Abbey Theatre also had a considerable influence on the development of theatre programs in American universities. In October 1911 Professor George Pierce Baker of Harvard, founder of the American educational theatre movement, invited Yeats to address his students on modern European stage design. In this lecture, entitled "The Theatre of Beauty", Yeats introduced the work of Gordon Craig to the United States and, in particular, to one of Baker's students, Robert Edmond Jones, who later became one of the foremost designers in the American theatre.[26] As a further result of the lecture and his subsequent talks with Yeats, Baker created a small experimental theatre in Boston devoted primarily to the production of new American plays.[27]

Baker ultimately left Harvard to found the famed Yale School of Drama. In 1926, extending an invitation to Lady Gregory to attend the opening ceremonies of the Yale Theatre, he credited his knowledge of what the Abbey

22. Byrne, *The Story of Ireland's National Theatre*, pp. 174-76.
23. Ida G. Everson, "Young Lennox Robinson and the Abbey Theatre's First American Tour (1911-1912)", *Modern Drama* (May 1966), pp. 83-84.
24. Herbert Blau, *The Impossible Theater, a Manifesto* (New York: Collier Books, 1965), pp. 127, 130-32.
25. *Globe and Mail*, Toronto (May 23, 1970), p. 13. Interview with Sean Mulcahy by Herbert Whittaker.
26. Published in *Harper's Weekly* (November 11, 1911), p. 11.
27. Wisner Payne Kinne, *George Pierce Baker and the American Theatre* (Cambridge: Harvard University Press, 1954), pp. 150-51.

Theatre had accomplished with little money as one of the chief inspirations of all his endeavours.[28] Robert Brustein, the present Dean of the Yale School of Drama and founder of the Yale Repertory Theatre, continues to cite the example of Yeats and the early Abbey Theatre as a model for what he is striving to accomplish.[29]

In 1908, writing out of the frustration of his own thwarted ambitions for the Abbey Theatre, Yeats offered his slight consolation: that the Irish dramatic movement—his "Idea of a Theatre"—would remain important "because of the principles it [was] rooted in whatever be its fruits".[30] We have seen that Yeats's prophecy was an accurate one. There has been no more important or influential dramatic movement in the twentieth century. Extravagant as the claim may seem, there has perhaps been no theatre for centuries that in theory and practice more closely approximates the ideals of that communal theatre on the slopes of the ancient Acropolis.

THE ALLEGED FAILURE OF YEATS

One most important aspect of the Irish dramatic movement has yet to receive its due recognition. That, of course, is the dramatic work of W. B. Yeats himself. The various reasons for Yeats's failure to win recognition during the early years of the Abbey Theatre have been discussed in previous chapters. But the reasons for his continued failure to win theatrical acceptance down to the present day are significant, not only within an Irish context, but within the social and cultural context of the twentieth century as a whole.

Yeats was correct in ascribing his chief failure as a dramatist to his audience and ultimately to the civilization in which he lived. The twentieth century has seen the triumph of nineteenth-century science, agnosticism, and materialism that men of letters from Ruskin, Morris, and Arnold to Yeats himself opposed. It has produced a civilization in which, in the words of William Erwin Thompson,

the man of Empire, the builder of wonders, from the entrepreneur to the astronaut ... and the élite of a scientific-industrial technocracy

28. *Lady Gregory's Journals*, p. 150.
29. *Yale Drama School Alumni News* (Spring 1972).
30. "The Irish Dramatic Movement", *Collected Works* (1908), Vol. V, p. 80.

may find outlets for their energies and imaginations, [while] the men of artistic, religious or humanistic sympathies seem to find the faceless imagery of the abstract . . . terrifying.[31]

The theatre has naturally been one of the primary victims of such a civilization. It has largely lost its popular following to the art of film—an art that by its very nature is singularly appropriate for a technological and depersonalized society. The projectionist, after all, asserts the only human element in a cinema performance when he switches on the projector; a film itself is the same whether shown in Tokyo, Helsinki, or New York.

In an effort to meet the demands of the objective twentieth-century mind, the theatre has desperately held on to outmoded naturalistic and realistic dramatic forms—forms which the camera can easily surpass in its minute scrutiny of the surface actions of life. As a result, theatre has played an increasingly less significant role in social life. Performer and spectator remain apart, numb in their isolation from one another, separated both symbolically and actually by the proscenium arch and the invisible "fourth wall" employed to create the illusion of real life.

To counteract this absence of meaning and genuine dramatic excitement, the modern theatre has been characterized by a host of reactionary movements. Dramatists from Shaw to Brecht have sought to make the theatre a forum for social and political action. Society, however, has changed little as a result of their didacticism. Worse yet, the theatre itself has become boring to a mass audience that naturally resents being "preached at".

Other twentieth-century reactions to realism have taken the form of attempts to "theatricalize the theatre".[32] Here the emphasis has been on new stage craft as a means of stimulating the audience into new and more exciting responses. Experiments have ranged from painting the scenery with light, as with the curved plaster dome invented by Mario Fortuny at the turn of the century, to employing projected scenery, film strips, slides, revolving stages, tread-

31. Thompson, *Imagination of an Insurrection*, p. 241.
32. Vide Mordecai Gorelik, *New Theatres for Old* (New York: E. P. Dutton, 1962), pp. 275-312.

mills, and other technical appurtenances. Max Reinhardt (1873-1943) became the most celebrated director of his time by using many of these techniques in a series of spectacular productions staged in Munich, Vienna, Salzburg, Paris, Venice, Stockholm, London, New York, and Hollywood. In a continuation of the actor-manager traditions of nineteenth-century England, Reinhardt sometimes employed hundreds of actors, as in his famous production of *Oedipus Rex*, staged in the huge Circus Schumann of Berlin in 1910, or his equally famous religious pantomime, *The Miracle*, which he restaged throughout the major capitals of Europe and in New York in 1911-12.

Reinhardt, "the great popularizer", became the idol of a whole generation of stage designers and directors who equated his work with "theatrical progress". Men such as Jessner and Piscator in Germany, Tairov, Vakhtangov, and Meyerhold in Russia and Norman Bel Geddes in the United States all followed Reinhardt's example, employing the technology of the theatre in order to arouse the optimum emotional response from the audience. Reinhardt's influence has continued on to the present day in such varied forms of so-called "New Theatre" as Mixed Media, Total Theatre, Environmental Theatre, and Happenings.

Naturally, in this tradition the literary element of the theatrical experience has largely been shunted aside and with it the actor as the image and reflector of man's private self. For all the immediate popular success of Reinhardt and his followers, few plays commissioned for them have any lasting dramatic value; fewer plays contain roles which remotely tap the full spiritual, intellectual, and physical resources of the actor.

Because there has been little support for an avowedly literary or poetic drama, dramatists of sensitivity who have sought to express the subjective life of man have either been forced to vulgarize their artistic style and personal feeling, as with Eugene O'Neill and T. S. Eliot, or seek their audiences in garrets or basement coffee houses, as with the initial dramatic efforts of Harold Pinter, Eugene Ionesco, and Samuel Beckett. Financial limitations and the psychological implications of writing for a limited minority audience undoubtedly have influenced the theatrical aspects of the

Ionesco
died. march 1994

latter playwrights' earlier work. It is significant to note that a larger number of characters and more elaborate stage settings have generally accompanied the rise of Ionesco and Pinter to a more popular theatrical acceptance. This increasing emphasis on external theoretical values has, unfortunately, not been accompanied by greater spiritual depth or insight. Beckett alone has remained theatrically consistent to his own bleak vision of man's destiny, each play of his requiring fewer actors and fewer appurtenances of the theatre. Despite one's admiration for Beckett's unflinching honesty, one cannot but conclude that by following his example and the logic of his intellectual development the theatre itself must cease to exist.

W. B. Yeats, in both his theatrical philosophy and actual practice as a dramatist, stands apart from these mainstream, reactionary, and purely experimental movements in the twentieth-century theatre, although he was deeply influenced by many of them. Where Yeats differs from the pure man of the theatre is in striving always to make the arts and technology of the theatre serve his personal vision as a poet. Where he differs from his fellow dramatists of the twentieth century, with the possible exception of Brecht, is that he became a complete man of the theatre to the extent that his plays, taken as a whole, employ all the instruments of the theatre to their maximum effect.

Why, then, the general opinion that Yeats was a failure as a dramatist, both within and without the world of the theatre? We have already answered part of the question by analysing modern theatre audiences in terms of the dominant actions of the age. Nothing could stand more starkly opposed to the spirit of the twentieth century than the challenge of Yeats's uncompromising tragic vision: to live as a complete individual while preserving one's communal ties and responsibilities; to cultivate a rich subjective life while remaining fully responsive to the reality of the objective world; to live with abundant joy in the face of a deepening awareness of the ephemeral nature of mortality; to respond to the existential *now* while maintaining a mythopoeic awareness of the total order of the universe and of man's coming and going within it.

These themes form the substance of Yeats's drama and poetry. Until fairly recently they have been understood and

shared by few. Indeed, it is only within the past ten or fifteen years that Yeats's stature even as a lyric poet has become recognized, as the strident rhetoric of the socialist poets and critics of the thirties and the dry analyses of the New Critics have gradually abated in their influence. This has allowed the work of T. R. Henn, Richard Ellmann, Norman Jeffares, Peter Ure, and many other distinguished Yeats scholars to illuminate the man and his art for us.

Yeats was deeply conscious of the importance of criticism if his unique contributions to the drama were to be recognized. "We shall do nothing till we have created a criticism which will insist on the poet's right to educate his audience as a musical composer does his," he wrote to T. Sturge Moore in 1907.[33] The Irish poet Austin Clarke recalled that over sixty years ago Yeats tried to persuade him to write an academic thesis on his plays because no one had written seriously of them.[34] It was mainly because of the lack of serious criticism that Yeats himself went to such lengths to try and explain his theories of the drama and even the practical means for staging his plays.

To the present time, except for occasional studies of the themes, language, symbolism, structure, and revisions of his plays written mainly by professors of English literature with a limited or underdeveloped theatrical sensibility, Yeats's dramatic works have not been analysed in terms of their intrinsic theatricality and dramatic significance. Because Yeats the dramatist has not been taken seriously by either academic critics or theatre critics, he has largely been ignored by theatre artists. As a result, the bulk of his plays have yet to be staged with the sensitive and imaginative treatment that they deserve and require in order to be successful in the theatre.

THE THEATRICAL RE-EVALUATION OF YEATS

There are signs that a major re-evaluation of Yeats the dramatist is about to occur. This is the result of a number of important theatrical and social changes that he himself both foreshadowed and foresaw. In 1911, Yeats declared in

33. Letter to T. Sturge Moore (October 4, 1907), *Correspondence*, p. 13.
34. Austin Clarke, *A Penny in the Clouds*, p. 205.

answer to Reinhardt's overblown attempts to theatricalize the theatre: "If one would work honestly in any art, it is necessary to ask what that art possesses as distinguished from all other arts."[35] A few years later, inspired in part by the example of Japanese Noh drama, Yeats turned to a ritualistic form of drama staged within an intimate environment, with scenery and lighting almost totally eliminated so as to focus the attention of a small number of spectators on the pure energy of the actor's voice and body. He summed up his new aesthetic of the theatre by stating: "Whatever we lose in mass and power we should recover in elegance and subtlety."[36]

In 1959 the Polish director Jerzy Grotowski set out upon a quest similar to that of Yeats in an effort to "define what is distinctively theatre, what separates this activity from other categories of performance and spectacle". Like Yeats, Grotowski was inspired by the example of Oriental theatre, to which he added his own practical knowledge of Stanislavskian acting techniques. Working at a tiny experimental theatre, "The Theatre of Thirteen Rows", in Opole, Poland, Grotowski gradually evolved the theory and practice of what he terms "Poor Theatre". To Grotowski, the traditional costumes, scenery, properties, lighting, and music of "Rich Theatre" are irrelevant. His "Poor Theatre" strips away all of this elaborate paraphernalia, making "the personal and scenic techniques of the actor . . . the core of theatre art".[37]

Like Yeats, Grotowski originally sought to create a ritualistic "Holy Theatre" in the image of the great theatres of the past when spectators and performers shared a profoundly spiritual understanding of life. In this respect Grotowski was strongly influenced by the ideas of Antonin Artaud (1896-1948), the visionary French actor-director-writer who sought by means of a highly theatrical deployment of myth, symbol, ritual, and gesture to break through the rational bondage of language in order to reach the deepest levels of the unconscious.[38] Grotowski also hoped to draw upon the

35. "Theatre of Beauty".
36. *Four Plays for Dancers*, p. 16.
37. *Towards a Poor Theatre*, p. 15.
38. Vide Antonin Artaud, *The Theatre and Its Double* (New York: Grove Press, 1958), pp. 89-100.

national tradition of service to martyred "Holy Poland"—a tradition born out of centuries of brutal oppression and celebrated in a romantic literature that combined an almost mystical union of religious sacrifice with revolutionary politics.[39] However, Grotowski found, as did Artaud and Yeats, that in the secular modern world there are few shared myths. It was therefore impossible to establish a "group identification with myth" or even to "shock" the audience sufficiently to "get at those psychic layers behind the life mask". Thus, again like Artaud and Yeats, Grotowski turned to a form of theatre which involved "confrontation with myth rather than identification".[40]

Artaud's body of ideas was brilliant and bold, his vision shocking and imaginative; but his greatest weakness was his inability to put his theories into practice. It was one thing to imagine a spatial poetry of the senses that effected a spiritual transformation in the audience, but Artaud needed practical artists who could execute his ideas. Moreover, the kind of rigorous training methods necessary to bring Artaud's theories to life would have meant a total revolution in acting techniques. Grotowski's Polish Theatre Laboratory made a particular point of meeting this challenge. In his work Grotowski moved beyond the Stanislavsky method of psychologically motivated action to focus upon the root impulses buried deep in the psyche of the actor. Through a strenuous series of physical and vocal exercises and through an "act of confrontation" with his stereotyped everyday mask, Grotowski forced his actors to extend themselves far beyond their normal limitations. Actor training thus became a form of psychotherapy in which the ultimate objective was not only a fully integrated personality but performances that consisted of a "psychoanalytic language" of sounds and gestures as unique to and expressive of the individual actor as the language of words created by a great poet.[41] For

39. Vide Croyden, *Lunatics, Lovers and Poets*, pp. 137-47.
40. *Towards a Poor Theatre*, pp. 22-23, 14. Vide Croyden's discussion of Grotowski's "dialectic of egotheosis and derision"—that is, a montage of scenes juxtaposing classic, mythic, and traditional beliefs undercut by mockery, self-parody, and nightmare—in *Lunatics, Lovers and Poets*, pp. 147-49. The resemblance to Yeats's theory and practice is, again, obvious.
41. *Towards a Poor Theatre*, p. 35.

Grotowski the art of performance became essentially a matter of giving oneself "totally, in one's deepest intimacy, with confidence, as when one gives oneself in love".[42]

In order to evoke the maximum response from the "act of confrontation", Grotowski sought to create a new actor-audience relationship. This involved various technical experiments including the placement of actors amidst the spectators, speaking to and through them as if they were not present, as well as changing the relationship between the auditorium and the stage for each production. Here Grotowski's experiments were based upon another fundamental principle with which Yeats would have concurred: that the theatre is different from film or television in its human-to-human contact or, as Grotowski expresses it, "the closeness of the living organism".[43]

This principle led in turn to Grotowski's insistence on performing for audiences of no larger than eighty to one hundred spectators. Grotowski has no hesitancy in terming this a "theatre for the élite", or "chamber theatre". Reacting, as Yeats did, against the tendency of modern audiences to go to the theatre simply in order to escape the tedium of mundane existence, Grotowski declares that his concept of "élite" has nothing to do with a spectator's social background, financial situation, or even education. Rather, he says, "we are concerned with the spectator who has genuine spiritual needs and who really wishes, through confrontation with the performance, to analyze himself".[44]

One of Grotowski's principal champions has been the brilliant English director Peter Brook. In an essay entitled "The Holy Theatre", or "The Theatre of the Invisible-Made-Visible", Brook equates Grotowski's actor-audience relationship with the relationship between priest and worshipper:

The priest performs the ritual for himself and on behalf of others. Grotowski's actors offer their performance as a ceremony for those who wish to assist: the actor invokes, lays bare what lies in every man, and what daily life covers. This theatre is holy because its purpose is

42. Ibid., p. 38.
43. Ibid., p. 41.
44. Ibid., p. 40.

holy; it has a clearly defined place in the community and it responds to a need the churches can no longer fill.[45]

In 1971, following a series of remarkable experimental productions carried out within the context of the commercial theatre, Brook created his own laboratory theatre, the International Centre for Theatre Research, in Paris. With a small group of dedicated professional actors and directors selected from applicants around the world, Brook has focussed on what he considers to be the most essential problem facing the contemporary theatre: how to bring about a profound and meaningful relationship between actor and audience, a relationship that will expand the quality of people's experiences within and without the theatre Like Grotowski, Brook believes that the idea of a community sharing indigenous roots no longer has any valid meaning. However, in terms that remind one of Yeats, Brook argues that through an "act of communion—an experience of intense recognizable quality"[46] the theatre can touch "at certain short moments a quite genuine but fleeting experience of what could be a higher state of evolution".[47]

Again like Artaud and Grotowski, much of Brook's work has been concerned with extending non-verbal communication, because, he says, "words have either become debased or actors have become imprisoned by them".[48] As their first project Brook and his company embarked upon a series of exercises and experiments designed to explore the primal impulse in the sound of words and the relationship between movement, gesture, and tonal patterns in a number of different languages including Greek, Latin, Spanish, German, and Armenian. The basic objective of their research was to magnify the "metaphorical" relationship between sounds and feeling at the expense of verbal explicitness.[49] This work culminated in an experimental theatre piece entitled *Orghast* which was performed at Persepolis, the remains of the ancient capital of the Persian Empire, in the summer of 1971.

45. Brook, *The Empty Space*, p. 60.
46. Interview with Croyden quoted in *Lunatics, Lovers and Poets*, p. 276.
47. Interview with A. C. Smith, *Orghast at Persepolis* (London: Eyre Methuen, 1972), p. 52.
48. Interview with Croyden, p. 259.
49. *Orghast*, pp. 40-42, 45.

Orghast was both the title of the piece and of an entirely new language created by the English poet Ted Hughes to embody the mythic narrative he was composing at the same time. Sounds were created by Hughes to represent specific physical actions such as eating ("GR"), to imply other actions or objects ("DADA" = the outside world), and even to convey certain abstract ideas ("BULLORGA" = darkness). Some of the words were pieced together from Greek, Latin, and Gaelic root words and from Avesta, the ceremonial language of the ancient religion of Zoroastrianism in Persia which was used in an incantational form like a mantra. Other words were invented by Hughes in a purely intuitive manner by concentrating on what was to be expressed until an appropriate sound emerged.[50] Neither the creative method nor the ultimate result was as arbitrary as it may at first appear. Hughes discovered that some of his "invented" words had identical sounds and meanings in other languages far removed from the sources of Orghast. From this Hughes inferred that there exists in the human race a common tonal consciousness, "a language belonging below the level where differences appear". Orghast also approximated many of the speech patterns of his own native tongue. This confirmed Hughes' belief—a belief with which Yeats obviously would have concurred—that "in writing verse there is a predilection for sounds and sound-sequences which is unique to every poet".[51]

Orghast was a remarkable experiment in other respects than in its deployment of a new language. Drawing mainly upon ancient sources—abstracts from literary themes, allusions to Greek and Roman myths, Zoroastrian rituals, and Oriental legends—Hughes created an evocative, non-literal but unified dramatic poem. Brook staged the piece on the mountains high above the brooding ruins of Persepolis. In her splendid chronicle of the contemporary experimental theatre, *Lunatics, Lovers and Poets*, Margaret Croyden has provided a vivid description of the performance:

Hughes and Brook force the spectator to listen to the work as they would listen to music, and to watch the action as if it were a religious

50. Ibid., pp. 43-45, 48-49.
51. Ibid., p. 47.

experience. The sound of the language—its rhythm, tone and texture as it reverberates and echoes all over the mountains—is virile and austere, yet touched with pity and human suffering. The actors, speaking with completely new vocal techniques, produce a symphony of sound and work which underscores their international composition, and evokes the lost memory of the commingling of tongues. Hard "or", "gr", "tr", soft "sh" sounds, and the five vowels, sliding from one to the other to blend into one word, transport the listener to Oriental-African-Semitic-Persian worlds, or perhaps to a time when language was magic and primordial.[52]

It is the strength, not the weakness, of such productions that they appear as much like splendid archaic rites as dramas of the human condition. They help to confirm how well founded was Yeats's conviction that, even in the twentieth century, religious experience and the ritualistic expression of that experience can provide the basis of profoundly significant theatre. Moreover, they indicate that, given an appropriate realization of their innate theatricality, plays such as Yeats wrote are by no means too recondite to be immensely exciting and appealing for a general audience.

In North America during the late 1960s Grotowski's ideas as well as those of Artaud had an enormous influence on the development of such new experimental ensembles as the Living Theatre, the Open Theatre, and the Performance Group. Techniques borrowed from the modern dance of Martha Graham, the mask work of Jacques Lecoq, and the corporal mime studies of Étienne Decroux (the latter a deliberate attempt to realize in human terms Gordon Craig's seemingly impossible ideal of the *übermarionette*), paratheatrical disciplines such as Gestalt awareness training, encounter groups, dance and movement therapy, and Oriental disciplines such as Hatha Yoga and T'ai Chi Ch'uan were employed to train "total actors"—actors having a profound spiritual, intellectual, and physical commitment to, and understanding of, their art. The exploration of myth and ritual through an act of confrontation took on further dimensions as it became wedded to a revolution against the traditional technocratic American way of life. Few North American troupes of the sixties

52. Lunatics, Lovers and Poets, p. 263.

achieved the absolute and rigorous precision of Grotowski's Polish Laboratory Theatre. None possessed the unified phi-losophy, craftsmanship, and sheer practical resources of Peter Brook's International Centre for Theatre Research. Indeed, many eschewed such ideals as an infringement on their efforts to discover a collective form of freedom. But the important thing to note is the motivation for their very existence—a search for a "counterculture", subjective rather than objective, tribal or communitarian rather than individualistic, transcen-dental rather than worldly. It is a search that is manifested in a reaction against reason, pragmatism, order, and science in favour of magic, mystical experience, astrology, Oriental religion, drugs, folk art, and humanist psychology.[53]

And this, of course, brings us back to Yeats. There is no doubt that Yeats, with his aristocratic sense of order and beauty, would have reacted against the chaos, self-indulgence, and downright vulgarity that characterizes so much of the counter-culture, just as he reacted against the dissipation of his Rhymers' colleagues of the nineties.[54] Instinctively, Yeats understood what the counter-culture has yet to realize: that discipline rather than "doing your own thing" is the way to true individualism, that the torture of self-consciousness is preferable to mindless happiness, and that certain kinds of suffering, far from being morbid, are a form of health in so far as they activate the energies of the total personality.

While Yeats would undoubtedly have opposed the ten-dency of Grotowski, Brook, and especially their much less gifted followers to concentrate on non-verbal forms of expression at the expense of vibrant poetic language, I am certain that he would have recognized the value of their theatrical techniques and, moveover, sought to apply them in his own work. Above all, the deeper implications of both the counter-culture and the response to the idea of a "Holy Theatre" would not have escaped Yeats. He would have seen them as evidence that his own much maligned idea of a ritual-istic, communal theatre for the few was at last being under-stood in its true significance. He would have recognized that

53. Vide Chapter Two, Note 111.
54. Yeats, "The Rhymers' Club", *Letters to the New Island*, pp. 142-48.

the gyres were beginning to turn and that his plays were about to find the kind of audience and theatre that would enable them to come into their own.

Indeed, the re-evaluation of Yeats the dramatist that we spoke of earlier has already begun. In Paris in 1969 a company of young professional actors, working according to Grotowski's principles, established Le Théâtre d'Aran, a theatre devoted primarily to exploring and performing the dramatic work of Yeats. The motto of Le Théâtre d'Aran is: "Il nous semble poétiquement déraisonnable d'oublier Yeats."[55] In the same year eighteen productions of ten plays by Yeats took place in American universities.[56] Another production, staged at Stanford University, successfully "confronted" the texts of the Cuchulain cycle by inviting the audience to a Grotowski "feast" at which the actors and musicians, "candidly students", began by engaging in meditations and exercises until they conjured up a bright jewel into their midst. With this gift, they were enabled to assume roles, don costumes, and begin the plays, each of which were given a different stylistic treatment appropriate to their individual themes.[57]

The most significant North American Yeats production in recent years took place in February 1970 at the noted Off-Off-Broadway experimental theatre, Café La Mama. This was a production of The Only Jealousy of Emer, scored almost as an opera for a seven-piece orchestra and singer-actors. The production was marred by a continuing conflict between the intrinsic music of Yeats's poetry and the elaborate melodies imposed by the composer. But the essential dramatic power of the action was most effectively rendered, eliciting from critics such as Walter Kerr comparisons between Yeats and Aeschylus.[58]

55. Les Cahiers d'Aran, No. 1 (Paris: Jean Meunier, avril, mai, juin 1969).

56. Leighton M. Ballew and Gerald Kahan, "The AETA Production Lists Project Survey, 1967-68: Minor Variations on Established Themes", Educational Theatre Journal, XXI, 3 (October 1969), p. 335.

57. Ruby Cohn, "Theatre in Review: Cuchulain", Educational Theatre Journal, XXI, 2 (May 1969), p. 227. As we have noted, Reg Skene's The Cuchulain Plays of W. B. Yeats is based, to a large extent, upon his production of the entire cycle at the University of Winnipeg in 1969.

58. Walter Kerr, "Drama, Not Long Out of the Womb", The New York Times (April 26, 1970).

An extremely perceptive review of the production was written by the playwright Arthur Sainer for the *Village Voice*. Sainer confessed that he came to the production with the traditional "Yeats the dramatist prejudice", motivated chiefly by his own inclination towards "a theatre of contact, of confrontation", as opposed to "theatre as tunnel down which the spectator peers towards some distant playing out of events which proceed seemingly without regard to his own presence". Sainer went on, however, to describe how his prejudice against Yeats and his own aesthetic principles of the theatre were shaken by the production, which was presented along with Stravinsky's *Renard*:

It was an exquisite evening. Yeats's mysticism and the tortuous, Racine-like decisions of Emer seem to me at best tenuously connected to our own age; nevertheless, the productions were little jewels. They asked nothing of us except to watch in admiration, exhilaration, and a moment or two of terror, and a moment of great sadness. They are works of art, lovingly conceived and meticulously and finely wrought. They don't confront, they're dazzling little worlds unto themselves and ask nothing of us that we're not prepared to give.[59]

I could give further illustrations of similar responses based upon my own productions of *The Shadowy Waters*, *A Full Moon in March*, and *The King of the Great Clock Tower* at the University of Ottawa, a production of *Calvary* and *The Resurrection* which I directed for the 1965 Dublin Theatre Festival,[60] and another production of *At the Hawk's Well*, *A Full Moon in March*, and *The Cat and the Moon* which I staged for one of Canada's leading regional theatres, The Centaur Theatre, Montreal, in 1972. In New York City, the Open Eye, an Off-Off-Broadway company led by the dancer-choreographer Jean Erdman, has recently been founded specifically to specialize in the works of Yeats. But perhaps the point has been made. The theatrical challenge of staging Yeats remains as formidable as ever, but at long last that challenge is being seriously, if not always successfully, met. Yeats is finally being given the opportunity of proving him-

59. *The Village Voice* (February 12, 1970), p. 11.
60. Vide James Flannery, "Action and Reaction at the Dublin Theatre Festival", *Educational Theatre Journal*, XIX, 4 (December 1967), pp. 72-80.

self as a dramatist in the only place where such proof can be valid: before an audience in the living theatre.

The one place where Yeats's true stature as a dramatist remains still unrecognized is, ironically but not surprisingly, Ireland.[61] This is mainly because his work is seldom played at the Abbey Theatre—and then played badly. Yeats once defined a national literature as "the work of writers who are moulded by influences that are moulding their country, and who write out of so deep a life that they are accepted there in the end".[62] Yeats was speaking in defence of Synge, who of course, has long since become an accepted part of Irish tradition. By his own definition, however, Yeats the dramatist has yet to become fully part of that tradition. Likewise, Yeats's plan for the Abbey Theatre to become the matrix of a true Unity of Culture in Ireland remains unfulfilled.

As I have tried to demonstrate, Yeats's plays are not merely theatrically successful but also immensely important as the harbinger and in many ways the ritual embodiment of a new and higher state of human consciousness. However, it is also my belief that the true significance of Yeats's dramatic endeavour will not be realized until a company similar to Grotowski's Polish Laboratory Theatre or Brook's Centre for Theatre Research is created in Ireland to meet the manifold challenges of his plays in a systematic, disciplined, and theatrically imaginative manner. I specify Ireland because, universal as I believe Yeats's plays are in their basic thematic and theatrical appeals, one cannot totally divorce them from the Irish traditions in which they are rooted. The particular examples provided by Grotowski and my own experience have convinced me that a profound understanding of those traditions is at least as important for interpreters of Yeats's plays as for their potential audiences. At present the creation of such an Irish company appears unlikely. But somehow it seems appropriate to leave the last word to that practical optimist, Lady Gregory:

61. Terence de Vere White, current literary editor of *The Irish Times*, dismisses Yeats as a dramatist with a particularly stubborn prejudice: "Nothing will persuade me that Yeats had as much drama in him as Browning. And I would not want to spend an evening at a Browning play. Would you?" *The Irish Times* (January 7, 1967), p. 8.

62. *Explorations*, p. 156.

If the dreamer had never tried to tell the dream that had come across him, even though to "betray his secret to the multitude must shatter his own perfect vision," the world would grow clogged and dull with the weight of flesh and of clay. And so we must say "God love you" to the Image-makers, for do we not live by the shining of those scattered fragments of their dreams?[63]

63. Augusta, Lady Gregory, "Notes for *The Image*", *The Collected Plays of Lady Gregory*, Vol. II, p. 297.

Selected Bibliography

1. BOOKS

Antoine, André.. *Mes Souvenirs sur le Théâtre Libre*. Arthème Fayarde, Paris, 1929.

——————. *Le Théâtre*. Les éditions de France, Paris, 1932.

Arbois de Jubainville, Henri d'. *The Irish Mythological Cycle and Celtic Mythology*. Translated by Richard Irvine Best. Hodges, Figgis & Co., Dublin, 1903.

Archer, William. *English Dramatists of Today*. Sampson, Low, Marston, Searle & Rivington, London, 1892.

——————. *The Old Drama and the New*. Heinemann, London, 1923.

——————, and Harley Granville-Barker. *A National Theatre Scheme and Estimates*. Duckworth & Co., London, 1907.

Arensberg, Conrad M. *The Irish Countryman*. Peter Smith, Gloucester, Mass., 1959.

——————, and Kimball, Solon T. *Family and Community in Ireland*. Harvard University Press, Cambridge, 1940.

Arnold, Matthew. *Lectures & Essays in Criticism*. Edited by R. H. Super. University of Michigan Press, Ann Arbor, 1962.

——————. *Letters of an Old Playgoer*. Dramatic Museum of Columbia University, New York, 1919.

Artaud, Antonin. *The Theatre and Its Double*. Grove Press, New York, 1958.

Bablet, Denis. *Edward Gordon Craig*. Translated by Daphne Woodward. Heinemann, London, 1966.

Balfour, Arthur James, M.P. *Nationality and Home Rule*. Longmans, Green & Co., London, 1913.

Barker, Ernest. *Ireland in the Last Fifty Years*. 2nd ed. Clarendon Press, Oxford, 1919.

Barnet, S., Berman, M., Burto, W., eds. *The Genius of the Irish Theatre*. Mentor Books, New York, 1960.

Bax, Arnold. *Farewell, My Youth*. Longmans, Green & Co., London, 1943.

Bax, Clifford. *Some I Knew Well*. Phoenix, London, 1951.

Beckson, Karl, ed. *Aesthetes and Decadents of the 1890's*. Random House, New York, 1966.

Becque, Henry. *Souvenirs d'un auteur dramatique*. Bibliothèque Artistique et Littéraire, Paris, 1895.

Beerbohm, Max. *Around Theatres*. Vols. I & II. Alfred A. Knopf, New York, 1930.

Benedikt, Michael, and Wellwarth, George E., eds. and trans. *Modern French Theatre, An Anthology of Plays*. E. P. Dutton & Co., New York, 1966.

Bentley, Eric, ed. *In Search of Theatre*. Vintage Books, New York, 1954.

—————. *The Playwright as Thinker*. Meridian Books, New York, 1960.

—————. *The Theory of the Modern Stage*. Penguin Books, Baltimore, Md., 1968.

Bjersley, Brigit. *The Interpretation of the Cuchulain Legend in the Works of W. B. Yeats*. A.-B. Lundequistska Bokhanden, Uppsala, 1950.

Blau, Herbert. *The Impossible Theatre: A Manifesto*. Collier Books, New York, 1965.

Blavatsky, Helen P. B. *The Secret Doctrine: The Synthesis of Science, Religion and Philosophy*. 2nd ed. 2 vols. Theosophical Publishing Co., London, 1888.

Block, Haskell M. *Mallarmé and the Symbolist Drama*. Wayne State University Press, Detroit, 1963.

Blunt, Wilfred S. *My Diaries*. Foreword by Lady Gregory. 2 vols. Martin Secker, London, 1919-20.

Book of the Rhymers' Club, The. Elkin Matthews, London, 1892.

Bourgeois, Maurice. *John Millington Synge and the Irish Theatre*. Constable & Co., London, 1913.

Boyd, Ernest. *Appreciations and Depreciations: Irish Literary Studies*. The Talbot Press, Dublin, 1917.

—————. *The Contemporary Drama of Ireland*. The Talbot Press, Dublin, 1915.

—————. *Ireland's Literary Renaissance*. Alfred A. Knopf, New York, 1922.

Boyle, William. *The Building Fund*. Maunsel & Co., Dublin, 1905.

—————. *The Eloquent Dempsey*. Gill & Sons, Dublin, 1911.

—————. *The Mineral Workers*. Gill & Sons, Dublin, 1910.

Brook, Peter. *The Empty Space*. MacGibbon & Kee, London, 1968.

Brown, Malcolm. *The Policies of Irish Literature from Thomas Davis to W. B. Yeats*. George Allen & Unwin, Ltd., London, 1972.

Byrne, Dawson. *The Story of Ireland's National Theatre*. The Talbot Press Dublin, 1929.

Butler, Dom Cuthbert. *Western Mysticism.* Arrow Books, London, 1960.

Campbell, Beatrice (Mrs. Patrick). *My Life and Some Letters.* Hutchinson, London, 1922.

Canfield, Curtis. *Plays of Changing Ireland.* Macmillan Co., New York, 1936.

————, ed. *Plays of the Irish Renaissance.* Ives Washburn, New York, 1938.

Chisholm, Cecil. *Repertory: An Outline of the Modern Theatre Movement.* Peter Davies, London, 1939.

Clark, David R. *W. B. Yeats and the Theatre of Desolate Reality.* Dolmen Press, Dublin, 1965.

————, and Mayhew, George P. *A Tower of Polished Black Stones: Early Version of "The Shadowy Waters".* Dolmen Press, Dublin, 1971.

Clark, William Smith. *The Early Irish Stage.* Clarendon Press, Oxford, 1955.

Clarke, Austin. *A Penny in the Clouds.* Routledge & Kegan Paul, London, 1968.

————. *Twice Round the Black Church: Early Memories of Ireland and England.* Routledge & Kegan Paul, London, 1962.

Coffey, Diarmid. *Douglas Hyde.* The Talbot Press, Dublin, 1936.

Colum, Mary Maguire. *Life and the Dream.* Macmillan & Co., London, 1947.

Colum, Mary and Padraic. *Our Friend James Joyce.* Gollancz, London, 1939.

Colum, Padraic. *Arthur Griffith.* Browne & Nolan, Dublin, n.d.

————. *My Irish Year.* Mills & Boon, London, 1912.

————. *The Road Round Ireland.* Macmillan Co., New York, 1926.

————. *Thomas Muskerry.* Maunsel & Co., Dublin, 1910.

————. *Three Plays.* Allen Figgis, Dublin, 1963.

Coquelin, C. *The Art of the Actor.* Translated by Elsie Fogerty. Allen & Unwin, London, 1935.

Corkery, Daniel. *The Hidden Ireland.* Gill & Sons, Dublin, 1967.

————. *Synge and Anglo-Irish Literature.* Cork University Press, Cork, 1931.

Corrigan, Robert W., and Rosenberg, James L., eds. *The Context and Craft of Drama.* Chandler Publishing Company, San Francisco, 1964.

————, ed. *Theatre in the Twentieth Century.* Grove Press, New York, 1963.

Courtney, Sister Marie-Thérèse. *Edward Martyn and the Irish Theatre.* Vantage Press, New York, 1957.

Courtney, W. L. *The Development of Maurice Maeterlinck.* Grant Richards, London, 1904.

Cousins, James H. and Margaret E. *We Two Together.* Ganesh & Co., Madras, 1950.

Cox, Harvey. *The Feast of Fools: A Theological Essay on Festivity and Fantasy.* Harvard University Press, Cambridge, 1969.

Coxhead, Elizabeth. *Daughters of Erin.* Secker & Warburg, London, 1965.

————. *Lady Gregory: A Literary Portrait.* Macmillan & Co., London, 1961.

Craig, Edward. *Gordon Craig: The Story of His Life.* Gollancz, London, 1968.

Craig, Edward Gordon. *The Art of the Theatre.* T. Foulis, London, 1905.

_____. *Designs for the Theatre*. Edited by Janet Leeper. Penguin Books, Harmondsworth, 1948.

_____. *Henry Irving*. Dent & Sons, London, 1938.

_____. *Index to the Story of My Days: Some Memoirs of Edward Gordon Craig, 1872-1907*. Hutton, London, 1959.

_____. *Scene*. Oxford University Press, London, 1923.

Cronbach, Lee J. *Educational Psychology*. Harcourt, Brace & World, New York, 1964.

Croydon, Margaret. *Lunatics, Lovers and Poets: The Contemporary Experimental Theatre*. McGraw-Hill Book Co., New York, 1974.

Csato, Edward. *Contemporary Polish Theatre*. Interpress Publishers, Warsaw, 1968.

Curtis, Edmund. *A History of Ireland*. Methuen & Co., London, 1936.

Daniels, May. *The French Drama of the Unspoken*. Edinburgh University Press, Edinburgh, 1953.

De Fréine, Sean. *The Great Silence*. Foilseachain Naisiunta Teoranta, Dublin, 1965.

Denson, Alan, ed. *Letters from A. E.* Abelard-Schuman, London, 1961.

Dickinson, P. L. *Dublin of Yesteryear*. Methuen & Co., London, 1929.

Digby, Margaret. *Horace Plunkett: An Anglo-American Irishman*. Basil Blackwell, Oxford, 1949.

Dillon, Myles, and Chadwick, Nora. *The Celtic Realms*. New American Library, New York, 1967.

Dodds, E. R. *The Greeks and the Irrational*. University of California Press, Berkeley, 1969.

Donoghue, Denis, ed. *The Integrity of Yeats*. The Thomas Davis Lectures. The Mercier Press, Cork, 1964.

Dorrington, Arnold. *The Work and Ideas of Arnold Dolmetsch*. Dolmetsch Foundation, Haslemere, 1932.

Dubois, L. Paul. *Contemporary Ireland*. With an Introduction by T. M. Kellie. Maunsel & Co., Dublin, 1908.

Duffy, The Honourable Sir Charles C. *Young Ireland: A Fragment of Irish History, 1840-1845*. T. Fisher Unwin, London, 1896.

Duggan, George C. *The Stage Irishman*. The Talbot Press, Dublin, 1937.

Dunraven, The Right Honourable Earl of. *The Outlook in Ireland*. Hodges, Figgis Co., Dublin, 1908.

Eglington, John (W. K. Magee). *Anglo-Irish Essays*. The Talbot Press, Dublin, 1917.

_____. *Irish Literary Portraits*. Macmillan & Co., London, 1935.

_____. *Literary Ideals in Ireland*. T. Fisher Unwin, London, 1899.

Eliade, Mircea. *Rites and Symbols of Initiation*. Harper & Row, New York, 1965.

Ellmann, Richard. *Eminent Domain: Yeats among Wilde, Joyce, Pound, Eliot, and Auden*. Oxford University Press, New York, 1967.

———. *The Identity of Yeats*. Macmillan & Co., London, 1954.

———. *James Joyce*. Oxford University Press, New York, 1959.

———. *Yeats: The Man and the Mask*. Faber & Faber, London, 1961.

Engelberg, Edward. *The Vast Design: Patterns in W. B. Yeats's Aesthetics*. University of Toronto Press, Toronto, 1964.

Ervine, St. John. *John Ferguson*. Maunsel & Co., Dublin, 1915.

———. *The Magnanimous Lover*. Maunsel & Co., Dublin, 1912.

———. *Mixed Marriage*. Maunsel & Co., Dublin, 1911.

———. *The Organised Theatre*. Allen & Unwin, London, 1924.

———. *Some Impressions of My Elders*. Allen & Unwin, London, 1923.

———. *The Theatre in My Time*. Rich & Cowen, London, 1933.

Fallon, Gabriel. *Sean O'Casey, the Man I Know*. Routledge & Kegan Paul, London, 1965.

Farr, Florence (S.S.D.D.). *A Short Enquiry Concerning the Hermetic Art*. Theosophical Publishing House, London, 1894.

———. *The Music of Speech, containing the words of some poets, thinkers and music-makers regarding the practice of Bardic Art together with Fragments of verse set to its own melody by Florence Farr*. Elkin Matthews, London, 1909.

Farrington, Brian. *Malachi-Stilt-Jack: A Study of W. B. Yeats and His Work*. Connolly Publications, London, 1965.

Fay, Frank. *Towards a National Theatre: Dramatic Criticism of Frank Fay*. Edited by Robert Hogan. Dolmen Press, Dublin, 1970.

Fay, Gerard. *The Abbey Theatre: Cradle of Genius*. Hollis and Carter, London, 1958.

———. *Fay's Third Book*. Hutchinson, London, 1964.

Fay, William G. Foreword to *Five Three-Act Plays*. Rich & Cowen, London, 1933.

———. *How to Make a Simple Stage and the Scenery for It*. Samuel French, London, 1931.

———. *Merely Players*. Rich & Cowen, London, 1931.

———, and Catherine Carswell. *The Fays of the Abbey Theatre*. Rich & Cowen, London, 1935.

Fergusson, Francis. *The Idea of a Theatre*. Doubleday & Co., New York, 1949.

Fingall, Countess Elizabeth of. *Seventy Years Young*. As told to Pamela Hinkson. Collins, London, 1937.

Fitzmaurice, George. *Five Plays*. Little, Brown & Co., Boston, 1917.

Flacelière, Robert. *Daily Life in Greece at the Time of Pericles*. Translated by Peter Green. Weidenfeld and Nicolson, London, 1959.

Flannery, James W. *Miss Annie F. Horniman and the Abbey Theatre*. Dolmen Press, Dublin, 1970.

Fletcher, Iaian, and Kermode, Frank, eds. *Poets of the Nineties*. John Baker, London, 1965.

Frazer, J. G. *The Golden Bough: A Study in Magic and Religion*. Abridged ed. Macmillan Co., New York, 1922.

Galsworthy, John. *The Inn of Tranquillity*. Heinemann, London, 1912.

Gassner, John. *Form and Idea in Modern Theatre*. The Dryden Press, New York, 1956.

————, and Allen, Ralph G. *Theatre and Drama in the Making*. Vols. I & II. Houghton Mifflin Co., Boston, 1964.

Gaunt, William. *The Aesthetic Adventure*. Jonathan Cape, London, 1945.

Goble, Frank G. *The Third Force: The Psychology of Abraham Maslow*. Simon & Schuster, New York, 1970.

Goethe, Wolfgang von. *Autobiography: Poetry and Truth from My Own Life*. Translated by R. O. Moon. Public Affairs Press, Washington, D. C., 1949.

Goffman, Erving. *The Presentation of Self in Everyday Life*. Doubleday, Garden City, N. Y., 1959.

Gogarty, Oliver St. John. *As I Was Going Down Sackville Street*. Rich & Cowen, London, 1937.

————. *It Isn't This Time of Year At All*. MacGibbon & Kee, London, 1954.

————. *W. B. Yeats, A Memoir*. Dolmen Press, Dublin, 1963.

Goldie, Grace Wyndham. *The Liverpool Repertory Theatre, 1911-34*. The University Press of Liverpool, Hodder & Stoughton, London, 1935.

Good, James Winder. *Irish Unionism*. The Talbot Press, Dublin, 1920.

Gorelik, Mordecai. *New Theatres for Old*. Samuel French, New York, 1957.

Greene, David H., and Stephens, Edward M. *J. M. Synge*. Collier Books, New York, 1961.

Greeves, C. Desmond. *The Life and Times of James Connelly*. Lawrence & Wishart, London, 1961.

Gregory, Lady Isabella Augusta, ed. *Autobiography of Sir William Gregory*. Murray, London, 1894.

————. *A Book of Saints and Wonders*. Dun Emer, Dundrum, 1906.

————. *A Case for the Return of Sir Hugh Lane's Pictures to Dublin*. The Talbot Press, Dublin, 1926.

————. *Coole*. Cuala Press, Dublin, 1931.

————. *Cuchulain of Muirthemne: The Story of the Men of the Red Branch of Ulster*. Preface by W. B. Yeats. Murray, London, 1902.

————. *Gods and Fighting Men: The Story of the Tuatha de Danaan and of the Fianna of Ireland*. Preface by W. B. Yeats. Murray, London, 1904.

————. *The Golden Apple*. Murray, London, 1916.

————. *The Collected Plays*. Edited by Ann Saddlemyer. Colin Smythe, Gerrards Cross, 1970.

————. *Hugh Lane's Life and Achievement*. With some account of the Dublin Galleries. Murray, London, 1921.

————, ed. *Ideals in Ireland*. Unicorn Press, London, 1901.

————. *The Image and Other Plays*. Putnam, London, 1922.

_____. *Irish Folk History Plays*, First Series. Putnam, London, 1912.

_____. *Journals: 1916-1930*. Edited by Lennox Robinson. Putnam, London, 1946.

_____. *The Kiltartan History Book*. Maunsel & Co., Dublin, 1909.

_____. *The Kiltartan Molière*. Maunsel & Co., Dublin, 1909.

_____. *The Kiltartan Poetry Book:* Translated from the Irish. Putnam, London, 1919.

_____. *The Kiltartan Wonder Book*. Maunsel & Co., Dublin, 1910.

_____. *Kincora*. 2nd ed. Maunsel & Co., Dublin, 1905.

_____. *Mirandolina*. Putnam, London, 1924.

_____, ed. *Mr. Gregory's Letter Box: 1813-1830*. Smith, Elder, London, 1898.

_____. *My First Play, Colman and Guaire*. Elkin Matthews & Marrot, London, 1930.

_____. *New Comedies*. Putnam, London, 1913.

_____. *On the Racecourse*. Putnam, London, 1926.

_____. *Our Irish Theatre*. Putnam, London, 1913.

_____. *Poets and Dreamers*. 3rd ed. Hodges & Figgis, Dublin, 1903.

_____. *Selected Plays*. Edited by Elizabeth Coxhead. Putnam, London, 1962.

_____. *Seven Short Plays*. Maunsel & Co., Dublin, 1909.

_____. *The Story Brought by Brigit*. Putnam, London, 1924.

_____. *Three Last Plays*. Putnam, London, 1928.

_____. *Three Wonder Plays*. Putnam. London, 1923.

_____. *Visions and Beliefs in the West of Ireland*. With two essays and notes by W. B. Yeats. 2 vols. Putnam, London, 1920.

Grein, J. T. *Dramatic Criticism*. J. Long, London, 1899.

Griffith, Arthur, ed. *Thomas Davis: The Thinker and Teacher*. Gill & Sons, Dublin, 1914.

Grotowski, Jerzy. *Towards a Poor Theatre*. Simon & Schuster, New York, 1968.

Guicharnaud, Jacques. *Modern French Theatre from Giraudoux to Beckett*. Yale University Press, New Haven, 1961.

Gwynn, Denis. *Edward Martyn and the Irish Revival*. Jonathan Cape, London, 1930.

Gwynn, Stephen. *Experiences of a Literary Man*. Thornton Butterworth, London, 1926.

_____. *Irish Books and Irish People*. The Talbot Press, Dublin, 1919.

_____. *Irish Literature and Drama in the English Language*. Nelson, London, 1936.

_____, ed. *Scattering Branches: Tributes to the Memory of W. B. Yeats*. Macmillan & Co., London, 1940.

_____. *Today and Tomorrow in Ireland*. Hodges, Figgis Co., Dublin, 1903.

Hall, James, and Steinmann, Martin, eds. *The Permanence of Yeats: Selected Criticism*. Macmillan Co., New York, 1950.

Hamilton, Edith. *The Great Age of Greek Literature*. W. W. Morton & Co., New York, 1954.

————. *The Greek Way to Western Civilization*. Mentor Books, New York, 1961.

Harper, George. *Yeats's Golden Dawn*. Macmillan & Co., London, 1974.

Harrison, Jane. *Prolegomena to the Study of Greek Religion*. Meridian Books, New York, 1955.

————. *Themis, A Study of the Social Origins of Greek Religion*. Cambridge University Press, Cambridge, 1912.

Hayes, Carlton J. H. *The Historical Evolution of Modern Nationalism*. Macmillan Co., New York, 1931.

Henn, Thomas R. *The Lonely Tower: Studies in the Poetry of W. B. Yeats*. Methuen & Co., London, 1950.

Henry, Paul. *An Autobiography*. Foreword by Sean O'Faolain. B. T. Batsford, London, 1951.

Hertz, Frederick. *Nationality in History and Politics*. Routledge & Kegan Paul, London, 1944.

Hinkson, Katharine Tynan. *Memoires*. Nash & Grayson, London, 1924.

————. *The Middle Years*. Constable & Co., London, 1916.

————. *Miracle Plays*. John Lane, London, 1895.

————. *Twenty-Five Years: Reminiscences*. Smith, Elder, London, 1913.

Hogan, Robert. *After the Irish Renaissance*. Macmillan & Co., London, 1968.

————, and O'Neil, Michael J., eds. *Joseph Holloway's Abbey Theatre*. Southern Illinois University, Carbondale, 1967.

Hone, Joseph M. *W. B. Yeats, 1865-1939*. Macmillan & Co., London, 1965.

Horgan, John J. *Parnell to Pearse*. Browne & Nolan, Dublin, 1948.

Hough, Graham. *The Last Romantics*. Duckworth & Co., London, 1961.

Howarth, Herbert. *The Irish Writers 1880-1940: Literature under Parnell's Star*. Rockliff, London, 1958.

Howe, Percival P. *The Repertory Theatre: A Record and a Criticism*. Secker, London, 1910.

Hudson, Lynloir. *The English Stage, 1850-1950*. Harrap & Co., London, 1951.

Huneker, James. *Iconoclasts*. T. Werner Laurie, London, 1908.

Hyde, Douglas. *The Story of Early Gaelic Literature*. T. Fisher Unwin, London, 1895.

————, Duffy, Charles Gavan; and Sigerson, George. *The Revival of Irish Literature and Other Addresses*. T. Fisher Unwin, London, 1894.

Inglis, Brian. *West Briton*. Faber & Faber, London, 1962.

Jeffares, A. Norman. *W. B. Yeats, Man and Poet*. Routledge & Kegan Paul, London, 1962.

————, and Cross, K. G. W., eds. *In Excited Reverie: A Centenary Tribute to William Butler Yeats 1865-1939*. Macmillan & Co., London, 1965.

Josephson, Matthew. *Zola and His Time*. Russell & Russell, New York, 1969.

Jung, Carl. *Memories, Dreams, Reflections*. Edited by Aniela Jaffé, and translated by Richard and Clara Winston. Vintage Books, New York, 1963.

————. *Modern Man in Search of a Soul*. Translated by W. S. Dell and Cary F. Baynes. Harcourt, Brace & World, New York, 1933.

————. *The Portable Jung*. Edited by Joseph Campbell, and translated by R. F. C. Hull. Viking Press, New York, 1971.

————. *The Spirit in Man, Art, and Literature*. Translated by R. F. C. Hull. Routledge & Kegan Paul, London, 1966.

Kain, Richard M. *Dublin in the Age of W. B. Yeats and James Joyce*. Norman's University of Oklahoma Press, 1962.

Kavanagh, Peter. *The Story of the Abbey Theatre*. Devin-Adair, New York, 1950.

Kerr, Walter. *How Not to Write a Play*. Simon & Schuster, New York, 1955.

Kettle, Thomas. *The Day's Burden*. Browne and Nolan, Dublin, 1937.

Kingsford, Anna, and Maitland, Edward. *The Perfect Way*. John M. Watkins, London, 1882.

Kinne, Wisner Payne. *George Pierce Baker and the American Theatre*. Harvard University Press, Cambridge, 1954.

Kirby, Michael, ed. *Total Theatre*. E. P. Dutton & Co., New York, 1969.

Krause, David. *Sean O'Casey*. MacGibbon & Kee, London, 1960.

————. *A Self-Portrait of the Artist as a Man: Sean O'Casey's Letters*. Dolmen Press, Dublin, 1968.

Larkin, Emmett. *James Larkin, Irish Labour Leader*. Routledge & Kegan Paul, London, 1965.

Lawrence, W. J. *Old Theatre Days and Ways*. Harrap & Co., London, 1935.

Le Gallienne, Richard. *The Romantic '90's*. Putnam, London, 1951.

Lehmann, Andrew G. *The Symbolist Aesthetics in France: 1885-1895*. Basil Blackwell, Oxford, 1950.

Loftus, Richard J. *Nationalism in Modern Anglo-Irish Poetry*. University of Wisconsin Press, Madison, 1964.

Lyons, F. S. L. *The Fall of Parnell*. Routledge & Kegan Paul, London, 1960.

————. *The Irish Parliamentary Party: 1890-1910*. Faber & Faber, London, 1951.

Lyons, George A. *Some Recollections of Griffith and His Times*. The Talbot Press, Dublin, 1923.

Lytton, Constance. *Letters*. Selected and arranged by Betty Balfour. Heinemann, London, 1925.

Macardle, Dorothy. *The Irish Republic*. Corgi Books, London, 1968.

MacBride, Maud Gonne. *A Servant of the Queen*. Gollancz, London, 1938.

MacCana, Prionsias. *Celtic Mythology*. Hamlyn Publishing Group, London, 1970.

MacCarthy, Desmond. *The Court Theatre: 1904-1907*. A. H. Bullen, London, 1907.

MacDonagh, Thomas *Literature in Ireland: Studies Irish and Anglo-Irish*. The Talbot Press, Dublin, 1916.

_____. *When the Dawn is Come*. Maunsel & Co., Dublin, 1905.

MacGowan, Kenneth, and Melnitz, William. *The Living Stage*. Prentice-Hall, New York, 1962.

MacLiammoir, Michéal. *All for Hecuba*. Progress House, Dublin, 1961.

_____, and Smith, Edwin. *Ireland*. Thames & Hudson, London, 1966.

_____. *The Theatre in Ireland*. The Cultural Relations Committee of Ireland, Dublin, 1964.

MacManus, Francis, ed. *The Irish Struggle: 1916-1926*. Routledge & Kegan Paul, London, 1964.

_____. *The Yeats We Knew*. The Thomas Davis Lectures. The Mercier Press, Cork, 1965.

MacManus, Seamus. *The Townland of Tamney*. P. U. Malloy, Donegal, 1902.

MacNeice, Louis. *The Poetry of W. B. Yeats*. Oxford University Press, London, 1941.

MacSwiney, Terence. *The Revolutionist*. Maunsel & Co., Dublin, 1914.

Maeterlinck, Maurice. *The Treasury of the Humble*. Translated by Alfred Sutro. Allen, London, 1897.

Malone, Andrew E. *The Irish Drama*. Constable & Co., London, 1929.

Mansergh, Nicholas. *The Irish Question, 1840-1921*. Allen & Unwin, London, 1965.

Marcus, Phillip L. *Yeats and the Beginning of the Irish Renaissance*. Cornell University Press, Ithaca, 1970.

Marshall, Norman. *The Other Theatre*. John Lehman, London, 1948.

Martin, F. X., o.s.a., ed. *Leaders and Men of the Easter Rising: Dublin 1916*. Methuen & Co., London, 1967.

Martyn, Edward. *The Dream Physician*. The Talbot Press, Dublin, 1914.

_____. *Grangecolman*. Maunsel & Co., Dublin, 1912.

_____. *The Heather Field and Maeve*. Introduction by George Moore. Duckworth & Co., London, 1899.

_____. *Ireland's Battle for Her Language*. Gaelic League, Dublin, n.d.

_____(Sirius). *Morgante the Lesser: His Notorious Life and Wonderful Deeds*. Swan Sonnenschein, London, 1890.

_____. *The Tale of a Town and an Enchanted Sea*. T. Fisher Unwin, London, 1902.

Mathers, Macgregor S. L. *The Kabbalah Unveiled*. Routledge and Kegan Paul, London, 1951.

Masefield, John. *John M. Synge: A Few Personal Recollections with Biographical Notes*. Macmillan Co., New York, 1915.

_____. *Some Memories of W. B. Yeats*. Cuala Press, Dublin, 1940.

Maslow, Abraham H. *Religious Values and Peak Experiences*. Viking Press, New York, 1964.

Maxwell, D. E. S., and Bushrui, S. B., eds. *W. B. Yeats, 1865-1965: Centenary Essays*. Ibadan University Press, 1965.

May, Rollo. *Love and Will*. Dell Publishing Co., New York, 1969.

McCann, Sean, ed. *The Story of the Abbey Theatre*. Four Square Books, London, 1967.

Melchiori, Giorgio. *The Whole Mystery of Art*. Routledge & Kegan Paul, London, 1960.

Merton, Thomas, *Mystics and Zen Masters*. Dell Publishing Co., New York, 1967.

Miller, Anna Irene. *The Independent Theatre in Europe*. Long & Smith, New York, 1931.

Mitchell, Susan. *Aids to the Immortality of Certain Persons in Ireland*. Maunsel & Co., Dublin, 1913.

Montague, Charles E. *Dramatic Values*. Methuen & Co., London, 1911.

Moore, George A. *Avowals*. Heinemann, London, 1919.

————. *The Bending of the Bough*. T. Fisher Unwin, London, 1900.

————. *Confessions of a Young Man*. Heinemann, London, 1916.

————. *Hail and Farewell: Ave, Salve, and Vale*. 3 vols. Heinemann, London, 1911-14.

————. *Impressions and Opinions*. T. Werner Laurie, London, 1913.

————. *The Lake*. Heinemann, London, 1921.

————. *Memoirs of My Dead Life*. Heinemann, London, 1921.

————. *Parnell and His Ireland*. Sonnenschein, London, 1887.

————. *Letters from George Moore to Edward Dujardin, 1886-1922*. Edited by John Eglington. Crosby Craige, New York, 1929.

————. *The Untilled Field*. T. Fisher Unwin, London, 1903.

Moore, John Rees. *Masks of Love and Death*. Cornell University Press, Ithaca, 1971.

Moore, Virginia. *The Unicorn: William Butler Yeats's Search for Reality*. Macmillan Co., New York, 1954.

Moran, D. P. *The Philosophy of Irish Ireland*. James Duffy & Co., Dublin, 1903.

Murray, Thomas C. *Maurice Harte*. George Allen, London, 1934.

————. *The Pipe in the Fields and Birthright*. Allen & Unwin, London, 1928.

————. *Spring and Other Plays*. The Talbot Press, Dublin, 1917.

Nathan, Leonard E. *The Tragic Drama of William Butler Yeats: Figures in a Dance*. Columbia University Press, New York, 1965.

Newman, Ernest. *Wagner as Man and Artist*. Tudor Publishing Co., New York, 1946.

Nicoll, Allardyce. *British Drama*. Harrap & Co., London, 1962.

————. *Late Nineteenth-Century Drama*. 2nd ed. Cambridge University Press, Cambridge, 1959.

————. *The Theatre and Dramatic Theory*. Harrap & Co., London, 1962.

————. *World Drama*. Harrap & Co., London, 1966.

Nic Shiubhlaigh, Maire, and Kenny, Edward. *The Splendid Years*. James Duffy, Dublin, 1955.

O'Brien, Conor Cruise. *Parnell and His Party*. Clarendon Press, Oxford, 1957.

————. *The Shaping of Modern Ireland*. Routledge & Kegan Paul, London, 1960.

O'Brien, The Honourable Georgina. *The Heart of the Peasant*. With an introduction by the Right Honourable Sir Edward Carson. Sirley's, London, 1908.

O'Casey, Sean. *Autobiographies*. Vols. 1 & 2. Macmillan & Co., London, 1963.

————. *Selected Plays*. Braziller, New York, 1954.

O'Connor, Frank. *The Backward Look*. Macmillan & Co., London, 1967.

————. *My Father's Son*. Gill & Macmillan, Dublin, 1968.

O'Connor, Ulick. *Oliver St. John Gogarty*. Jonathan Cape, London, 1964.

O'Donnell, Frank Hugh. *The Stage Irishman of the Pseudo-Celtic Drama*. John Long, London, 1904.

O'Driscoll, Robert, ed. *Theatre and Nationalism in Twentieth Century Ireland*. University of Toronto Press, Toronto, 1971.

————, and Reynolds, Lorna, eds. *Yeats and the Theatre*. Macmillan of Canada, Toronto, 1975.

O'Faolain, Sean. *The Irish*. Penguin Books, Harmondsworth, 1947.

————. *She Had to Do Something*. Jonathan Cape, London, 1938.

————. *Vive Moi!* Rupert Hart-Davies, London, 1965.

O'Grady, Hugh A. *Standish James O'Grady: The Man and the Writer*. The Talbot Press, Dublin, 1929.

O'Grady, Standish James. *History of Ireland*. 2 vols. E. Ponsonby, Dublin, 1878.

————. *Selected Essays and Passages*. Introduction by Ernest A. Boyd. T. Fisher Unwin, London, 1918.

O'Hanlon, Henry B. *The All-Alone*. Preface by Edward Martyn. Kiersey, Dublin, 1922.

O'Moore, Professor John J. *Education in the Republic of Ireland*. Encyclopaedia Britannica, London, 1965.

O'Neill, Michael J. *Lennox Robinson*. Twayne Publishers, New York, 1964.

Orme, Michael (Mrs. Alix A. Grein). *J. T. Grein: The Story of a Pioneer, 1862-1935*. Murray, London, 1936.

Ostrander, Sheila, and Schroeder, Lynn, eds. *Psychic Discoveries Behind the Iron Curtain*. Bontour Books, New York, 1970.

O'Sullivan, Donal. *Songs of the Irish*. Browne & Nolan, Dublin, 1967.

O'Sullivan, Seumas. *Essays and Recollections*. The Talbot Press, Dublin, 1946.

————. *The Rose and Bottle and other essays*. The Talbot Press, Dublin, 1946.

Ouspensky, P. D. *The Fourth Way*. Vintage Books, New York, 1971.

Parkinson, Thomas. *W. B. Yeats—Self-Critic*. University of California Press, 1951.

Pater, Walter. *Greek Studies*. Macmillan & Co., London, 1910.

Peacock, Ronald. *The Poet in the Theatre*. Hill & Wang, New York, 1960.

Pearse, Padraic H. *Plays, Stories, Poems*. The Talbot Press, Dublin, 1966.

Pearson, Hesketh. *The Last Actor-Managers*. Methuen & Co., London, 1950.

Plunkett, The Right Honourable Sir Horace, K.C.V.O., F.R.S. *Ireland in the New Century*. Murray, London, 1905.

Pogson, Rex. *Miss Horniman and the Gaiety Theatre, Manchester*. Rockliff, London, 1952.

Pound, Ezra, ed. *Passages from the Letters of John Butler Yeats*. Cuala Press, Dundrum, 1917.

Price, Alan. *Synge and Anglo-Irish Drama*. Methuen & Co., London, 1961.

Raine, Kathleen. *Yeats, The Tarot, and The Golden Dawn*. Dolmen Press, Dublin, 1972.

Regardie, Israel. *The Golden Dawn: An Account of the Teachings, Rites, and Ceremonies of the Order of the Golden Dawn*. 4 vols. Aries Press, Chicago, 1937-40.

——————. *My Rosicrucian Adventure*. Aries Press, Chicago, 1936.

——————. *The Tree of Life: A Study in Magic*. Samuel Weiser, New York, 1969.

Renan, Joseph Ernest. *The Poetry of the Celtic Races*. Walter Scott, London, 1892.

Reynolds, Ernest. *Early Victorian Drama: 1830-1870*. Heffer, Cambridge, 1936.

Rhys, John. *Early Celtic Britain*. Society for Promoting Christian Knowledge, London, 1908.

——————. *Lectures on the Origin and Growth of Religion as Illustrated by Celtic Heathendom*. Williams & Morgate, London. 1888.

Ricketts, Charles. *A Bibliography of the Books Issued by Bacon and Ricketts at the Vale Press*. Ballantyne Press, London, 1914.

——————. *Charles Ricketts, R.A.: Sixty-Five Illustrations*. Introduction by T. Sturge Moore. Cassell, London, 1933.

——————. *Pages of Art*. Constable & Co., London, 1913.

——————. *Self-Portrait: Letters and Journals of Charles Ricketts*. Compiled by T. Sturge Moore, and edited by Cecil Lewis. Peter Davies, London, 1939.

Robichez, Jacques. *Le Symbolisme au Théâtre*. L'Arche, Paris, 1955.

Robinson, John A. T., Bishop of Woolwich, *Honest to God*, SCM Press, London, 1963.

Robinson, Lennox, ed. *Further Letters of John Butler Yeats*. Cuala Press, Dundrum, 1920.

——————. *Ireland's Abbey Theatre: A History, 1899-1951*. Sidgwick and Jackson, London, 1951.

——————. *I Sometimes Think*. The Talbot Press, Dublin, 1956.

Rogers, Carl R. *On Becoming a Person*. Houghton Mifflin Co., Boston, 1961.

Roose-Evans, James. *Experimental Theatre from Stanislavsky to Today*. Universe Books, New York, 1973.

Roszak, Theodore. *The Making of a Counter-Culture: Reflections on the Technocratic Society and Its Youthful Opposition*. Doubleday, New York, 1969.

Rothenstein, William. *Men and Memories*. 3 vols. Faber & Faber, London, 1931-39.

Rougemont, E. de. *Villiers de l'Isle Adam: Biographie et Bibliographie*. Mercure de France, Paris, 1910.

Rowell, George. *The Victorian Theatre*. Oxford University Press, London, 1956.

Royal Institute of International Affairs. *Nationalism*. Oxford University Press, London, 1939.

Rudd, Margaret. *Divided Image: A Study of William Blake and W. B. Yeats*. Routledge & Kegan Paul, London, 1953.

Russell, George William (A.E.). *Imaginations and Reveries*. Maunsel & Co., Dublin, 1915.

————. *The Living Torch*. Edited by Monk Gibbon. Macmillan & Co., London, 1937.

————. *The National Being*. Maunsel & Co., Dublin, 1916.

————, ed. *New Songs*. O'Donoghue, Dublin, 1904.

————. *Passages from the Letters of A. E. to W. B. Yeats*. Cuala Press, Dublin, 1936.

————. *Some Irish Essays*. Maunsel & Co., Dublin, 1906.

Ryan, Frederick L. *Criticism and Courage and Other Essays*. Maunsel & Co., Dublin, 1921.

Ryan, W. R. *The Irish Literary Movement*. Published by the author, London, 1894.

Saddlemyer, Ann. *In Defence of Lady Gregory, Playwright*. Dolmen Press, Dublin, 1966.

Salvadori, Corinna. *Yeats Poet and Castiglione Courtier*. Allen Figgis, Dublin, 1965.

Schechner, Richard. *Public Domain: Essays on the Theatre*. Bobbs-Merrill Co., Indianapolis, 1969.

Schoenderwoerd, N. H. G. *J. T. Grein: Ambassador of the Theatre*. Van Gorcum & Camp, Netherlands, 1963.

Second Book of the Rhymers' Club, The. Elkin Matthews & John Lane, London, 1894.

Seiden, Morton Irving. *William Butler Yeats: The Poet as Mythmaker*. Michigan State University Press, East Lansing, 1962.

Sharp, Elizabeth A., comp. *William Sharp: A Memoir*. Heinemann, London, 1910.

————, and Matthay, J., eds. *Lyra Celtica*. With an introduction by William Sharp. John Grant, Edinburgh, 1932.

Shattuck, Roger. *The Banquet Years: The Origin of the Avant-Garde in France: 1885 to World War I*. Faber & Faber, London, 1959.

Shaw, George Bernard. *Our Theatre in the Nineties*. 3 vols. Constable & Co., London, 1948.

————. *The Perfect Wagnerite*. Constable & Co., London, 1902.

————. *Prefaces*. Constable & Co., London, 1934.

————. *The Quintessence of Ibsenism*. Hill & Wang, New York, 1960.

Sidnell, Michael J.; Mayhew, George P.; and Clark, David R. *Druid Craft: The Writing of "The Shadowy Waters"*. University of Massachusetts Press, Amherst, 1971.

Simons, Lee. *The Stage Is Set*. Harcourt, Brace & World, New York, 1932.

Skelton, Robin, and Clark, David R., eds. *Irish Renaissance*. Dolmen Press, Dublin, 1965.

——————, and Saddlemyer, Ann. *The World of W. B. Yeats: Essays in Perspective*. Dolmen Press, Dublin, 1965.

Skene, Reg. *The Cuchulain Plays of W. B. Yeats*. Macmillan Press, London, 1974.

Slade, Peter. *An Introduction to Child Drama*. University of London Press, London, 1958.

Slaughter, Howard K. *George Fitzmaurice and His Enchanted Land*. Dolmen Press, Dublin, 1972.

Smith, A. C. H. *Orghast at Persepolis*. Eyre Methuen, London, 1972.

Speaight, Robert. *William Poel and the Elizabethan Revival*. Heinemann, London, 1954.

Spirit of the Nation, The. T. Caldwell, Dublin, 1845.

Stanford, Derek, ed. *Poets of the Nineties*. John Baker Publishers, London, 1965.

Stanislavski, Constantin. *An Actor Prepares*. Translated by Elizabeth Reynolds Hapgood. Theatre Arts Books, New York, 1961.

——————. *My Life in Art*. Translated by J. J. Robbins. Theatre Arts Books, 1948.

Starkie, Edith. *Another Rimbaud*. New Directions, New York, 1961.

Stock, A. G. *W. B. Yeats: His Poetry and Thought*. Cambridge University Press, 1964.

Symons, Arthur. *The Collected Works of Arthur Symons*. 9 vols. Secker, London, 1924.

——————. *Plays, Acting and Music: A Book of Theory*. Constable & Co., London, 1909.

——————. *The Symbolist Movement in Literature*. Heinemann, London, 1899.

Synge, John Millington. *Collected Works: Plays, Books I & II*. Edited by Ann Saddlemyer. Oxford University Press, London, 1968.

——————. *Some Letters of J. M. Synge to Lady Gregory and W. B. Yeats*. Edited by Ann Saddlemyer. Cuala Press, Dublin, 1971.

——————. *The Works of John M. Synge*. 4 vols. Maunsel & Co., Dublin, 1910.

Taylor, Geoffrey, ed. *Irish Poets of the Nineteenth Century*. Routledge & Kegan Paul, London, 1951.

Taylor, Rex. *Michael Collins*. Four Square Books, London, 1958.

Teilhard de Chardin, Pierre. *The Future of Man*. Translated by Norman Denny. William Collins & Sons, Co., London, 1964.

——————. *The Phenomenon of Man*. Introduction by Julian Huxley, and translated by Bernard Wall. William Collins & Sons, Co., London, 1959.

Thalasso, Adolphe. *Le Théâtre Libre*. 2ᵉ ed. Mercure de France, Paris, 1909.

Thompson, William Irwin. *At the Edge of History: Speculations on the Transformation of Culture*. Harper & Row, New York, 1972.

——————. *The Imagination of an Insurrection:* Oxford University Press, New York, 1967.

——————. *Passages About Earth: An Explanation of the New Planetary Culture*. Harper & Row, New York, 1974.

Thomson, George. *Aeschylus and Athens*. Lawrence & Wishart, London, 1966.

Todhunter, John. *Alcestis*. Kegan Paul, London, 1879.

_____. *The Black Cat*. Henry, London, 1895.

_____. *Helena in Troas*. Kegan Paul, London, 1886.

_____. *Isolt of Ireland and the Poison Flower*. Dent, London, 1927.

_____. *A Sicilian Idyll*. Elkin Matthews, London, 1890.

Trewin, J. C. *The Birmingham Repertory Theatre*. Barrie and Rockliff, London, 1963.

Unterecker, John, ed. *Yeats: A Collection of Critical Essays*. Prentice-Hall, New York, 1963.

Ure, Peter. *Towards a Mythology: Studies in the Poetry of W. B. Yeats*. Hodder & Stoughton, London, 1946.

_____. *Yeats*. Oliver & Boyd, Edinburgh, 1963.

_____. *Yeats the Playwright: A Commentary on Character and Design in the Major Plays*. Routledge & Kegan Paul, London, 1963.

Ussher, Percy Arland. *The Face and Mind of Ireland*. Devin-Adair Co., New York, 1950.

_____. *Three Great Irishmen: Shaw, Yeats, Joyce*. Gollancz, London, 1952.

Vendler, Helen. *Yeats's Vision, and the Later Plays*. Harvard University Press, Cambridge, 1963.

Villiers de l'Isle Adam, Count Auguste. *Axël*. Maison Quantin, Paris, 1890.

_____. *La Révolte*. Lemerre, Paris, 1870.

Wagner, Richard. *Prose Works*. Translated by W. A. Ellis. 9 vols. Kegan Paul, Trench, Trubner, London, 1892-99.

Walkley, Arthur B. *Drama and Life*. Methuen & Co., London, 1908.

_____. *Dramatic Criticism*. Murray, London, 1903.

_____. *Playhouse Impressions*. T. Fisher Unwin, London, 1892.

Watts, Alan. *Behold the Spirit: A Study in the Necessity of Mystical Religion*. Vintage Books, New York, 1971.

_____. *Psychotherapy East and West*. Pantheon Books, N. Y., 1961.

Way, Brian. *Development Through Drama*. Longmans, Green & Co., London, 1967.

Wexman, S. M. *Antoine and the Théâtre Libre*. Harvard University Press, Cambridge, 1926.

Weygandt, Cornelius. *Irish Plays and Playwrights*. Constable & Co., London, 1913.

Whitaker, Thomas R., ed. *Twentieth Century Interpretations of the "Playboy of the Western World"*. Prentice-Hall, New York, 1969.

Wilde, Oscar. *Essays and Lectures*. 5th ed. Methuen & Co., London, 1926.

_____. *Oscar Wilde's Plays, Prose Writings, and Poems*. Everyman's, London, 1930.

Wilson, Colin. *The Occult*. Vintage Books, New York, 1973.

Wilson, Edmund. *Axel's Castle*. Charles Scribner's Sons, New York, 1943.

Wilson, Francis A. C. *W. B. Yeats and Tradition*. Gollancz, London, 1958.

Woodham-Smith, Cecil. *The Great Hunger: Ireland 1845-1849*. Harper & Row, New York, 1962.

Yeats, John Butler. *Early Memories: Some Chapters of Autobiography*. Cuala Press, Dundrum, 1923.

―――. *Essays Irish and American, with an Appreciation by A. E.* Books for Libraries Press, Freeport, New York, 1969.

―――. *Letters to His Son W. B. Yeats and Others, 1869-1922*. Edited by Joseph Hone. E. P. Dutton & Co., New York, 1946.

Yeats, William Butler. *Autobiographies*. Macmillan & Co., London, 1955.

―――. *The Celtic Twilight*. Maunsel & Co., Dublin, 1905.

―――. *The Collected Plays of W. B. Yeats*. Macmillan & Co., London, 1952.

―――. *The Collected Poems of W. B. Yeats*. Macmillan & Co., London, 1952.

―――. *The Collected Works of W. B. Yeats*. 8 vols. A. H. Bullen, Stratford-on-Avon, 1908.

―――. *The Countess Cathleen and Various Legends and Lyrics*. T. Fisher Unwin, London, 1892.

―――. *Essays and Introductions*. Macmillan & Co., London, 1961.

―――. *Four Plays for Dancers*. Macmillan & Co., London, 1921.

―――. *If I Were Four-and-Twenty*. Cuala Press, Dublin, 1940.

―――. *Images of a Poet*. Exhibition Catalogue. The Building Centre, Dublin, 1961.

―――. *John Sherman and Dhoya*. Edited by Richard J. Finnerman. Wayne State University Press, Detroit, 1969.

―――. *The King's Threshold and On Baile's Strand*. Bullen, London, 1904.

―――. *The Letters of W. B. Yeats*. Edited by Allen Wade. Rupert Hart-Davis, London, 1954.

―――. *Letters on Poetry from W. B. Yeats to Dorothy Wellesley*. Oxford University Press, London, 1964.

―――. *Letters to the New Island*. Edited by Horace Reynolds. Harvard University Press, Cambridge, 1934.

―――. *Memoirs*. Edited by Denis Donoghue. Macmillan & Co., London, 1972.

―――. *Mythologies*. Macmillan & Co., London, 1959.

―――. *On the Boiler*. Cuala Press, Dublin, 1939.

―――, ed. *The Oxford Book of Modern Verse*. Clarendon Press, Oxford, 1936.

―――. *Pages from a Dairy Written in Nineteen Hundred and Thirty*. Cuala Press, Dublin, 1944.

―――. *Plays and Controversies*. Macmillan & Co., London, 1923.

―――. *Plays for an Irish Theatre*. With designs by Gordon Craig. Bullen, London, 1911.

―――. *Plays in Prose and Verse Written for an Irish Theatre and Generally with the Help of a Friend*. Macmillan & Co., London, 1922.

_____. *Poems*. T. Fisher Unwin, London, 1927.

_____. *Poems: 1899-1905*. Bullen, London, 1906.

_____. *The Poems of W. B. Yeats*. 2 vols. Macmillan & Co., London, 1949.

_____. *The Secret Rose*. Bullen, London, 1897.

_____. *The Shadowy Waters*. Hodder & Stoughton, London, 1901.

_____. *Synge and the Ireland of His Time*. With a note concerning a walk through Connemara with him by Jack Butler Yeats. Cuala Press, Dundrum, 1911.

_____. *Uncollected Prose 1886-1896*. Edited by John B. Frayne. Columbia University Press, New York, 1970.

_____. *The Variorum Edition of the Plays of W. B. Yeats*. Edited by Russell K. Alspach. Macmillan & Co., London, 1966.

_____. *The Variorum Edition of the Poems of W. B. Yeats*. Edited by Peter Allt and Russell K. Alspach. Macmillan Co., New York, 1957.

_____. *A Vision*. T. Werner Laurie, London, 1925.

_____. *A Vision*. Macmillan & Co., London, 1937.

_____. *Where There is Nothing*. Bullen, London, 1903.

_____, and Ellis, Edwin John, eds. *The Works of William Blake: Poetic, Symbolic and Critical*. 3 vols. Quaritch, London, 1893.

_____, and Johnson, Lionel. *Poetry and Ireland*. Cuala Press, Dundrum, 1908.

_____, and Moore, T. Sturge. *Correspondence 1900-1937*. Edited by Ursula Bridges. Routledge & Kegan Paul, London, 1953.

_____, and Ruddock, Margot. *Ah, Sweet Dancer*. Edited by Roger McHugh. Macmillan & Co., London, 1970.

Zola, Emile. *Le Naturalisme au Théâtre*. Charpentier, Paris, 1889.

Zwerdling, Alec. *Yeats and the Heroic Ideal*. New York University Press, New York, 1965.

2. THESES

Borse, Abinash Chandra. *Mysticism in Poetry: A Study of A.E., W. B. Yeats, and Rabindranath Tagore*. Ph.D. Thesis for Trinity College, Dublin, 1937.

Butler, Henry J. *A Thesis on the Abbey Theatre and the Principal Writers Connected Therewith*. Ph.D. Thesis for the National University of Ireland, Dublin, 1952.

Cole, Alan Sargent. *Stagecraft in the Modern Dublin Theatre*. Ph.D. Thesis for Trinity College, Dublin, 1952.

Conlin, Rev. Matthew T., O.F.M. *T. C. Murray: A Critical Study of His Dramatic Work*. Ph.D. Thesis for University College, Dublin, 1952.

Davis, Richard Perceval. *The Rise of Sinn Fein, 1891-1910*. M. Litt. Thesis for Trinity College, Dublin, 1956.

Flannery, James W. *W. B. Yeats and the Idea of a Theatre: The Early Abbey Theatre in Theory and Practice*. Ph.D. Thesis for Trinity College, Dublin, 1970.

Gibbon, Monk. *The Early Years of George Russell (A.E.) and his Connection with the Theosophical Movement*. Ph.D. Thesis for Trinity College, Dublin, 1948.

Heaslip, E. W. *Irish Gaelic Literature*. B. Litt. Thesis for Trinity College, Dublin, 1954.

O'Brien, Frank P. *Poetry and Literary Attitudes in the Language Movement*. Ph.D. Thesis for Trinity College, Dublin, undated.

O'Driscoll, Robert. *A Critical Study of the Works of Samuel Ferguson*. Ph.D. Thesis for the University of London, 1963.

Saddlemyer, Ann. *Dramatic Theory and Practice in the Irish Literary Theatre*. Ph.D. Thesis for the University of London, 1961.

Young, Lorna D. *The Plays of Lady Gregory*. Ph.D. Thesis for Trinity College, Dublin, 1958.

3. MANUSCRIPTS

Abbey Theatre Management. Financial accounts, business correspondence, patents, 1904-1932. National Library of Ireland, Ms. 13068.

Collection Edward Gordon Craig, Bibliothèque Nationale, Paris. Correspondence between W. B. Yeats and Gordon Craig, 1902-1917.

Craig, Gordon. Letters to W. B. Yeats, 1903-1911. In the possession of Michael Yeats.

Fay, Frank J. Lectures and Articles on the Theatre. National Library of Ireland, Mss. 10951-52.

—————. Letters to J. M. Synge, 1903-1907. National Library of Ireland, P 5381.

—————. "Some Thoughts on Acting". National Library of Ireland, Ms. 10953.

Fay, W. G. Articles and Letters. National Library of Ireland, Mss. 10951-52.

—————. Articles on the Theatre. National Library of Ireland, Ms. 5981.

—————. Clippings, reviews, etc. National Library of Ireland, Ms. 5975.

—————. Correspondence, including letters from G. B. Shaw, W. B. Yeats, and Lady Gregory. National Library of Ireland, Ms. 2652.

—————. Letter dated August 31, 1913, concerning Gen. John Regan. F. S. Bourke collection. National Library of Ireland, Ms. 10951.

—————. Letters to W. B. Yeats. National Library of Ireland, Ms. 5977.

—————. List of plays produced by Fay. National Library of Ireland, Ms. 5980.

—————. Press clippings concerning W. G. Fay and the theatre in Ireland and Scotland, 1929-1947. National Library of Ireland, Ms. 5976.

—————. Rough draft for "The Fays at the Abbey Theatre". National Library of Ireland, Ms. 5988.

Financial Statement, July 1907 to November 1910. Henderson Press Cuttings. National Library of Ireland, Ms. 1733.

Gregory, Isabella Augusta, Lady. Letters to Sara Allgood, 1921-1929. Yeats Library, Sligo.

—————. Letters to J. M. Synge, 1898-1908. National Library of Ireland, P 5381.

_____. Letters to the Hon. W. H. Lecky, 1898. Trinity College, Dublin Library, Ms. 2449.

_____. Letters to W. B. Yeats, 1903-1905. In the possession of Michael Yeats.

Hannay, Rev. J. O. Correspondence concerning *The Playboy of the Western World*. Trinity College, Dublin Library, Ms. 374.

Harper, George. *The Mingling of Heaven and Earth: Yeats's Theory of the Theatre*.

Henderson, W. H. *The Irish National Theatre Movement*, press cuttings with annotations. 9 vols. National Library of Ireland, Mss. 1729-1732.

_____. *The Playboy and What He Did*, clippings and annotations concerning the controversy over *The Playboy of the Western World*. National Library of Ireland, Ms. 1720.

Holloway, Joseph. Correspondence. National Library of Ireland, Mss. 3267-69.

_____. *Impressions of a Dublin Playgoer 1895-1944*, closely detailed diary. 223 vols. National Library of Ireland, Mss. 1796-1905.

_____. "Letters". National Library of Ireland, Ms. 4455.

_____. Press Clippings of Abbey Theatre reviews, May 1899 to July 1921. National Library of Ireland, Mss. 4374-4453.

Horniman, A. E. F. Letters to Abbey Theatre directors and to W. B. Yeats, 1903-1911. National Library of Ireland, Ms. 13068.

Irish National Theatre Company. Correspondence and reports, 1902-1903. National Library of Ireland, Ms. 13068.

Lawrence, W. J. Press clippings. National Library of Ireland, Ms. 4296.

Roberts, George, Collection. Minutes of the Irish National Theatre Society and letters to Maire Garvey from Frank Fay and others. National Library of Ireland, Mss. 5651-2, 7267, and 5320.

Synge, John Millington. Letters to Brodney Brodsky. Trinity College, Dublin Library, Ms. 3460.

_____. Letters to Frank Fay, 1906. National Library of Ireland, Ms. 13617.

_____. Letters to Max Meyerfeld. Trinity College, Dublin Library, Ms. 778.

_____. Letters to Molly Allgood. National Library of Ireland, Ms. 13097.

_____. Letters to Publishers and a Young Playwright. Trinity College, Dublin Library, Ms. 3554.

Synge Papers. National Library of Ireland, P 5380.

Yeats, William Butler. Letters to Lady Gregory, 1903-1905. In the possession of Michael Yeats.

_____. Letters to Charles Ricketts, 1903-1905. In the possession of Michael Yeats.

_____. Letters to J. M. Synge, 1898-1908. National Library of Ireland, P 5381.

_____. Memoranda dated 1906, 1913, and 1915 to the Irish National Theatre Company. In the possession of Michael Yeats.

————. Memorandum written for Horace Plunkett on the occasion of the patent enquiry, 1904, entitled "Plays produced by the Irish Literary Theatre and the Irish National Theatre Company". In the possession of Michael Yeats.

————. Notebooks, 1911-1913, containing personal stage designs for the Abbey Theatre. In the possession of Michael Yeats.

4. PERSONAL INTERVIEWS

Blythe, Ernest. March 3, 1966.

Bodkin, Emma. August 9, 1966.

Brogan, Harry. July 13, 1966.

Byrne, Edward. June 24, 1966.

Clarke, Austin. October 18; 1965; May 1, 1966.

Colum, Padraic. February 3, 1966; February 20, 1966; March 17, 1966.

Craig, May. June 21, 1966.

Crowe, Eileen. July 28, 1966.

Curran, Dr. Constantin P. April 26, 1966.

Edwards, Hilton. November 13, 1964.

Fallon, Gabriel. June 8, 1966.

Fay, Gerard. July 19, 1966.

Gorman, Eric. May 24, 1966.

Hayden, Christine. August 4, 1966.

Larchet, Dr. John. July 11, 1966.

Leonard, Hugh. April 7, 1966.

MacGreevy, Dr. Thomas. May 10, 1966; August 3, 1966.

MacLiammoir, Micheal. August 4, 1966; May 24, 1966.

Moisievitch, Tanya. October 3, 1965.

Mooney, Ria. October 21, 1965; July 14, 1966; July 22, 1966.

O'Brien, Dr. George. June 30, 1966.

O'Connor, Frank. February 3, 1966.

O'Connor, Ulick. July 12, 1966.

Richards, Shelah. May 1, 1966.

Robinson, Dolly. July 4, 1966.

Saddlemyer, Ann. March 26, 1966; March 28, 1966.

Scott, Michael. July 21, 1966.

Ussher, Arland. July 11, 1966.

Watkinson, Eve. March 13, 1966.

Yeats, Anne. April 17, 1966.

Index

Auden - Plays. The Dance of Death,
 the Chase — changed because
Auden collaborated with Isherwood &
 it became; The Dog beneath the Skin
Co-author - Isherwood - Auden

Ubu Roi P. 120. by alfred Jarry

Lugné-Poes production of _Ubu Roi_
see p.115 in December 1896 — in Paris
114 f. for details — a riot followed the performance
Yeats was there — p.124

P. 109-127
French Symbolist Poets — axël
Movement — inspired by stéphane Mallarmé 1842-1898
Express mystical relationship between man & the
Villiers de l'Isle Adam — 1838-89 axël universe

P.147— The Countess Cathleen — Maude Gonne
P.155
George Moore — Edward Martyn & Yeats
Co. founders of the Irish Literary Theatre

P. 166 — Beginning P 55 — continued to pages 100 etc
Irish National Theatre

176-177— W. G. Fay and Frank Fay the Abbey Theatre
1st paragraph P.189 " clearly represented a historical
the Fays — philosophy & tradition entirely opposed to
190 that of Yeats —
(Frank Fay never learned to trust
"The Man of letters in the Theatre")

194— Henry — "Passion (to Yeats) conveyed an intensity
born from the sleepwalking of the unconscious", the
brooding of the mind! —"

204 — Henry Japanese Noh Drama — separated the actor from
the singer. For Yeats — The Dancer — a rapid ecstasy

205- For Henry 1st paragraph — "unconscious body keep the body
still — the mind awake & clear —"

208- " " Dancers 208-209 - Ste. Ninette de Valois-
[248-52] " " Gordon Craig & decorative design to p. 252
248 " " Correspondence Craig & Yeats
297 " " Program note for "Shadowy Waters"
[30 pages 300 + top of 301 —
" " He excelled at Poetic Drama —

314- " " Reaction to Synge's - In the Shadow of the Glen
[332- " " Battle lines between nationalism & art
[3373]
" " 1924 the Irish govt — granted the Abbey Theatre a
Yeats subsidy. The only subsidized theatre in the
English speaking World.
3359

P 175 Failure of Irish Literary Theatre

(P. 313 the motivation Grotowski's + Peters Brooks Deny existence top paragraph —

P 369 - 368 - 369 - 370 etc Irish yeats — Irish
Kratowski - Polish
The unconscious Art and — French root impulses buried deep in the heart of the actor

Peter Brook

Daimons Unity of Being a Vision
Plays.
The Only Jealousy of Emer
The Shadowy Waters
The this King's Threshold
The Herne's Egg
 a full moon in march —
 the most explicit rendering of the
 relationship of the sexes in term
 of a solar & lunar dialect
 to a full moon in march —
 p. 77 —

The death of Cuchulain
 He passes to phases one of the 1939
 lunar cycle —

3 Plays written in old age
 The King of the great clock tower 1939
a full moon in march — 1935
The Herne's Egg 1939
 these three focus on the act of coition
 as a symbol of the supernatural
 in natural life

Plays
on Baile's Strand
 Deirdre ordinary
 which lifted
 human life lifted to the height
 of tragic heroism — p. 49 —

p. 50 —
109 — Words — aesthetic approach — To Henry
110 — Symbolism — well expressed " "
 p. 110 — Stage Scenery — Henry Symbolism pg 110 — 111
 122 — Hen